THE HISTORY OF THE SAATCHI GALLERY

BOOTH-CLIBBORN EDITIONS

Memento Mori:
The YBA Generation
by Richard Cork

SECTION 12
SENSATION:
YOUNG BRITISH ARTISTS FROM
THE SAATCHI COLLECTION
387–405

Mayor Giuliani
Enters Brooklyn
by Steve Martin

SECTION 13
HELL
406–415

SECTION 14
416–431

SECTION 15
YOUNG AMERICANS
433–464

SECTION 16
465–476

SECTION 17
YOUNG GERMAN ARTISTS
476–495

SECTION 18
ALEX KATZ
496–505

SECTION 19
507–513

SECTION 20
514–525

Since 1985 the Saatchi Gallery has presented an ever-changing view of contemporary art from all over the world. It has had a profound influence on how contemporary art is perceived thanks to the vision of one very remarkable man, Charles Saatchi. This book is dedicated to that vision. We have selected 732 of the works Charles has owned in that time.

We by no means show everything he has owned, but the result does represent the eye of the person Sir Norman Rosenthal calls 'the country's greatest curator'.

Curating a book is very different from curating an exhibition, but in this book I have tried to give the reader the experience of walking through an exhibition.

Art will never go back to fixed collections. Charles has brought a new dimension to his gallery through the website he has created, which allows him to open up the world as a source of inspiration. We have just begun to benefit from that. This seems a good moment, then, to look back at the first twenty-five years of his curating.

I first met Charles in 1963 when he was working as an advertising copywriter at Collett, Dickenson, Pearce & Partners, then one of London's most creative advertising agencies. Great talent was working there: film directors Alan Parker, Ridley Scott and Adrian Lynne, producer David Puttnam, among others. Charles was also there, winning awards for the advertisements he wrote. He always had a very good visual sense. In 1968 he left to set up a consultancy with Ross Cramer and John Hegarty and two years later he joined up with his brother Maurice to set up Saatchi & Saatchi, which became one of the world's leading agencies. At that time we did not discuss art. One reason could be that Charles was doing the campaign for the Conservative Party and I was running the campaign for the Labour Party. As history proved, he did a great job.

In 1999 Charles agreed that I should publish Young British Art: The Saatchi Decade. Two years later I published a book of his gallery's exhibition, I Am A Camera, which showed work from his photography collection. Scotland Yard's Vice Squad visited the gallery telling them to remove images of children with masks and I was told to remove every copy of the book from every bookshop. When the Guardian newspaper published the 'offensive images' on their front page, the case was dropped. A third book followed on Damien Hirst.

In 2007 Charles was shown a Kraken Opus and was very impressed by the scale. I then put the idea to him that there should be an Opus on all the art he had ever owned and he readily agreed. I invited Sir Norman Rosenthal, Brian Sewell, Richard Cork and Steve Martin to give their impressions and views. The Saatchi Opus was published in 2009. This, the revised edition, has been updated. While the selection of works does not aim to represent all the art he has owned and many will question it, we hope the result reflects Charles's eye.

He showed his incredible foresight from the beginning. The book starts with Charles's first show at Boundary Road, a converted paint factory of 30,000 square feet, which opened on 15th March 1985, with works by Andy Warhol, Donald Judd, Brice Marden and Cy Twombly, today recognised as among America's greatest artists.

The book moves on from that point by period. The contents page, which lists the artists is your guide, while a timeline of the Saatchi Gallery's history provides a chronology of exhibitions.

One section includes a special focus on the so-called Young British Artists, including Damien Hirst, described to me by Rachel Whiteread in the early 1990s as 'the leader of the pack'. Richard Cork writes on these artists and Steve Martin captures the controversy created when Sensation, the Royal Academy exhibition of their work, travelled to the Brooklyn Museum, New York.

In 2003 Charles left Boundary Road because he wanted to introduce new art to as wide a public as possible and moved to County Hall on London's South Bank by the River Thames. He held a number of shows there before announcing, in 2005, that he was taking over the Duke of York's Headquarters in London's Chelsea, which he launched as the new Saatchi Gallery on 9th October 2008 with The Revolution Continues: New Art from China. Showing work in over 70,000 square feet and fifteen galleries, it has triumphed as one of Europe's largest spaces dedicated to contemporary art. The book ends with Newspeak, the 2010 exhibition of work by young British artists.

I have tried to keep the design and presentation of the book simple, with the minimum text on each page so one's eye concentrates on the works. Value and Service, as designers, have done a remarkable job in leaving plenty of space to show each piece at its best. I selected V&S because youth gives a fresh eye. You could say my view is from a different generation.

Looking at this book I realise that it is a celebration of the development of contemporary art over the last twenty-five years. That is a tribute to what Charles's eye has done in the past to stimulate the art world, and who knows what the future will bring?

1985

Charles Saatchi opens the 30,000-square foot Saatchi Gallery in Boundary Road, London NW8, featuring many key works by Donald Judd, Brice Marden, Cy Twombly and Andy Warhol. For Twombly and Marden this was their first UK exhibition.

1986

The Saatchi Gallery exhibits works by Anselm Kiefer and Richard Serra in their first UK show. The caretaker's flat and one wall of the gallery were demolished in order to allow the installation of large Serra sculptures.

1987

The *New York Art Now* show introduces Jeff Koons, Robert Gober, Ashley Bickerton, Carroll Dunham, Philip Taaffe and other artists to the UK for the first time. The cool blend of minimalism and pop has a profound influence on British art students.

1988–1991

The gallery introduces artists new to the UK, who include Leon Golub, Philip Guston, Sigmar Polke, Bruce Nauman, Richard Artschwager and Cindy Sherman.

1992

The Saatchi Gallery curates the first of a series of shows entitled *Young British Artists*, so coining the name 'YBA' for this generation of artists. Damien Hirst, Marc Quinn, Rachel Whiteread, Gavin Turk, Glenn Brown, Sarah Lucas, Jenny Saville and Gary Hume were all presented to a wider public in these shows.

1997

Sensation: Young British Artists from the Saatchi Collection opens at the Royal Academy of Arts. The exhibition features forty-two artists including Jake and Dinos Chapman, Marcus Harvey, Damien Hirst, Ron Mueck, Jenny Saville, Sarah Lucas and Tracey Emin. *Sensation* attracted over 300,000 visitors, a record-breaking attendance for a contemporary art exhibition in the UK.

The Gallery begins a series of one-person shows of major international artists who have been largely unseen in Britain, including Duane Hanson, Boris Mikhailov and Alex Katz. Shows entitled *Young Americans* and *Young German Artists* introduce a number of artists to the UK including John Currin, Andreas Gursky, Charles Ray, Richard Prince, Lisa Yuskavage and Elizabeth Peyton.

1999

Sensation travels to The National Galerie at the Hamburger Bahnhof in Berlin in the autumn, breaking attendance records.

Sensation tours to Brooklyn Museum, New York, creating unprecedented political and media controversy and becoming a touchstone for debate about the 'morality' of contemporary art. This exhibition also broke the museum's attendance records.

The Saatchi Gallery donates a hundred artworks to the Arts Council Collection of Great Britain, which operates a lending library to museums and galleries around Britain, with the aim of increasing awareness and promoting interest in younger artists.

2000

The Gallery donates forty works by young British artists through the National Arts Collection Fund to eight museum collections across Britain.

2001

I Am a Camera opens at the Gallery. The exhibition of photography and related works blurs traditional boundaries between photography and painting. The show included work by many artists who had never exhibited in the UK.

2002

The Gallery donates fifty artworks to the Paintings in Hospitals programme which provides a lending library of over 3,000 original works of art to National Health Service or public hospitals, hospices and health centres throughout England, Wales and Ireland.

2003

The Saatchi Gallery moves to County Hall, the Greater London Council's former headquarters on the South Bank, creating a 40,000-square foot exhibition space. The opening show included an exhibition of Damien Hirst as well as works by other YBAs such as Jake and Dinos Chapman, Tracey Emin, Jenny Saville and Sarah Lucas. The launch includes a 'nude happening' of 200 naked people staged by artist Spencer Tunick.

2004

A fire in the Momart storage warehouse destroys many works from the collection, including Tracey Emin's *Everyone I Have Ever Slept With 1963–95* ('The Tent'), and Jake and Dinos Chapman's tableau, *Hell*.

2005

The Saatchi Gallery launches a year-long, three-part exhibition, *The Triumph of Painting*. The first of the three exhibitions focuses on a number of influential European painters. Marlene Dumas, Martin Kippenberger, Luc Tuymans, Peter Doig and Jörg Immendorff are followed by Albert Oehlen, Wilhelm Sasnal, Thomas Scheibitz and others.

The gallery announces it is moving to the Duke of York's Headquarters building in Chelsea. This halts London shows while new premises are prepared.

A selection of works from *The Triumph of Painting* is exhibited in Leeds Art Gallery.

2006

The Saatchi Gallery website launches an open-access area on which artists can upload works of art and a biography. The site currently showcases over 140,000 artists' profiles.

USA Today: New American Art from the Saatchi Gallery opens at London's Royal Academy.

2007

Saatchi Online launches a new feature, *Museums Around the World,* in which over 3,000 of the world's leading museums display highlights of their collections and their exhibition programmes. In addition 2,900 universities and art colleges from around the world also display their prospectuses on the site.

USA Today: New American Art from the Saatchi Gallery tours to The State Hermitage Museum, St Petersburg.

2008

The Saatchi Gallery reopens in 70,000 square feet of space in the Duke of York's Headquarters in Chelsea, London. The inaugural exhibition for 2009, *The Revolution Continues: New Art from China,* brings together the work of thirty of China's leading young artists in a wide-reaching survey of recent painting, sculpture and installation. With over 400,000 visitors the show broke the previous attendance record set by *Sensation* for a contemporary art exhibition.

2009

Unveiled: New Art From the Middle East opens in January followed by *Abstract America: New Painting and Sculpture.* In October, *Newspeak: British Art Now* opens at the State Hermitage Museum in St Petersburg, Russia.

In the Gallery's Project Room Will Ryman's *The Bed* is shown in January, the first time the artist's work is exhibited in the UK.

A four-part series called *School of Saatchi* launches on BBC2 in November, exploring the world of contemporary art through a nationwide search to find one artist to show their work in *Newspeak: British Art Now* at the State Hermitage Museum in St Petersburg, Russia and at the Saatchi Gallery in London. Eugenie Scrase is chosen as the winner. She is also given a free studio for three years.

The first two exhibitions since the Gallery moved to the Duke of York's Headquarters, Chelsea — *The Revolution Continues: New Art from China* and *Unveiled: New Art from the Middle East* — were ranked as the first and second most visited shows in London in *The Art Newspaper*'s survey of 2009 attendance figures.

2009

The Saatchi Gallery attracted over 1.2 million visitors in its first year since relocating to Chelsea.

The Gallery continues its support of emerging artists with *New Sensations*, a prize for art graduates run with Channel 4. The exhibition of 20 shortlisted artists is shown at the A Foundation in London, and four films about the four finalists are aired on Channel 4. The Prize is won by Oliver Beer from the Ruskin School of Drawing and Fine Art, Oxford.

2010

The first show of the year at the Gallery is *The Empire Strikes Back: Indian Art Today,* followed in May by Part I of *Newspeak: British Art Now. Part II* opens in October. In January the Gallery's Project Room presents Emily Prince's *American Servicemen and Women Who Have Died in Iraq and Afghanistan (but not Including the Wounded, nor the Iraqis nor the Afghans),* an ongoing tribute to every American soldier killed in Iraq and Afghanistan since 2004.

The Silk Road, organised by lille3000, opens at the Tri Postal in Lille in October, presenting works from the Saatchi Gallery by Chinese, Indian, Iranian, Palestinian, Lebanese, Egyptian, Afghan and Pakistani artists.

The winner of the Saatchi Gallery and Channel 4's *New Sensations* Prize for graduates, now in its fourth year, is Nika Neelova from the Slade School of Fine Art. The exhibition of 20 shortlisted artists opens during Frieze Week and Channel 4 shows four films about the finalists during October.

EDWARD BOOTH-CLIBBORN founded Booth-Clibborn Editions as an independent publishing house in London in 1974. Since then he has earned a worldwide reputation for groundbreaking visual books on fine art and popular culture. He works in close collaboration with authors, artists, institutions and publishing partners, such as Sir Anthony Gormley, Damien Hirst, Mark Quinn, Bard College (United States), Iran University Press, The State Hermitage Museum (Russia) and the BBC.

RICHARD CORK is an award-winning art critic, historian, broadcaster and exhibition curator. Four acclaimed paperbacks of his critical writings on modern art were published by Yale University Press in 2003. A frequent contributor to BBC radio and television programmes, he has organised exhibitions at the Tate, The Hayward Gallery, the Royal Academy of Arts and elsewhere in Europe. He has acted as a judge for many leading art prizes and commissions, among them the Turner Prize. His books include *Vorticism & Abstract Art in the First Machine Age*, awarded the John Llewellyn Rhys Prize (1977), *Art Beyond the Gallery*, winner of the Banister Fletcher Award in 1985, a monograph on David Bomberg (1987), and *A Bitter Truth: Avant-Garde Art and the Great War*, winner of a National Art Fund Award (1995).

STEVE MARTIN, the multi-talented Grammy® and Emmy award winning actor, comedian, musician, art collector and bestselling author, has proven his star power as one of the most diversified performers in the entertainment industry today. Notable film credits include *The Jerk, Roxanne, Dirty Rotten Scoundrels, Father of the Bride, Sgt. Bilko, Bowfinger, Cheaper by the Dozen, Shopgirl*, which he adapted to the screen from his bestselling novella of the same name, and *The Pink Panther*. In 2008 Martin released his autobiography, *Born Standing Up*, a New York Times bestseller, which chronicles his early years as a stand-up comic. Most recently he has made a successful foray into the music world with the release of his first bluegrass album, *The Crow: New Songs for the Five-String Banjo*.

NORMAN ROSENTHAL was Exhibition Secretary of the Royal Academy of Arts, London from 1977 to December 2007. During that period he was in charge of the enabling and organisation of all loan exhibitions, among them significant contemporary shows: *Robert Motherwell* (1978), *A New Spirit in Painting* (1981), *Sensation* (1997), *Apocalypse: Beauty and Horror in Contemporary Art* (2000), *Frank Auerbach* (2001), *Georg Baselitz* (2007). In Berlin he was co-responsible for groundbreaking exhibitions *Zeitgeist* (1982), *Metropolis* (1991) and *The Age of Modernism — Art in the 20th Century* (1997). Since leaving the Royal Academy, he works as a freelance consultant and curator to museums, private galleries and individuals in Europe, Turkey and the USA. He sits on various boards connected to the arts. He was knighted in 2007.

BRIAN SEWELL has since 1984 been the art critic of the London *Evening Standard* and one of its political commentators, winning national and international press awards in both spheres. A graduate of the Courtauld Institute, he has written exhibition catalogues for the Royal Academy of Arts, the British Council and the Council of Europe, contributed to the catalogues of the Royal Collection, worked for Christie's, the international art auctioneers, as an expert on paintings and drawings by old masters, and been a consultant to museums and galleries in the USA, Germany, Switzerland and South Africa. As an occasional relief from western art he has, in Turkey, spent many months making inventories of early churches in Cappadocia and the old Armenian provinces. For mischief he performs with tongue in cheek on radio and television.

CHARLES SAATCHI founded the Saatchi & Saatchi advertising agency in 1970. It quickly grew to become the largest in the world. He started collecting art about the same time and opened his first gallery, a 30,000-square foot ex-paint factory in Boundary Road, London in 1985. In October 2008 he opened the new Saatchi Gallery in the Duke of York's Headquarters, King's Road, London.

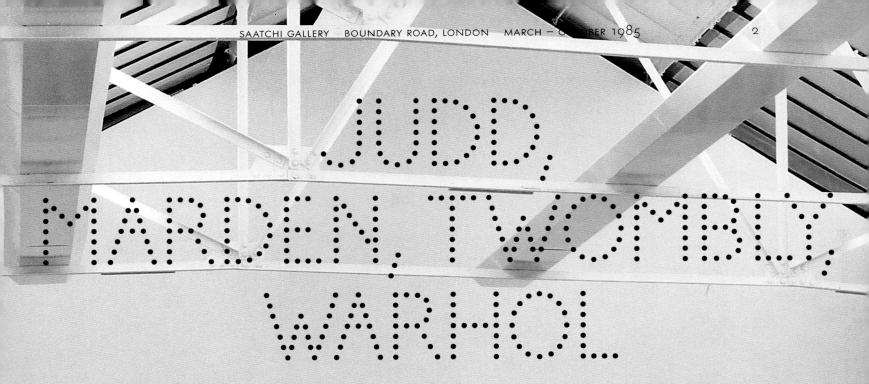

ANDY WARHOL
LEFT TO RIGHT
Marilyn × 100 1962 Acrylic and silkscreen on canvas 205.7 × 567.7 cm 81 × 223½"
Most Wanted Man No. 11, John Joseph H. 1963 Silkscreen on canvas (2 panels) 122 × 203.2 cm 48 × 80"

ANDY WARHOL *Most Wanted Man No. 11, John Joseph H.* 1963 Silkscreen on canvas (2 panels) 122 × 203.2 cm 48 × 80"

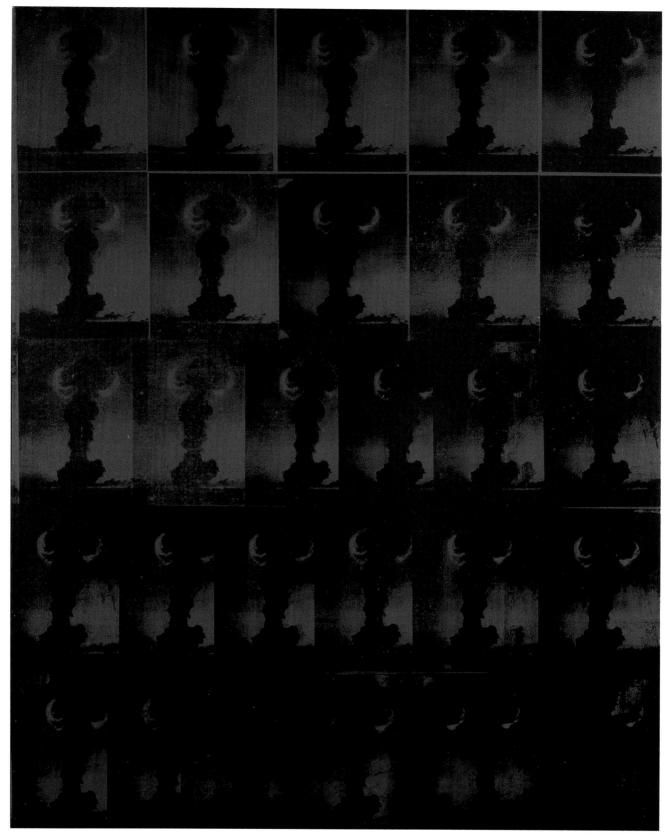

ANDY WARHOL *Atomic Bomb* 1965 Silkscreen on canvas 264 × 204.5 cm 104 × 80½"

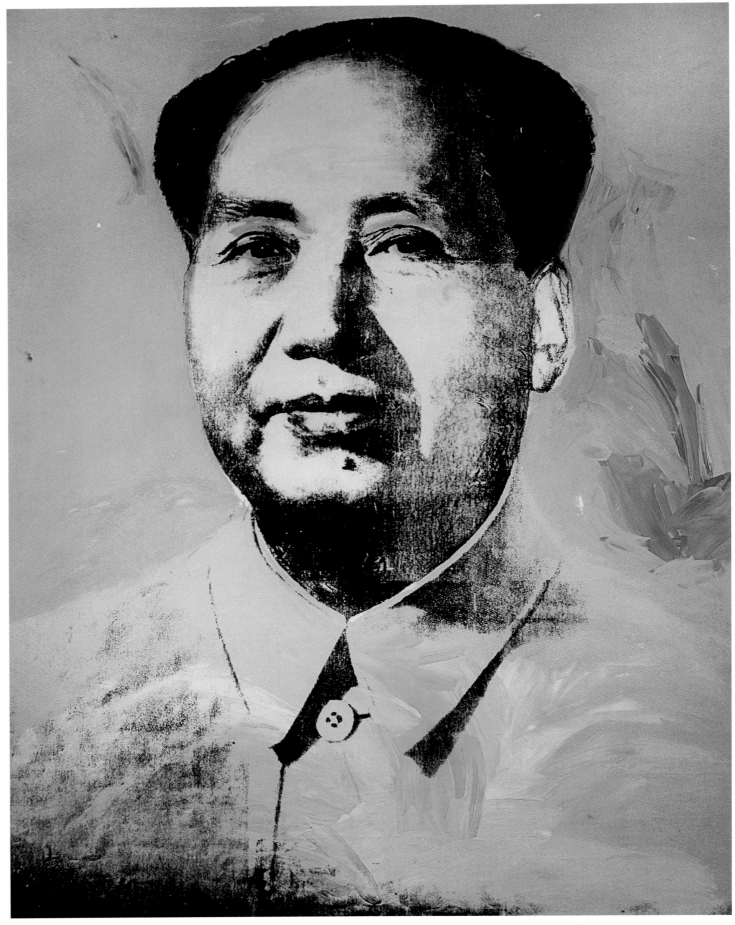

ANDY WARHOL Mao 1973 Acrylic and silkscreen on canvas 448.3 × 346.1 cm 176½ × 136¼"

ANDY WARHOL Mao 1073 (detail)

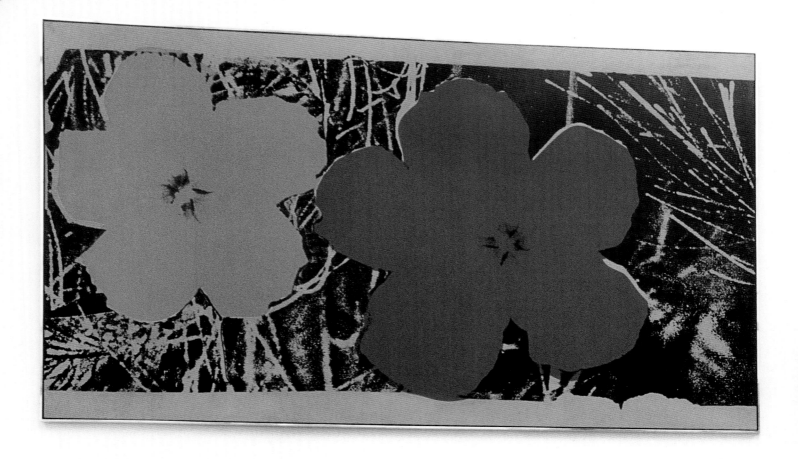

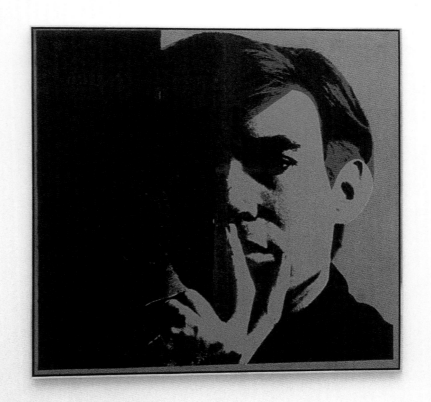

9

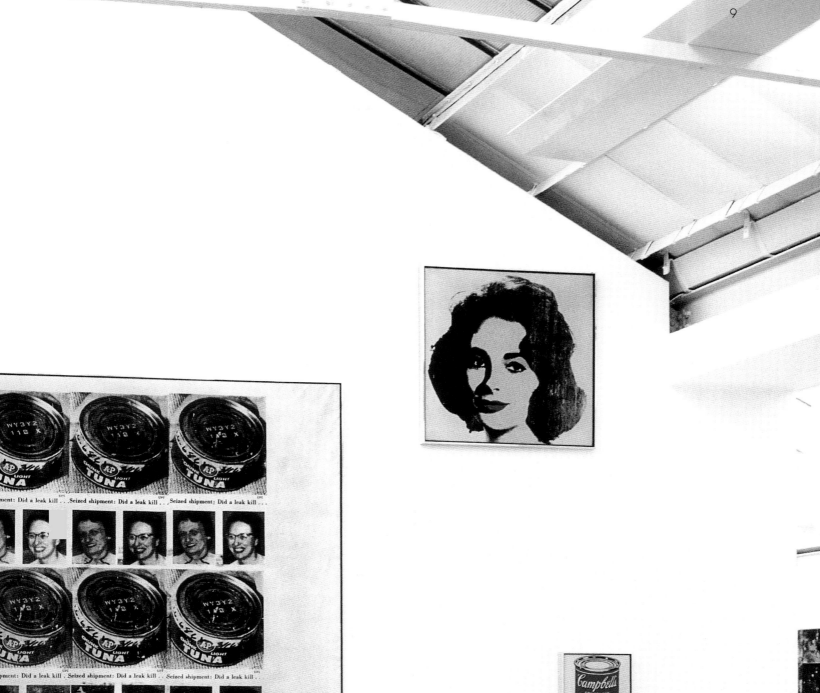
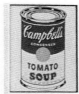

ANDY WARHOL
TOP ROW LEFT TO RIGHT
Flowers 1966 Acrylic and silkscreen enamel on canvas 207.6 × 356.9 cm 81¾ × 140½"
Liz 1964 Synthetic polymer paint and silkscreen on canvas 101.6 × 101.6 cm 40 × 40"
BOTTOM ROW LEFT TO RIGHT
Self-portrait 1967 Acrylic and silkscreen on canvas 183 × 183 cm 72 × 72"
Tunafish Disaster 1963 Synthetic polymer paint and silkscreen on canvas 316 × 211 cm 124½ × 83"
Campbell's Soup Can 1962 Oil on canvas 50.8 × 40.6 cm 20 × 16"

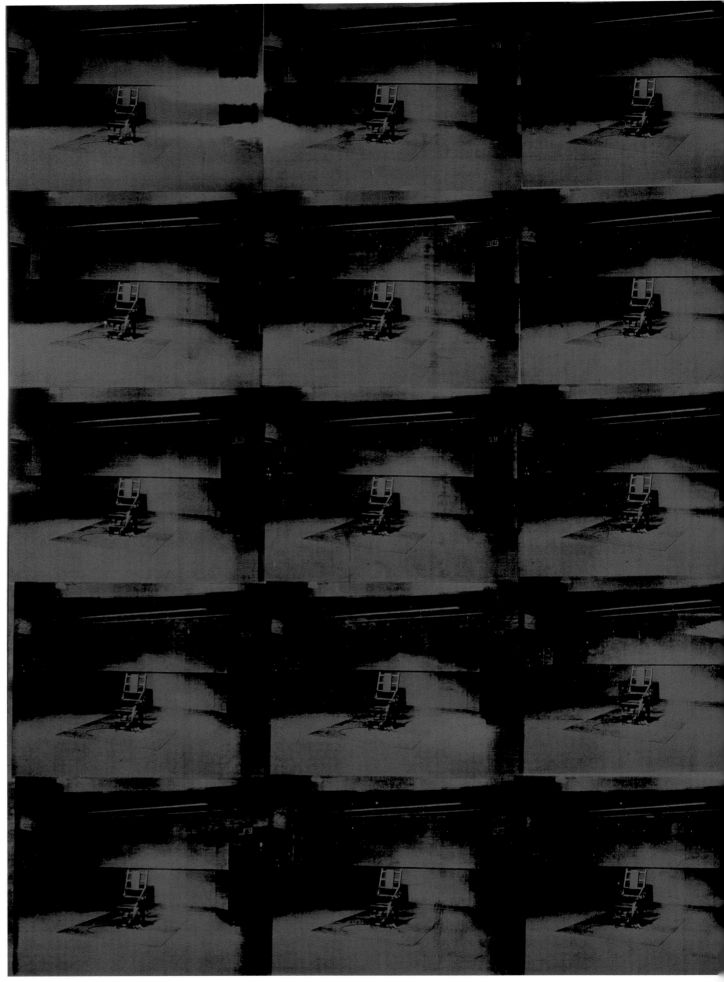

ANDY WARHOL *Blue Electric Chair* 1963 Acrylic and silkscreen on canvas (2 panels) 266.7 × 407.6 cm 105 × 160½"

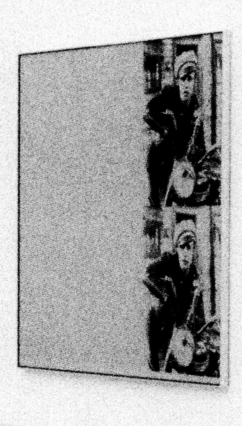
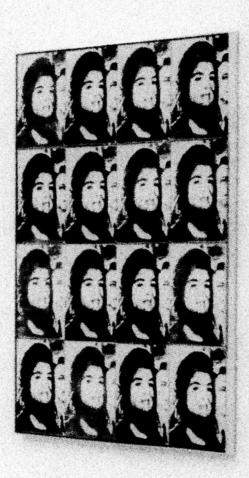

ANDY WARHOL
LEFT TO RIGHT
Double Marlon 1966 Printers ink and silkscreen on canvas 213.4 x 243.2 cm 84 x 95¾"
Jackie 1965 Synthetic polymer paint and silkscreen on canvas (16 panels) 203.2 x 162.6 cm 80 x 64"
Triple Elvis 1962 Acrylic and silkscreen on canvas 208.3 x 299.7 cm 82 x 118"

ANDY WARHOL *Triple Elvis* 1962 Acrylic and silkscreen on canvas 208.3 × 299.7 cm 82 × 118" (detail)

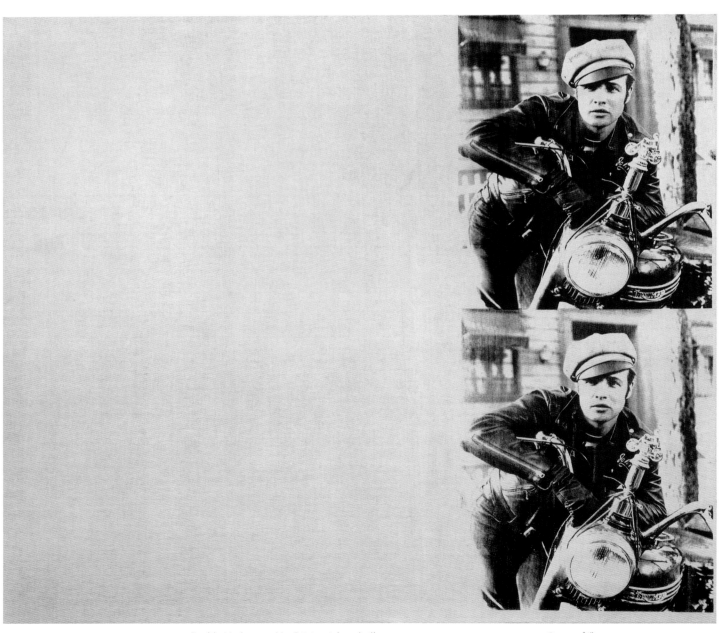

ANDY WARHOL *Double Marlon* 1966 Printers ink and silkscreen on canvas 213.4 × 243.2 cm 84 × 95¾"

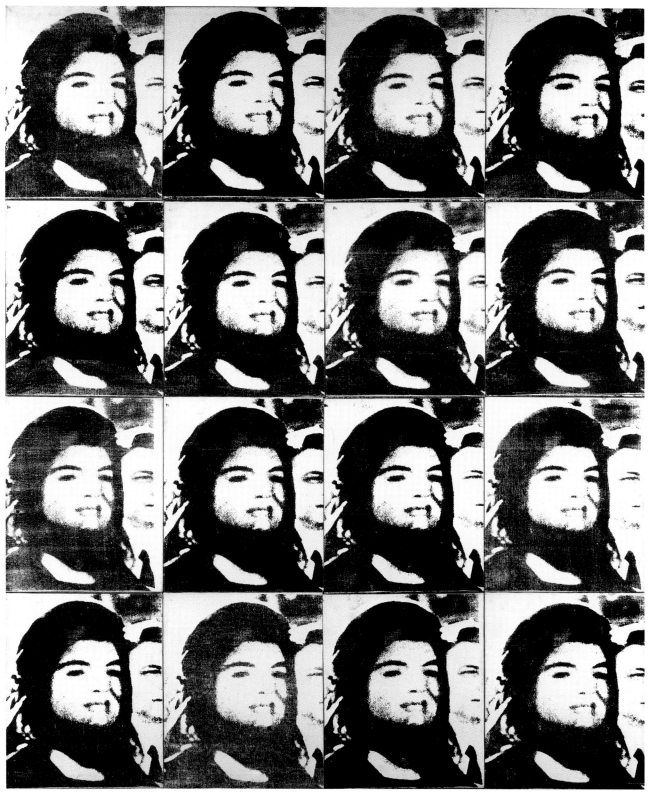

ANDY WARHOL *Jackie* 1965 Synthetic polymer paint and silkscreen on canvas (16 panels) 203.2 × 162.6 cm 80 × 64"

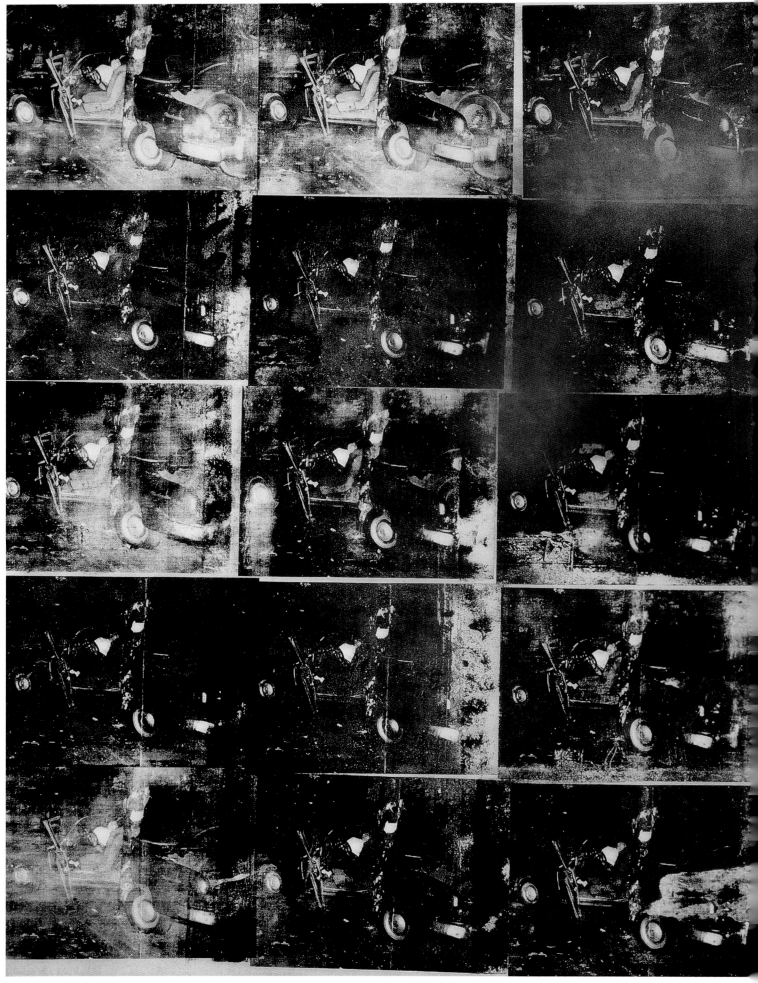

ANDY WARHOL *Double Disaster: Silver Car Crash* 1963 Silkscreen on canvas (2 panels) 266.7 × 421.6 cm 105 × 166"

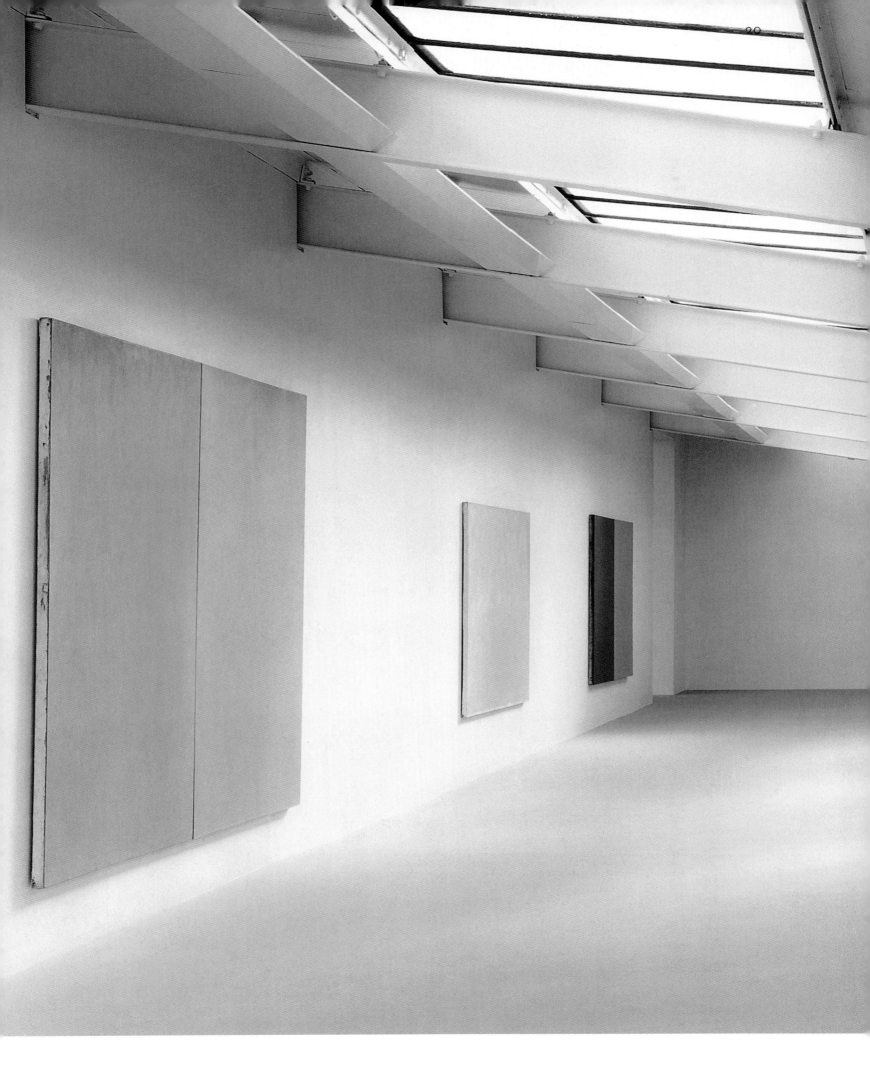

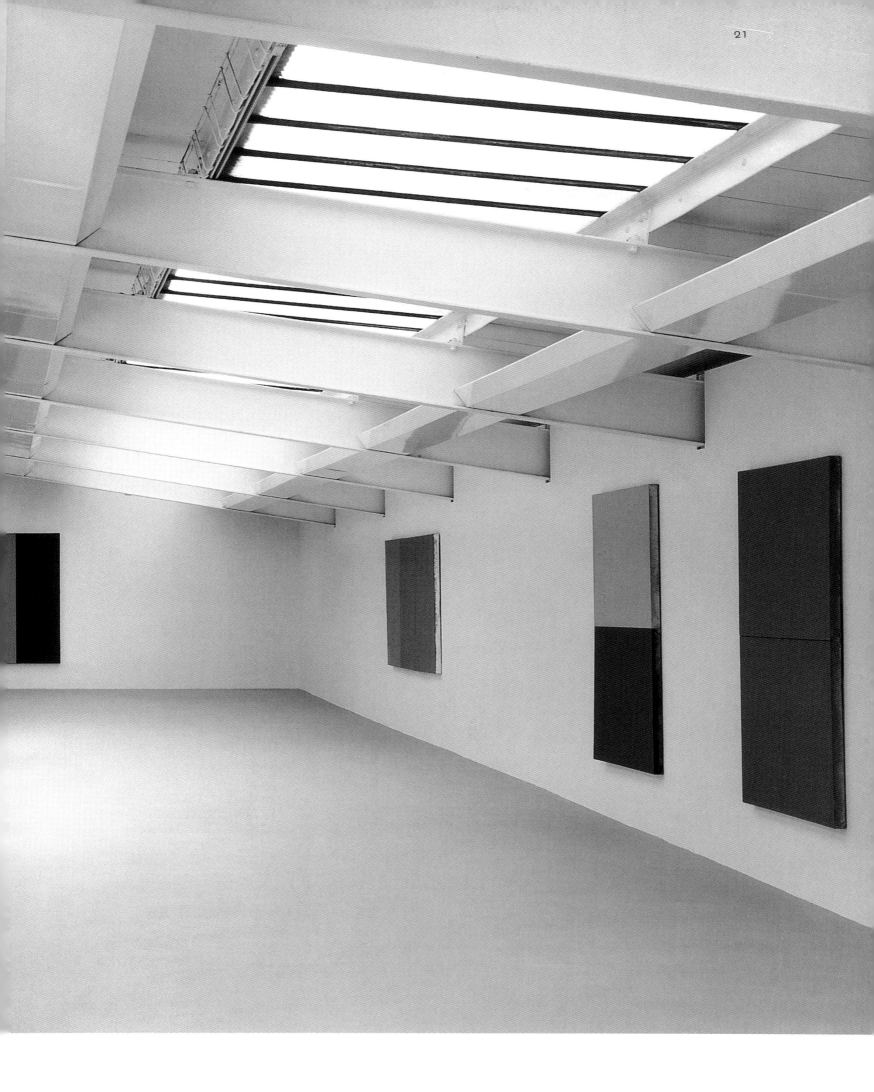

BRICE MARDEN INSTALLATION VIEW

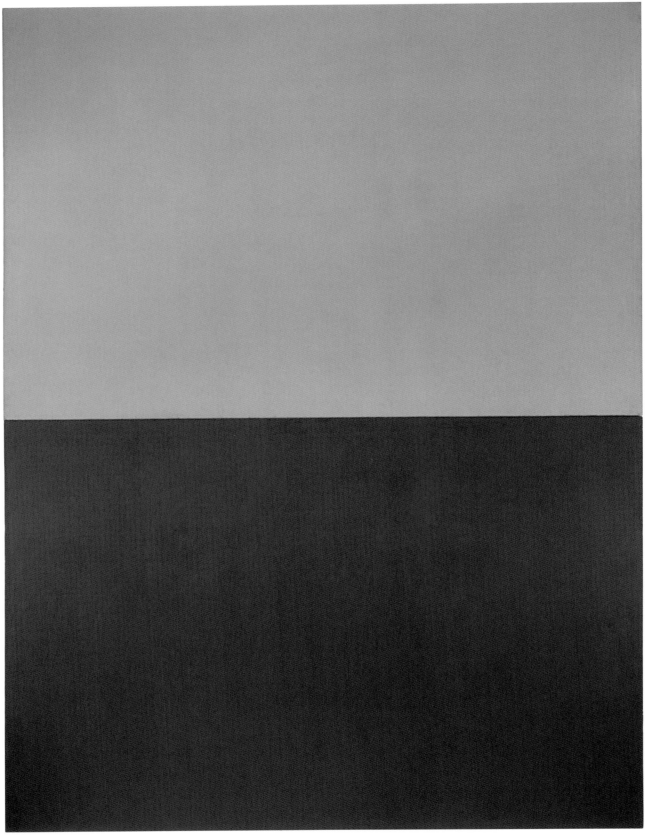

BRICE MARDEN *Sea Painting I* 1973–74 Oil and wax on canvas (2 panels) 183 × 137.8 cm 72 × 54¼"

BRICE MARDEN 4:1 (for David Novros) 1966 Oil and wax on canvas 152.4 × 165 cm 60 × 65"

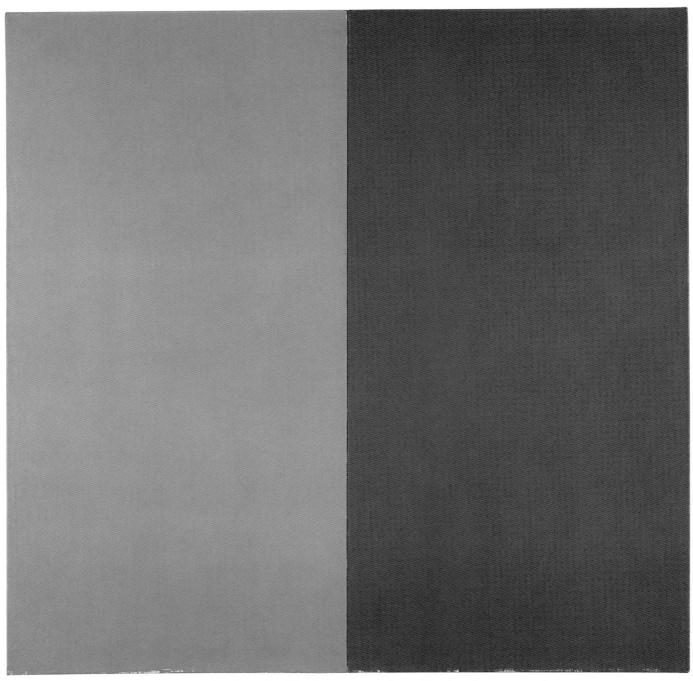

BRICE MARDEN *Blunder* 1969 Oil and wax on canvas (2 panels) 183 x 183 cm 72 x 72"

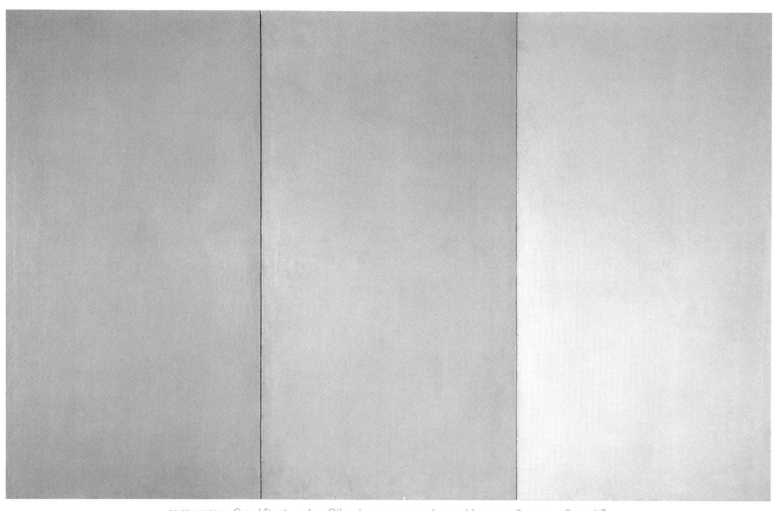

BRICE MARDEN *Grand Street* 1969 Oil and wax on canvas (3 panels) 122 × 183.5 cm 48 × 72¼"

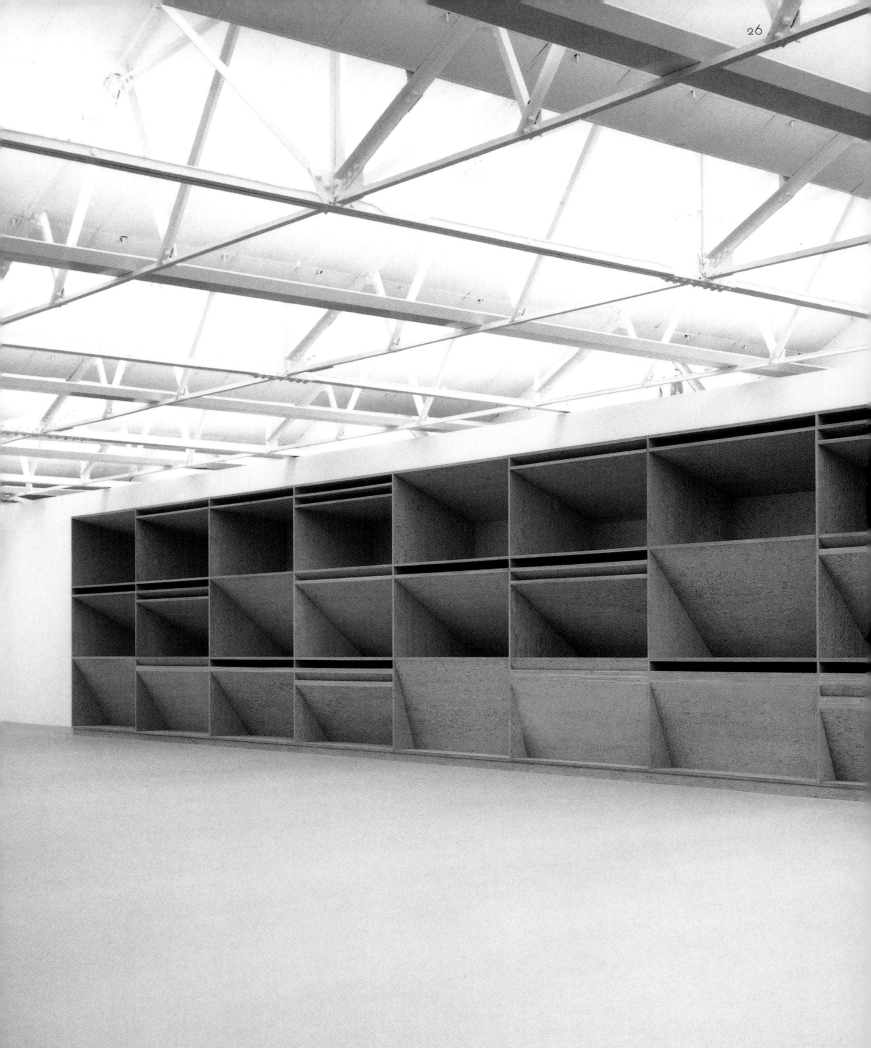

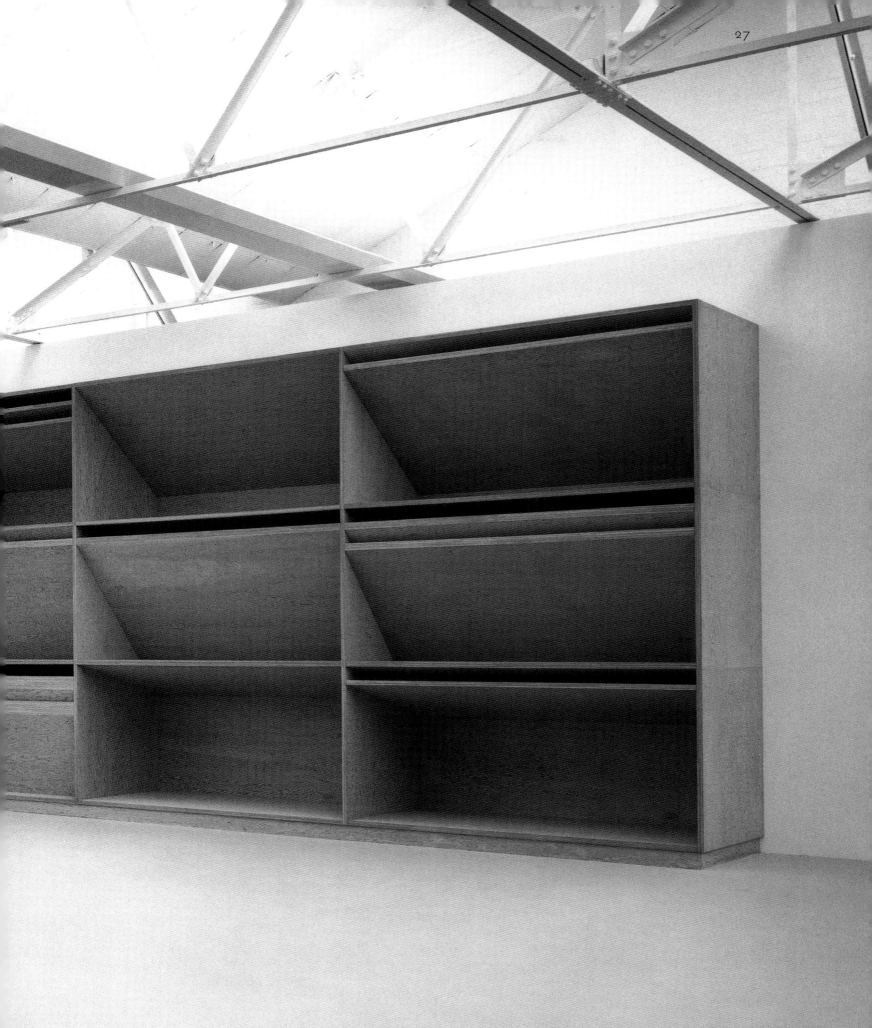

DONALD JUDD *Untitled* 1981 Plywood 352.1 × 2356.2 × 116.2 cm 138½ × 927½ × 45¾"

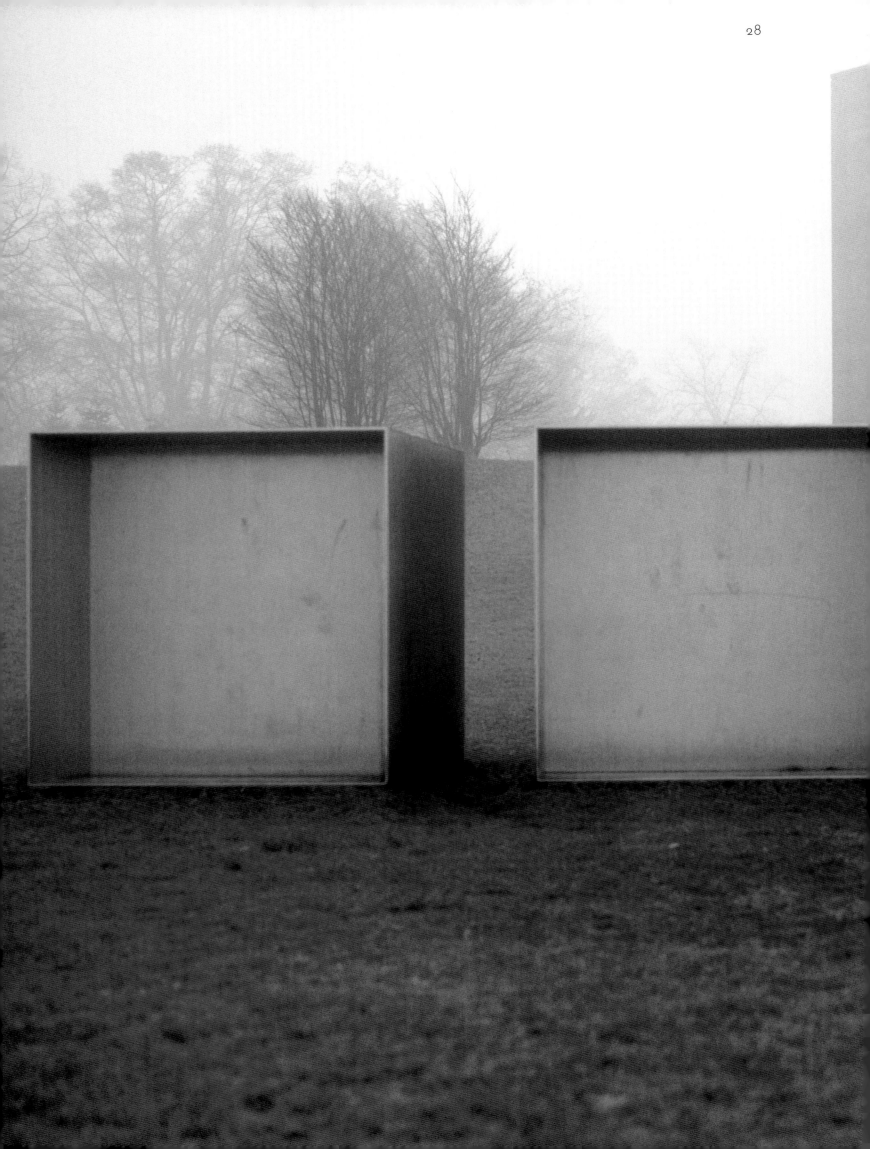

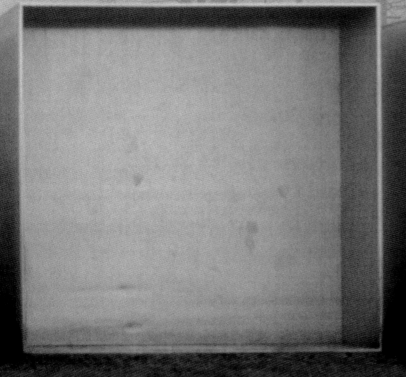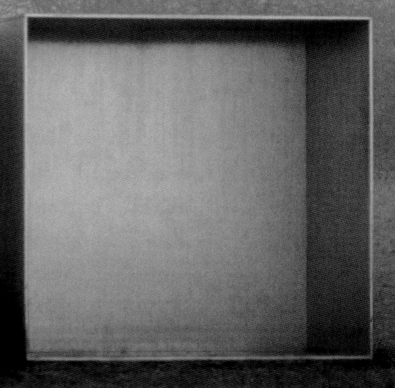

DONALD JUDD *Untitled* 1977 Stainless steel and nickel (4 units) Each unit: 150 × 150 × 150 cm 59 × 59 × 59"

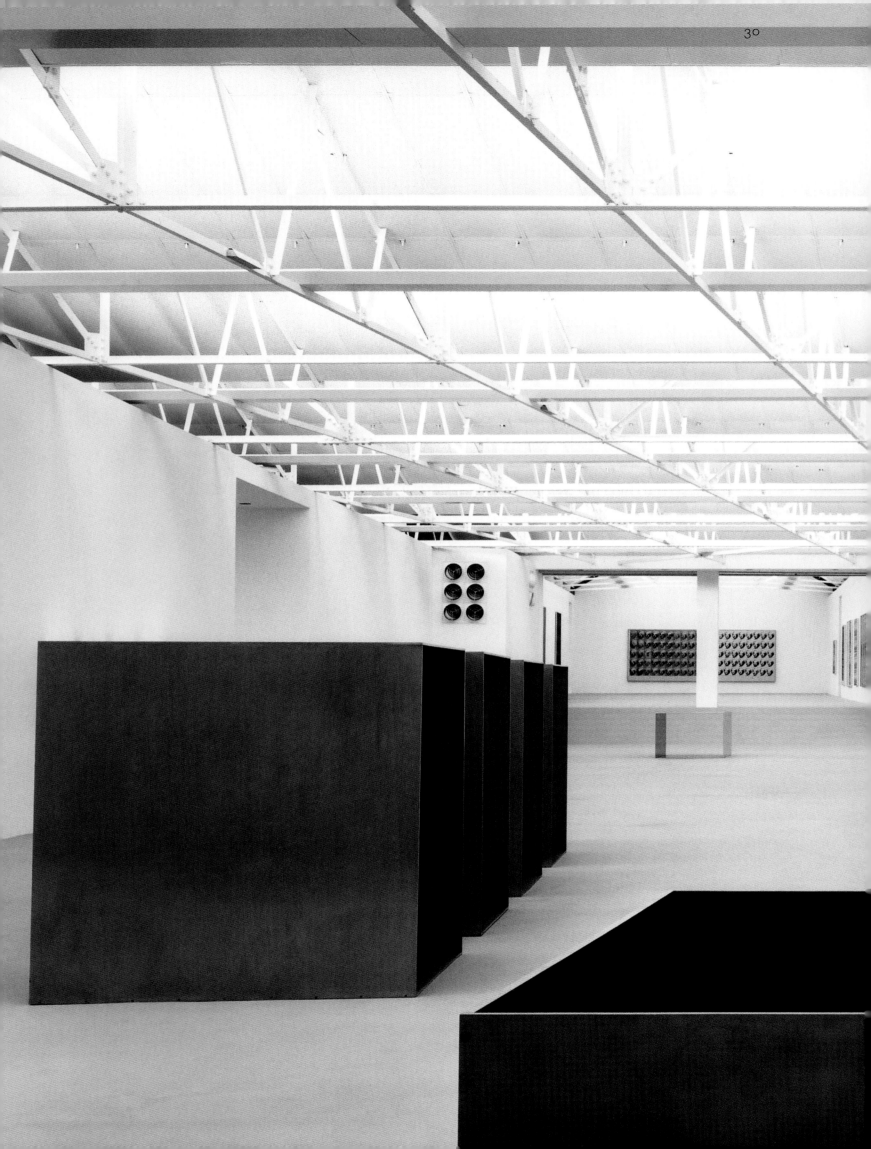

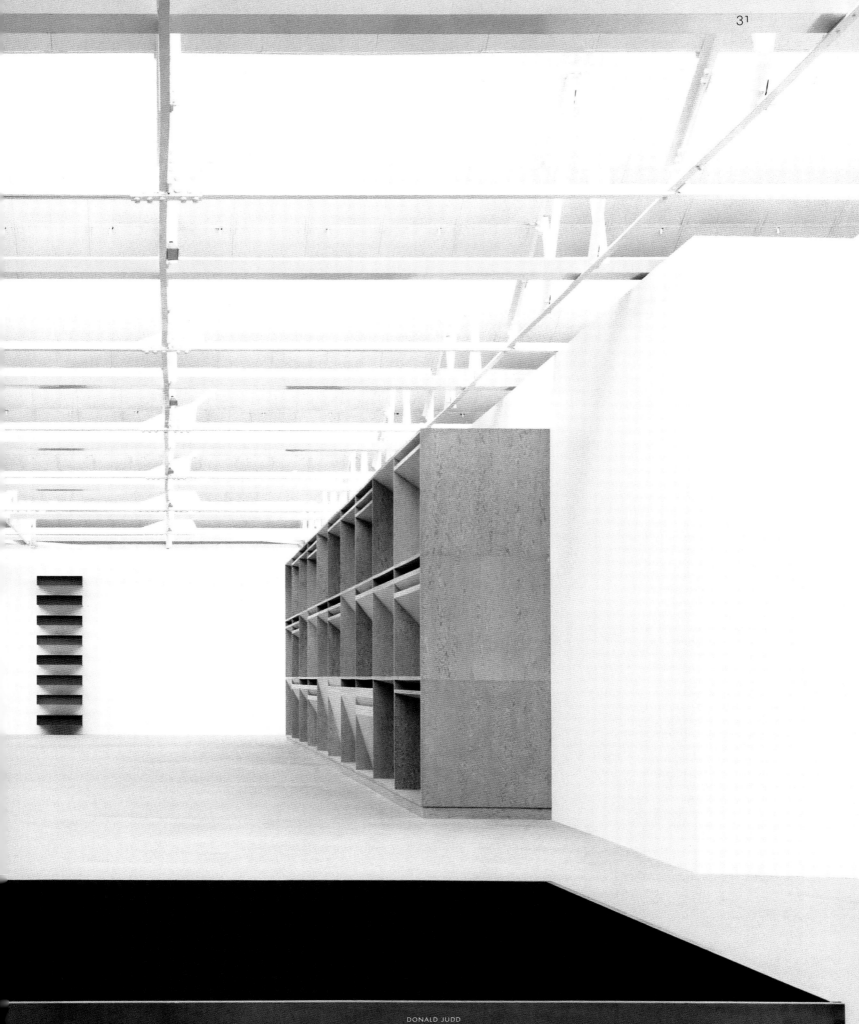

DONALD JUDD
CLOCKWISE FROM LEFT
Untitled 1977 Stainless steel and nickel (4 units) Each unit: 150 × 150 × 150 cm 59 × 59 × 59"
Untitled 1969 Clear anodised aluminium and violet plexiglass 83.8 × 172.7 × 152.4 cm 33 × 68 × 48"
Untitled 1978 Stainless steel and green adonised aluminium (10 units in all) Each unit: 23 × 101.6 × 78.7 cm 9 × 40 × 31"
Untitled 1981 Plywood 352.1 × 2356.2 × 116.2 cm 138½ × 927½ × 45¾"
Untitled 1973 Copper, aluminium and red lacquer 91.4 × 152.4 × 152.4 cm 36 × 60 × 60"

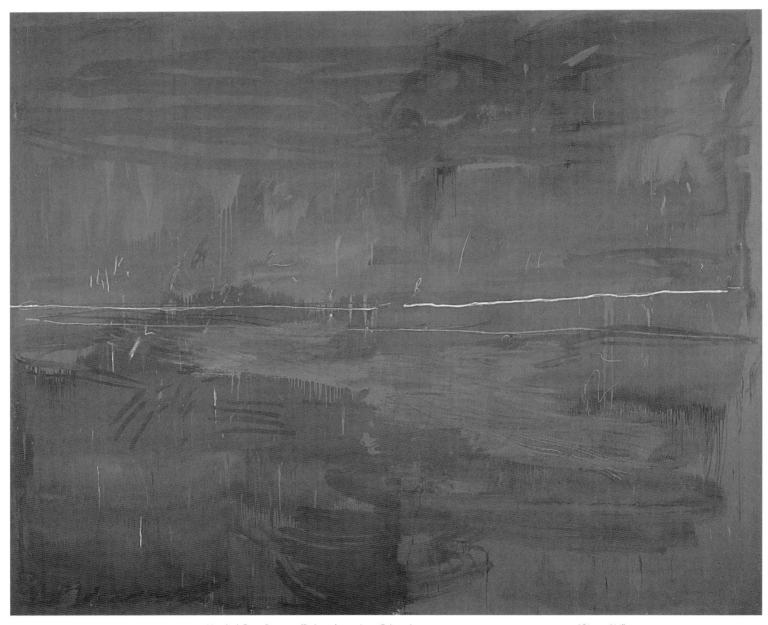

CY TWOMBLY *Untitled Grey Painting (Bolsena)* 1969 Oil and crayon on canvas 200 × 250 cm 78¾ × 98⅛"

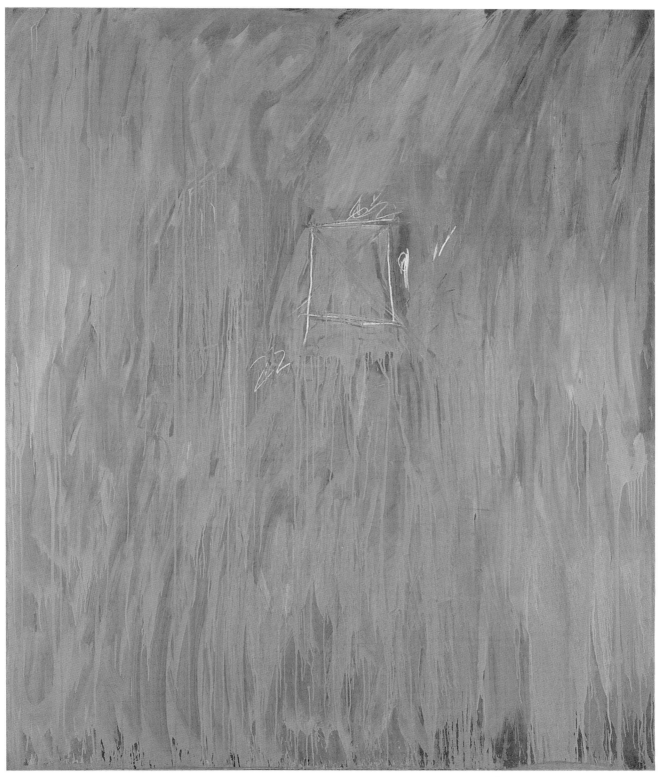

CY TWOMBLY *Untitled* 1969 House paint and crayon on canvas 200 × 166 cm 78¾ × 65¼"

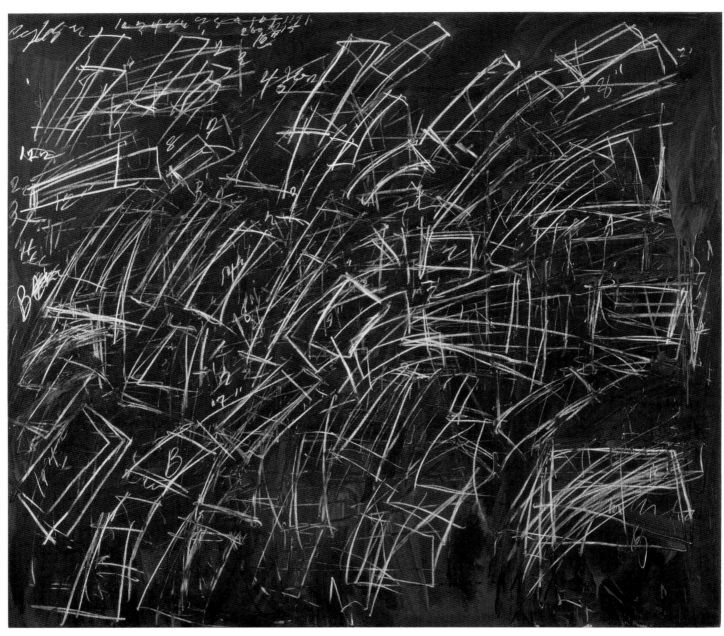

CY TWOMBLY *Untitled* 1968 Oil and crayon on canvas 150 × 170 cm 60 × 68"



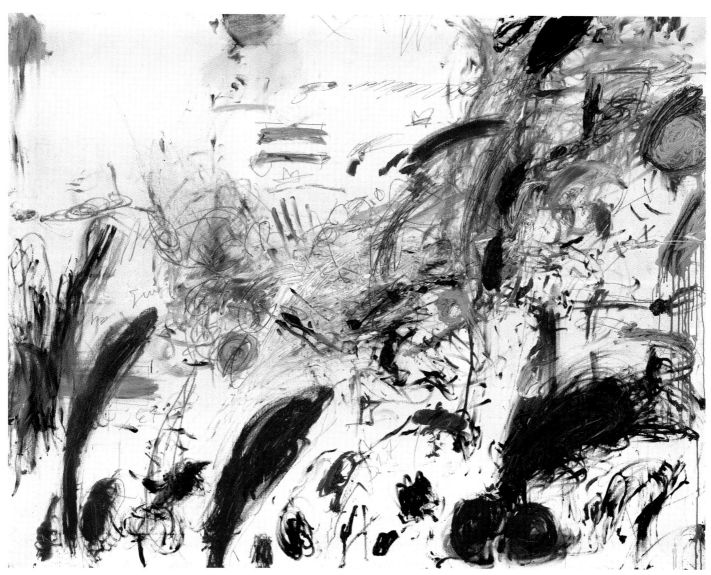

CY TWOMBLY *Red Painting* 1961 Oil, crayon and pencil on canvas 165 × 203 cm 66 × 80"

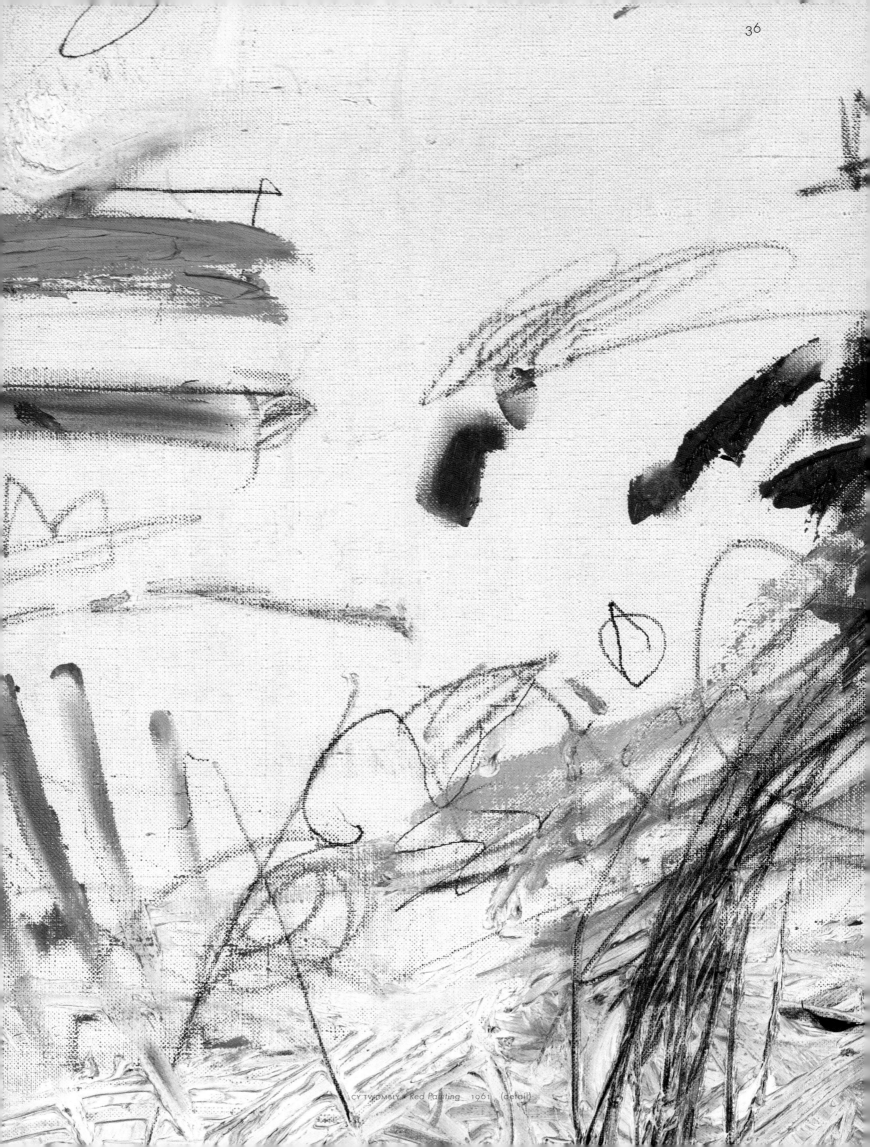

CY TWOMBLY : Red Painting 1961 (detail)

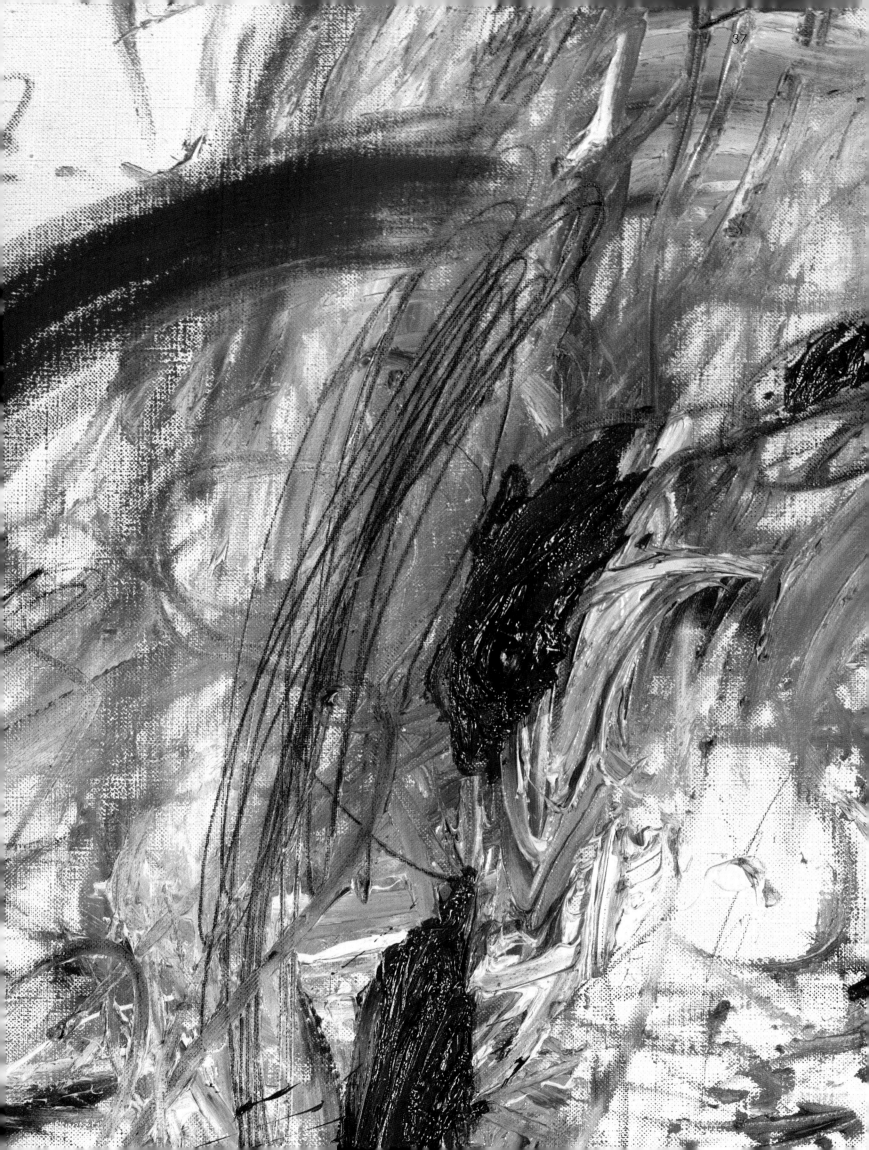

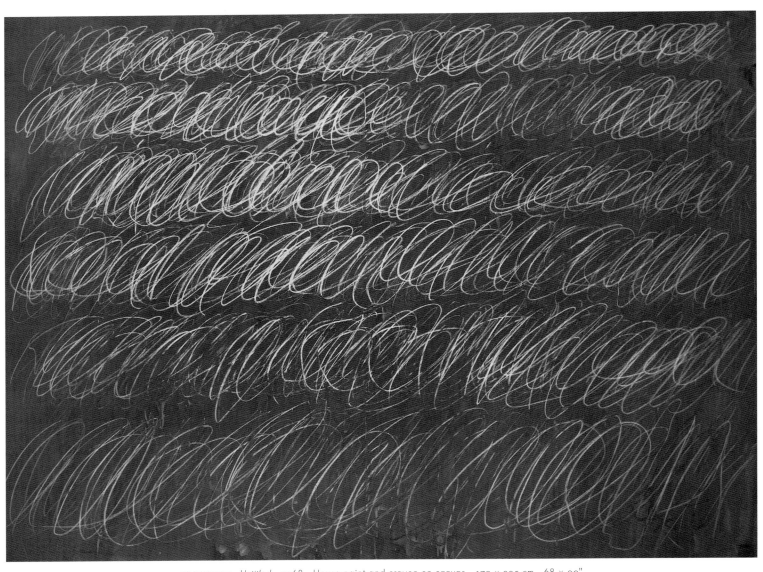

CY TWOMBLY *Untitled* 1968 House paint and crayon on canvas 170 × 225 cm 68 × 90"

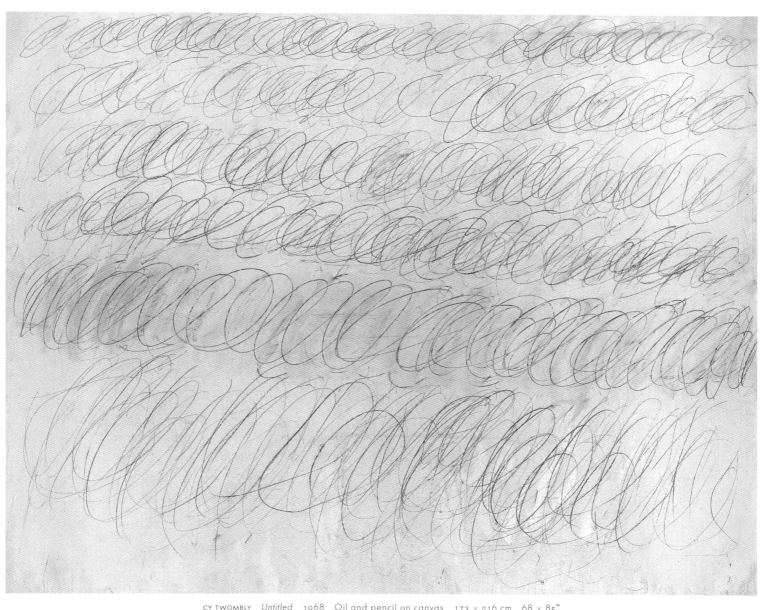

CY TWOMBLY *Untitled* 1968 Oil and pencil on canvas 173 × 216 cm 68 × 85"

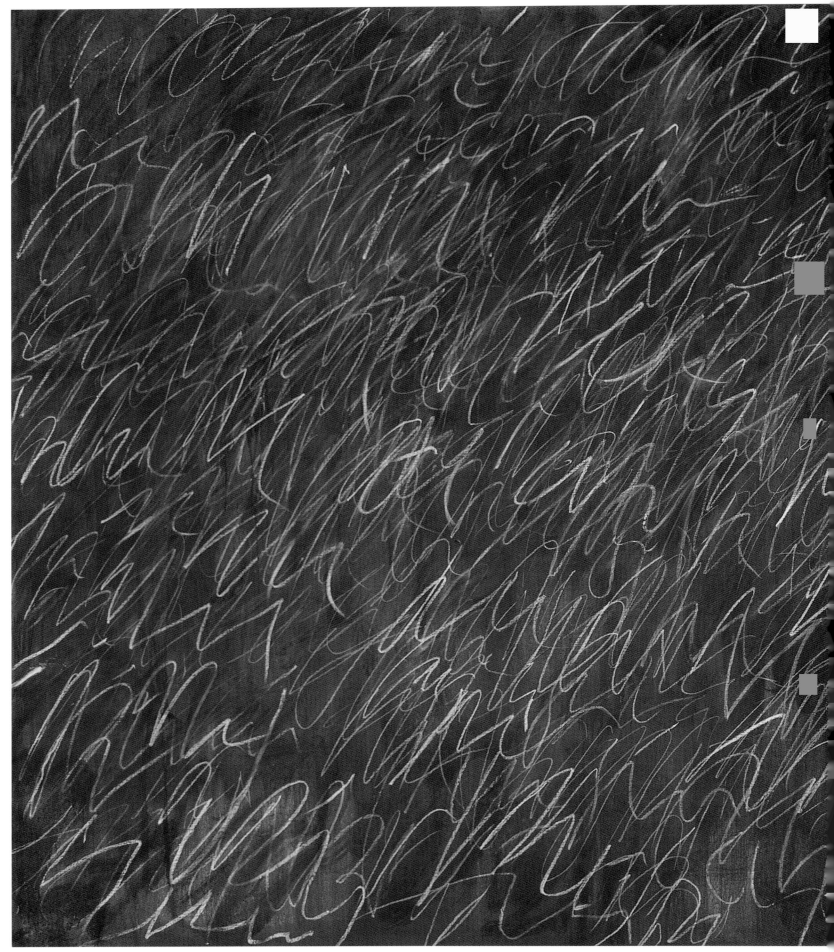

CY TWOMBLY *Untitled* 1971 Oil and crayon on canvas 300 × 478 cm 118 × 188¼"

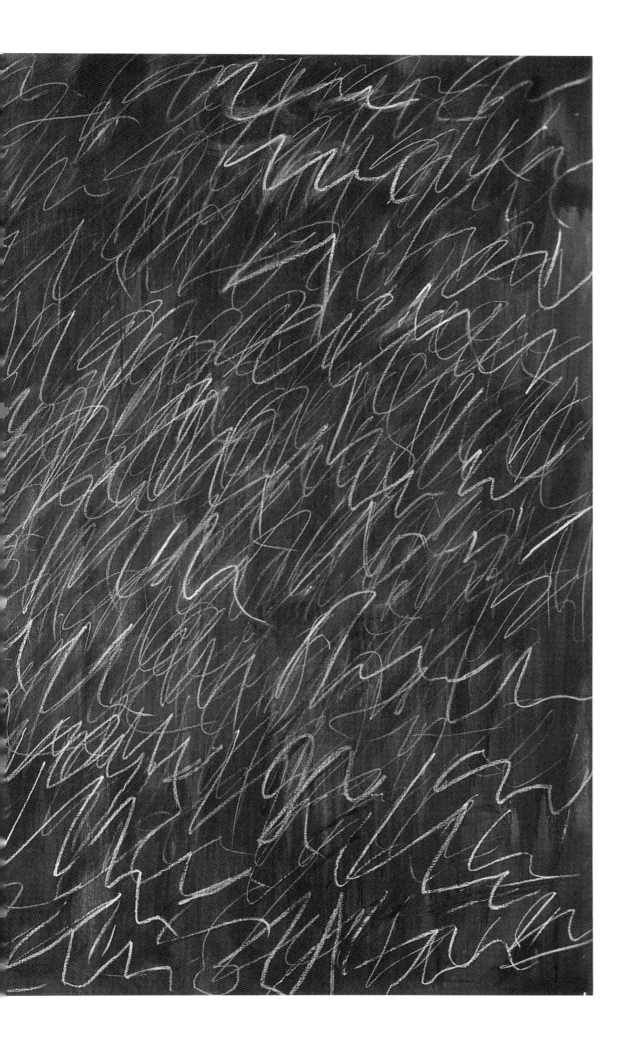

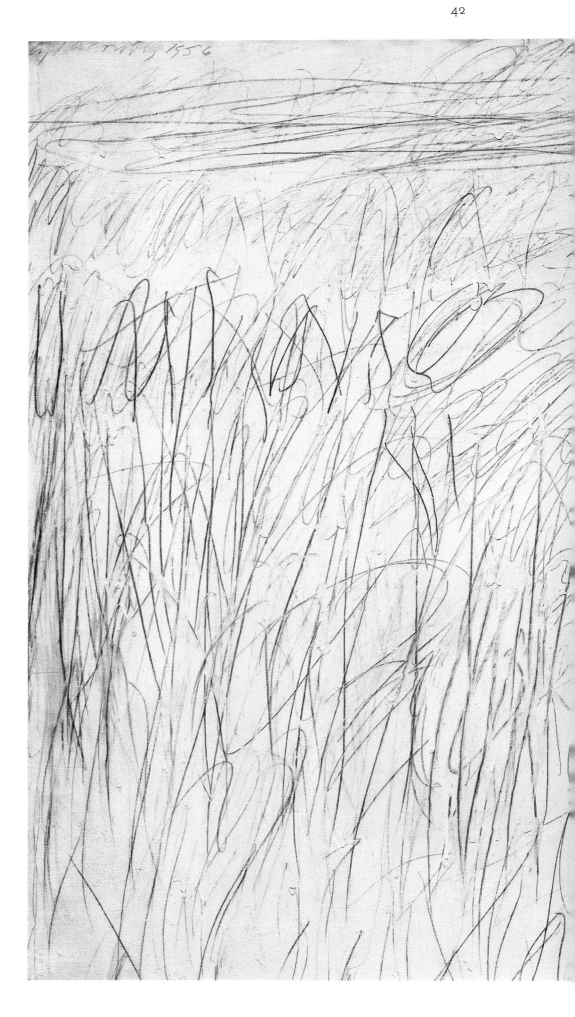

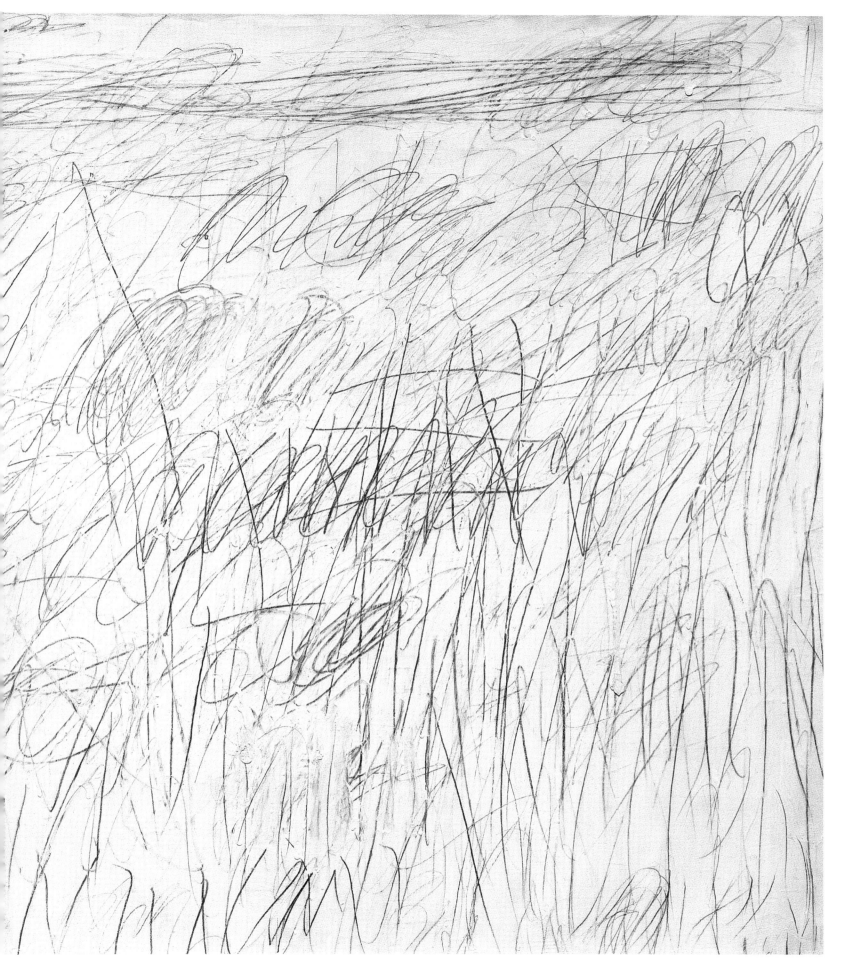

CY TWOMBLY *Untitled* 1956 Oil, crayon and pencil on canvas 122.2 × 175.3 cm 48 × 69"

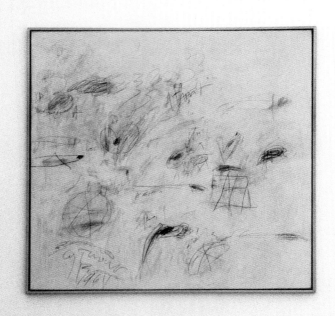

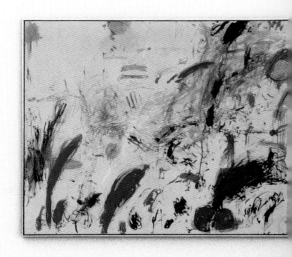

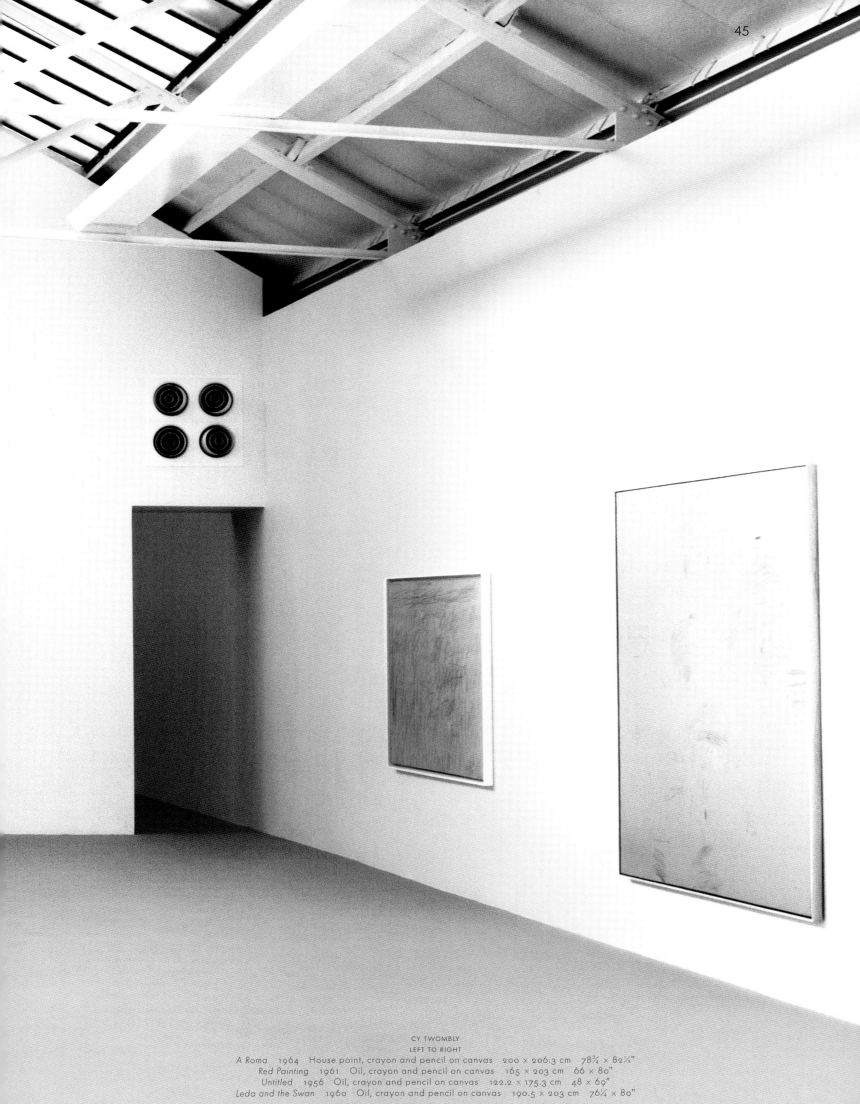

CY TWOMBLY
LEFT TO RIGHT
A Roma 1964 House paint, crayon and pencil on canvas 200 × 206.3 cm 78¾ × 82½"
Red Painting 1961 Oil, crayon and pencil on canvas 165 × 203 cm 66 × 80"
Untitled 1956 Oil, crayon and pencil on canvas 122.2 × 175.3 cm 48 × 69"
Leda and the Swan 1960 Oil, crayon and pencil on canvas 190.5 × 203 cm 76¼ × 80"

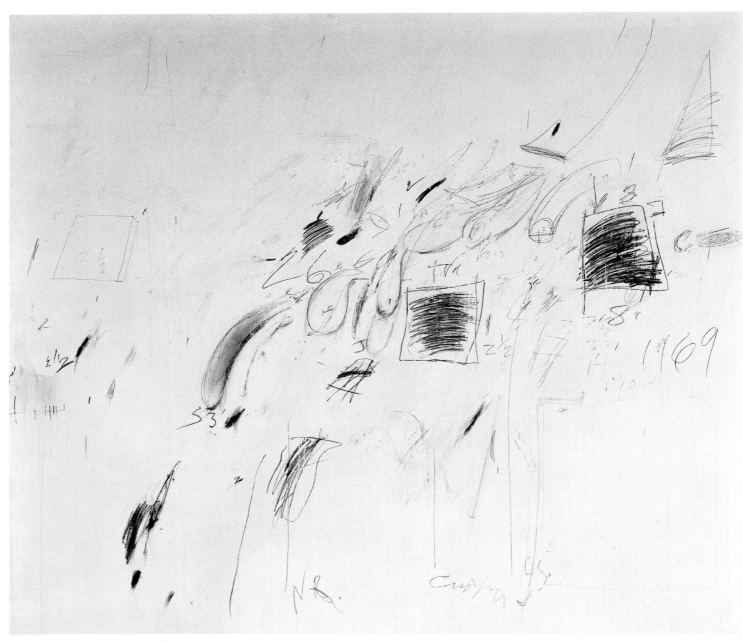

CY TWOMBLY *Untitled (Bolsena)* 1969 House paint, oil, crayon and pencil on canvas 200 × 250 cm 78¾ × 98½"

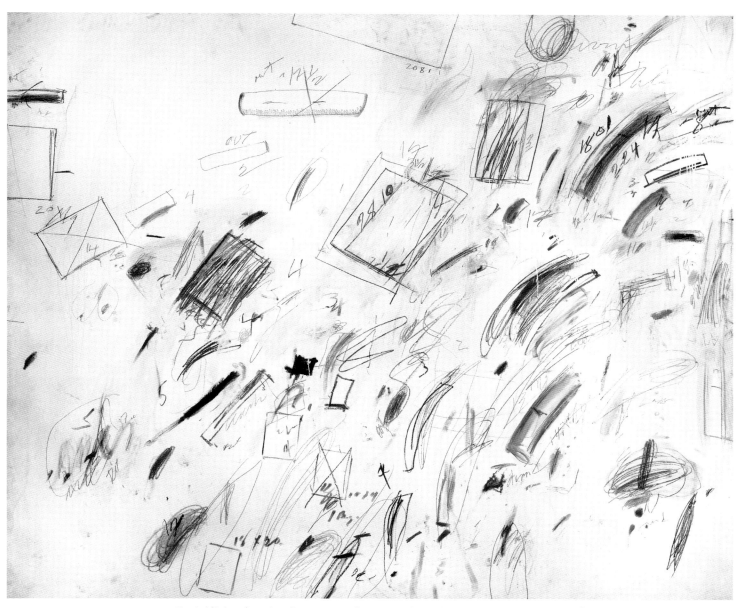

CY TWOMBLY *Untitled (Bolsena)* 1969 House paint, oil, crayon and pencil on canvas 200 × 250 cm 78¾ × 98½"

CY TWOMBLY *Sahara* 1960 Oil, crayon and pencil on canvas 203 × 275 cm 80 × 110"

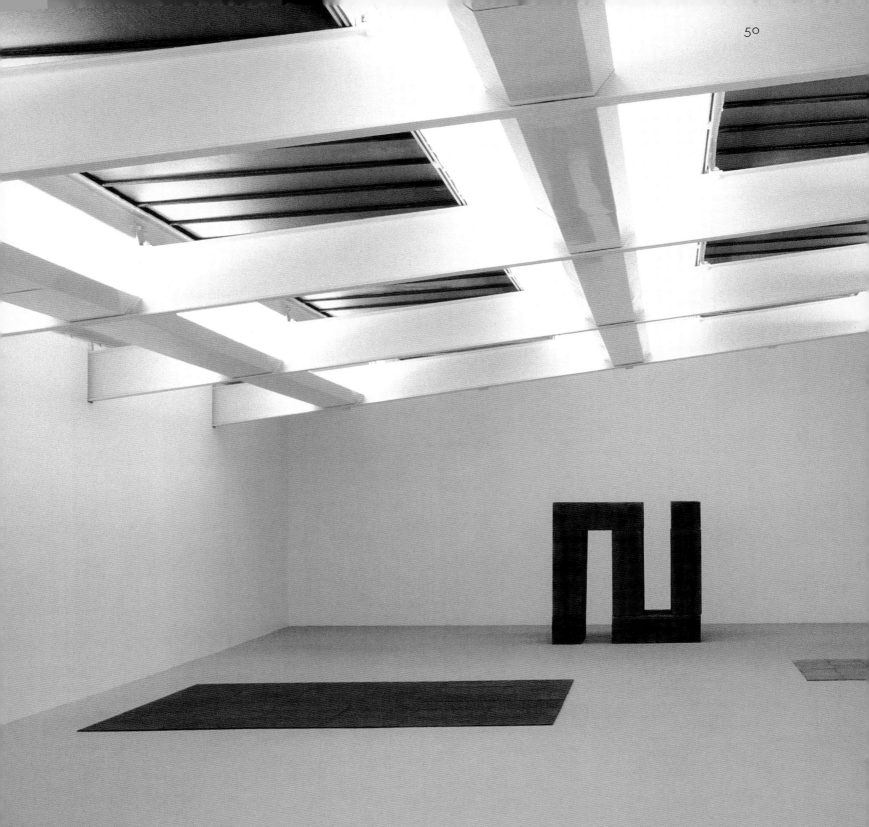

CARL ANDRE
CLOCKWISE FROM LEFT
Mönchengladbach Square 1968 Hot-rolled steel (36 units) 0.6 × 300 × 300 cm ¼ × 118 × 118"
Furrow 1981 Red cedar (12 elements) 150 × 150 × 90 cm 59 × 59 × 35½"
Aluminium and Zinc Plain 1970 Aluminium (18 squares) and zinc (18 squares) 1 × 183 × 183 cm ¼ × 72 × 72"
Cascade 1984 Gas benton blocks (550 units) 174.9 × 240 × 490.2 cm 68¾ × 94½ × 193"

ANDRE, CHAMBERLAIN, FLAVIN, LEWITT, RYMAN, STELLA

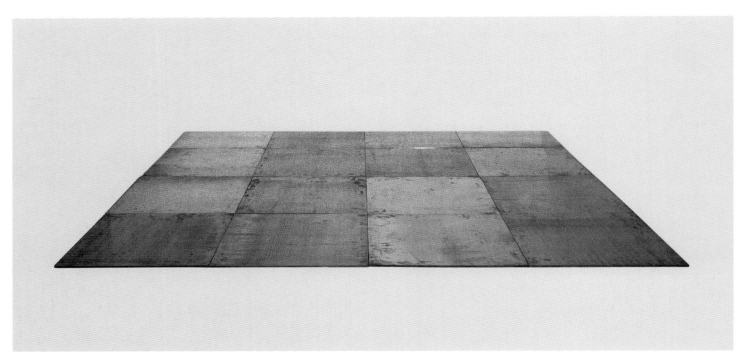

CARL ANDRE *Sixteenth Copper Cardinal* 1976 Copper (16 squares) 0.6 × 200 × 200 cm ¼ × 78¾ × 78¾"

CARL ANDRE *Aluminium and Zinc Plain* 1970 Aluminium (18 squares) and zinc (18 squares) 1 × 183 × 183 cm ⅜ × 72 × 72"

CARL ANDRE *Equivalent VI* 1966 120 firebricks 12.5 × 274 × 57 cm 5 × 108½ × 22½"

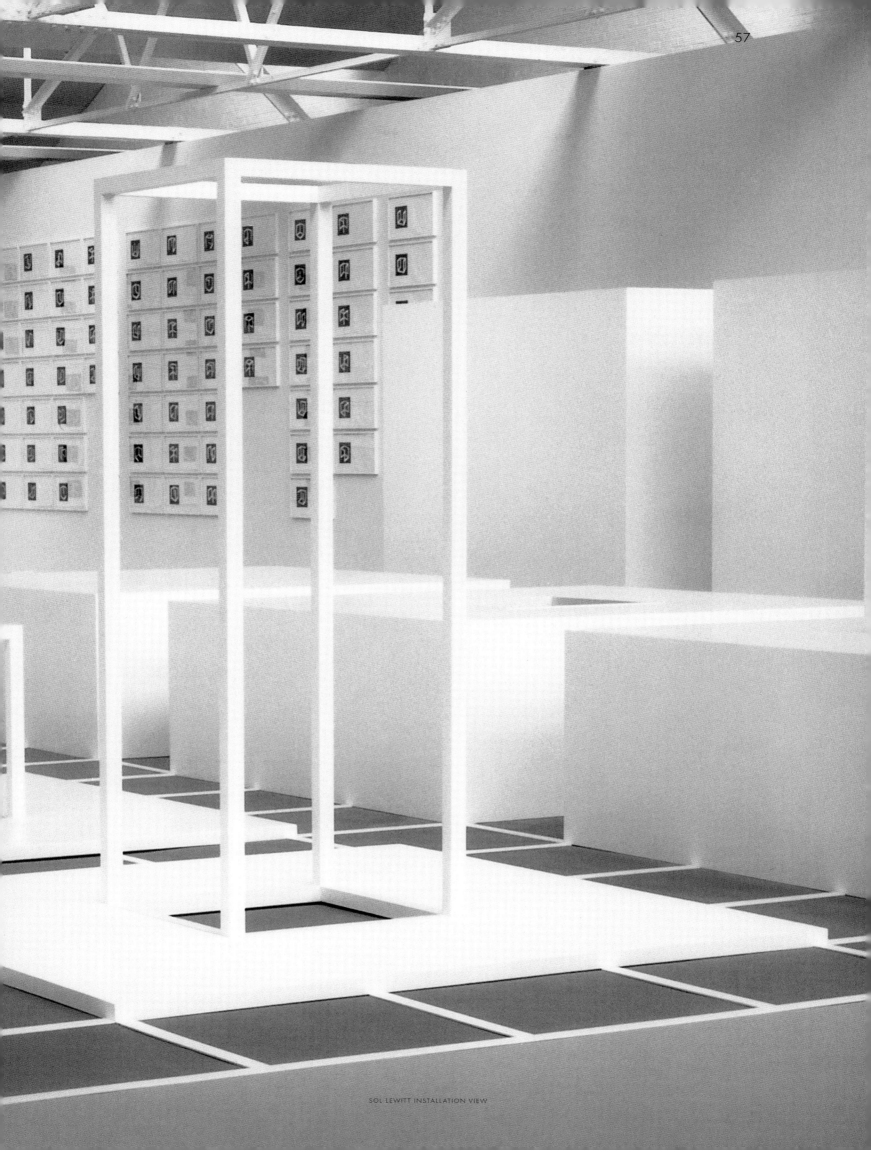

SOL LEWITT INSTALLATION VIEW

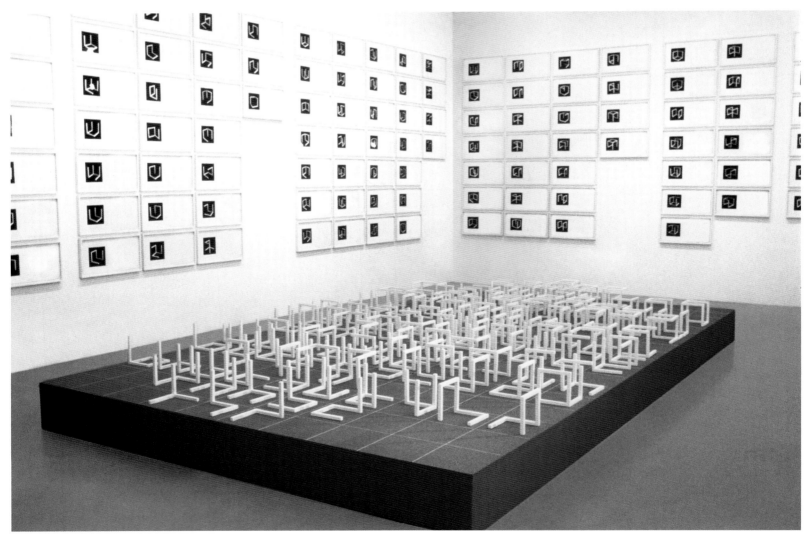

SOL LEWITT *All Variations of Incomplete Open Cubes* 1974 Wood sculptures with white paint (122 pieces) Each piece: 20.3 cm square 8" square
Framed photographs and drawings (131 pieces) Each piece: 66 × 35.6 cm 26 × 14" Base: 30.5 × 304.8 × 548.6 cm 12 × 120 × 216"

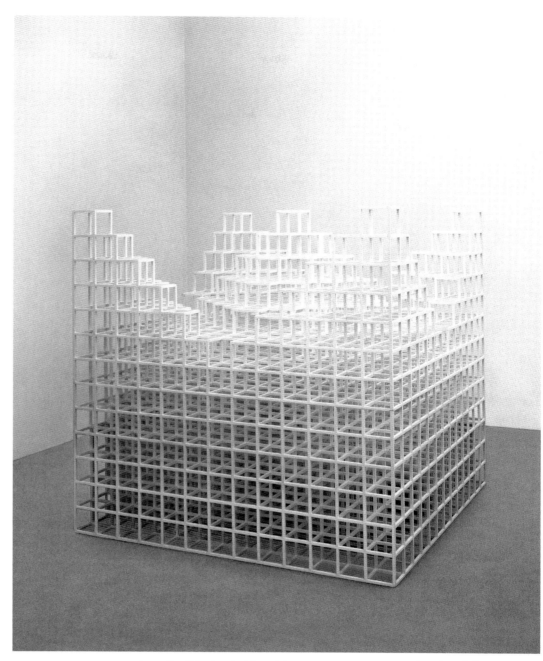

SOL LEWITT 13/1 1980 Wood and white paint 157.5 × 157.5 × 157.5 cm 62 × 62 × 62"

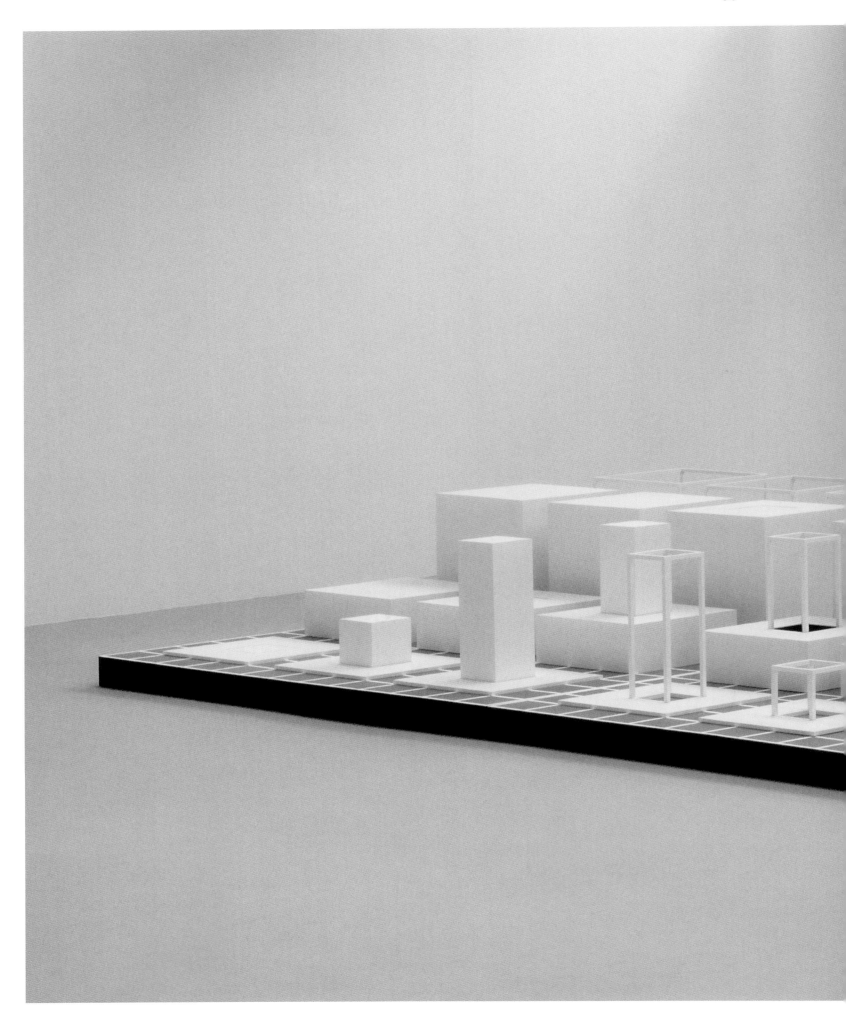

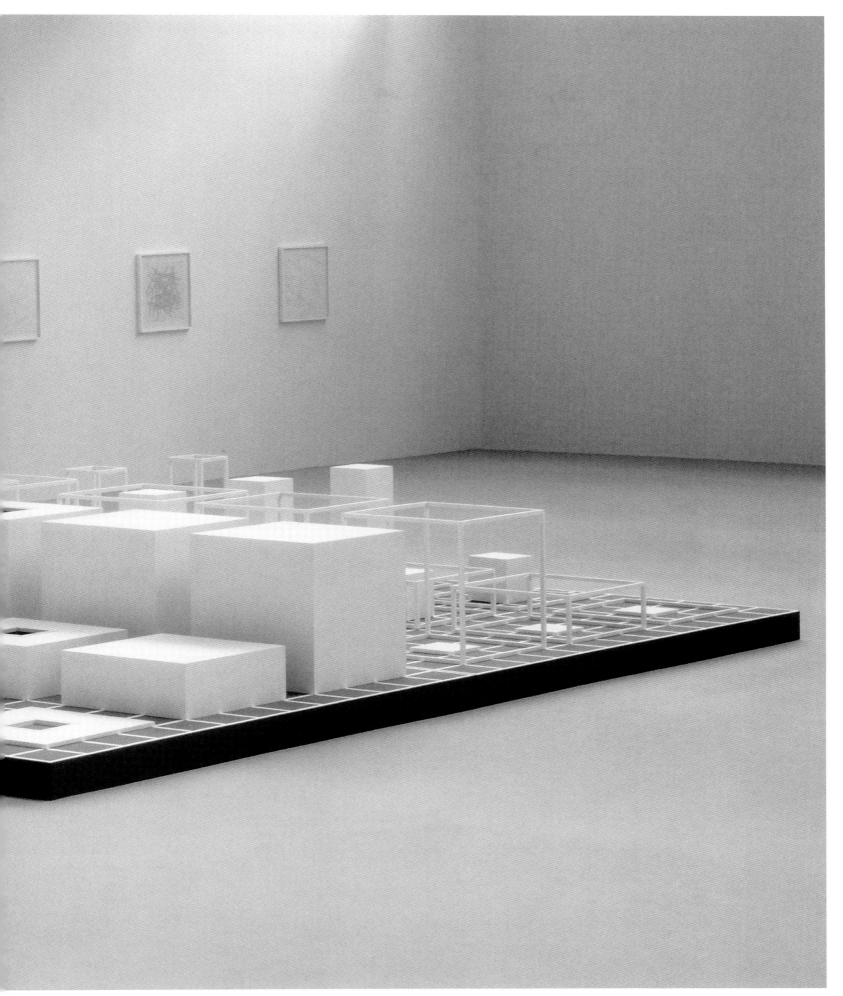

SOL LEWITT *Serial Project I (A, B, C, D)* 1966 White stove enamel on aluminium 83 × 576 × 576 cm 32¾ × 226¾ × 226¾"

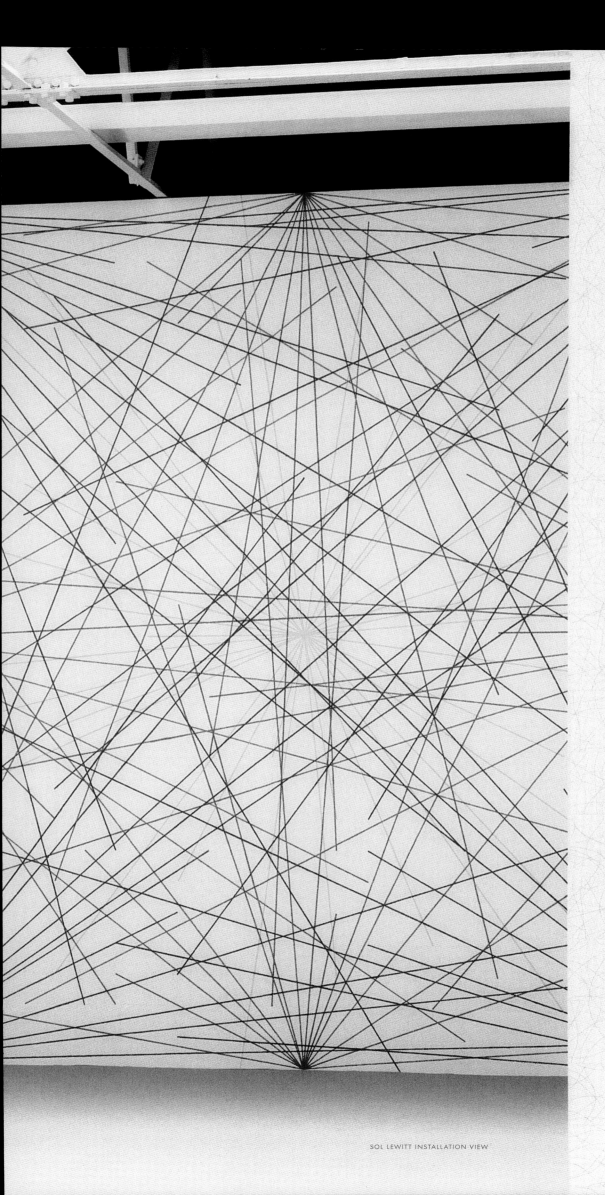

SOL LEWITT INSTALLATION VIEW

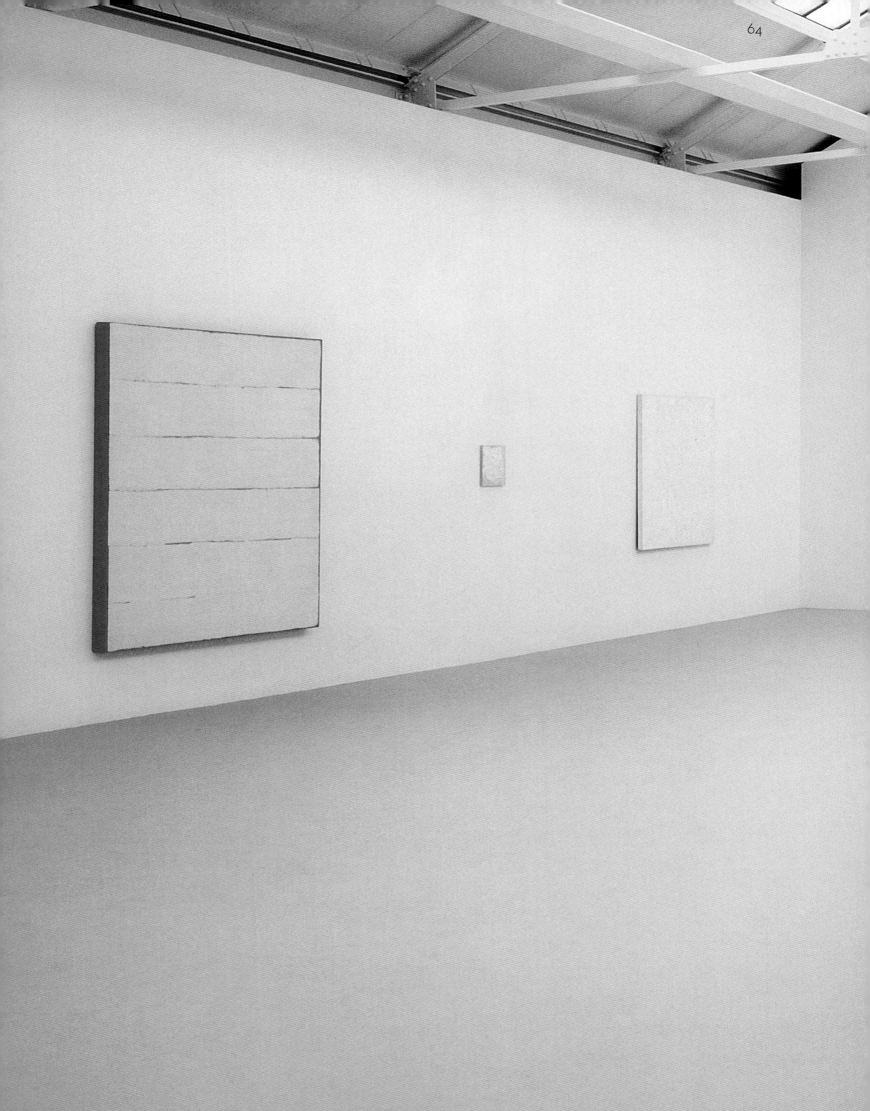

ROBERT RYMAN INSTALLATION VIEW

ROBERT RYMAN *Untitled* 1960 Oil on canvas 136 × 136 cm 53½ × 53½"

ROBERT RYMAN *Cable* 1983 Oil and enamelac on fibreglass with aluminium fasteners 210.5 × 198.1 cm 82¾ × 78"

ROBERT RYMAN *Mayco* 1965 Oil on canvas 198 × 198 cm 76 × 76"

ROBERT RYMAN *Untitled* 1961 Oil on paper 31.7 × 31.7 cm 12½ × 12½"

ROBERT RYMAN *Untitled* 1961 Oil on paper 30.5 × 30.5 cm 12 × 12"

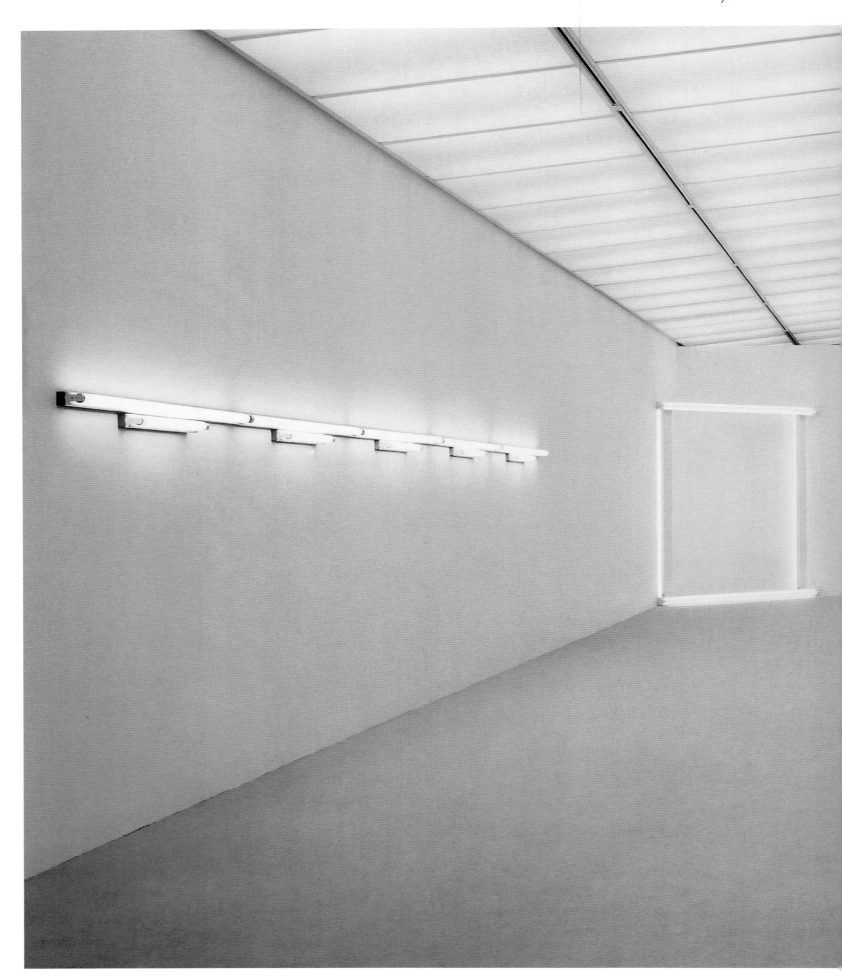

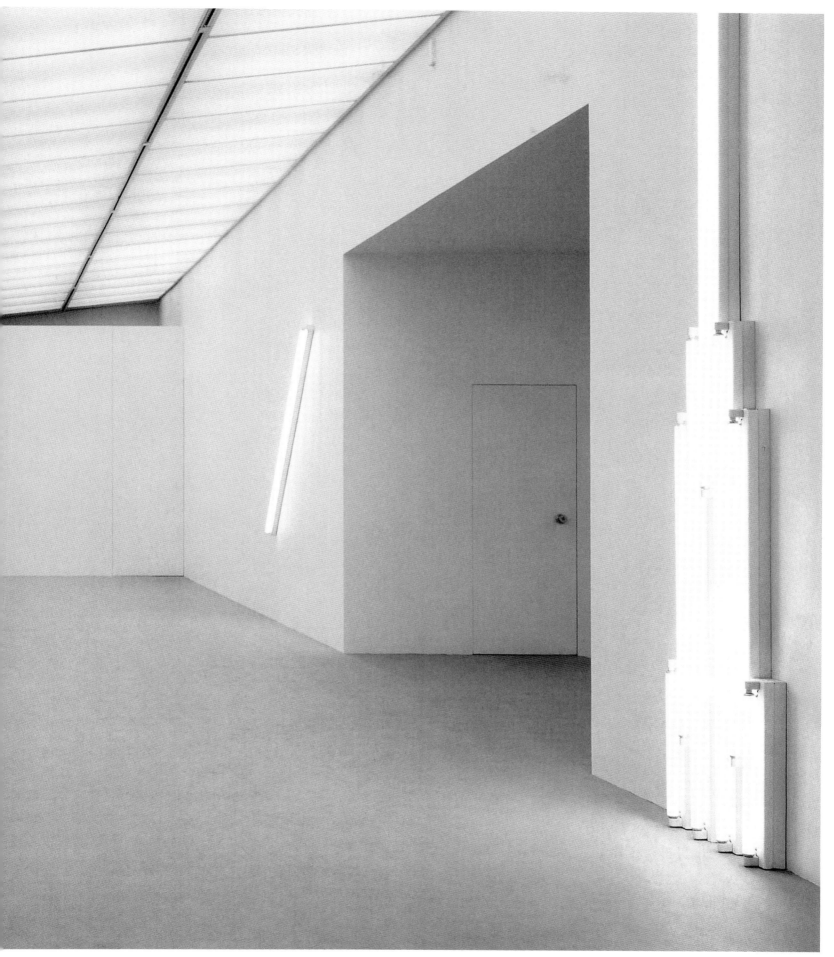

DAN FLAVIN INSTALLATION VIEW

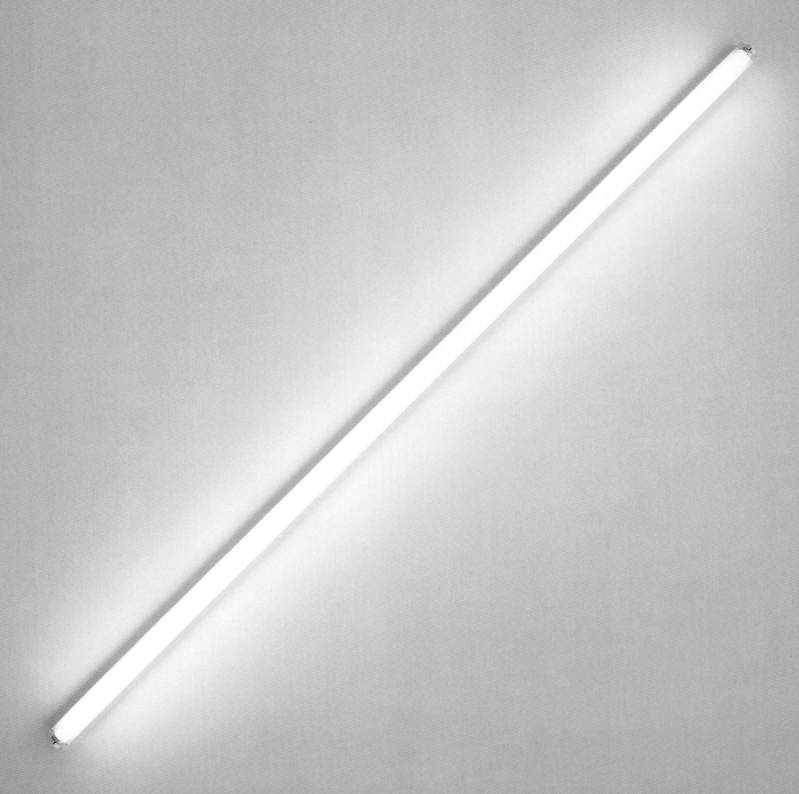

DAN FLAVIN *Diagonal of May 25, 1963* 1963 Cool white fluorescent light Length: 243.8 cm 96"

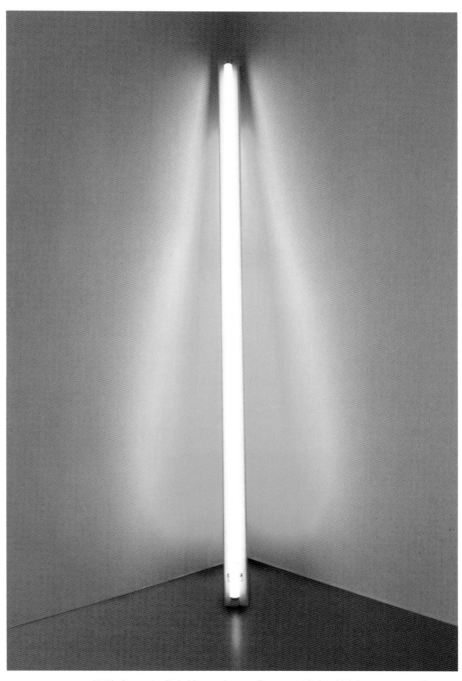

DAN FLAVIN *Untitled* 1976 Pink, blue and green fluorescent light Height: 244 cm 96"

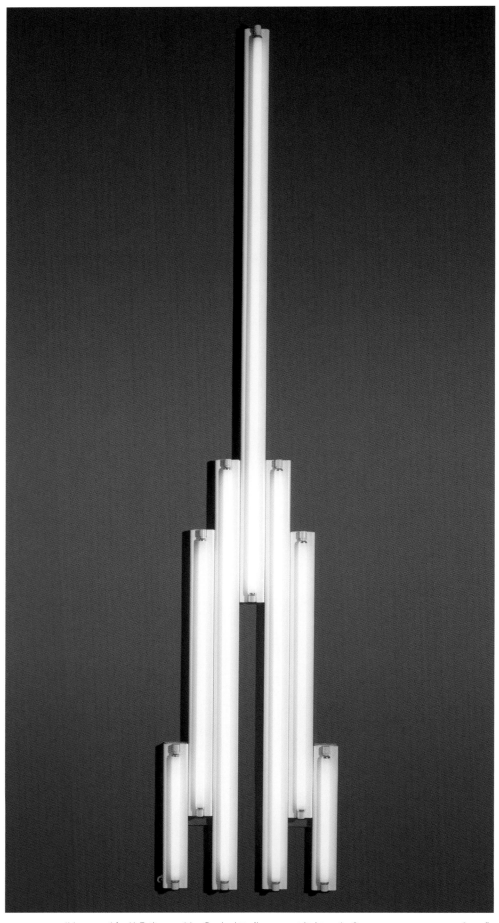

DAN FLAVIN 'Monument' for V. Tatlin 1966 Cool white fluorescent light 365.8 × 71 × 11 cm 144 × 28 × 4"

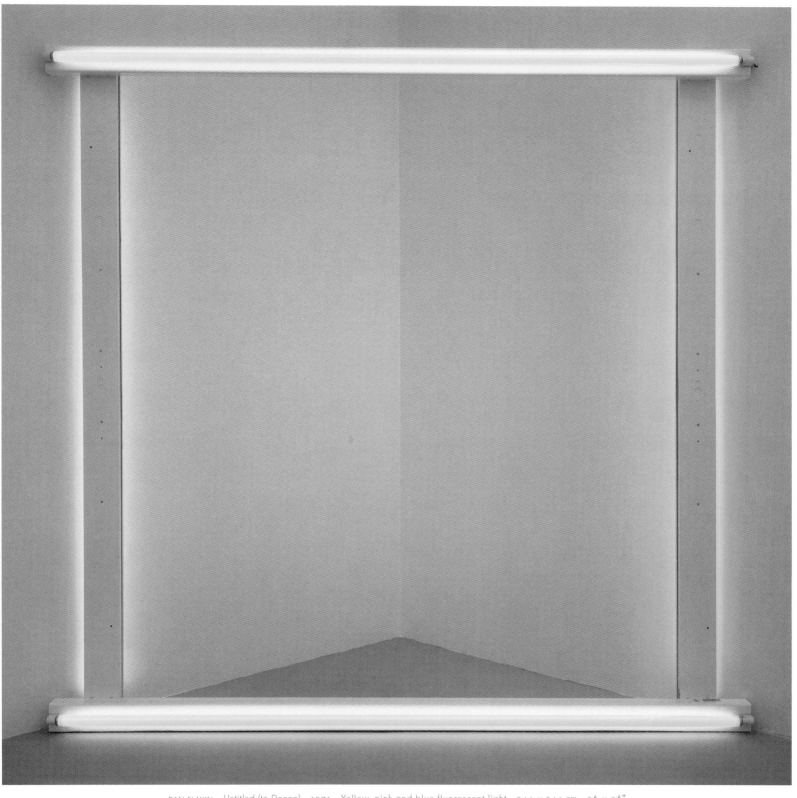

DAN FLAVIN *Untitled (to Donna)* 1971 Yellow, pink and blue fluorescent light 244 × 244 cm 96 × 96"

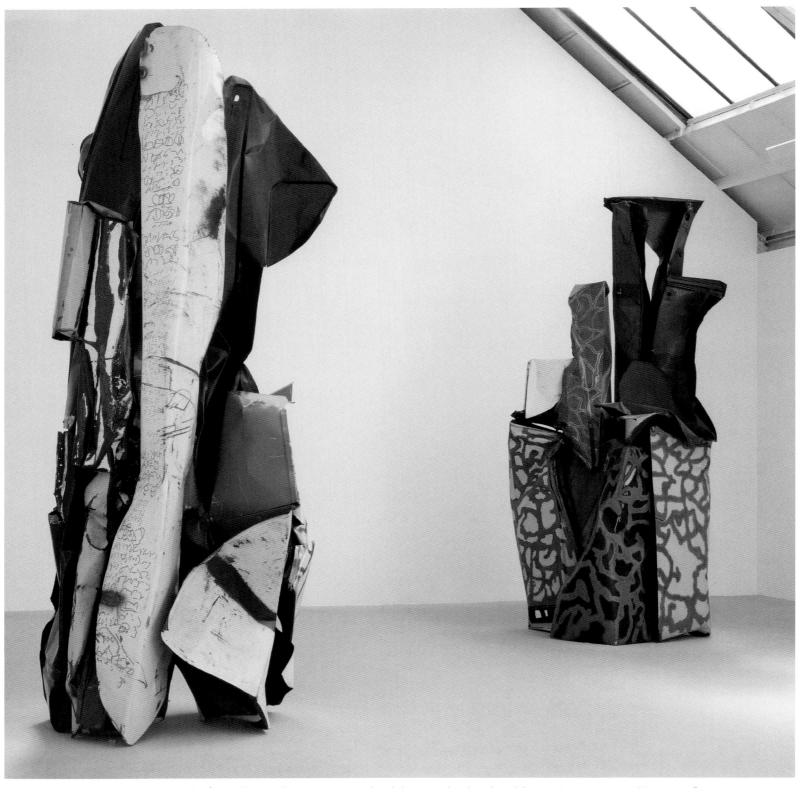

JOHN CHAMBERLAIN (LEFT) *Fenollosa's Column* 1983 Painted and chromium-plated steel 318.8 × 134.6 × 120.7 cm 125½ × 53 × 47"
JOHN CHAMBERLAIN (RIGHT) *The Arch of Lumps* 1983 Painted and chromium-plated steel 360.7 × 162.6 × 146 cm 142 × 64 × 57½"

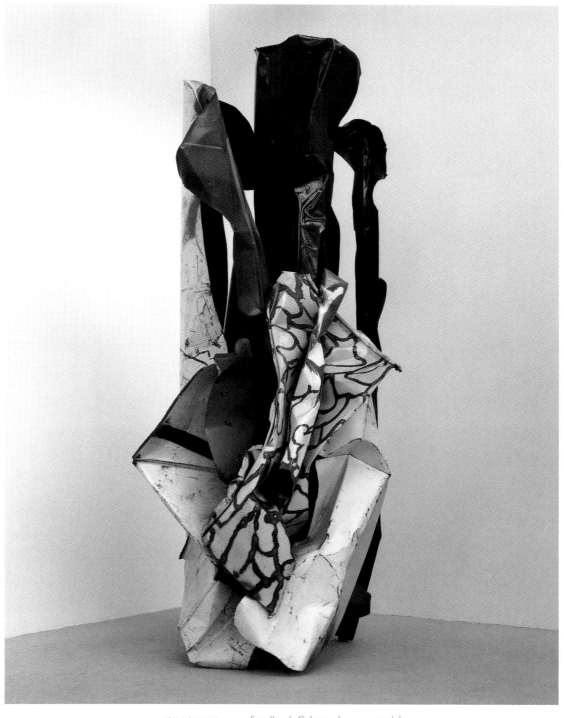

JOHN CHAMBERLAIN *Fenollosa's Column* (reverse angle)

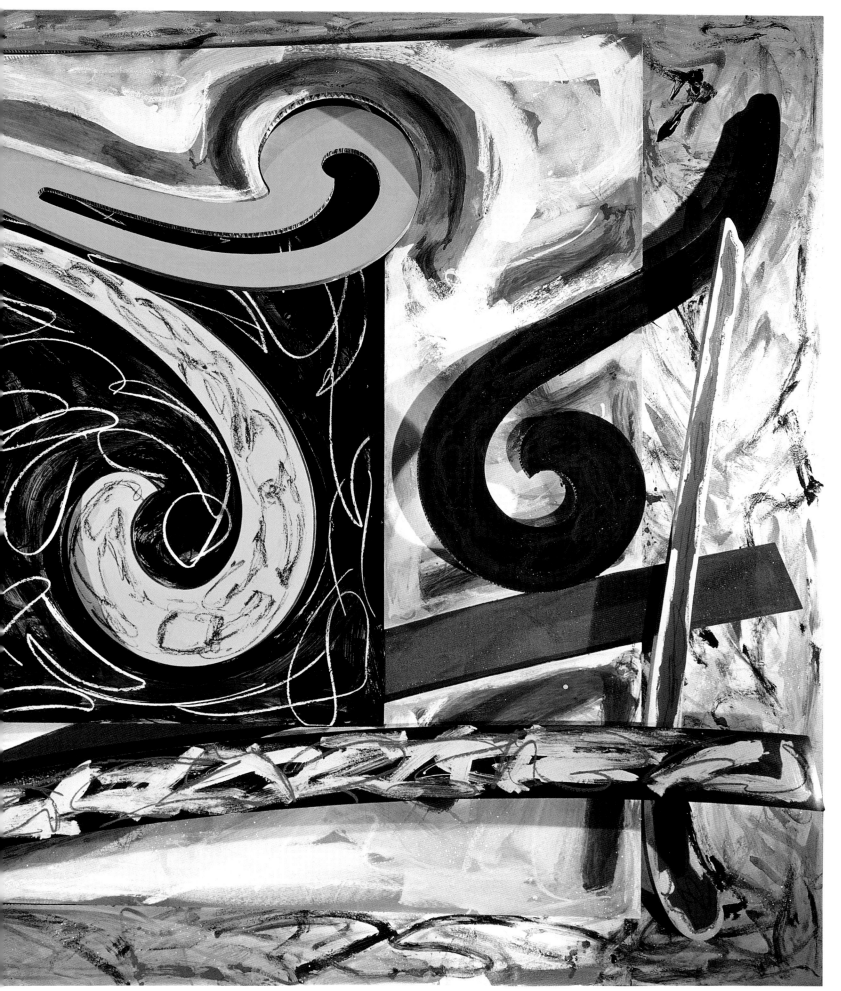

FRANK STELLA *Steller's Albatross* 1976 Mixed media on aluminium 304.8 × 419 cm 120 × 165"

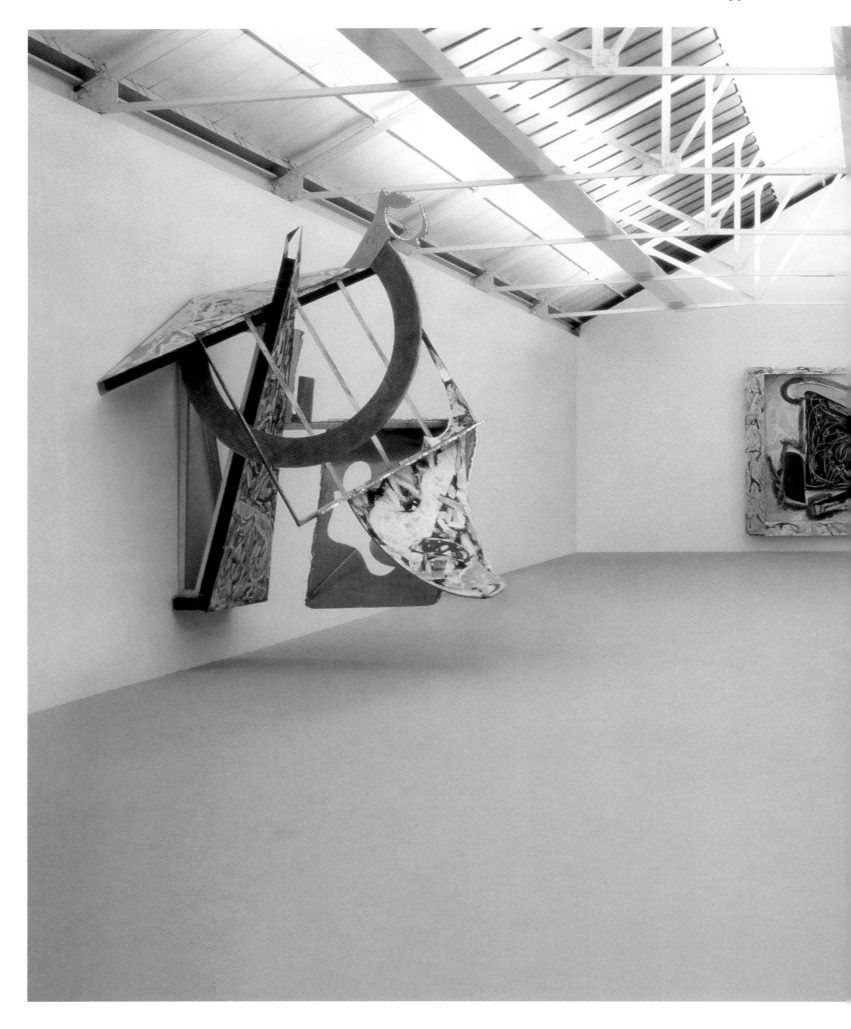

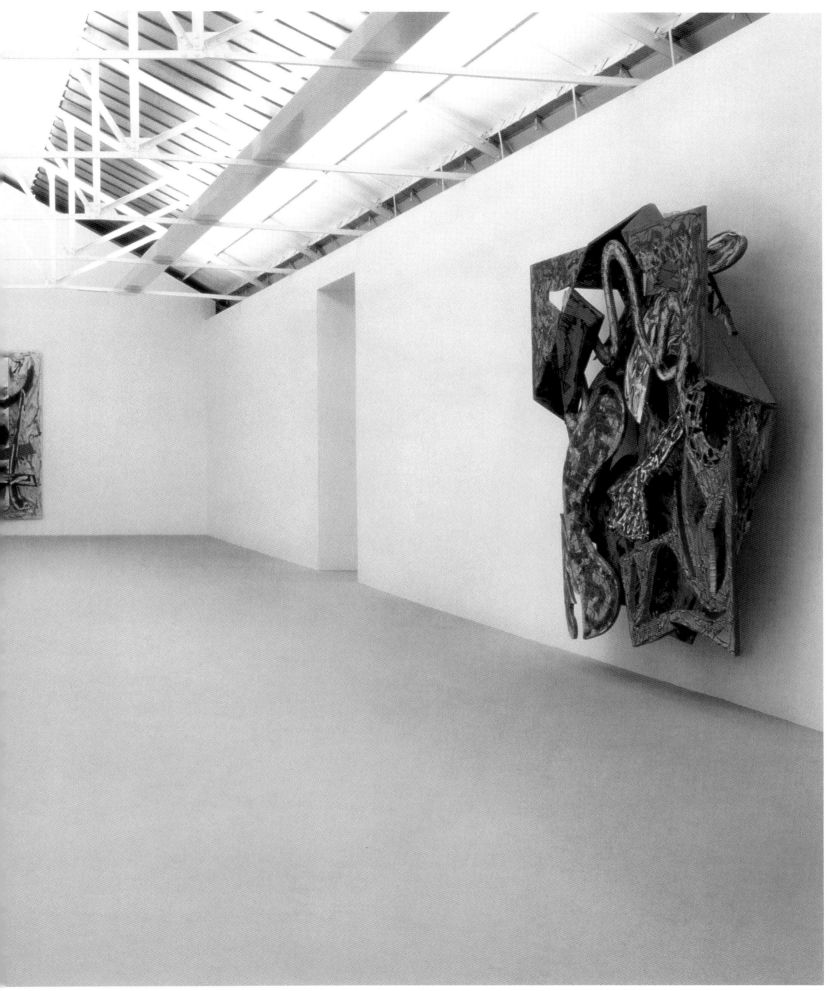

FRANK STELLA (LEFT) *Western Holdings* 1983 Mixed media on aluminium 304.8 × 280 × 245 cm 120 × 112 × 98"
FRANK STELLA (MIDDLE) *Steller's Albatross* 1976 Mixed media on aluminium 304.8 × 419 cm 120 × 165"
FRANK STELLA (RIGHT) *Thruxton* 1982 Mixed media on etched magnesium 273.8 × 277 × 57.5 cm 109⅛ × 110¾ × 23"

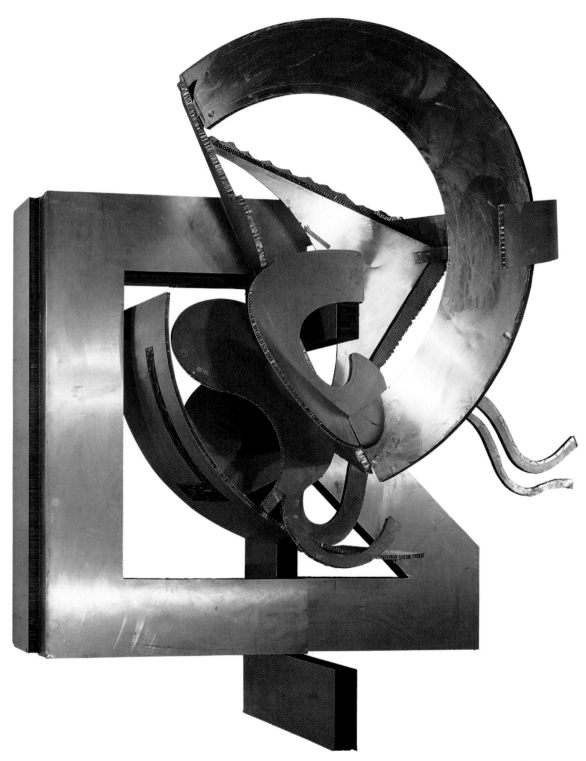

FRANK STELLA *President Brand* 1982 Honeycomb aluminium 302.5 × 252.5 × 195 cm 121 × 101 × 78"

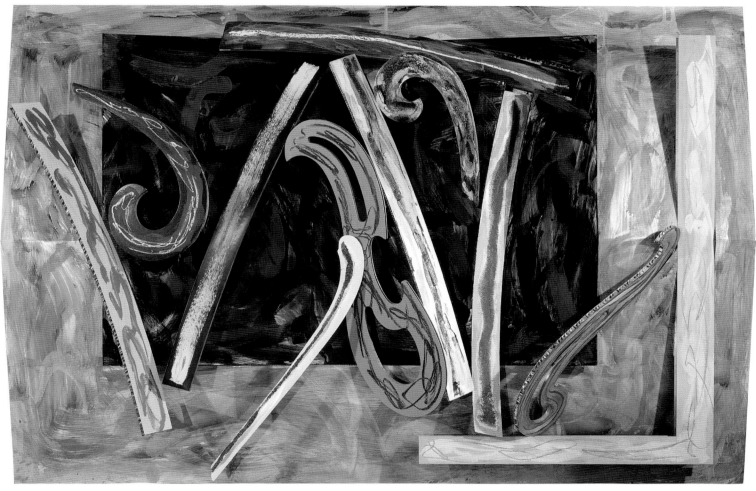

FRANK STELLA *Laysan Millerbird* 1977 Mixed media on aluminium 207.5 × 307.5 × 37.5 cm 83 × 123 × 15"

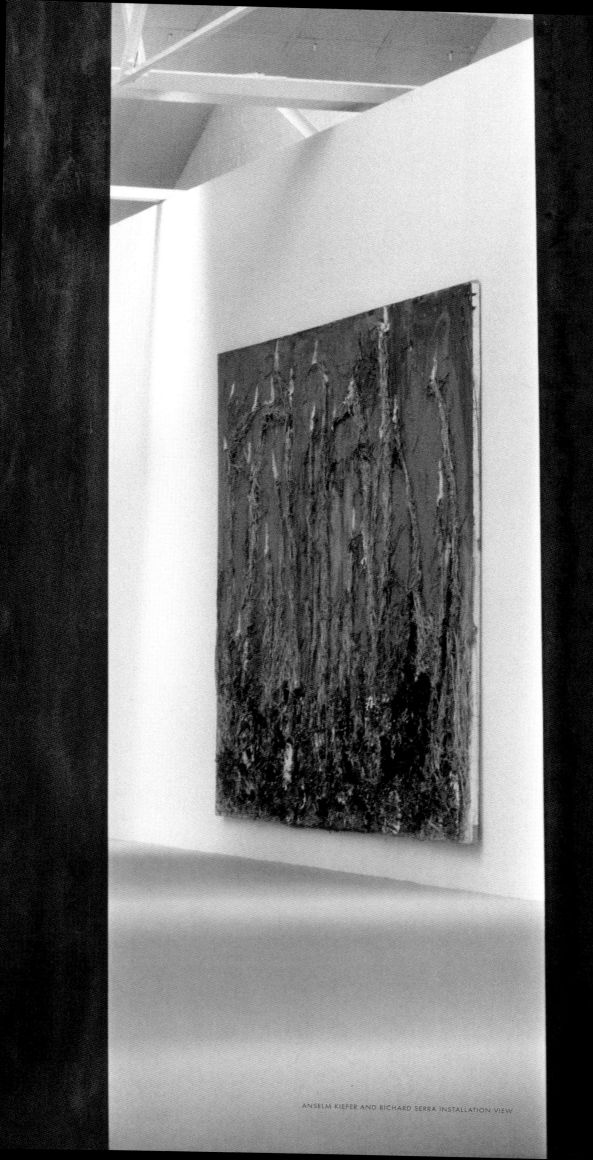

ANSELM KIEFER AND RICHARD SERRA INSTALLATION VIEW

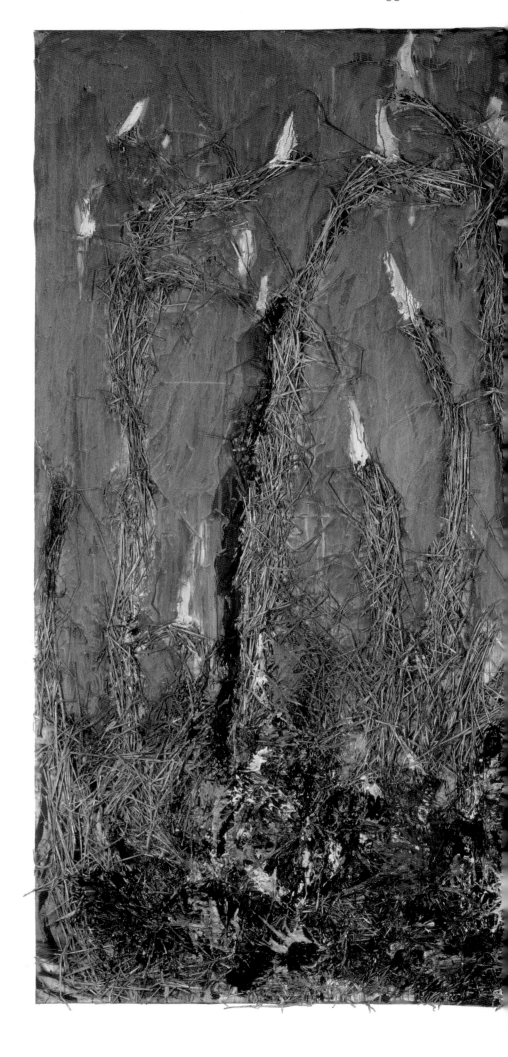

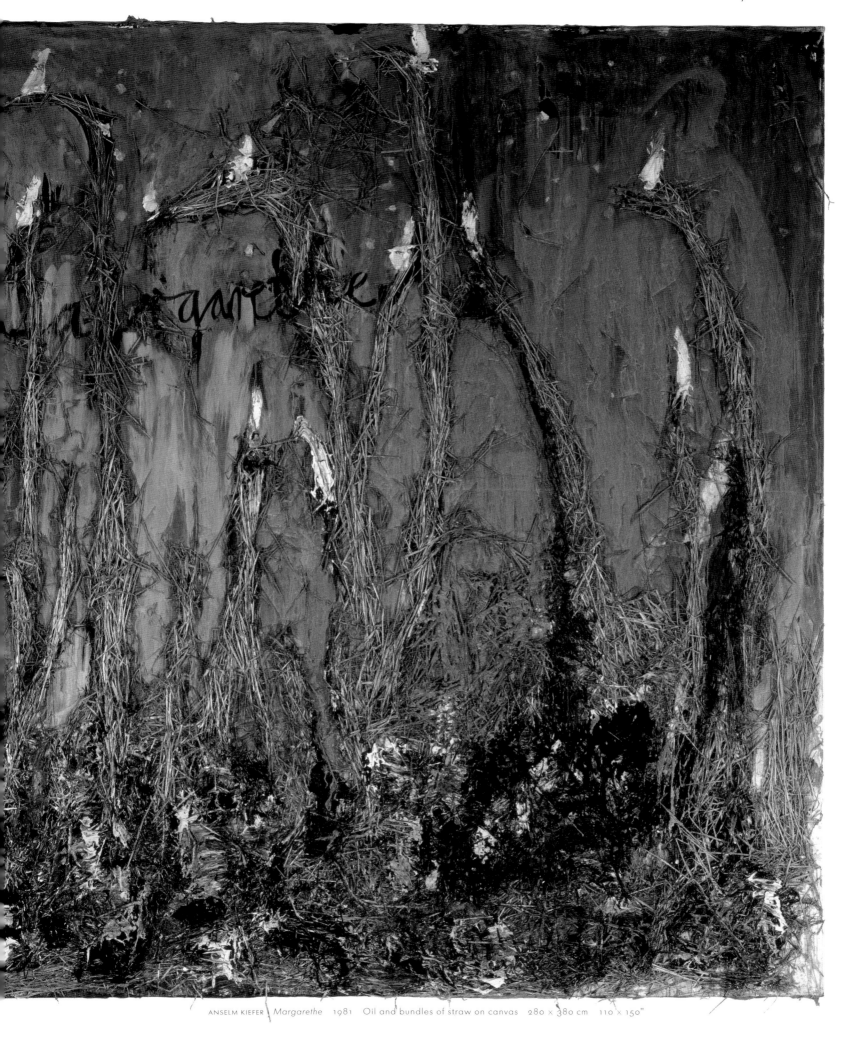

ANSELM KIEFER *Margarethe* 1981 Oil and bundles of straw on canvas 280 × 380 cm 110 × 150"

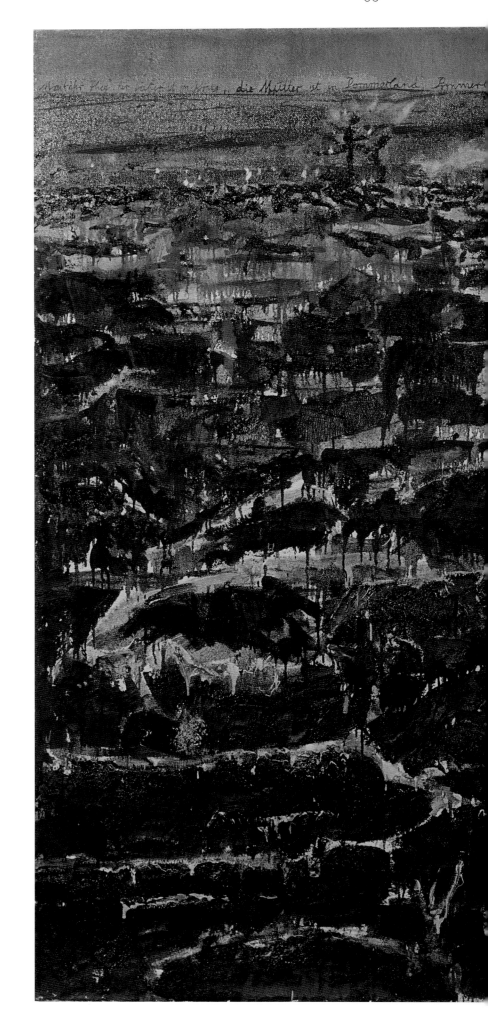

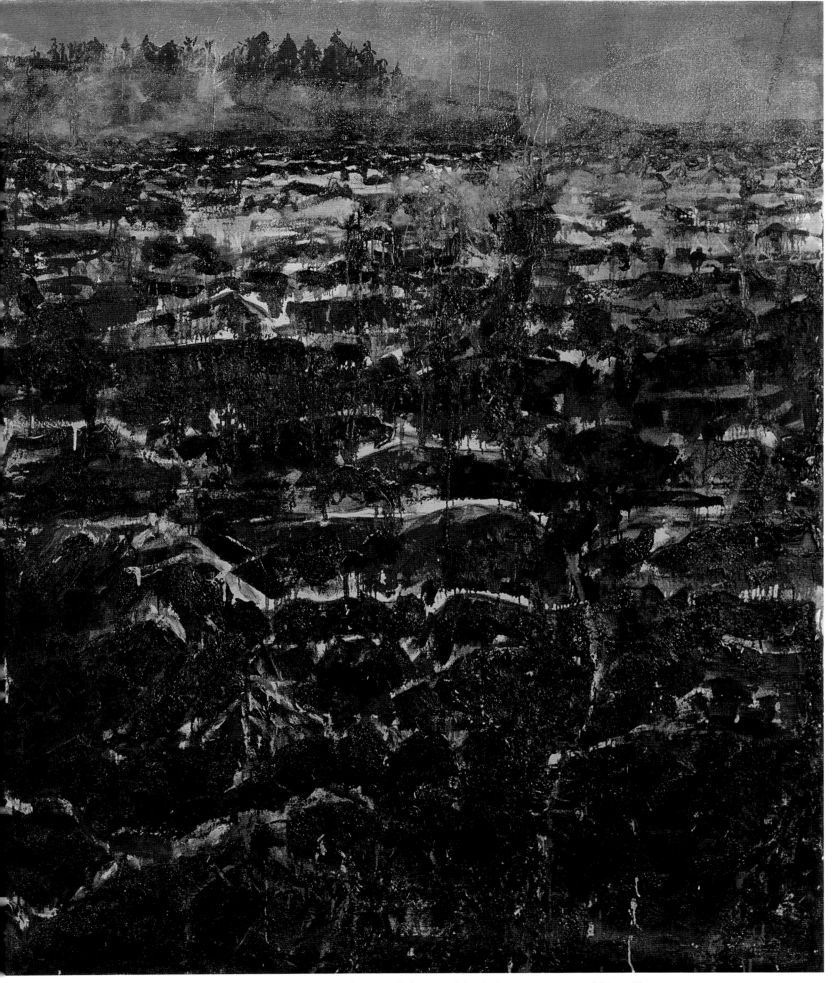

ANSELM KIEFER *Maikäfer flieg* [May Bug, Fly] 1974 Oil on burlap 220 x 300 cm 86½ x 118"

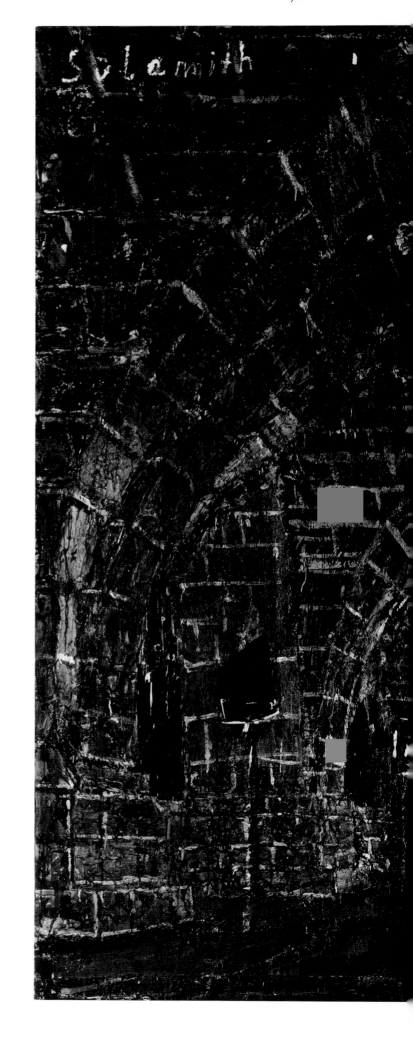

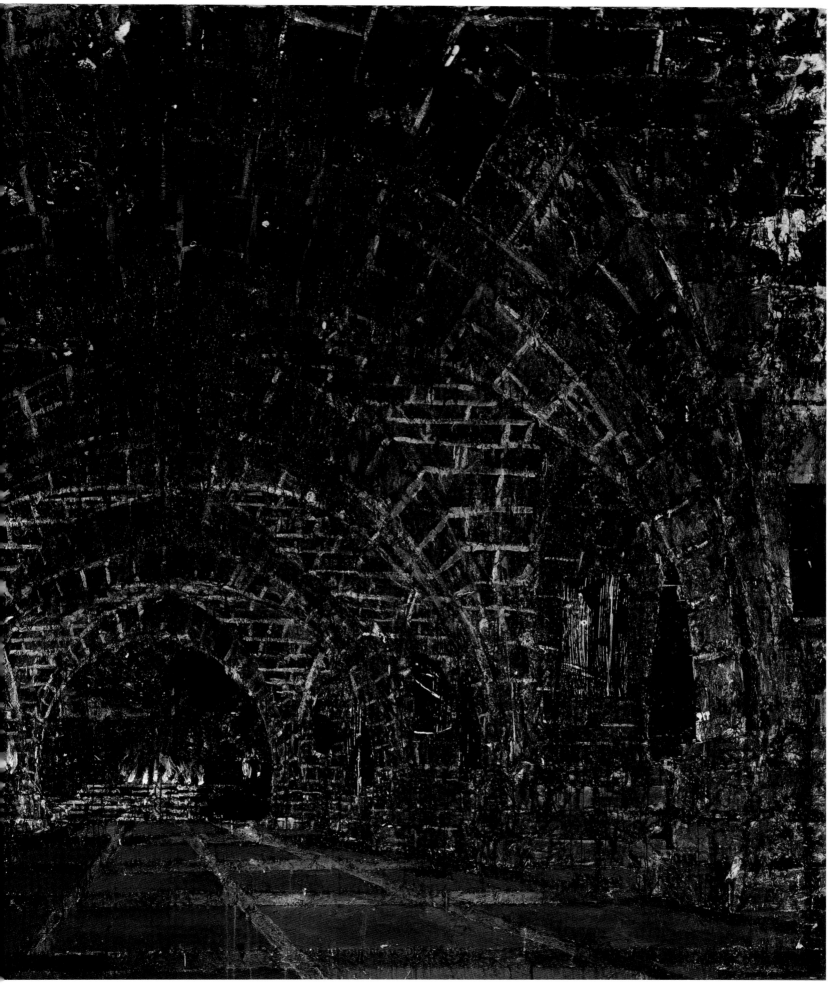

ANSELM KIEFER *Sülamith* 1983 Oil, emulsion, woodcut, shellac and straw on canvas 290 × 370 cm 114¼ × 145¾"

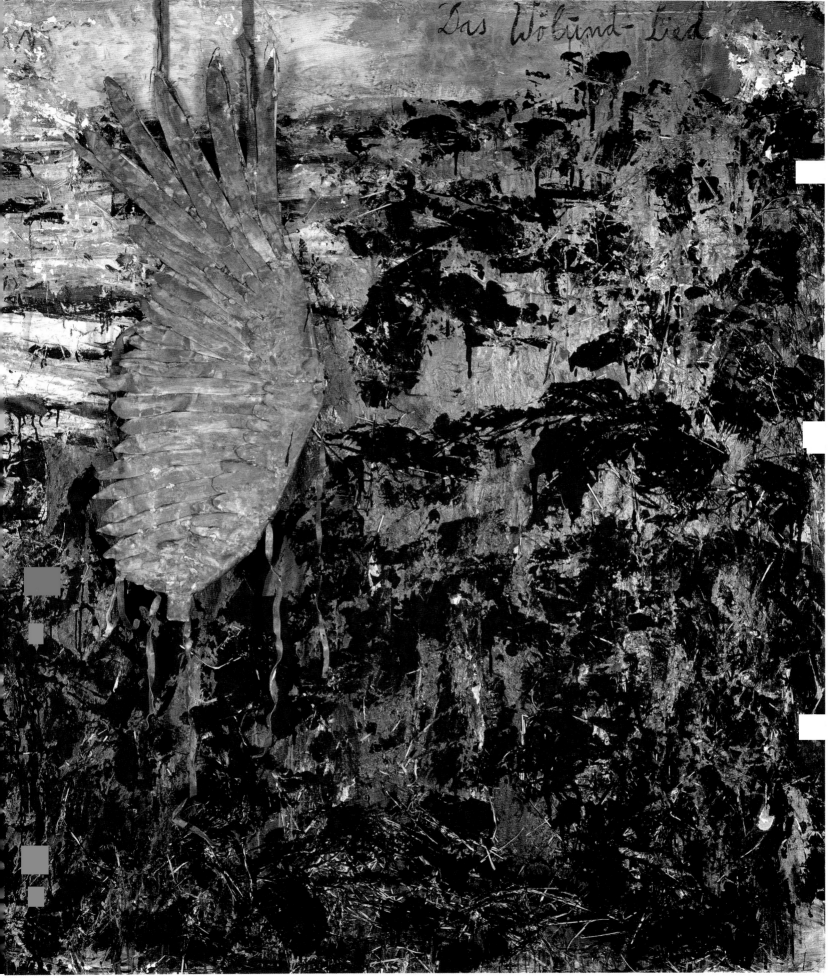

ANSELM KIEFER *Das Wölund-Lied* [Wayland's Song] 1982 Oil, emulsion, straw, photograph on canvas with lead wing 280 × 380 cm 110 × 150"

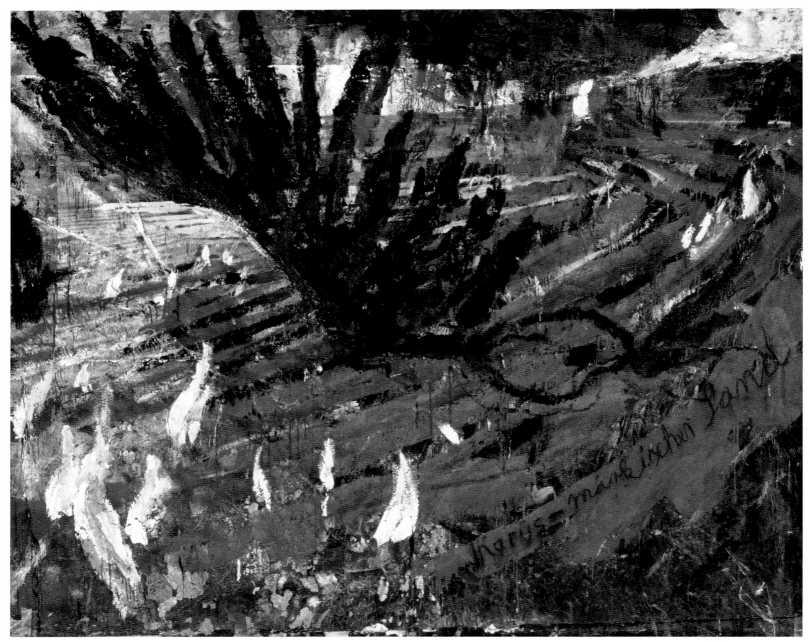

ANSELM KIEFER *Ikarus — märkischer Sand* *[Icarus — Sand of the Brandenburg March]* 1981 Oil, emulsion, shellac, sand and photograph on canvas 290 × 360 cm 114¼ × 141¾"

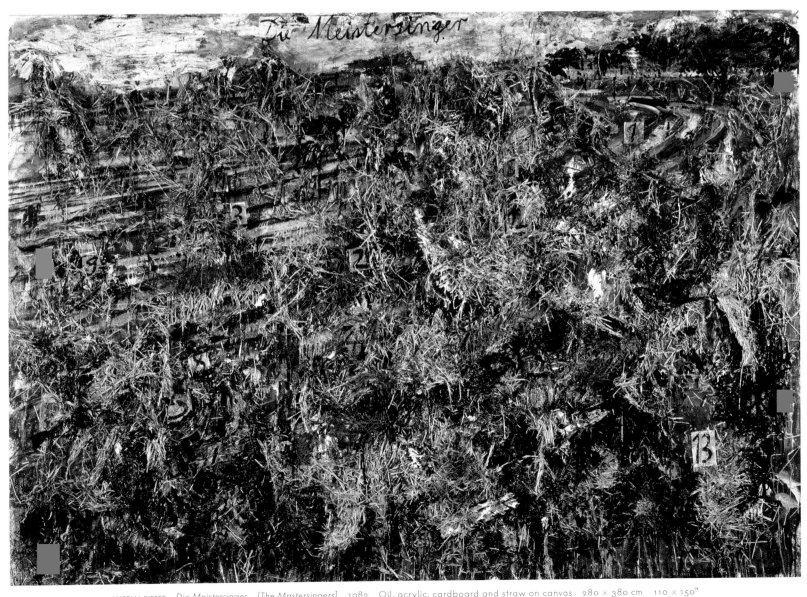

ANSELM KIEFER *Die Meistersinger* [The Mastersingers] 1982 Oil, acrylic, cardboard and straw on canvas 280 x 380 cm 110 x 150"

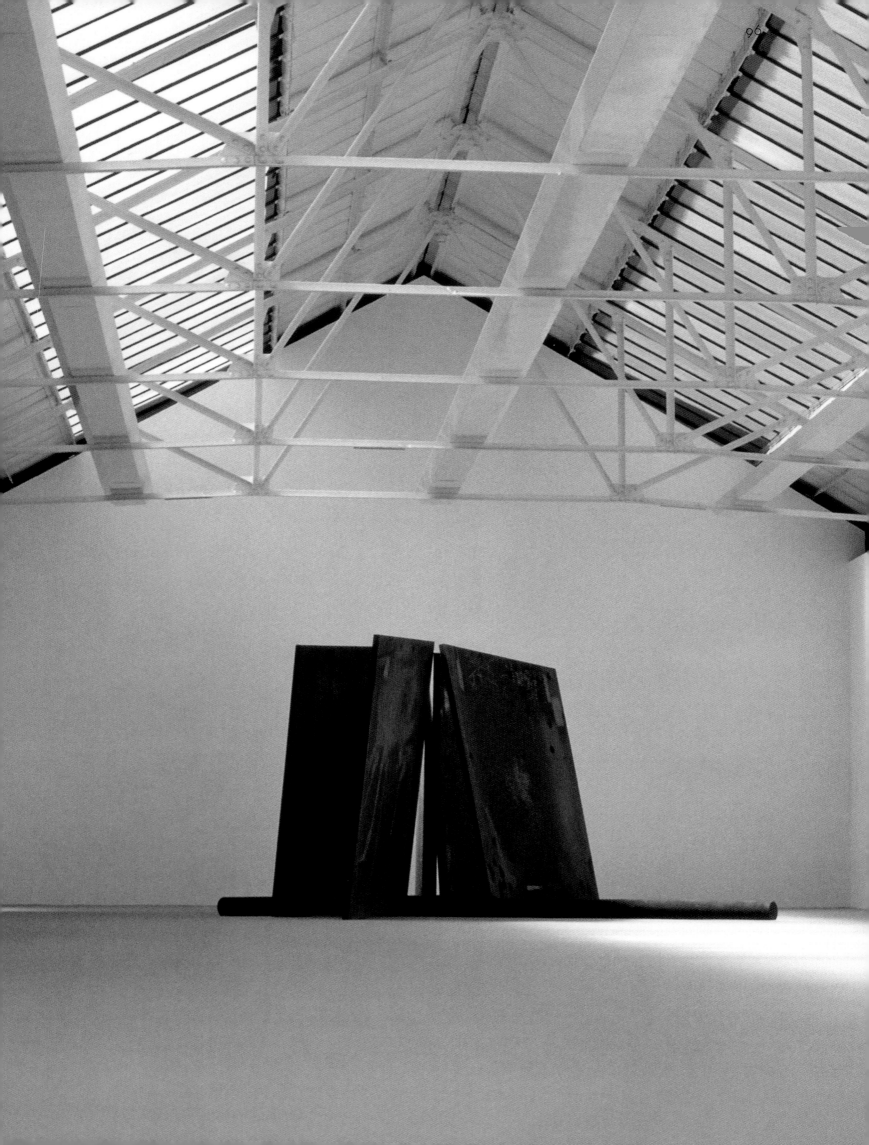

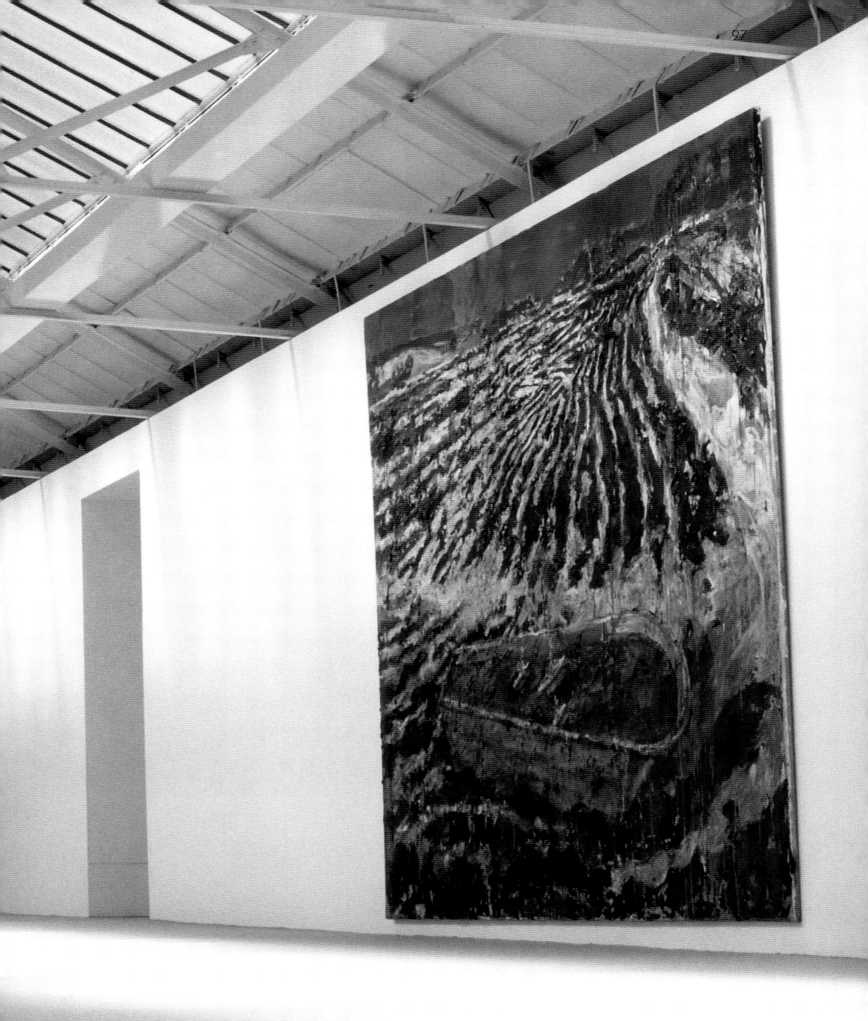

LEFT TO RIGHT
RICHARD SERRA *Five Plates, Two Poles* 1971 Hot-rolled steel 243.8 × 701 × 548.6 cm 96 × 276 × 216"
ANSELM KIEFER *Unternehmen Seelöwe* [*Operation Sea Lion*] 1983–84 Oil, emulsion, shellac, acrylic, straw and photograph on canvas 380 × 555 cm 150 × 218½"

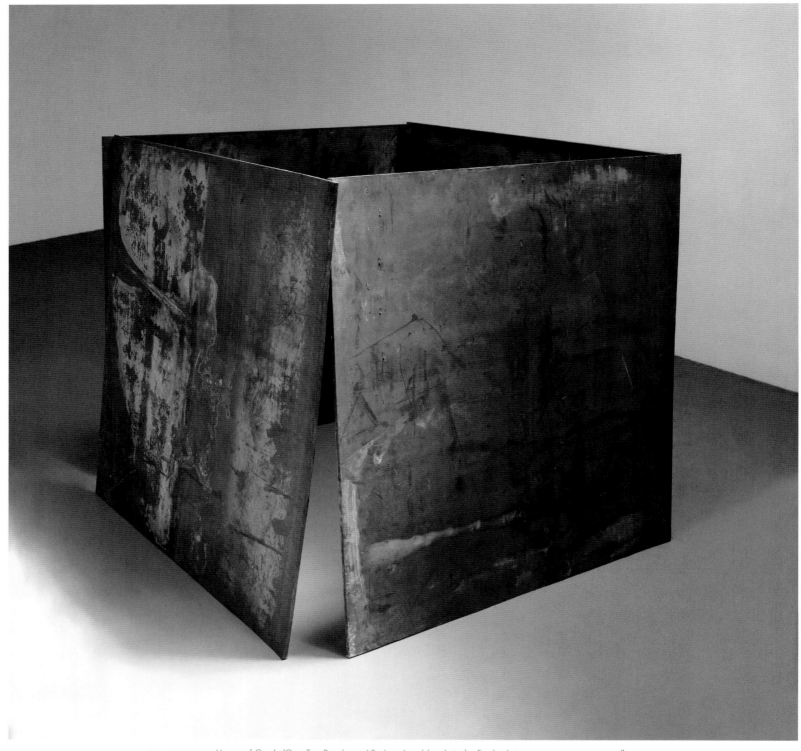

RICHARD SERRA *House of Cards (One Ton Prop)* 1968–69 Lead (4 plates) Each plate: 139.7 cm square 55" square

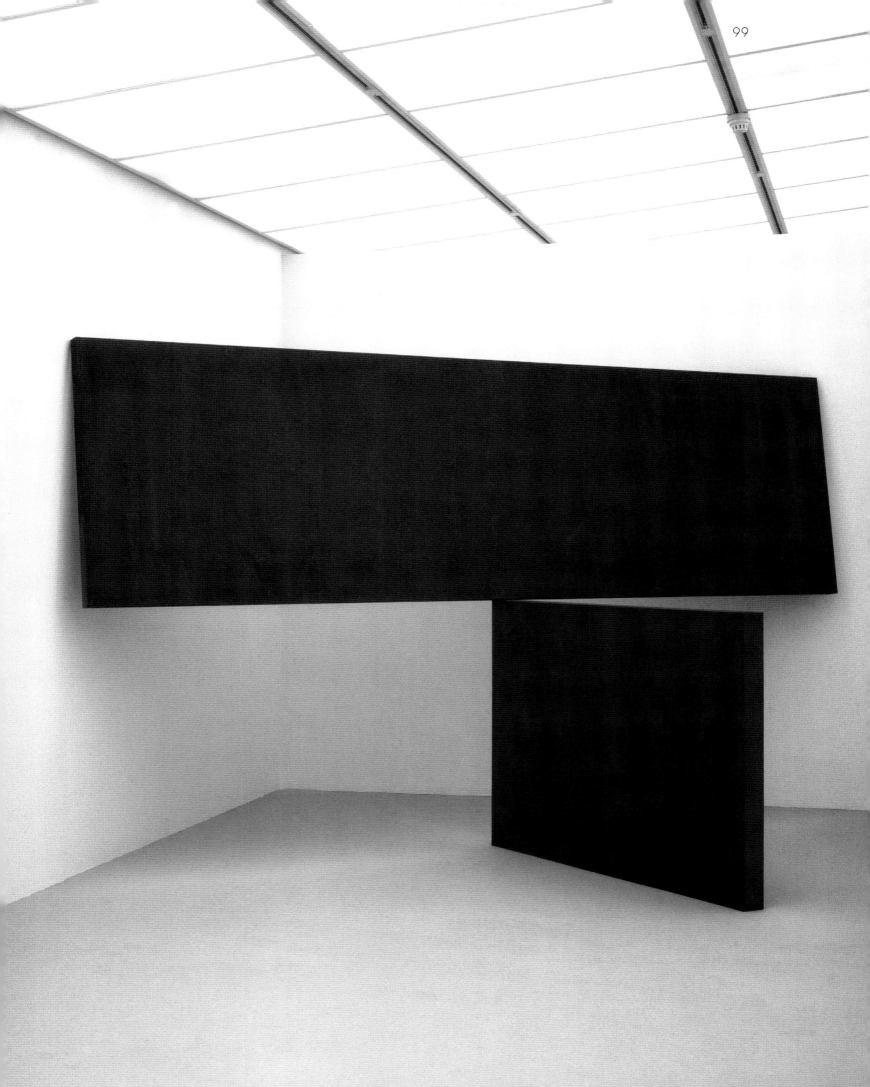

RICHARD SERRA *Kitty Hawk* 1983 Corten steel (2 plates) Upper plate: 122 × 426.7 × 6.7 cm 48 × 168 × 2⅝" Lower plate: 183 × 122 × 10.2 cm 48 × 72 × 4"

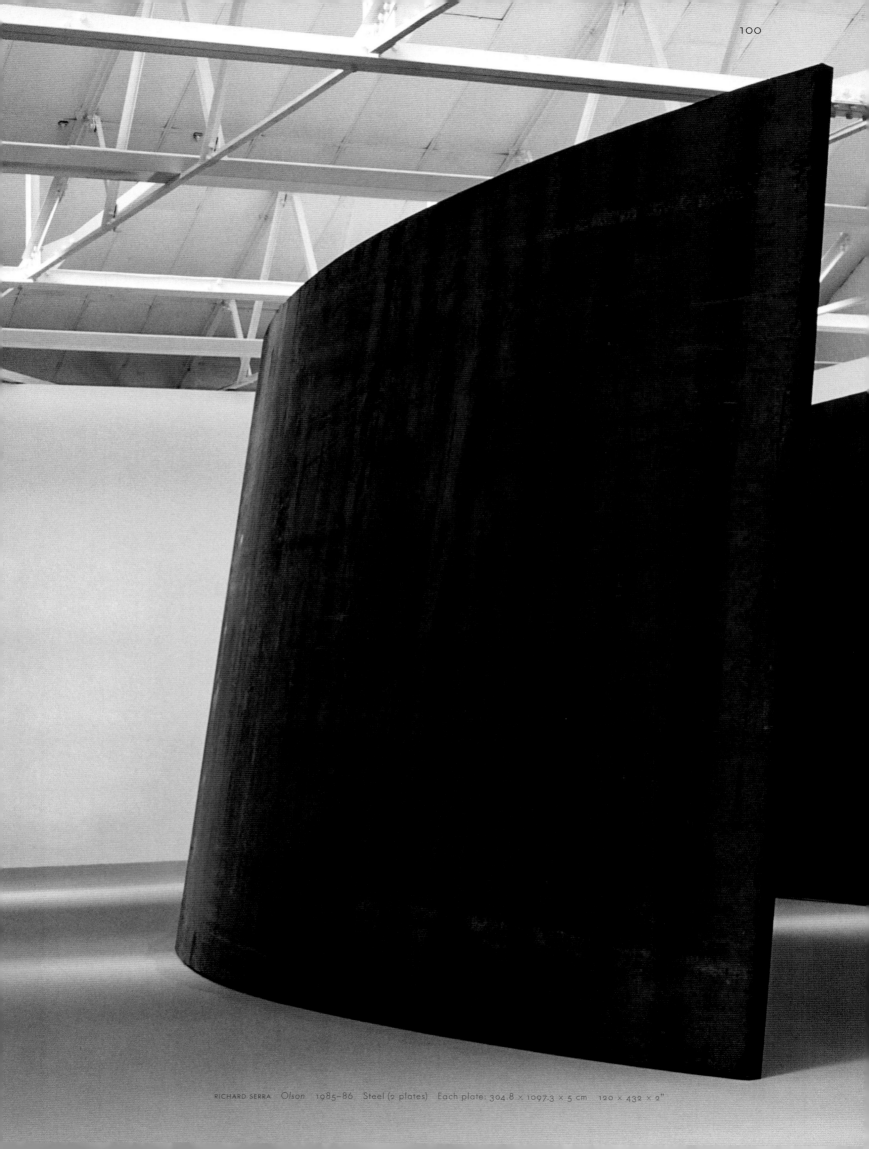

RICHARD SERRA · *Olson* · 1985–86 · Steel (2 plates) · Each plate: 304.8 × 1097.3 × 5 cm · 120 × 432 × 2"

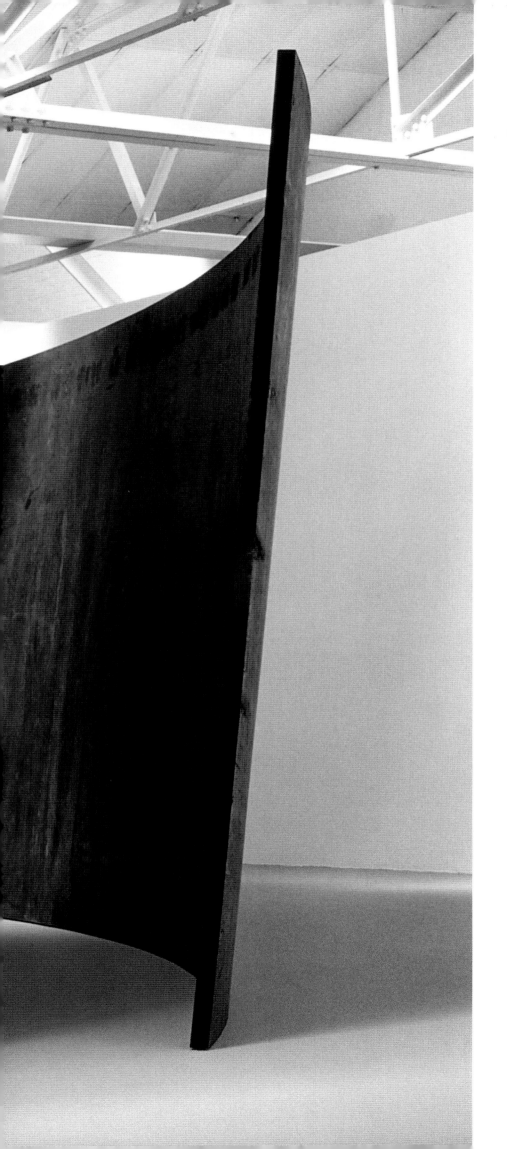

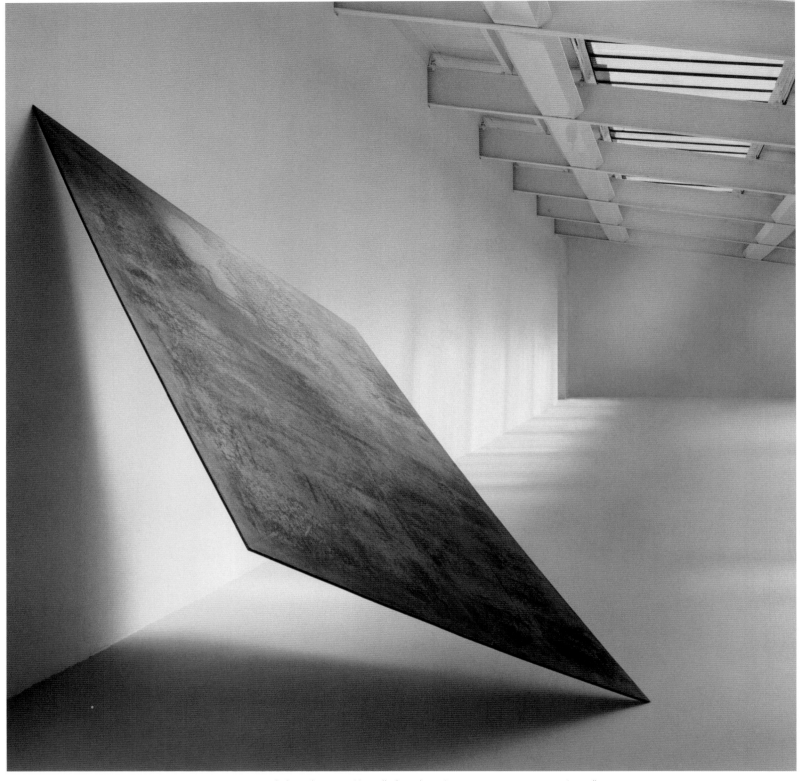

RICHARD SERRA *Balanced* 1970 Hot-rolled steel 246.4 × 157.5 × 2.5 cm 97 × 62 × 1"

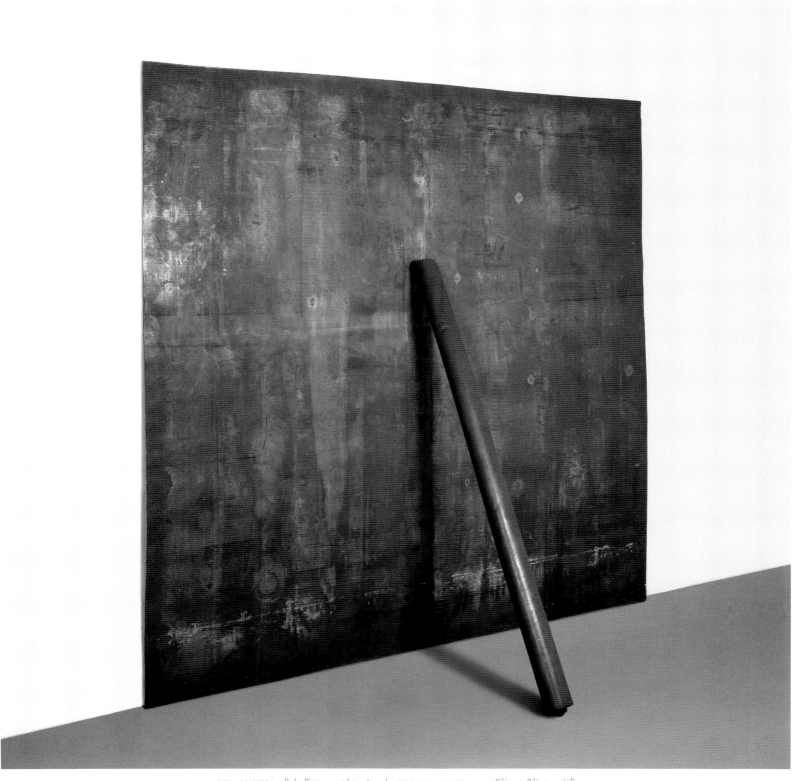

RICHARD SERRA *Pole Piece* 1969 Lead 200 × 200 × 70 cm 78¾ × 78¾ × 27½"

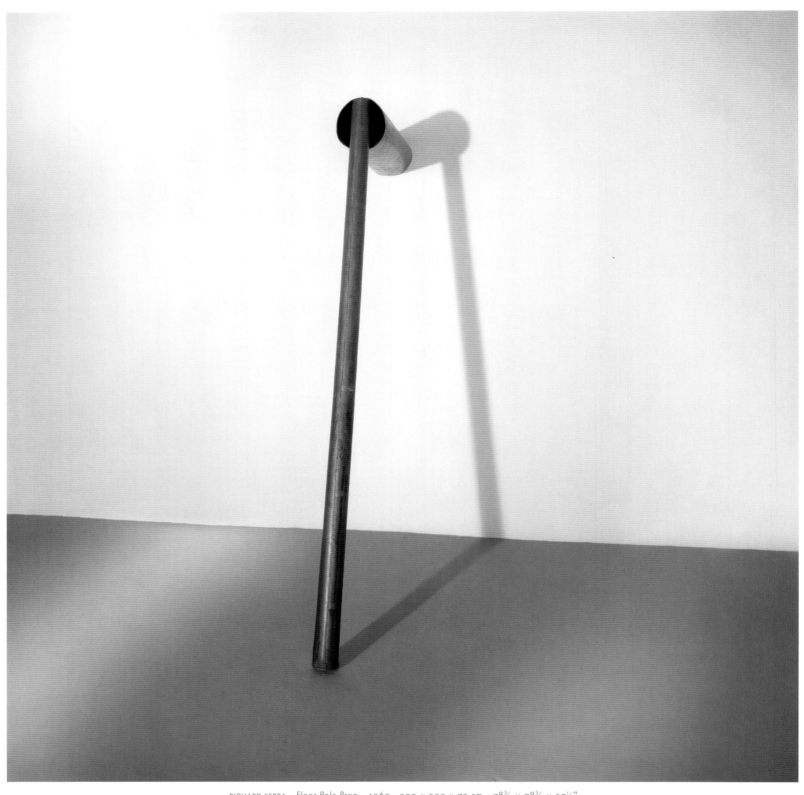

RICHARD SERRA *Floor Pole Prop* 1969 200 x 200 x 70 cm 78¾ x 78¾ x 27½"

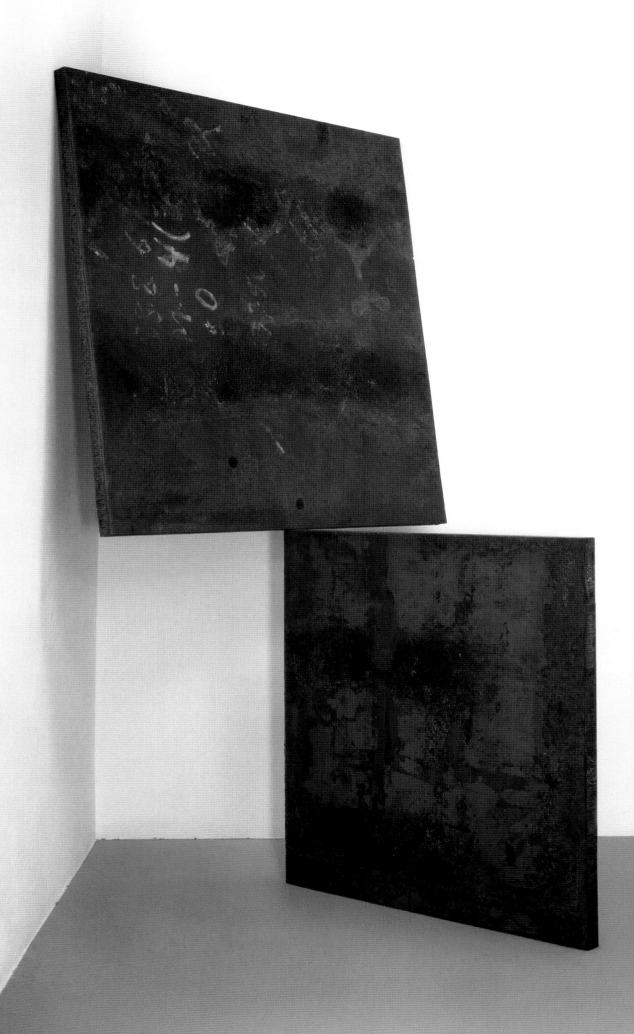

RICHARD SERRA Corner Prop No.8 (Orozco and Siqueiros) 1983 Corten steel (2 plates)
Upper plate: 182 × 191 × 6.3 cm 71¾ × 75¼ × 2⅛" Lower plate: 145 × 150 × 6.3 cm 57 × 59 × 2½"

ART OF OUR TIME

BASELITZ, CLOSE, HESSE, MARTIN, MC CRACKEN, MORLEY, MORRIS, SCHNABEL

MALCOLM MORLEY *Camels and Goats* 1980 Oil on canvas 169 × 254 cm 66½ × 100"

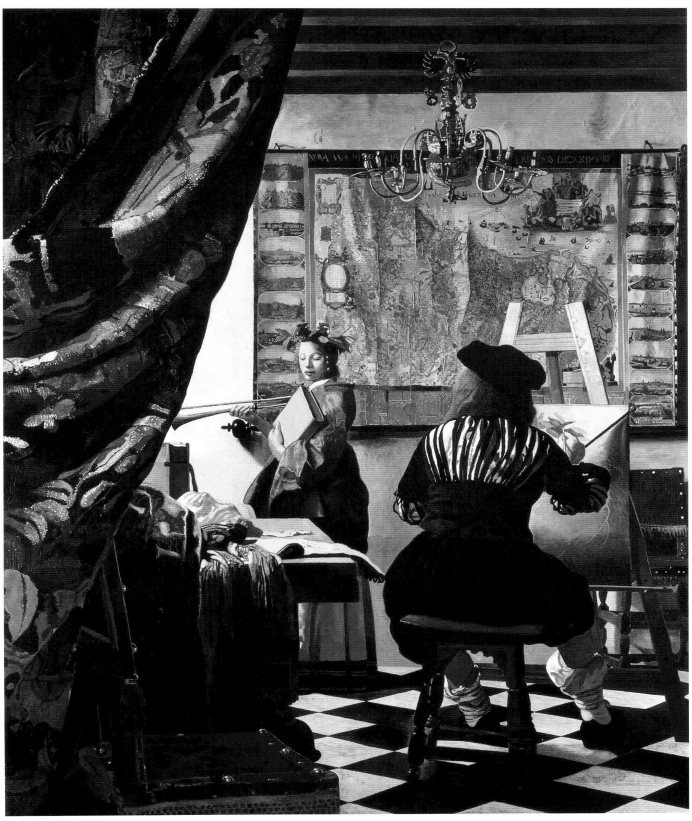

MALCOLM MORLEY *Vermeer, Portrait of the Artist in His Studio* 1968 Acrylic on canvas 266.5 × 221 cm 105 × 87"

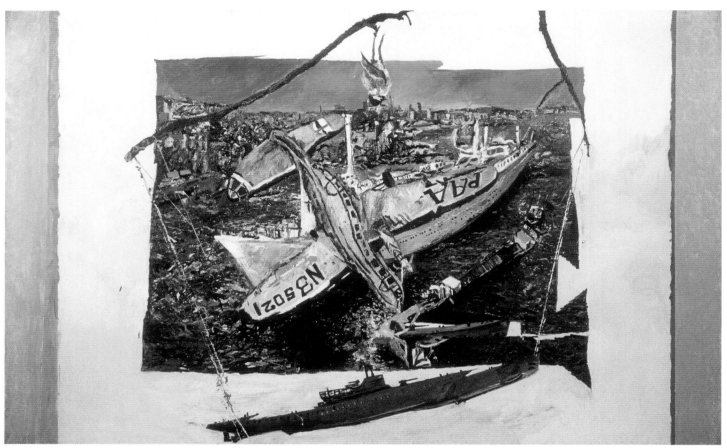

MALCOLM MORLEY *Age of Catastrophe* 1976 Oil on canvas 152.5 × 244 cm 60 × 96"

MALCOLM MORLEY *SS Amsterdam in front of Rotterdam* 1966 Acrylic on canvas 157.5 × 213.5 cm 62 × 84"

MALCOLM MORLEY *Macaws, Bengals, with Mullet* 1982 Oil on canvas 305 × 203 cm 120 × 80"

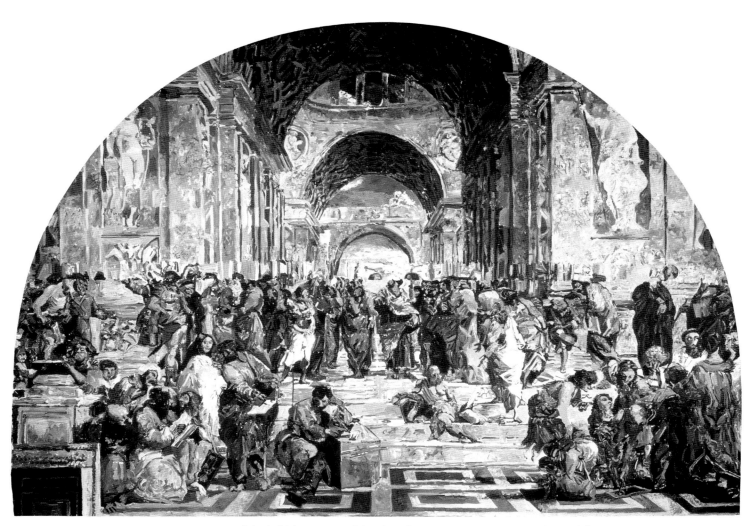

MALCOLM MORLEY *School of Athens* 1972 Oil and acrylic on canvas 170 × 240 cm 67 × 94½"

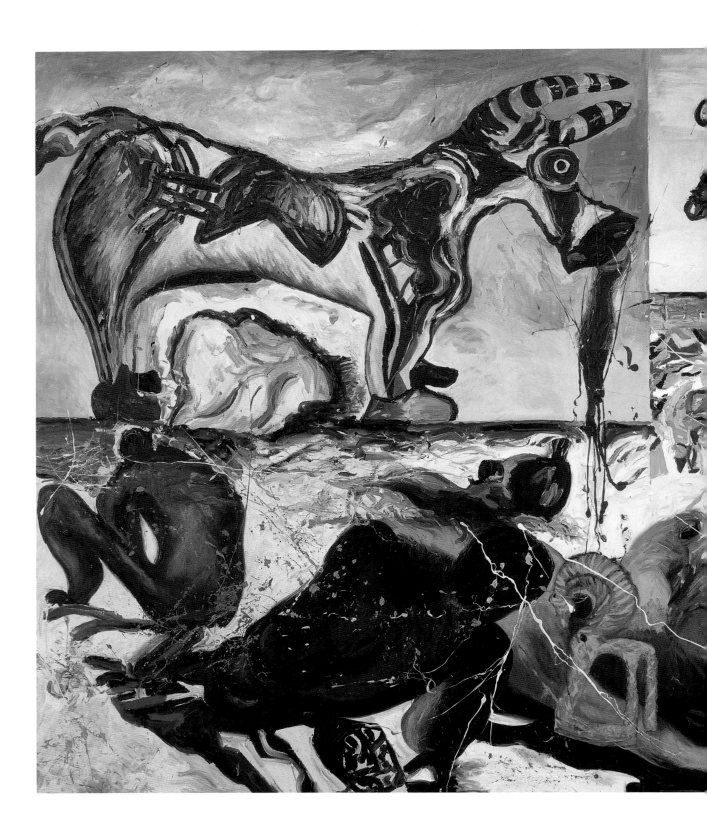

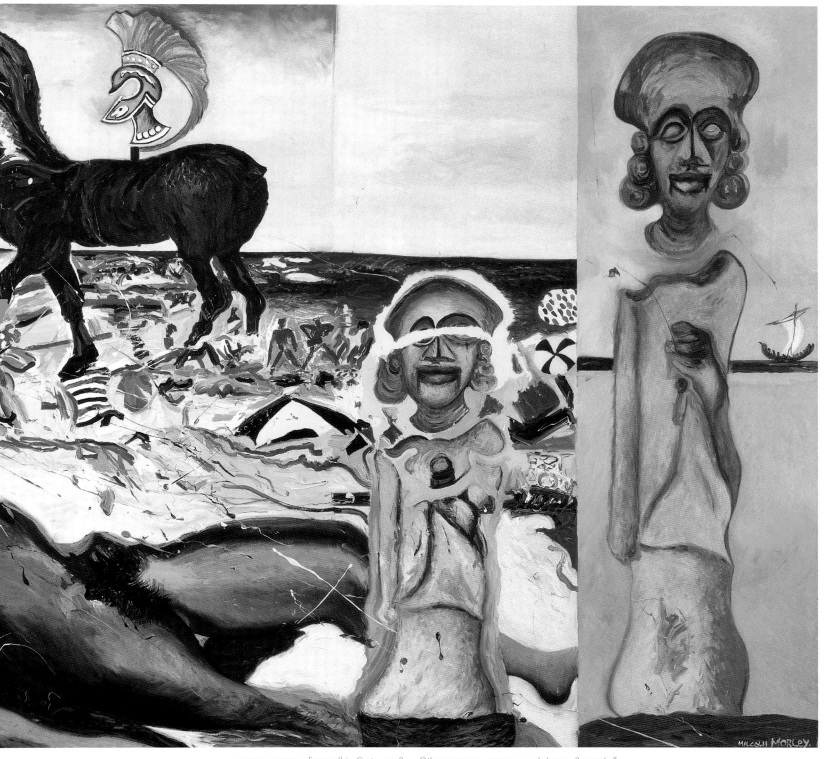

MALCOLM MORLEY *Farewell to Crete* 1984 Oil on canvas 203.2 × 416.6 cm 80 × 164"

JULIAN SCHNABEL *Oar: For the One who Comes Out to Know Fear* 1981 Oil, crockery, car body filler paste and wood on wood 318 × 438 × 32.5 cm 127 × 175 × 13"

JULIAN SCHNABEL *The Sea* 1981 Oil, crockery on wood 274 × 390 cm 108 × 156"

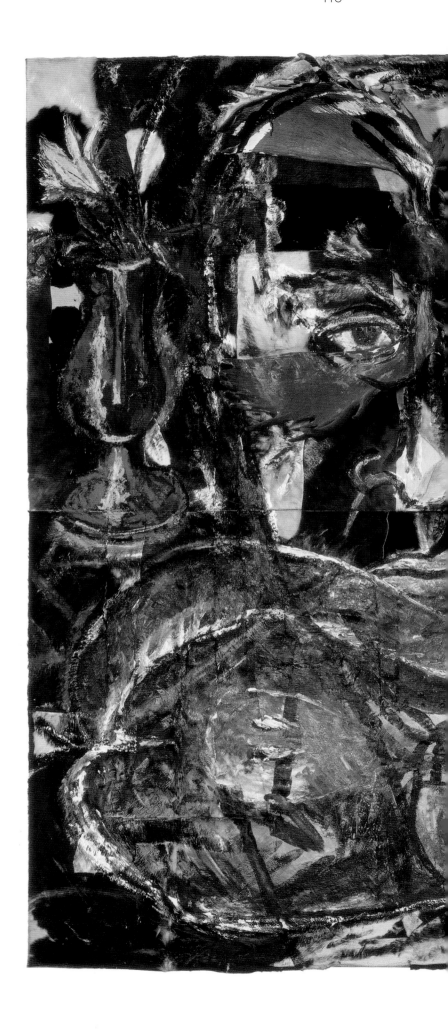

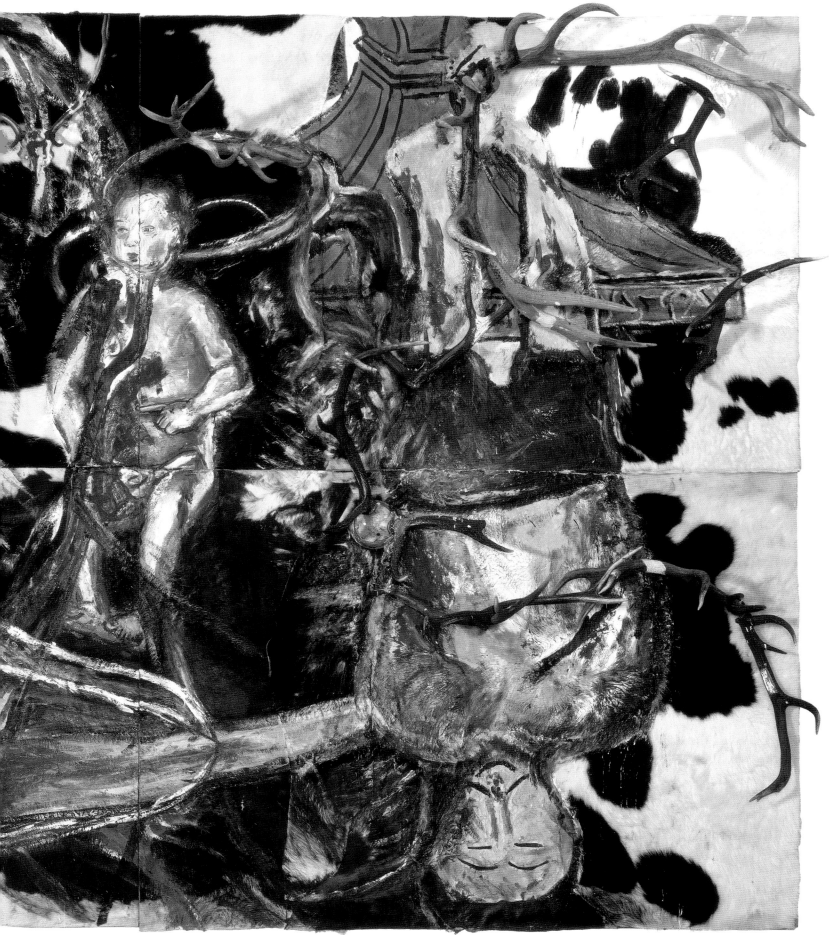

JULIAN SCHNABEL *Pre-History: Glory, Honor, Privilege and Poverty* 1981 Oil and antlers on pony skin 324 × 450 cm 128 × 177"

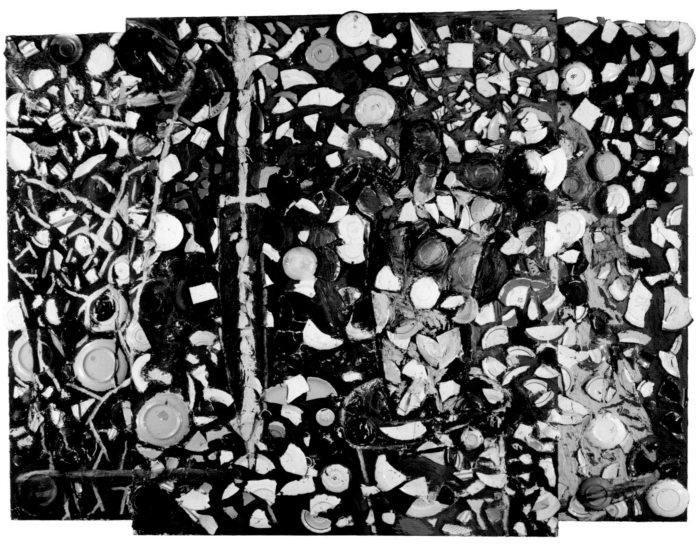

JULIAN SCHNABEL *The Death of Fashion* 1978 Oil, crockery on canvas and wood 225 × 300 × 23.5 cm 90 × 120 × 13"

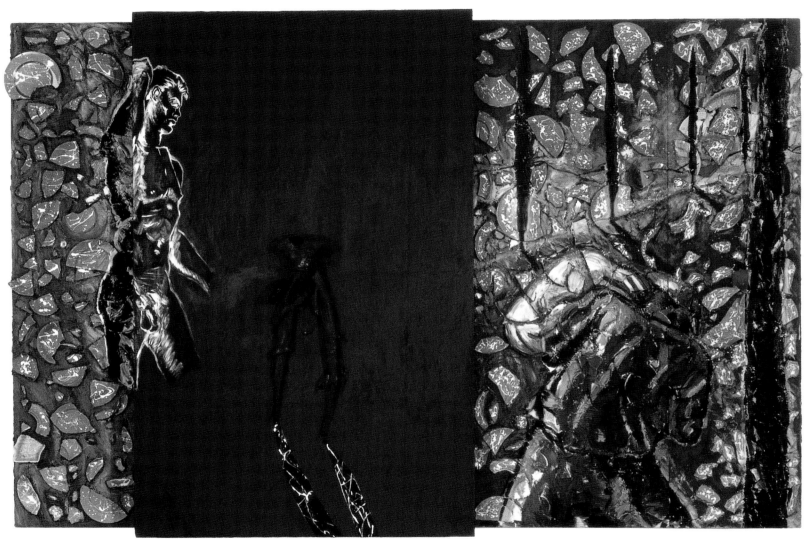

JULIAN SCHNABEL *Bob's Worlds* 1980 Oil, wax, crockery on wood and canvas 243.8 × 365.7 cm 97½ × 146"

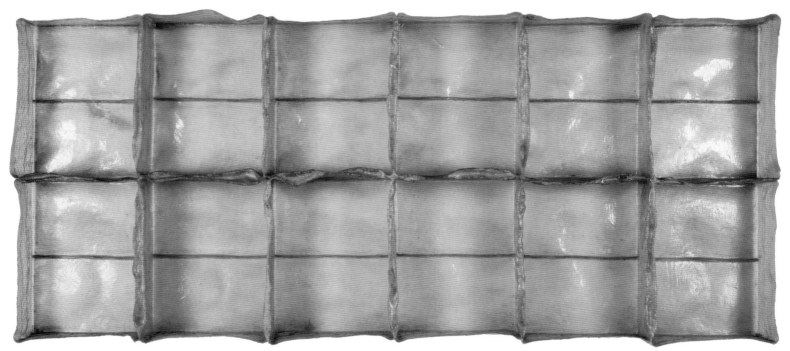

EVA HESSE *Sans II* 1968 Fibreglass 96.5 × 218.4 × 15.6 cm 38 × 86 × 6¼"

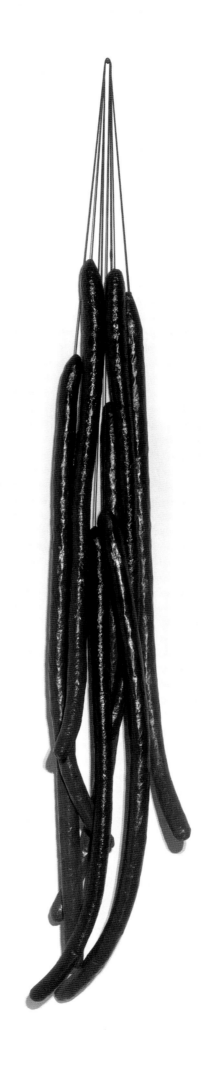

EVA HESSE *Several* 1965 Acrylic, papier-mâché, latex and rubber (4 units) 223.5 × 28 × 17.8 cm 88 × 11 × 7"

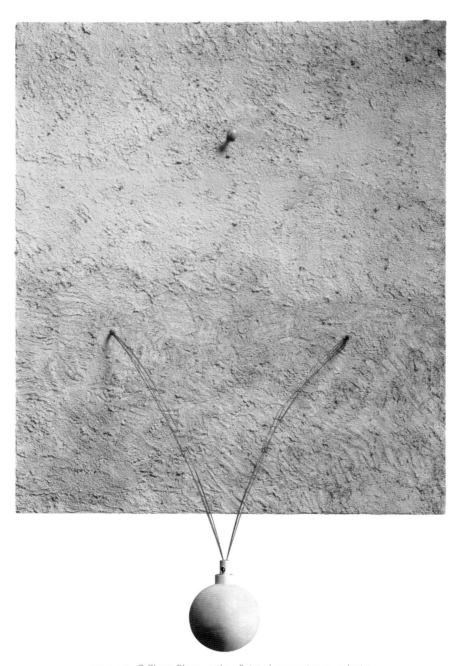

EVA HESSE *C-Clamp Blues* 1965 Painted concretion, metal wire,
bolt and painted plastic ball 218.4 × 96.5 × 15.6 cm 86 × 38 × 6¼"

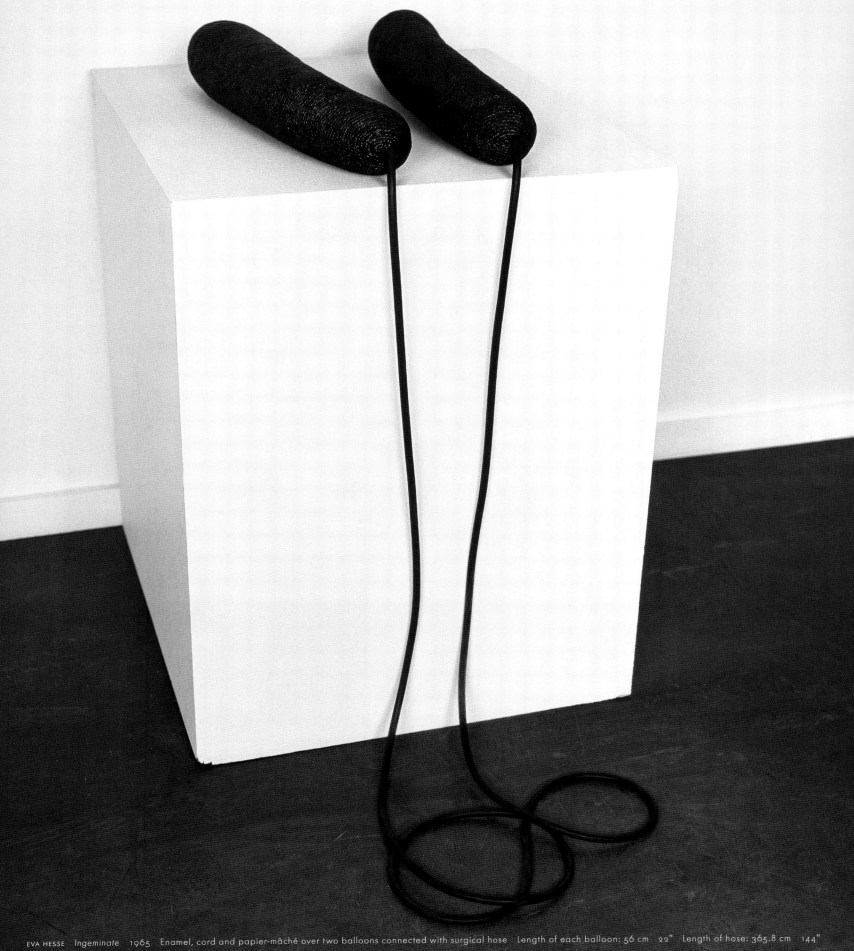

EVA HESSE *Ingeminate* 1965 Enamel, cord and papier-mâché over two balloons connected with surgical hose Length of each balloon: 56 cm 22" Length of hose: 365.8 cm 144"

EVA HESSE *Sequel* 1967 Latex (91 spheres) Each sphere: 6.4 cm 2½"
Overall: 81.3 × 76.2 cm 32 × 30"

EVA HESSE *Top Shot* 1965 Flexible metal cord, electrical cord, metal hardware, paint, plastic hard ball
and porcelain socket on masonite 54.6 × 70.5 × 24.8 cm 21½ × 27¾ × 9¾"

CHUCK CLOSE Joe 1969 (detail)

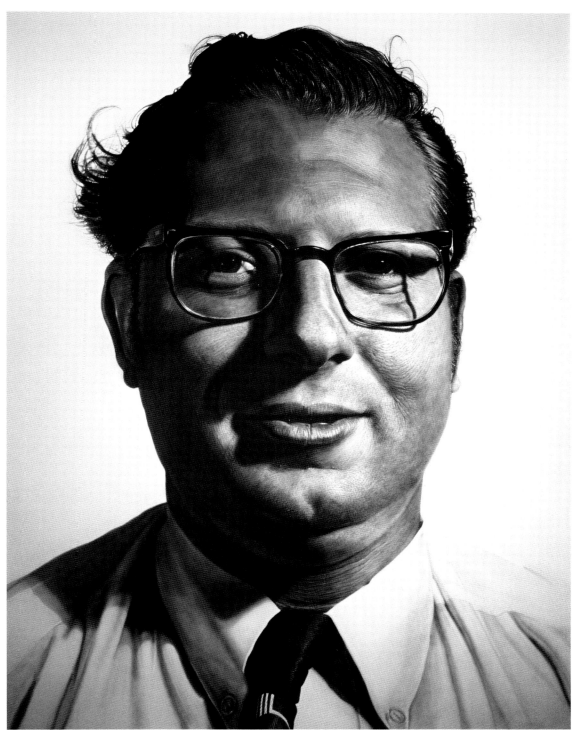

CHUCK CLOSE Joe 1969 Acrylic on canvas 274 × 213 cm 108 × 84"

AGNES MARTIN *Drift of Summer* 1965 Acrylic and graphite on canvas 183 × 183 cm 72 × 72"

AGNES MARTIN *Night Sea* 1963 Oil and gold leaf on canvas 183 × 183 cm 72 × 72"

AGNES MARTIN *Happy Valley* 1967 Acrylic, graphite and ink on canvas 183 x 183 cm 72 x 72"

AGNES MARTIN *Stone* 1960 Oil and graphite on canvas 183 × 183 cm 72 × 72"

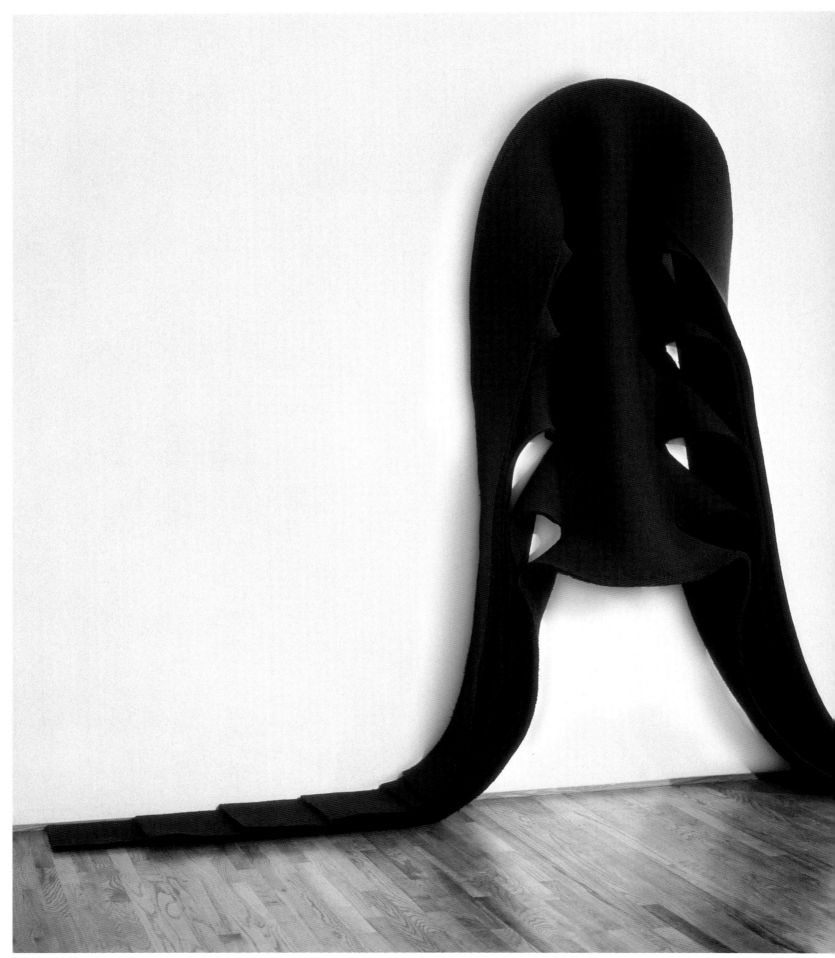

ROBERT MORRIS *Untitled* 1970 Brown felt 182.9 × 548.6 cm 72 × 216"

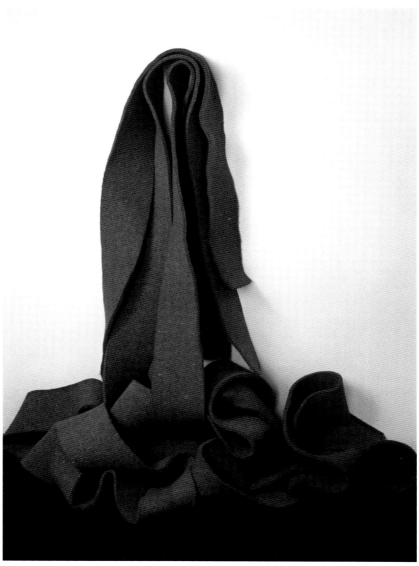

ROBERT MORRIS *Untitled* 1968 Tan felt (9 strips) Each strip: 304.8 × 20.3 cm 120 × 8"

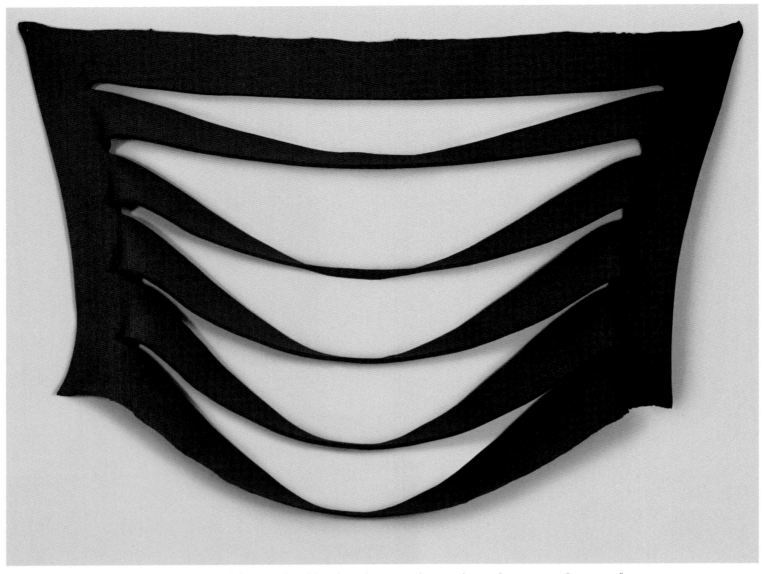

ROBERT MORRIS *Untitled* 1967 Grey felt and metal mounting plates 198.1 × 348 × 43.2 cm 78 × 137 × 17"

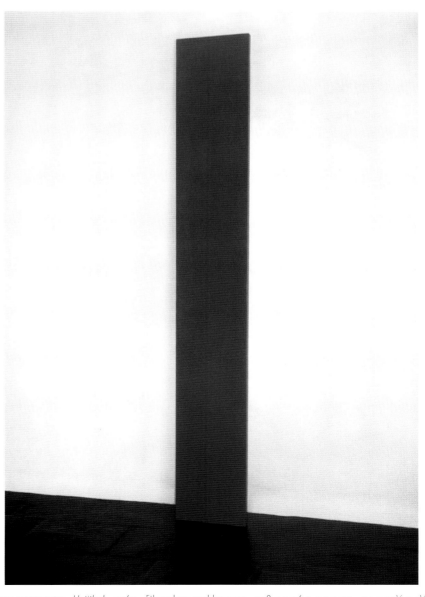

JOHN MCCRACKEN *Untitled* 1967 Fibreglass and lacquer 238.5 × 36.2 × 3.2 cm 94 × 14¼ × 1¼"

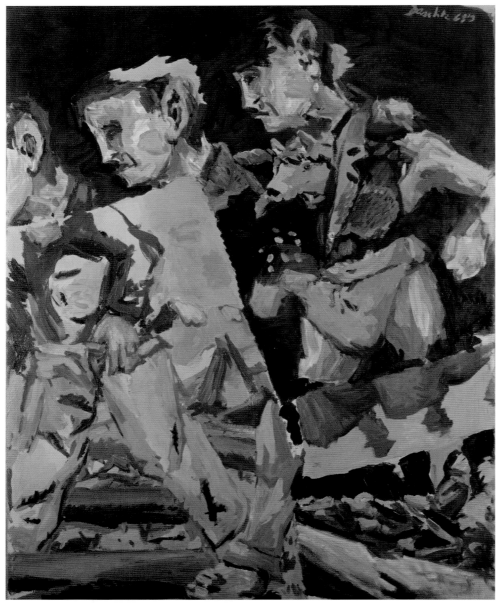

GEORG BASELITZ *Meissener Waldarbeiter [Meissen Woodsmen]* 1968–69
Oil on canvas 250 × 200 cm 98½ × 79"

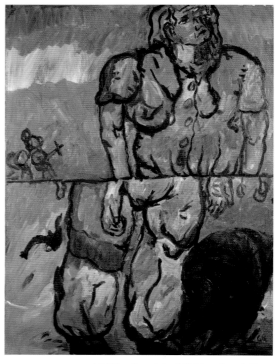

GEORG BASELITZ *MMM in G und A [MMM in G and A]*
1961–66 Oil on canvas 195 × 145 cm 78 × 58"

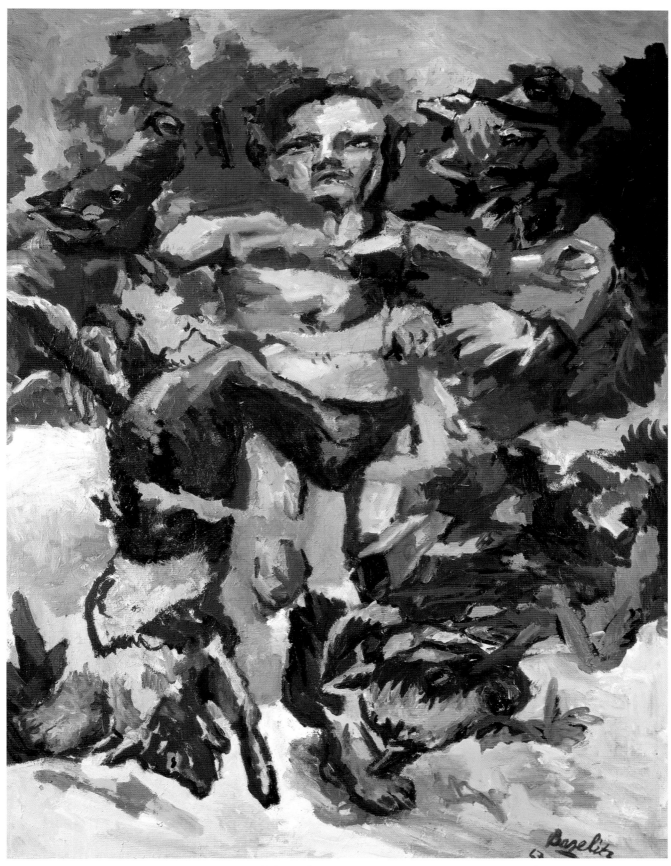

GEORG BASELITZ *B. für Larry* [B for Larry] 1967 Oil on canvas 250 × 200 cm 98½ × 79"

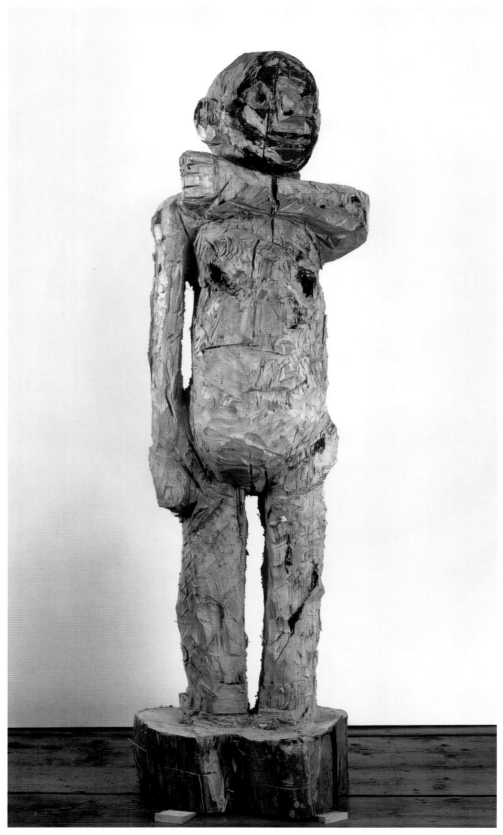

GEORG BASELITZ *Untitled* 1982–83 Lime wood 250 × 73 × 59 cm 98⅜ × 28¾ × 23¼"

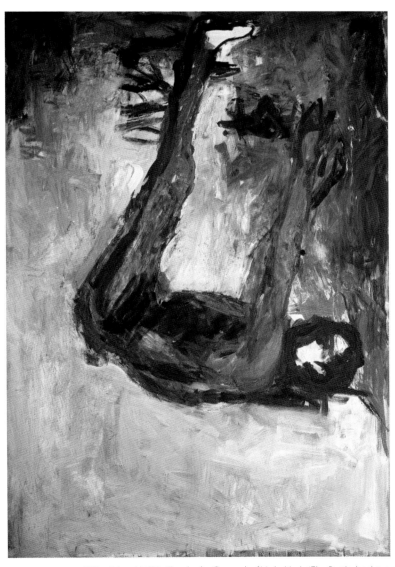 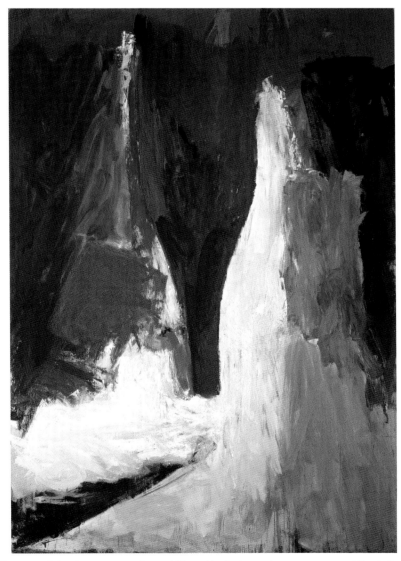

GEORG BASELITZ *Männlicher Akt/Die Flasche (2. Gruppe)* *[Male Nude/The Bottle (2nd group)]* 1977 Oil and tempera on plywood (diptych) Each panel: 250 × 170 cm 98⅓ × 67"

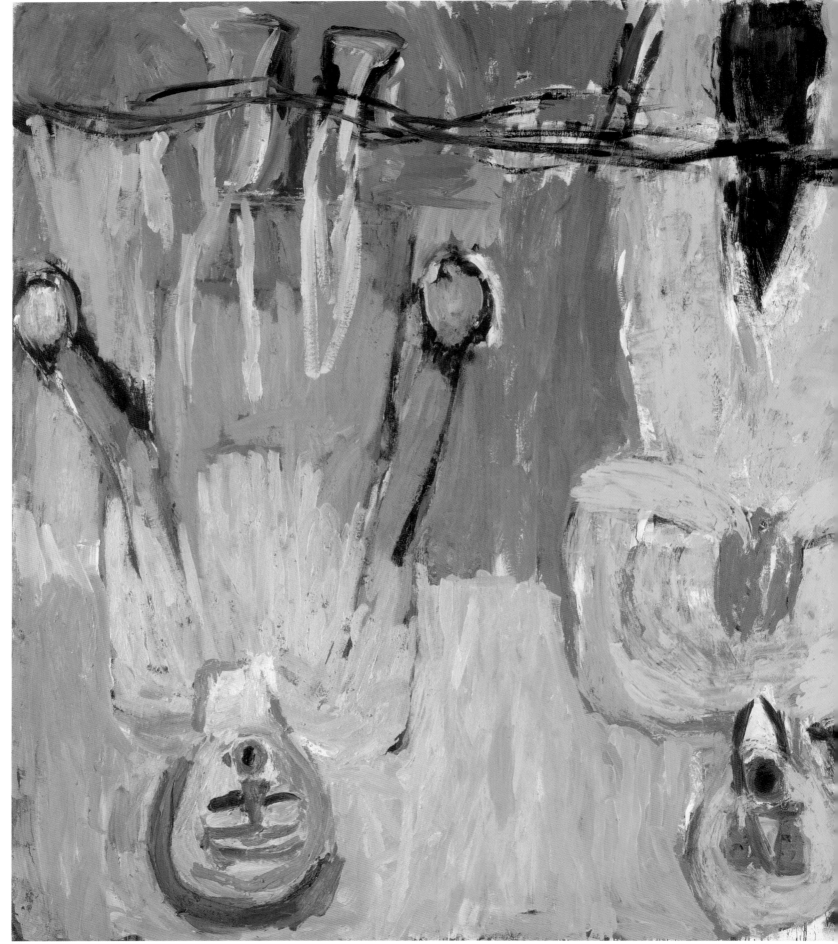

GEORG BASELITZ *Der Brückechor* [*The Brücke Chorus*] 1983 Oil on canvas 280 × 450 cm 110 × 177"

GEORG BASELITZ *Nachtessen in Dresden* [Supper in Dresden] 1983 Oil on canvas 280 × 450 cm 110 × 177"

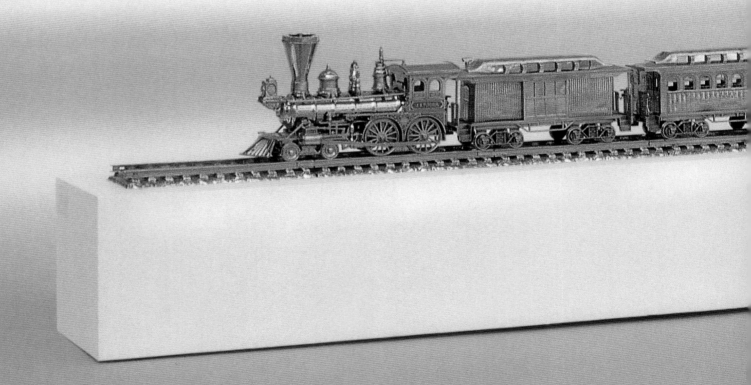

GOBER, KOONS

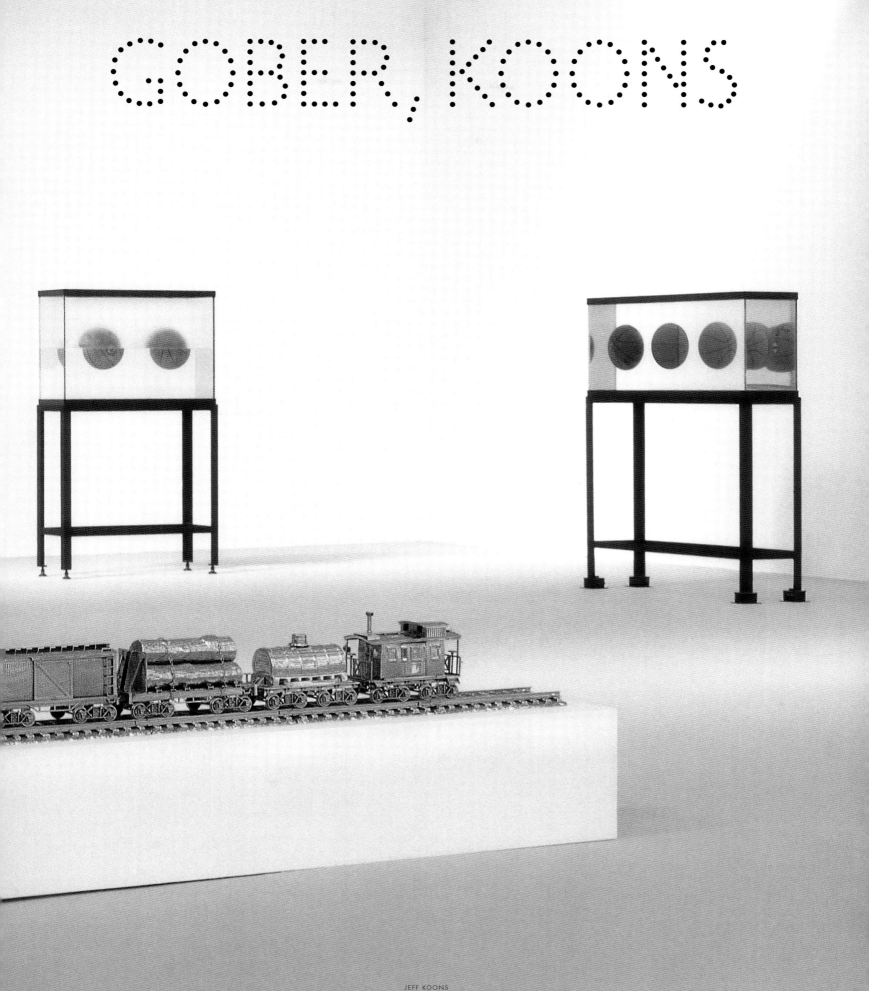

JEFF KOONS
BACKGROUND FROM LEFT
Two Ball 50/50 Tank (Spalding Dr. J. Silver Series, Spalding Dr. J. 241 Series) 1985 Mixed media 159.4 × 98.4 × 33.6 cm 62¾ × 36¾ × 13¼"
Three Ball Total Equilibrium Tank (Two Dr. J. Silver Series, Spalding NBA Tip-off) 1985 Mixed media 153.6 × 123.8 × 33.6 cm 60½ × 48¾ × 13¼"
FOREGROUND
Jim Beam – J.B. Turner Train 1986 Stainless steel and bourbon 27.9 × 289.6 × 16.5 cm 11 × 114 × 6½"

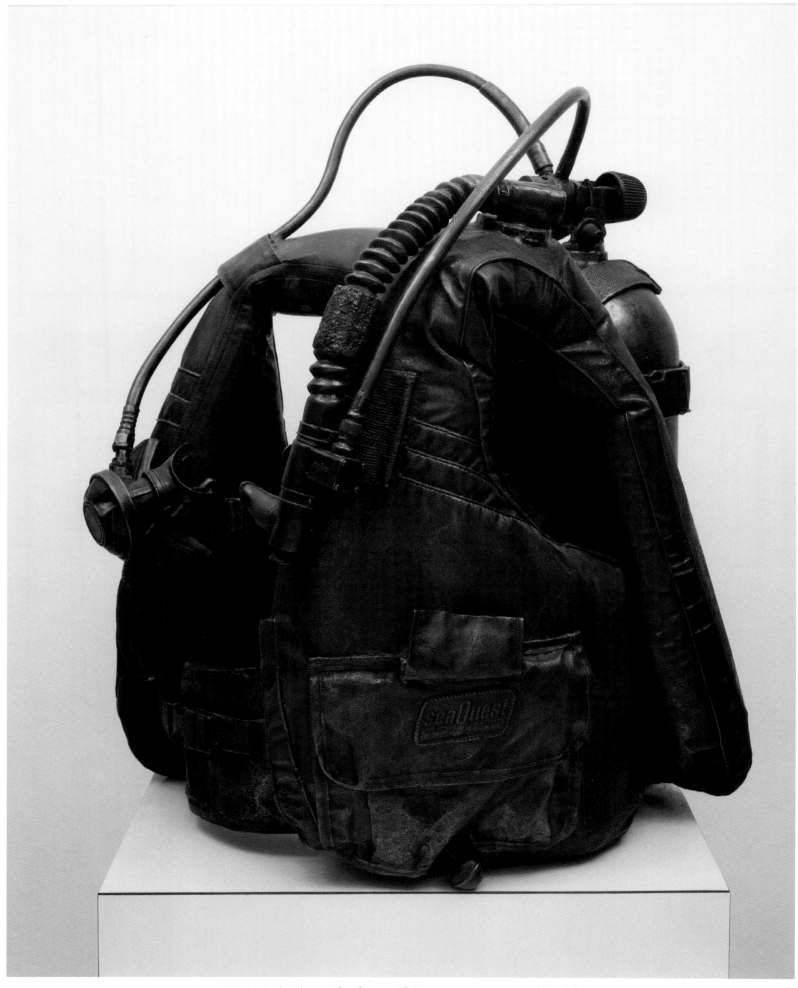

JEFF KOONS *Aqualung* 1985 Bronze 68.6 × 44.5 × 44.5 cm 27 × 17½ × 17½"

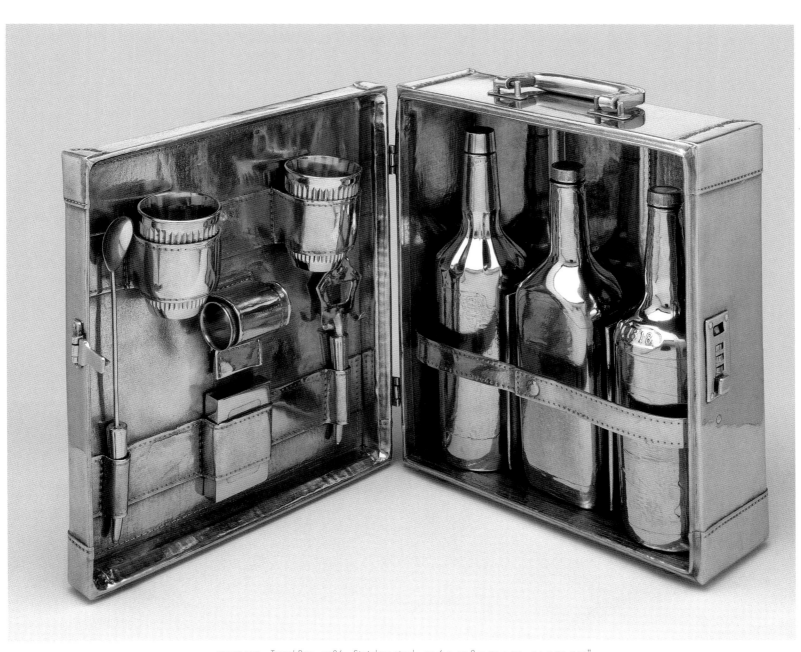

JEFF KOONS *Travel Bar* 1986 Stainless steel 35.6 × 50.8 × 30.5 cm 14 × 20 × 12"

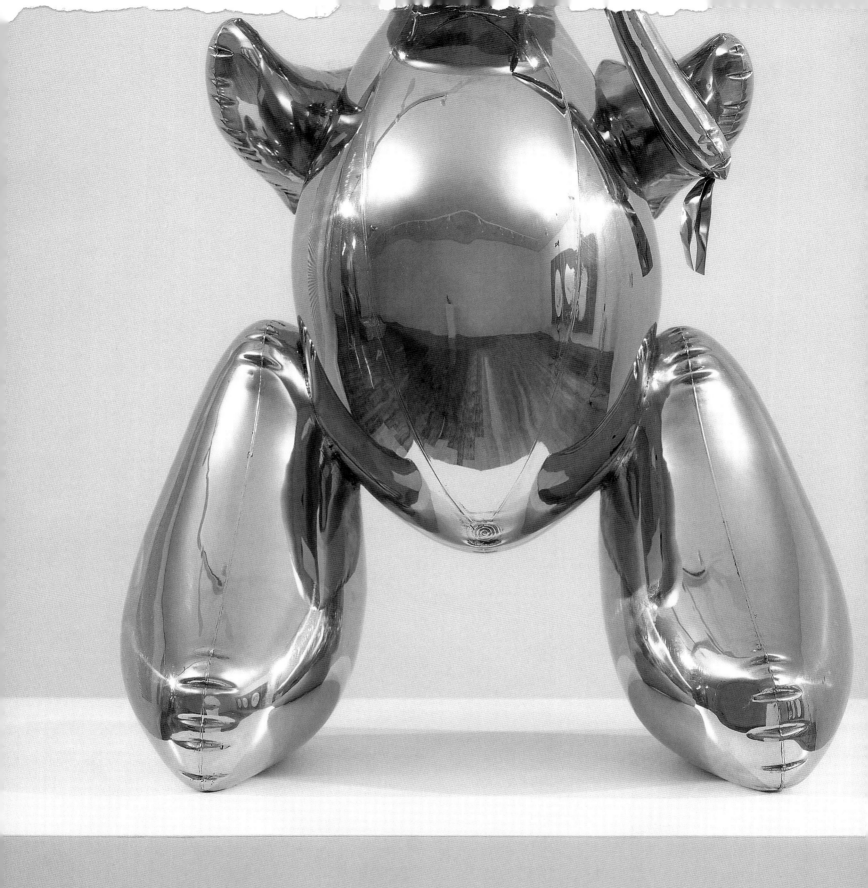

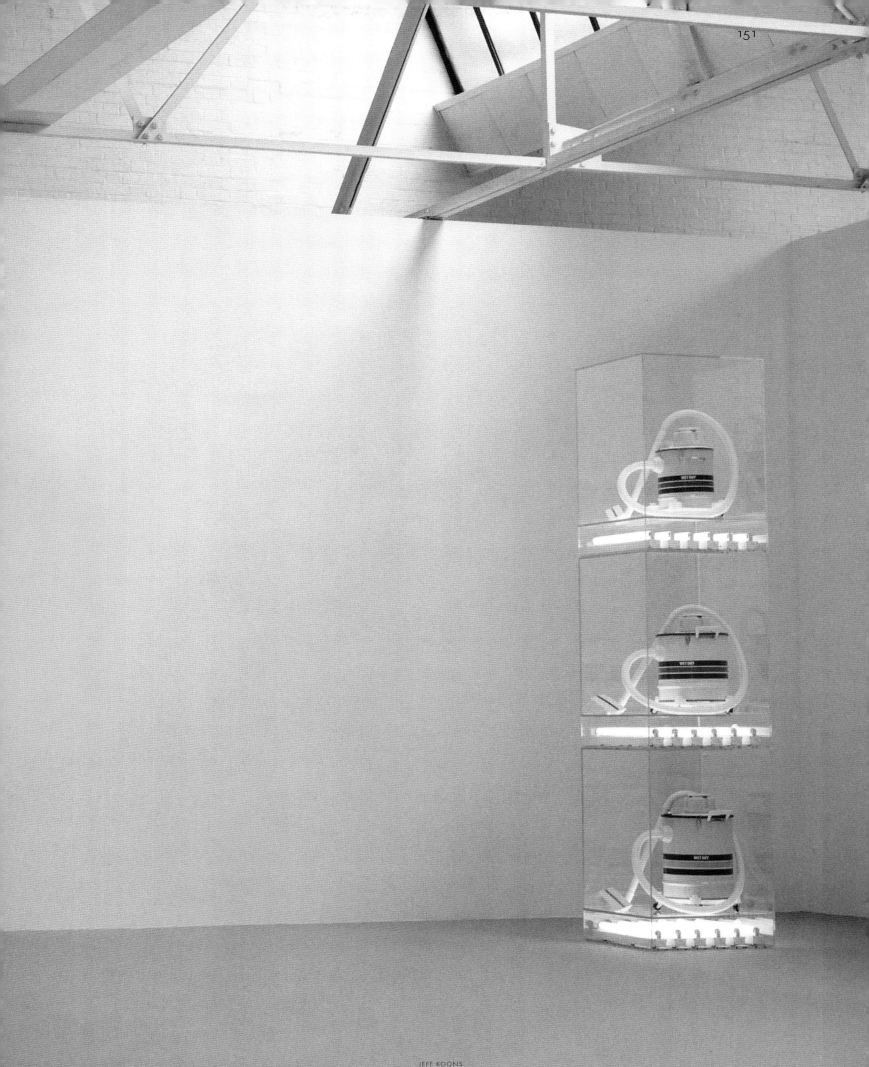

JEFF KOONS
LEFT TO RIGHT
One Ball Total Equilibrium Tank (Spalding Dr. J. Silver Series) 1985 Mixed media 164.5 × 78.1 × 33.7 cm 64¾ × 30¾ × 13¼"
New Shelton Wet/Dry Tripledecker 1981 Three vacuum cleaners, acrylic, plexiglass and fluorescent lights 316.2 × 71.1 × 71.1 cm 124½ × 28 × 28"

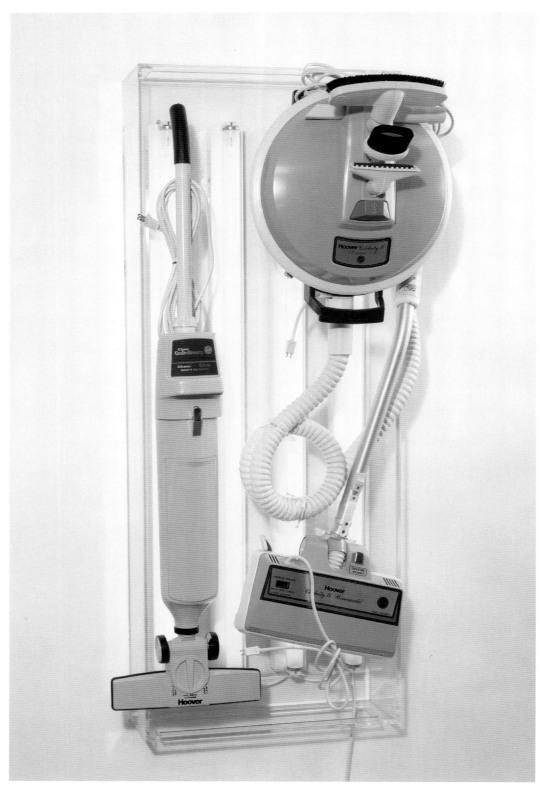

JEFF KOONS *New Hoover Quickbroom, New Hoover Celebrity IV* 1980 Two vacuum cleaners, acrylic, plexiglass and fluorescent lights
142.2 × 55.9 × 48.9 cm 56 × 22 × 19¼"

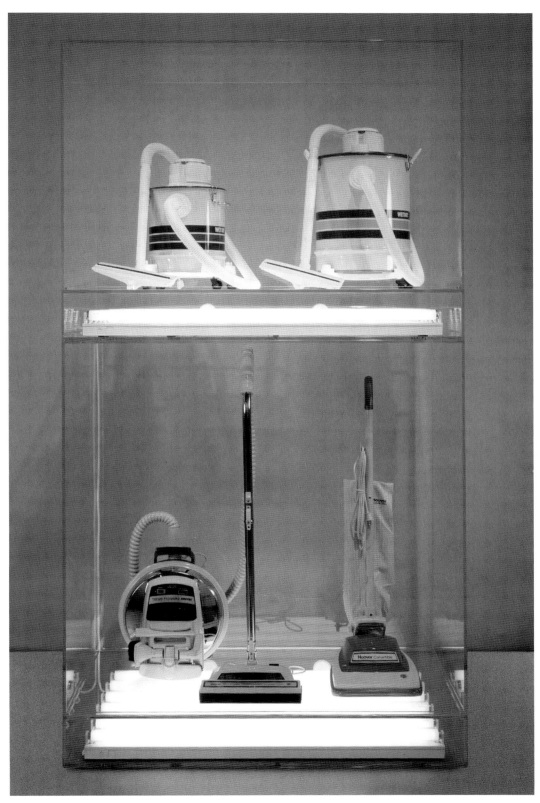

JEFF KOONS *New Hoover Celebrity IV, New Hoover Convertible, New Shelton 5 Gallon Wet/Dry, New Shelton 10 Gallon Wet/Dry, Double-decker*
1981–86 Four vacuum cleaners, acrylic, plexiglass and fluorescent lights 251.5 × 135.9 × 71.1 cm 99 × 53½ × 28"

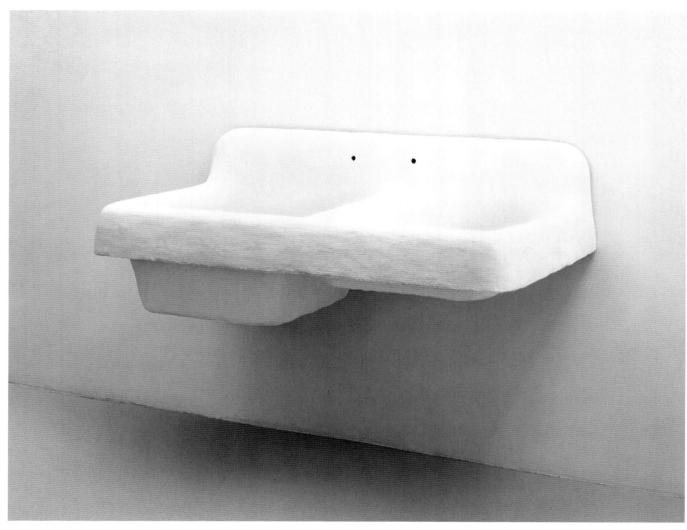

ROBERT GOBER *Untitled Sink* 1984 Plaster, wood, steel, wire lath and oil paint 66 × 167.6 × 86.4 cm 26 × 66 × 34"

ROBERT GOBER
BACKGROUND
Corner Sink 1984 Plaster, wood, wire lath, semi-gloss and enamel paint 40.6 × 116.8 × 93.4 cm 16 × 46 × 37"
FOREGROUND
Partially Buried Sink 1986–87 Cast iron, paint, concrete and grass 200 × 200 × 35 cm 78¾ × 78¾ × 13¾"

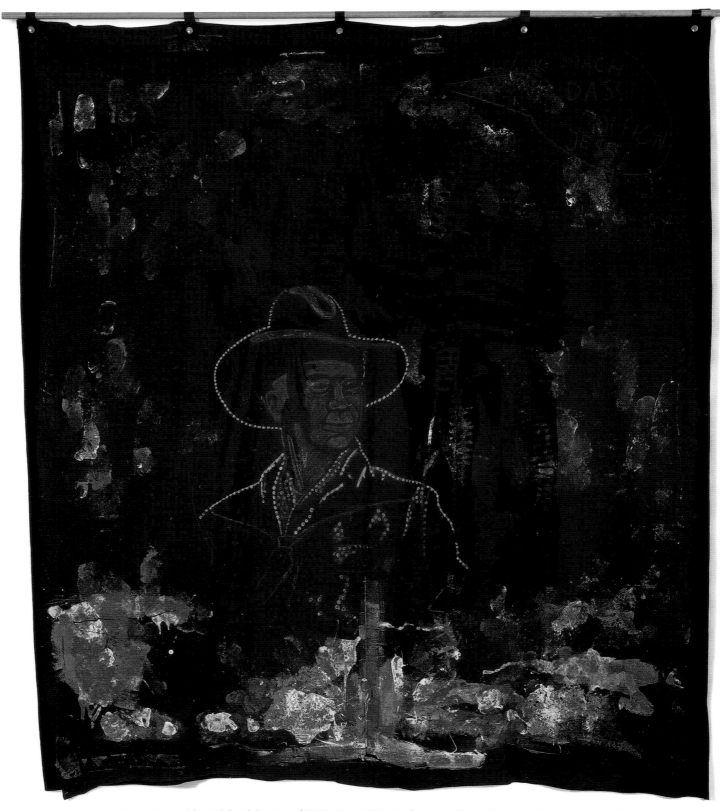

SIGMAR POLKE *Ich Mach Das Schon Jess* *[I'll Take Care of That, Jess]* 1972 Oil on felt 315 × 285 cm 124 × 112"

GOLUB, GUSTON, POLKE

SIGMAR POLKE *Hannibal mit seinen Panzerelefanten [Hannibal with his Armoured Elephants]* 1982
Lacquer on canvas 260 × 200 cm 102½ × 79"

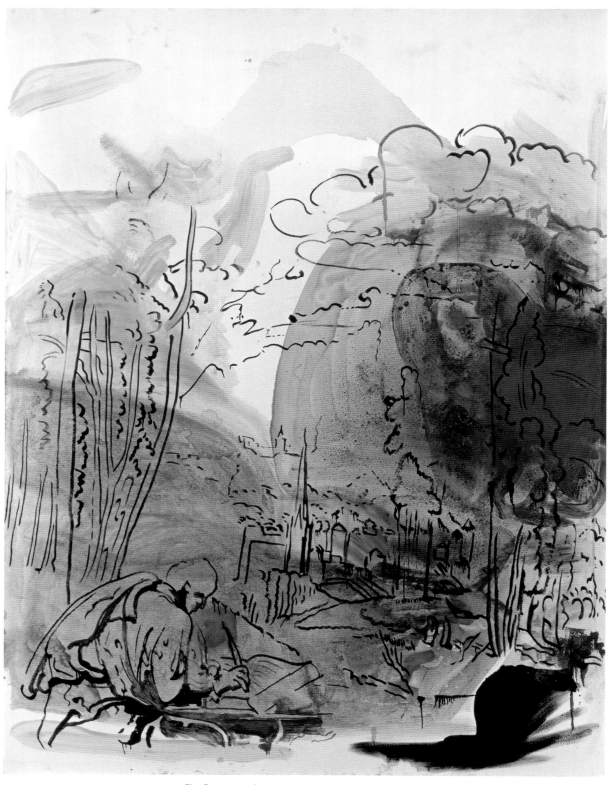

SIGMAR POLKE *The Copyist* 1982 Lacquer on canvas 260 × 200 cm 102½ × 79"

SIGMAR POLKE *Liebespaar II [Lovers II]* 1965 Oil and enamel on canvas 190 × 140 cm 75 × 55"

SIGMAR POLKE *Reiherbild II* *[Herons II]* 1968 Acrylic on flannel blanket 190 × 150 cm 74¾ × 59"

SIGMAR POLKE
TOP ROW LEFT TO RIGHT
Rasterbild mit Palmen [Half-tone Dot Painting with Palm Trees] 1966 Oil on canvas 130 × 110 cm 51 × 44"
Zwei Köpfe [Two Heads] 1971–73 Oil and cellulose on canvas 130 × 110 cm 51 × 44"
Plastik-Wannen [Plastic Tubs] 1964 Oil on canvas 94 × 120 cm 37 × 47¼"
BOTTOM ROW LEFT TO RIGHT
Portrait of David Lamelas (Obelisk) 1971 Acrylic and spray enamel on canvas 130 × 150 cm 51 × 59"
Bunnies 1966 Oil on canvas 150 × 100 cm 59 × 39½"

SIGMAR POLKE *Bunnies* 1966 Oil on canvas 150 × 100 cm 59 × 39½"

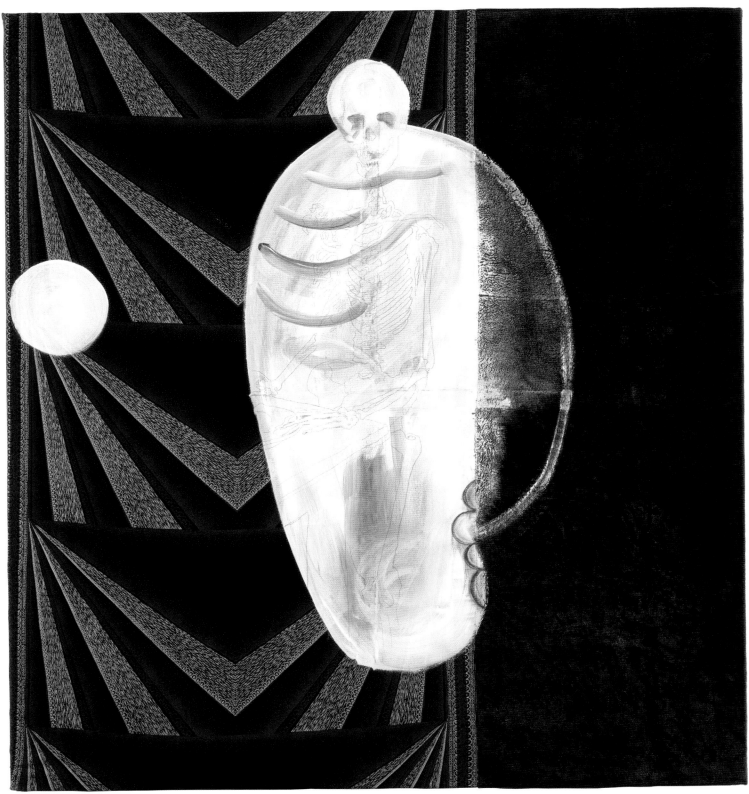

SIGMAR POLKE *Skelett [Skeleton]* 1974 Dispersion on fabric 196 × 183 cm 77 × 72"

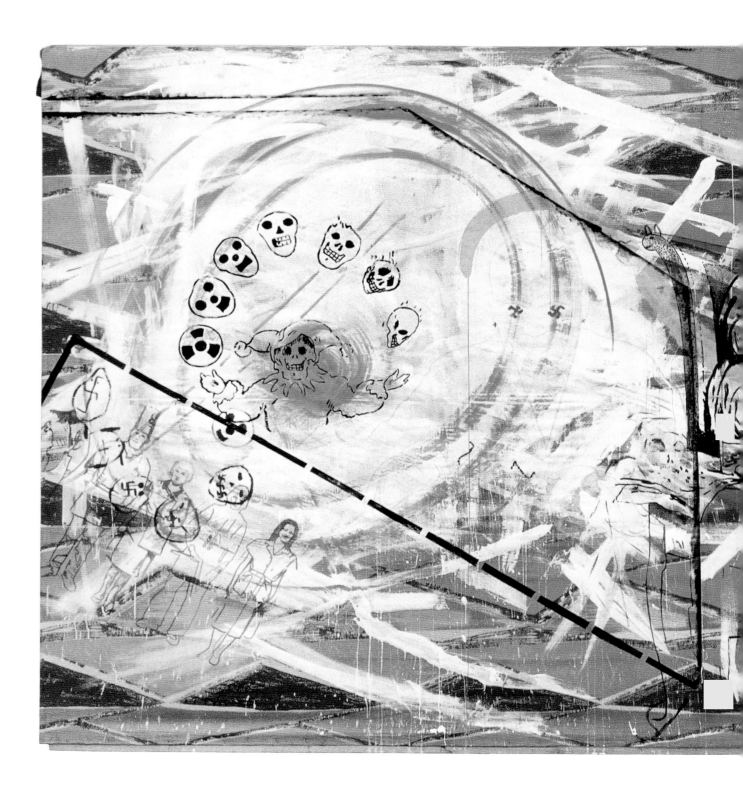

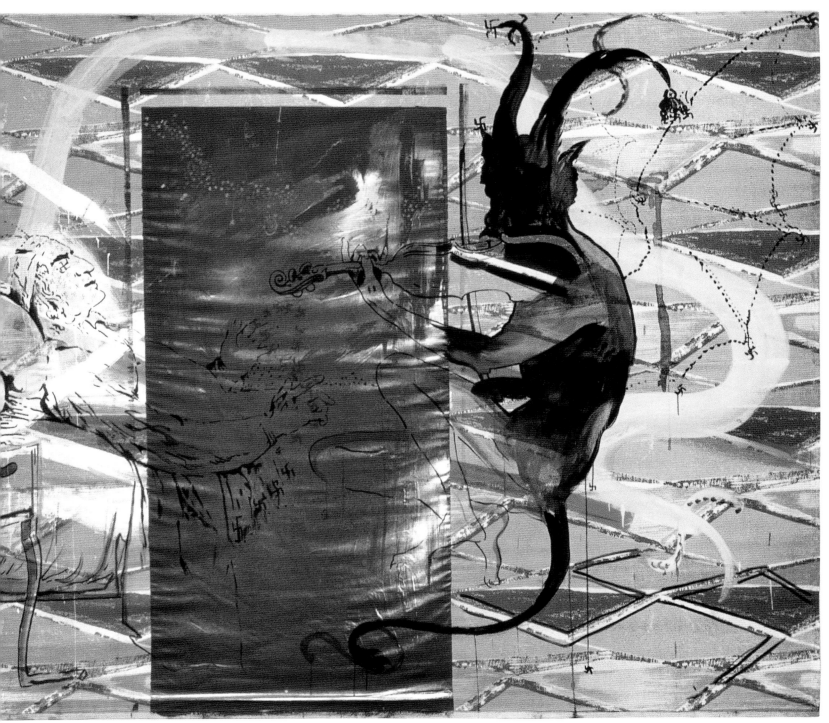

SIGMAR POLKE *Paganini* 1982 Dispersion on canvas 200 × 450 cm 78¾ × 177"

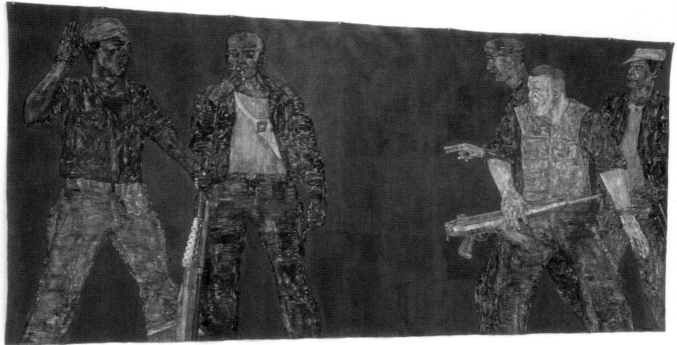

LEON GOLUB
LEFT TO RIGHT
Mercenaries IV 1980 Acrylic on canvas 305 × 584 cm 120 × 230"
Mercenaries I 1979 Acrylic on canvas 305 × 416.6 cm 120 × 164"

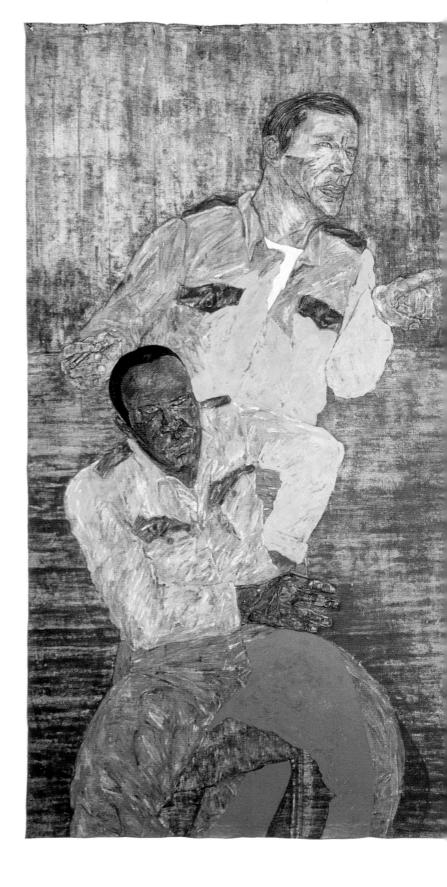

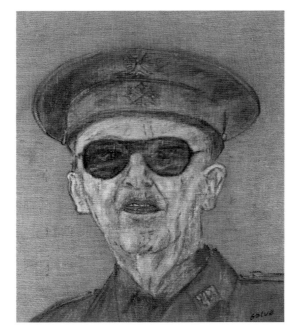

LEON GOLUB *Francisco Franco (1975)* 1976 Acrylic on unprimed linen 51 × 43 cm 20 × 17"

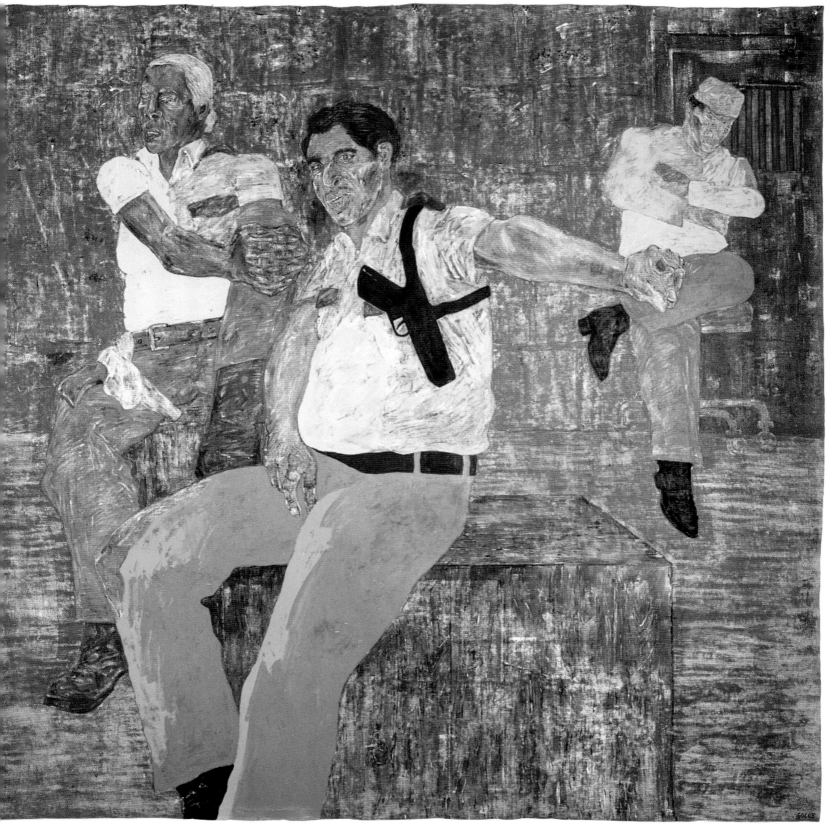

LEON GOLUB *The Go-Ahead* 1986 Acrylic on canvas 304.8 × 487.7 cm 120 × 192"

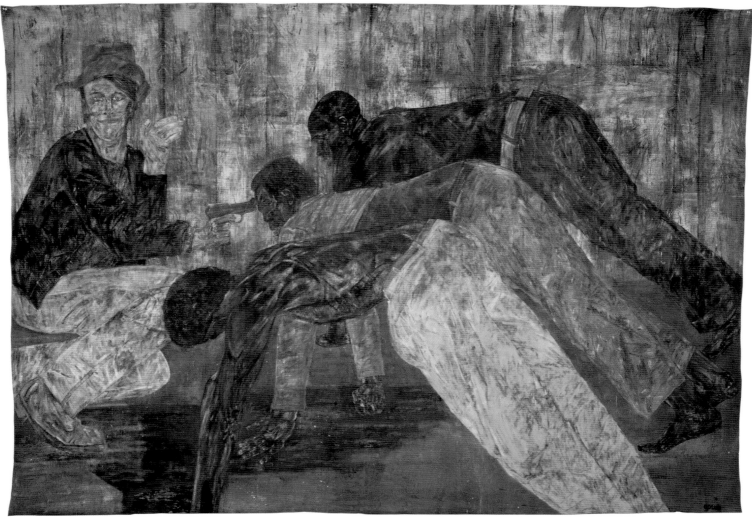

LEON GOLUB *Mercenaries V* 1984 Acrylic on linen 305 × 437 cm 120 × 172"

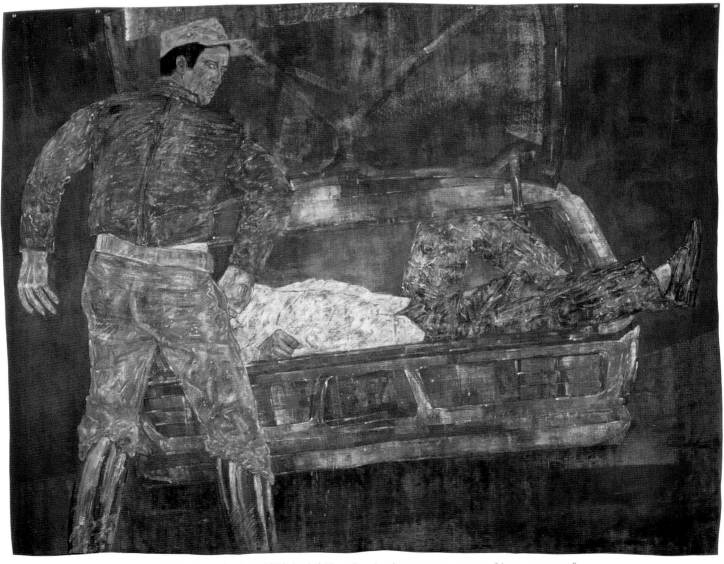

LEON GOLUB *White Squad (El Salvador) IV* 1983 Acrylic on canvas 305 × 386 cm 120 × 152"

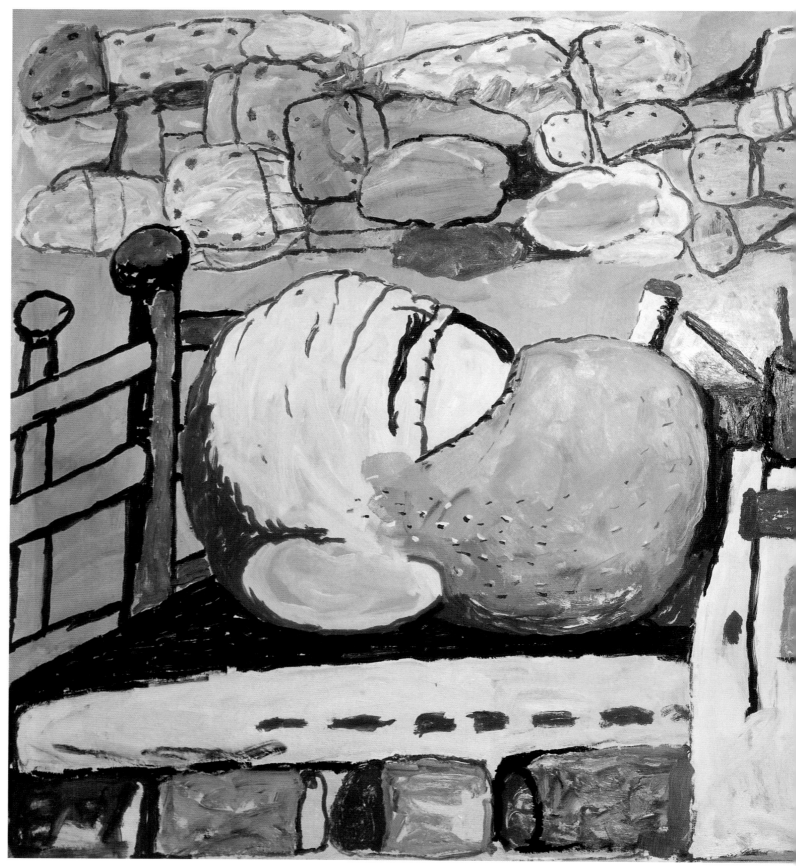

PHILIP GUSTON *Painter in Bed* 1973 Oil on canvas 152.4 × 264.2 cm 60 × 104"

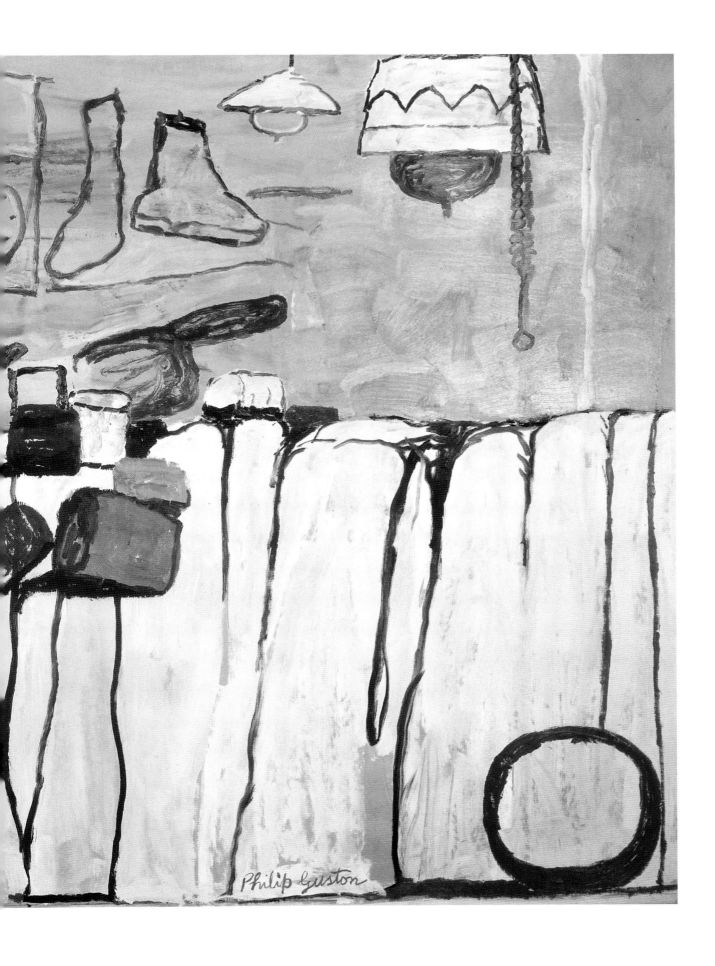

Philip Guston

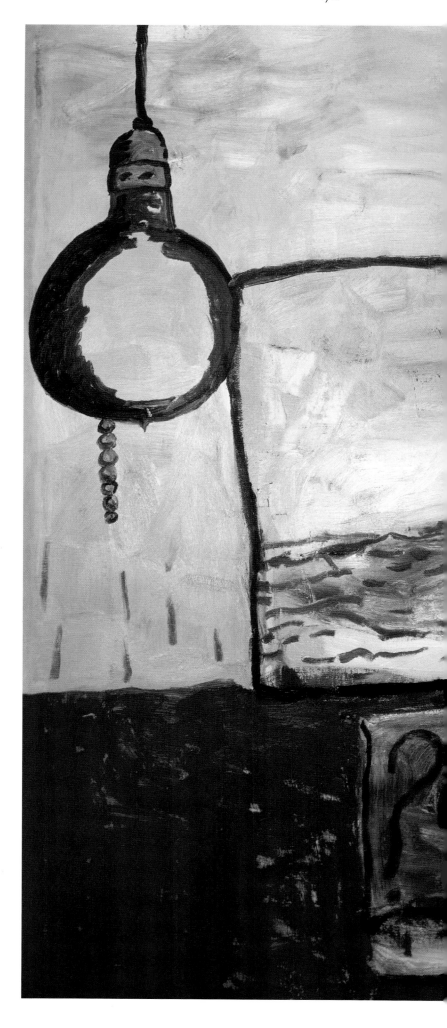

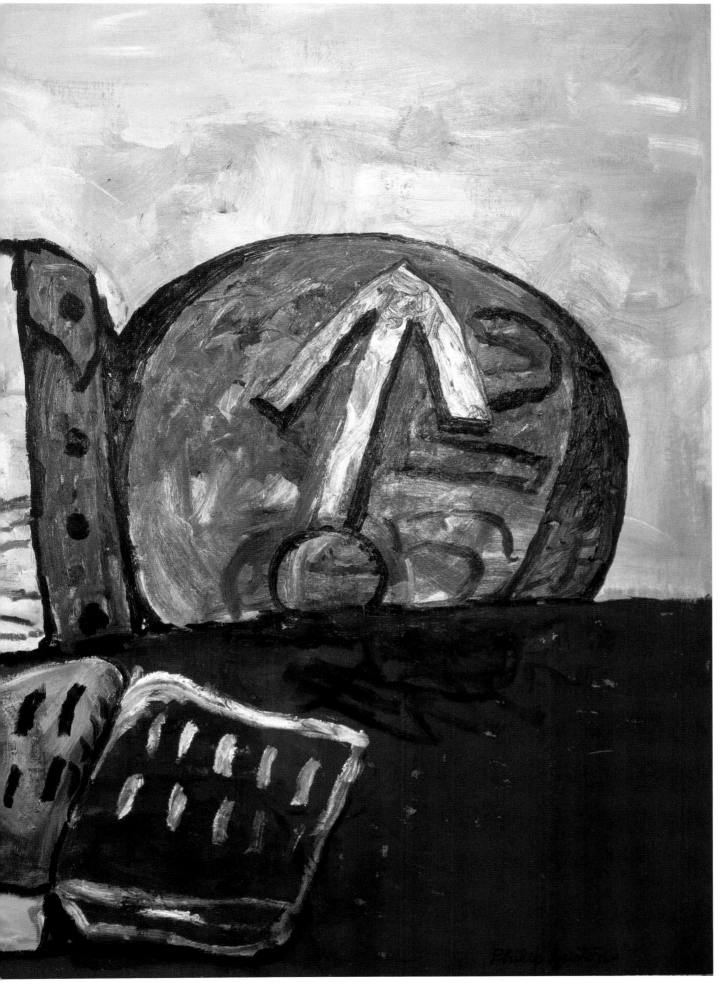

PHILIP GUSTON *The Magnet* 1975 Oil on canvas 171.5 × 204.5 cm 67½ × 80½"

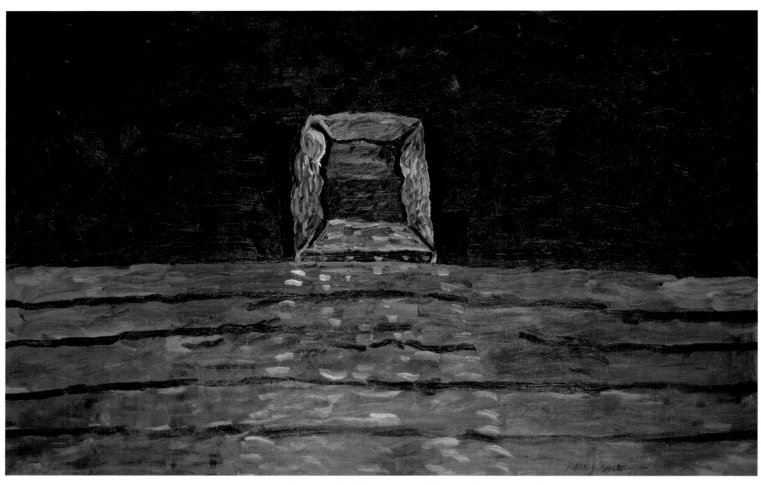

PHILIP GUSTON *Frame* 1976 Oil on canvas 188 × 294.6 cm 74 × 116"

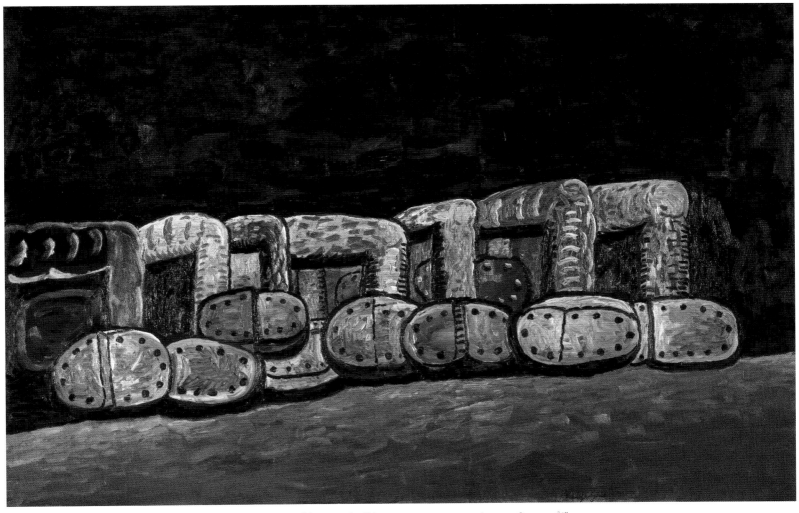

PHILIP GUSTON *Edge* 1976 Oil on canvas 203.3 × 316.9 cm 80 × 124¾"

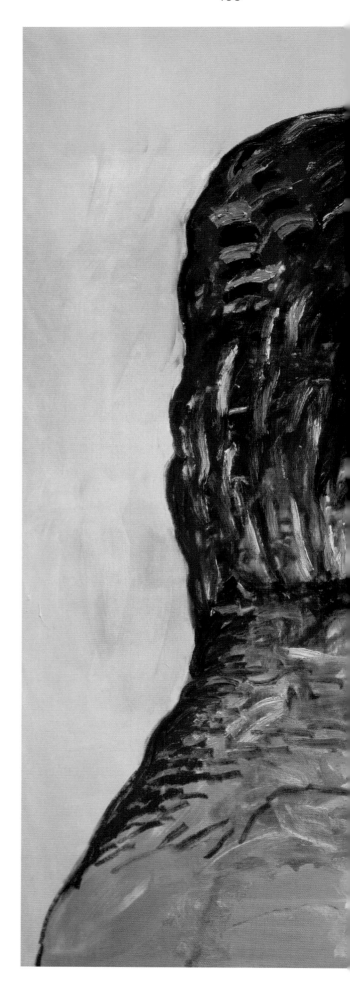

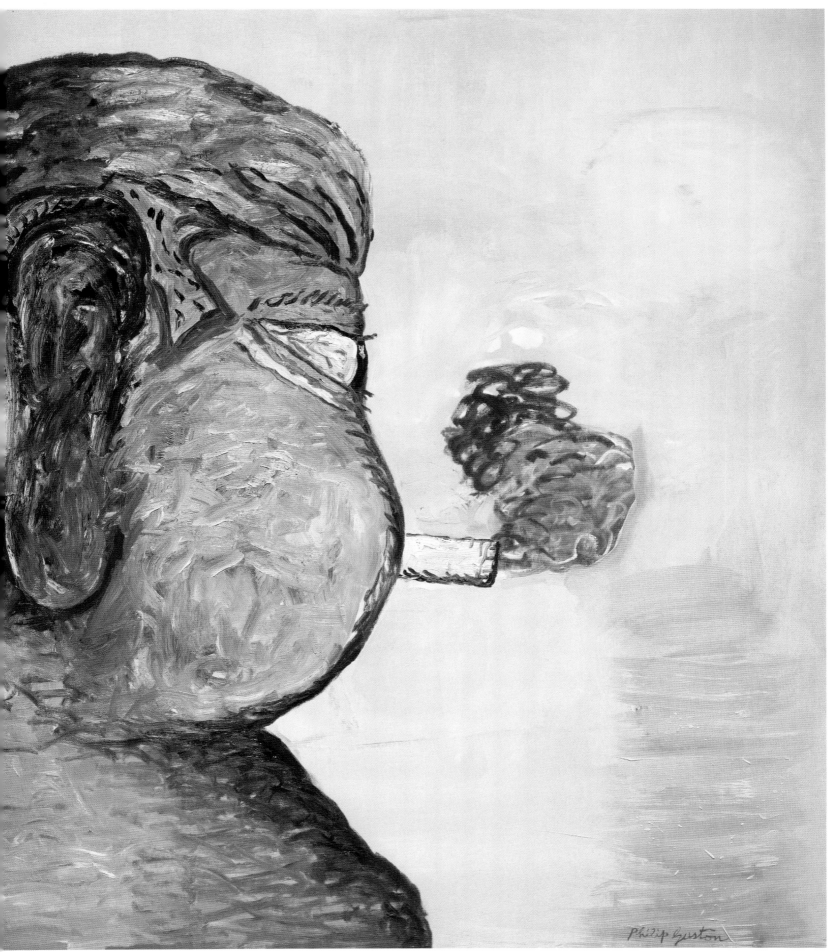

PHILIP GUSTON *Friend — to M. F.* 1978 Oil on canvas 172.7 × 223.5 cm 68 × 88"

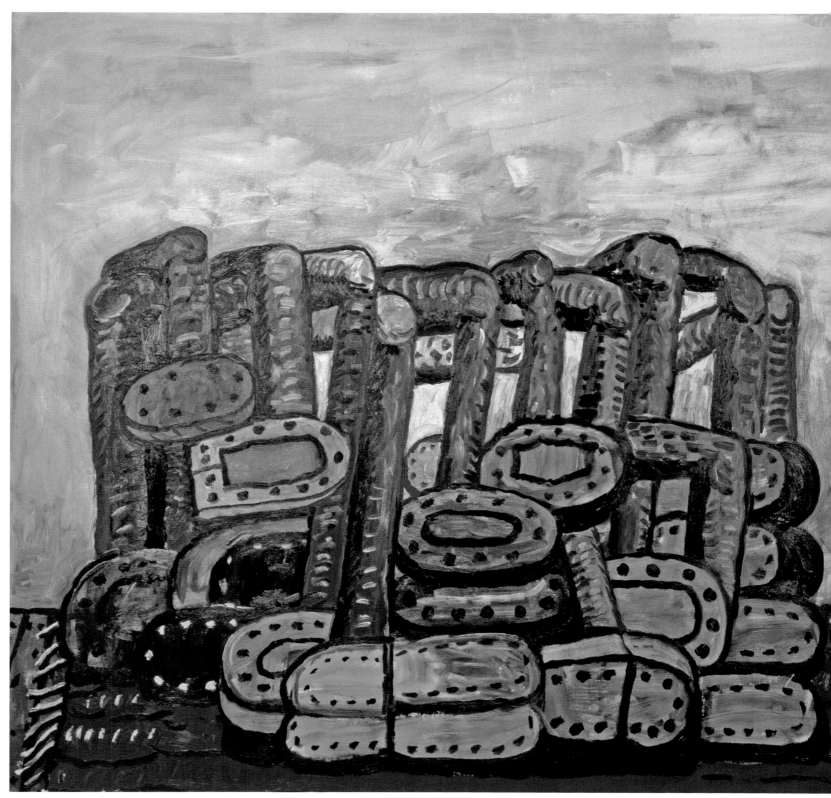

PHILIP GUSTON *Rug III* 1976 Oil on canvas 172.5 × 276.3 cm 69 × 110⅛"

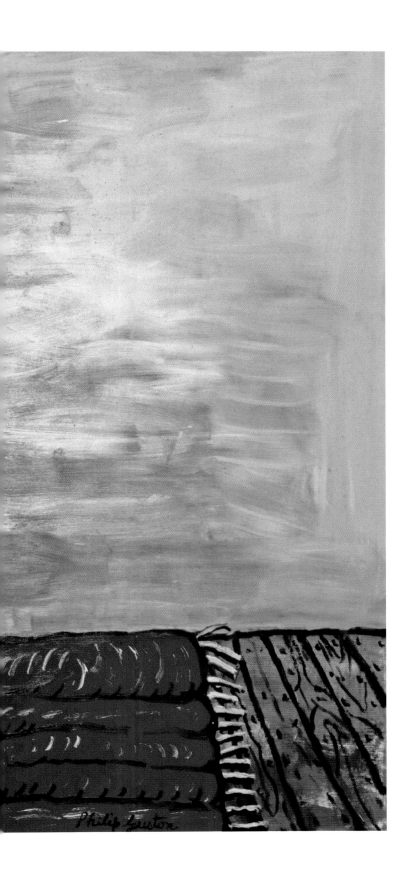

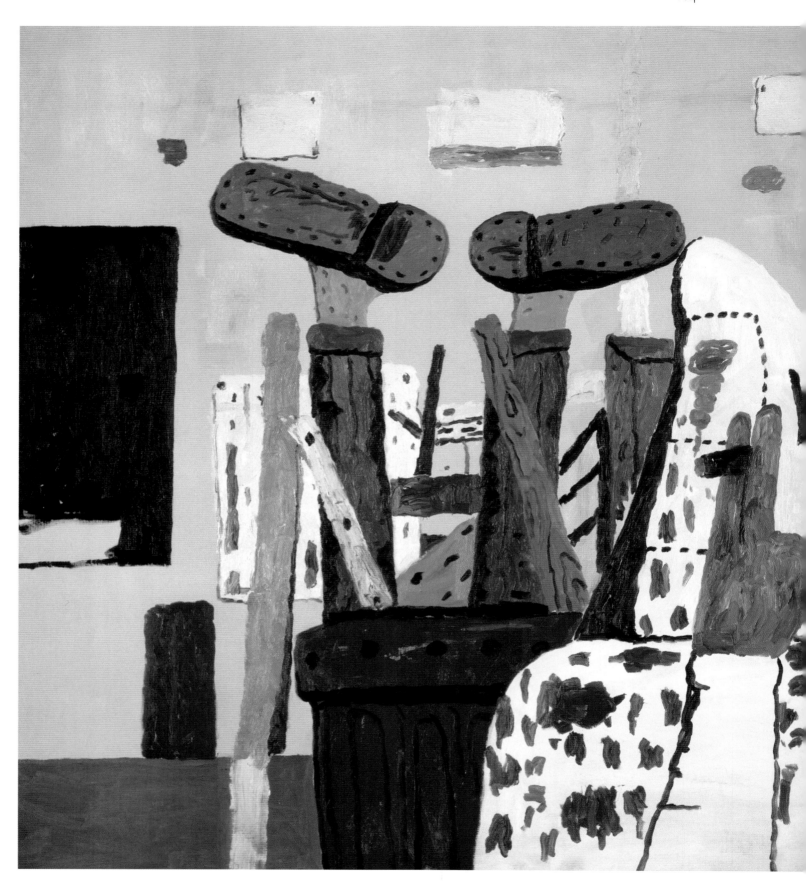

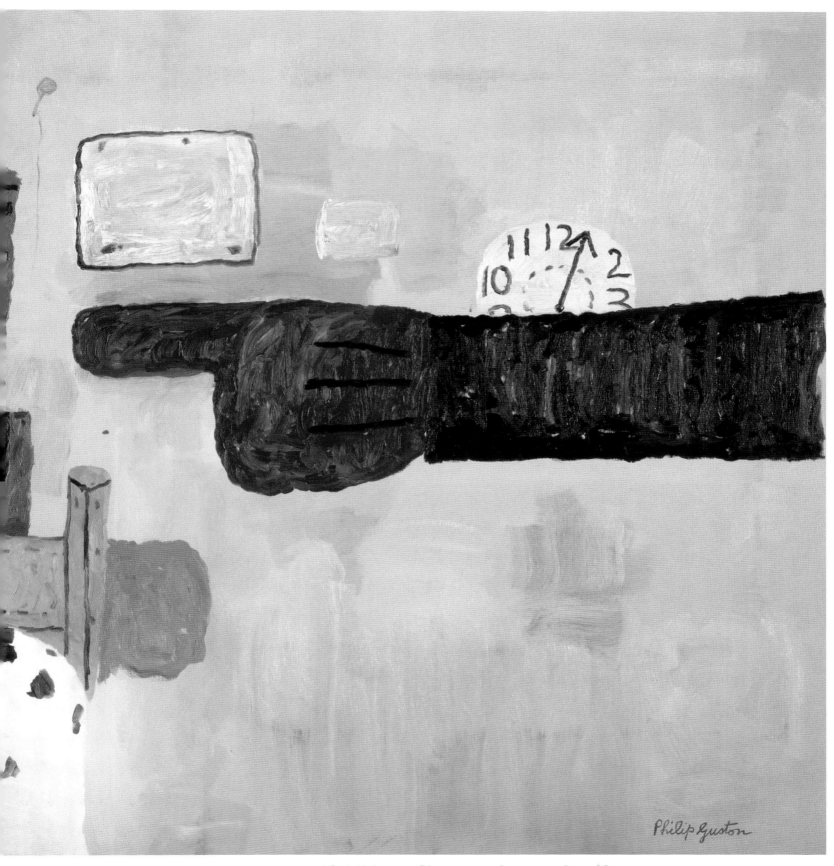

PHILIP GUSTON *A Day's Work* 1970 Oil on canvas 198 × 279 cm 78 × 109¾"

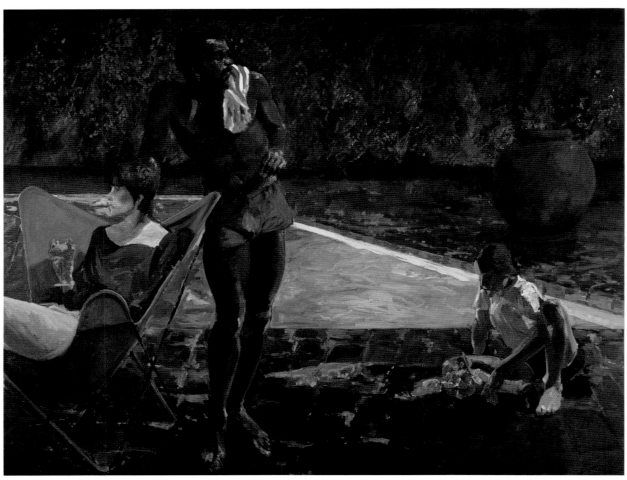

ERIC FISCHL *The Brat II* 1984 Oil on canvas 213.4 × 274.3 cm 84 × 108"

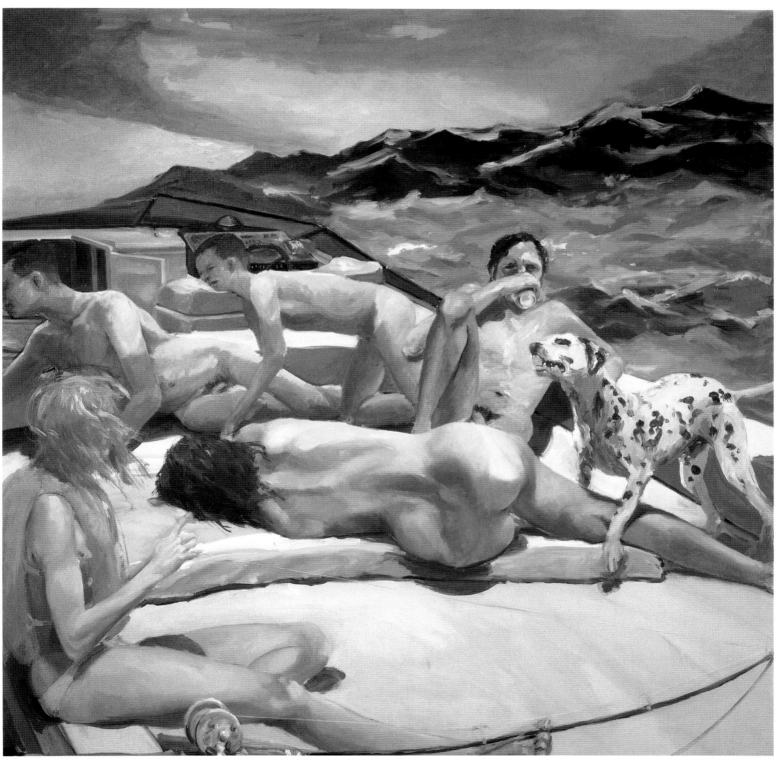

ERIC FISCHL *The Old Man's Boat and the Old Man's Dog* 1982 Oil on canvas 213.4 × 213.4 cm 84 × 84"

ERIC FISCHL *The Life of Pigeons* 1987 Oil on linen 297.2 × 741.7 cm 117 × 292"

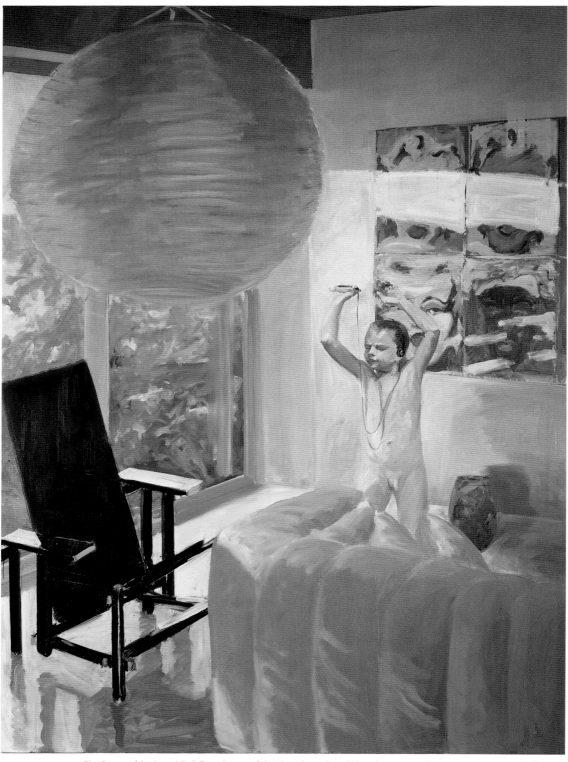

ERIC FISCHL *The Power of Rock and Roll (from Rooms of the House)* 1984 Oil on linen 304.8 × 223.5 cm 120 × 88"

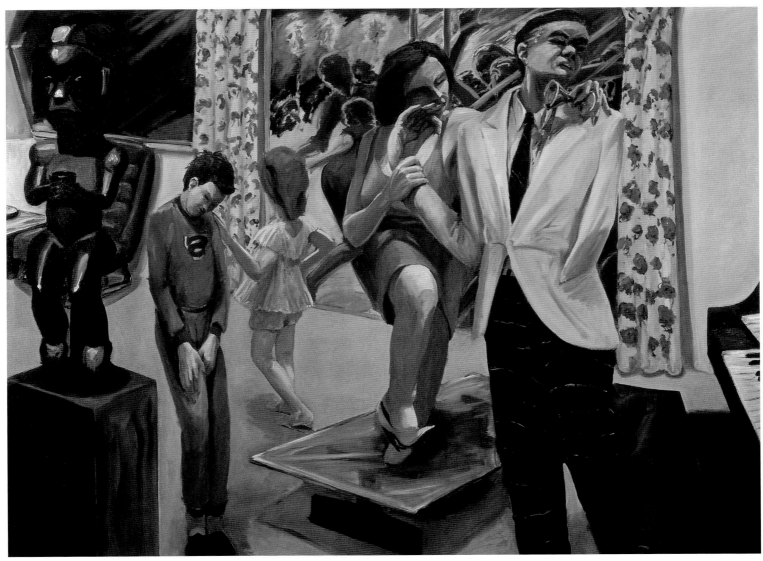

ERIC FISCHL *Time for Bed* 1981 Oil on canvas 182.9 × 243.8 cm 72 × 96"

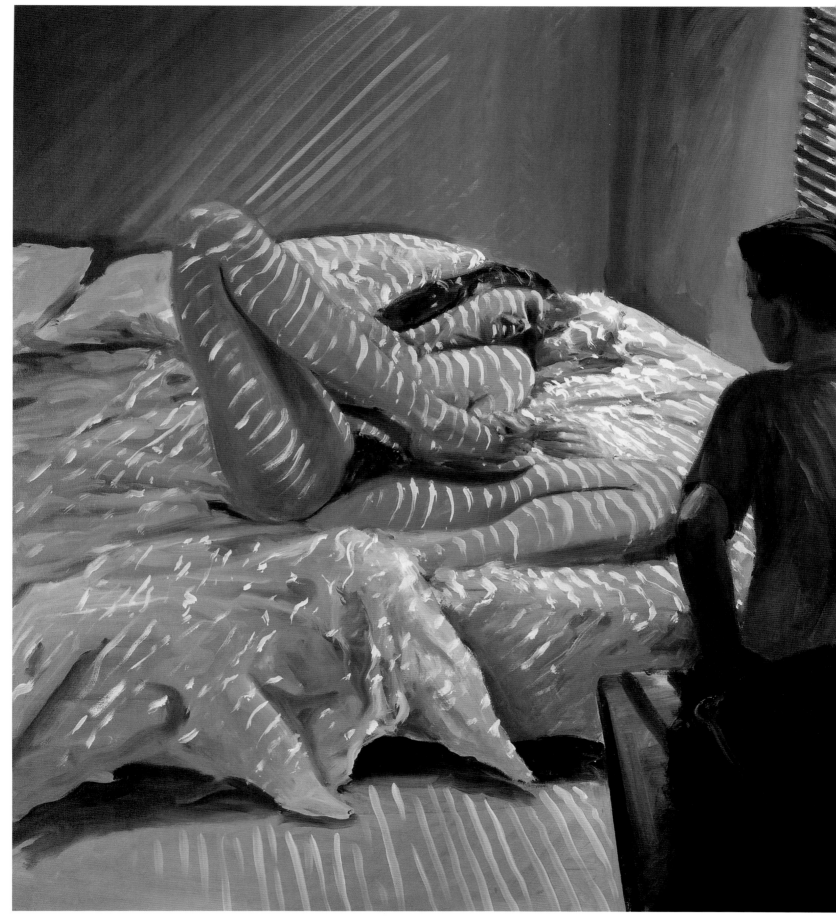

ERIC FISCHL *Bad Boy* 1981 Oil on canvas 168 × 244 cm 66 × 96"

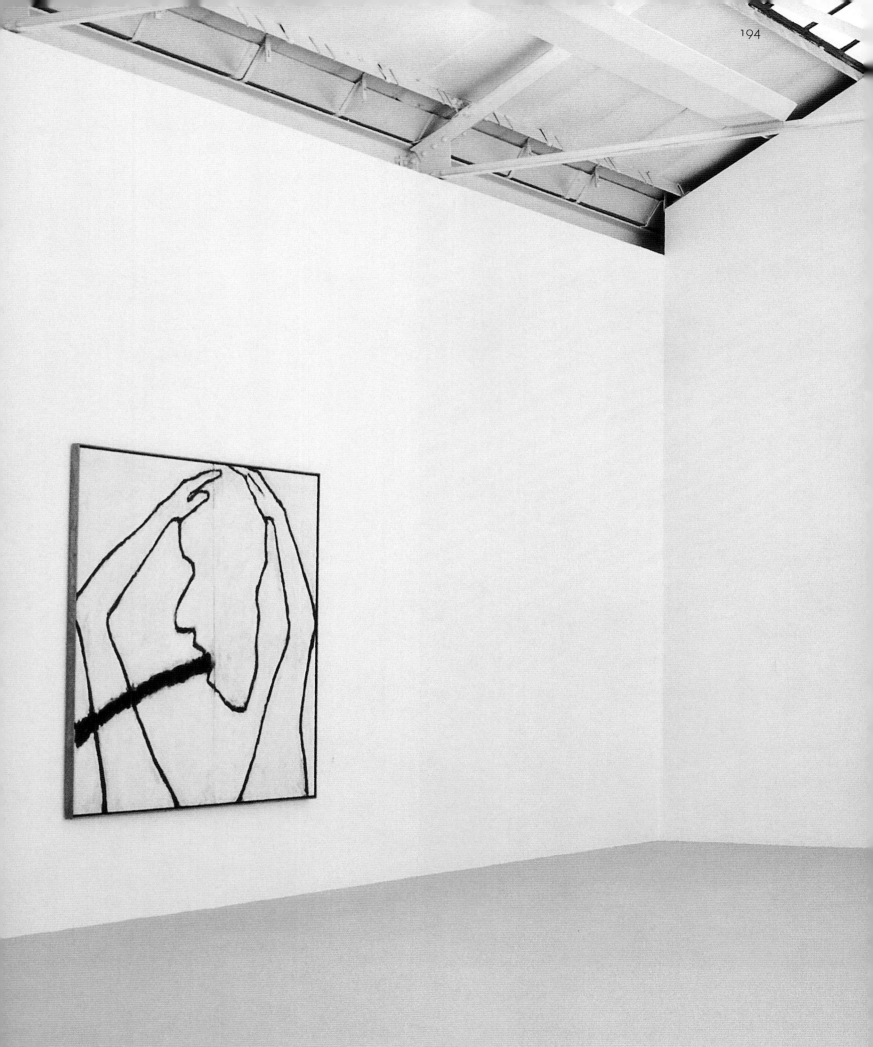

SUSAN ROTHENBERG
LEFT TO RIGHT
Untitled (Head) 1978 Acrylic on canvas 173 × 197 cm 68 × 77½"
United States 1975 Acrylic and tempera on canvas 289.6 × 480.1 cm 114 × 189"

SUSAN ROTHENBERG *Cabin Fever* 1976 Acrylic and tempera on canvas 170 × 214.6 cm 66¾ × 84½"

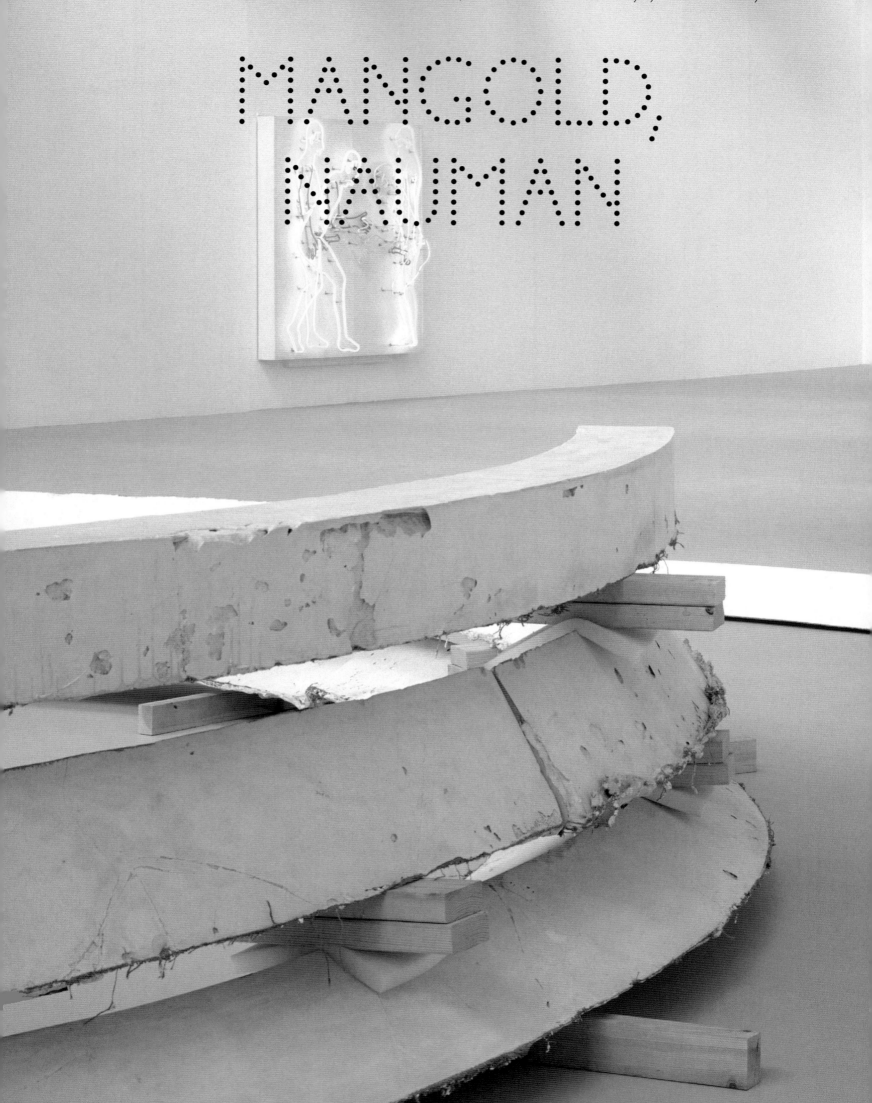

ROBERT MANGOLD AND BRUCE NAUMAN INSTALLATION VIEW

BRUCE NAUMAN
BACKGROUND
Life Death/Knows Doesn't Know 1983 Neon tubing with clear glass suspension frames Diameter of *Life Death*: 203.2 cm 80"
Dimensions of *Knows Doesn't Know*: 273 × 271.8 cm 107½ × 107"
FOREGROUND
Untitled 1965 Fibreglass 61 × 335 × 13 cm 24 × 132 × 5"

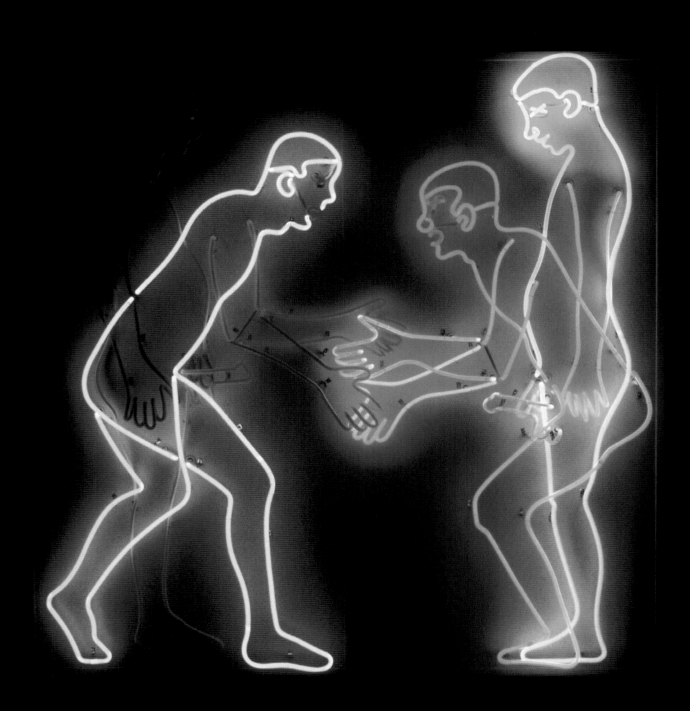

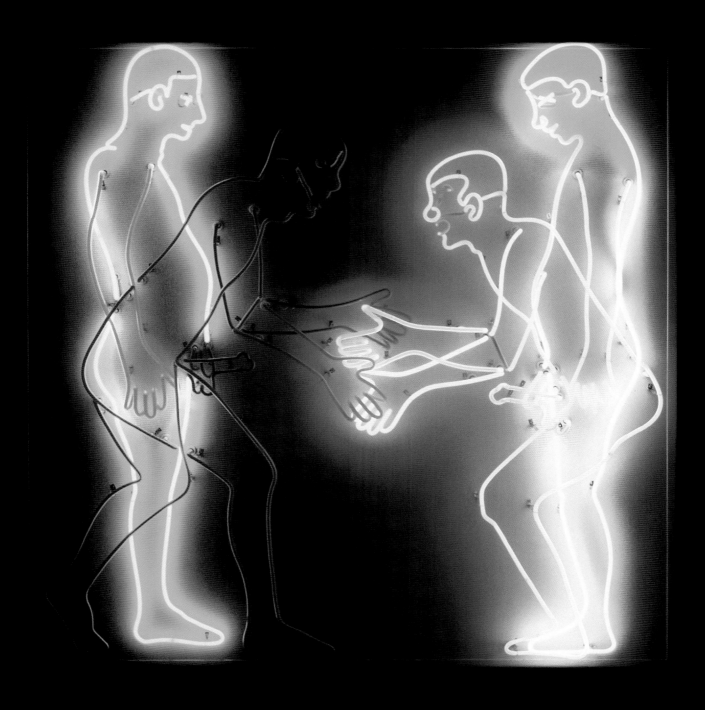

BRUCE NAUMAN *Welcome Shaking Hands* 1985 Neon and glass tubing 182.8 × 182.8 × 25.4 cm 72 × 72 × 10"

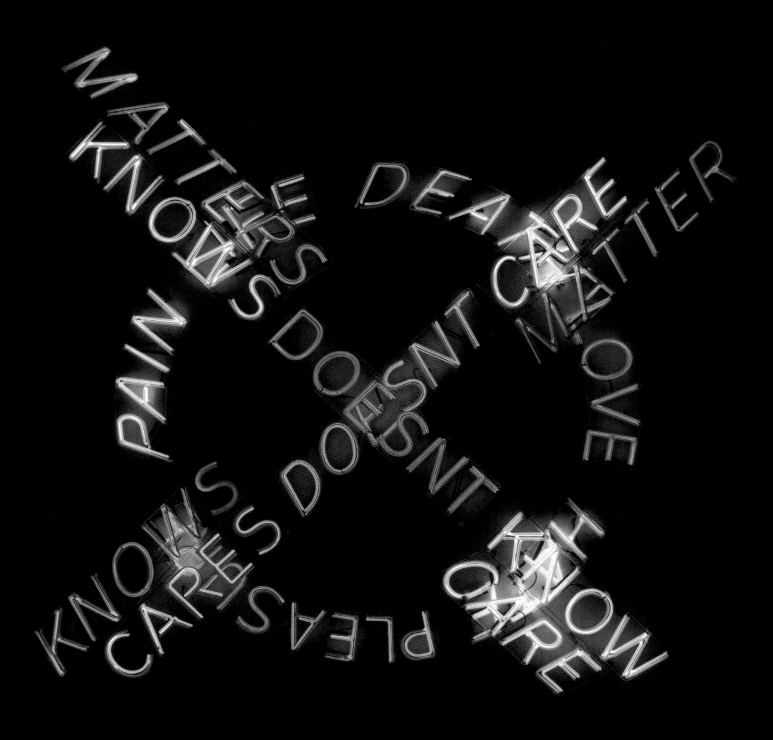

BRUCE NAUMAN *Life Death/Knows Doesn't Know* 1983 Neon tubing with clear glass suspension frames
Diameter of *Life Death*: 203.2 cm 80" *Knows Doesn't Know*: 273 × 271.8 cm 107½ × 107"

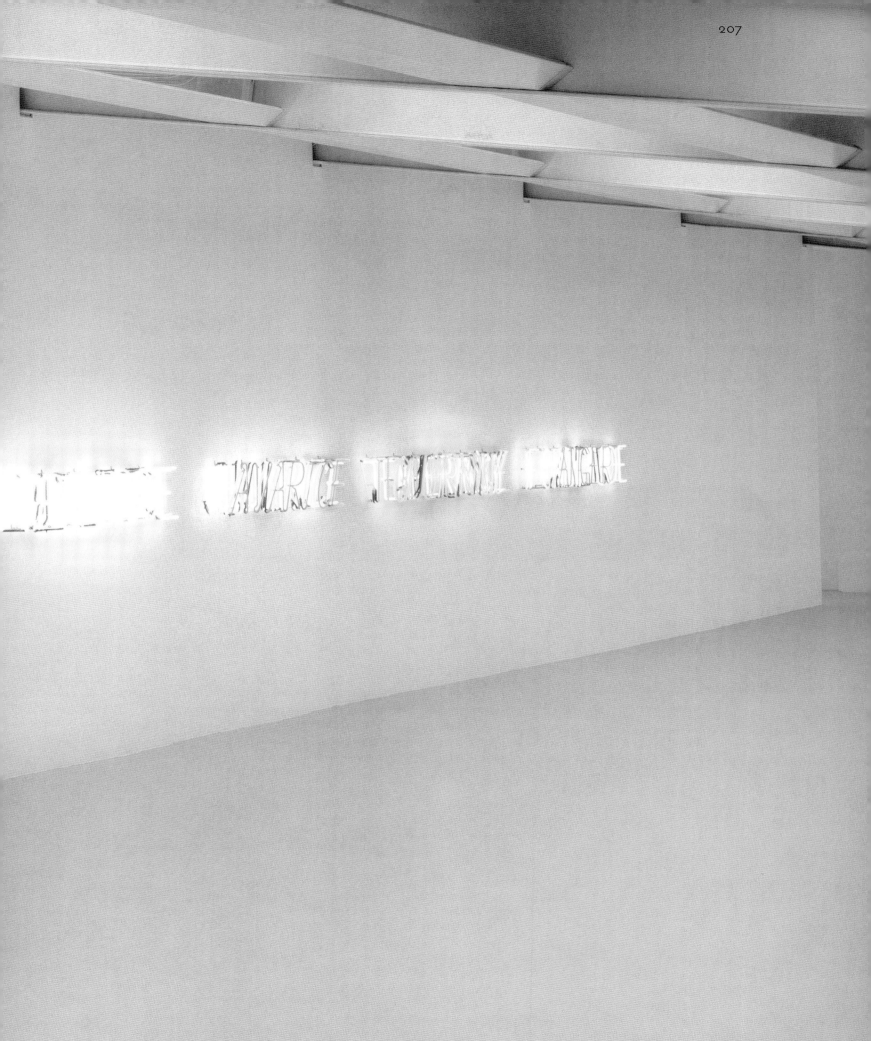

BRUCE NAUMAN *Seven Virtues and Seven Vices* 1983 Neon tubing with clear glass suspension frames 30.5 × 1524 cm 12 × 600"

BRUCE NAUMAN *Wax Impression of the Knees of Five Famous Artists* 1966 Fibreglass 7 × 216.5 × 39.7 cm 2¾ × 85¼ × 15½"

BRUCE NAUMAN *Collection of Various Flexible Materials Separated by Layers of Grease with Holes the Size of My Waist and Wrists* 1966
Aluminium foil, plastic sheet, foam rubber, felt and grease 4 × 228.6 × 45.7 cm 1½ × 90 × 18"

BRUCE NAUMAN *Lead Piece with Wedge* 1968 Lead and paint 10 × 120 × 120 cm 4 × 47¼ × 47¼"

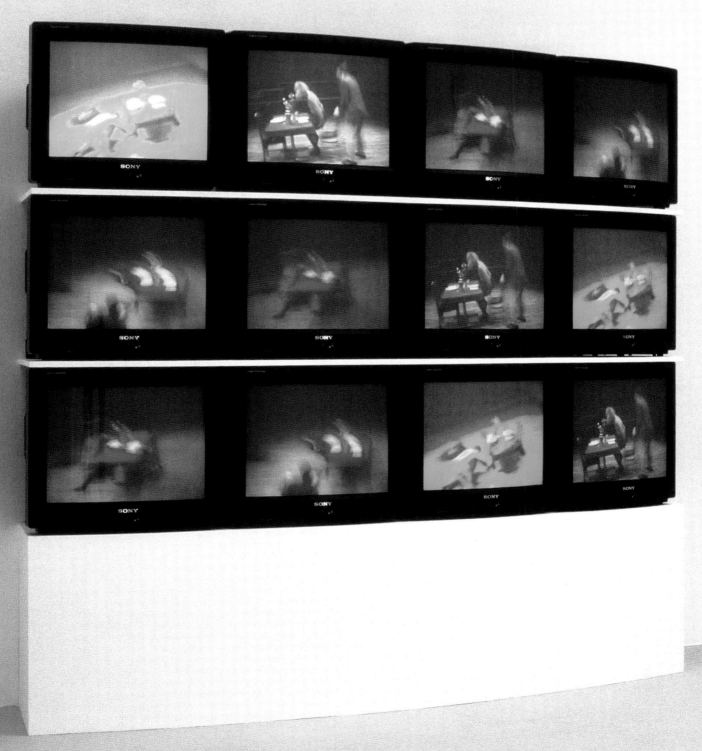

BRUCE NAUMAN *Violent Incident* 1986 Installation with four video tapes Dimensions variable

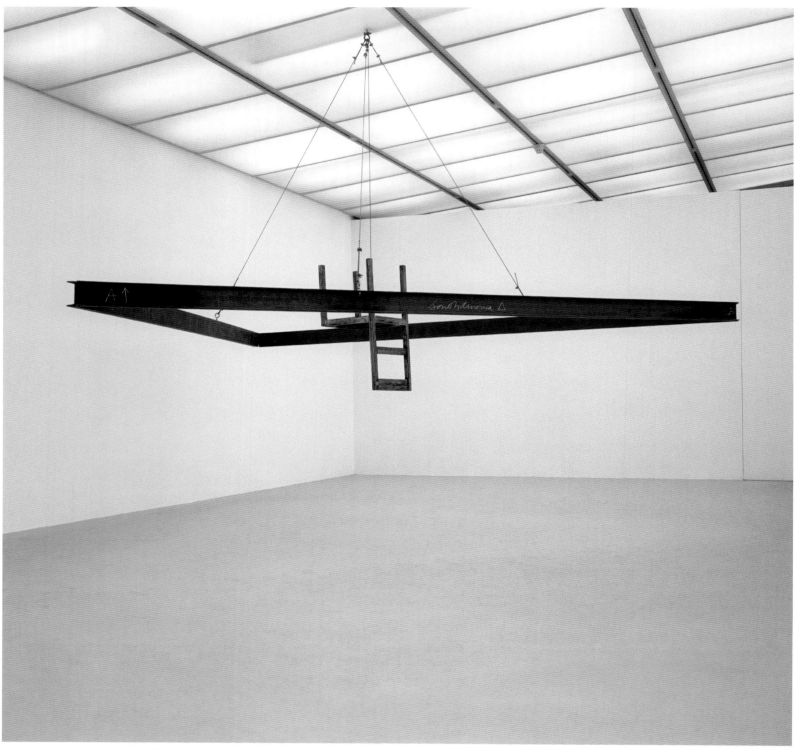

BRUCE NAUMAN *South America Triangle* 1981 Steel beams and cast iron Length of each side: 426.7 cm 168" Dimensions of chair: 90.5 × 44 × 43 cm 35½ × 17½ × 17"

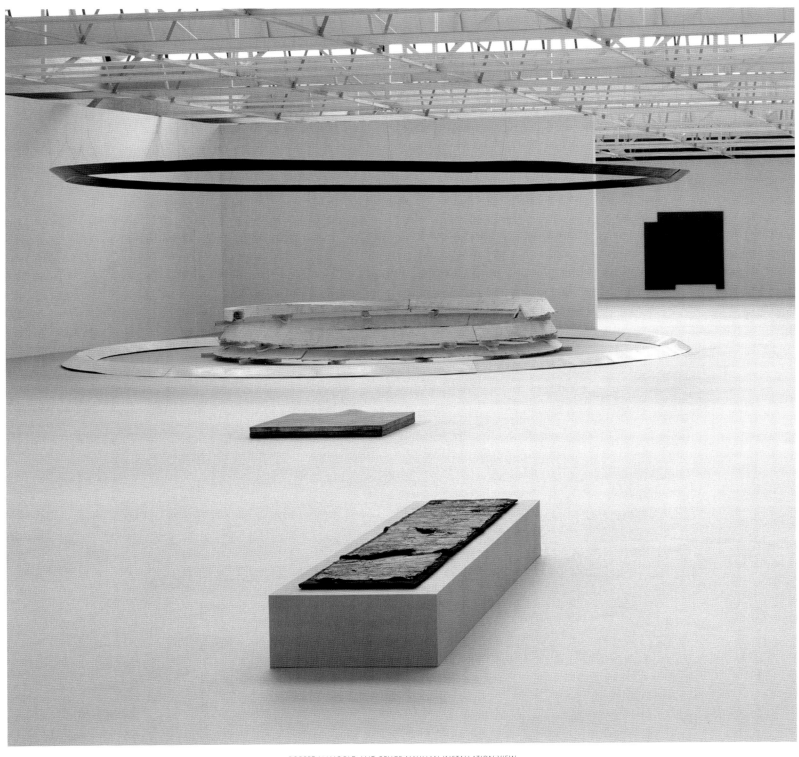

ROBERT MANGOLD AND BRUCE NAUMAN INSTALLATION VIEW

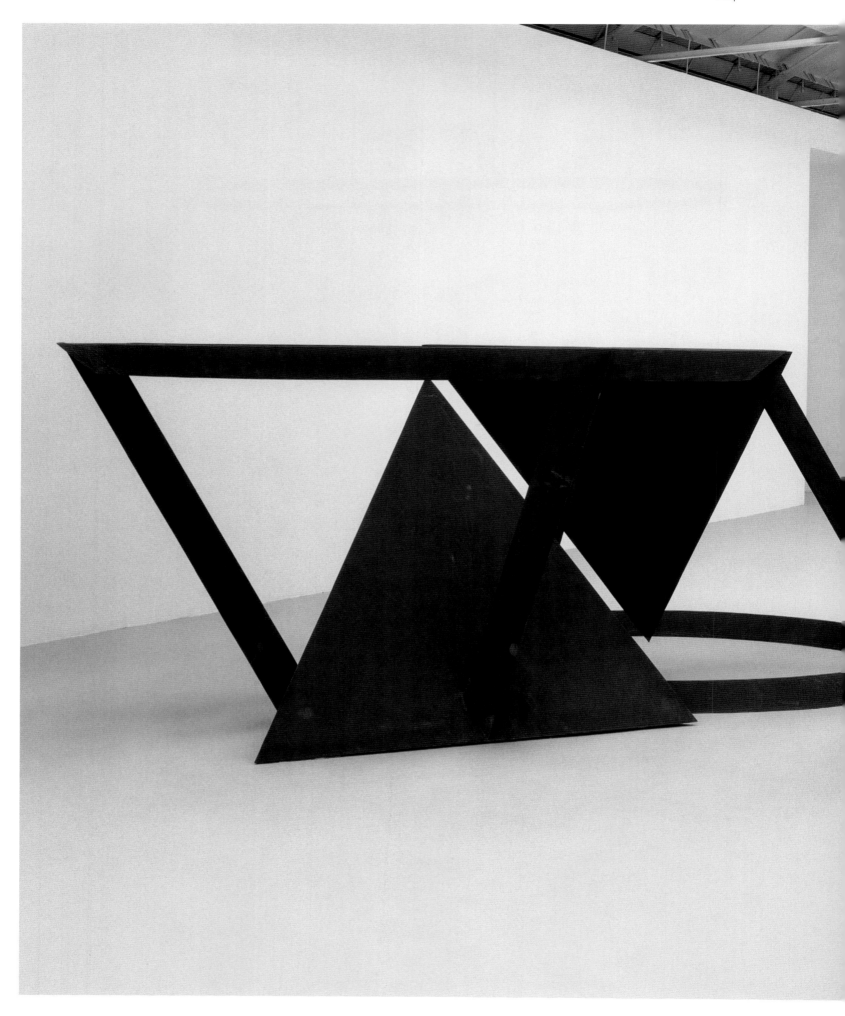

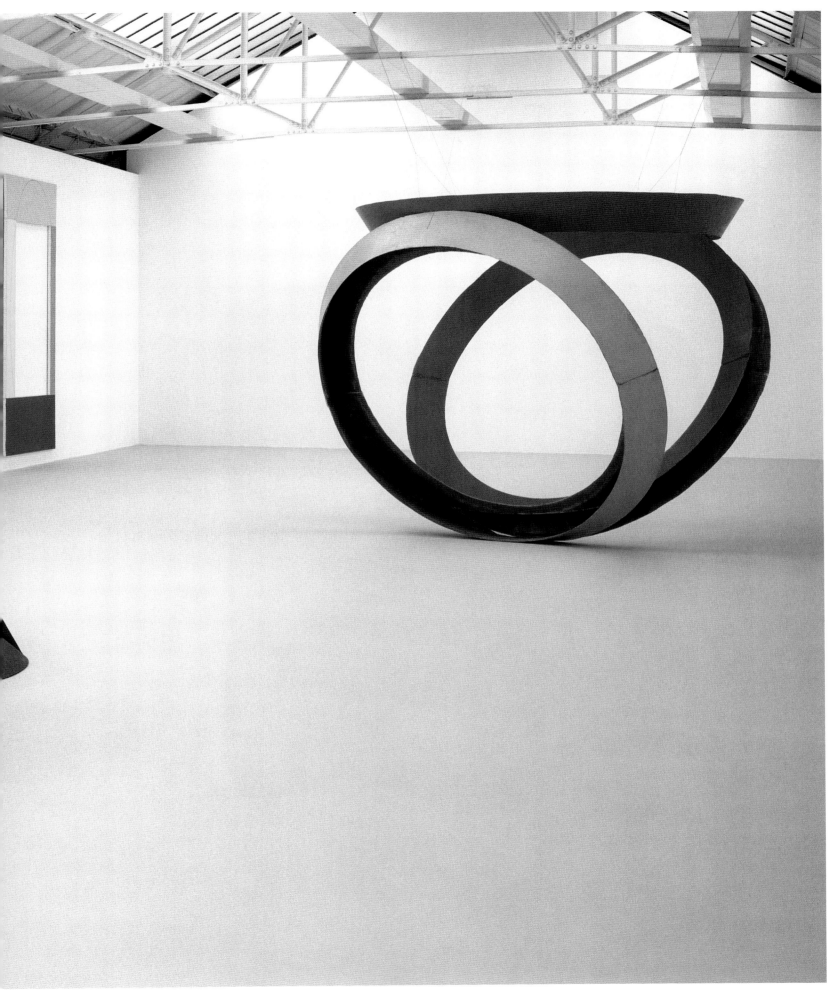

BRUCE NAUMAN (LEFT) *Untitled (Trench, Shaft, Pit, Tunnel and Chamber)* 1978 Corten steel 167.6 × 274.3 × 518.1 cm 66 × 108 × 204"
ROBERT MANGOLD (MIDDLE) *4 Colour Frame Painting No.3 (Pink, Yellow-Green, Red, Green)* 1983 Acrylic and black pencil on canvas 335.3 × 213.4 cm 132 × 84"
BRUCE NAUMAN (RIGHT) *Untitled (Model for Trench, Shaft and Tunnel)* 1978 Fibreglass and polyester resin 330 × 300 × 300 cm 130 × 118 × 118"

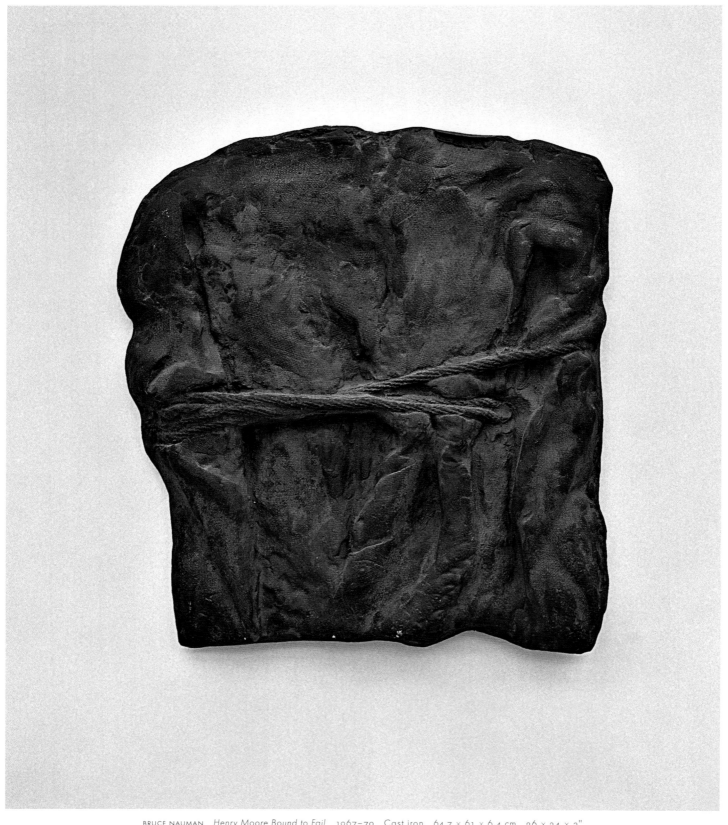

BRUCE NAUMAN *Henry Moore Bound to Fail* 1967–70 Cast iron 64.7 × 61 × 6.4 cm 26 × 24 × 3"

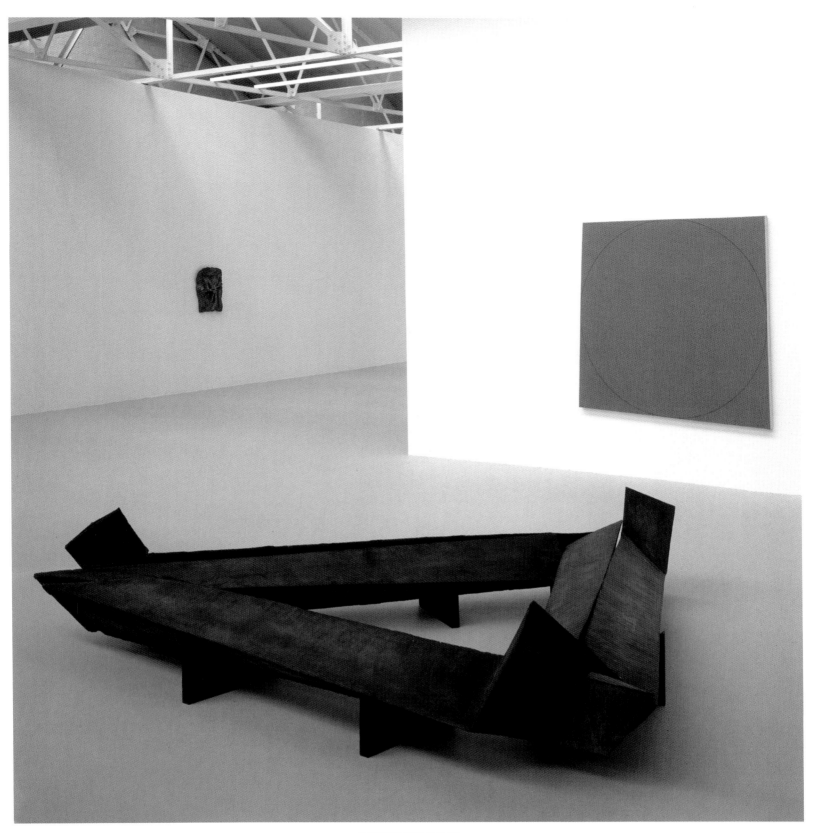

CLOCKWISE FROM FAR LEFT
BRUCE NAUMAN *Henry Moore Bound to Fail* 1967–70 Cast iron 64.7 × 61 × 6.4 cm 25½ × 24 × 2½"
ROBERT MANGOLD *Distorted Square/Circle (Red)* 1971 Acrylic and black pencil on canvas 160 × 160 cm 63 × 63"
BRUCE NAUMAN *Three Dead End Adjacent Tunnels, not Connected* 1981 Cast iron 53.3 × 292.1 × 264.1 cm 21 × 115 × 104"

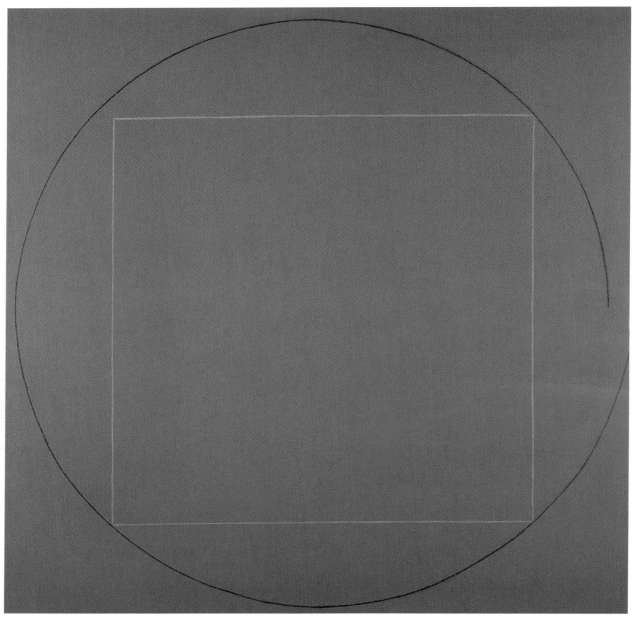

ROBERT MANGOLD *Untitled (Blue-Violet)* 1973 Acrylic and black pencil on canvas 122 × 122 cm 48 × 48"

ROBERT MANGOLD *Untitled (Purple)* 1974 Acrylic, black and white pencil on canvas 198 × 198 cm 78 × 78"

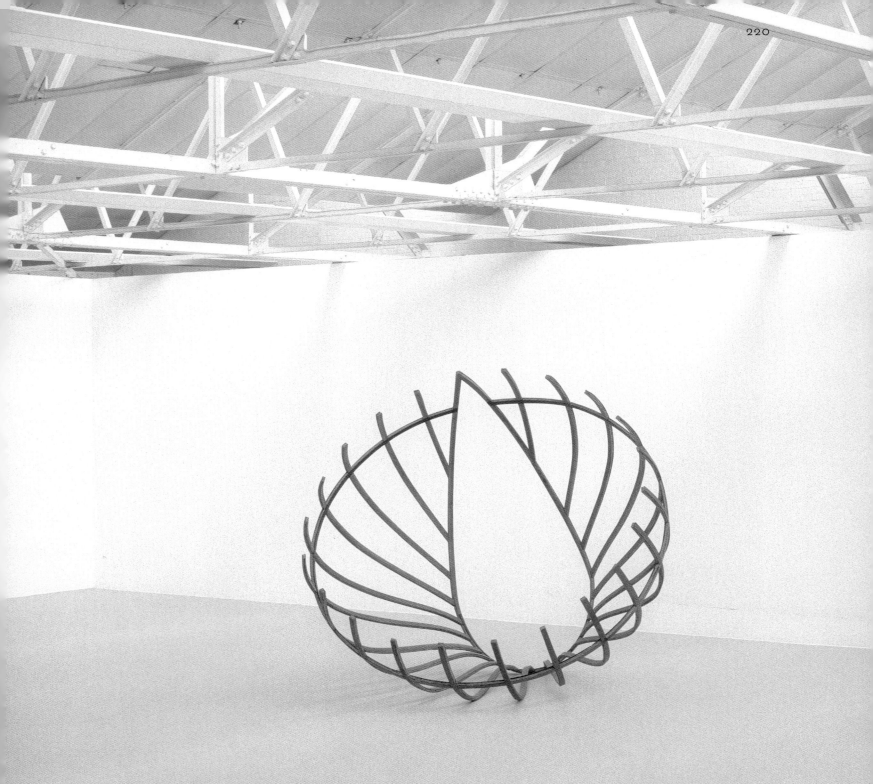

RICHARD DEACON
LEFT TO RIGHT
Untitled 1980 Laminated wood with rivets 300 × 290 × 290 cm 118 × 114 × 114"
Art for Other People No.9 1983 Galvanised steel with rivets 53 × 34 × 11 cm 21 × 13¼ × 4¼"
If the Shoe Fits 1981 Galvanised and corrugated sheet steel with rivets 152.5 × 331 × 152.5 cm 60 × 130½ × 60"

AUERBACH, DEACON, FREUD, HODGKIN, KITAJ, KOSSOFF

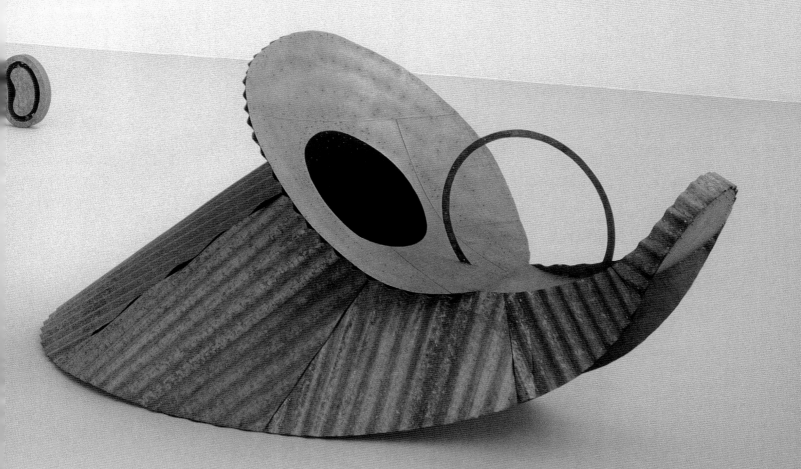

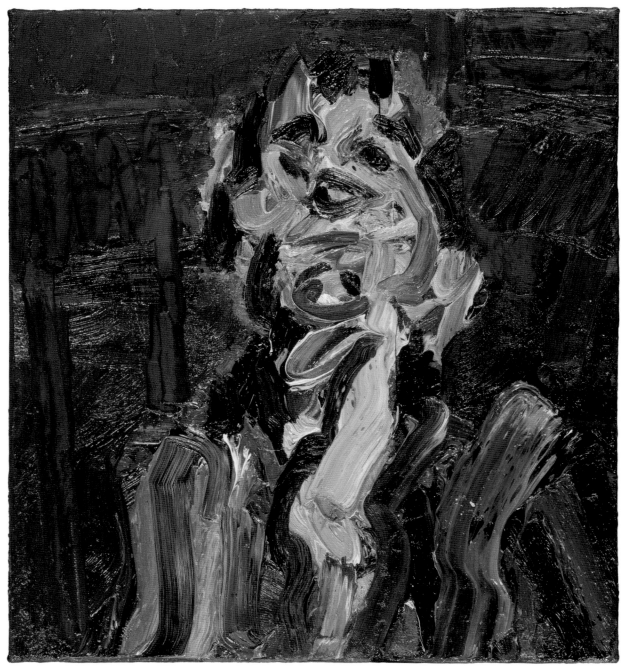

FRANK AUERBACH *Head of J.Y.M.* 1969 Oil on paper laid down on board 78.1 x 59 cm 30¾ x 23¼"

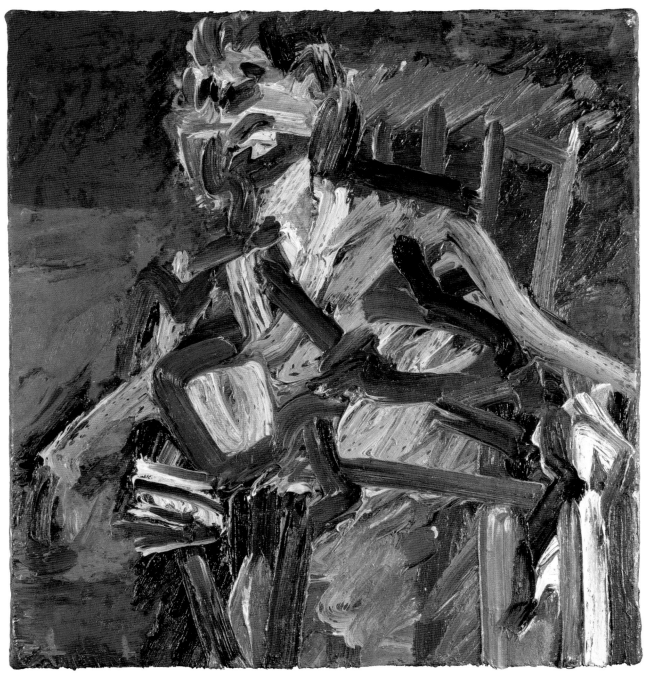

FRANK AUERBACH *J.Y.M. Seated* 1986–87 Oil on canvas 71.1 × 66 cm 28 × 26"

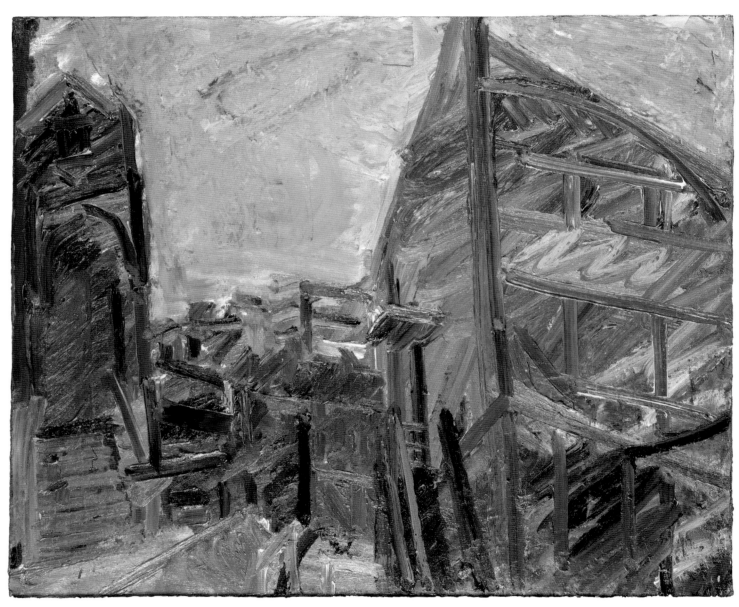

FRANK AUERBACH *To the Studio* 1982–83 Oil on canvas 103 x 122 cm 40½ x 48"

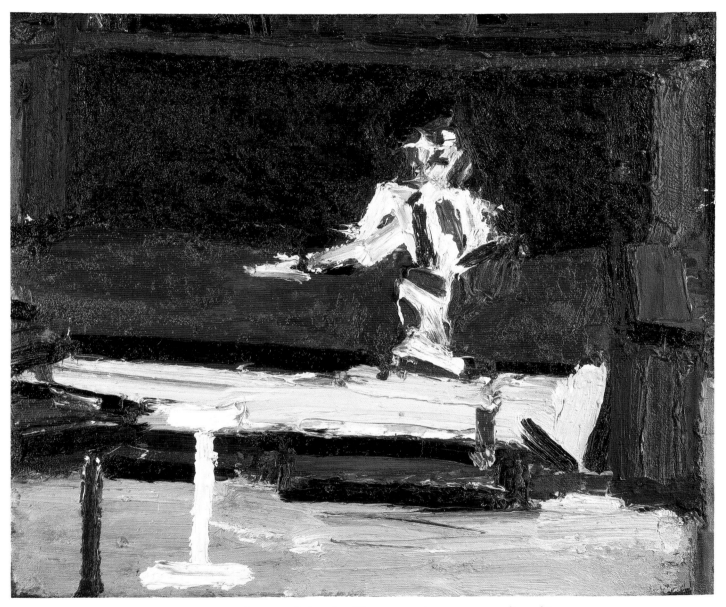

FRANK AUERBACH *Figure on a Bed* 1969 Oil on canvas 60.3 × 70.5 cm 23¾ × 27¾"

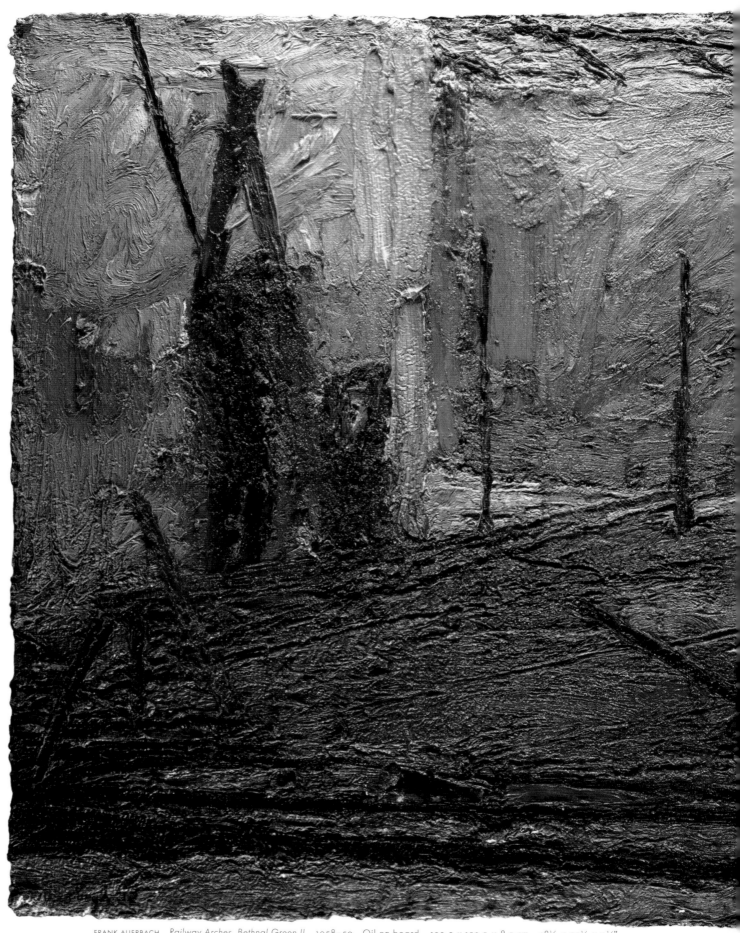

FRANK AUERBACH *Railway Arches, Bethnal Green II* 1958–59 Oil on board 122.5 × 150.5 × 8.5 cm 48¼ × 59¼ × 3½"

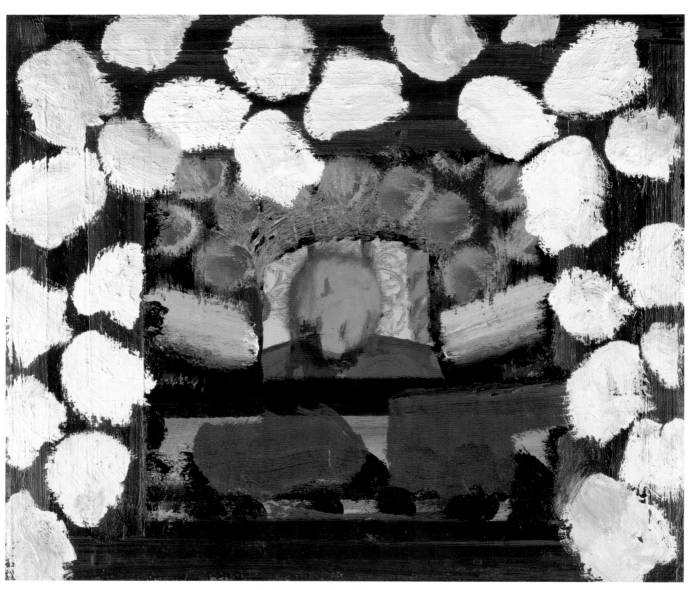

HOWARD HODGKIN *Paul Levy* 1976–80 Oil on panel 53 × 61 cm 21 × 24"

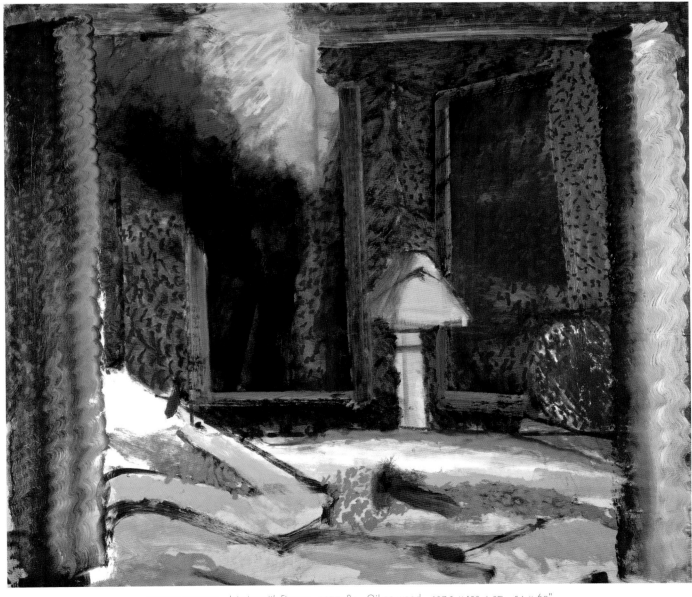

HOWARD HODGKIN *Interior with Figures* 1977–84 Oil on wood 137.2 × 152.4 cm 54 × 60"

HOWARD HODGKIN *A Henry Moore at the Bottom of the Garden* 1975–77 Oil on canvas 102.9 × 102.9 cm 40½ × 40½"

HOWARD HODGKIN *Menswear* 1980–85 Oil on wood 83 × 108 cm 32¾ × 42½"

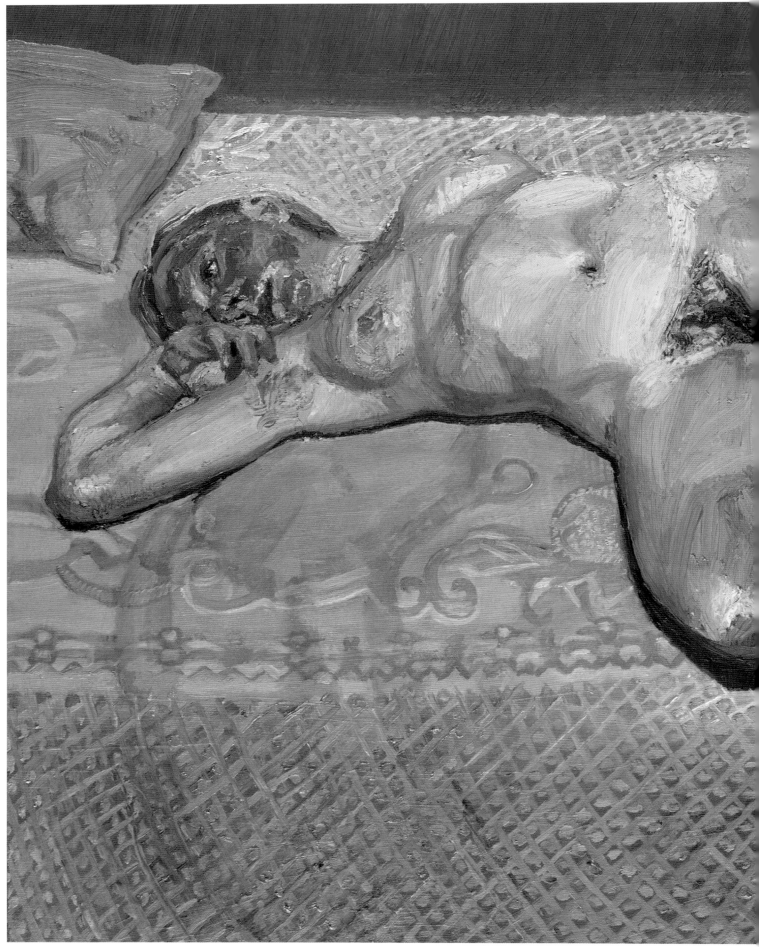

LUCIAN FREUD *Blond Girl on a Bed* 1987 Oil on canvas 41 × 51 cm 16¼ × 20"

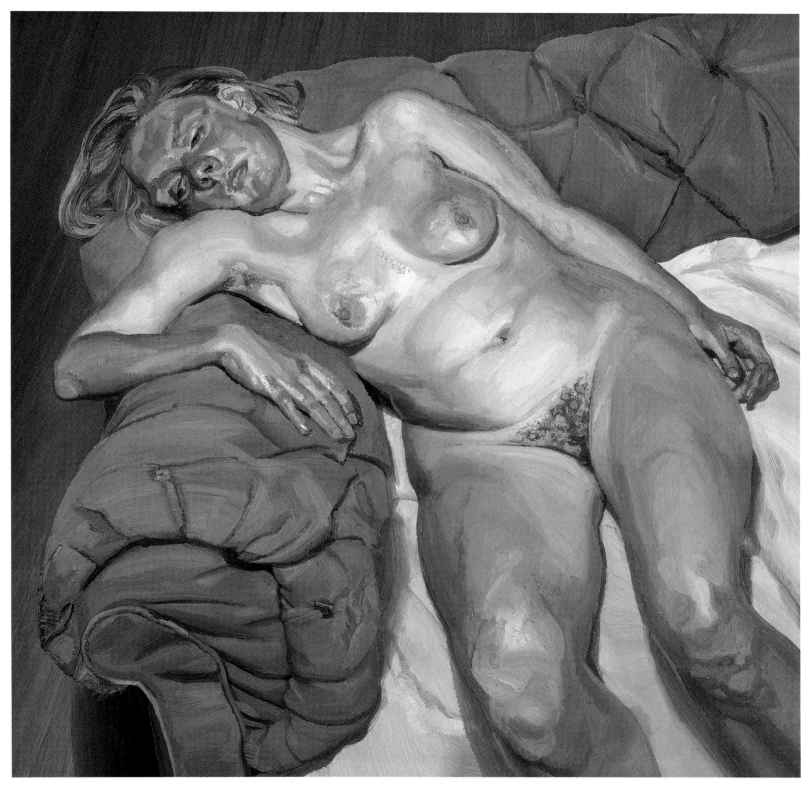

LUCIAN FREUD *Blond Girl, Night Portrait* 1980–85 Oil on canvas 71 × 71 cm 28 × 28"

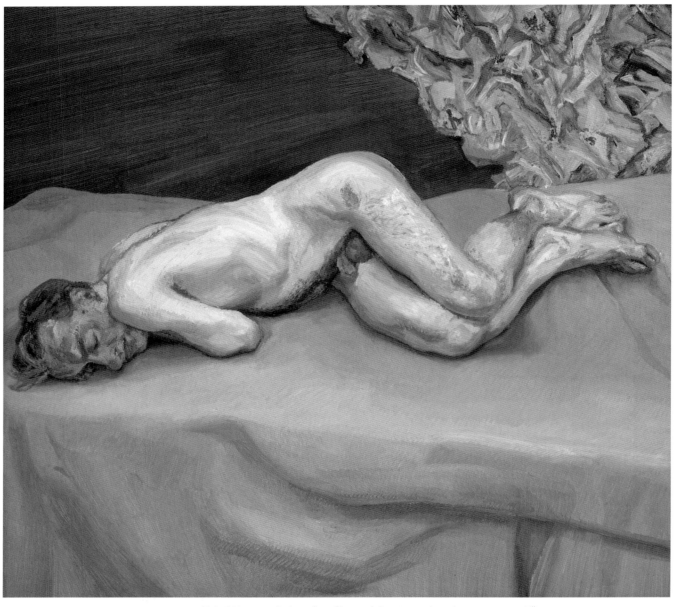

LUCIAN FREUD *Naked Man on a Bed* 1989 Charcoal drawing 76 × 56.5 cm 30 × 22½"

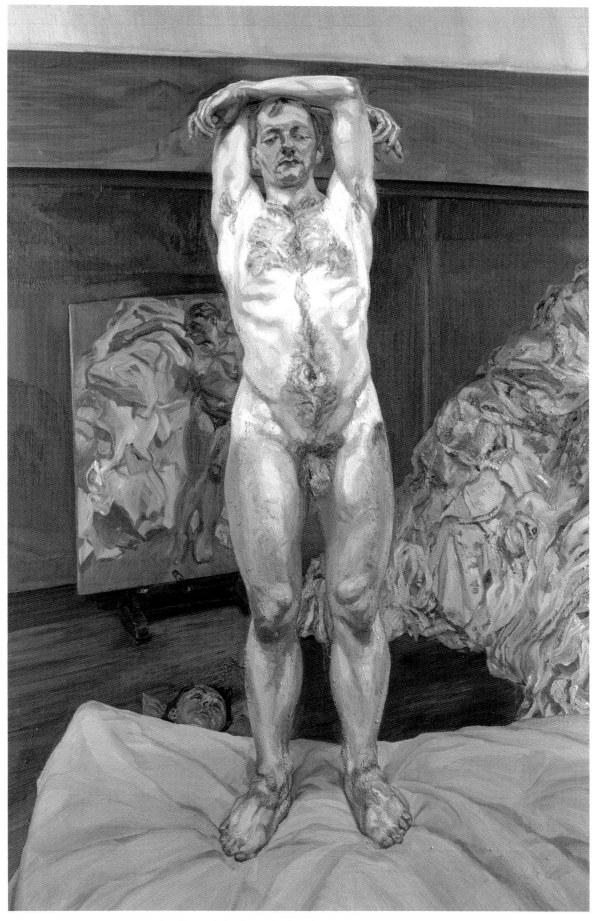

LUCIAN FREUD *Two Men in the Studio* 1987–89 Oil on canvas 185.4 × 120.7 cm 73 × 47½"

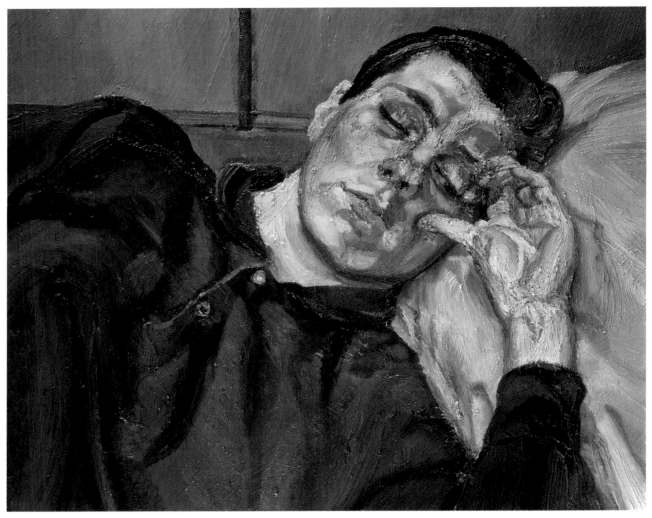

LUCIAN FREUD *Rose* 1990 Oil on canvas 50.2 × 61 cm 19¾ × 24"

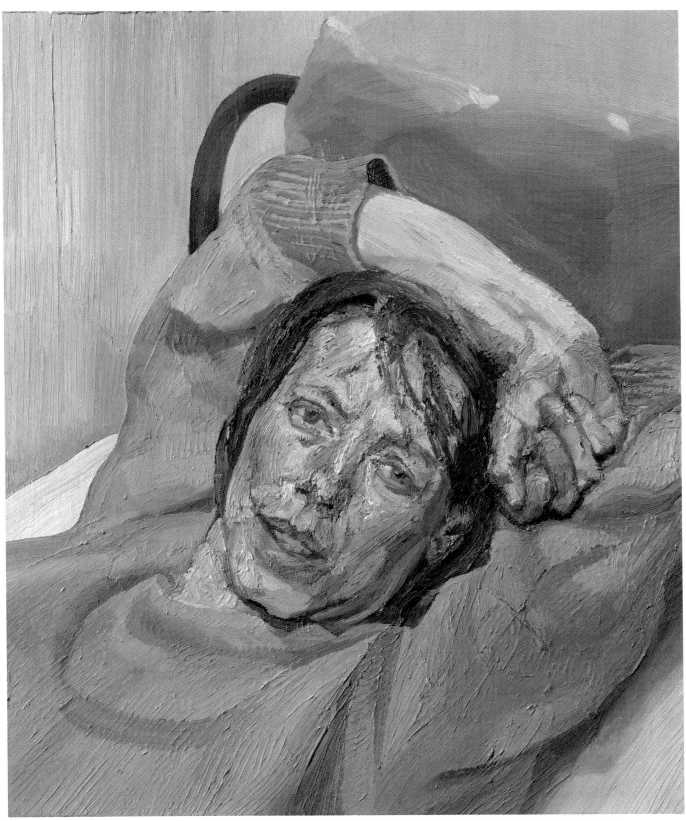

LUCIAN FREUD *Woman in Grey Sweater* 1988 Oil on canvas 55.6 × 45.3 cm 22 × 18"

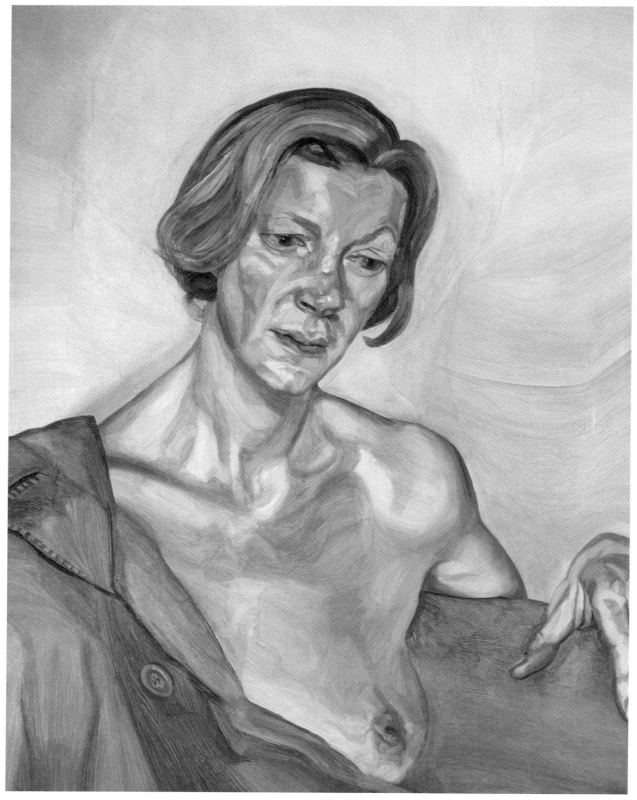

LUCIAN FREUD *Woman with a Bare Breast* 1970–72 Oil on canvas 63.5 × 49.5 cm 25 × 19½"

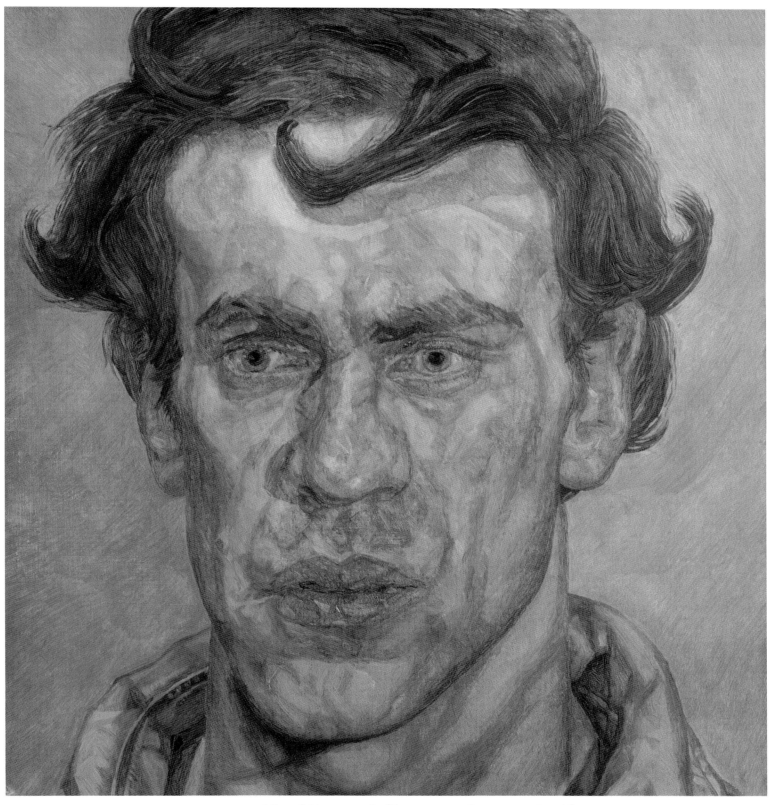

LUCIAN FREUD *A Young Painter* 1957–58 Oil on canvas 40.8 × 39.4 cm 16 × 15½"

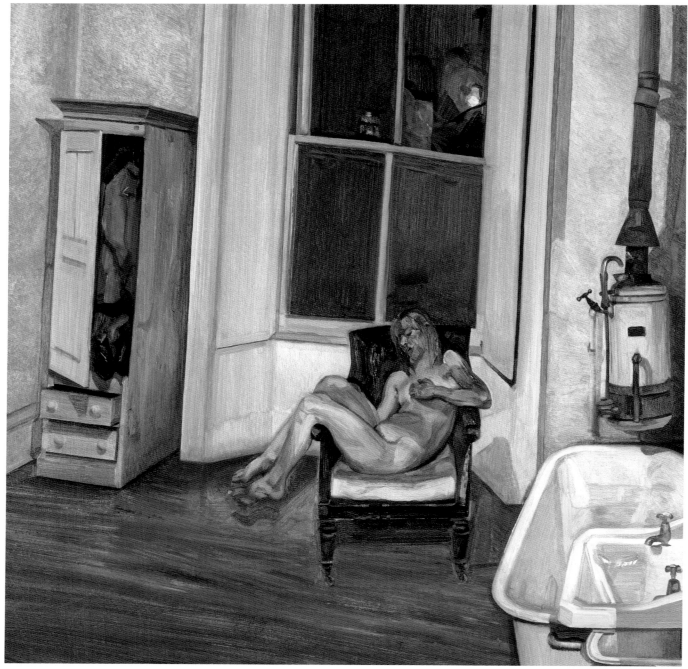

LUCIAN FREUD *Night Interior* 1969–70 Oil on canvas 56 × 56 cm 22 × 22"

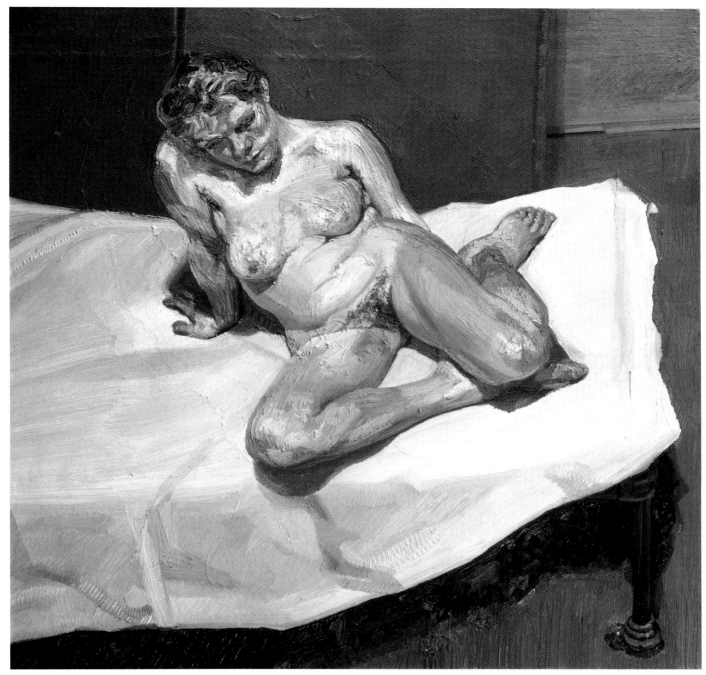

LUCIAN FREUD *Girl Sitting* 1987–88 Oil on canvas 54 × 55.6 cm 21½ × 22"

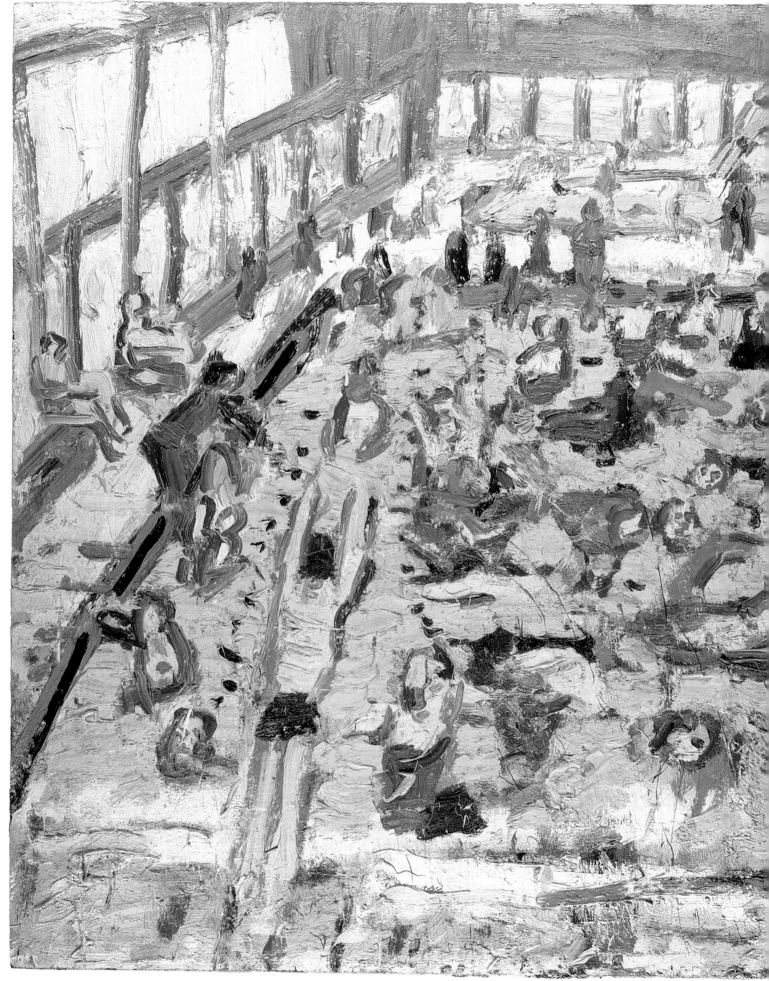

LEON KOSSOFF *Children's Swimming Pool, 11 o'clock Saturday Morning, August 1969* 1969 Oil on board 152 × 205 cm 60 × 81"

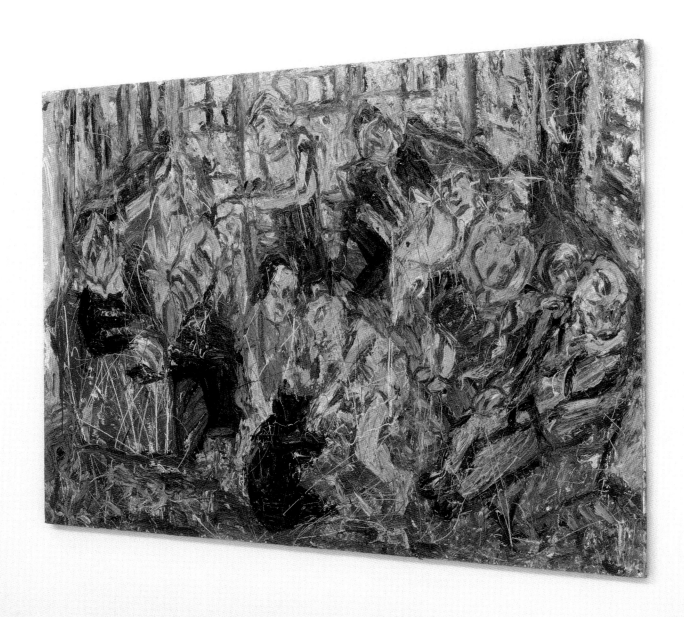

LEON KOSSOFF
LEFT TO RIGHT
Inside Kilburn Underground, Summer 1983 1983 Oil on board 137.8 × 168.3 cm 54¼ × 66¼"
Family Party, January 1983 1983 Oil on board 167.6 × 249.5 cm 66 × 98¼"

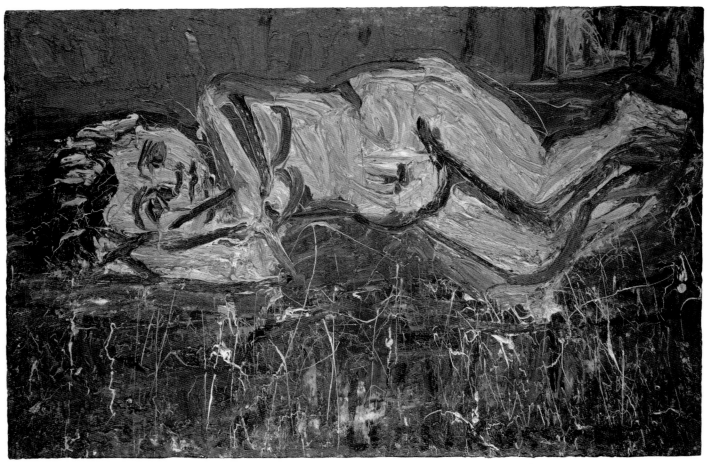

LEON KOSSOFF *Nude on a Red Bed* 1972 Oil on board 122 × 183 cm 48 × 72"

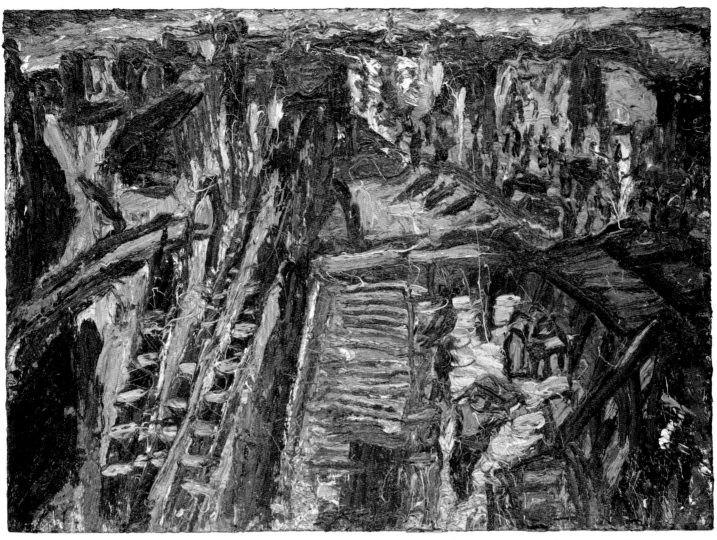

LEON KOSSOFF *Dalston Junction, Ridley Road Street Market, Stormy Morning* 1973 Oil on board 139.7 × 183 cm 55 × 72"

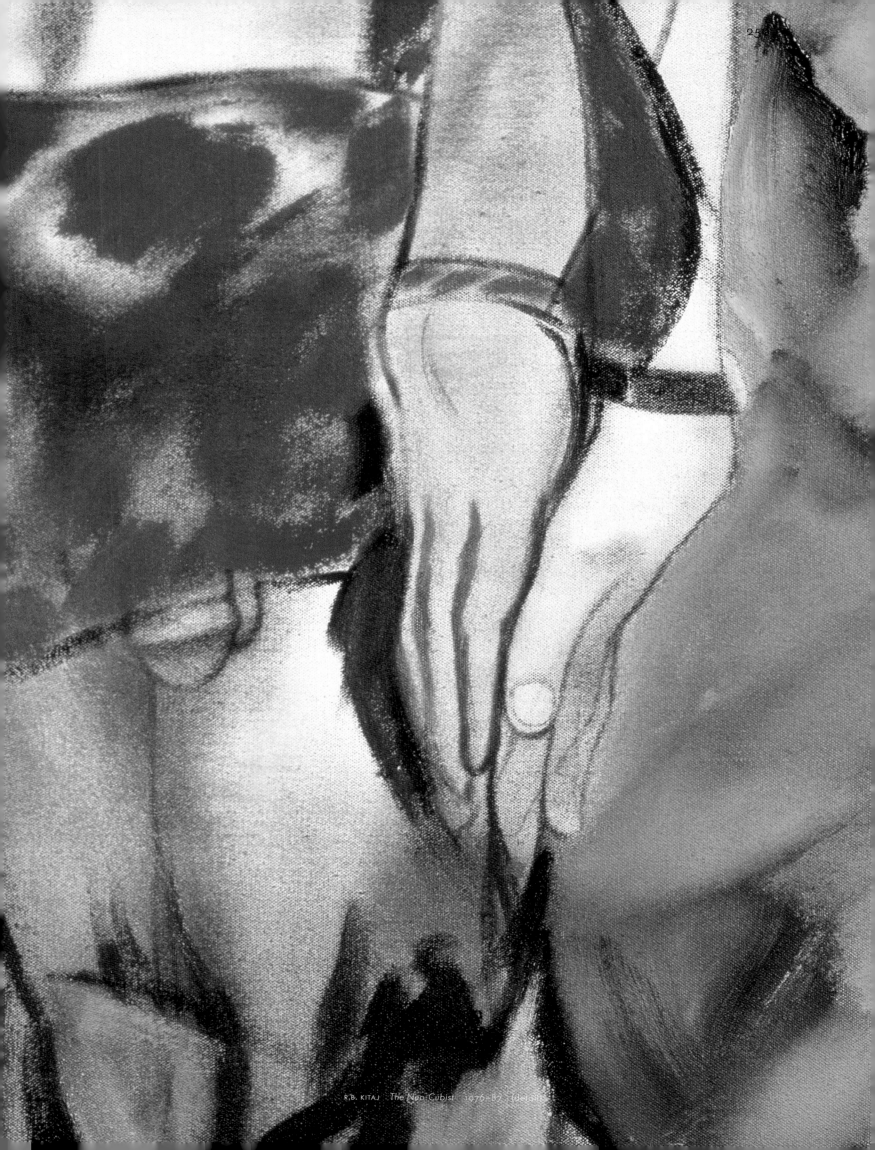

R.B. KITAJ *The Neo-Cubist* 1976–87 (detail)

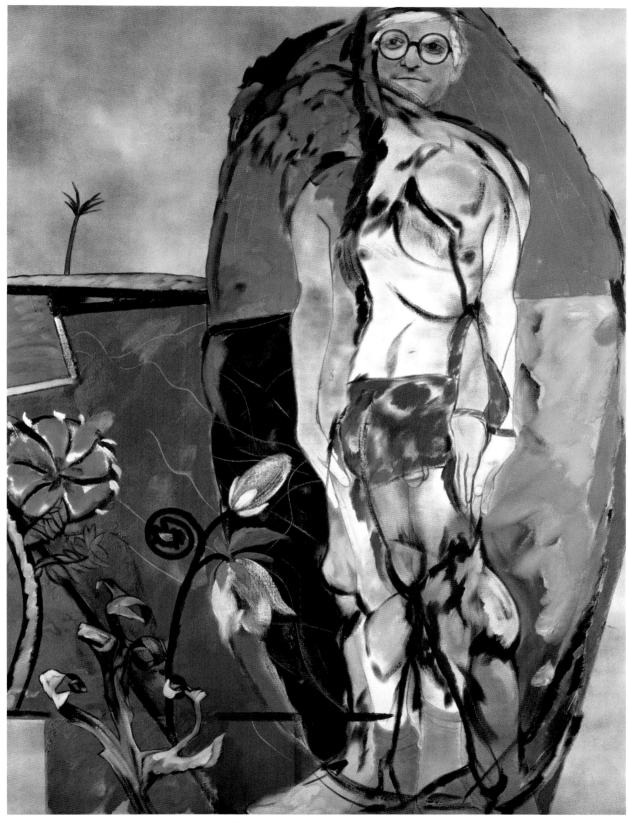

R.B. KITAJ *The Neo-Cubist* 1976–87 Oil on canvas 177.8 × 132 cm 70 × 52"

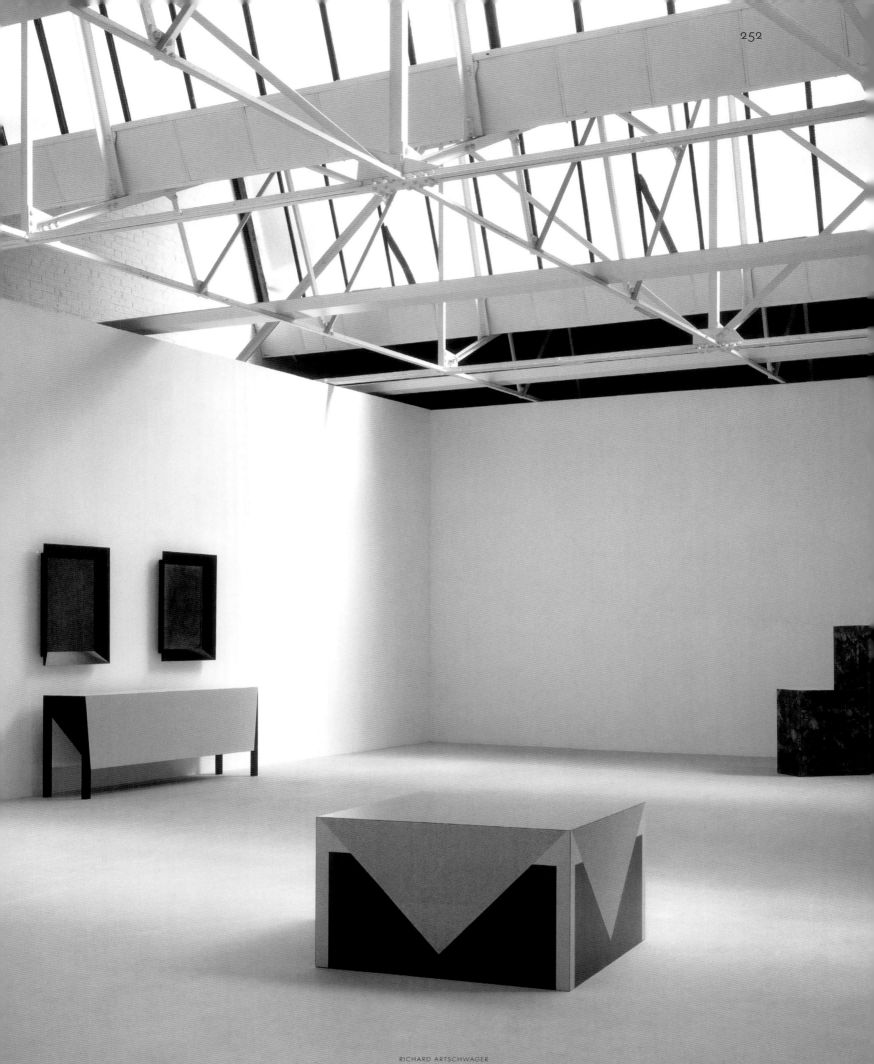

RICHARD ARTSCHWAGER
CLOCKWISE FROM LEFT
Long Table with Two Pictures 1964 Formica on wood and acrylic on celotex with formica Table: 86 × 244 × 56 cm 33¾ × 96 × 22¼" Each picture: 107 × 82 cm 42 × 32¼"
Chair 1966 Formica 151 × 46 × 77 cm 59 × 18 × 30"
Table with Pink Tablecloth 1964 Formica on wood 64 × 112 × 112 cm 25¼ × 44 × 44"

ARTSCHWAGER, SHERMAN, WILSON

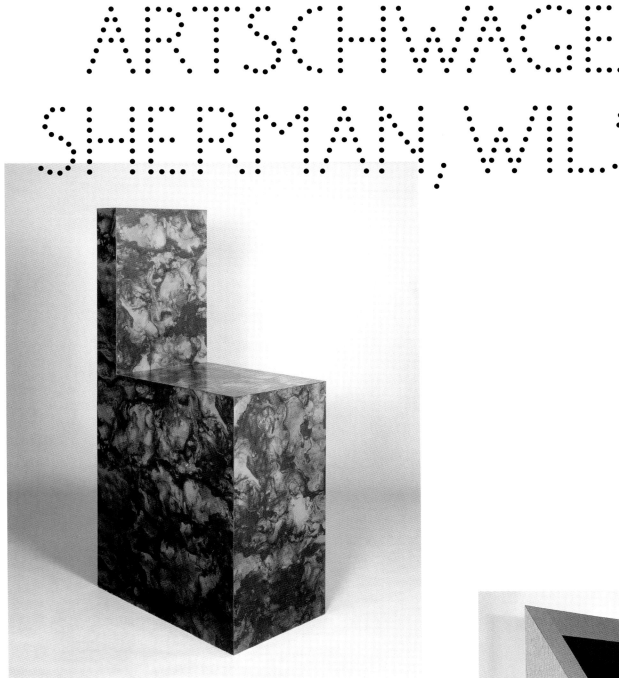

RICHARD ARTSCHWAGER *Chair* 1966 Formica 151 × 46 × 77 cm 59 × 18 × 30"

RICHARD ARTSCHWAGER *Rocker I* 1964
Formica on plywood with steel counterweight 157 × 65 × 72 cm 62 × 26 × 28"

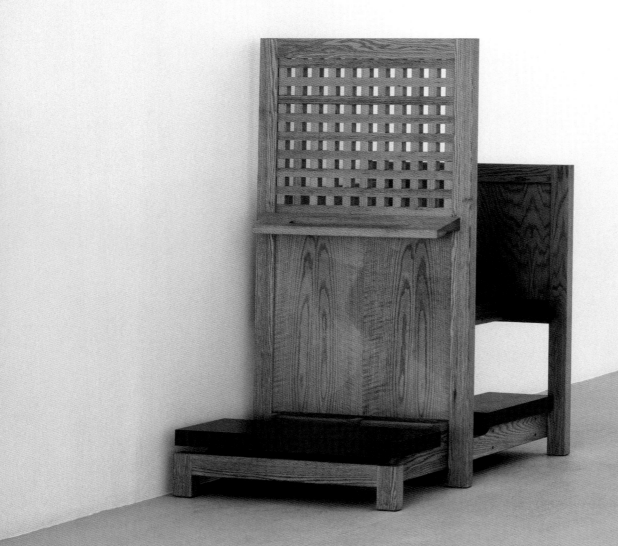

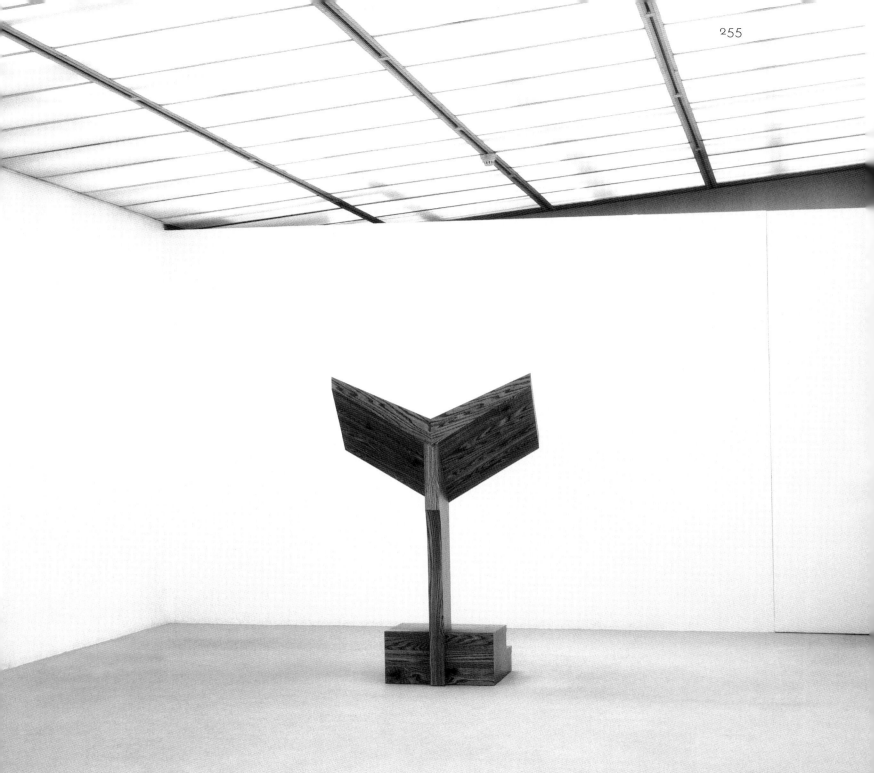

RICHARD ARTSCHWAGER
LEFT TO RIGHT
Tower III (Confessional) 1980 Formica and oak 153 × 120 × 81 cm 60 × 47 × 32"
Book II (Nike) 1981 Formica 188 × 116 × 117 cm 74 × 45¾ × 46"

RICHARD ARTSCHWAGER
BACKGROUND FROM LEFT
Table with Pink Tablecloth 1964 Formica on wood 64 × 112 × 112 cm 25¼ × 44 × 44"
Chair 1966 Formica 151 × 46 × 77 cm 59 × 18 × 30"
Chair 1963 Formica on wood 94 × 51 × 56 cm 37 × 20 × 22"
Handle 1965 Formica 108 × 33 × 31 cm 42½ × 13 × 12"

FOREGROUND
CINDY SHERMAN *Untitled Film Still No.122* 1983 Colour photograph 220 × 146.7 cm 86¾ × 57¾"

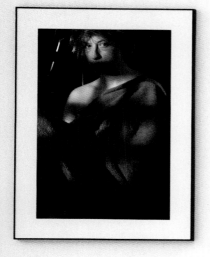
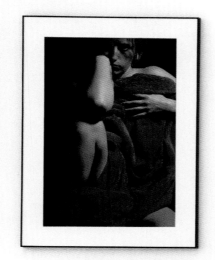
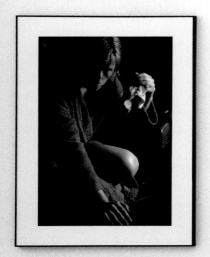
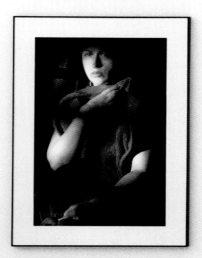

CINDY SHERMAN
FOREGROUND FROM LEFT
1ST GROUP CLOCKWISE FROM TOP LEFT
Untitled Film Still No.98/No.97/No.99/No.100 1982 Colour photographs Each photograph: 114.3 x 76 cm 45 x 30"
2ND GROUP TOP TO BOTTOM
Untitled Film Still No.88/No.87/No.96/No.92 1981 Colour photographs Each photograph: 61 x 122 cm 24 x 48"

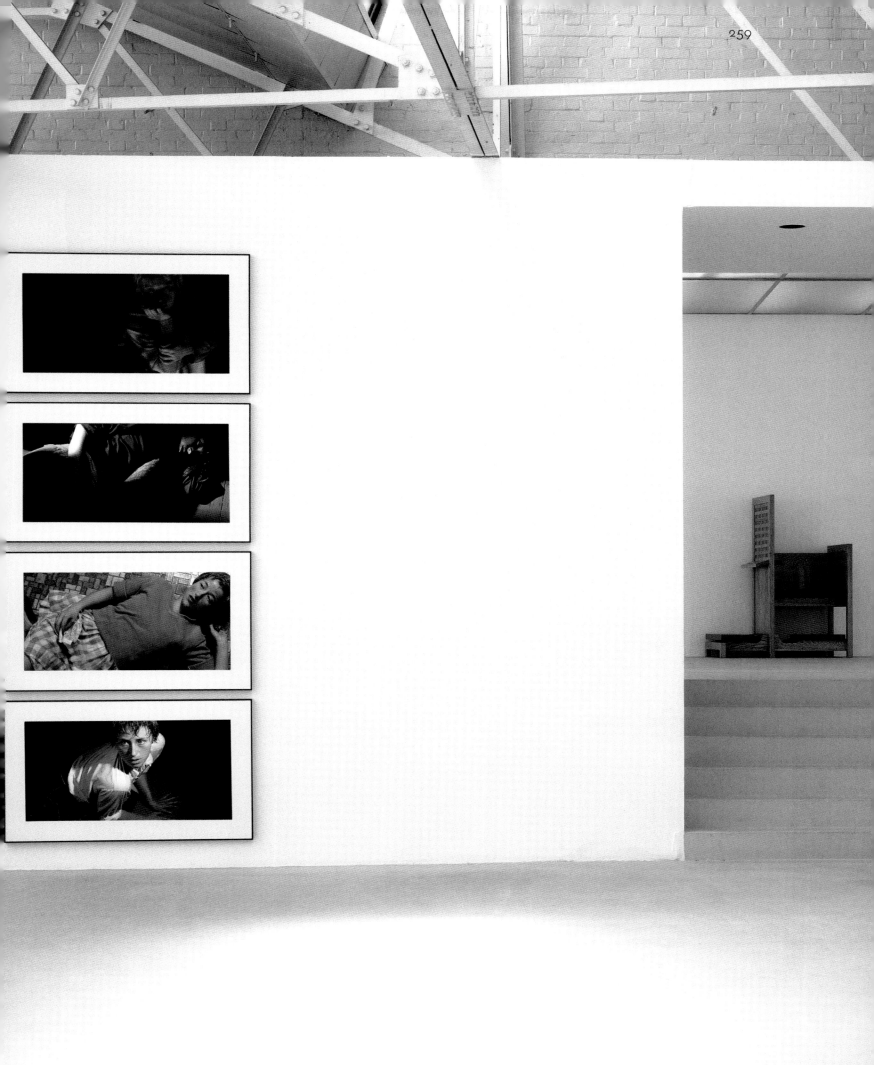

BACKGROUND
RICHARD ARTSCHWAGER *Tower III (Confessional)* 1980 Formica and oak 153 × 120 × 81 cm 60 × 47 × 32"

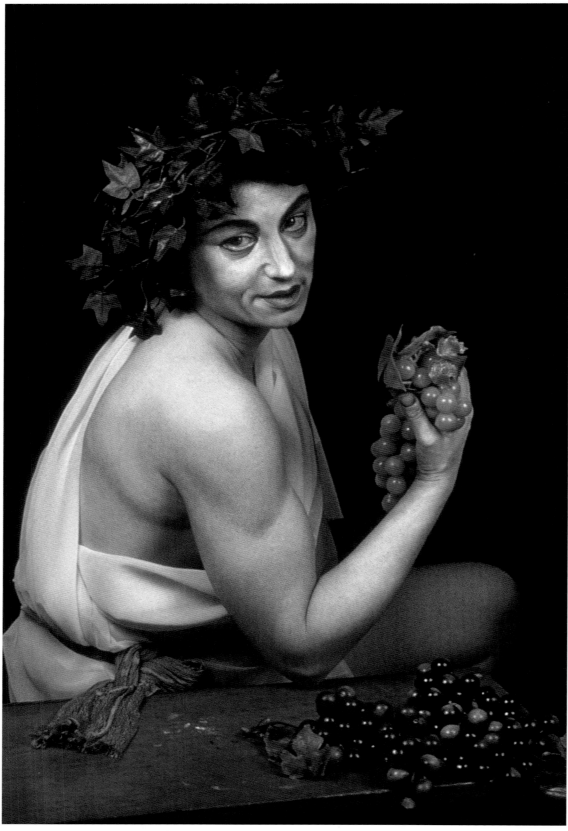

CINDY SHERMAN *Untitled Film Still No.224* 1990 Colour photograph 122 × 96.5 cm 48 × 38"

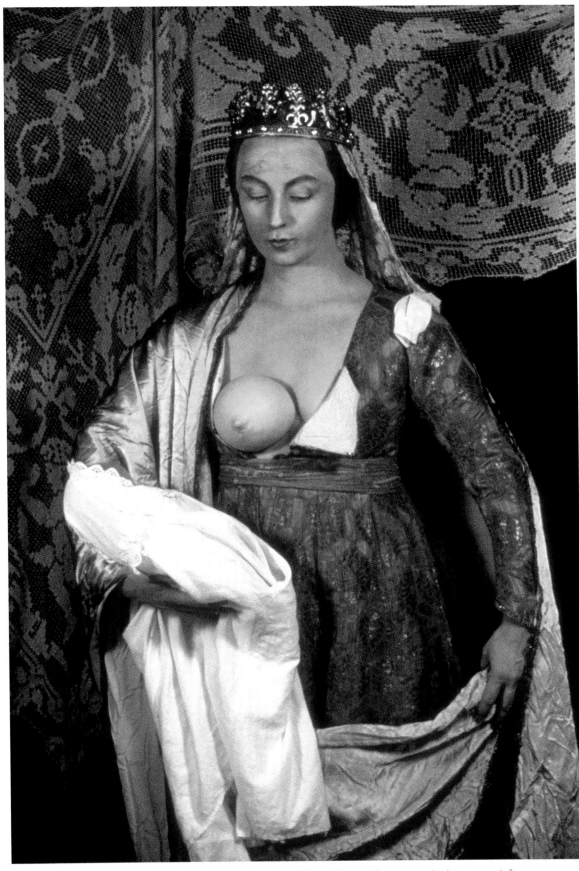

CINDY SHERMAN *Untitled Film Still No.216* 1989 Colour photograph 241.3 × 162.6 cm 95 × 64"

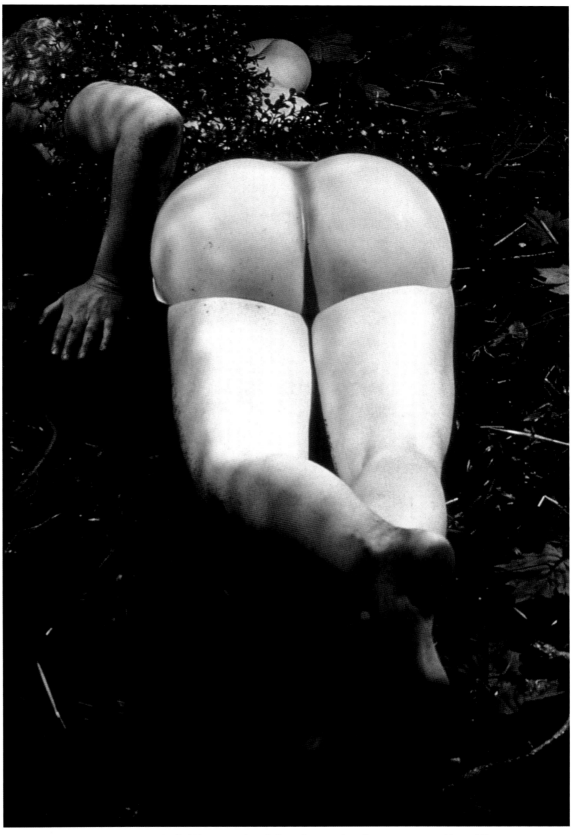

CINDY SHERMAN *Untitled No.155* 1985 Colour photograph 184.2 × 125 cm 72½ × 49¼"

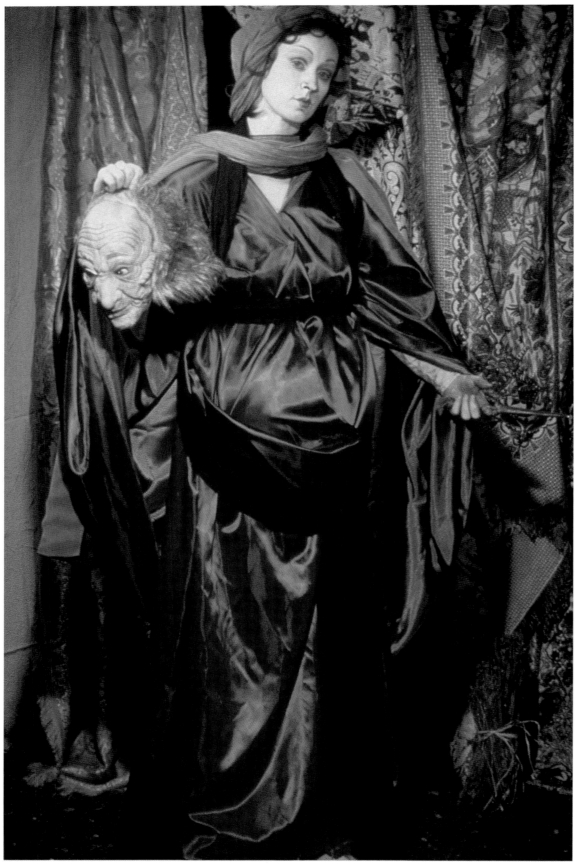

CINDY SHERMAN *Untitled Film Still No.228* 1990 Colour photograph 208.3 × 121.9 cm 82 × 48"

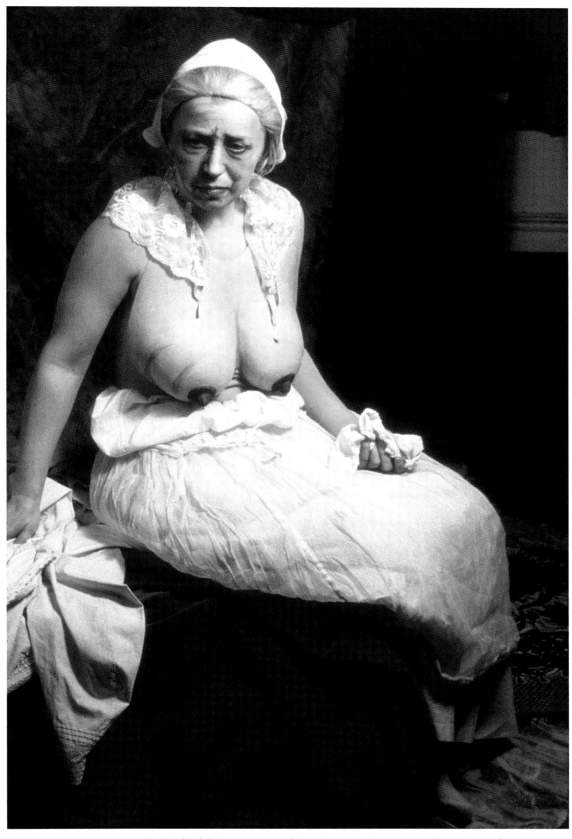

CINDY SHERMAN *Untitled Film Still No.222* 1990 Colour photograph 152.4 × 111.8 cm 60 × 44"

CINDY SHERMAN *Untitled Film Still No.25* 1978
Black and white photograph 40.6 × 50.8 cm 16 × 20"

CINDY SHERMAN *Untitled Film Still No.16* 1978
Black and white photograph 50.8 × 40.6 cm 20 × 16"

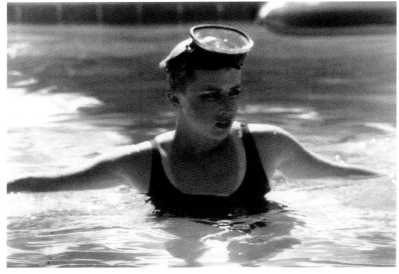

CINDY SHERMAN *Untitled Film Still No.45* 1979
Black and white photograph 40.6 × 50.8 cm 16 × 20"

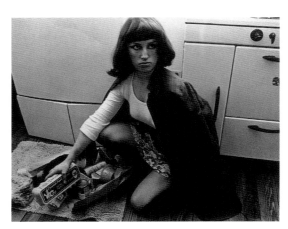

CINDY SHERMAN *Untitled Film Still No.10* 1980
Black and white photograph 40.6 × 50.8 cm 16 × 20"

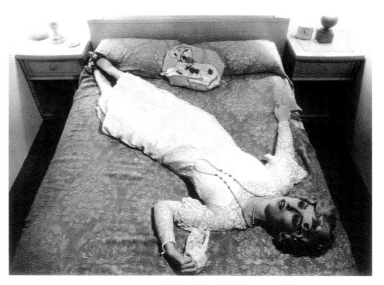

CINDY SHERMAN *Untitled Film Still No.11* 1978
Black and white photograph 40.6 × 50.8 cm 16 × 20"

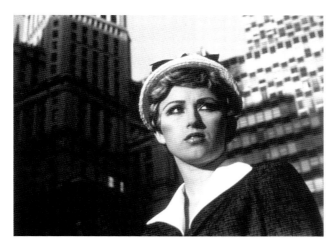

CINDY SHERMAN *Untitled Film Still No.21* 1978
Black and white photograph 40.6 × 50.8 cm 16 × 20"

CINDY SHERMAN *Untitled Film Still No.47* 1979
Black and white photograph 40.6 × 50.8 cm 16 × 20"

CINDY SHERMAN *Untitled Film Still No.35* 1979
Black and white photograph 50.8 × 40.6 cm 20 × 16"

CINDY SHERMAN *Untitled Film Still No.15* 1978
Black and white photograph 50.8 × 40.6 cm 20 × 16"

CINDY SHERMAN *Untitled Film Still No.48* 1979
Black and white photograph 40.6 × 50.8 cm 16 × 20"

CINDY SHERMAN *Untitled Film Still No.4* 1979
Black and white photograph 40.6 × 50.8 cm 16 × 20"

CINDY SHERMAN *Untitled Film Still No.18* 1978
Black and white photograph 40.6 × 50.8 cm 16 × 20"

CINDY SHERMAN *Untitled Film Still No.13* 1978
Black and white photograph 50.8 × 40.6 cm 20 × 16"

CINDY SHERMAN *Untitled Film Still No.54* 1980
Black and white photograph 40.6 × 50.8 cm 16 × 20"

CINDY SHERMAN *Untitled Film Still No.44* 1979
Black and white photograph 40.6 × 50.8 cm 16 × 20"

CINDY SHERMAN *Untitled Film Still No.37* 1979
Black and white photograph 50.8 × 40.6 cm 20 × 16"

CINDY SHERMAN *Untitled Film Still No.50* 1979
Black and white photograph 40.6 × 50.8 cm 16 × 20"

CINDY SHERMAN *Untitled Film Still No.7* 1978
Black and white photograph 50.8 × 40.6 cm 20 × 15"

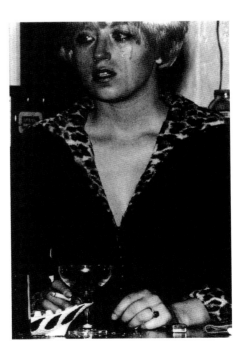

CINDY SHERMAN *Untitled Film Still No.27* 1979
Black and white photograph 50.8 × 40.6 cm 20 × 16"

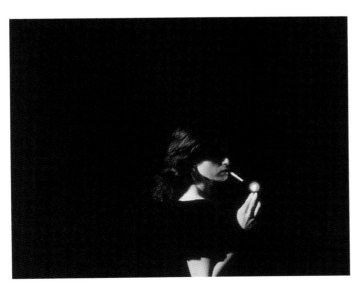

CINDY SHERMAN *Untitled Film Still No.32* 1979
Black and white photograph 40.6 × 50.8 cm 16 × 20"

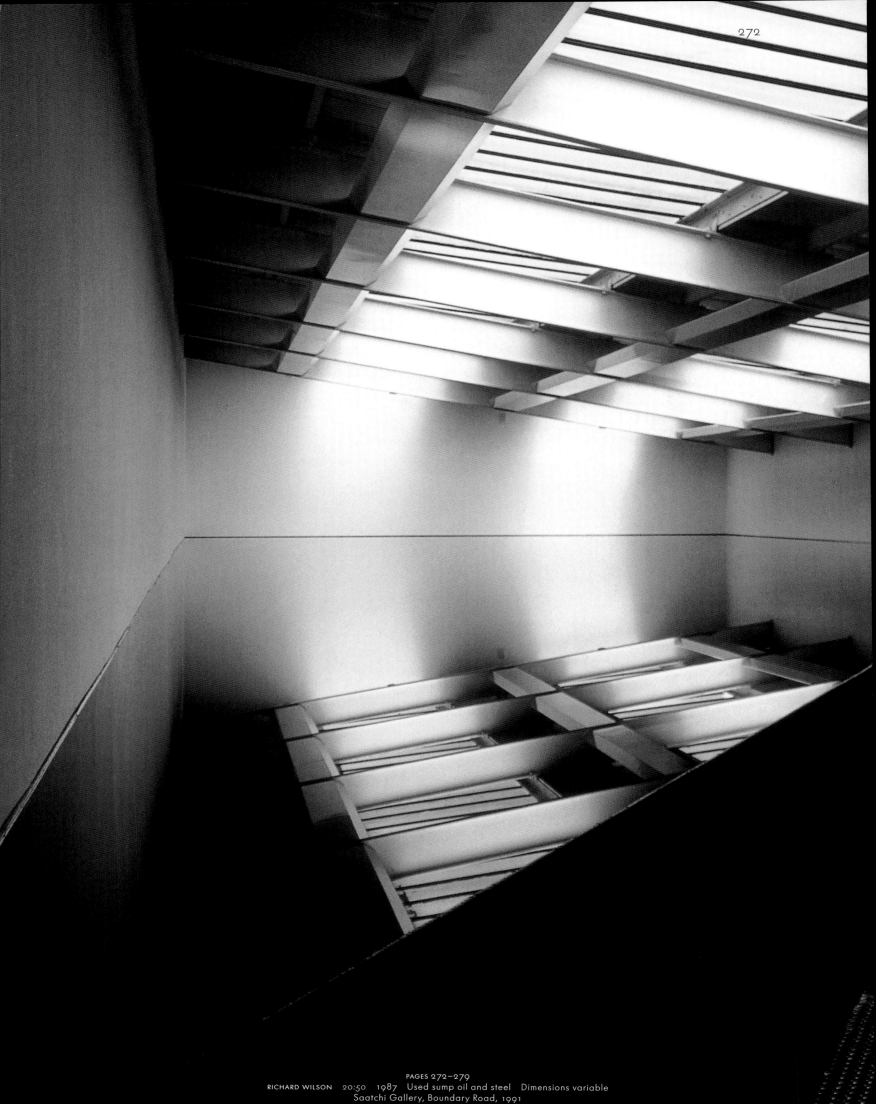

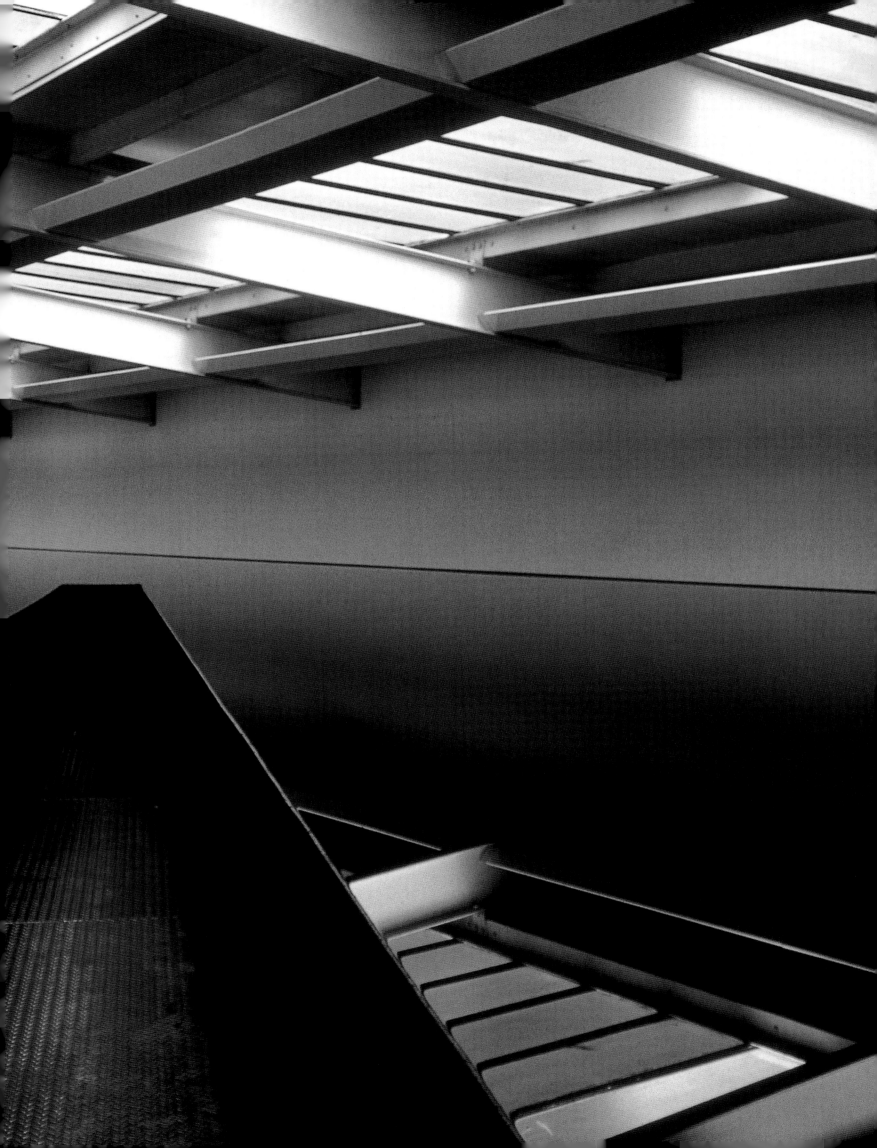

Saatchi Gallery, County Hall, 2003

Saatchi Gallery, Duke of York's HQ, 2010

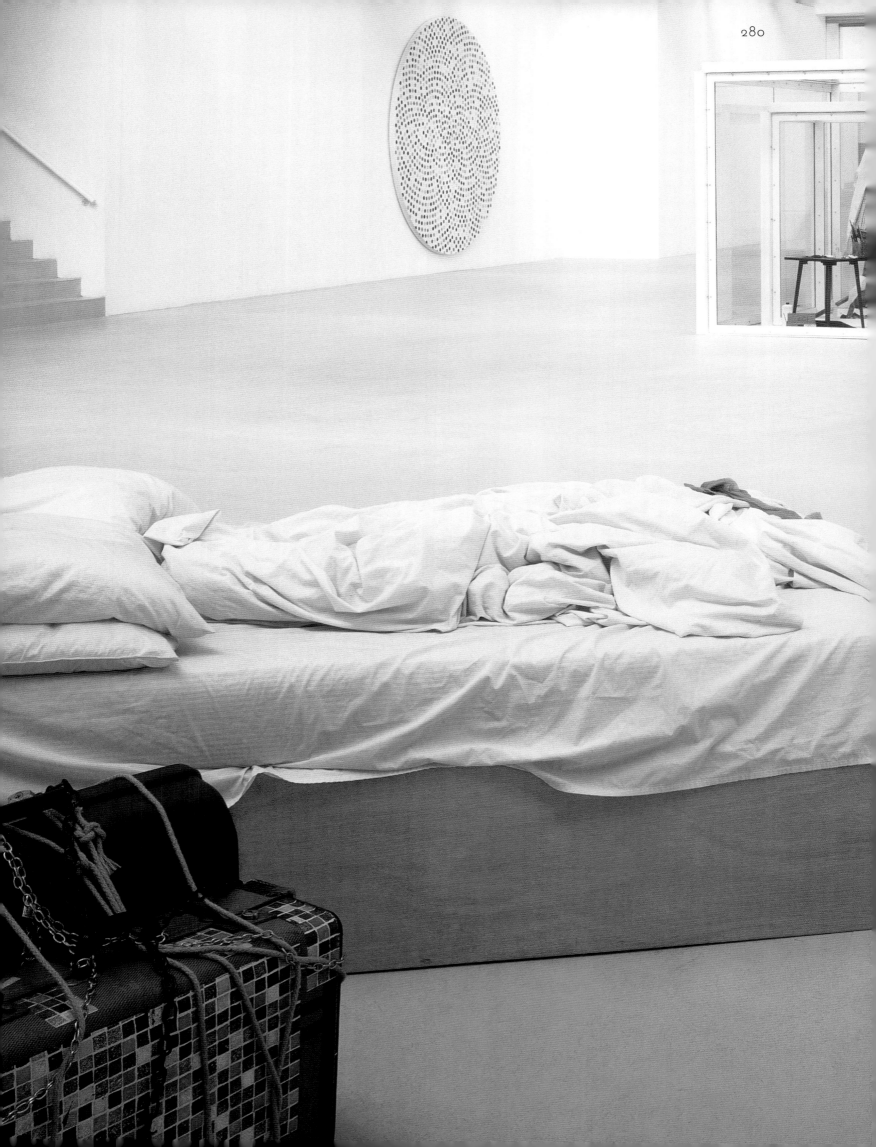

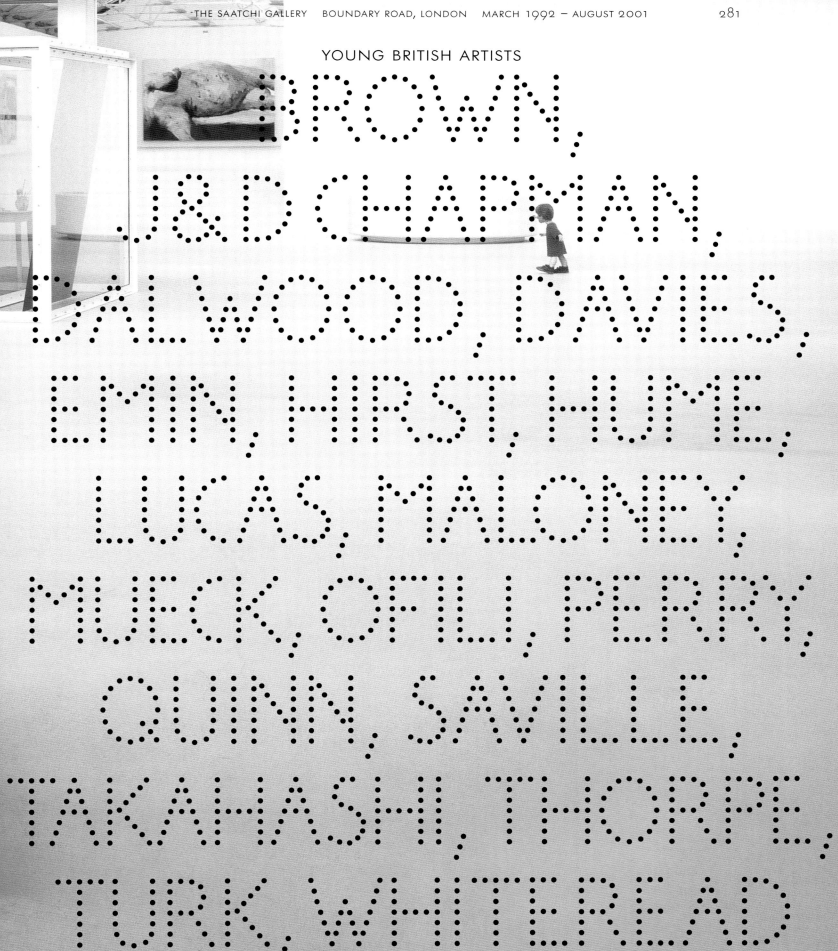

YOUNG BRITISH ARTISTS

BROWN, J&D CHAPMAN, DALWOOD, DAVIES, EMIN, HIRST, HUME, LUCAS, MALONEY, MUECK, OFILI, PERRY, QUINN, SAVILLE, TAKAHASHI, THORPE, TURK, WHITEREAD

TRACEY EMIN, DAMIEN HIRST, JAKE AND DINOS CHAPMAN, AND SARAH LUCAS INSTALLATION VIEW

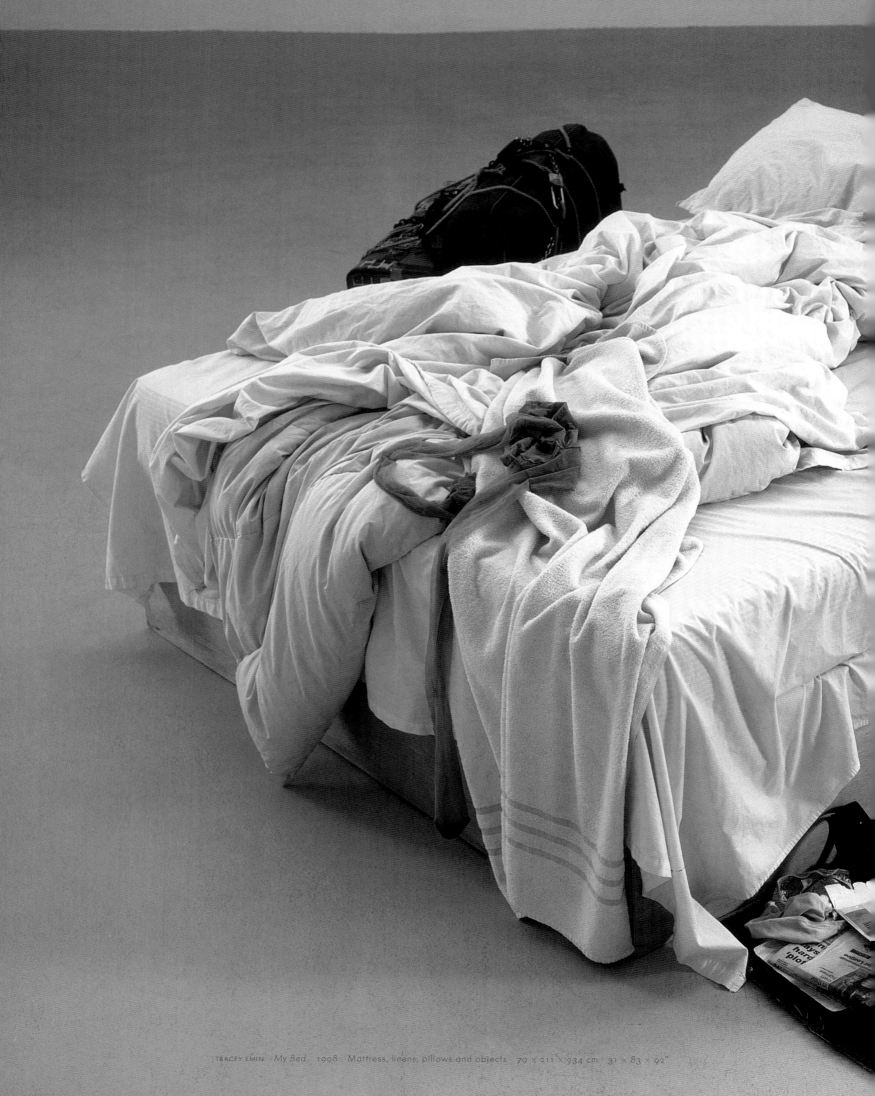

TRACEY EMIN *My Bed* 1998 Mattress, linens, pillows and objects 79 × 211 × 234 cm 31 × 83 × 92"

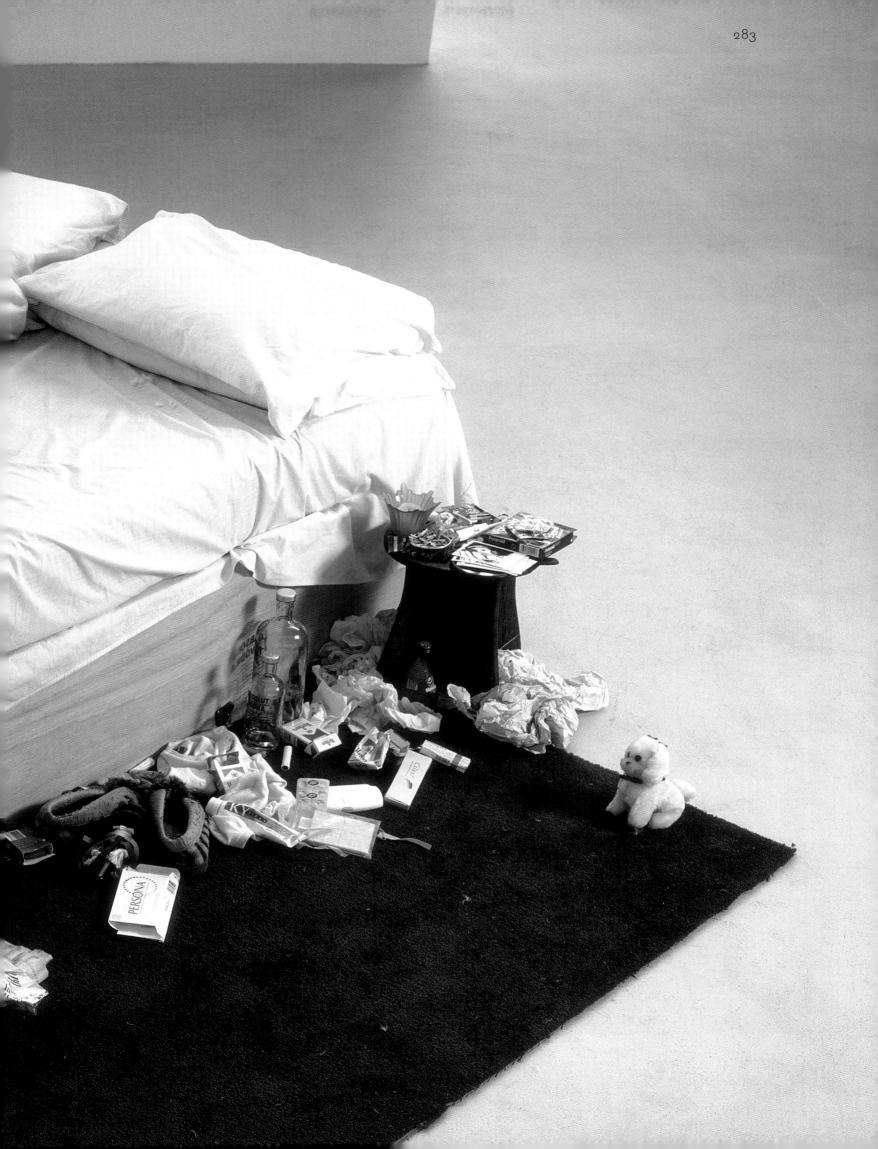

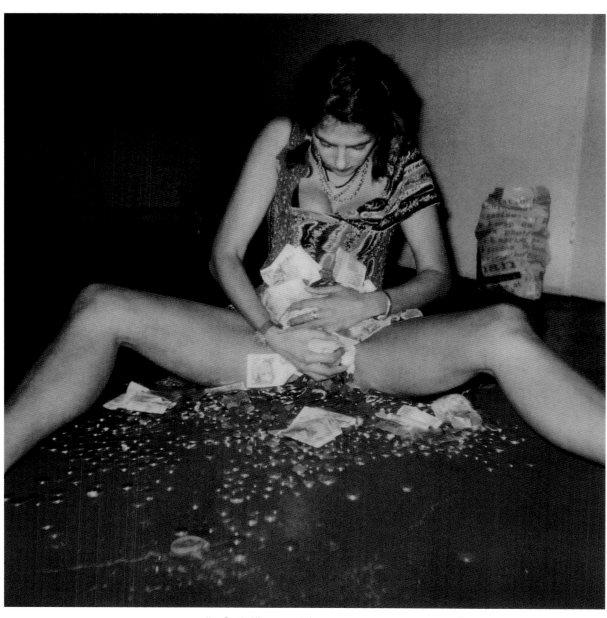

TRACEY EMIN *I've Got It All* 2000 Ink-jet print 122 × 91 cm 48 × 36"

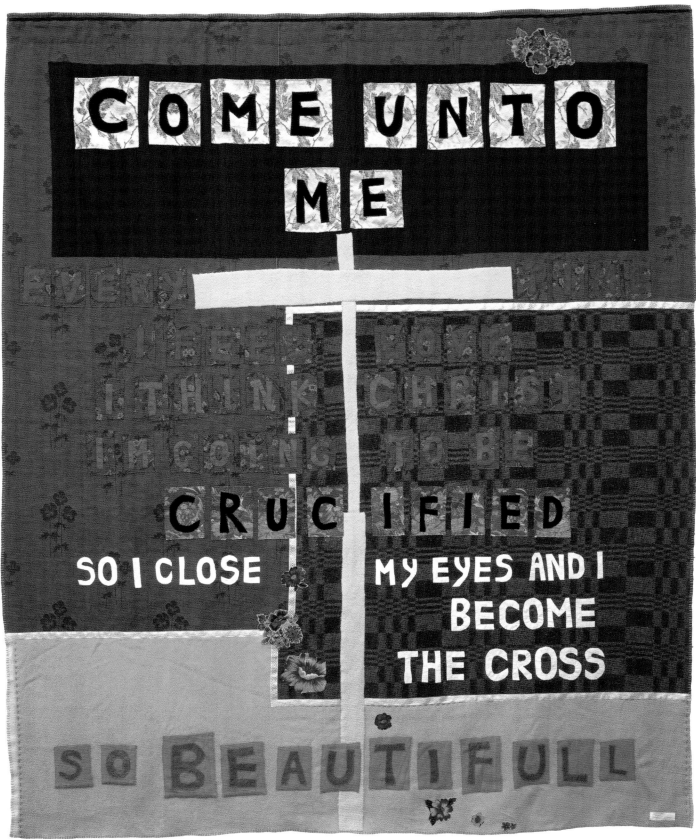

COME UNTO ME

CRUCIFIED

SO I CLOSE MY EYES AND I
 BECOME
 THE CROSS

SO BEAUTIFULL

TRACEY EMIN *Automatic Orgasm* 2001 Appliquéd blanket 263 × 214 cm 103½ × 84¼"

HOW COULD I EVER
LEAVE YOU

I LOVE YOU

I SEARCH THE
WORLD
I KISS YOU
I'M WET WITH
FEAR
I AM
INTERNATIONAL WOMAN

TRACEY EMIN *Terminal 1* 2000 Appliquéd blanket 230 x 210 cm 90½ x 82¾"

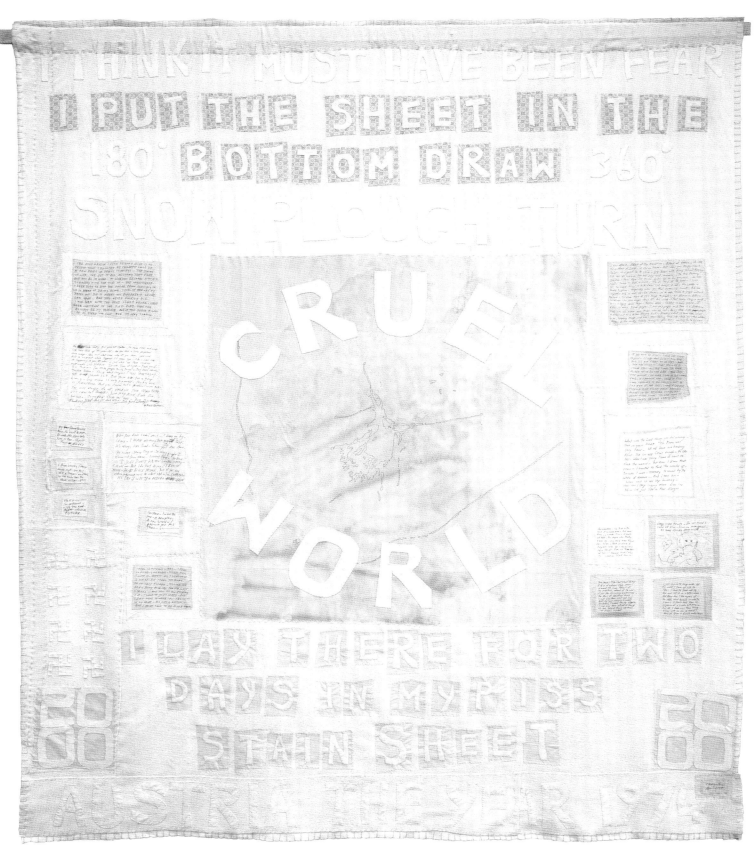

TRACEY EMIN *I Think It Must Have Been Fear* 2000 Appliquéd blanket 232 × 200 cm 91¼ × 78¾"

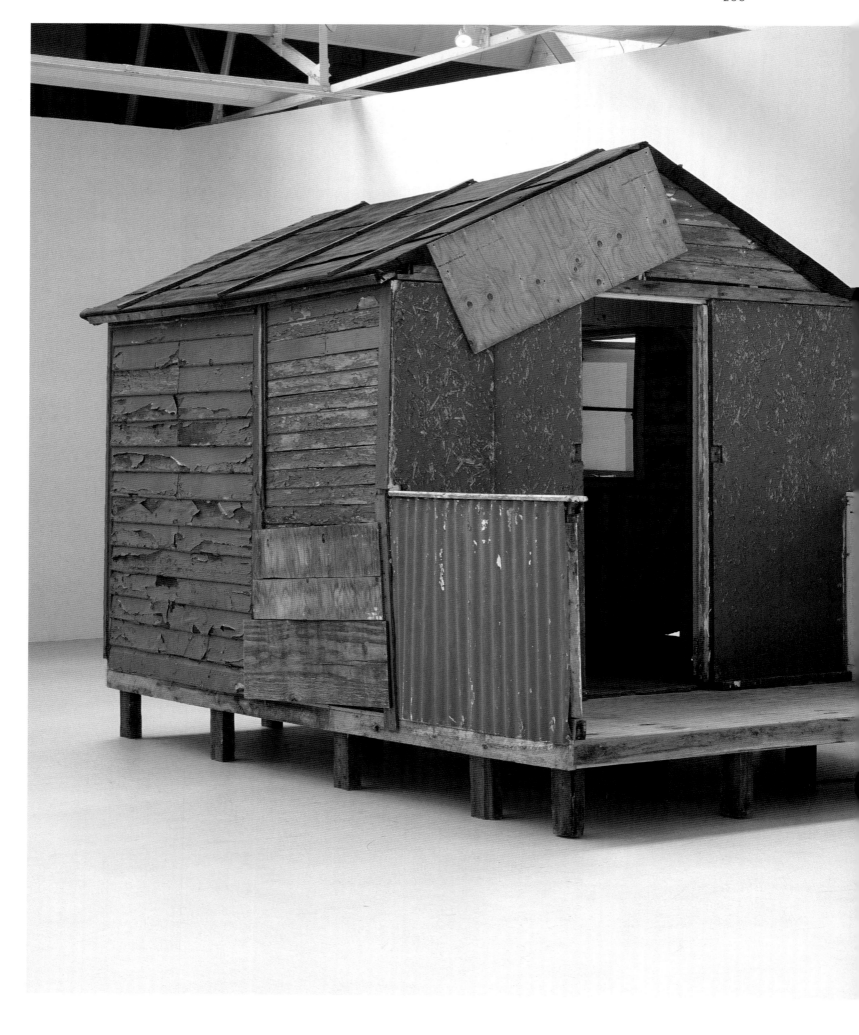

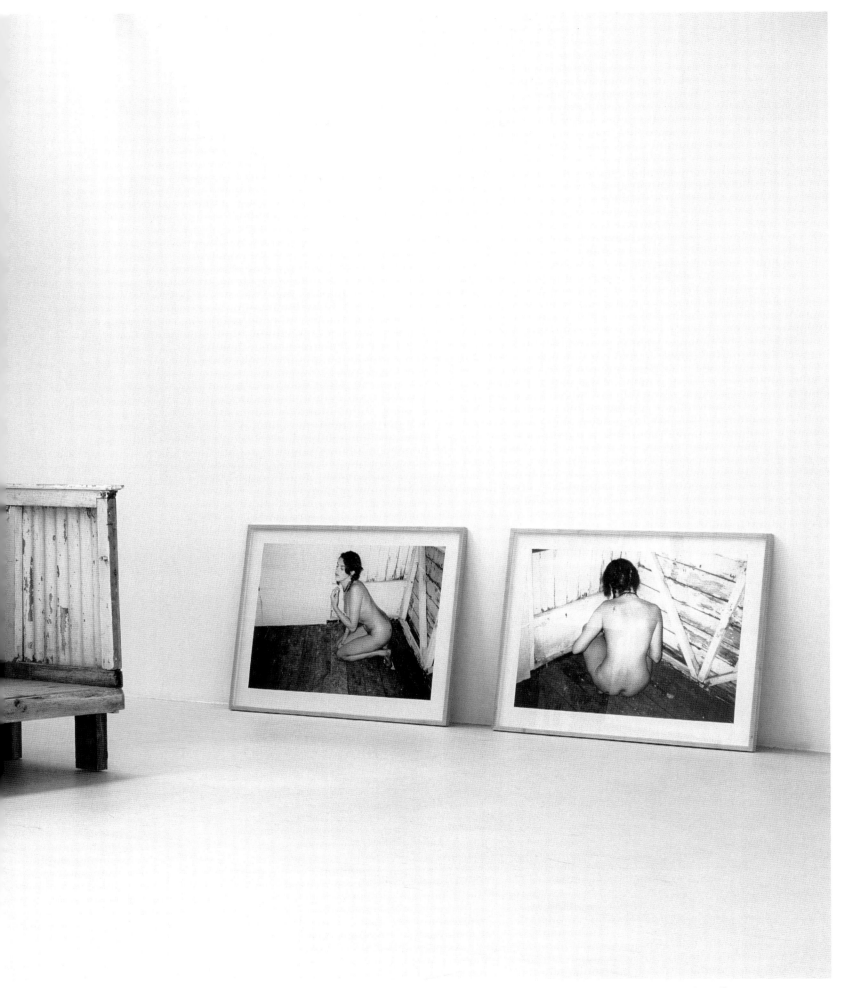

TRACEY EMIN (LEFT) *The Last Thing I Said to You Is Don't Leave Me Here* 1999 Mixed media 292 × 447 × 244 cm 115 × 176 × 96"
TRACEY EMIN (MIDDLE) *Untitled* 2000 Photographic print 104 × 130 cm 41 × 51¼"
TRACEY EMIN (RIGHT) *Untitled* 2000 Photographic print 104 × 130 cm 41 × 51¼"

RACHEL WHITEREAD *Ghost* 1990 Plaster on steel frame 269 × 355.5 × 317.5 cm 106 × 140 × 125"

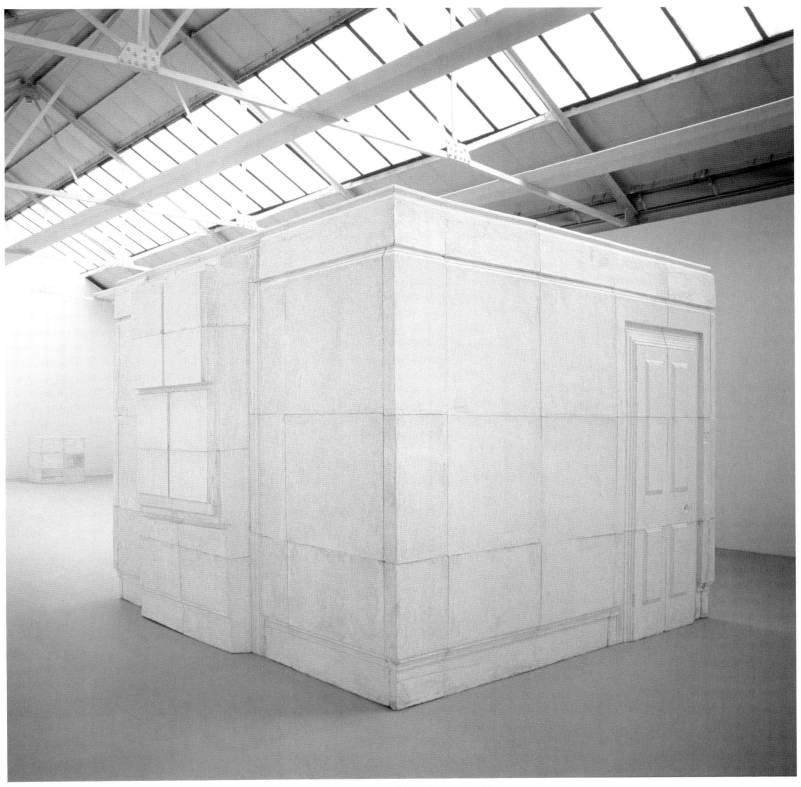

RACHEL WHITEREAD *Ghost* (reverse angle)

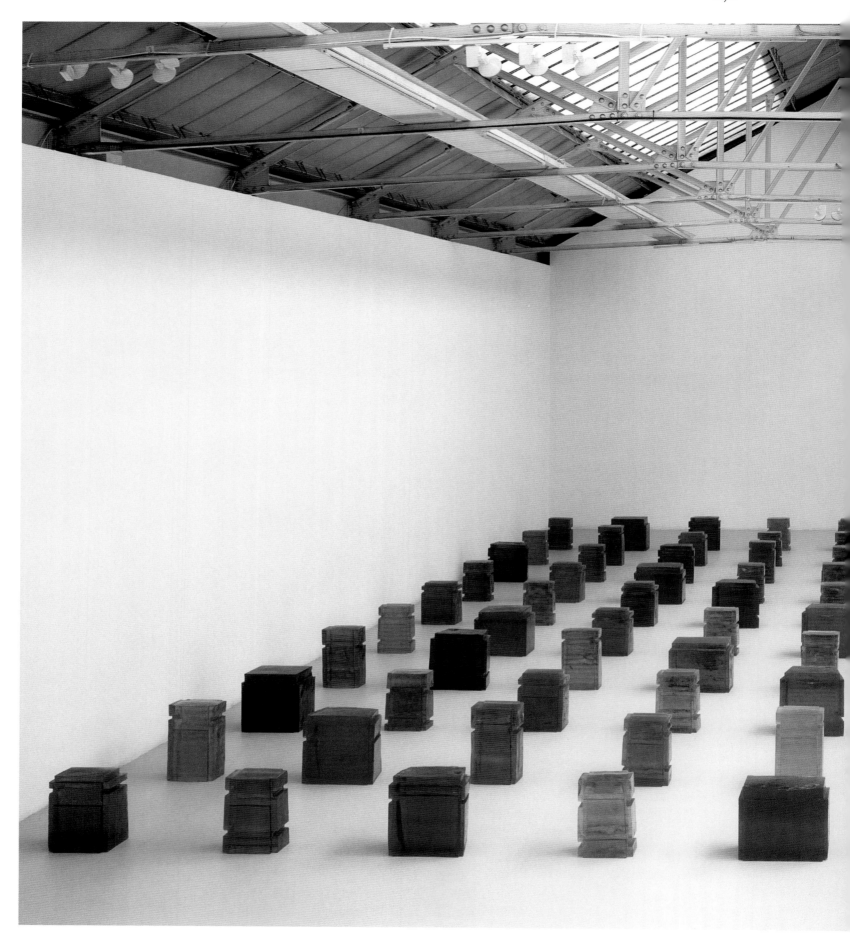

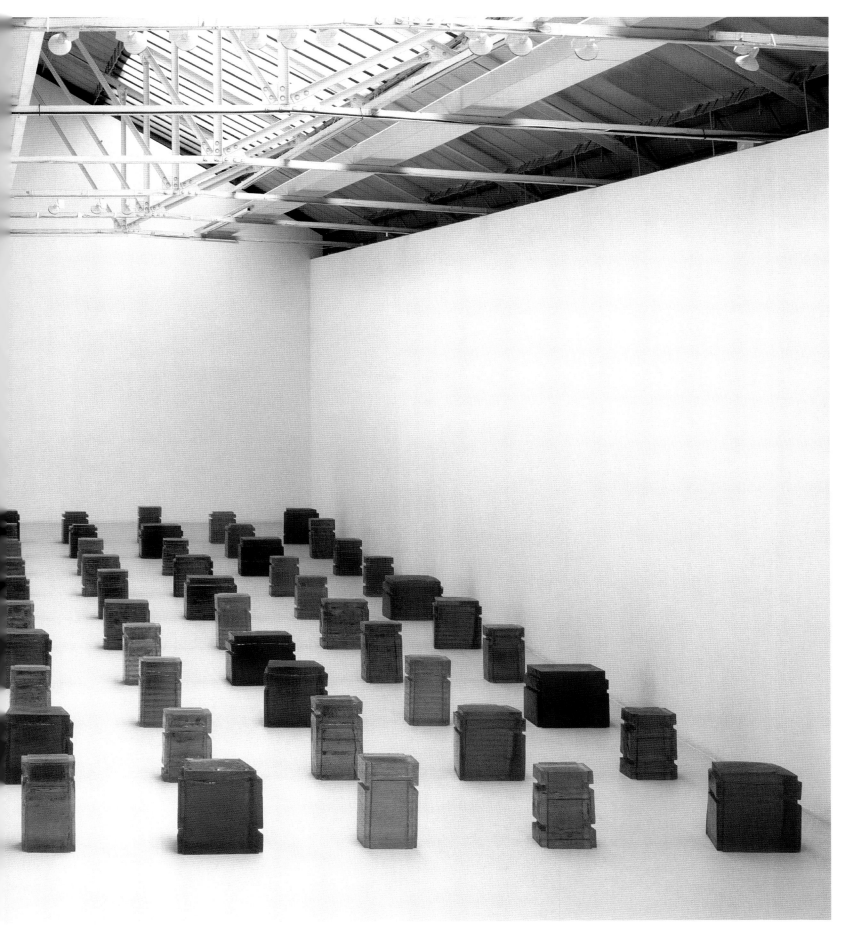

RACHEL WHITEREAD *Untitled (One Hundred Spaces)* 1995 Resin (100 units) Dimensions variable

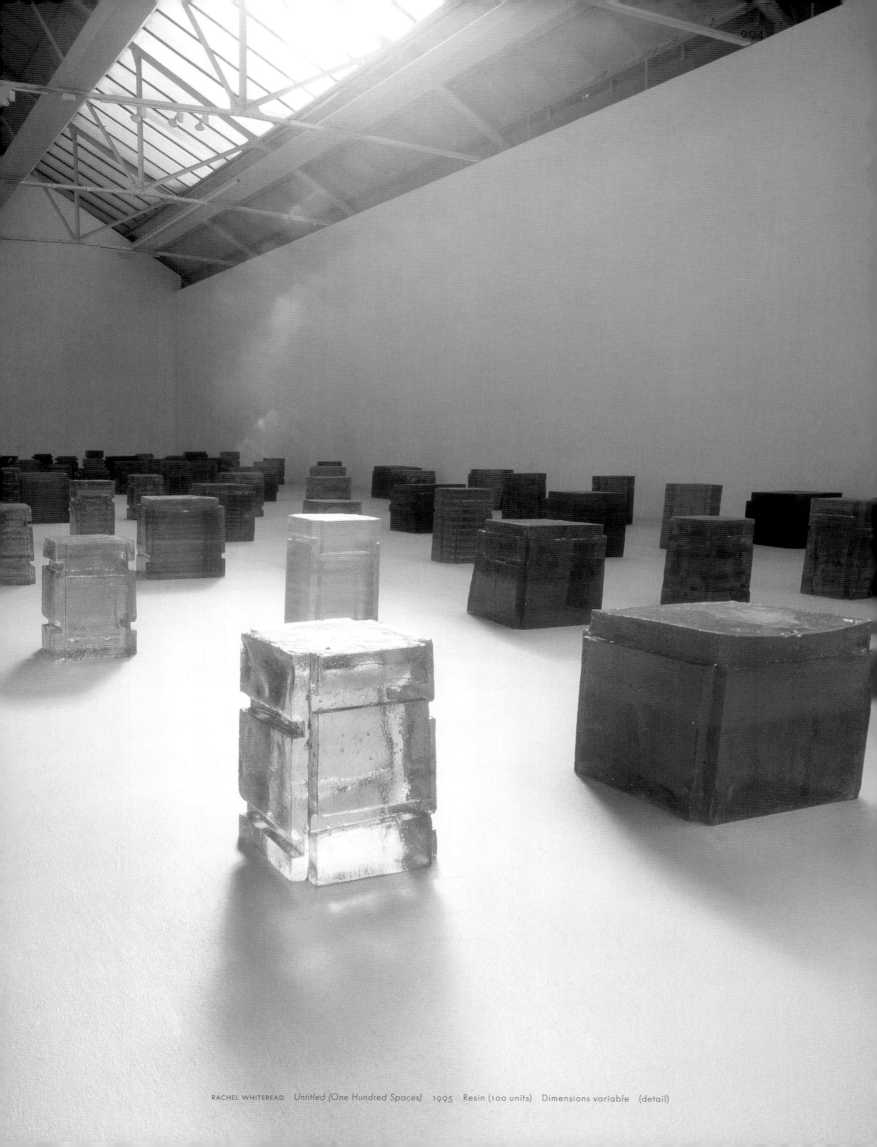

RACHEL WHITEREAD *Untitled (One Hundred Spaces)* 1995 Resin (100 units) Dimensions variable (detail)

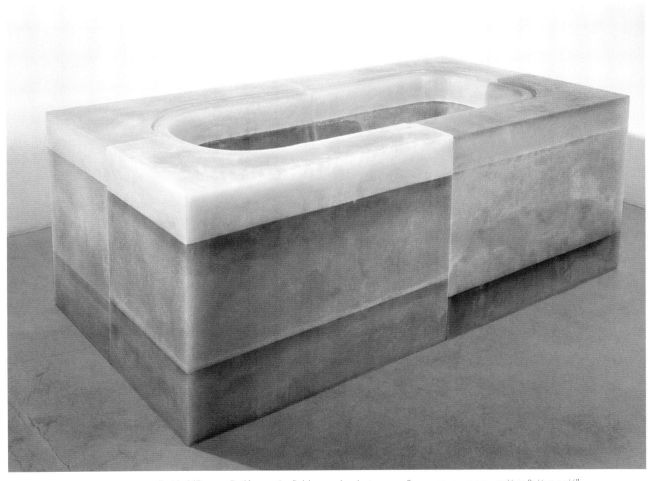

RACHEL WHITEREAD *Untitled (Orange Bath)* 1996 Rubber and polystyrene 80 × 207 × 110 cm 31½ × 81½ × 43¼"

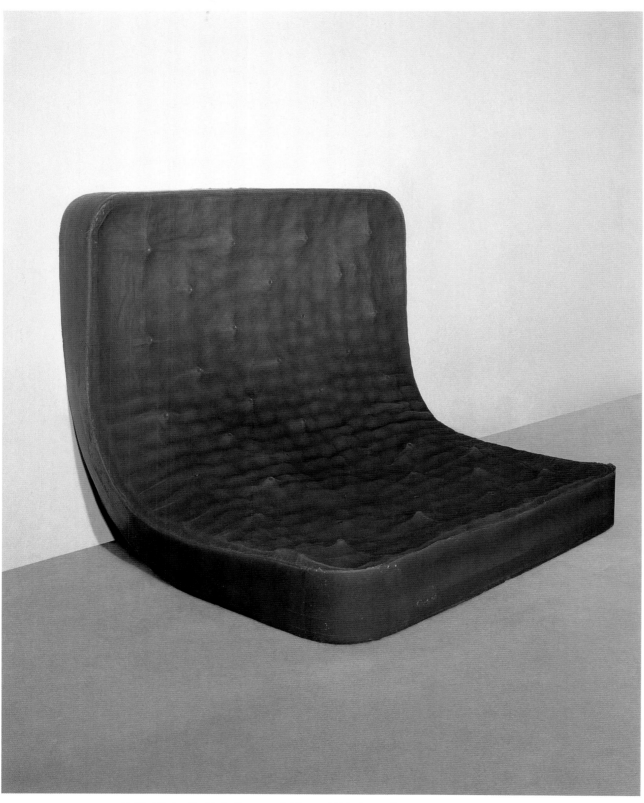

RACHEL WHITEREAD *Untitled (Amber Double Bed)* 1991 Rubber and high-density foam 119.4 × 137.2 × 104.1 cm 47 × 54 × 41"

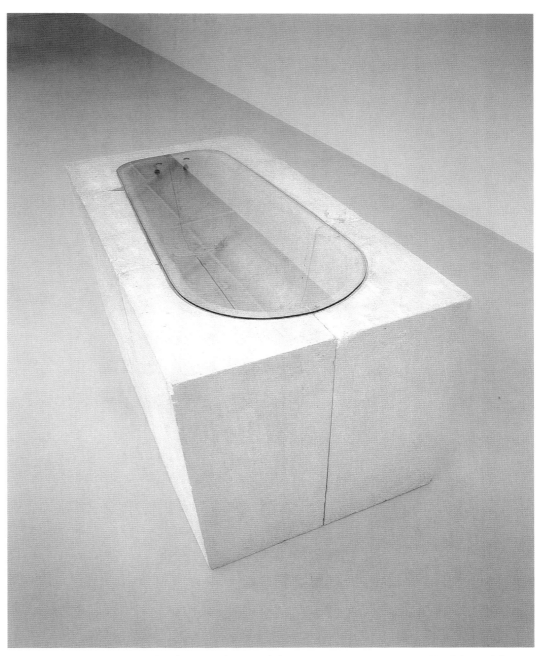

RACHEL WHITEREAD *Untitled (Bath)* 1990 Plaster and glass 103 × 209.5 × 105.5 cm 40½ × 82½ × 41⅛"

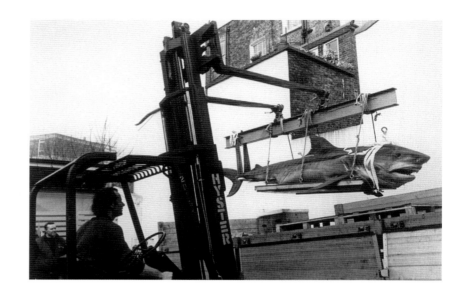

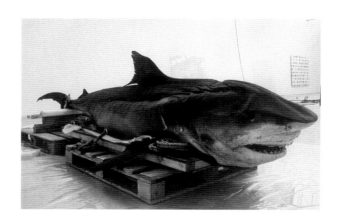

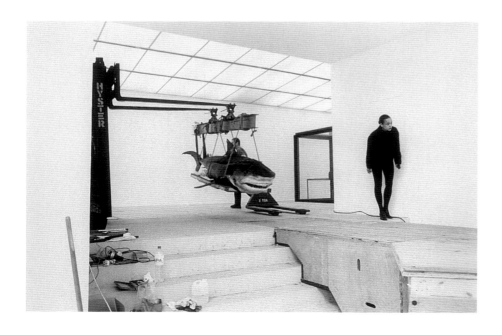

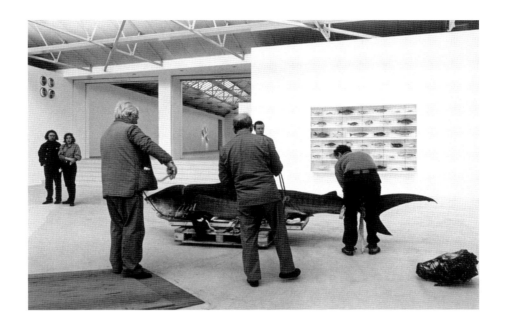

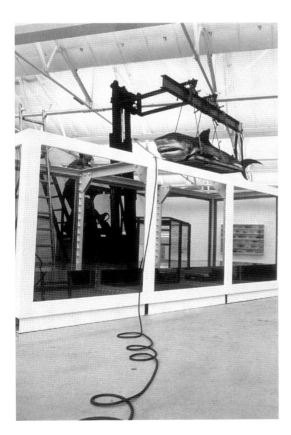

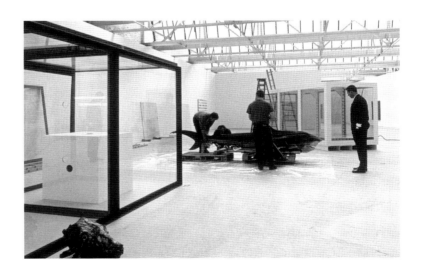

INSTALLING DAMIEN HIRST'S *The Physical Impossibility of Death in the Mind of Someone Living* AT THE SAATCHI GALLERY

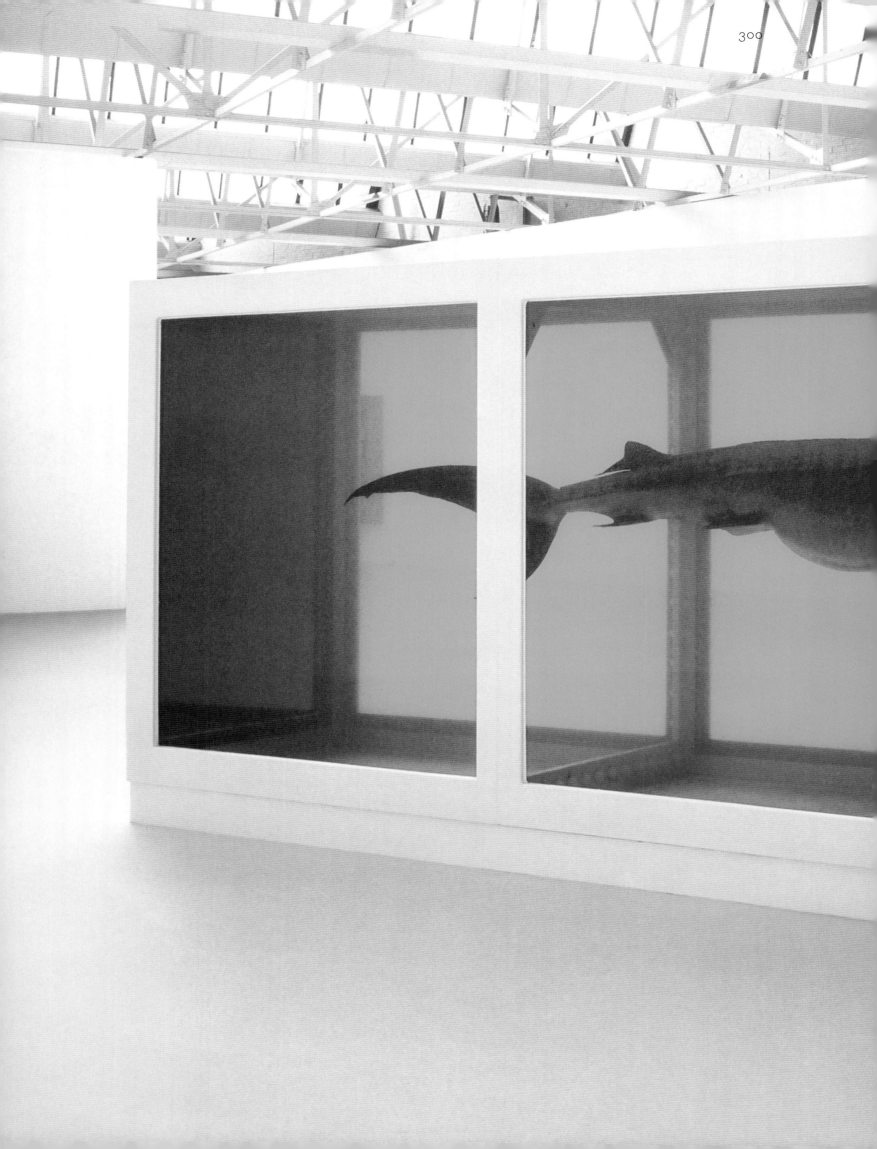

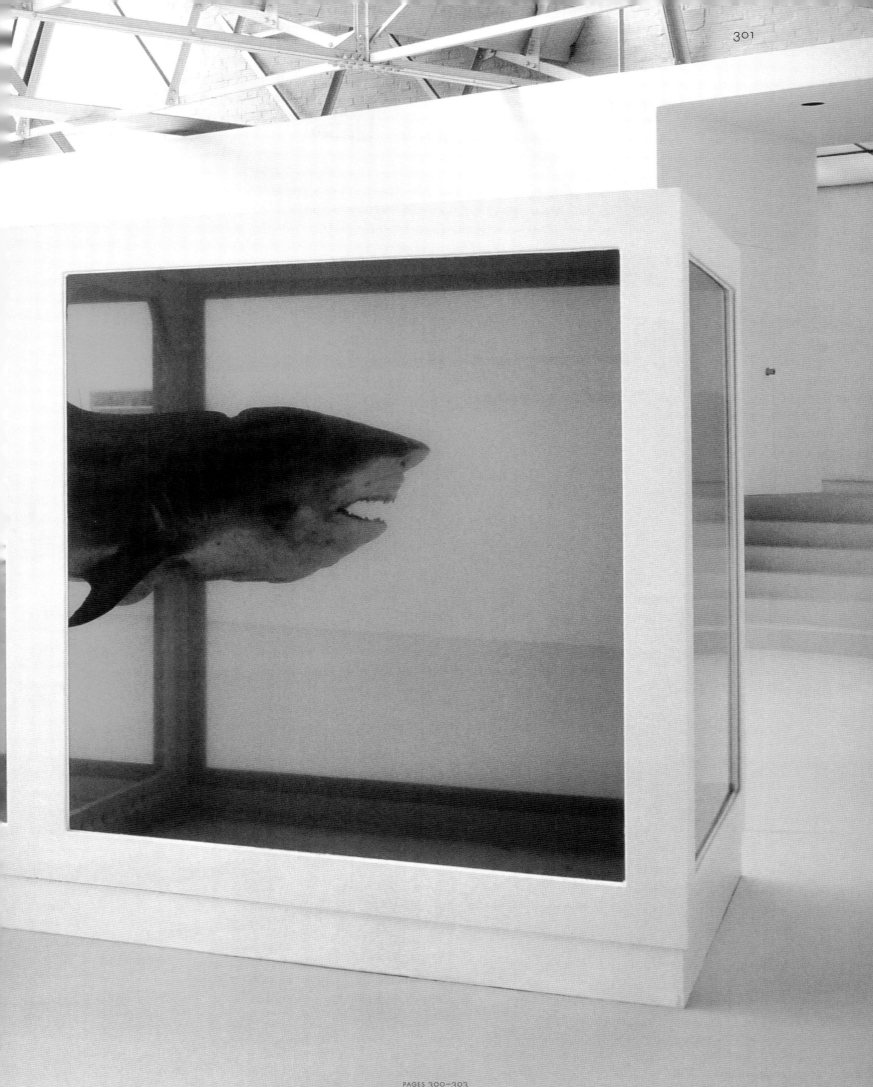

PAGES 300–303

DAMIEN HIRST *The Physical Impossibility of Death in the Mind of Someone Living* 1991 Tiger shark, glass, steel and formaldehyde solution 213 × 518 × 213 cm 83¾ × 204 × 83¾″

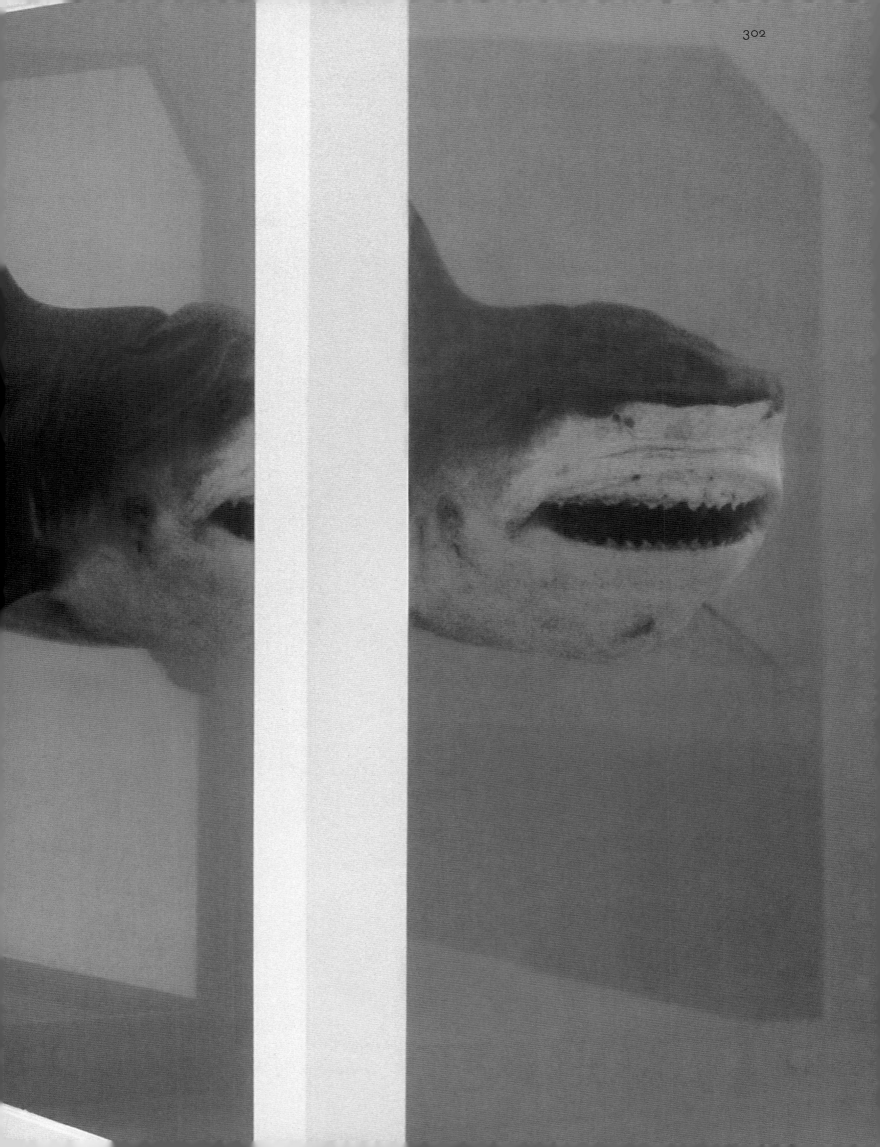

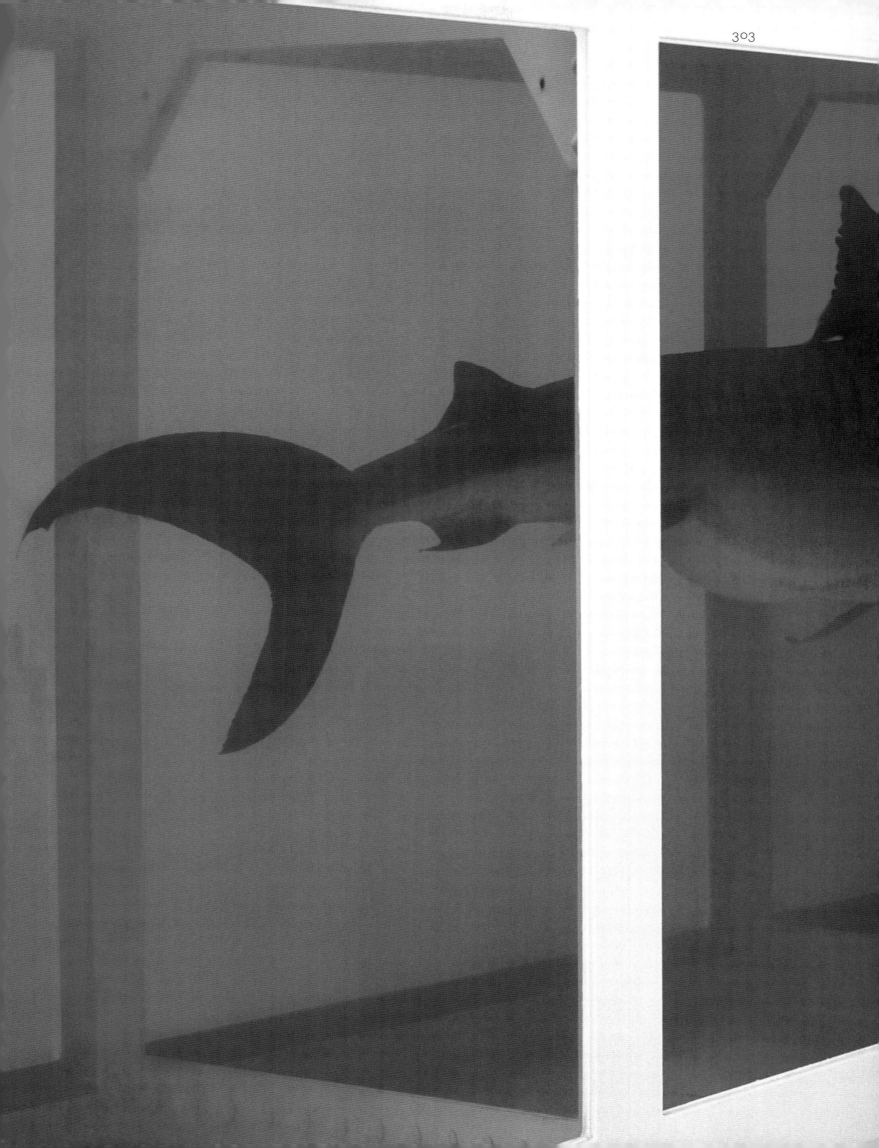

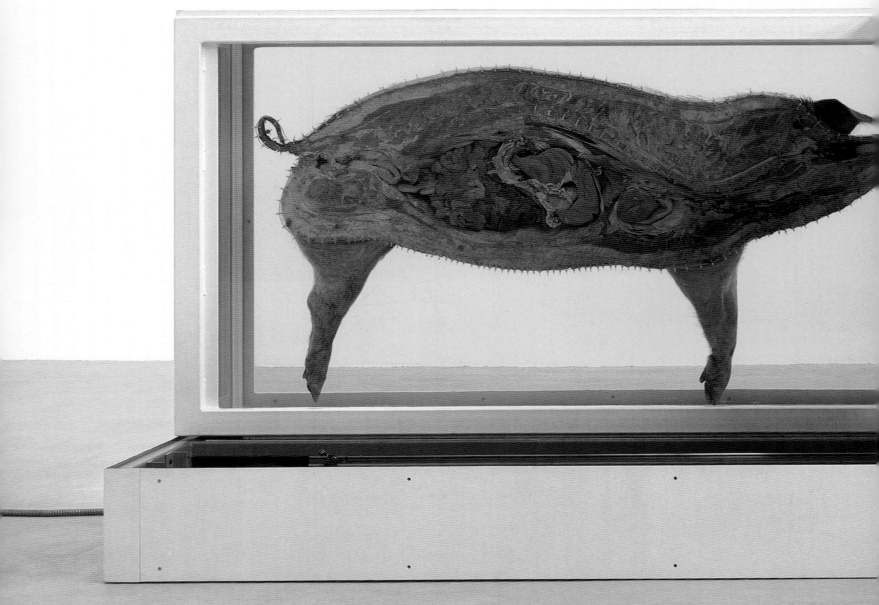

DAMIEN HIRST *This Little Piggy Went to Market, This Little Piggy Stayed at Home* 1996
Steel, GRP composites, glass, pig, electric motor and formaldehyde solution (2 tanks) Each tank: 120 x 210 x 60 cm 47¼ x 82¾ x 23½"

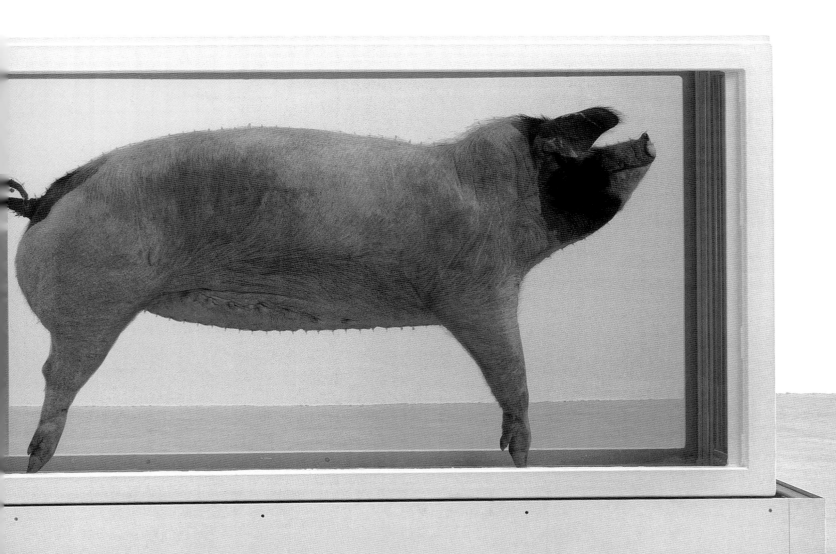

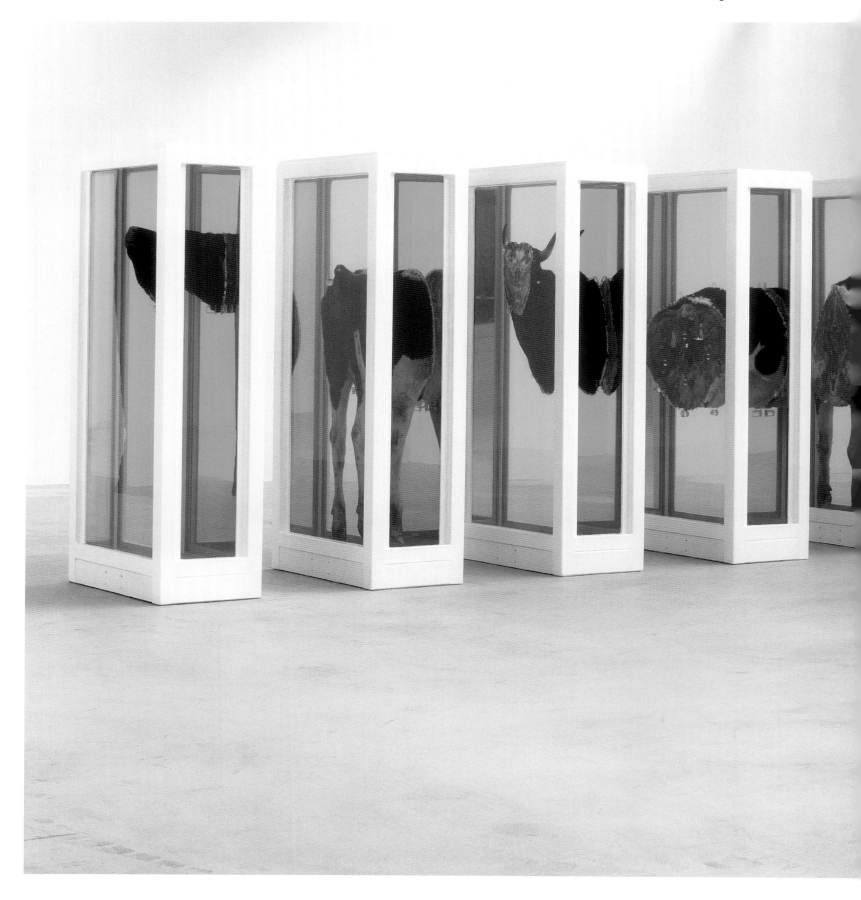

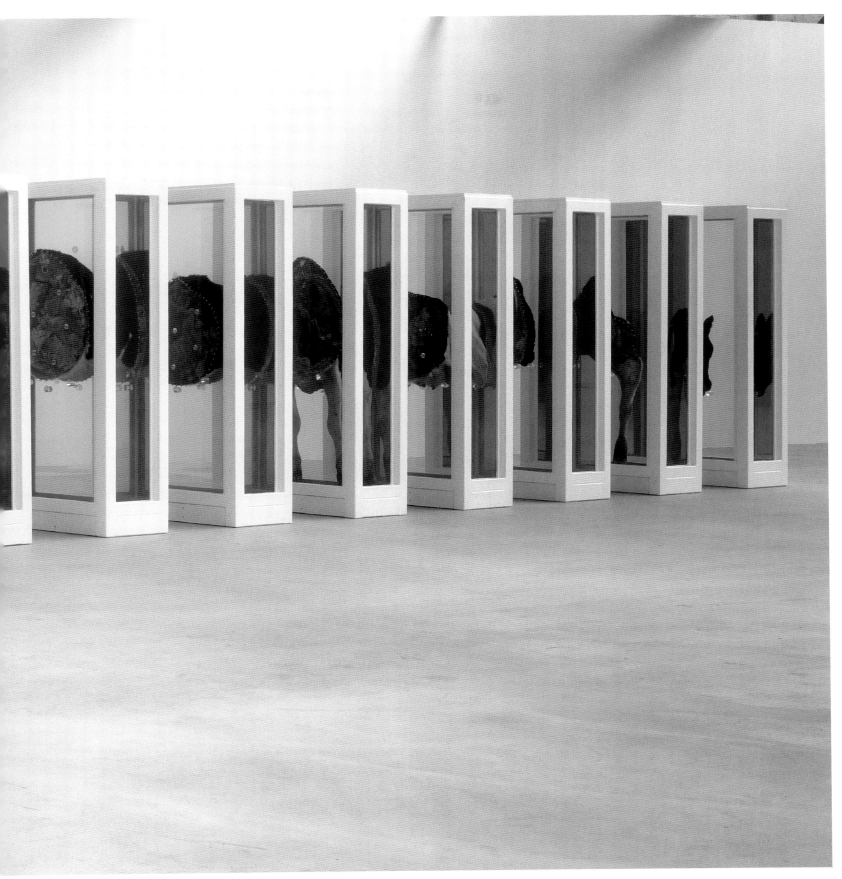

DAMIEN HIRST *Some Comfort Gained from the Acceptance of the Inherent Lies in Everything* 1996
Steel, glass, cows and formaldehyde solution (12 tanks) Each tank: 200 × 90 × 30 cm 78¾ × 35½ × 11¾"

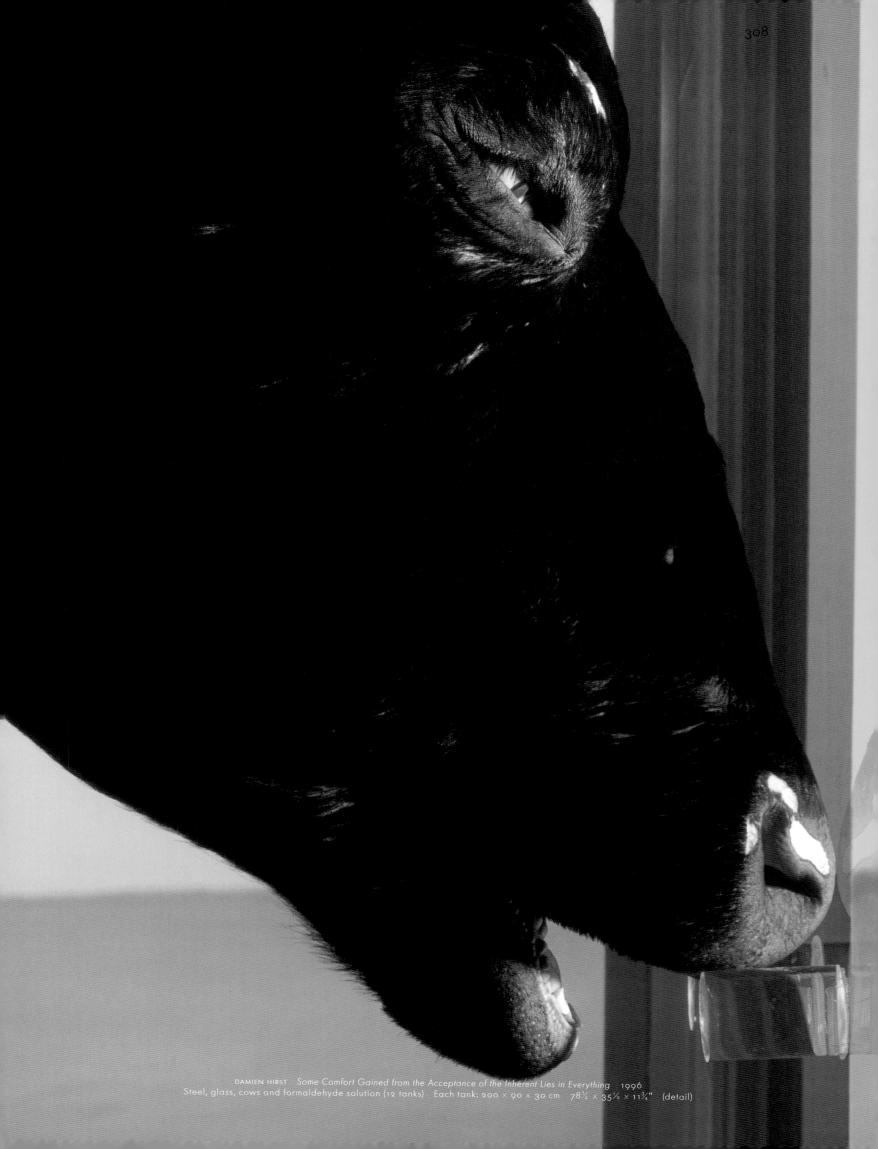

DAMIEN HIRST *Some Comfort Gained from the Acceptance of the Inherent Lies in Everything* 1996
Steel, glass, cows and formaldehyde solution (12 tanks) Each tank: 200 × 90 × 30 cm 78¾ × 35½ × 11¾" (detail)

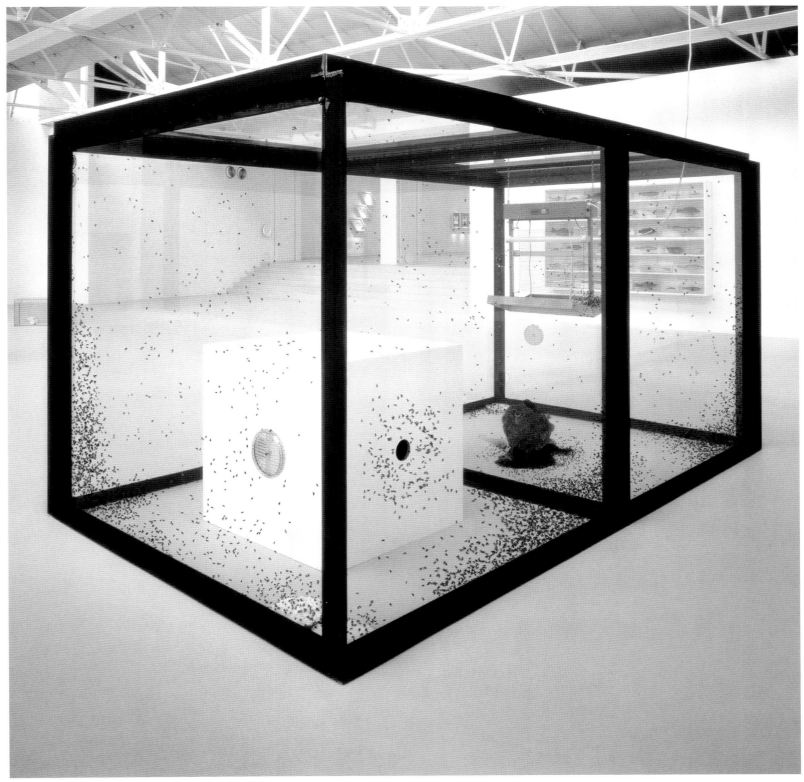

DAMIEN HIRST *A Thousand Years* 1990 Glass, steel, MDF, cow's head, flies, maggots, insect-o-cutor, sugar and water 213 × 427 × 213 cm 84 × 168 × 84"

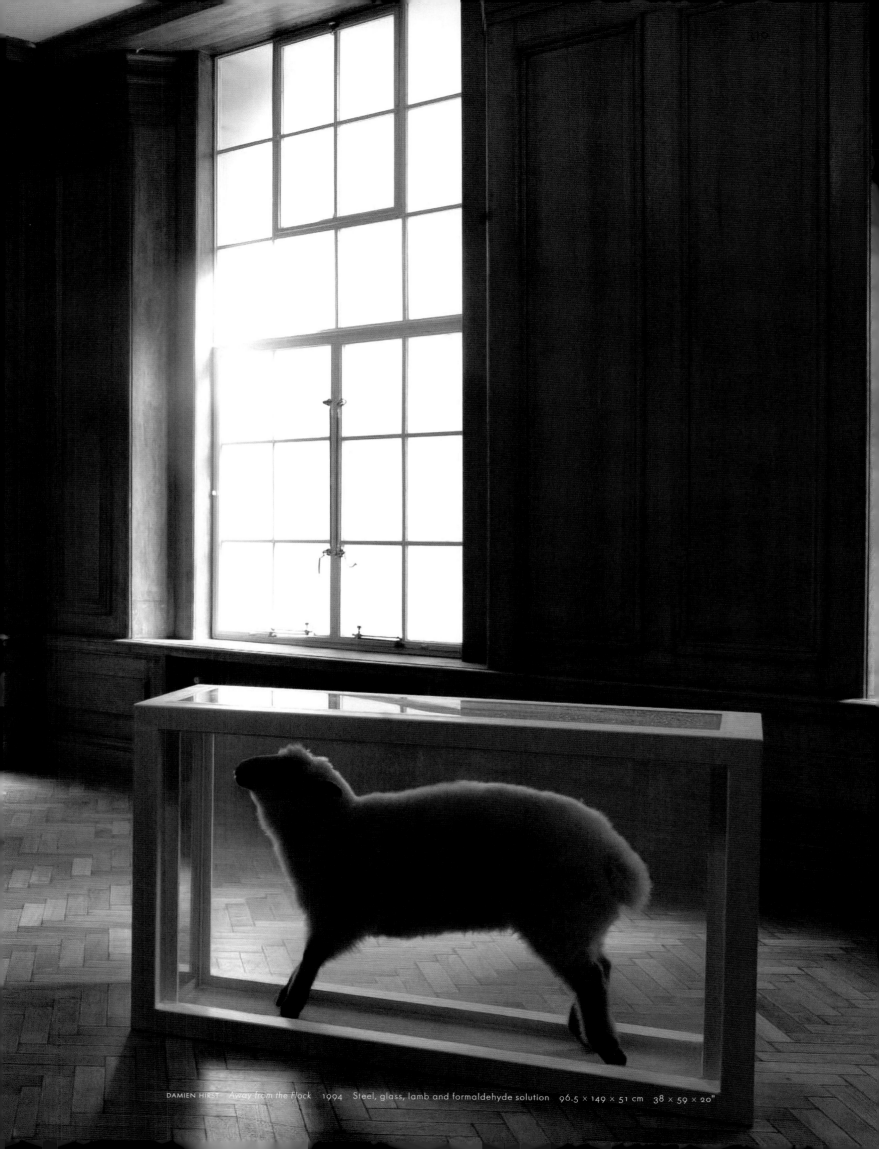

DAMIEN HIRST *Away from the Flock* 1994 Steel, glass, lamb and formaldehyde solution 96.5 × 149 × 51 cm 38 × 59 × 20"

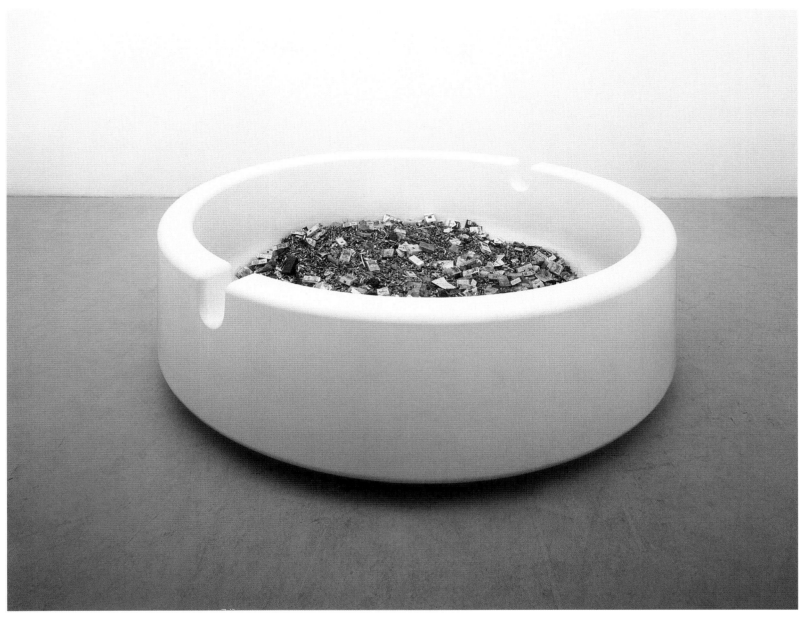

DAMIEN HIRST *Horror at Home* 1995 GRP composites, foam and contents of ashtray 243.8 × 70 cm 96 × 27½"

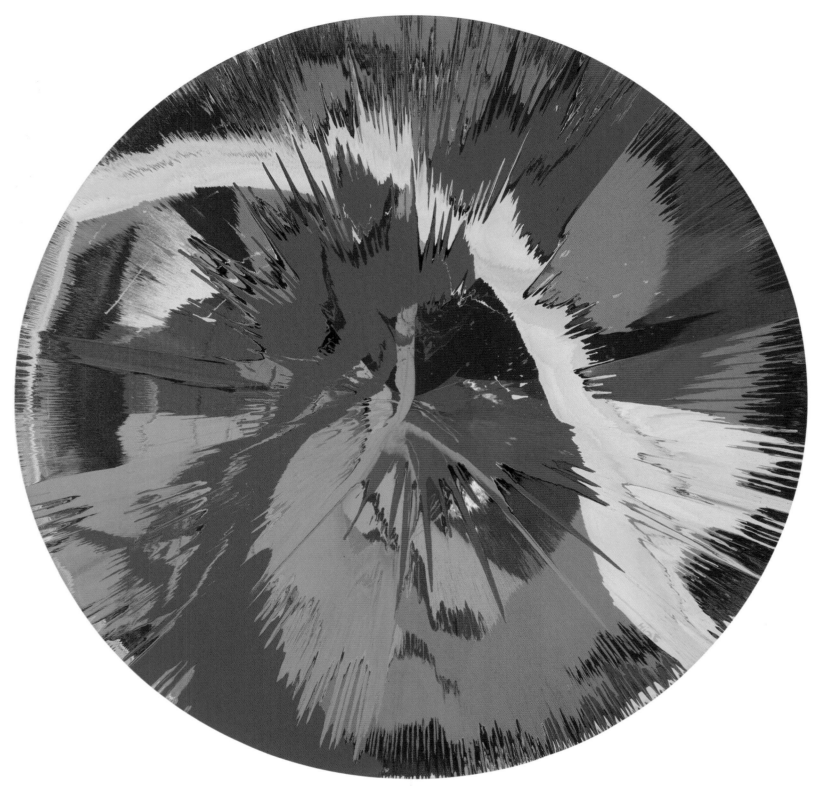

DAMIEN HIRST *Beautiful, Kiss My Fucking Ass Painting* 1996 Gloss household paint on canvas Diameter: 213.4 cm 84"

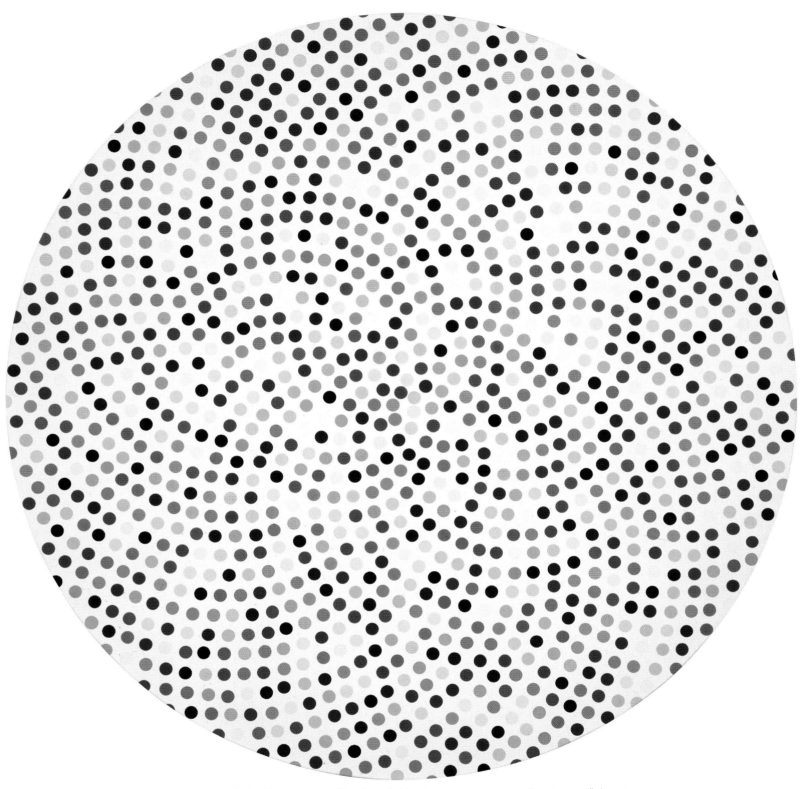

DAMIEN HIRST *Zeolite Mixture* 1999 Gloss household paint on canvas 300 cm diameter 120" diameter

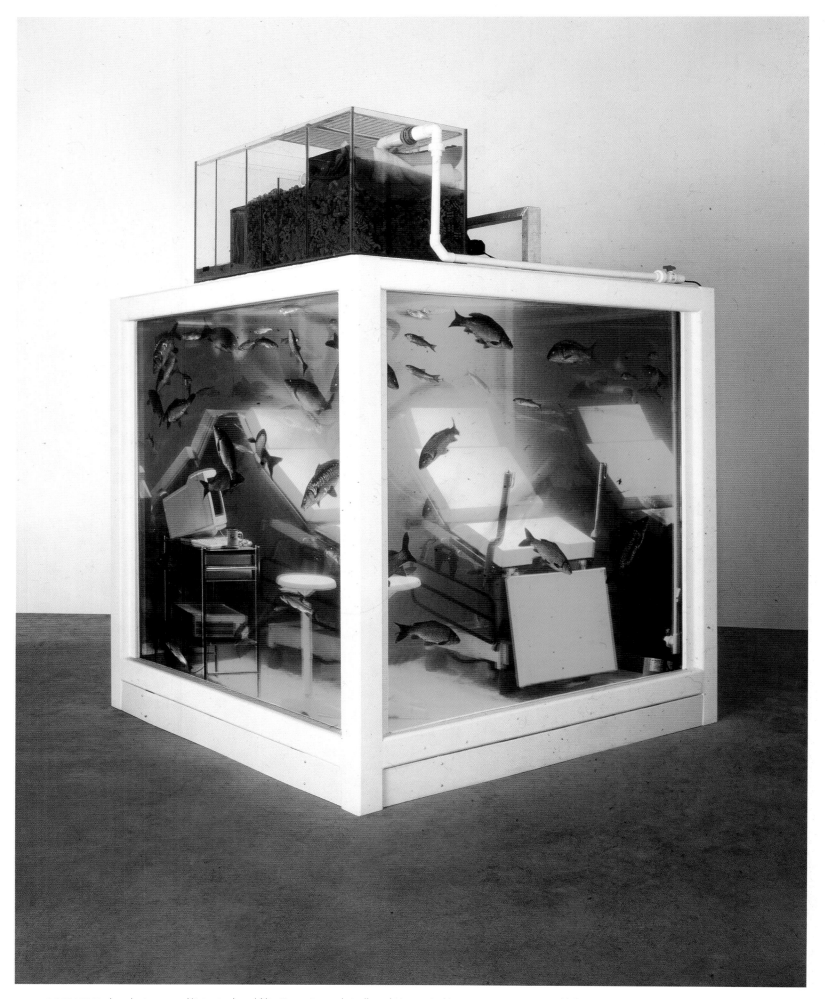

DAMIEN HIRST *Love Lost* 2000 Vitrine tank and filtration unit, couch, trolley, chair, surgical instruments, computer and fish 213.4 × 213.4 × 213.4 cm 84 × 84 × 84"

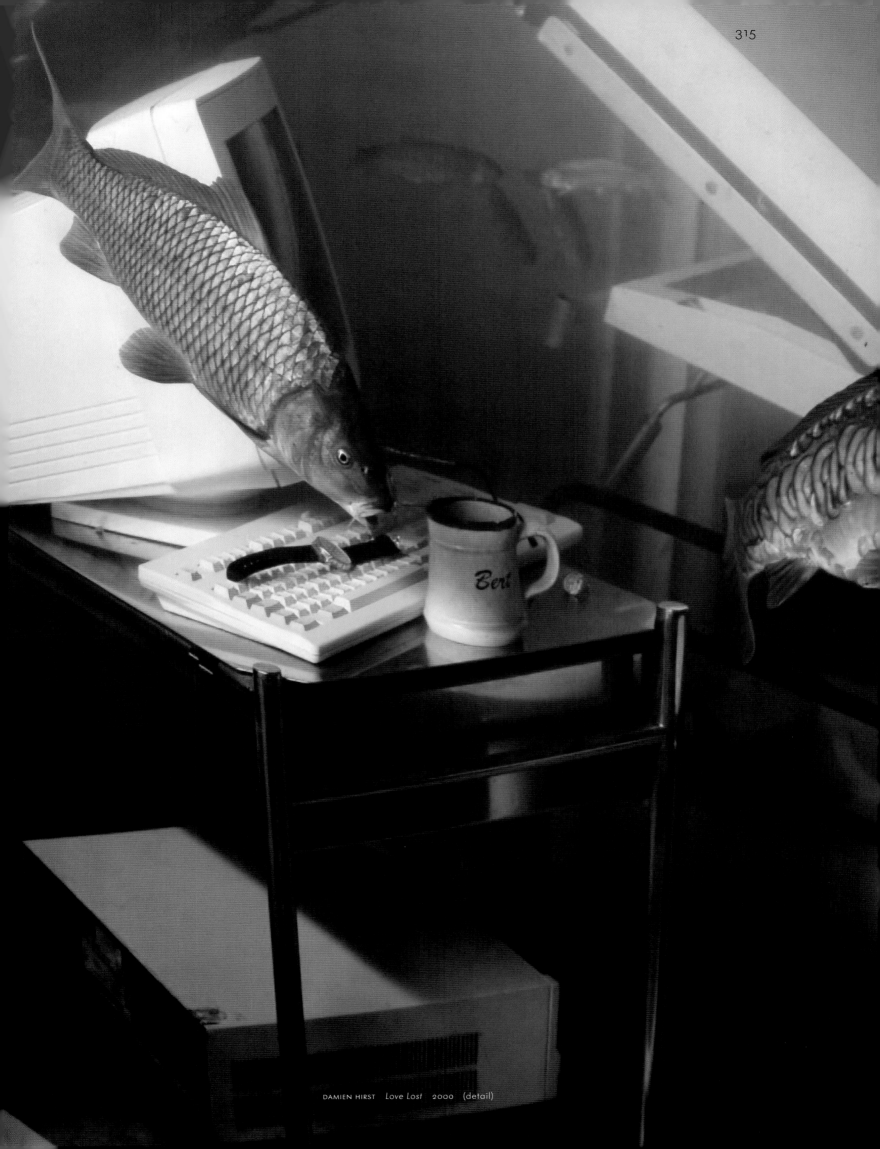

DAMIEN HIRST *Love Lost* 2000 (detail)

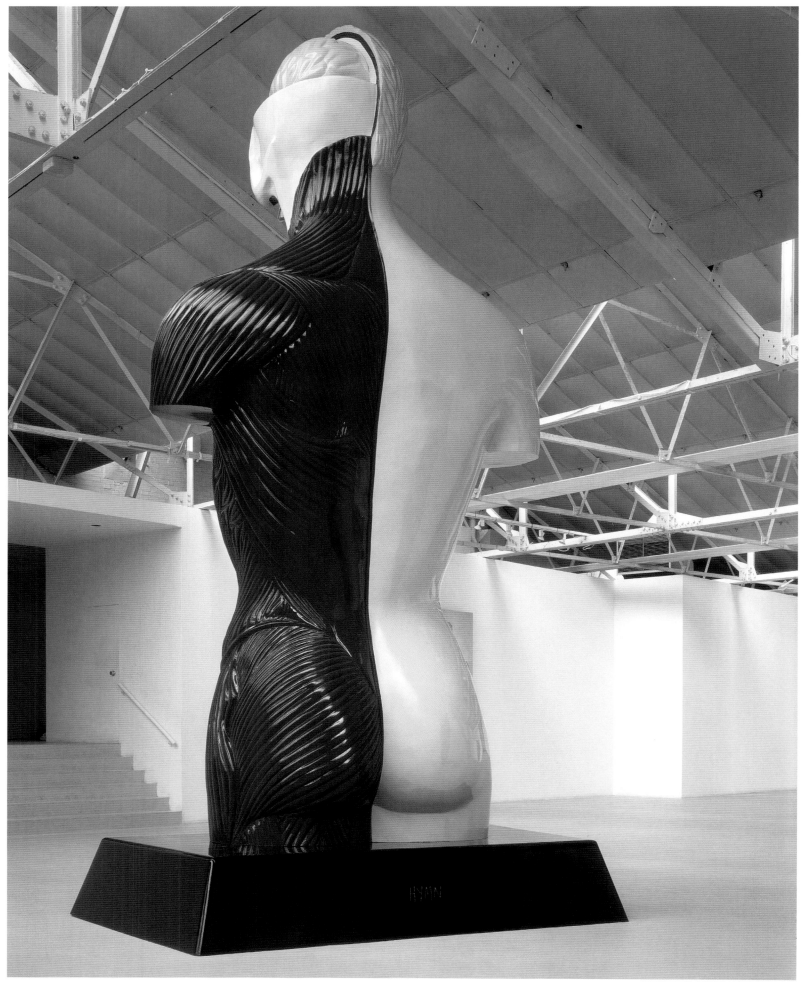

DAMIEN HIRST *Hymn* 1999 Painted bronze 594.4 × 335.3 × 205.7 cm 234 × 132 × 81"

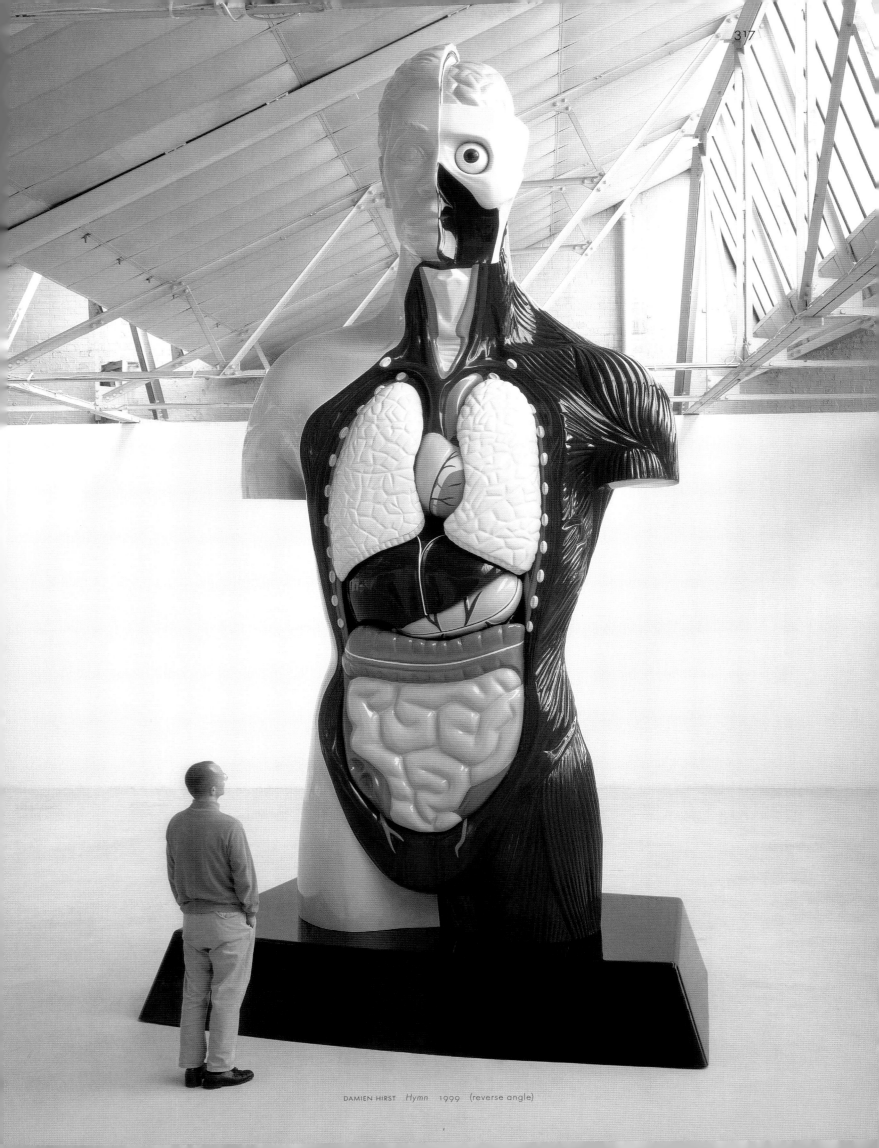

DAMIEN HIRST *Hymn* 1999 (reverse angle)

DAMIEN HIRST *Isolated Elements Swimming in the Same Direction for the Purpose of Understanding* 1991
MDF, melamine, wood, steel, glass, perspex, fish and formaldehyde solution 183 × 274 × 30.5 cm 72 × 108 × 12"

DAMIEN HIRST *Holidays/No Feelings* 1989 Drug bottles in cabinet (2 cabinets) Each cabinet: 137 × 102 × 23 cm 54 × 40 × 9"

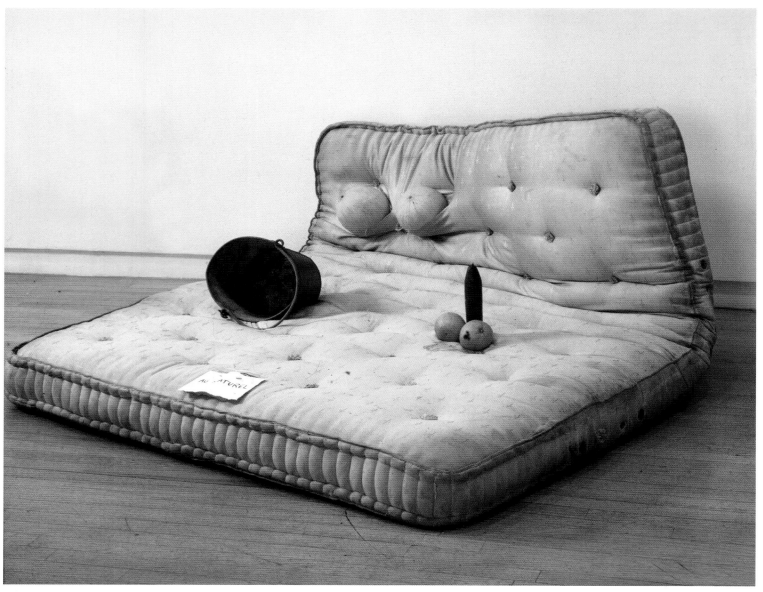

SARAH LUCAS *Au Naturel* 1994 Mattress, water bucket, melons, oranges and cucumber 84 × 168 × 145 cm 33¼ × 66¼ × 57¼"

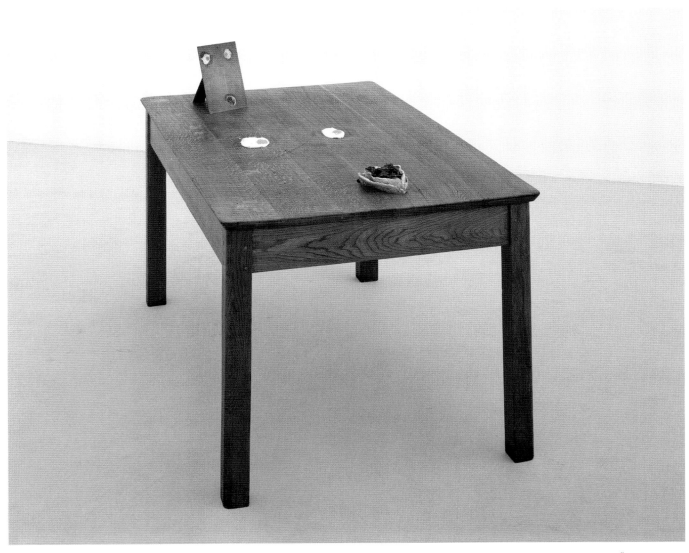

SARAH LUCAS *Two Fried Eggs and a Kebab* 1992 Photograph Fried eggs, kebab, table Table 76.2 × 152.4 × 89 cm 30 × 60 × 35"

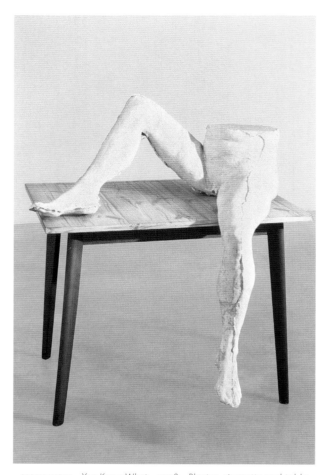

SARAH LUCAS *You Know What* 1998 Plaster, cigarette and table
85.1 × 78.7 × 94 cm 33⅓ × 31 × 37"

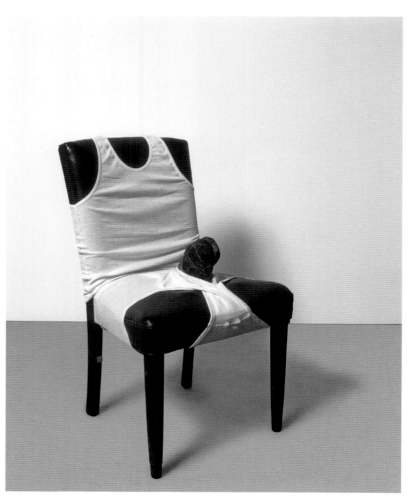

SARAH LUCAS *Tongue and Groove, Always Goes Down Well* 2000
Chair, vest, pants and meat 85 × 49.5 × 49.5 cm 33⅓ × 19½ × 19½"

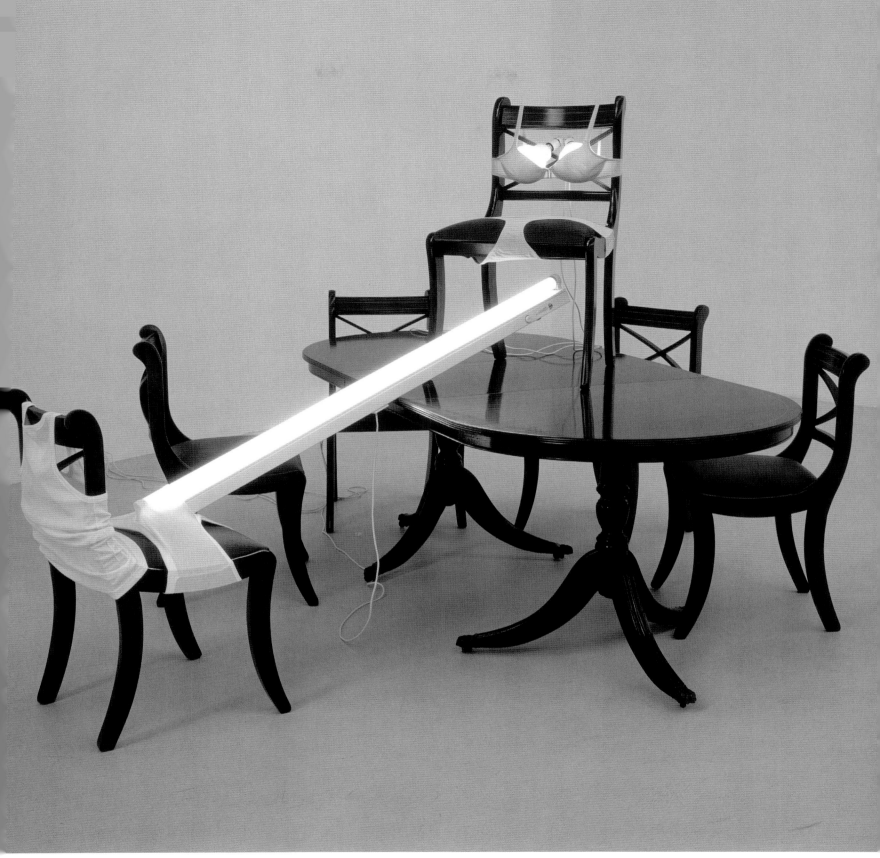

SARAH LUCAS *The Pleasure Principle* 2000 Chairs, neon tube, light bulbs and underwear 116 × 181 × 251 cm 45¾ × 71¼ × 98¾"

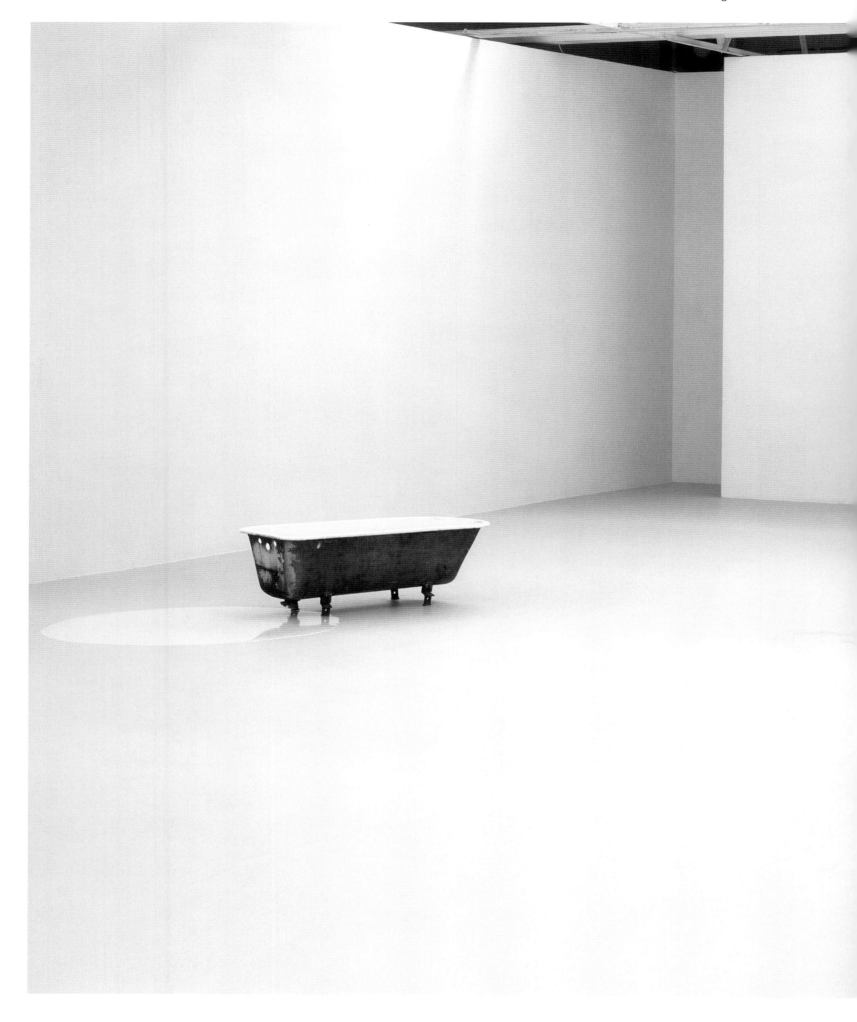

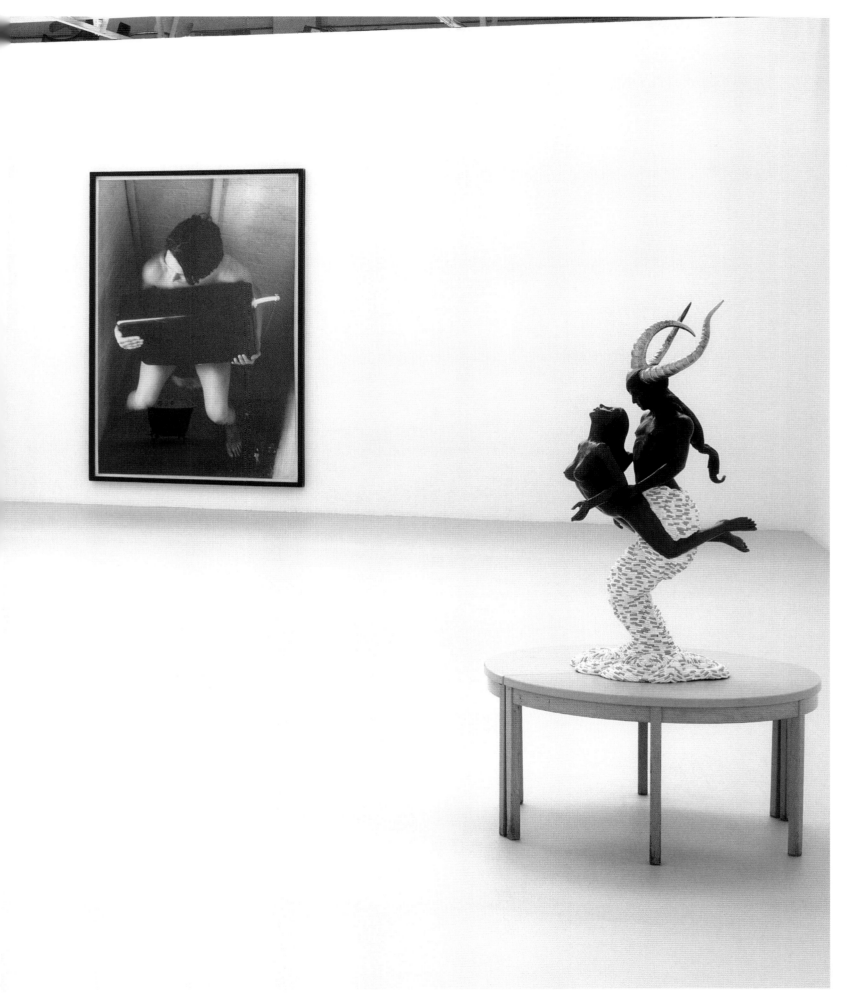

SARAH LUCAS (LEFT) *Down Below* 1997 Enamel bath, rubber and acrylic Bath: 55 × 60.5 × 165 cm 21¾ × 23¾ × 65" Spill: 193 × 179 cm 76 × 70½"
SARAH LUCAS (MIDDLE) *Human Toilet* 1997 Colour print 244 × 188.5 cm 96 × 74"
SARAH LUCAS (RIGHT) *Dreams Go Up in Smoke* 2000 Cast bronze and cigarettes 142 × 82 × 62 cm 60 × 32¼ × 24⅛"

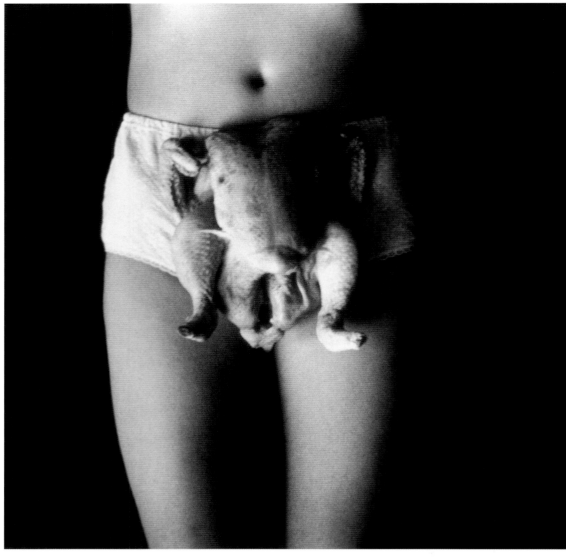

SARAH LUCAS *Chicken Knickers* 2000 C-print 273.2 × 196.3 cm 107½ × 77¼"

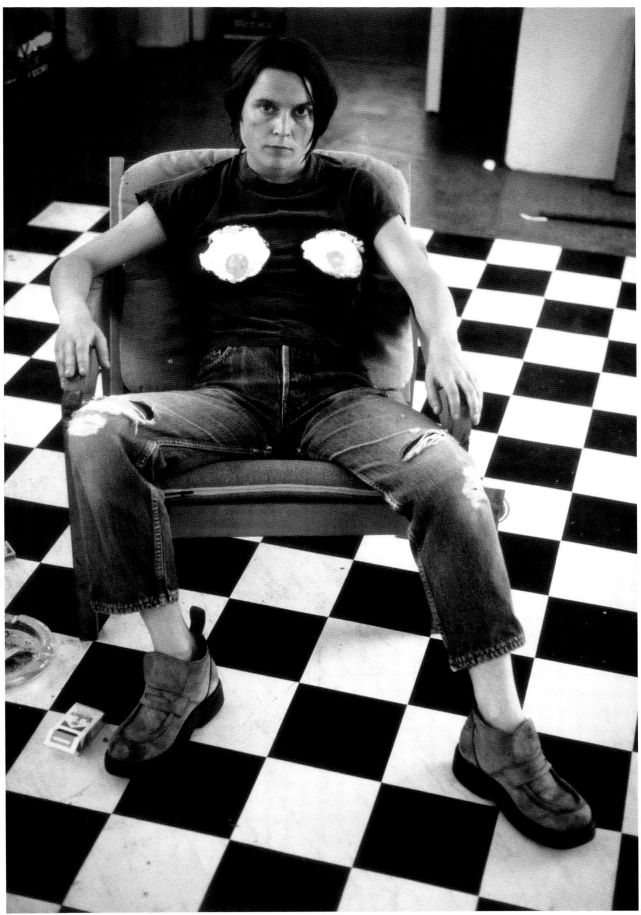

SARAH LUCAS *Self-portrait with Fried Eggs* 1996 C-print 167 × 119 cm 65¾ × 47"

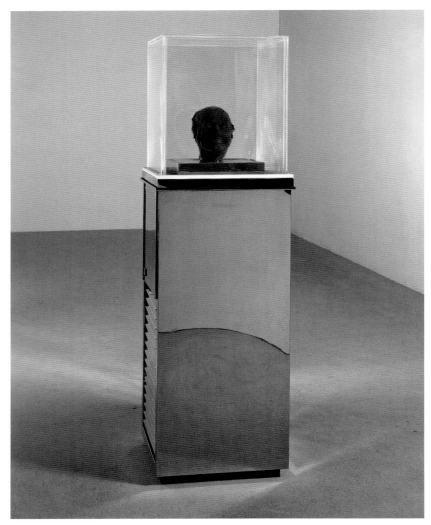

MARC QUINN *Self* 1991 Blood, stainless steel, perspex and refrigeration equipment 208 × 63 × 63 cm 82 × 24¾ × 24¾"

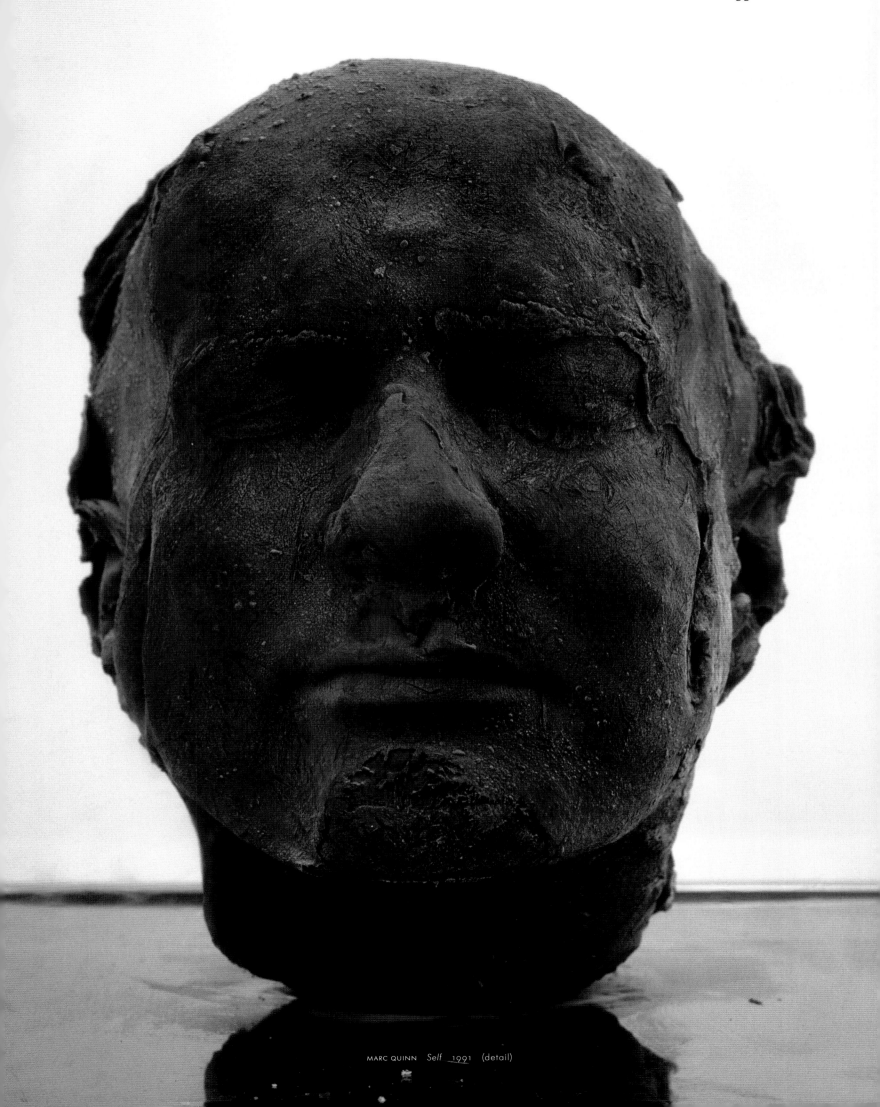

MARC QUINN *Self* 1991 (detail)

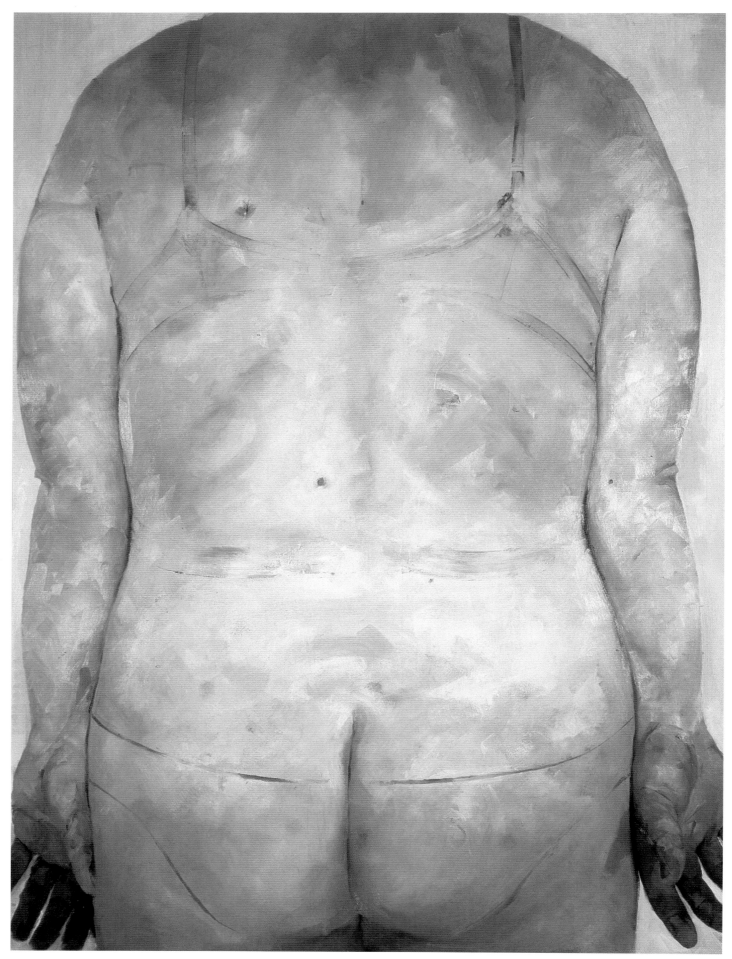

JENNY SAVILLE *Trace* 1993–94 Oil on canvas 213.5 × 165 cm 84 × 65"

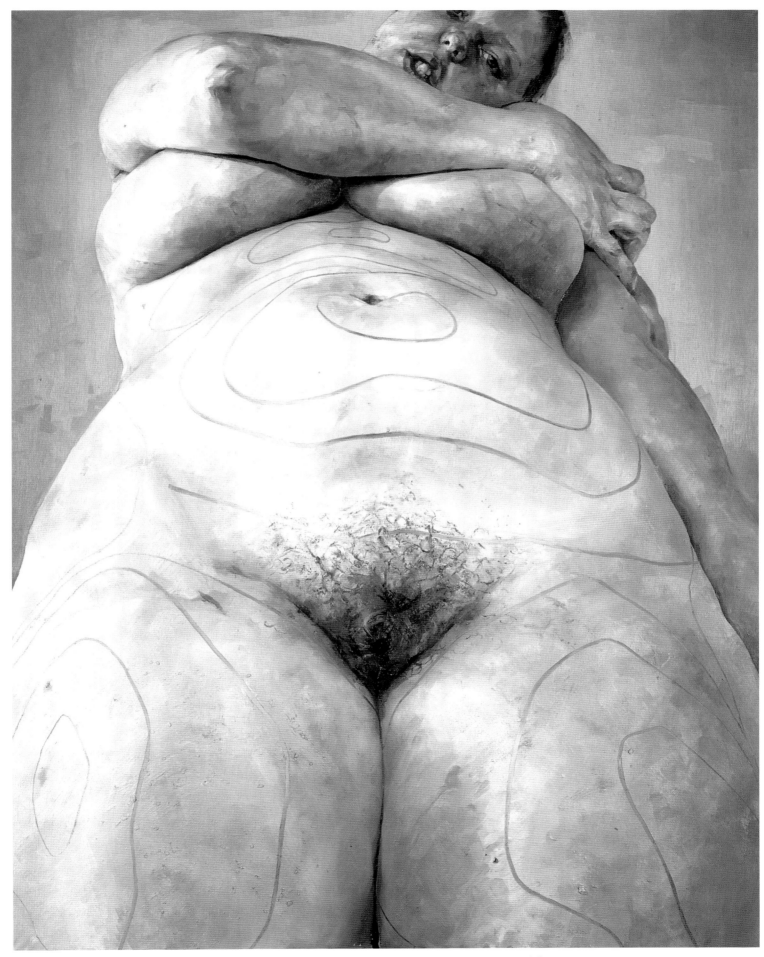

JENNY SAVILLE *Plan* 1993 Oil on canvas 274 x 213.5 cm 108 x 84"

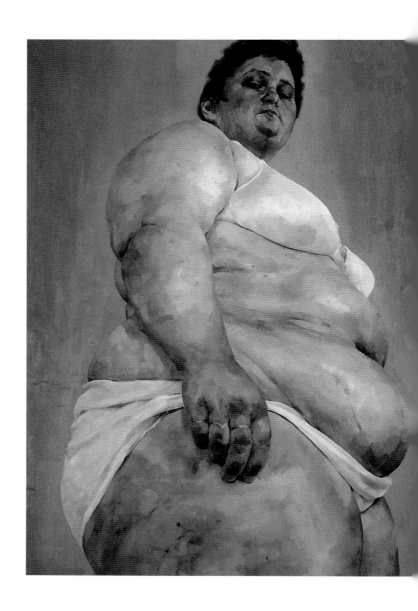

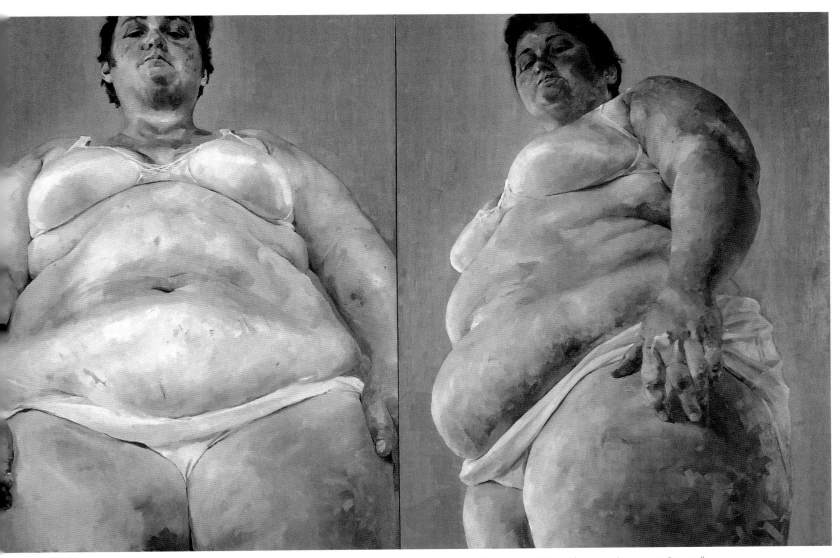

JENNY SAVILLE *Strategy (South Face/Front Face/North Face)* 1993-94 Oil on canvas (triptych) 274 × 640 cm 108 × 252"

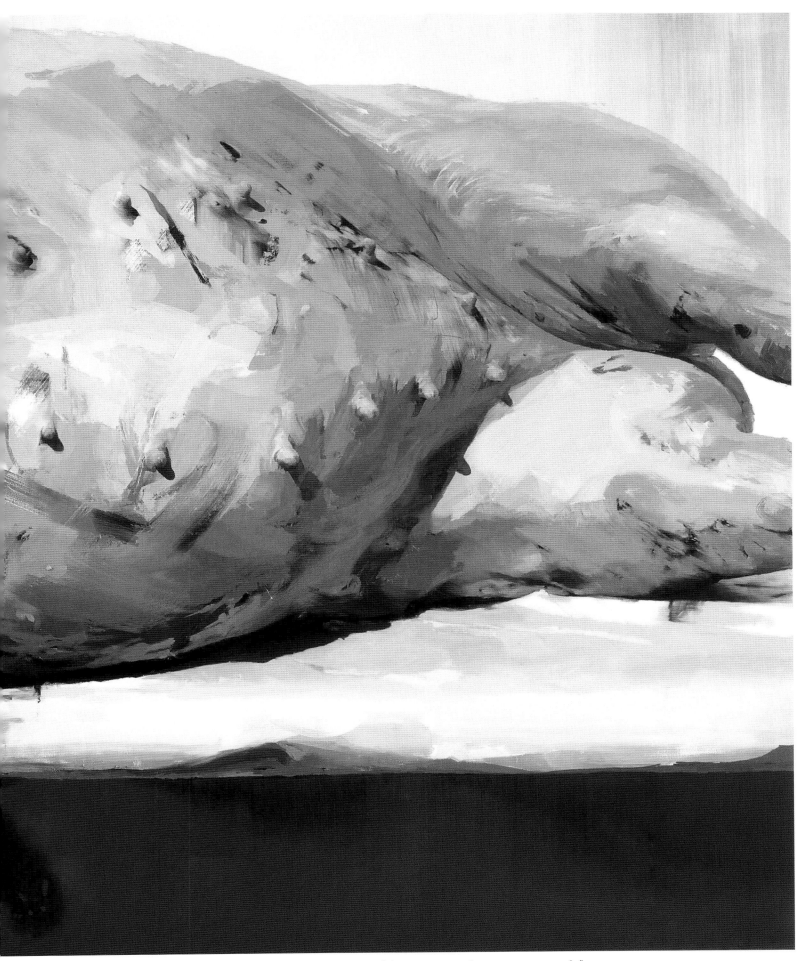

JENNY SAVILLE *Host* 2000 Oil on canvas 304.8 × 457.2 cm 120 × 180"

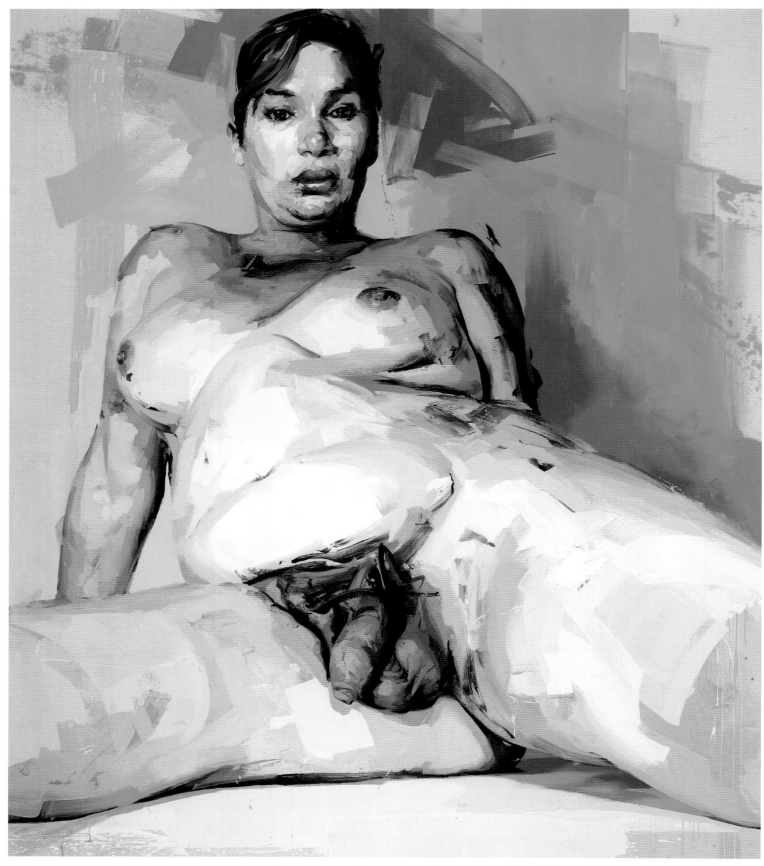

JENNY SAVILLE *Passage* 2004 Oil on canvas 336 × 290 cm 132¼ × 114¼"

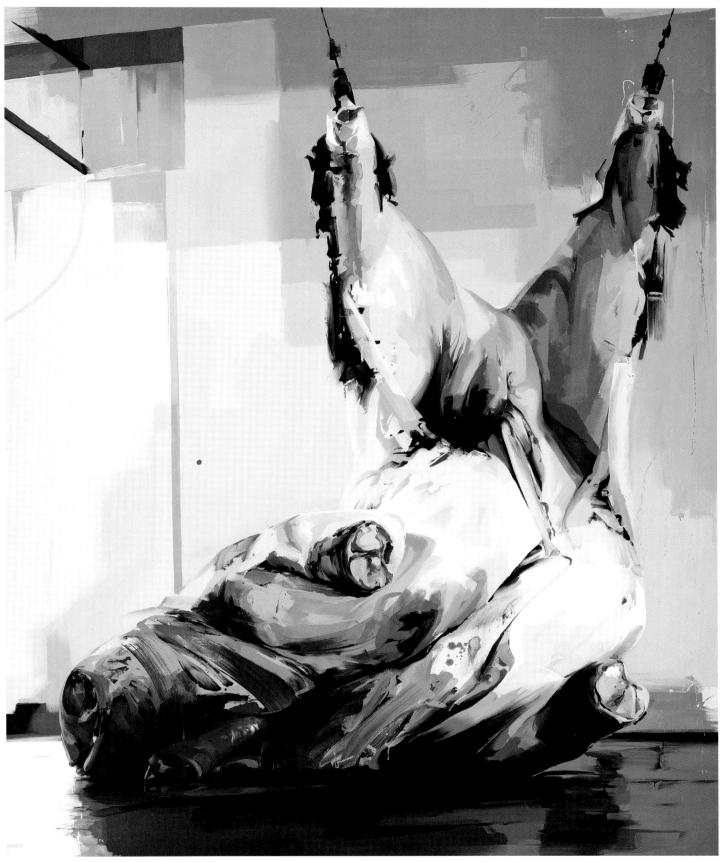

JENNY SAVILLE *Torso 2* 2004 Oil on canvas 360 × 294 cm 141¾ × 115¾"

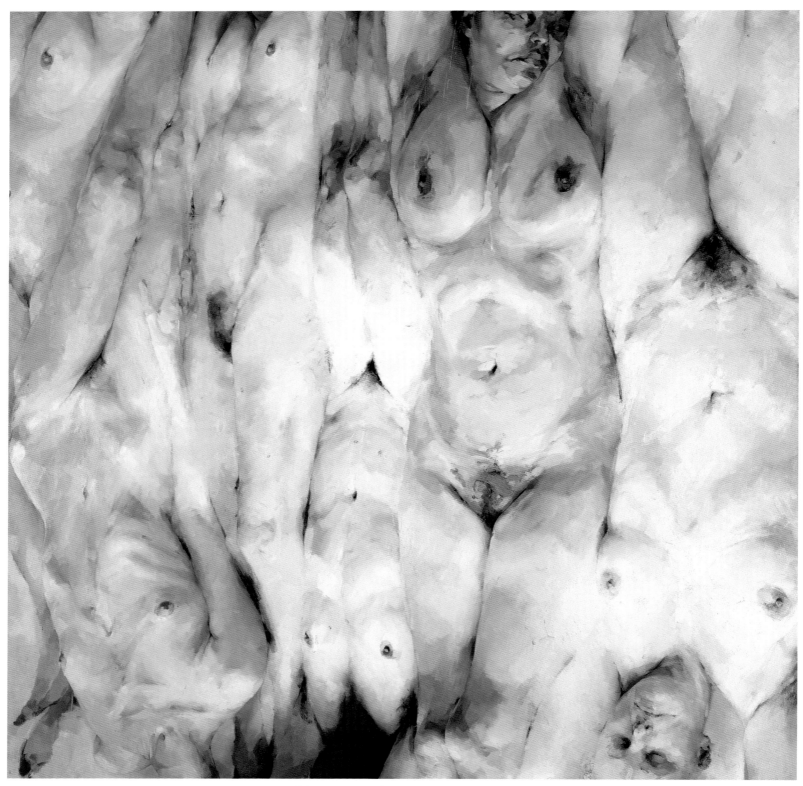

JENNY SAVILLE *Shift* 1996–97 Oil on canvas 330.2 × 330.2 cm 130 × 130"

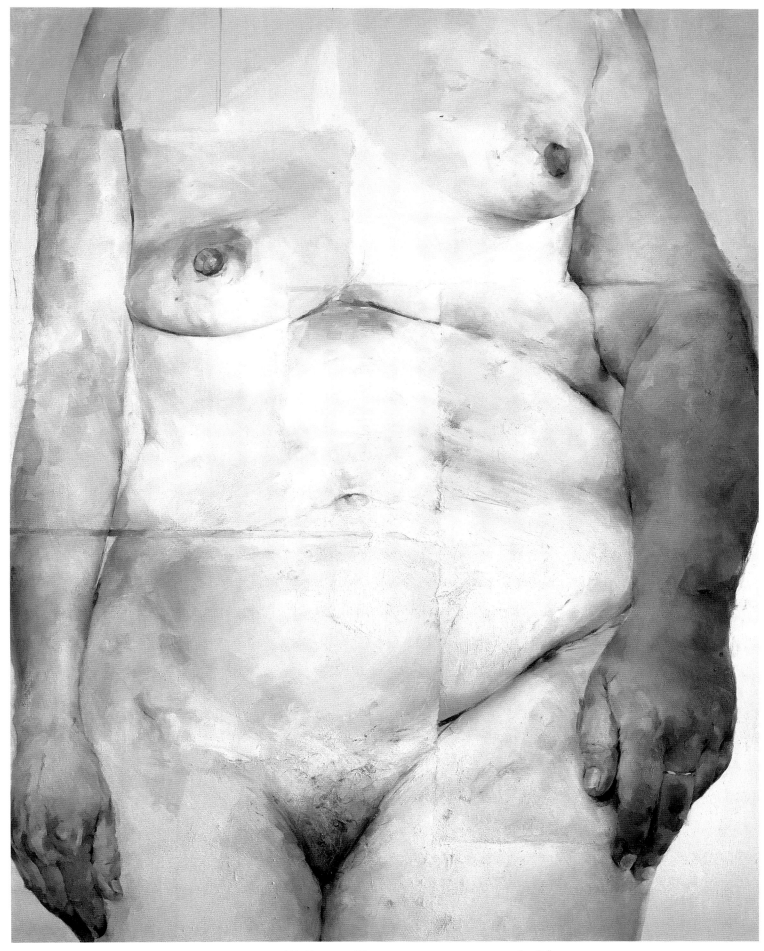

JENNY SAVILLE *Hybrid* 1997 Oil on canvas 274.3 × 213.4 cm 108 × 84"

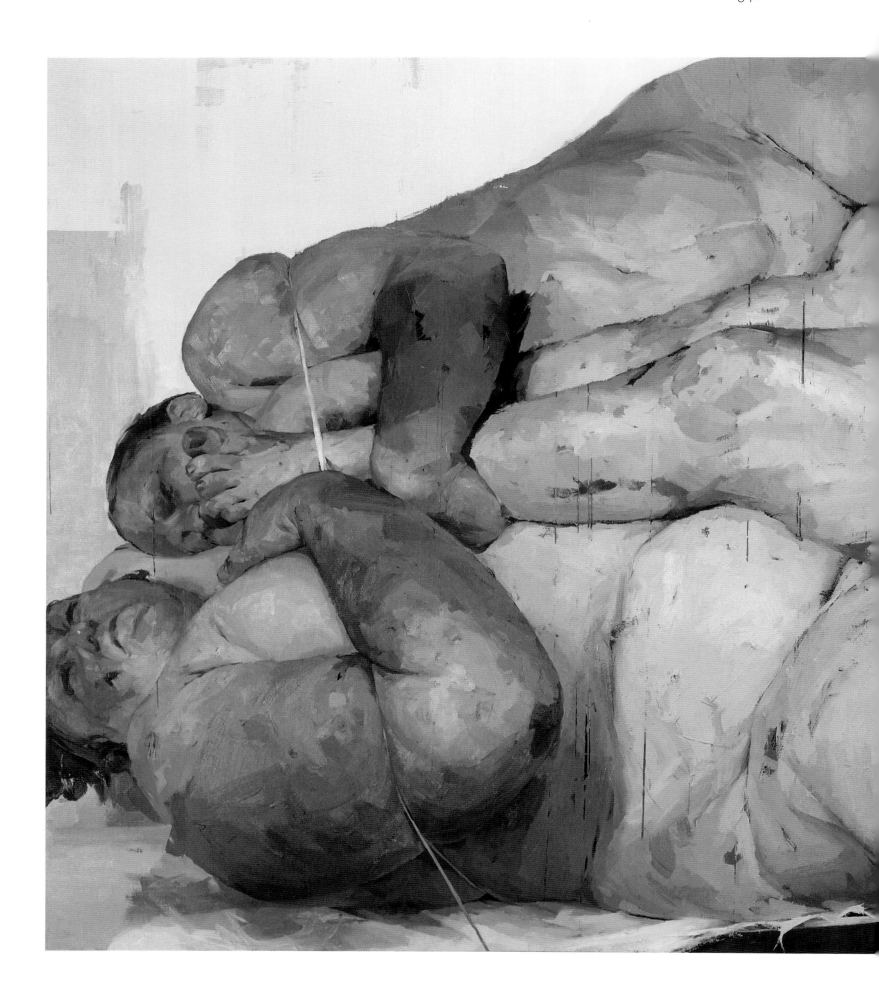

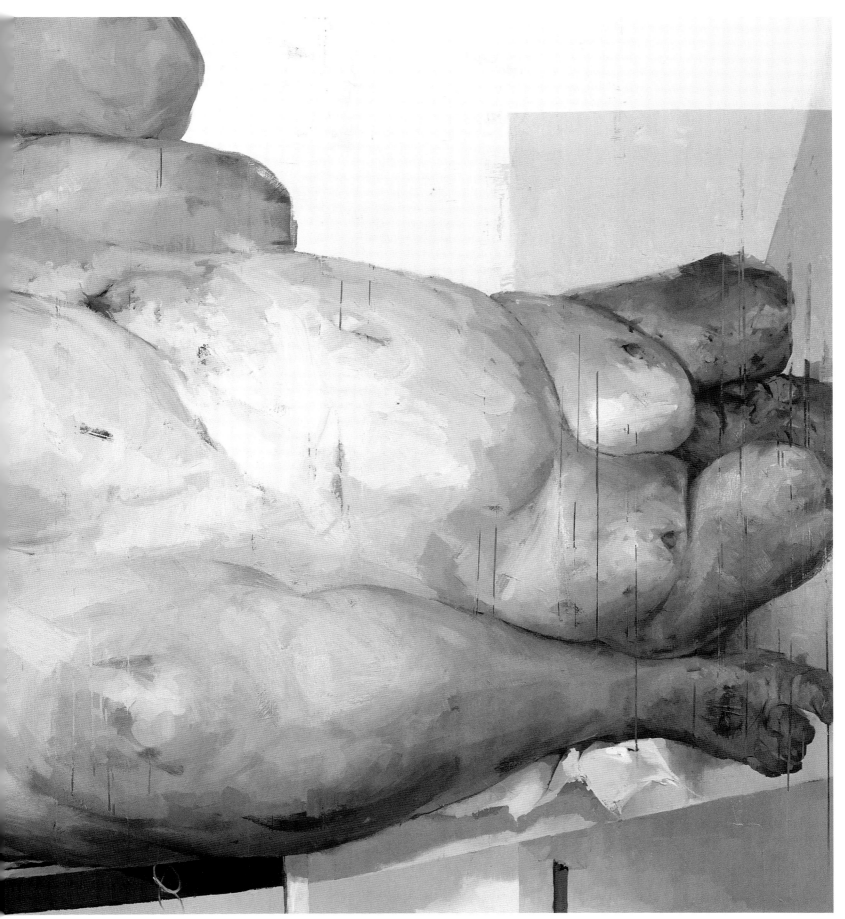

JENNY SAVILLE *Fulcrum* 1999 Oil on canvas 261.6 × 487.7 cm 103 × 193"

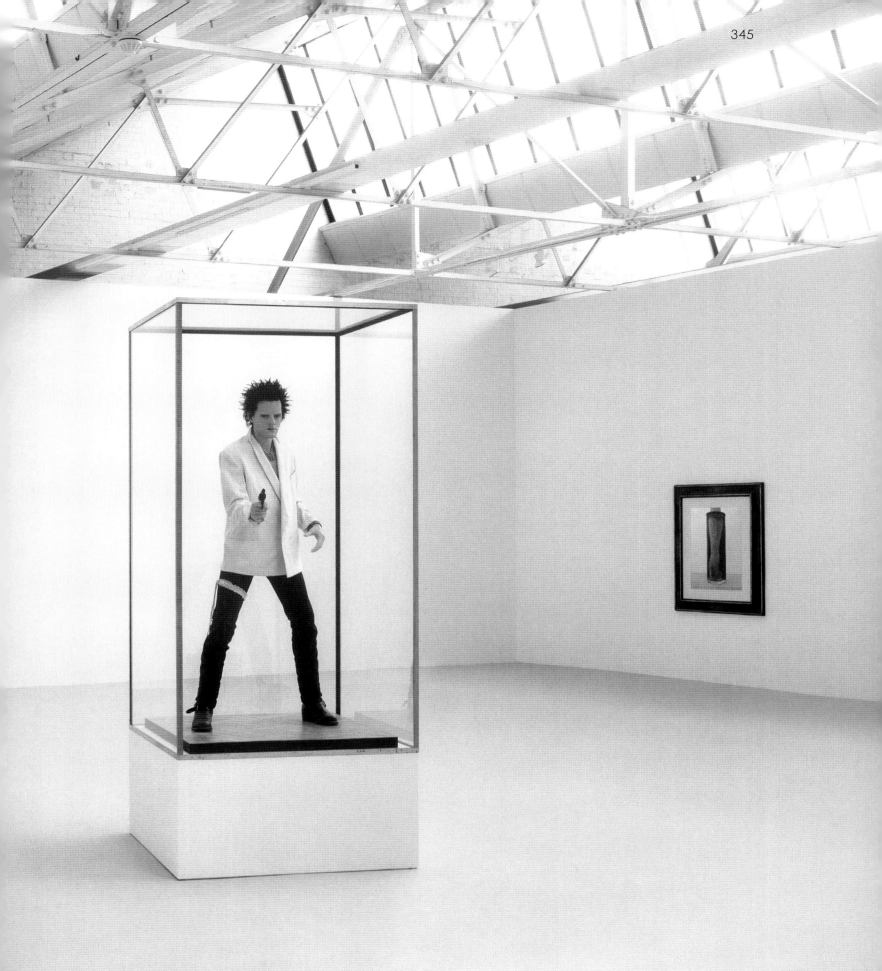

GAVIN TURK
LEFT TO RIGHT
Title 1990 Pigment on canvas 183 × 274 cm 72 × 108"
Pop 1993 Glass, brass, MDF, fibreglass, wax, clothing and gun 279 × 115 × 115 cm 110 × 45 × 45"
Gavin Turk Right Hand and Forearm 1992 Silkscreen on paper 86 × 68 cm 34 × 27"

GLENN BROWN
LEFT TO RIGHT
The Pornography of Death (Painting for Ian Curtis) after Chris Foss 1995 Oil on canvas 209.6 × 327.7 cm 82½ × 129"
Dali-Christ 1992 Oil on canvas 274 × 183 cm 80¼ × 60"

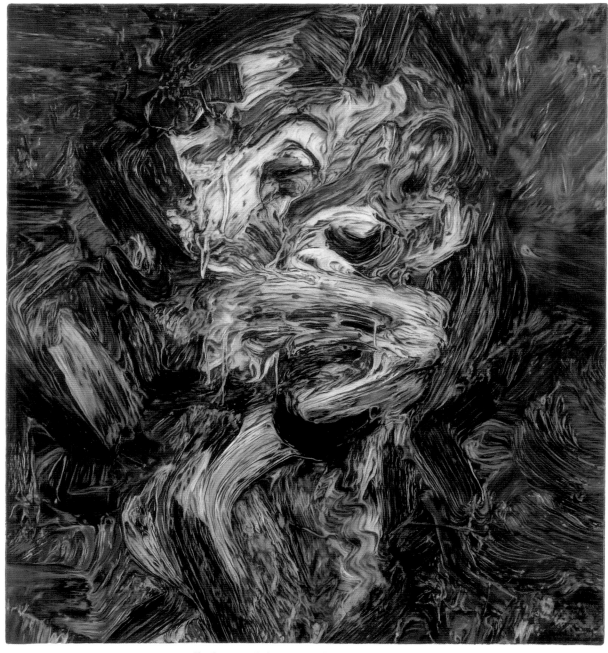

GLENN BROWN *The Creeping Flesh* 1991 Oil on canvas 56 × 50.5 cm 22 × 20"

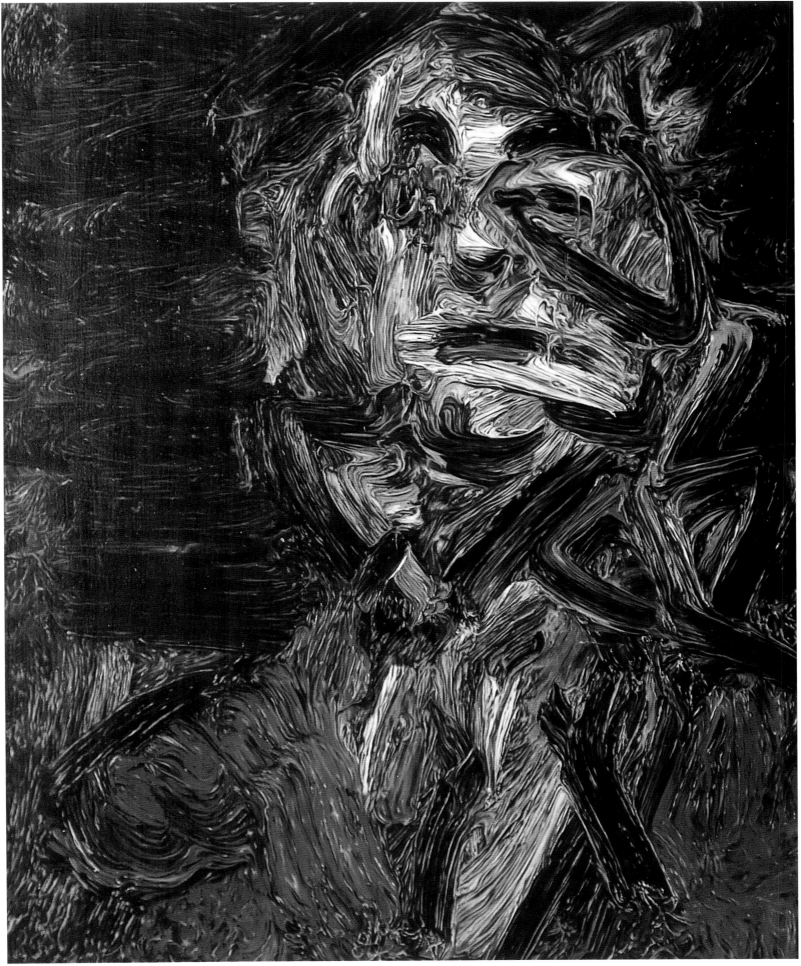

GLENN BROWN *The Day The World Turned Auerbach* 1992 Oil on canvas 56 × 50.5. cm 22 × 20"

DAVID THORPE *Covenant of the Elect* 2002 Mixed media collage 63 × 111 cm 24¾ × 43¾"

GARY HUME *Vicious* 1994 Gloss paint on panel 218 × 181 cm 86 × 71"

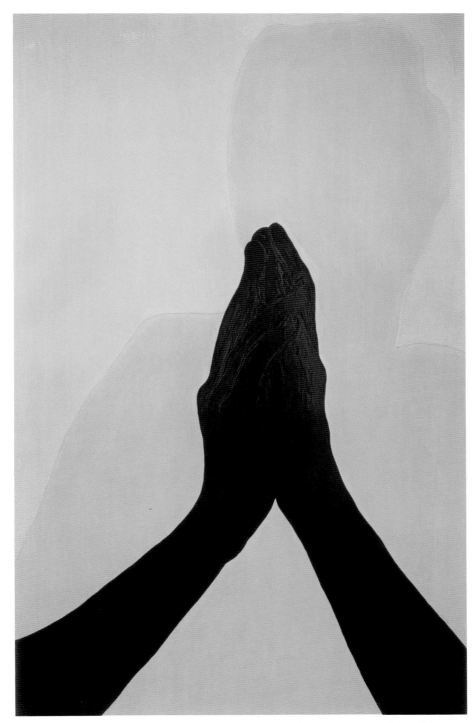

GARY HUME *Begging For It* 1994 Gloss paint on panel 200 × 150 cm 78¾ × 59"

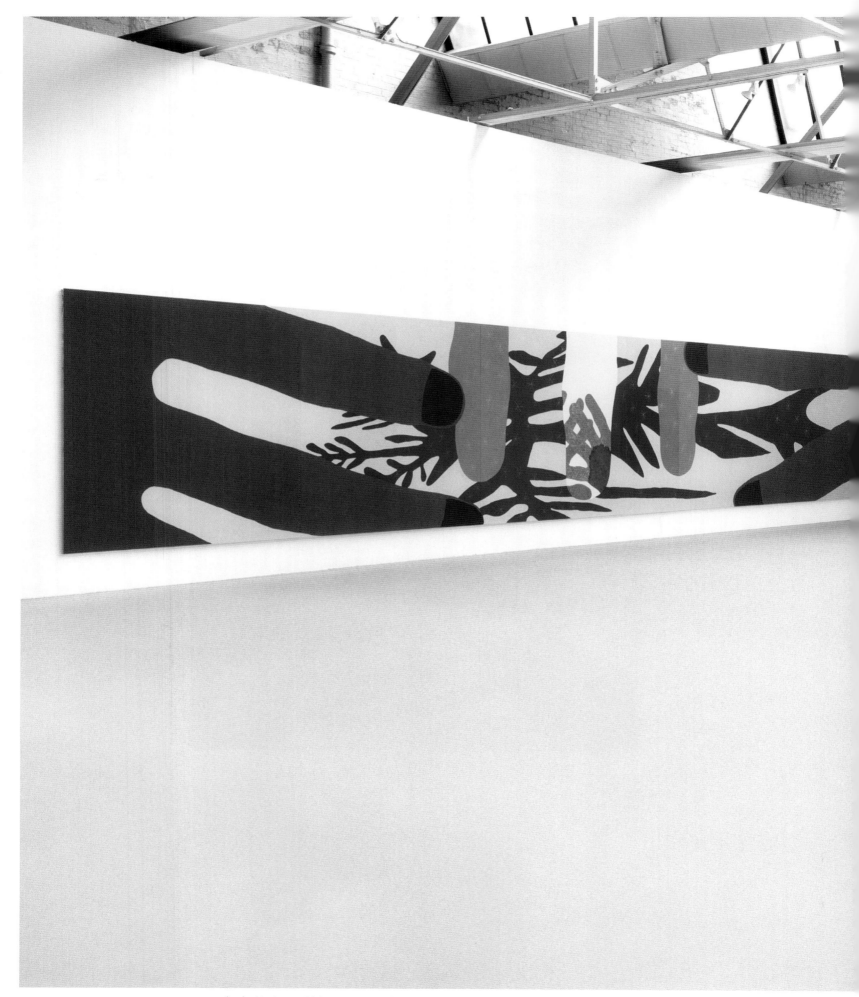

GARY HUME (LEFT) *My Aunt and I Agree* 1995 Gloss paint on aluminium panel 200 × 1100 cm 78¾ × 433"
GARY HUME (MIDDLE) *Garden Painting No.4* 1996 Gloss paint on aluminium panel 172.7 × 172.7 cm 68 × 68"
GARY HUME (RIGHT) *Vicious* 1994 Gloss paint on panel 218 × 181 cm 86 × 71"

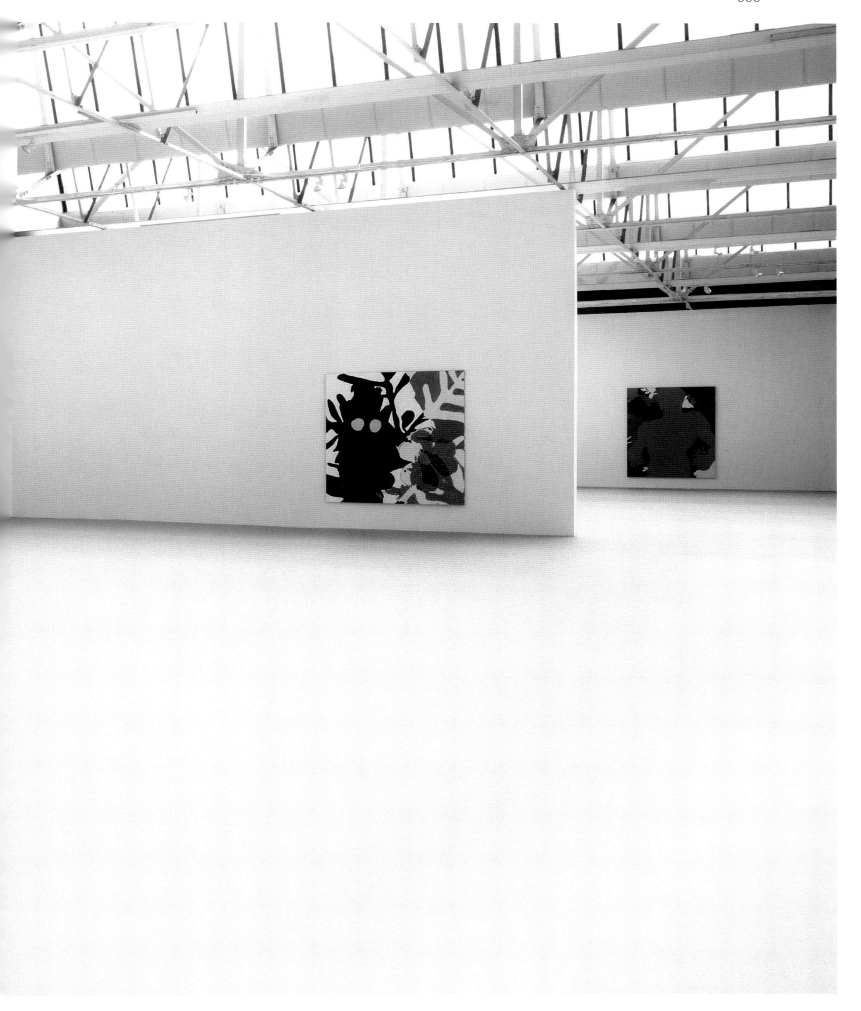

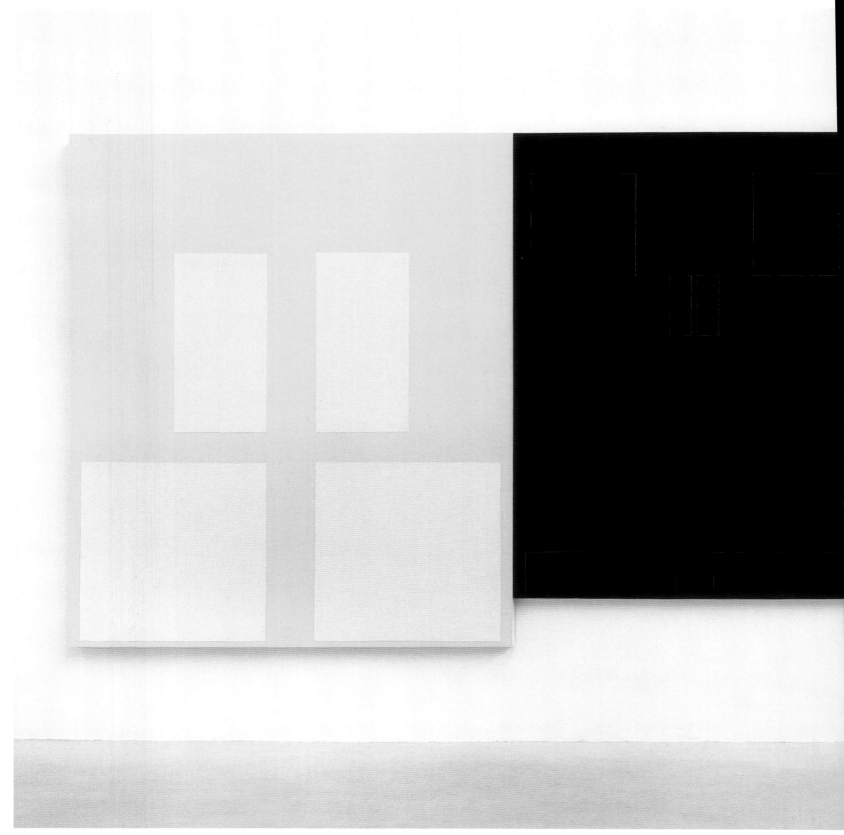

GARY HUME *Dolphin Painting No.4* 1991 Gloss paint on MDF board 222 × 643 cm 87½ × 253"

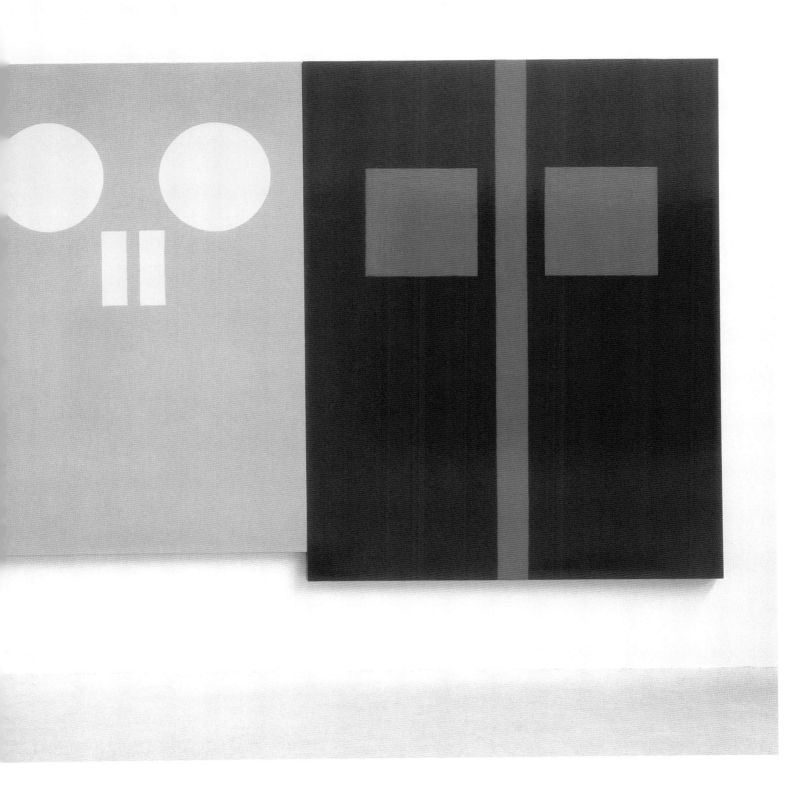

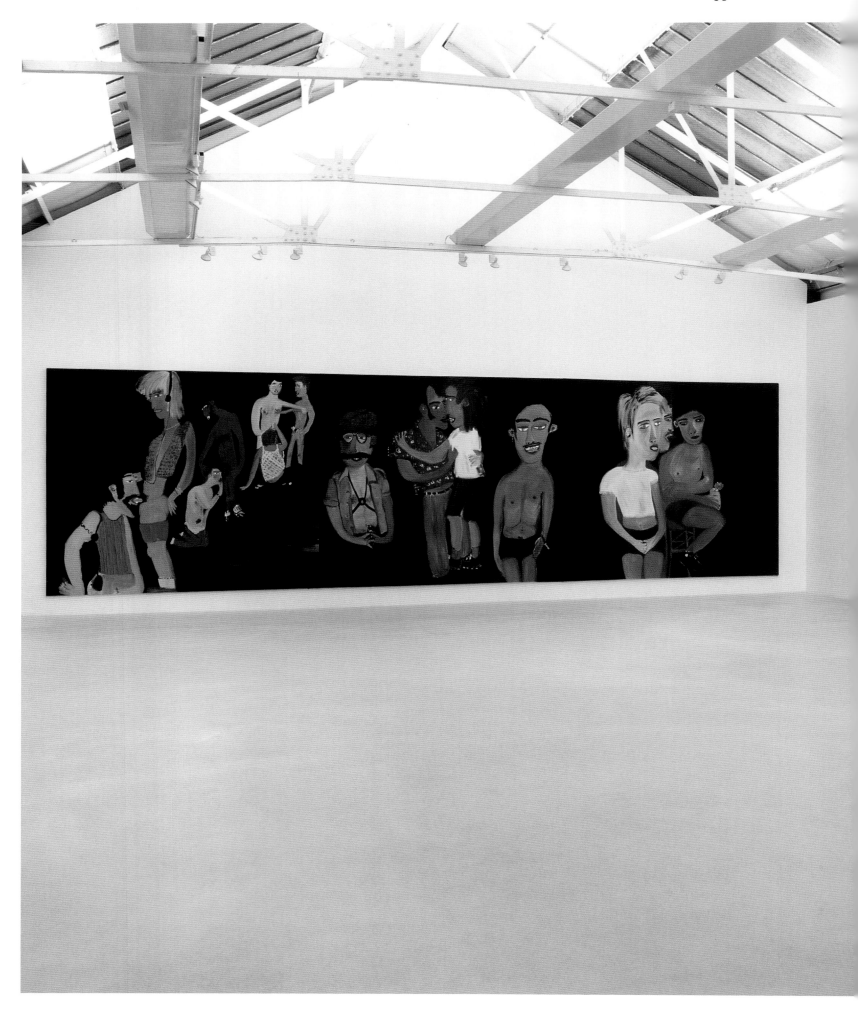

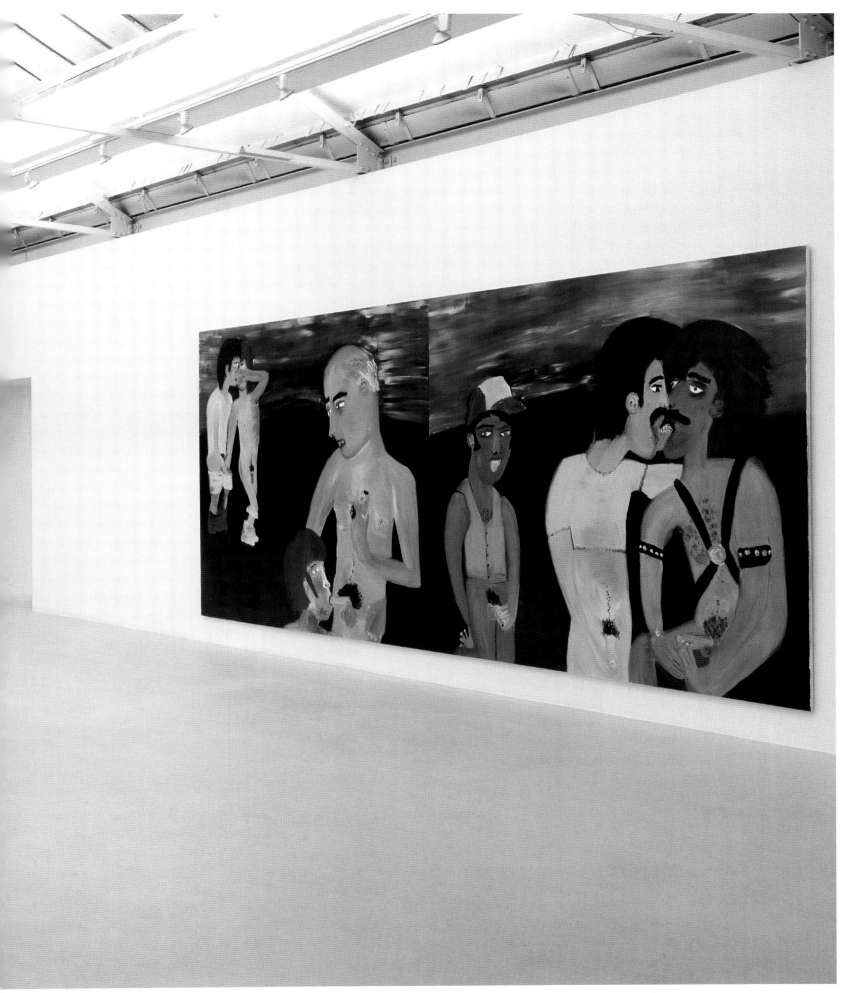

MARTIN MALONEY (LEFT) *Sex Club (Cocktail)* 1998 Oil on canvas 274.3 × 914.4 cm 108 × 360"
MARTIN MALONEY (RIGHT) *Sex Club (Blow Job)* 1998 Oil on canvas 274.3 × 609.6 cm 108 × 240"

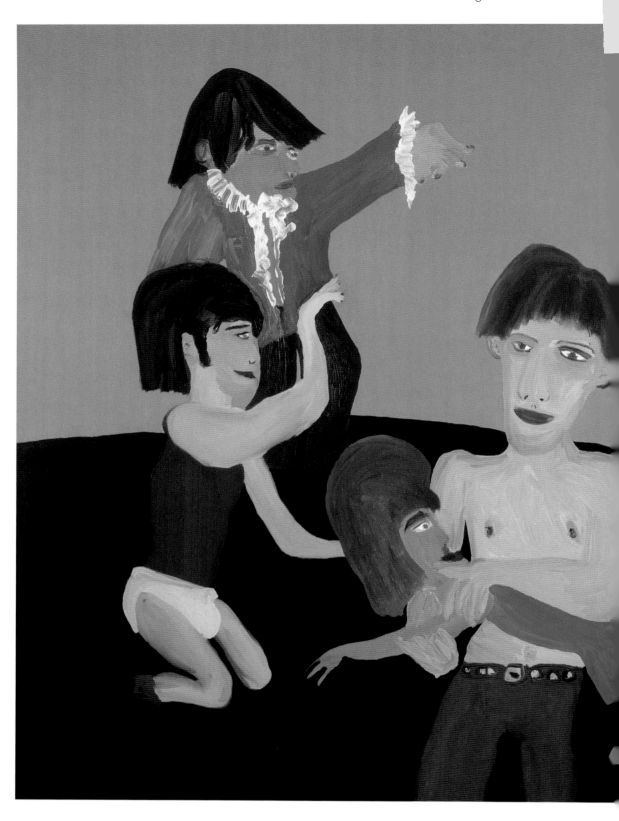

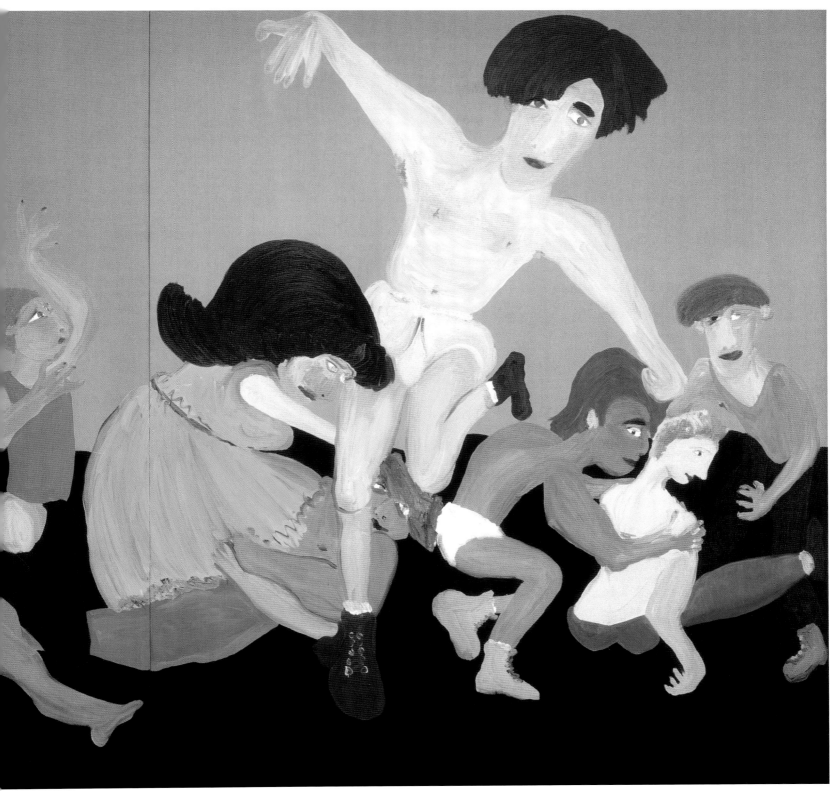

MARTIN MALONEY *Rave (after Poussin's Triumph of Pan)* 1997 Oil on canvas 244 × 457 cm 96 × 180"

PETER DAVIES *The Hip One Hundred* 1998 Acrylic on canvas 254 × 609.6 cm 100 × 240"

PETER DAVIES *Fun with the Animals: Joseph Beuys Text Painting* 1998
Acrylic on canvas 396.2 × 243.8 cm 156 × 96"

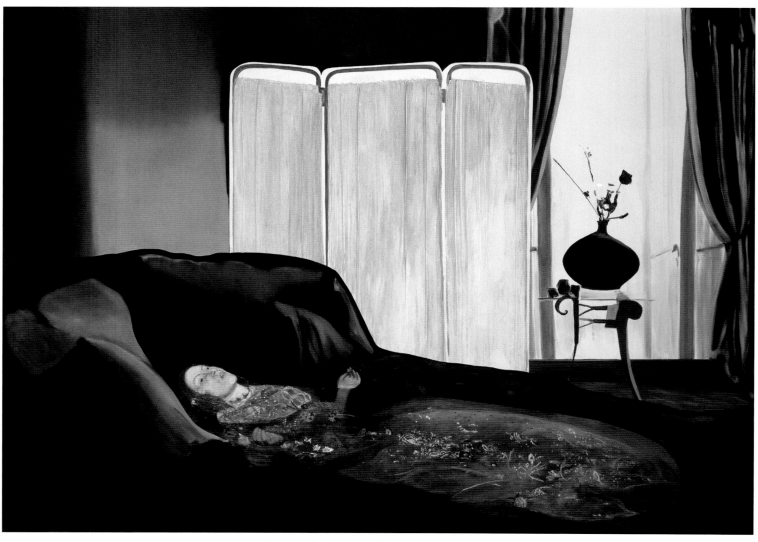

DEXTER DALWOOD *Sunny von Bulow* 2003 Oil on canvas 105 × 207 cm 41¼ × 81½"

DEXTER DALWOOD *Kurt Cobain's Greenhouse* 2000 Oil on canvas 214 × 258 cm 84 × 102"

DEXTER DALWOOD *The Deluge* 2006 Oil on canvas 274 x 457 cm 274 × 107¾ × 179¾"

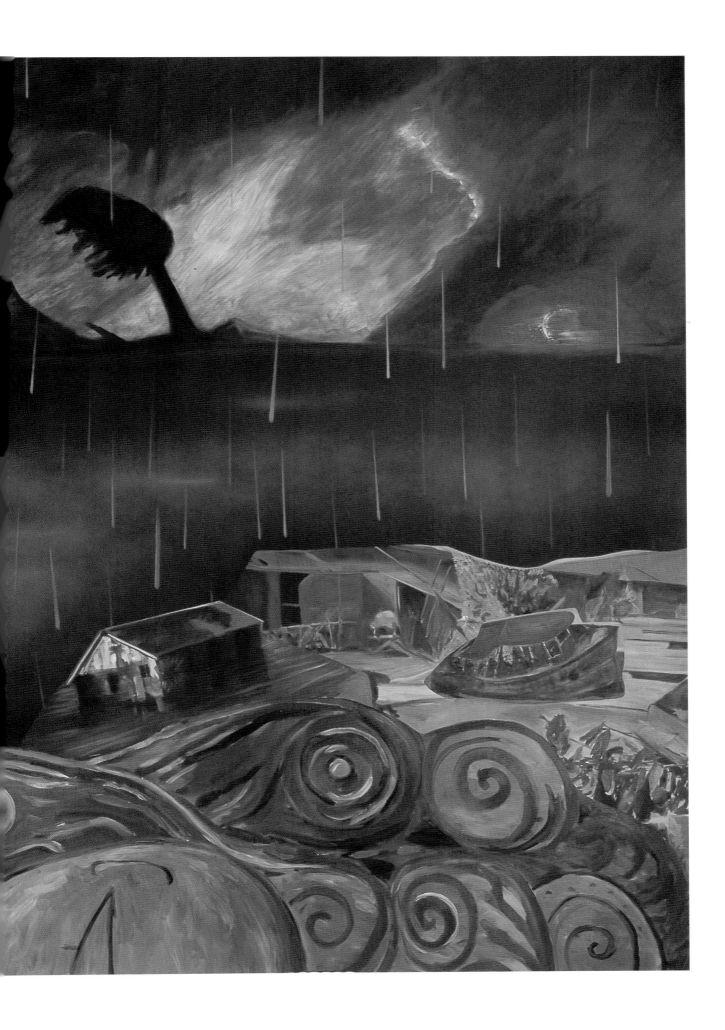

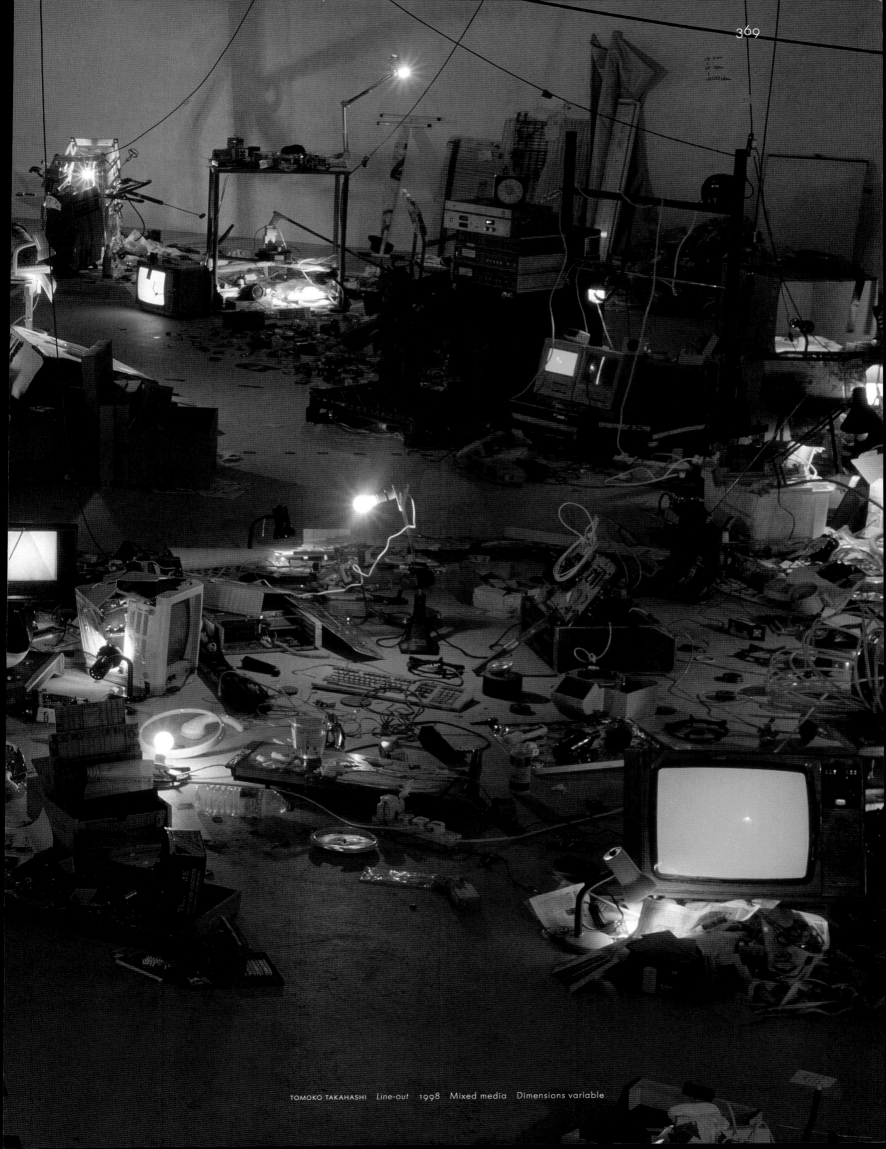

TOMOKO TAKAHASHI *Line-out* 1998 Mixed media Dimensions variable

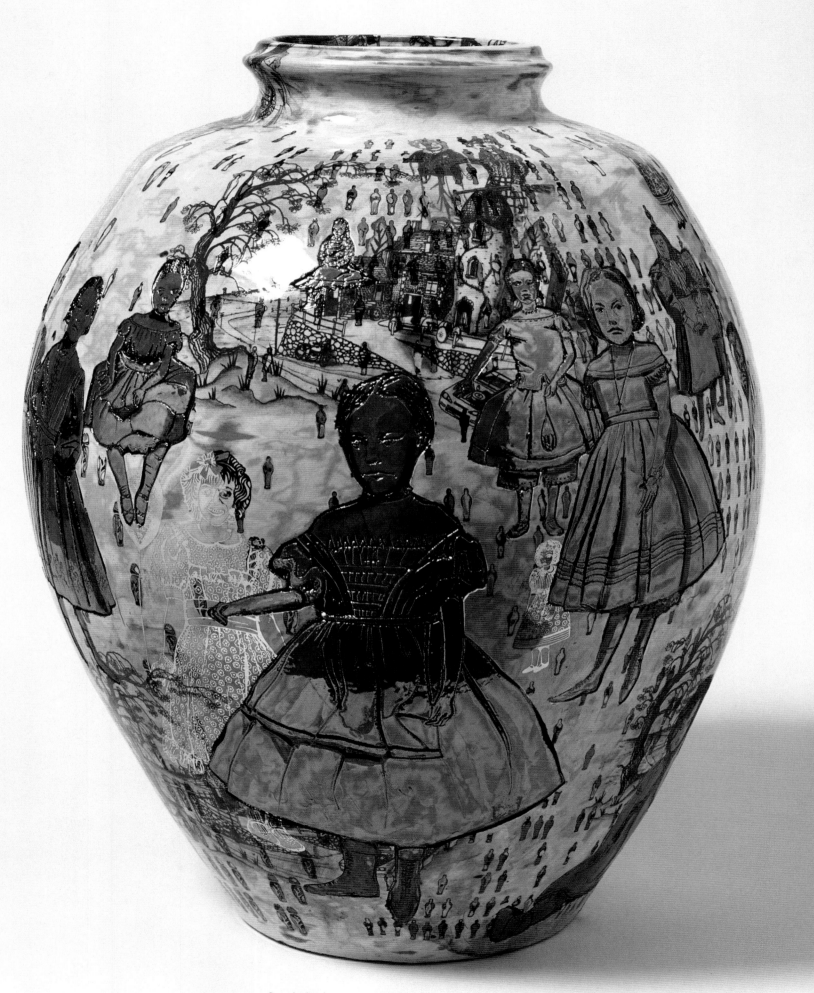

GRAYSON PERRY *Over the Rainbow* 2001 Earthenware 53.5 × 41 × 41 cm 21 × 16¼ × 16¼"

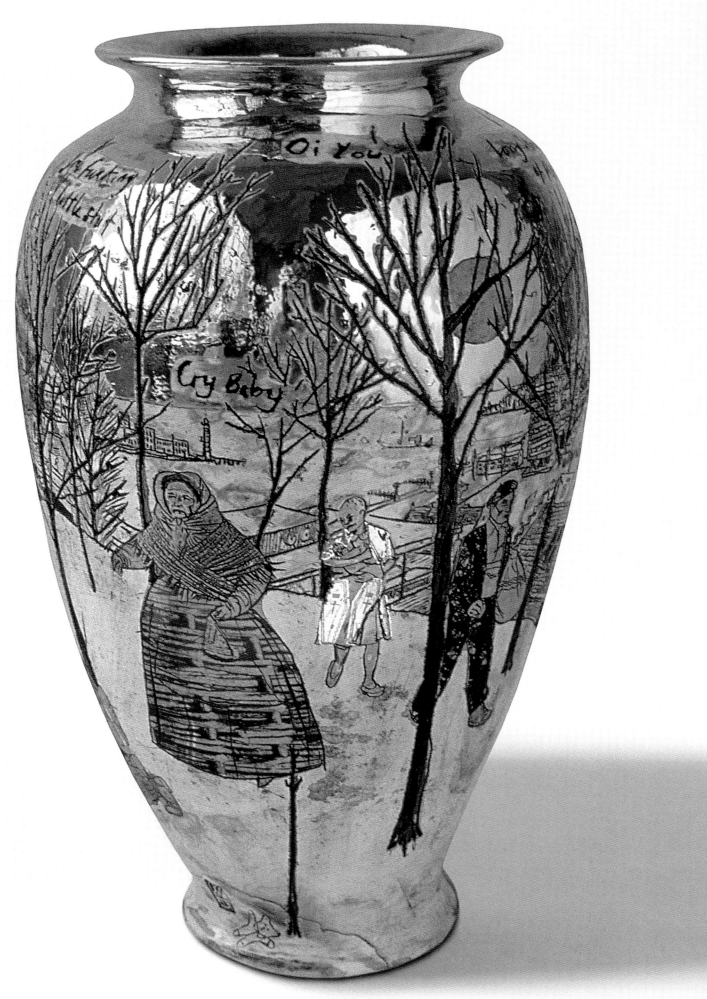

GRAYSON PERRY *We've Found the Body of Your Child* 2000 Earthenware 49 × 30 × 30 cm 19¼ × 11¾ × 11¾"

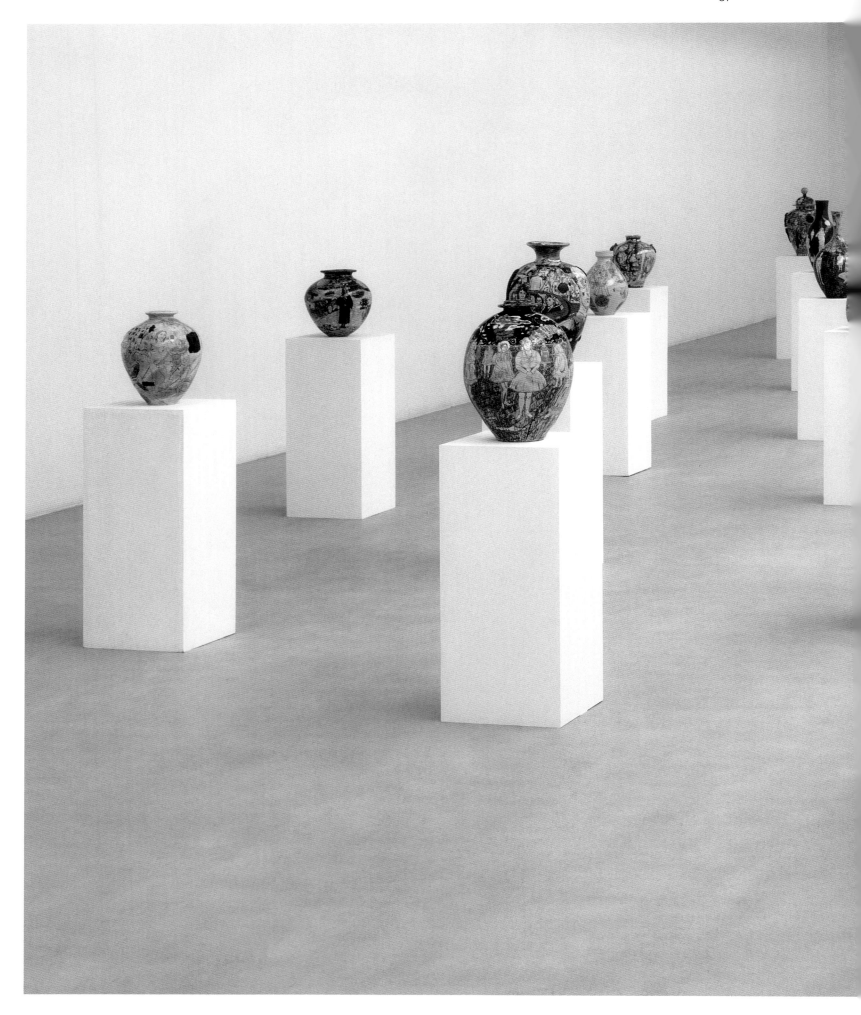

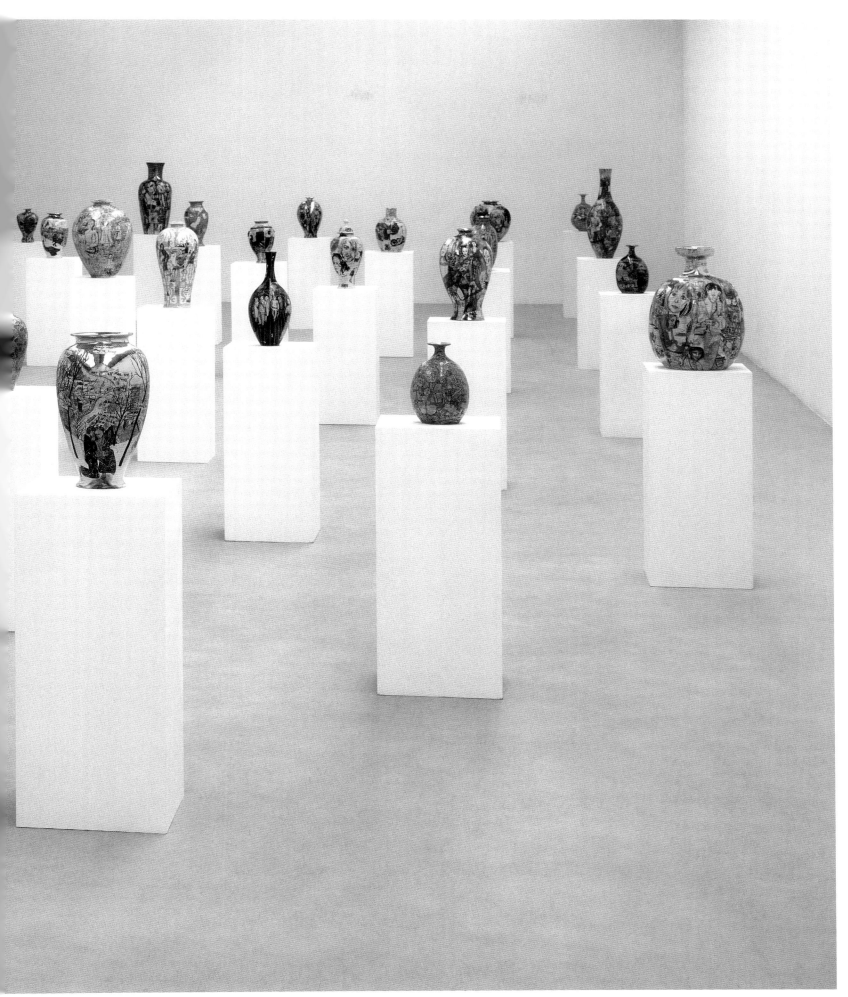

GRAYSON PERRY INSTALLATION VIEW

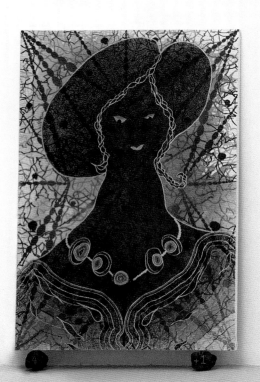

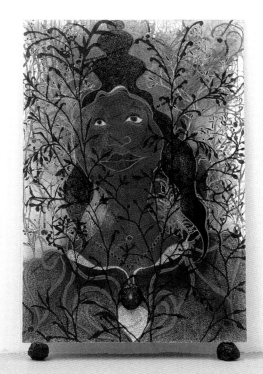

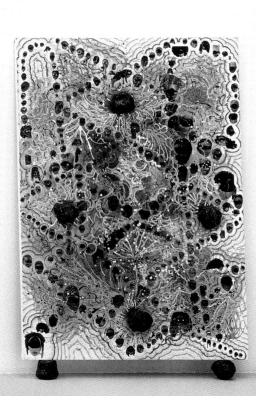

CHRIS OFILI (LEFT) *Four Plus One More* 1998 Mixed media on canvas 182.8 × 121.9 cm 72 × 48"
CHRIS OFILI (MIDDLE) *Untitled* 1998 Mixed media on canvas 190.5 × 120 cm 75 × 47¼"
CHRIS OFILI (RIGHT) *Blind Popcorn* 1996 Oil paint, paper collage, glitter, polyester resin, map pins and elephant dung on linen 182.9 × 121.9 cm 72 × 48"

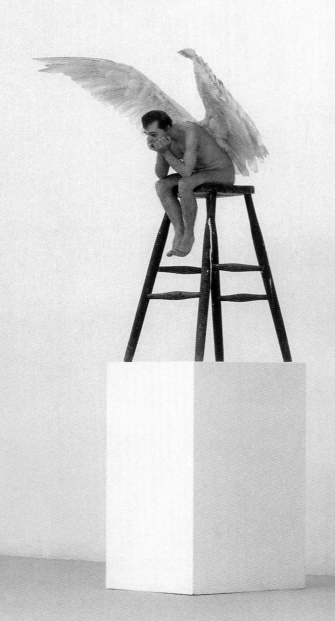

RON MUECK
LEFT TO RIGHT
Angel 1997 Silicone rubber and mixed media 110 × 87 × 81 cm 43¼ × 34¼ × 32"
Pinocchio 1996 Polyester resin, fibreglass and human hair 83.8 × 20 × 20 cm 33 × 8 × 8"

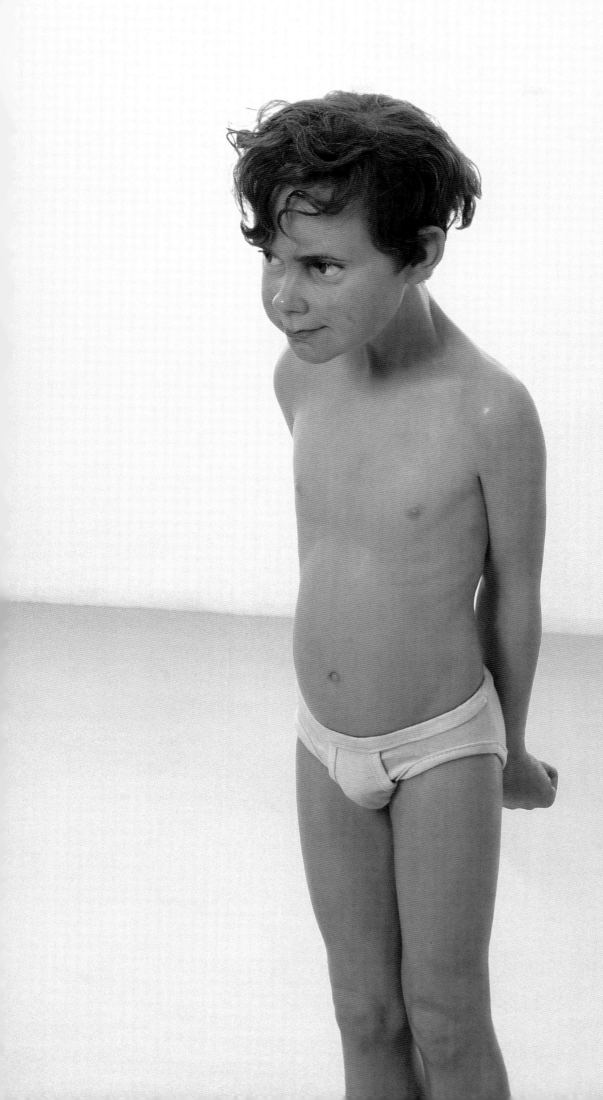

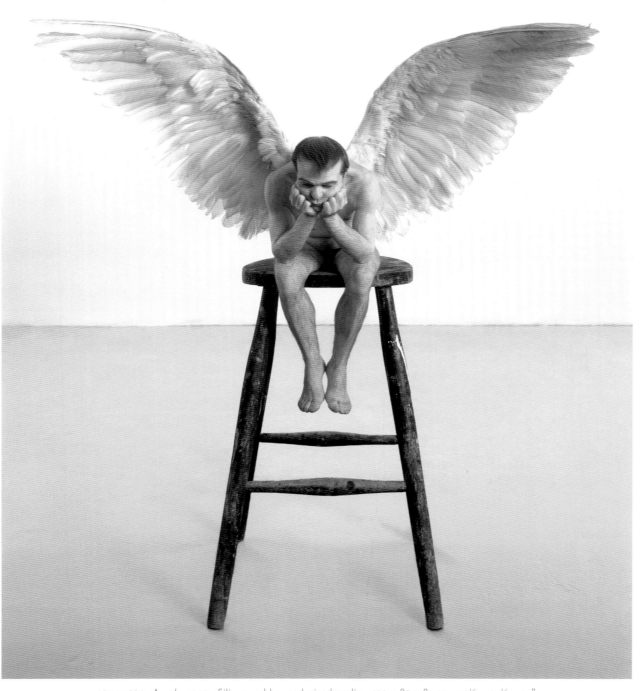

RON MUECK *Angel* 1997 Silicone rubber and mixed media 110 × 87 × 81 cm 43¼ × 34¼ × 32"

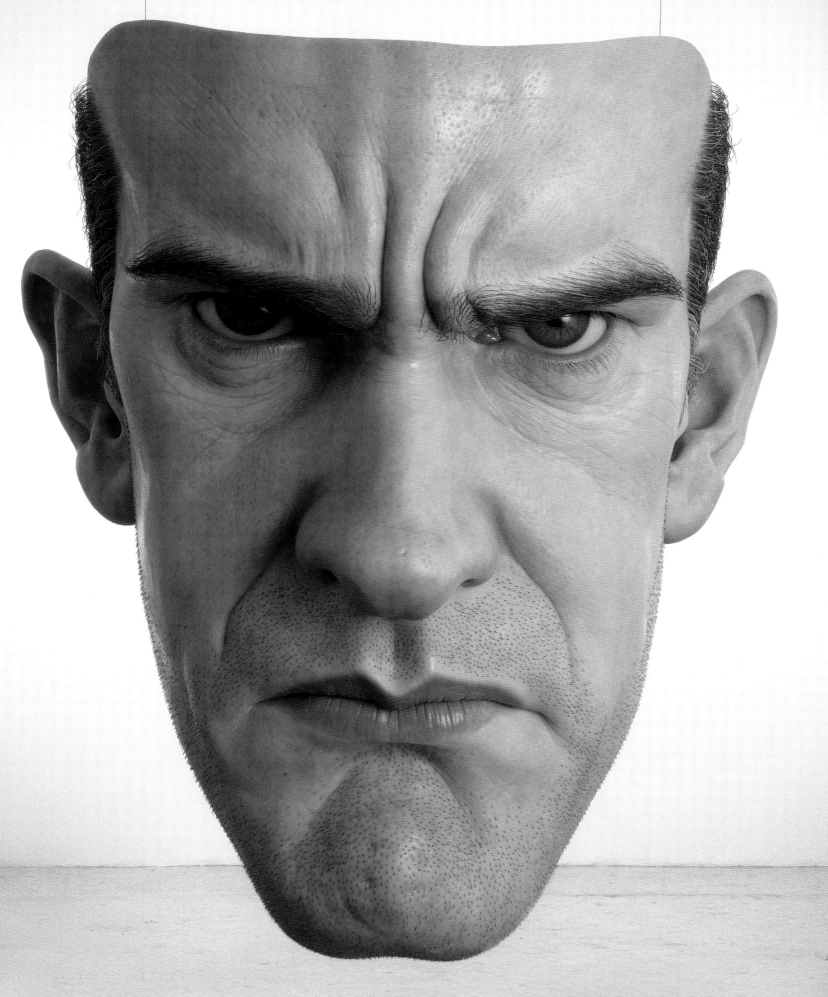

RON MUECK Mask 1997 Polyester resin and mixed media 158 x 153 x 124 cm 62¼ x 60¼ x 48¾"

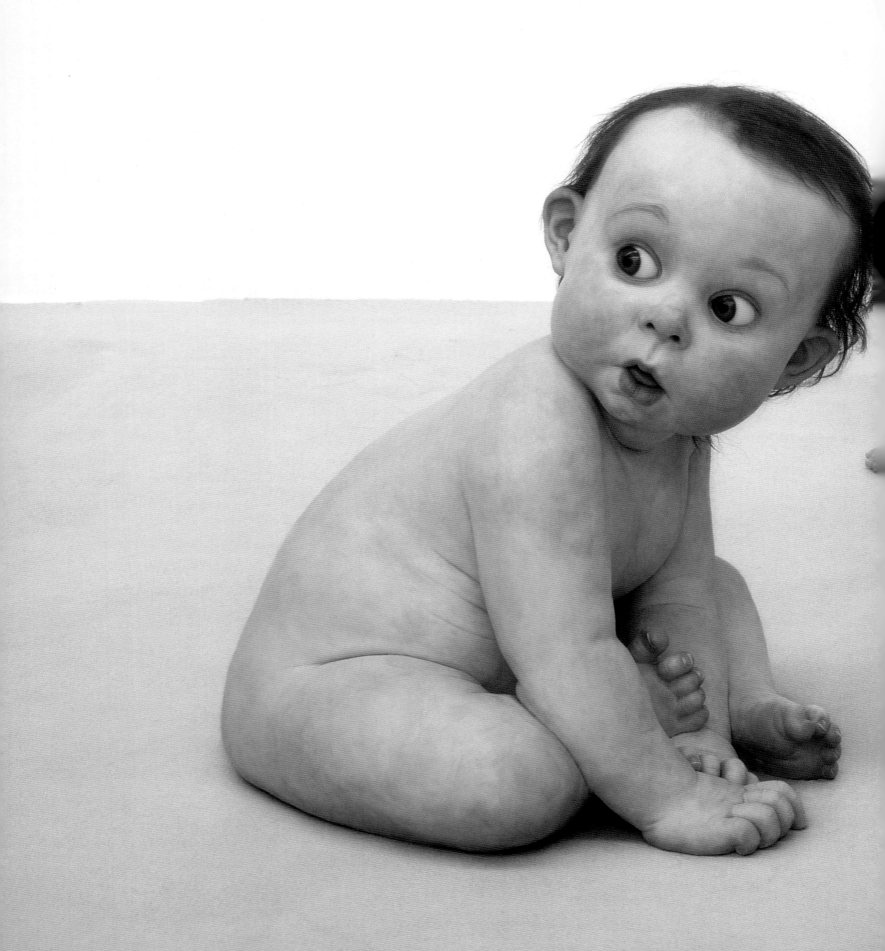

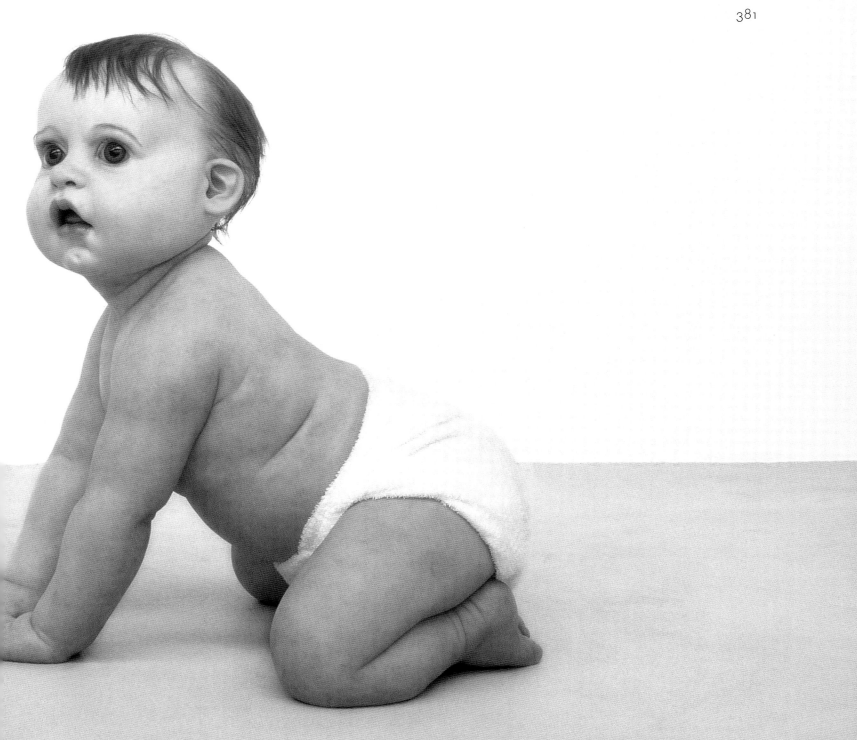

RON MUECK
LEFT TO RIGHT
Big Baby 1996 Polyester resin, fibreglass and human hair 85 × 71 × 70 cm 33⅓ × 28 × 27½"
Big Baby 3 1996–97 Polyester resin and mixed media 86 × 81 × 70 cm 34 × 32 × 27½"

JAKE AND DINOS CHAPMAN
BACKGROUND
Disasters of War 2000 83 hand-coloured etchings Each etching: 24.5 × 34.5 cm 9⅝ × 13½"
FOREGROUND
DNA Zygotic 1997 Fibreglass, resin and paint 190 × 90 × 90 cm 74¾ × 35½ × 35½"

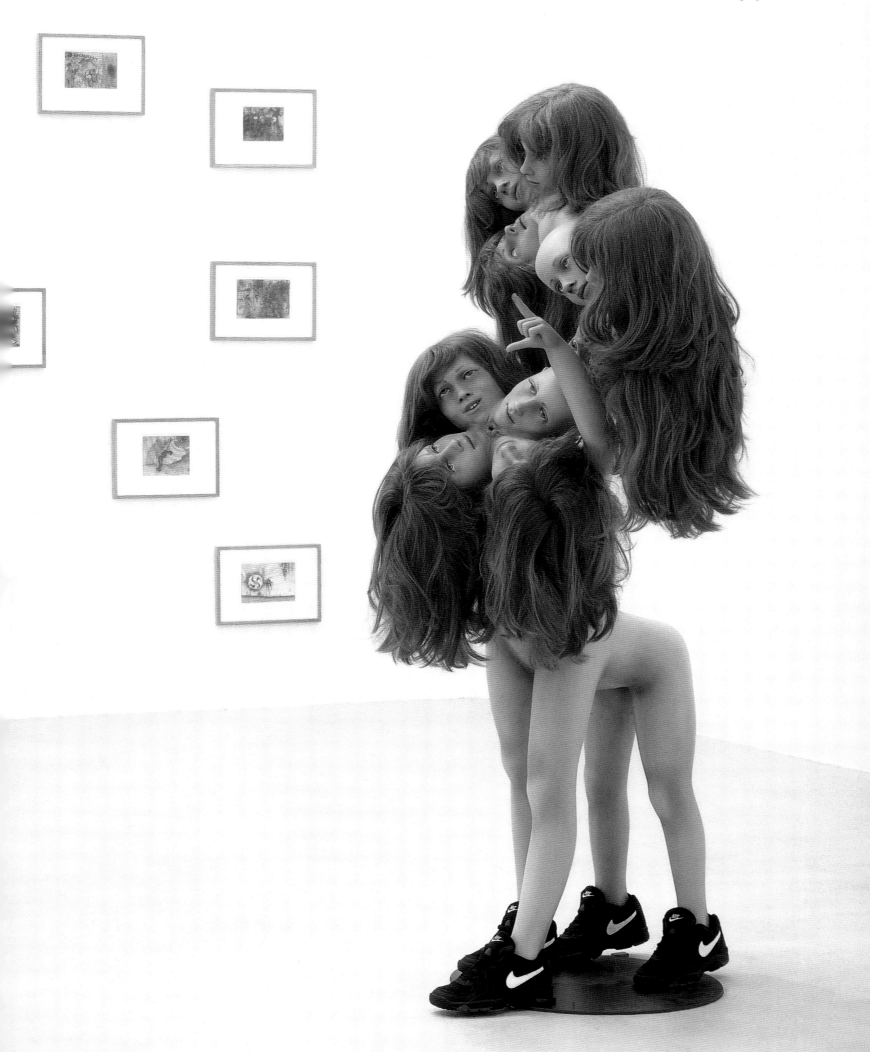

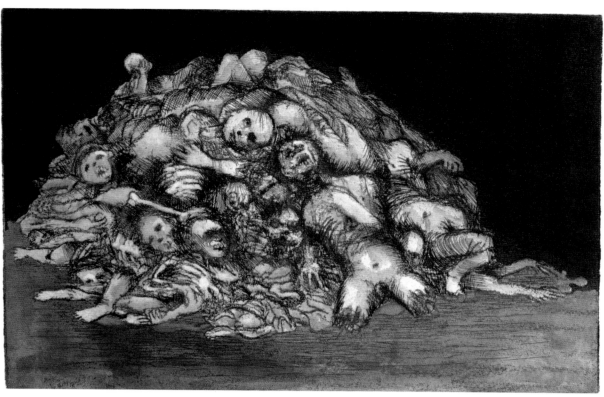

JAKE AND DINOS CHAPMAN *Disasters of War No.3* 2000 Hand-coloured etching 24.5 × 34.5 cm 9½ × 13½"

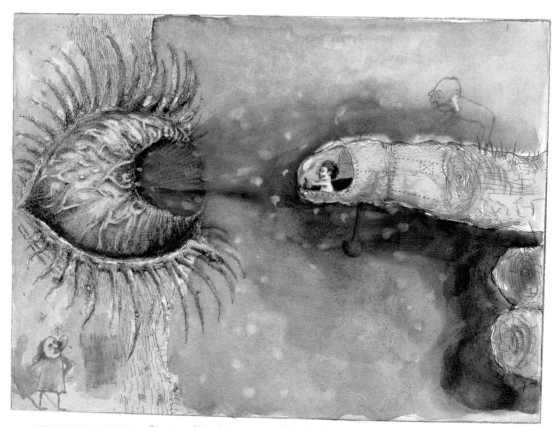

JAKE AND DINOS CHAPMAN *Disasters of War No.72* 2000 Hand-coloured etching 24.5 × 34.5 cm 9½ × 13½"

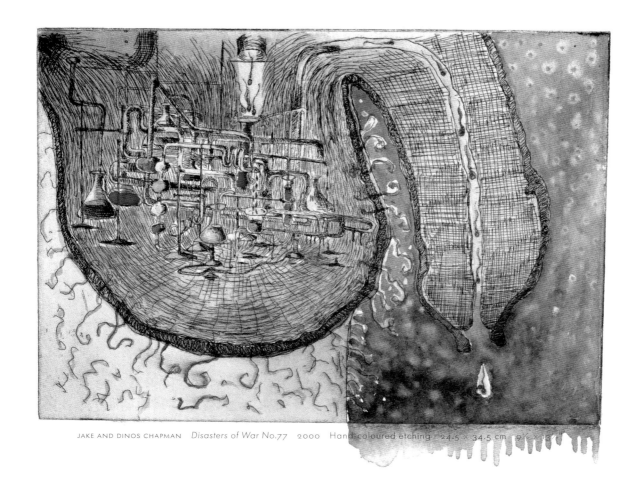

JAKE AND DINOS CHAPMAN *Disasters of War No.77* 2000 Hand-coloured etching 24.5 × 34.5 cm 9½ × 1

JAKE AND DINOS CHAPMAN *Disasters of War No.37* 2000 Hand-coloured etching 24.5 × 34.5 cm 9½ × 13½"

SENSATION:
YOUNG BRITISH ARTISTS FROM THE SAATCHI COLLECTION

MARCUS HARVEY *Myra* 1995 Acrylic on canvas 396 × 320 cm 156 × 126"

CHRIS OFILI *The Holy Virgin Mary* 1996 Paper collage, oil paint, glitter, polyester resin, map pins and elephant dung on linen
243.8 × 182.9 cm 96 × 72"

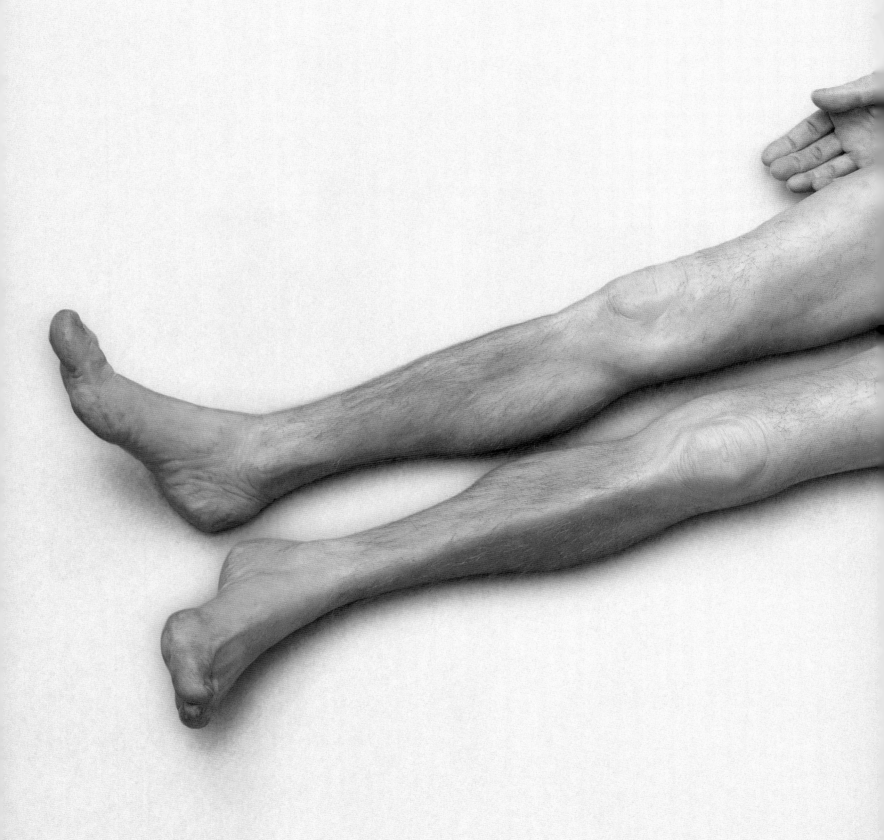

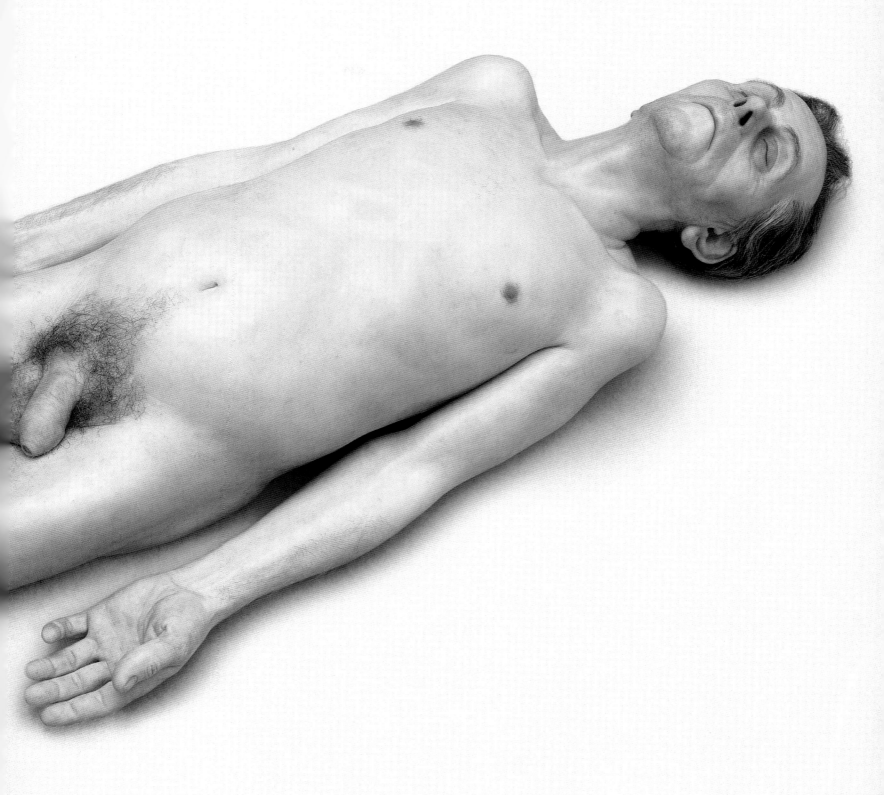

RON MUECK *Dead Dad* 1996–97 Silicone and acrylic 20 × 102 × 38 cm 7¾ × 40¼ × 15"

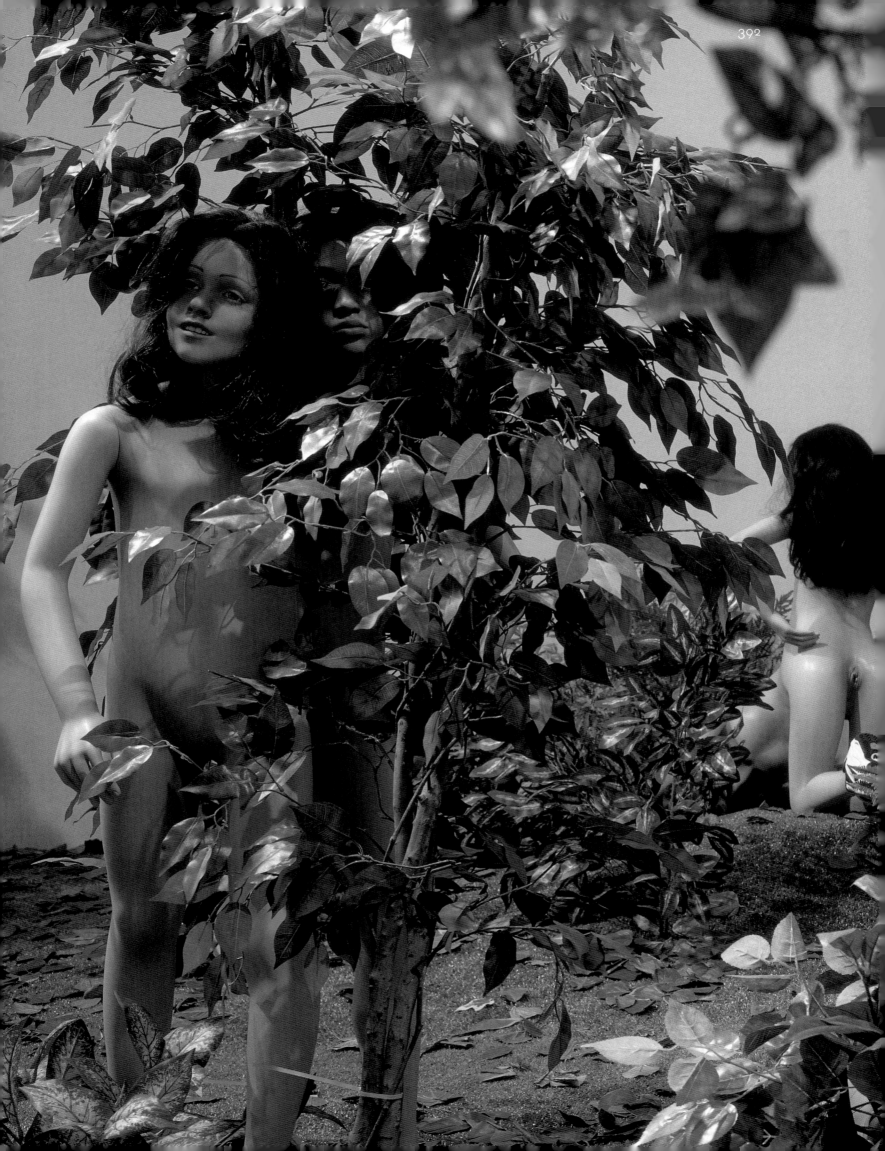

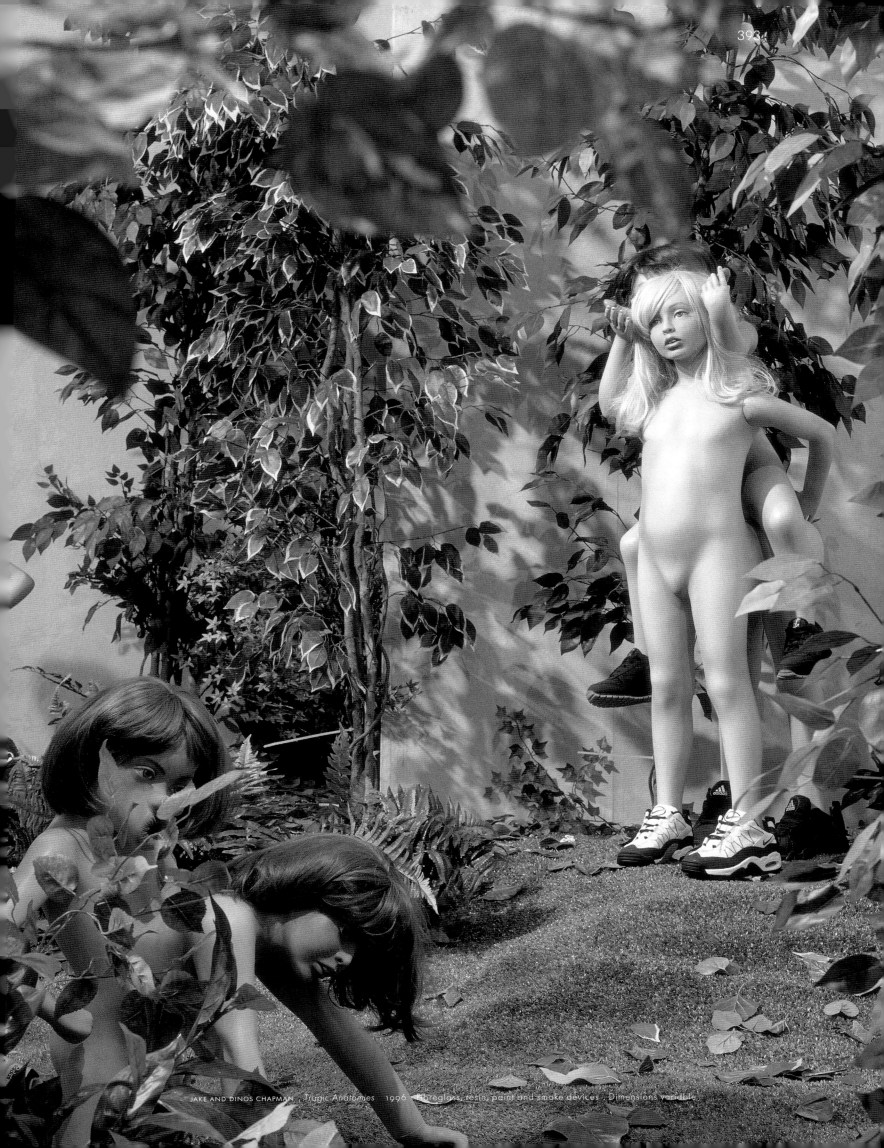

JAKE AND DINOS CHAPMAN · *Tragic Anatomies* · 1996 · Fibreglass, resin, paint and smoke devices · Dimensions variable

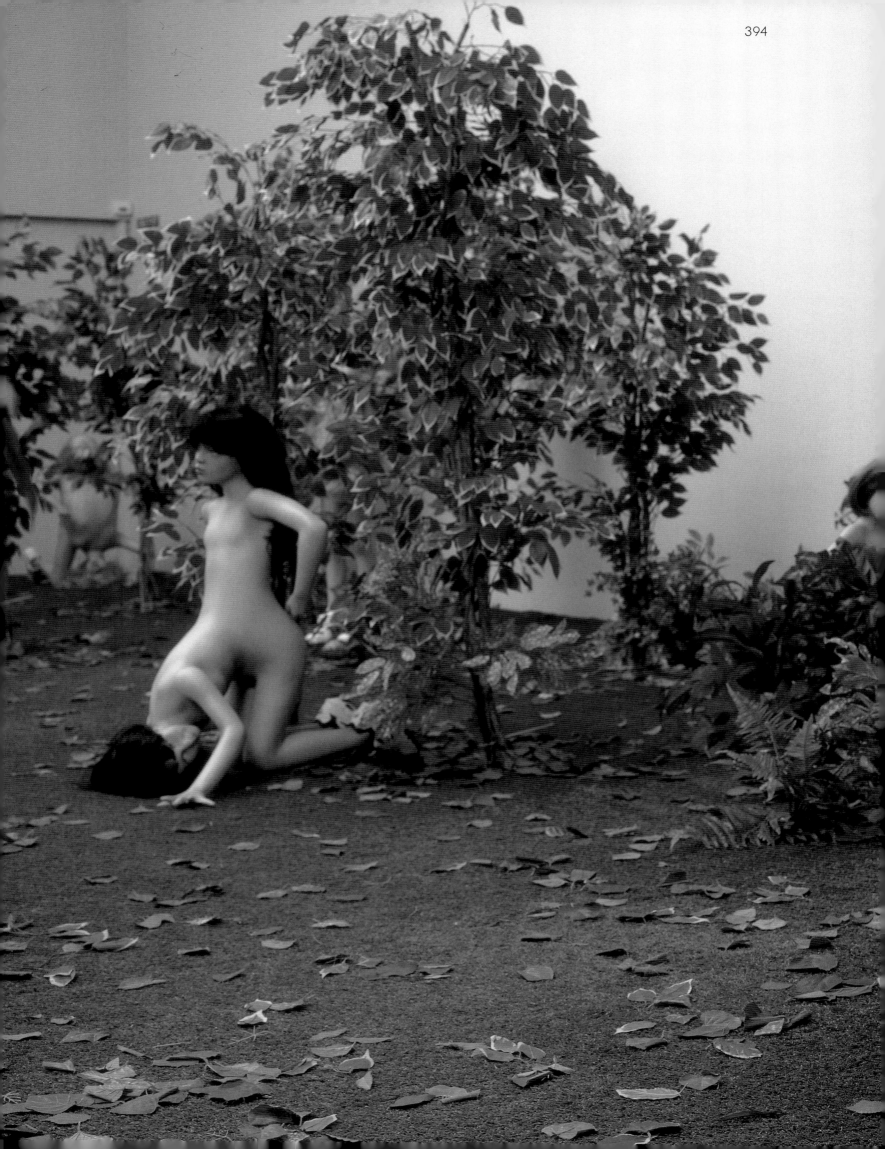

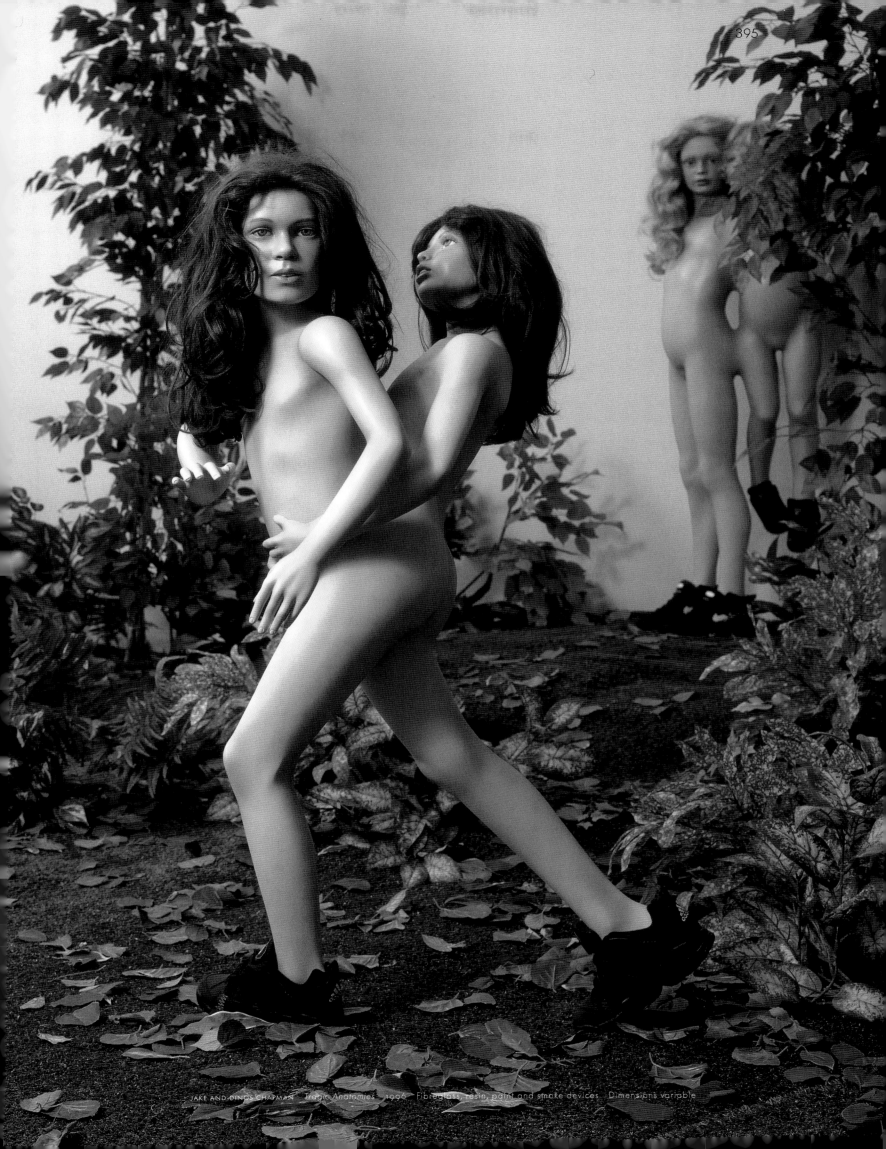

JAKE AND DINOS CHAPMAN Tragic Anatomies 1996 Fibreglass, resin, paint and smoke devices Dimensions variable

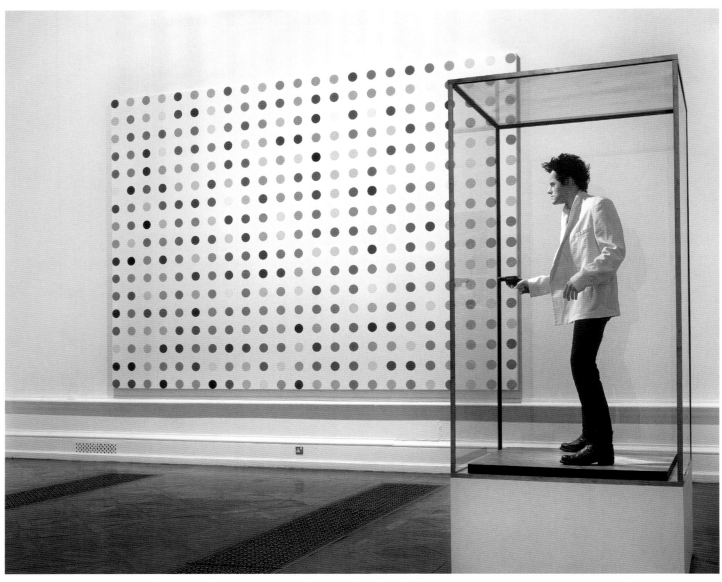

DAMIEN HIRST (BACKGROUND) *Argininosuccinic Acid* 1995 Gloss household paint on canvas 335 × 457.2 cm 132 × 180"
GAVIN TURK (FOREGROUND) *Pop* 1993 Glass, brass, MDF, fibreglass, wax, clothing and gun 279 × 115 × 115 cm 110 × 45 × 45"

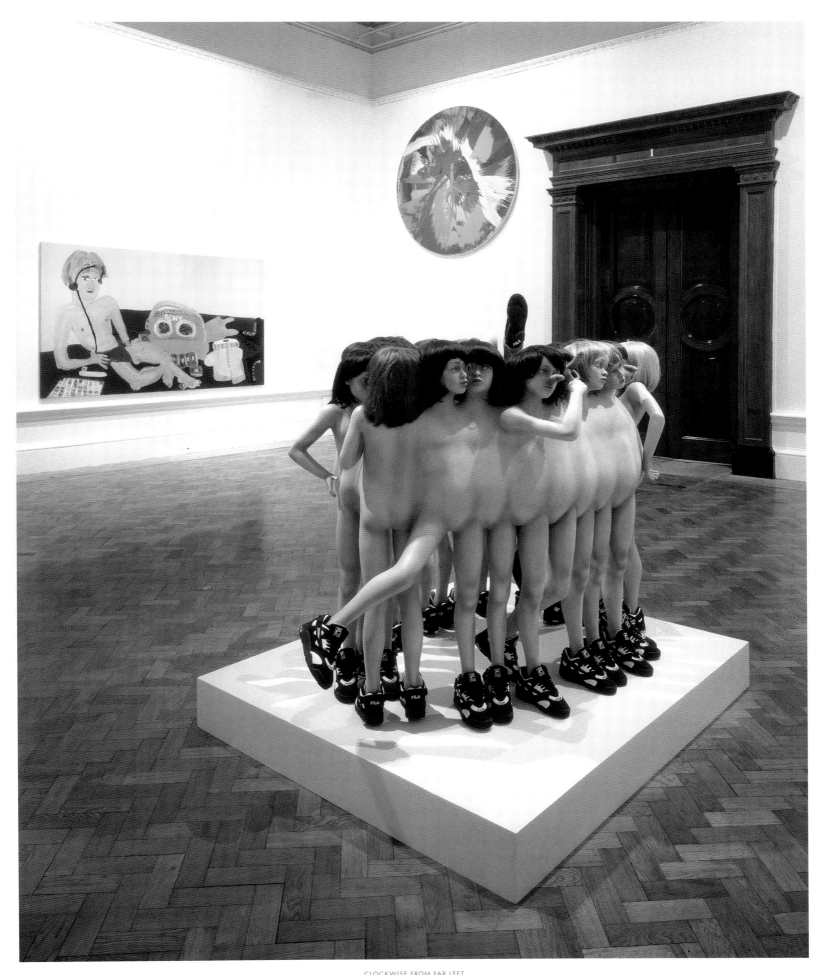

CLOCKWISE FROM FAR LEFT
MARTIN MALONEY *Sony Levi* 1997 Oil on canvas 173.5 × 298 cm 68¼ × 117¼"
DAMIEN HIRST *Beautiful, Kiss My Fucking Ass Painting* 1996 Gloss household paint on canvas Diameter: 213.4 cm 84"
JAKE AND DINOS CHAPMAN *Zygotic Acceleration, Biogenetic, De-sublimated Libidinal Model (Enlarged × 1000)* 1995 Fibreglass 150 × 180 × 140 cm 59 × 70¾ × 55¼"

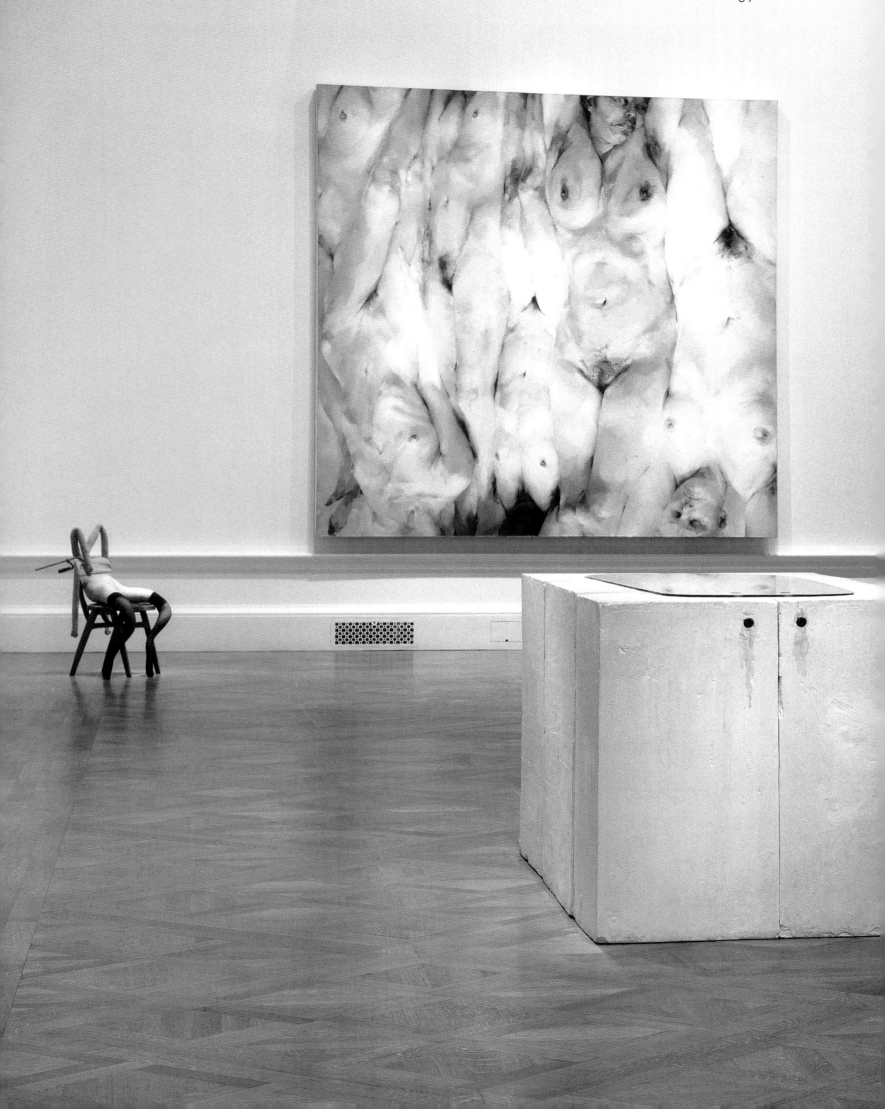

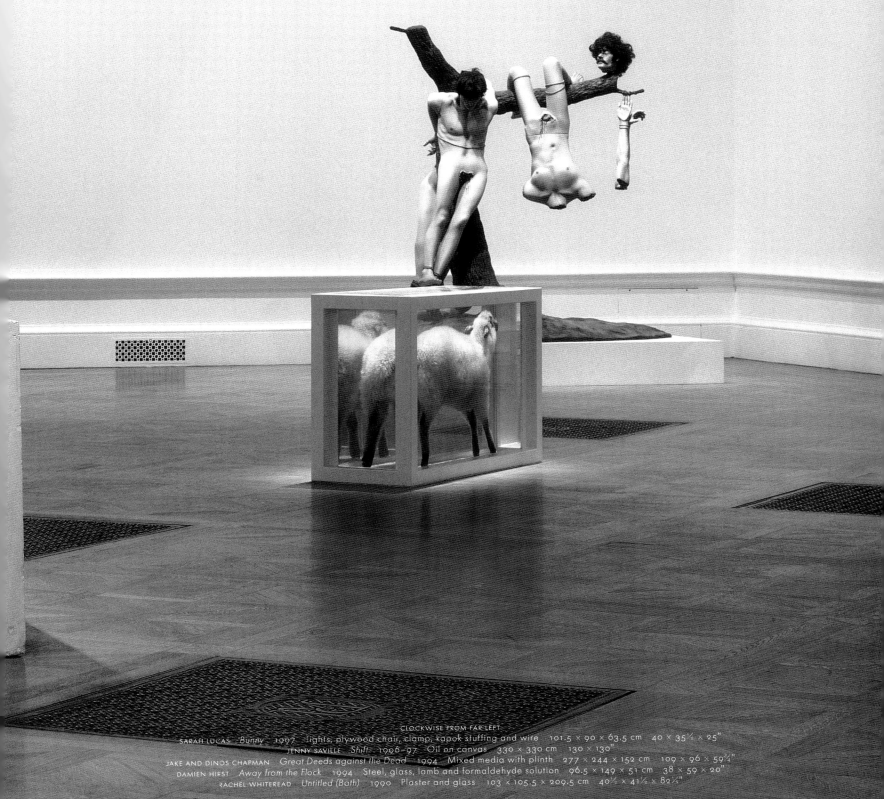

CLOCKWISE FROM FAR LEFT:
SARAH LUCAS *Bunny* 1997 Tights, plywood chair, clamp, kapok stuffing and wire 101.5 × 90 × 63.5 cm 40 × 35½ × 25"
JENNY SAVILLE *Shift* 1996–97 Oil on canvas 330 × 330 cm 130 × 130"
JAKE AND DINOS CHAPMAN *Great Deeds against the Dead* 1994 Mixed media with plinth 277 × 244 × 152 cm 109 × 96 × 59¾"
DAMIEN HIRST *Away from the Flock* 1994 Steel, glass, lamb and formaldehyde solution 96.5 × 149 × 51 cm 38 × 59 × 20"
RACHEL WHITEREAD *Untitled (Bath)* 1990 Plaster and glass 103 × 105.5 × 209.5 cm 40½ × 41½ × 82½"

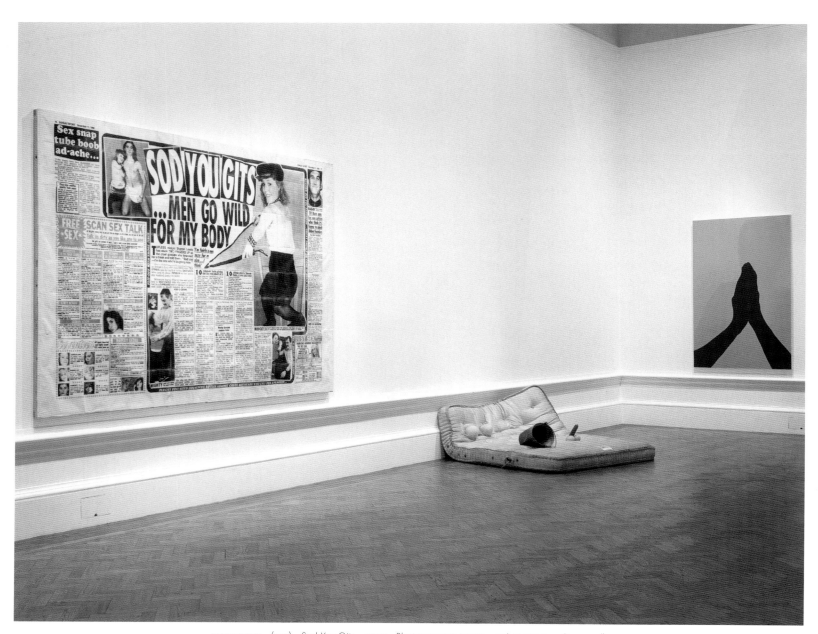

SARAH LUCAS (LEFT) *Sod You Gits* 1990 Photocopy on paper 216 × 315 cm 85 × 124"

SARAH LUCAS (MIDDLE) *Au Naturel* 1994 Mattress, water bucket, melons, oranges and cucumber 83.8 × 167.6 × 144.8 cm 33 × 66 × 57"

GARY HUME (RIGHT) *Begging For It* 1994 Gloss paint on panel 200 × 150 cm 78¾ × 59"

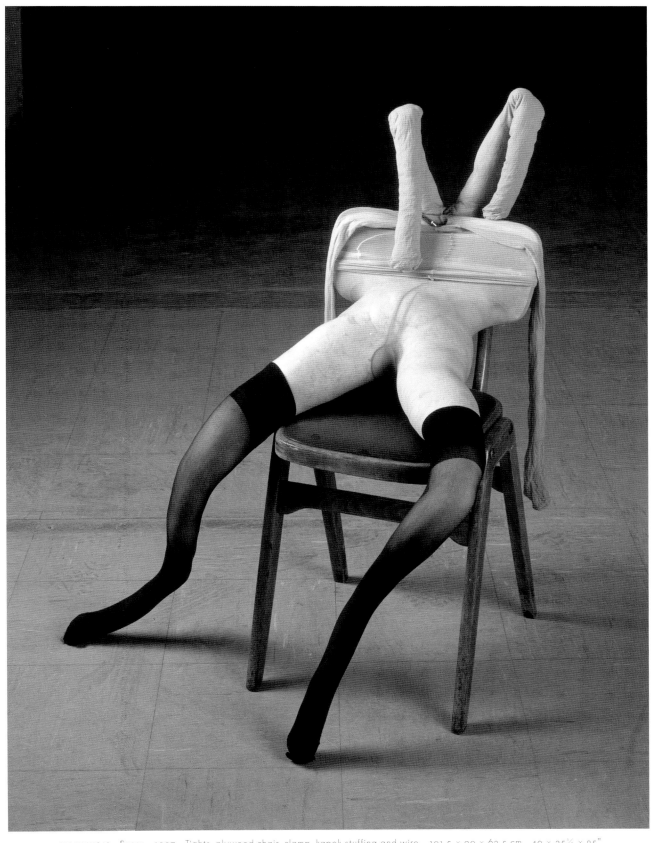

SARAH LUCAS *Sunny* 1997 Tights, plywood chair, clamp, kapok stuffing and wire 101.5 × 90 × 63.5 cm 40 × 35½ × 25"

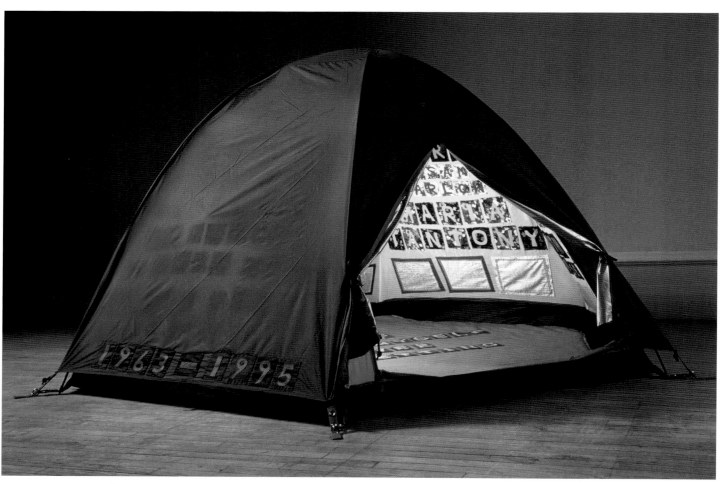

TRACEY EMIN *Everyone I Have Ever Slept With 1963–1995* 1995 Appliquéd tent, mattress and light 122 × 245 × 214 cm 48 × 96⅓ × 84¼"

TRACEY EMIN *Everyone I Have Ever Slept With 1963–1995* 1995 (detail)

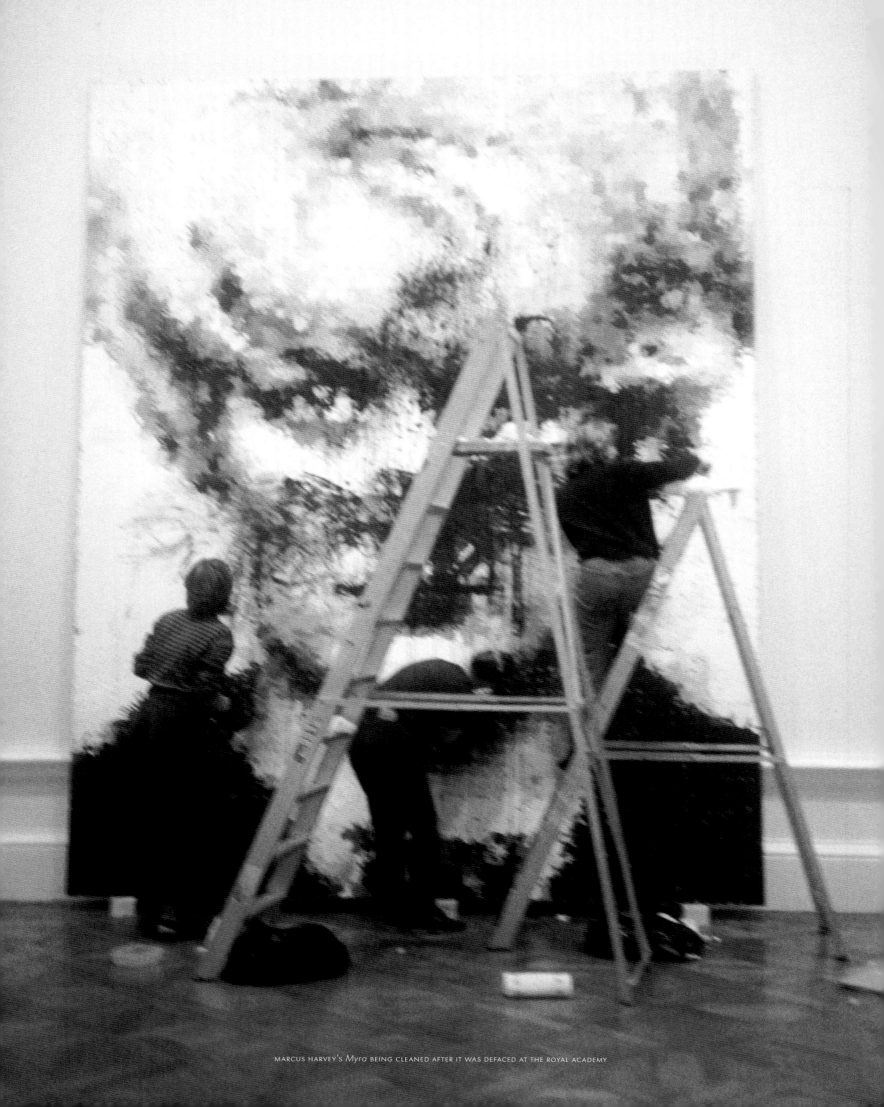

MARCUS HARVEY'S *Myra* BEING CLEANED AFTER IT WAS DEFACED AT THE ROYAL ACADEMY

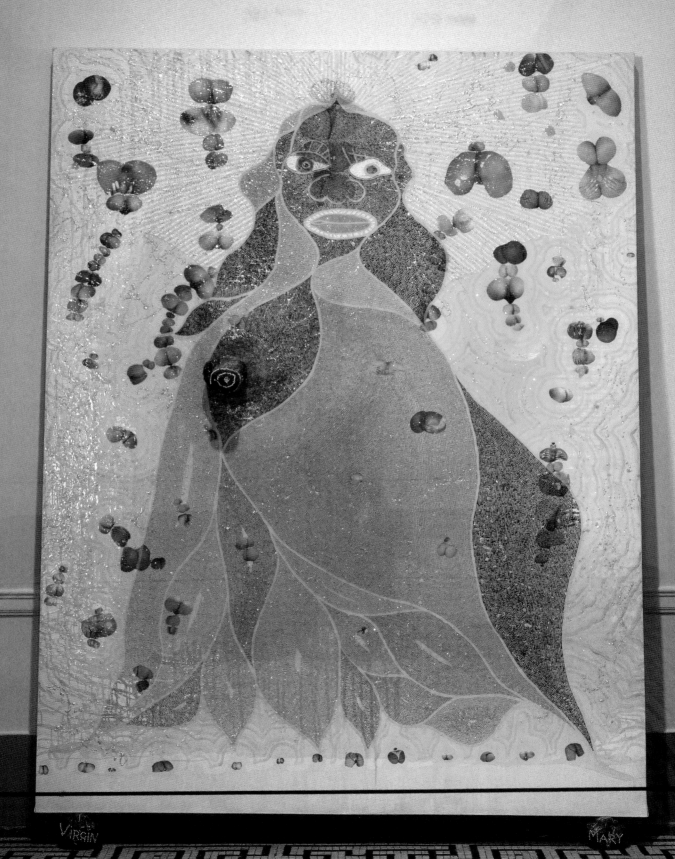

CHRIS OFILI'S CONTROVERSIAL WORK, *The Holy Virgin Mary*, DISPLAYED BEHIND A PROTECTIVE PLEXIGLASS SHIELD AT THE BROOKLYN MUSEUM,
AFTER IT WAS VANDALISED AND QUICKLY RESTORED

HELL

J&D CHAPMAN

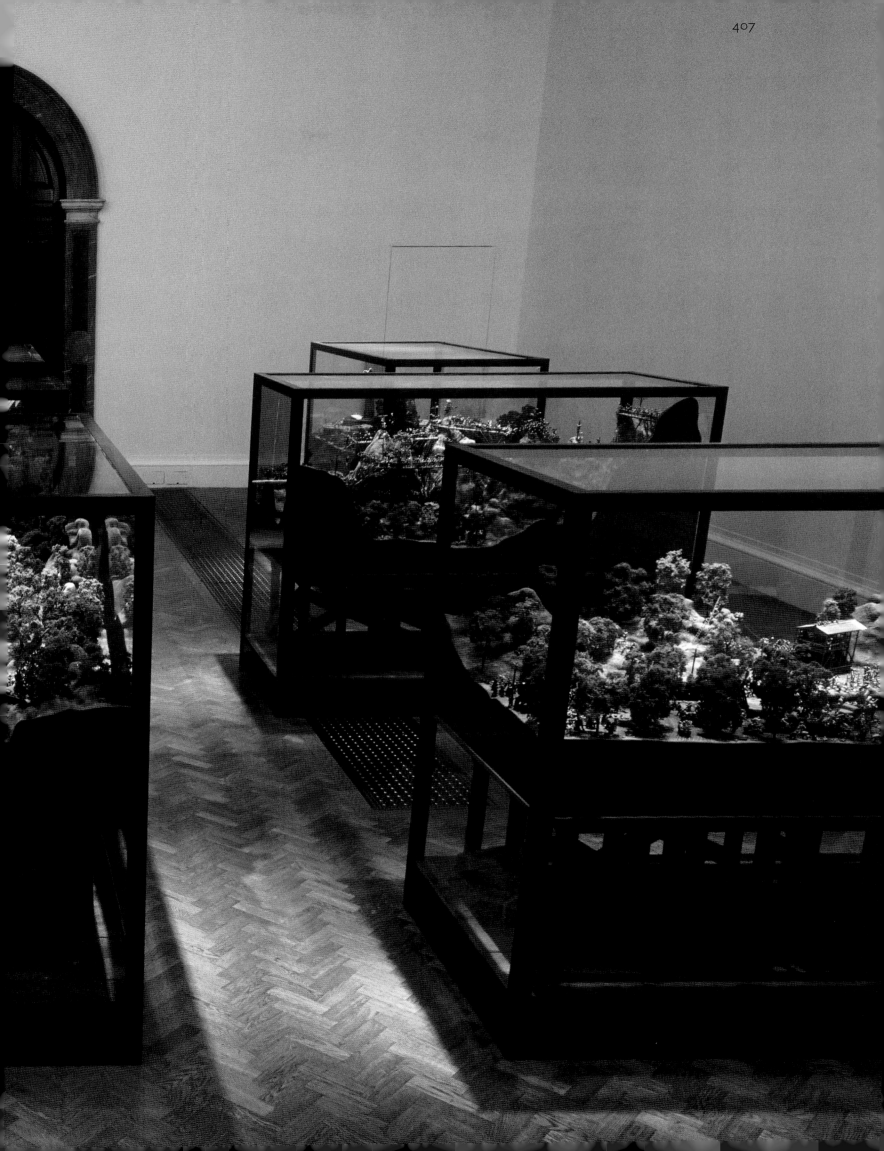

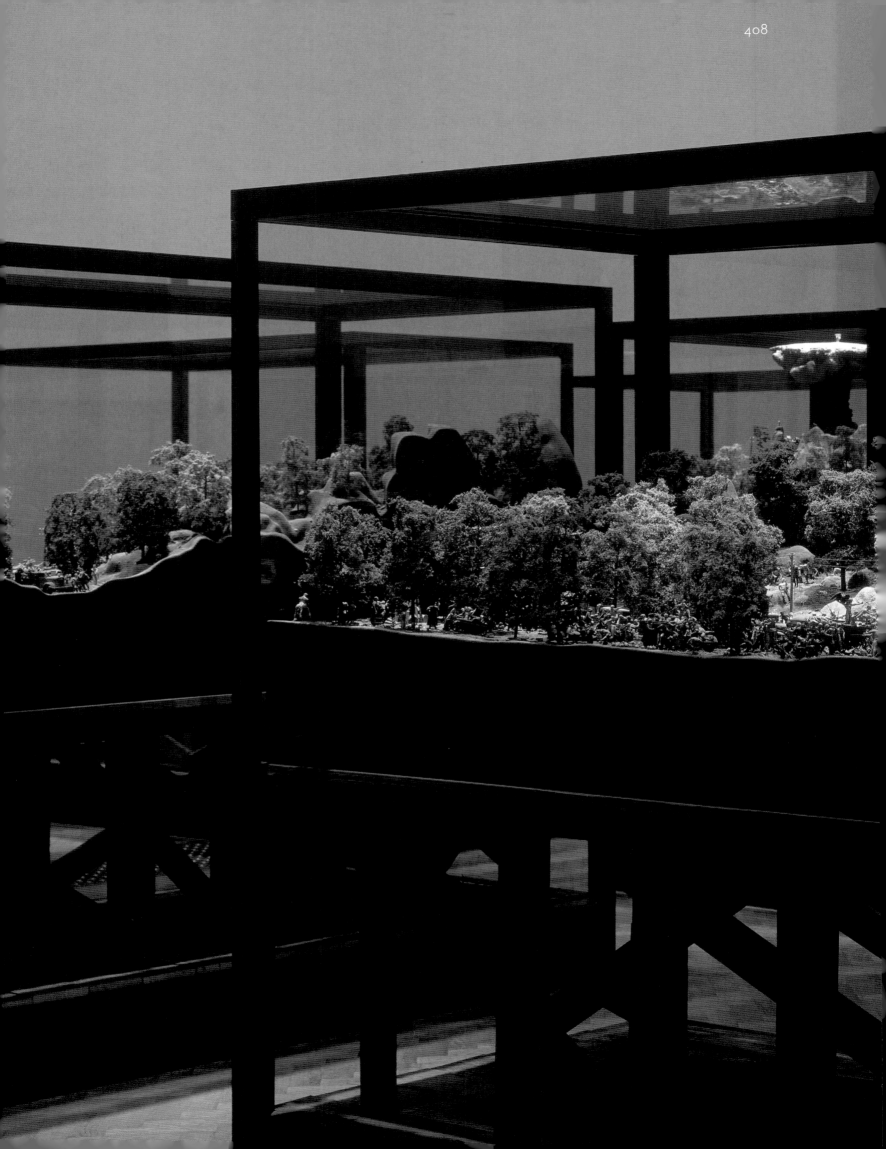

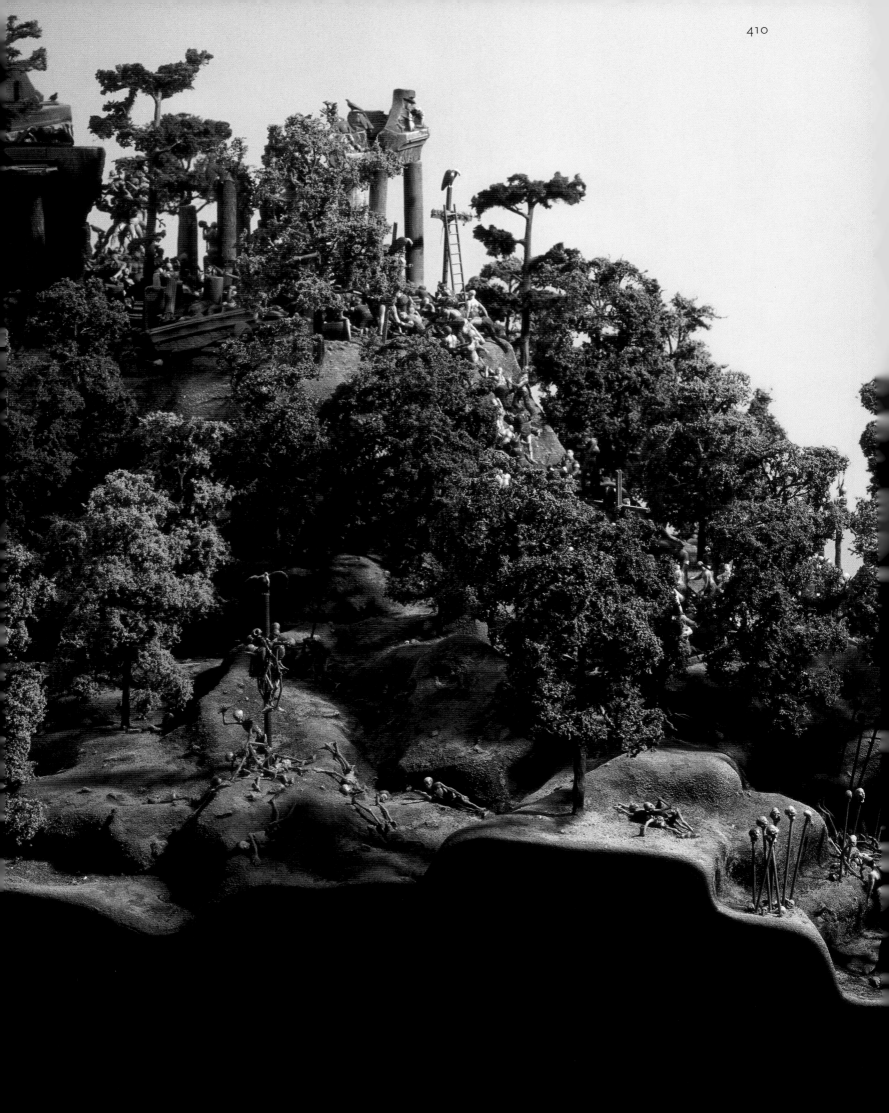

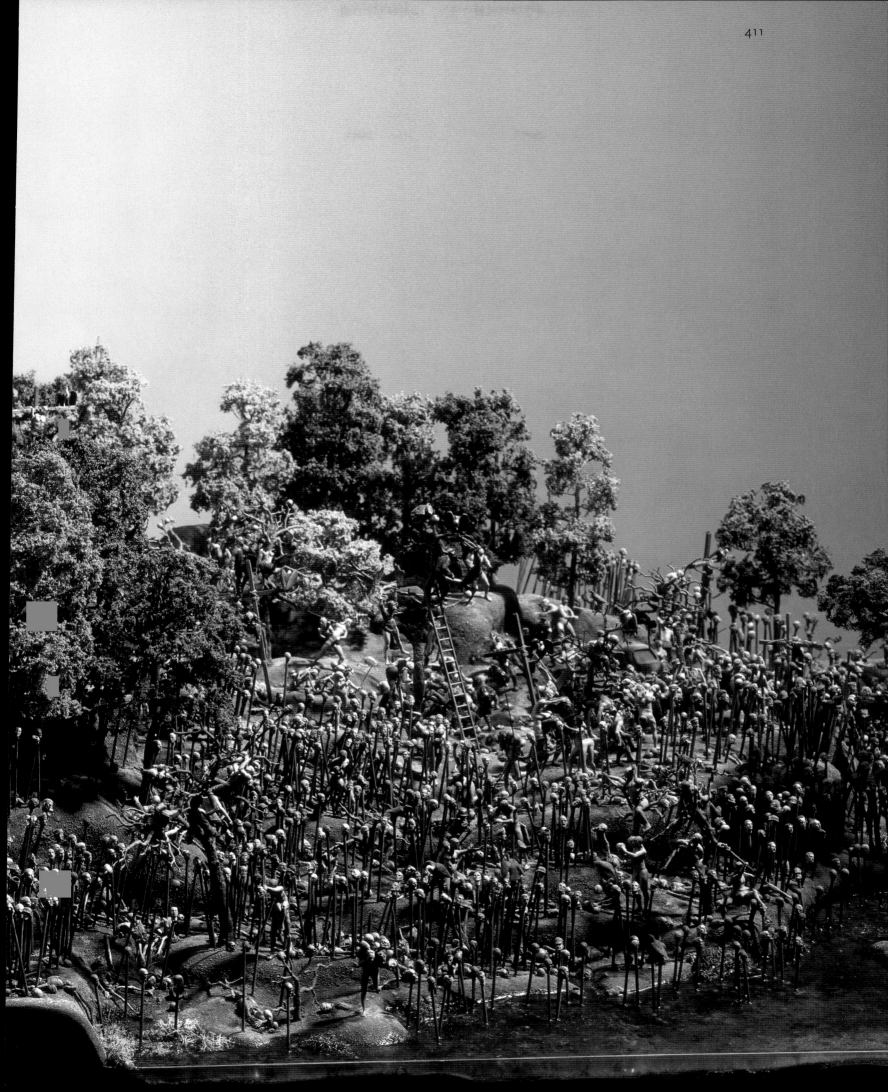

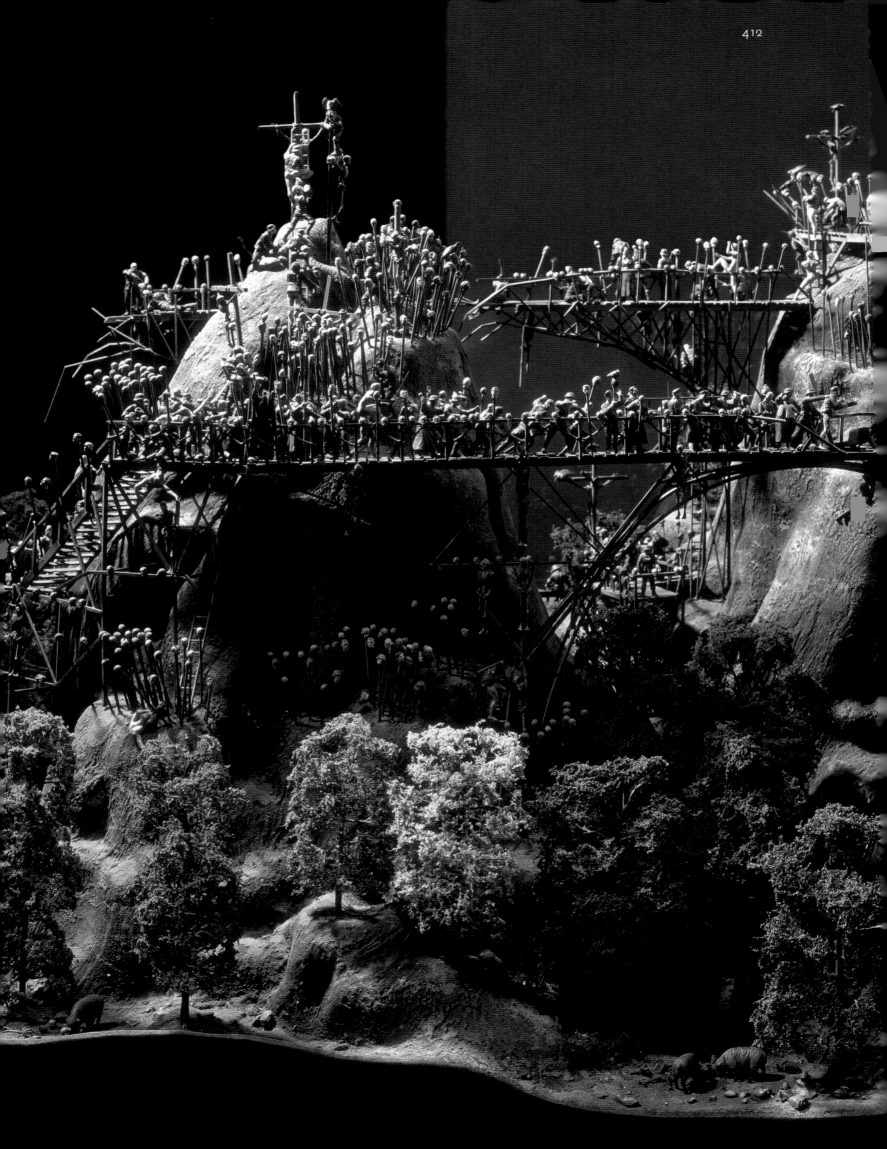

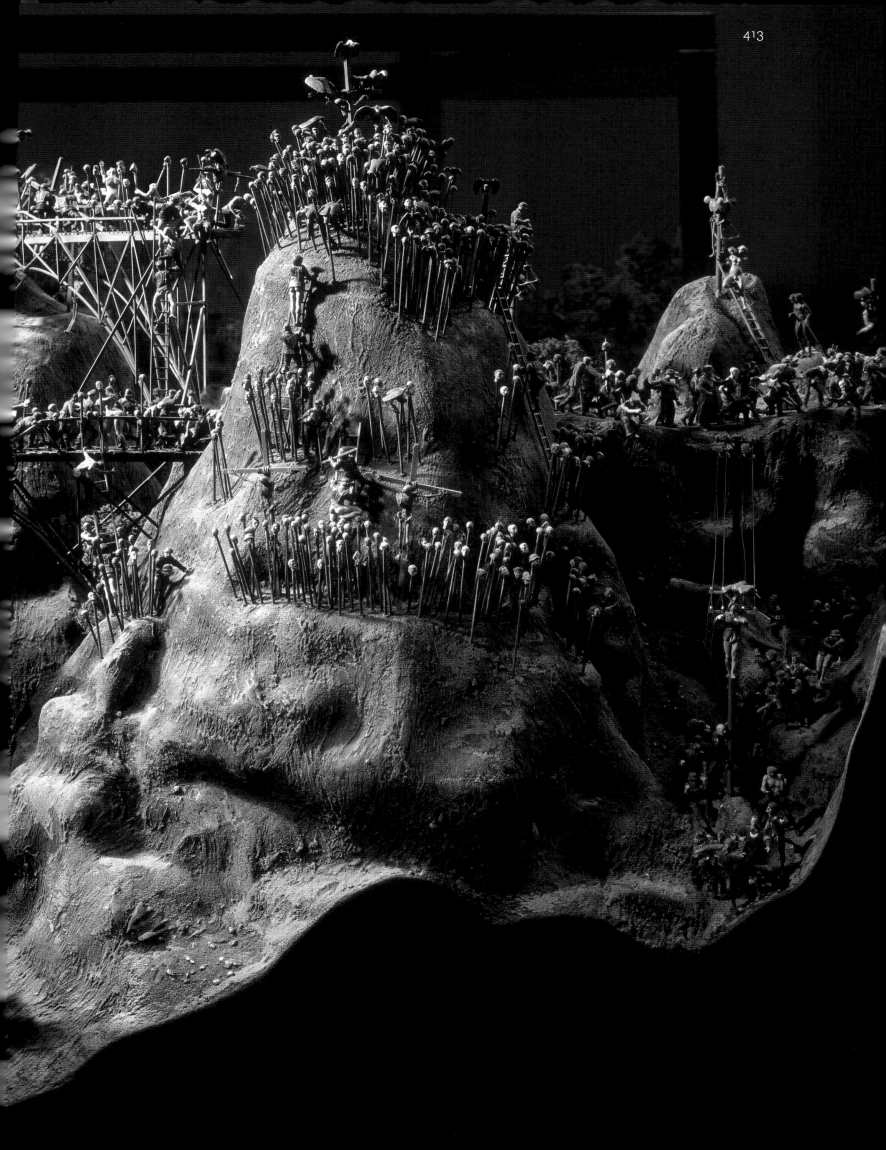

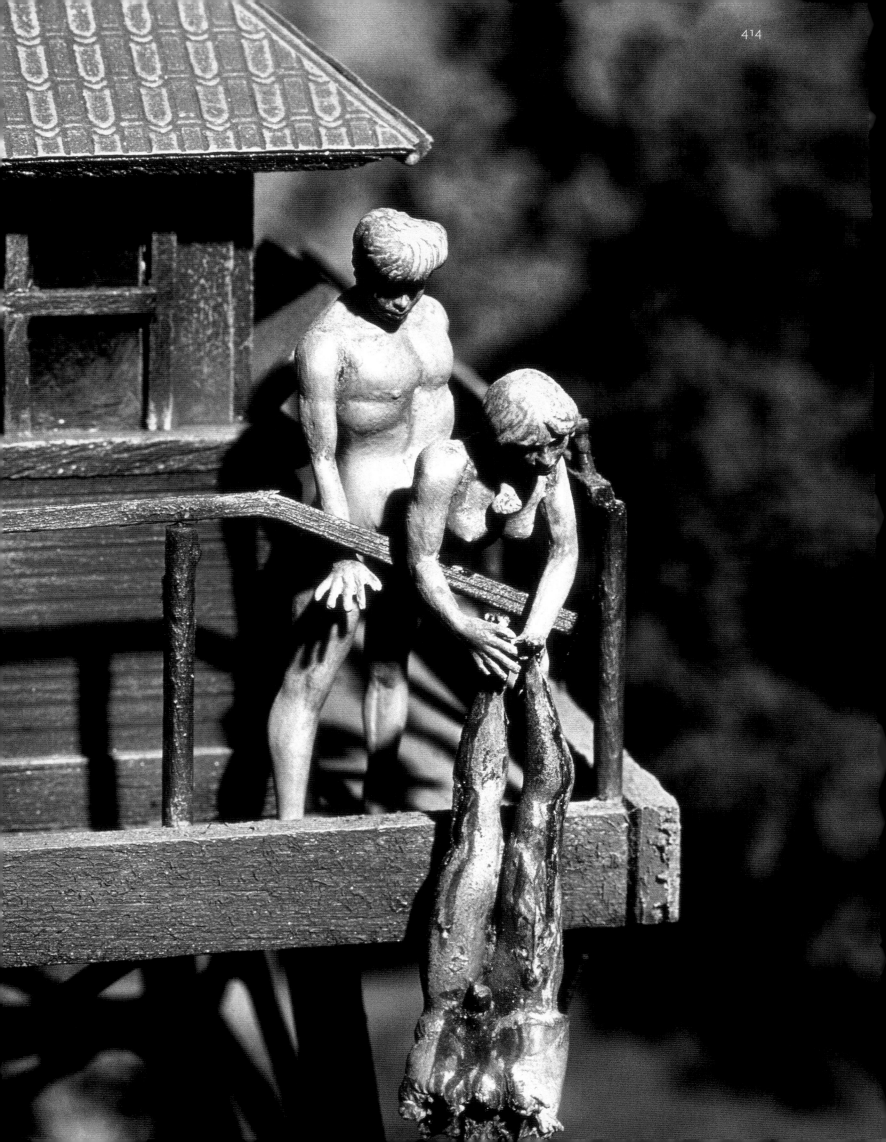

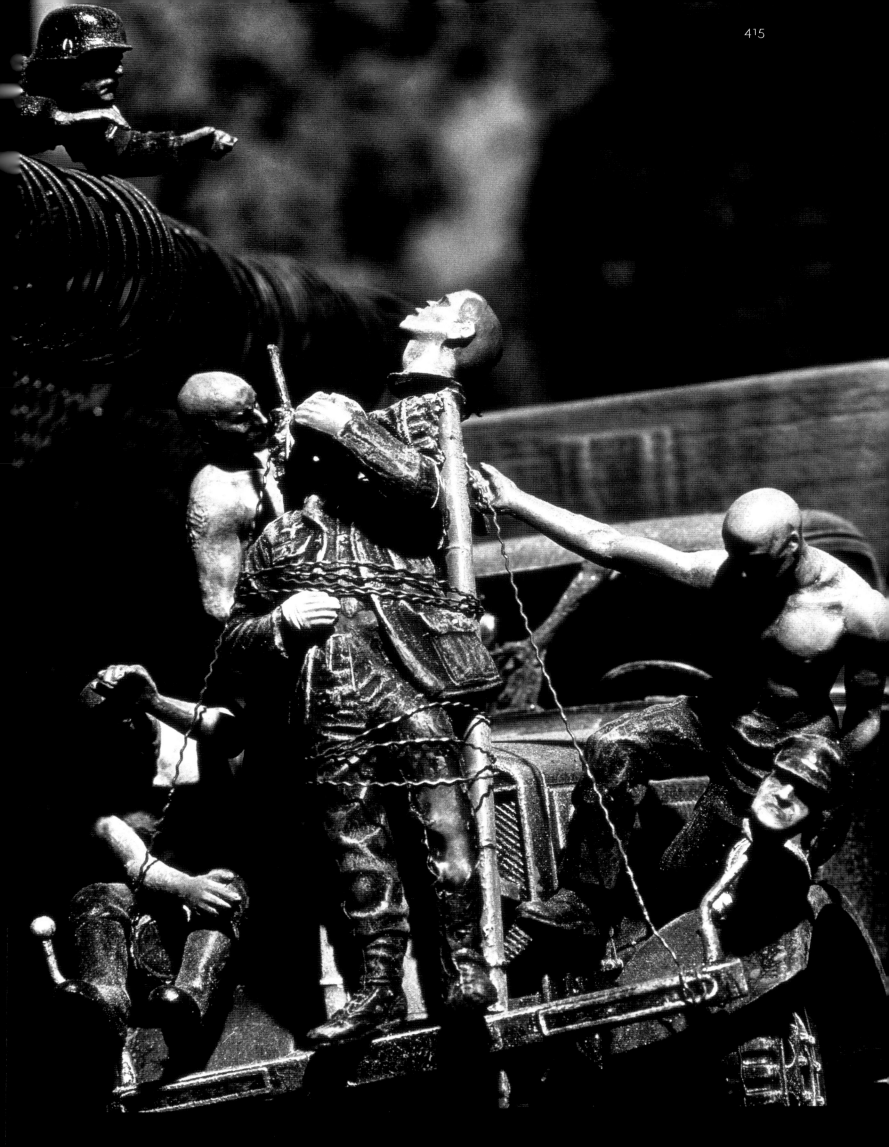

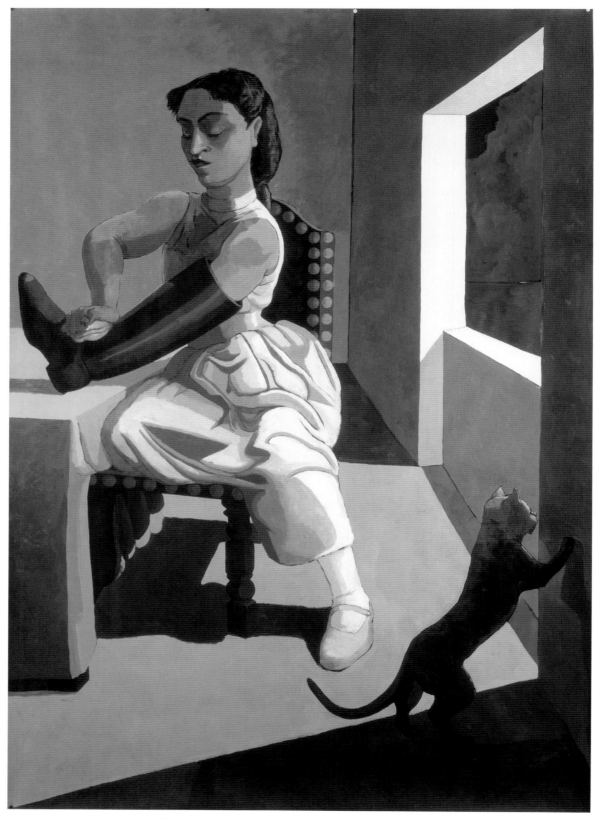

PAULA REGO *The Policeman's Daughter* 1987 Oil on canvas 213 × 152 cm 89 × 63½"

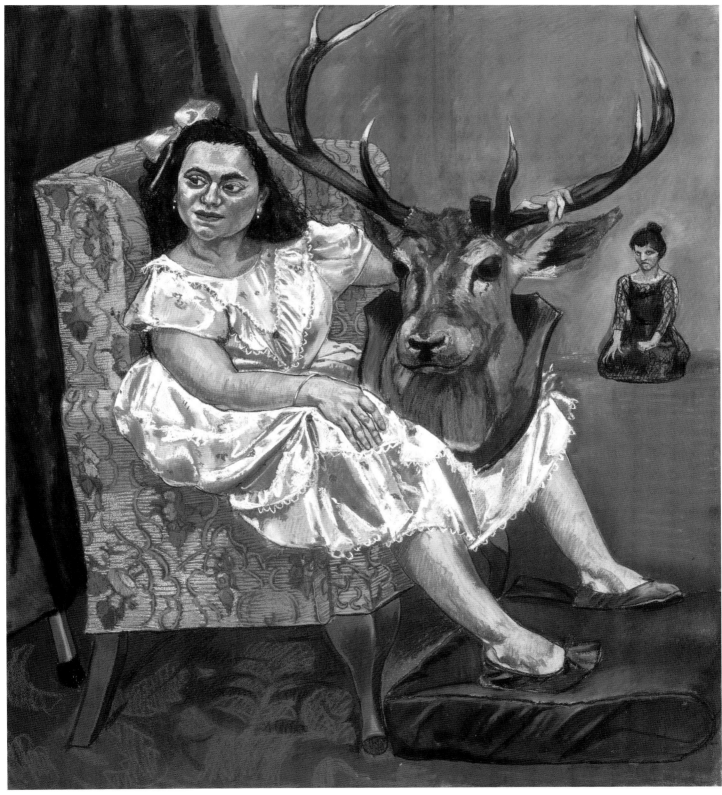

PAULA REGO *Snow White Playing with her Father's Trophies* 1995 Pastel on paper, mounted on aluminium 178 × 150 cm 70 × 59"

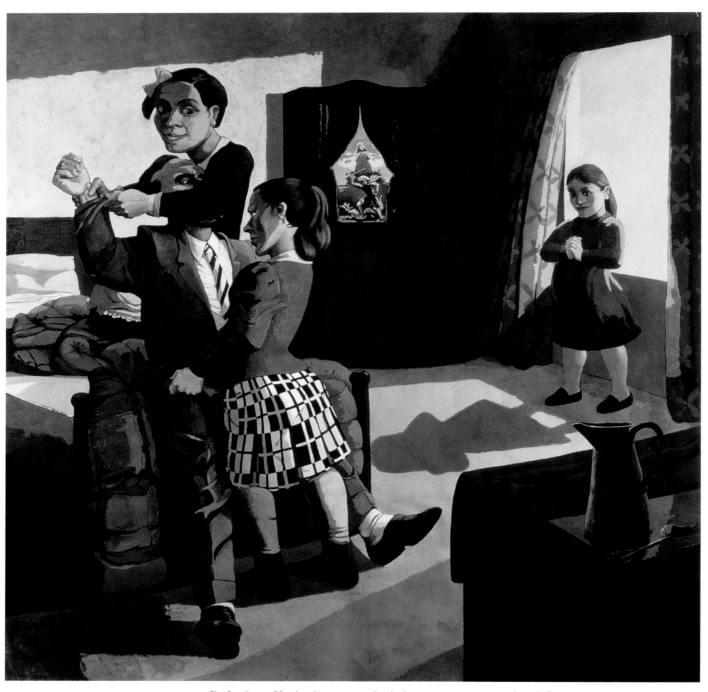

PAULA REGO *The Family* 1988 Acrylic on canvas-backed paper 213 × 213 cm 89 × 89"

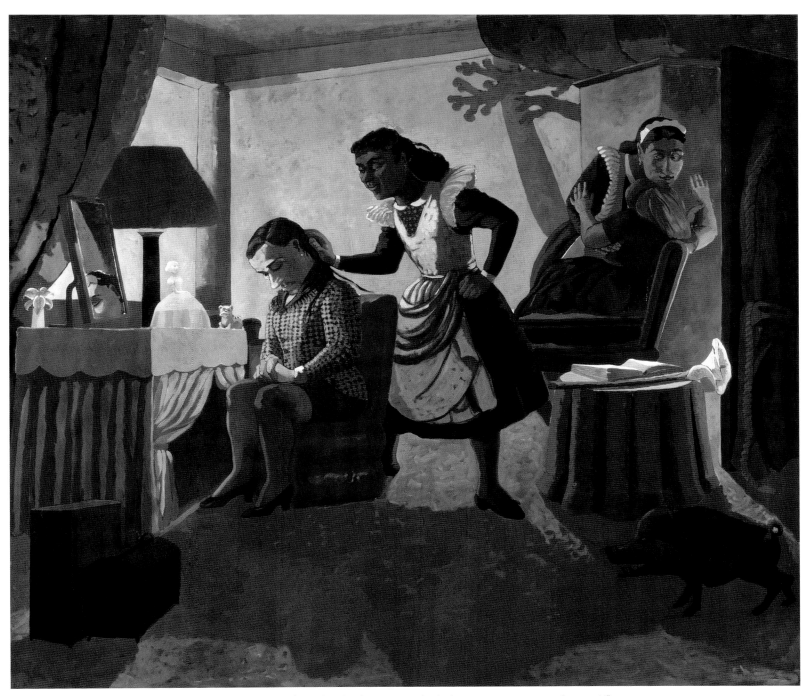

PAULA REGO *The Maids* 1987 Acrylic on canvas-backed paper 213 × 244 cm 89 × 101½"

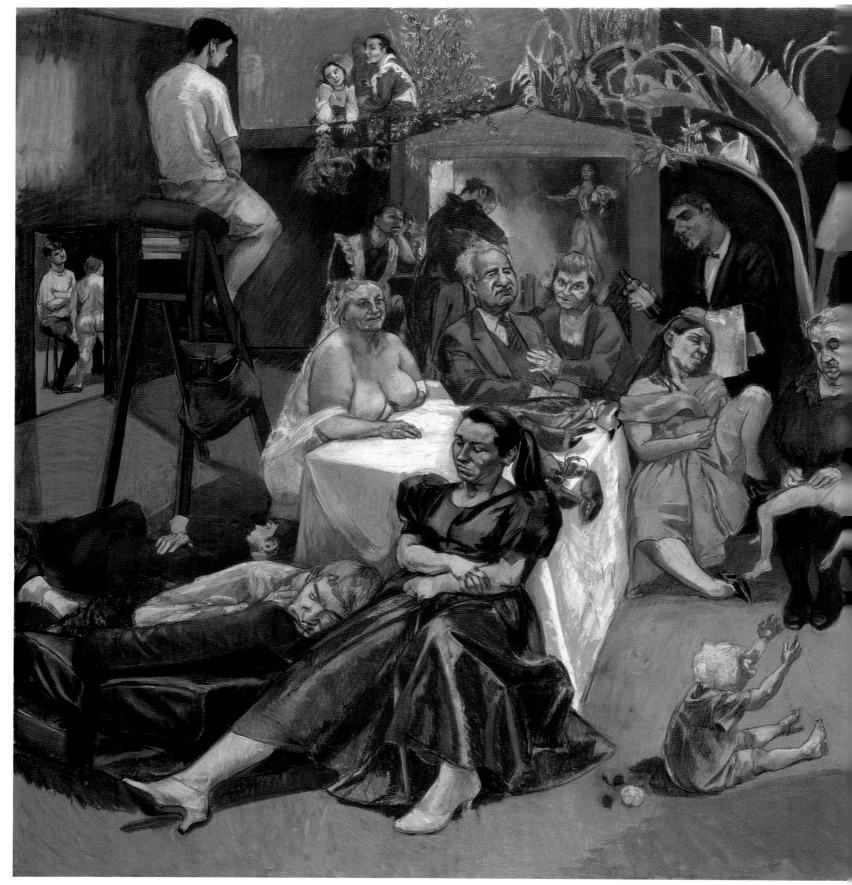

PAULA REGO *Celestina's House* 2000–01 Pastel on paper 200 × 240 cm 78¾ × 94½"

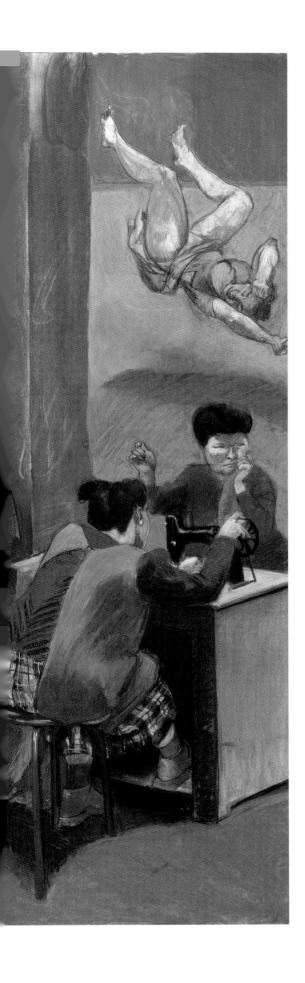

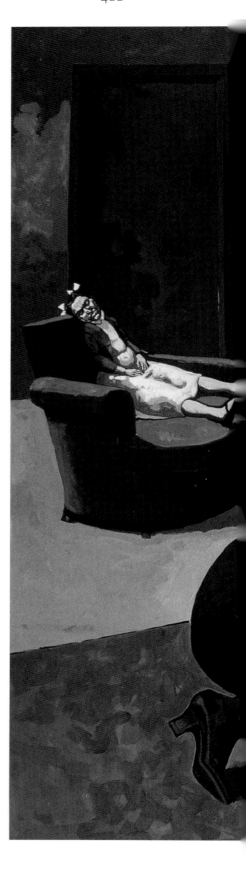

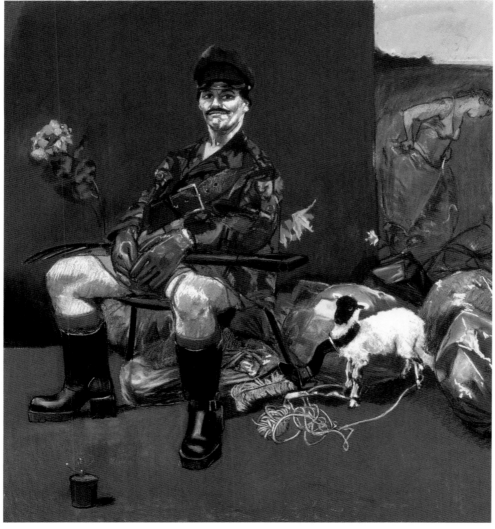

PAULA REGO *The Interrogator's Garden* 2000 Pastel on paper, mounted on aluminium 120 × 110 cm 47¼ × 43¼"

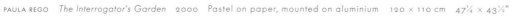

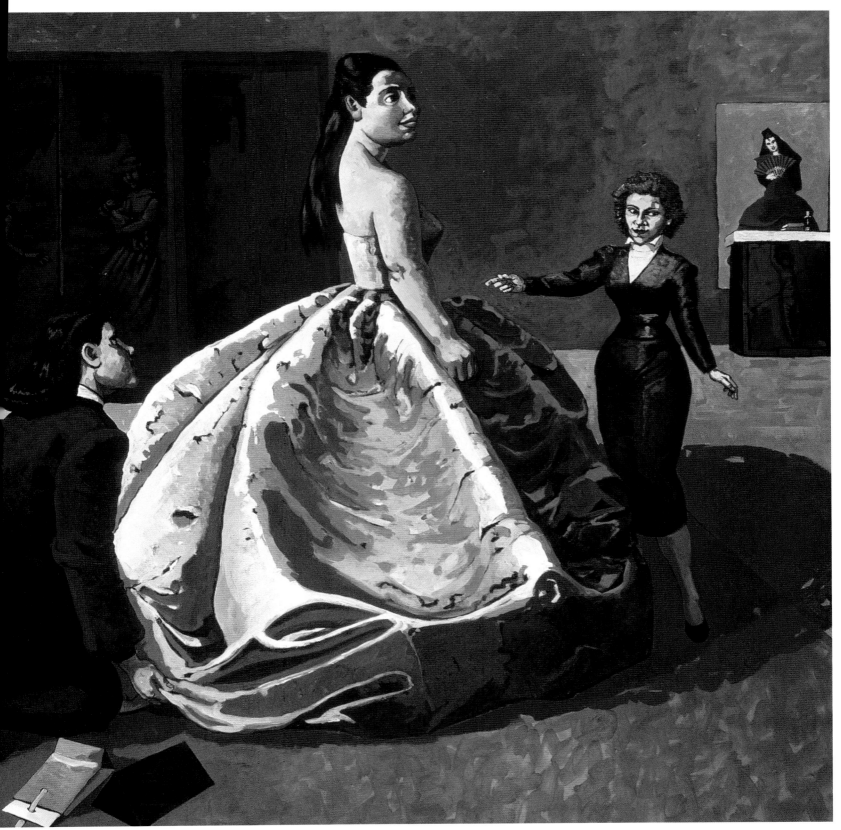

PAULA REGO *The Fitting* 1989 Acrylic on canvas-backed paper 132 × 183 cm 52 × 72"

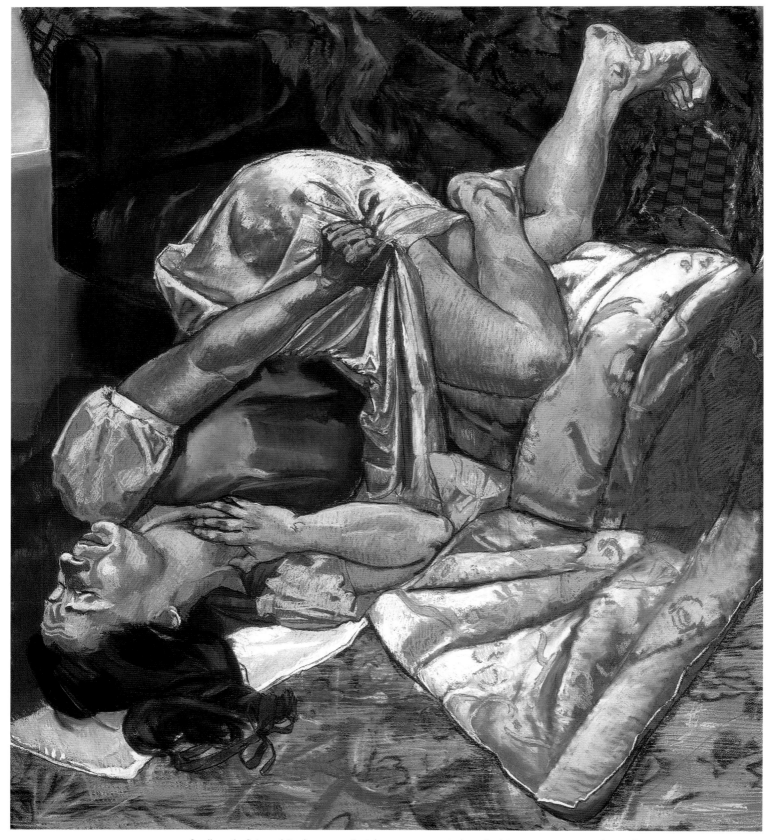

PAULA REGO *Swallows the Poisoned Apple* 1995 Pastel on paper, mounted on aluminium 170 × 150 cm 67 × 59"

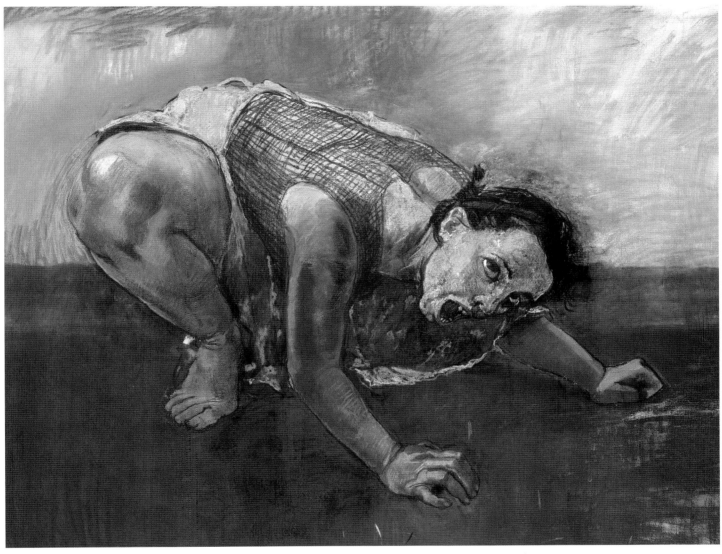

PAULA REGC *Dog Woman* 1994 Pastel on canvas 120 × 160 cm 50 × 66¾"

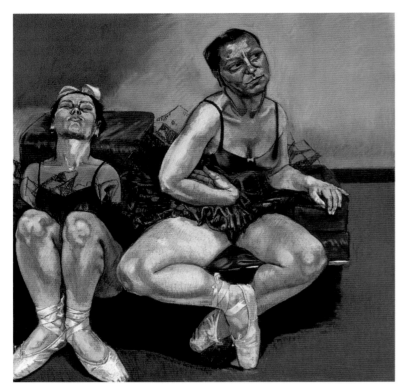 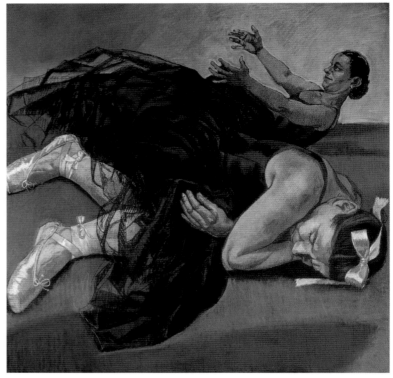

PAULA REGO *Dancing Ostriches from Disney's 'Fantasia'* 1995 Pastel on paper, mounted on aluminium (triptych) Each panel: 150 × 150 cm 59 × 59"

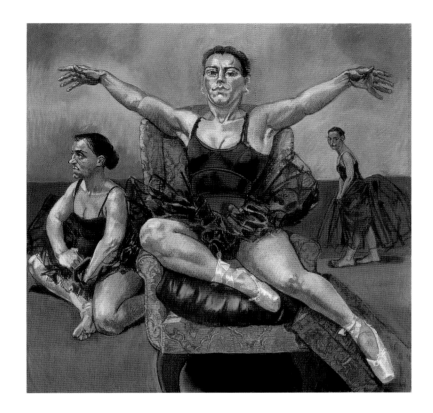

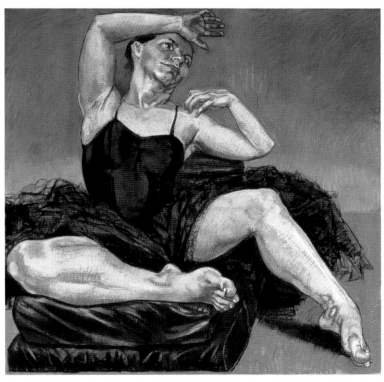

PAULA REGO *Dancing Ostriches from Disney's 'Fantasia'* 1995
Pastel on paper, mounted on aluminium 150 × 150 cm 59 × 59"

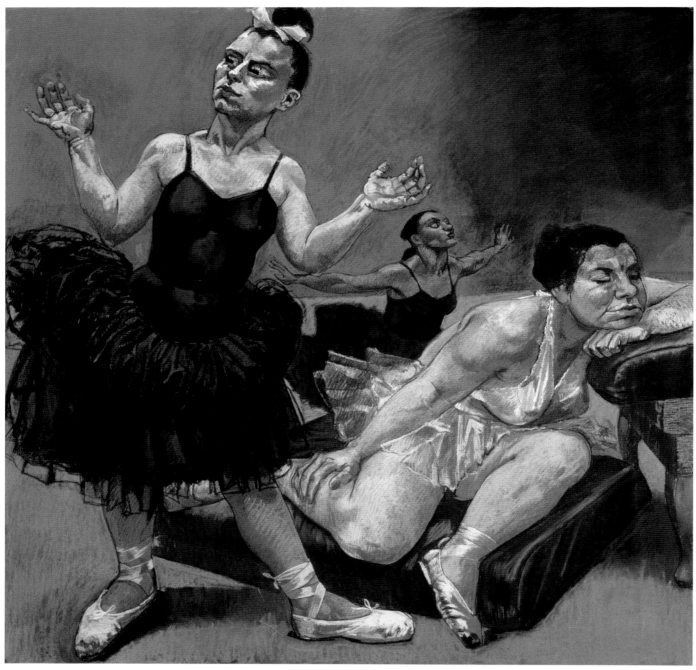

PAULA REGO *Dancing Ostriches from Disney's 'Fantasia'* 1995 Pastel on paper, mounted on aluminium 150 × 150 cm 59 × 59"

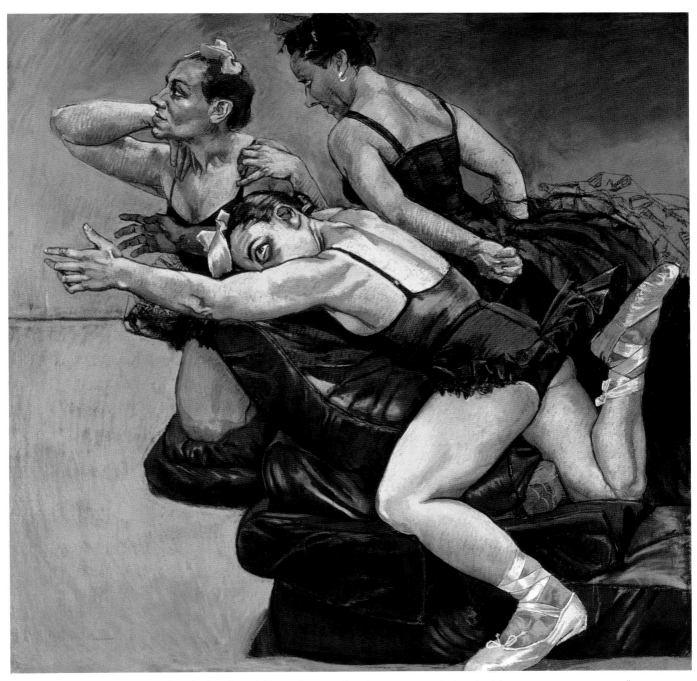

PAULA REGO *Dancing Ostriches from Disney's 'Fantasia'* 1995 Pastel on paper, mounted on aluminium 150 × 150 cm 59 × 59"

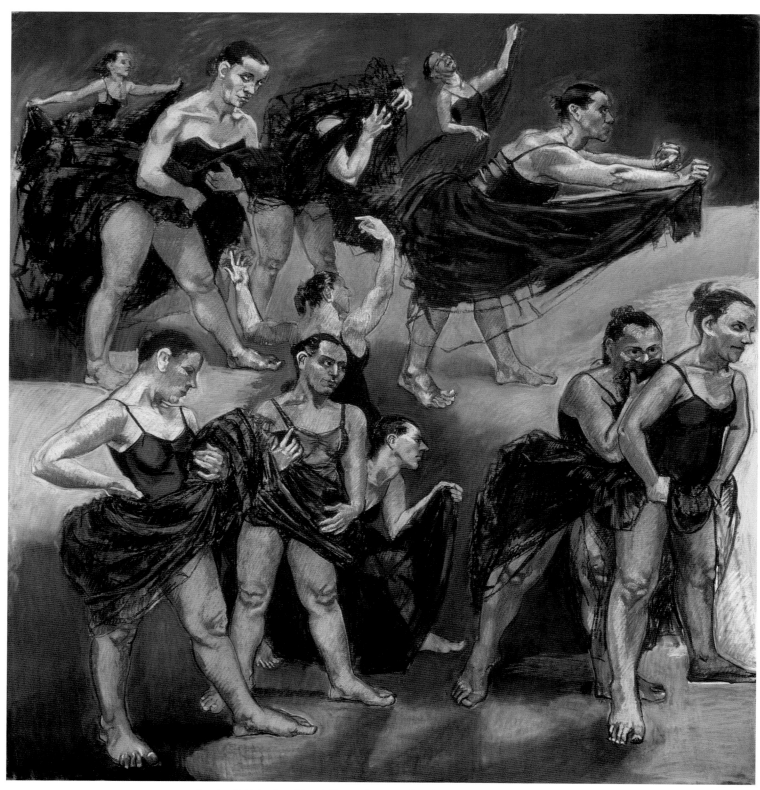

PAULA REGO *Dancing Ostriches from Disney's 'Fantasia'* 1995 Pastel on paper, mounted on aluminium (diptych)
Left panel: 162 × 155 cm 63¾ × 61" Right panel: 160 × 120 cm 63 × 47¼"

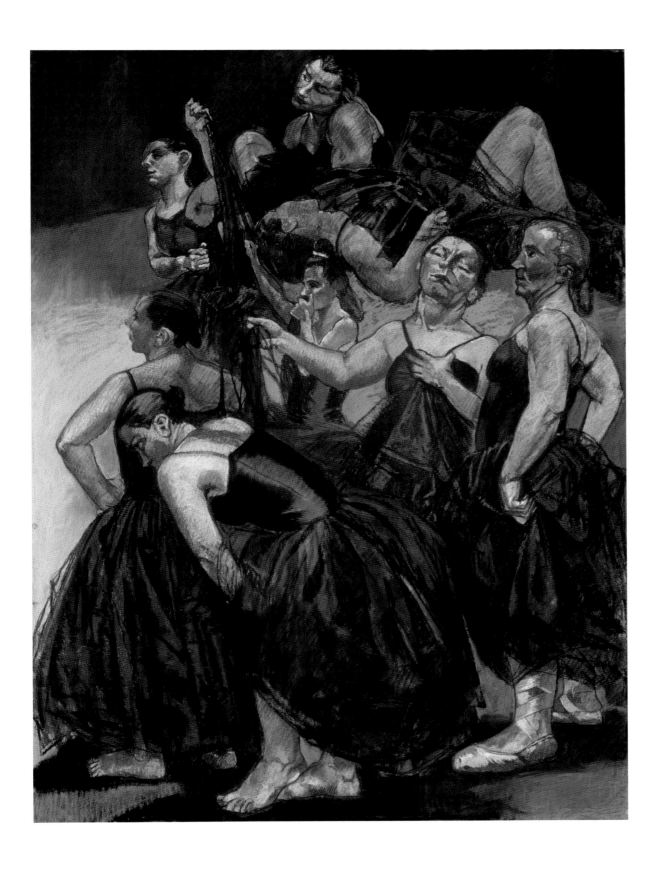

YOUNG AMERICANS

ANTONI, CURRIN, FRIEDMAN, PEYTON, PRINCE, RAY, SALLE, YUSKAVAGE

CHARLES RAY *Firetruck* 1993 Painted aluminium, fibreglass and plexiglass 365.8 × 243.8 × 1417.3 cm 144 × 96 × 558"

CHARLES RAY *Untitled* 1973/1993 Black and white photograph mounted on rag board 49.2 × 102 cm 19¼ × 40¼"

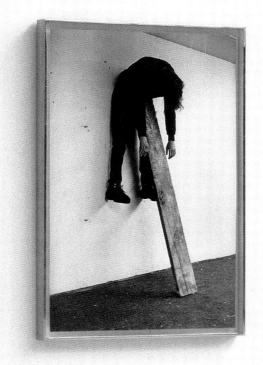
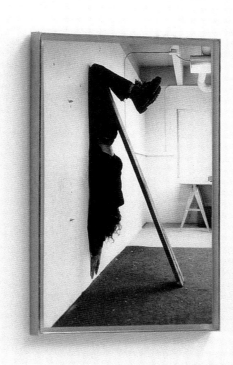
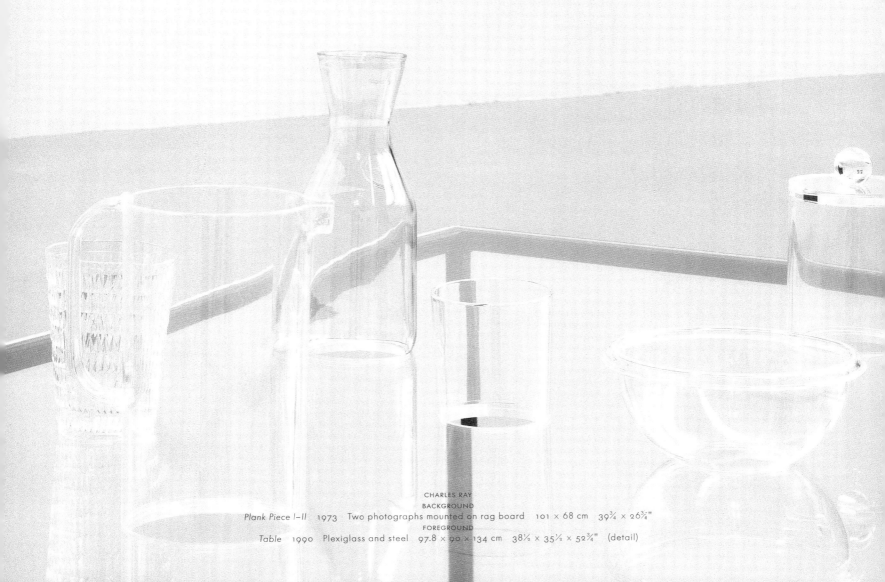

CHARLES RAY
BACKGROUND
Plank Piece I–II 1973 Two photographs mounted on rag board 101 × 68 cm 39¾ × 26¾"
FOREGROUND
Table 1990 Plexiglass and steel 97.8 × 90 × 134 cm 38½ × 35½ × 52¾" (detail)

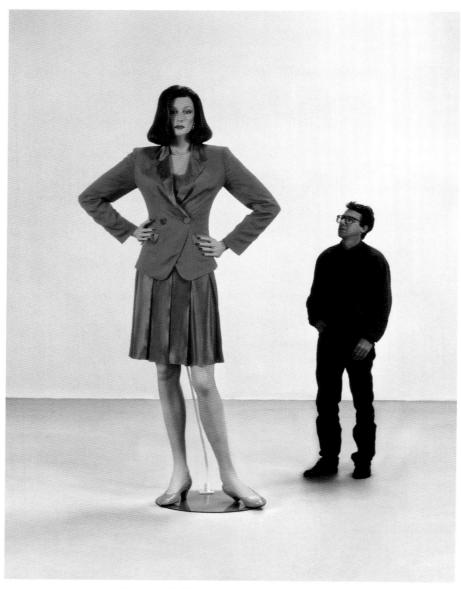

CHARLES RAY *Mannequin Fall '91* 1991 Mixed media Height: 244 cm 96"

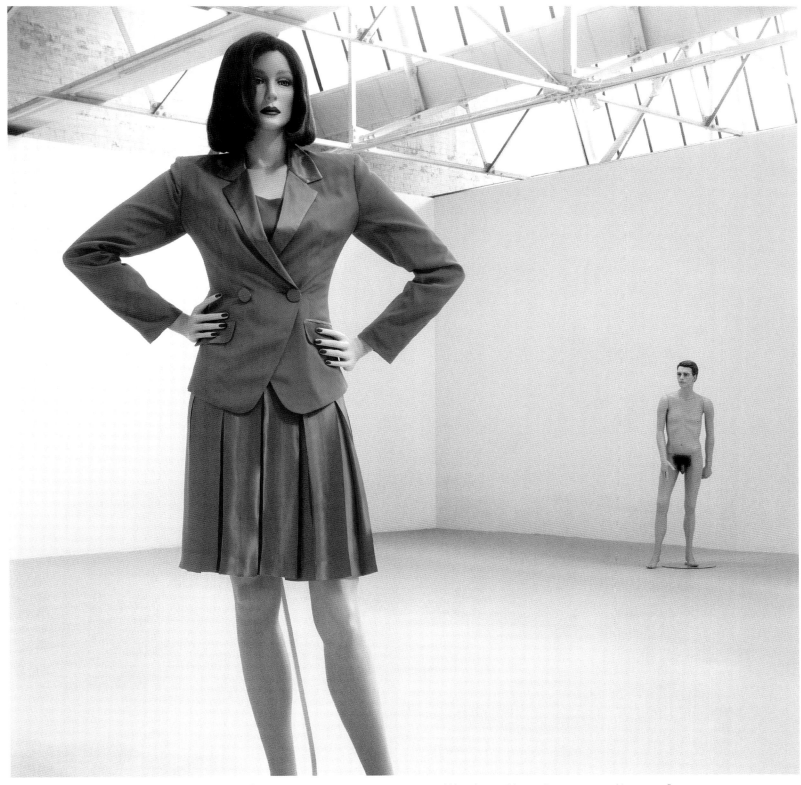

CHARLES RAY (BACKGROUND) *Male Mannequin* 1989 Mannequin and fibreglass 186.7 × 38 × 35.5 cm 73½ × 15 × 14"
CHARLES RAY (FOREGROUND) *Mannequin Fall '91* 1991 Mixed media Height: 244 cm 96"

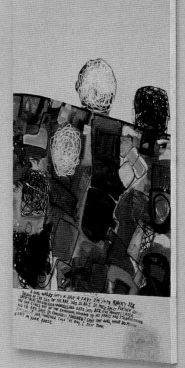

RICHARD PRINCE
BACKGROUND FROM LEFT:
All You Can Eat 1995 Silkscreen and acrylic on canvas 213.4 × 243.8 cm 84 × 96"
Untitled (My Parents) 1995 Silkscreen and acrylic on canvas 190.5 × 147.3 cm 75 × 58"
My Boyfriend Married a Girl 1995 Silkscreen and acrylic on canvas 147.3 × 190.5 cm 58 × 75"
Untitled 1995 Silkscreen and acrylic on canvas 229 × 147.3 cm 90 × 58"

FOREGROUND
CHARLES RAY *Table* 1990 Plexiglass and steel 97.8 × 90 × 134 cm 38⅓ × 35¼ × 52¾"

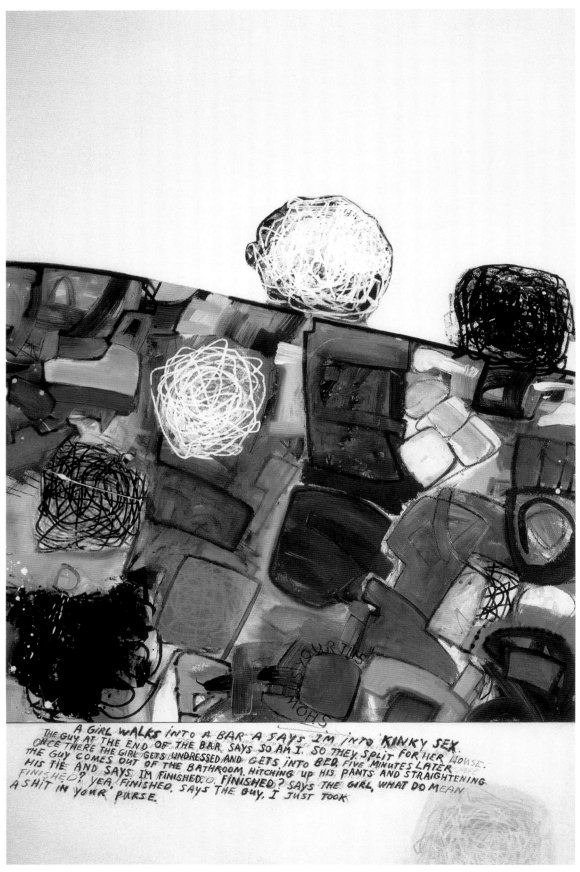

A GIRL WALKS INTO A BAR A SAYS IM INTO KINKY SEX.
THE GUY AT THE END OF THE BAR. SAYS SO AM I. SO THEY SPLIT FOR HER HOUSE.
ONCE THERE THE GIRL GETS UNDRESSED AND GETS INTO BED, FIVE MINUTES LATER
THE GUY COMES OUT OF THE BATHROOM. HITCHING UP HIS PANTS AND STRAIGHTENING.
HIS TIE AND SAYS. IM FINISHED. FINISHED? SAYS THE GIRL, WHAT DO MEAN
FINISHED? YEA, FINISHED, SAYS THE GUY, I JUST TOOK
A SHIT IN YOUR PURSE.

RICHARD PRINCE *Untitled* 1995 Silkscreen and acrylic on canvas 229 × 147.3 cm 90 × 58"

RICHARD PRINCE (LEFT) *Untitled* 1995 Silkscreen and acrylic on canvas 157.5 × 122 cm 62 × 48"
RICHARD PRINCE (MIDDLE) *Untitled* 1995 Silkscreen and acrylic on canvas 157.5 × 122 cm 62 × 48"
RICHARD PRINCE (RIGHT) *Untitled* 1995 Silkscreen and acrylic on canvas 157.5 × 122 cm 62 × 48"

DAVID SALLE *Mingus in Mexico* 1990 Acrylic and oil on canvas 243.8 × 312.4 cm 96 × 123"

DAVID SALLE *Mr. Lucky* 1998 Acrylic and oil on canvas and linen 239 × 340 cm 94 × 134"

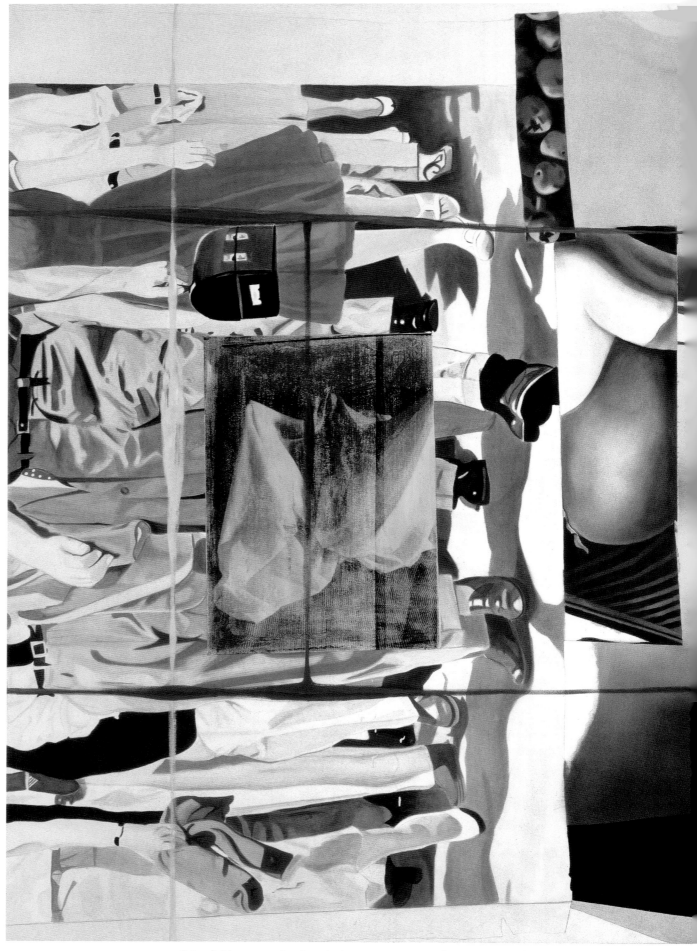

DAVID SALLE *Picture Builder* 1993 Acrylic and oil on canvas 213.4 × 289.6 cm 84 × 114"

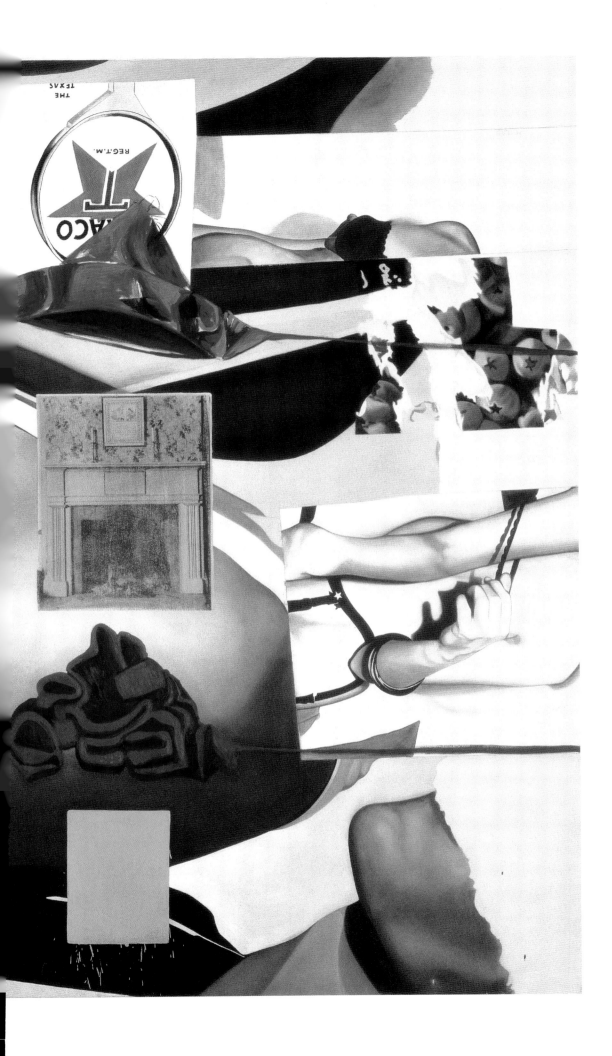

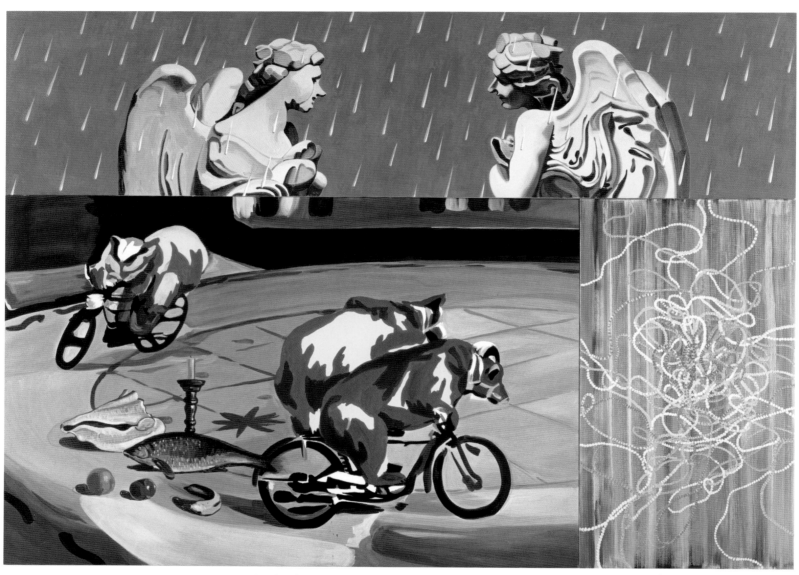

DAVID SALLE *Angels in the Rain* 1998 Acrylic and oil on canvas 244 × 335 cm 96 × 132"

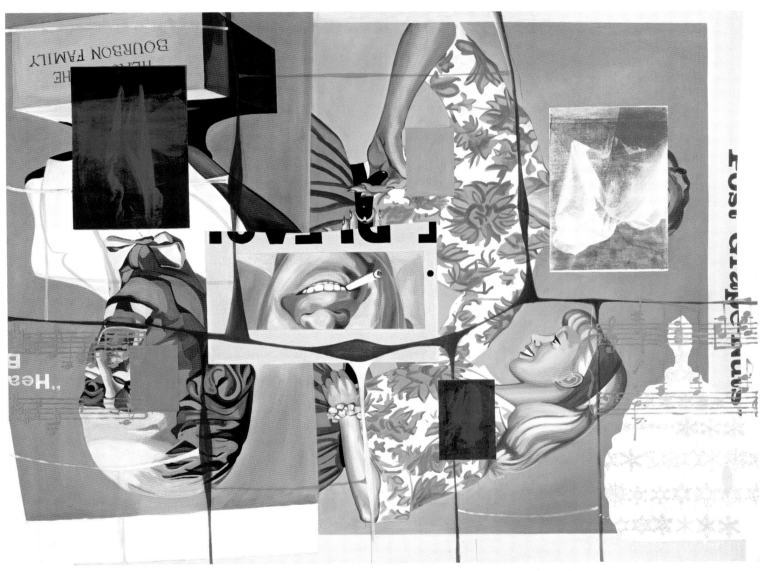

DAVID SALLE *Bigger Rack* 1998 Acrylic and oil on canvas 244 × 335 cm 96 × 132"

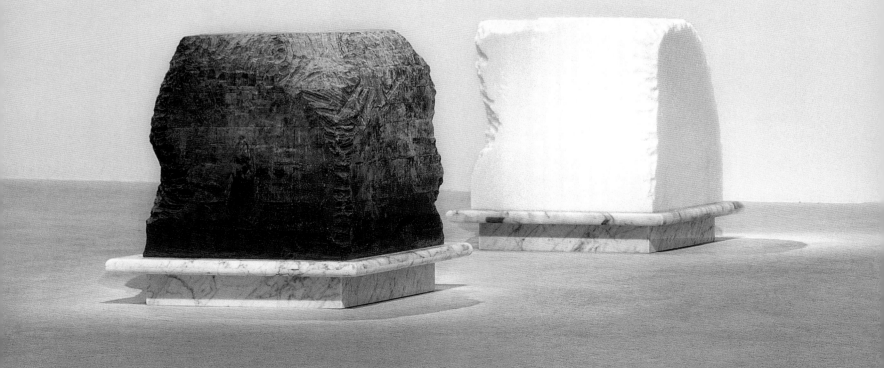

JANINE ANTONI · *Gnaw* · 1992 · 600 lbs of chocolate and 600 lbs of lard, gnawed by the artist · Each cube: 61 × 61 × 61 cm · 24 × 24 × 24″ · (detail)

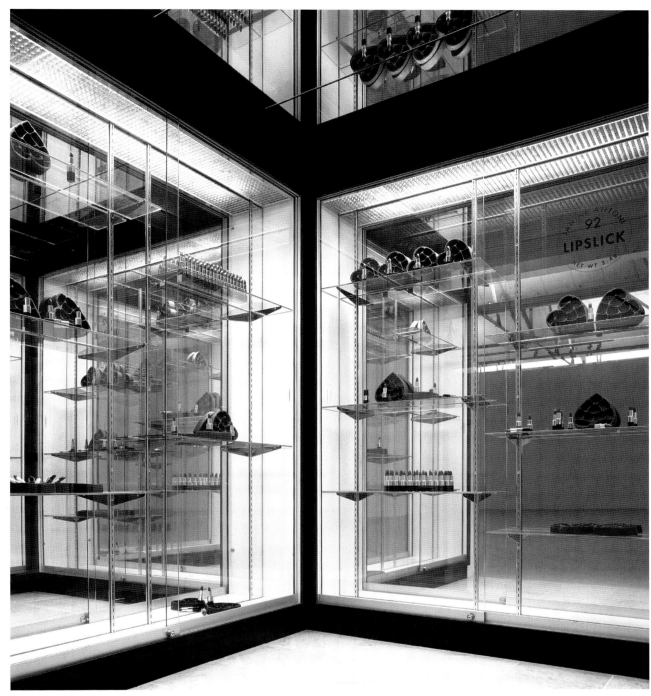

JANINE ANTONI *Gnaw* 1992 Display case with 45 heart-shaped packages for chocolate made from chewed chocolate removed from the chocolate cube and 400 lipsticks made with pigment, beeswax and chewed lard removed from the lard cube Dimensions variable (detail)

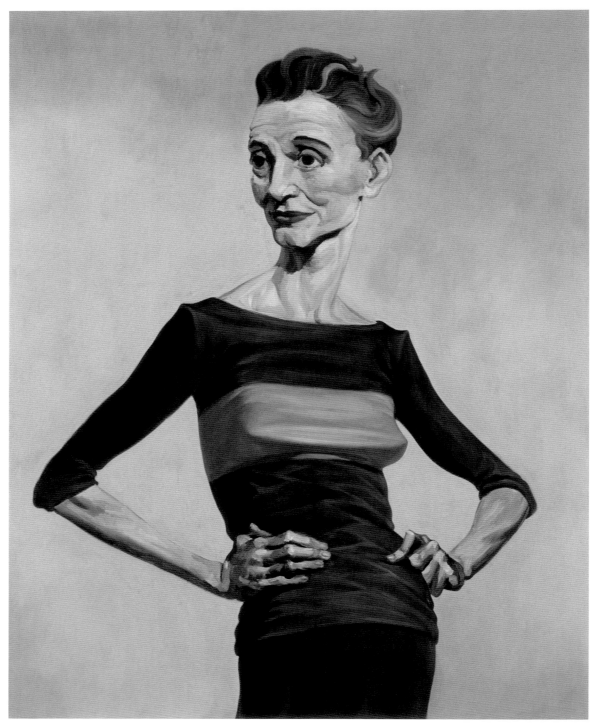

JOHN CURRIN *Ms. Omni* 1993 Oil on canvas 122 × 96.5 cm 48 × 38"

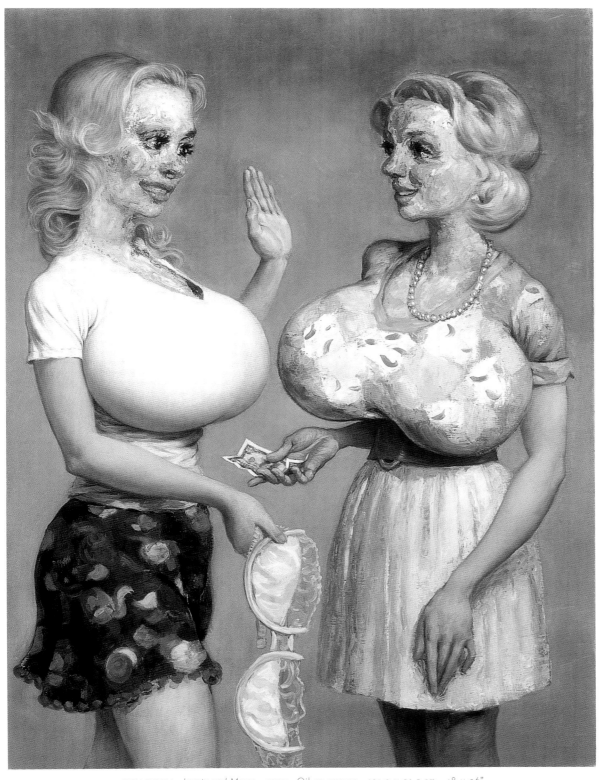

JOHN CURRIN *Jaunty and Mame* 1997 Oil on canvas 121.9 × 91.5 cm 48 × 36"

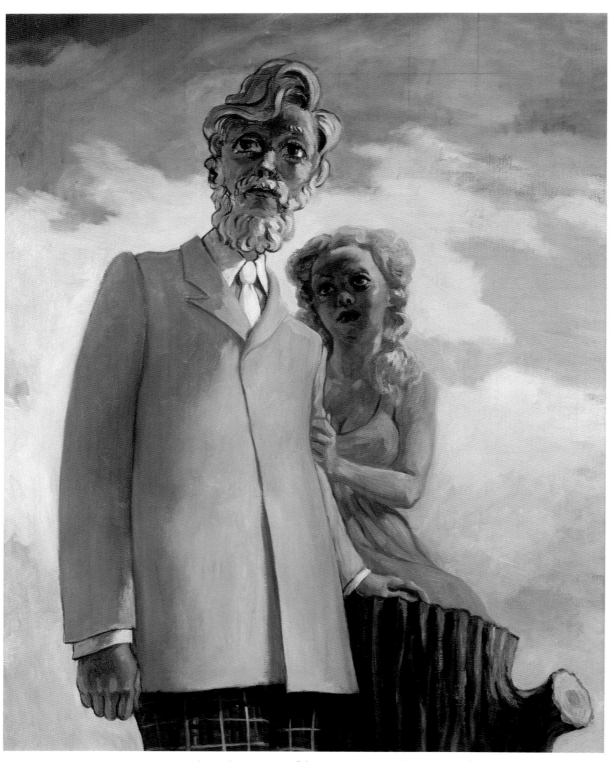

JOHN CURRIN *Autumn Lovers* 1994 Oil on canvas 101.5 × 81 cm 40 × 32"

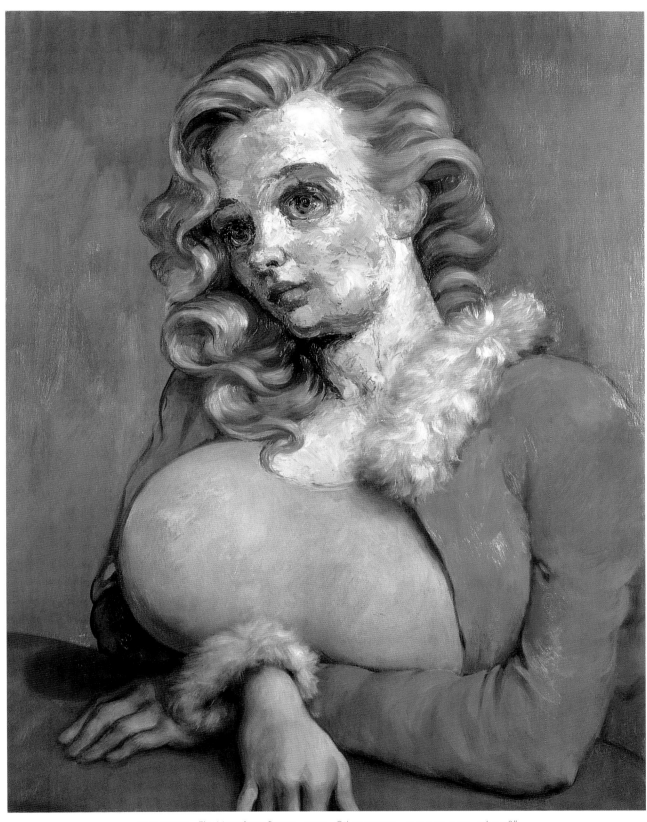

JOHN CURRIN *The Magnificent Bosom* 1997 Oil on canvas 91.7 × 71.2 cm 36 × 28"

JOHN CURRIN *The Dream of the Doctor* 1997 Oil on canvas 198.1 × 154.9 cm 78 × 61"

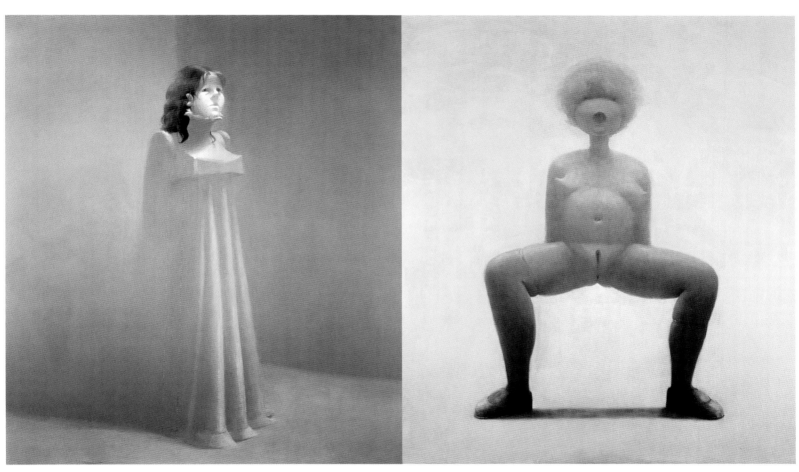

LISA YUSKAVAGE *Transference Blot Portrait of My Shrink in Her Starched Nightgown with My Face and Her Hair/Rorschach Blot* 1995
Oil on linen (diptych) Each panel: 213.4 × 183 cm 84 × 72"

TOM FRIEDMAN *Untitled* 1990 A partially used bar of soap inlaid with a spiral of pubic hair 7.6 × 10.2 × 3.8 cm 3 × 4 × 1½"

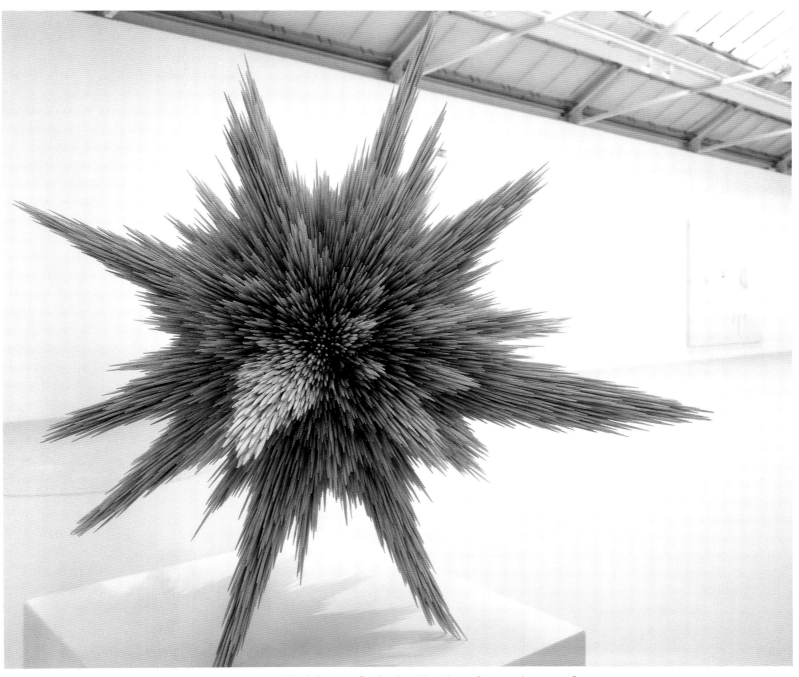

TOM FRIEDMAN *Untitled* 1995 Toothpicks 66 × 76.2 × 58.4 cm 26 × 30 × 23"

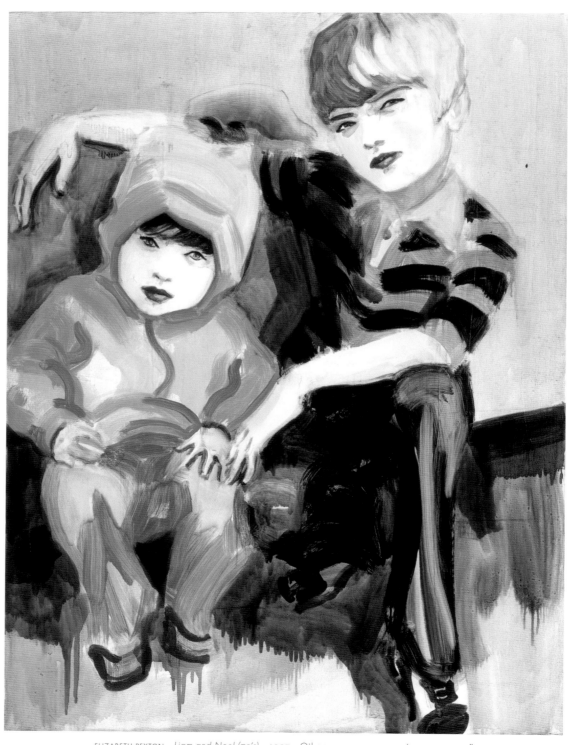

ELIZABETH PEYTON *Liam and Noel (70's)* 1997 Oil on canvas 102 × 76 cm 40 × 30"

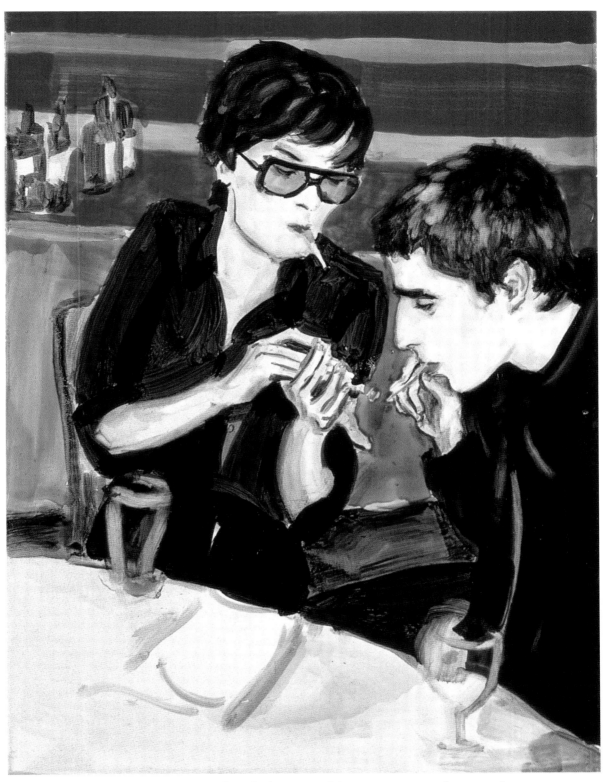

ELIZABETH PEYTON *Jarvis and Liam Smoking* 1997 Oil on canvas 30.4 × 22.8 cm 12 × 9"

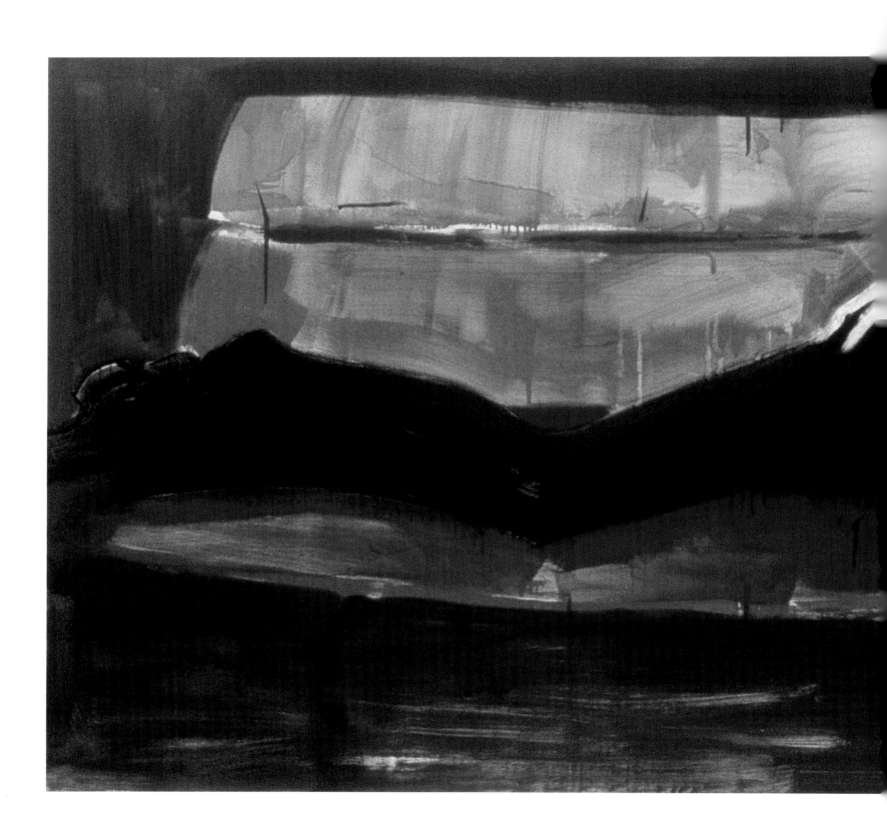

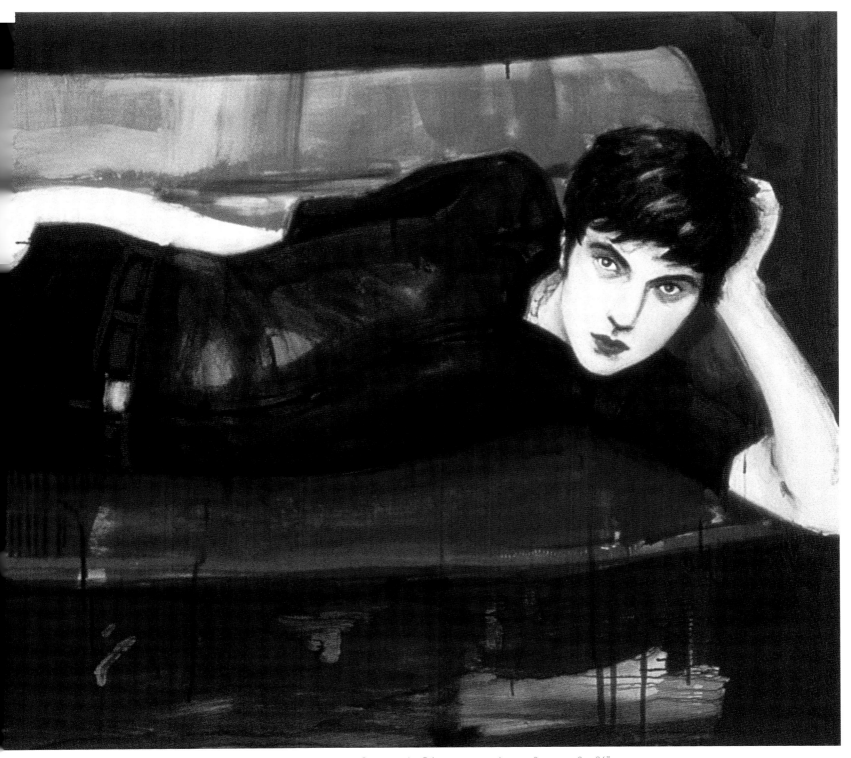

ELIZABETH PEYTON *Piotr* 1996 Oil on canvas 96.5 × 218.4 cm 38 × 86"

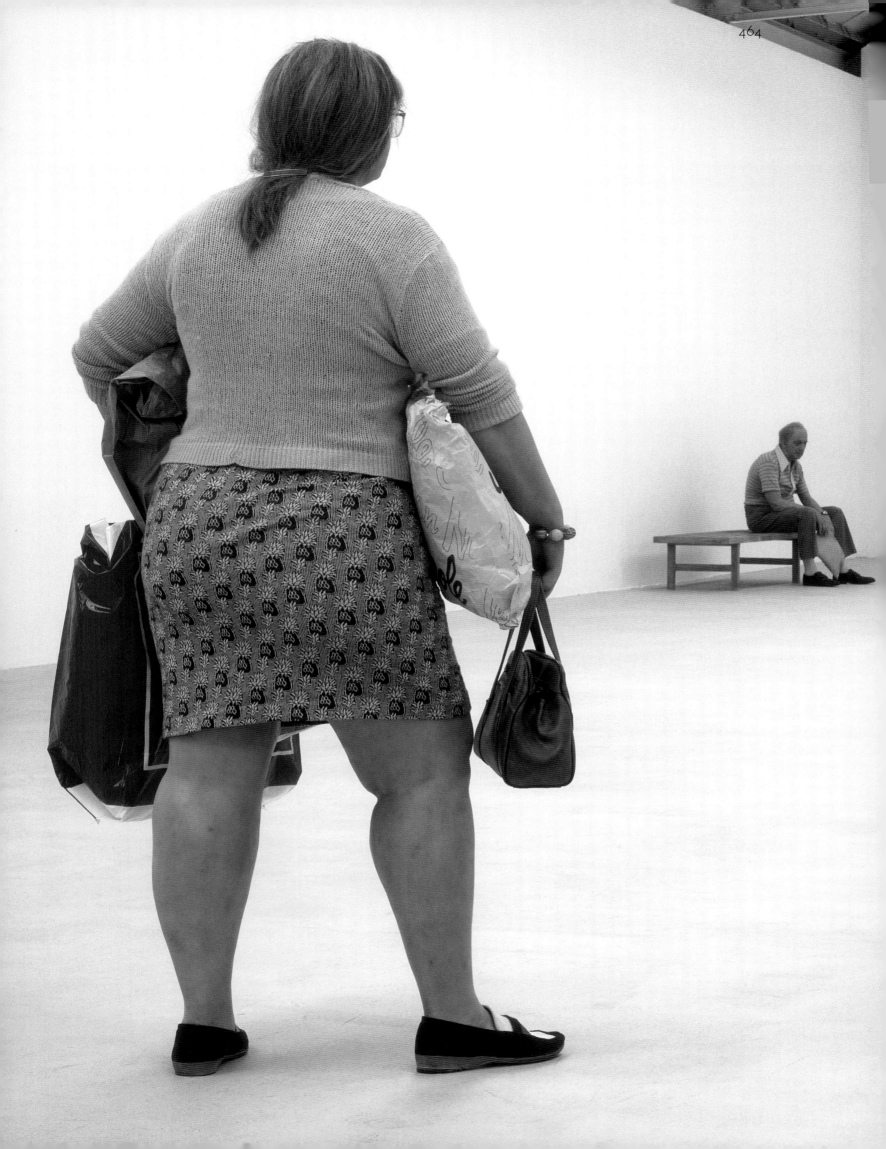

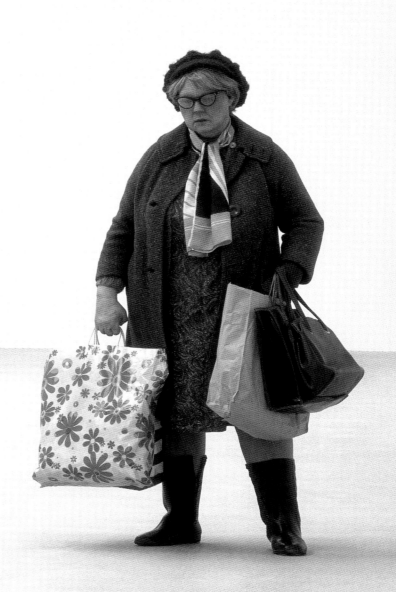

DUANE HANSON
LEFT TO RIGHT
Young Shopper 1973 Polyester and fibreglass, polychromed in oil, with accessories Life-size
Man on a Bench 1977–78 Vinyl, polychromed in oil, with accessories Life-size
Lady with Shopping Bags 1972 Polyester resin and fibreglass, polychromed in oil, with accessories Life-size

DUANE HANSON *Man on a Bench* 1977–78 Vinyl, polychromed in oil, with accessories Life-size

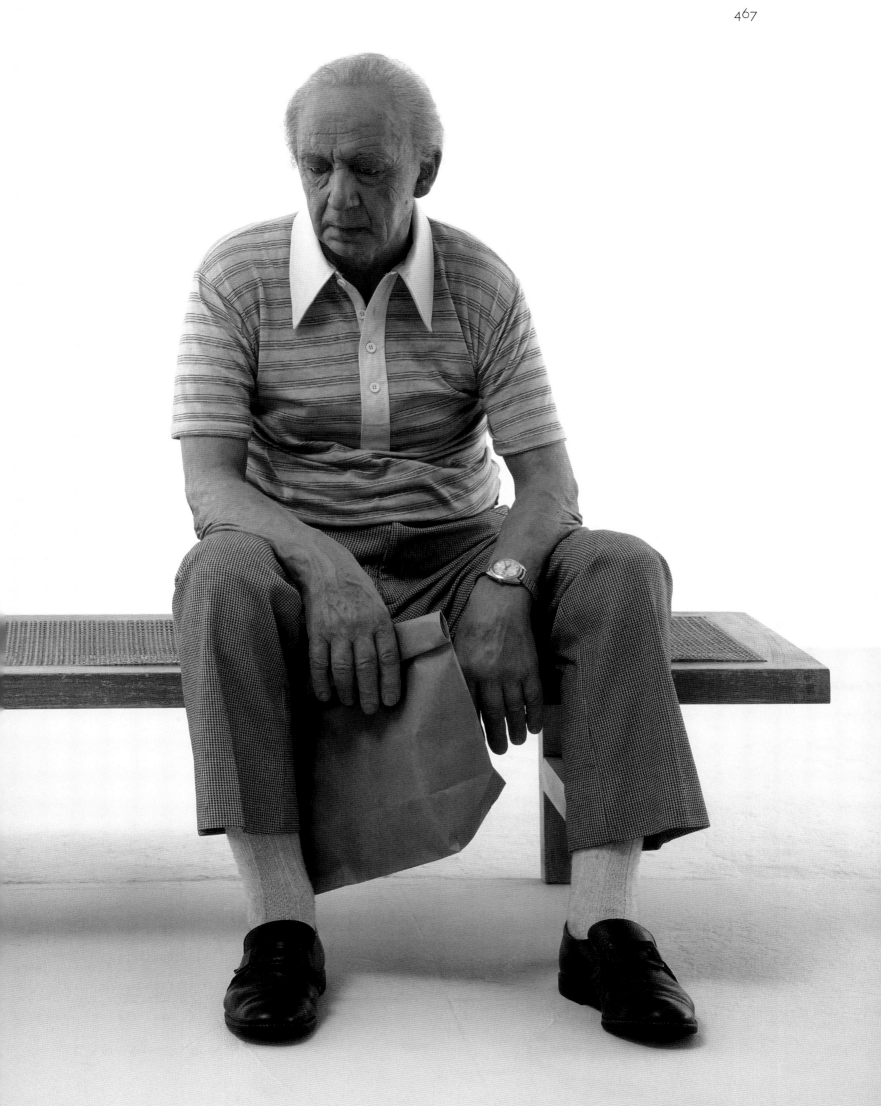

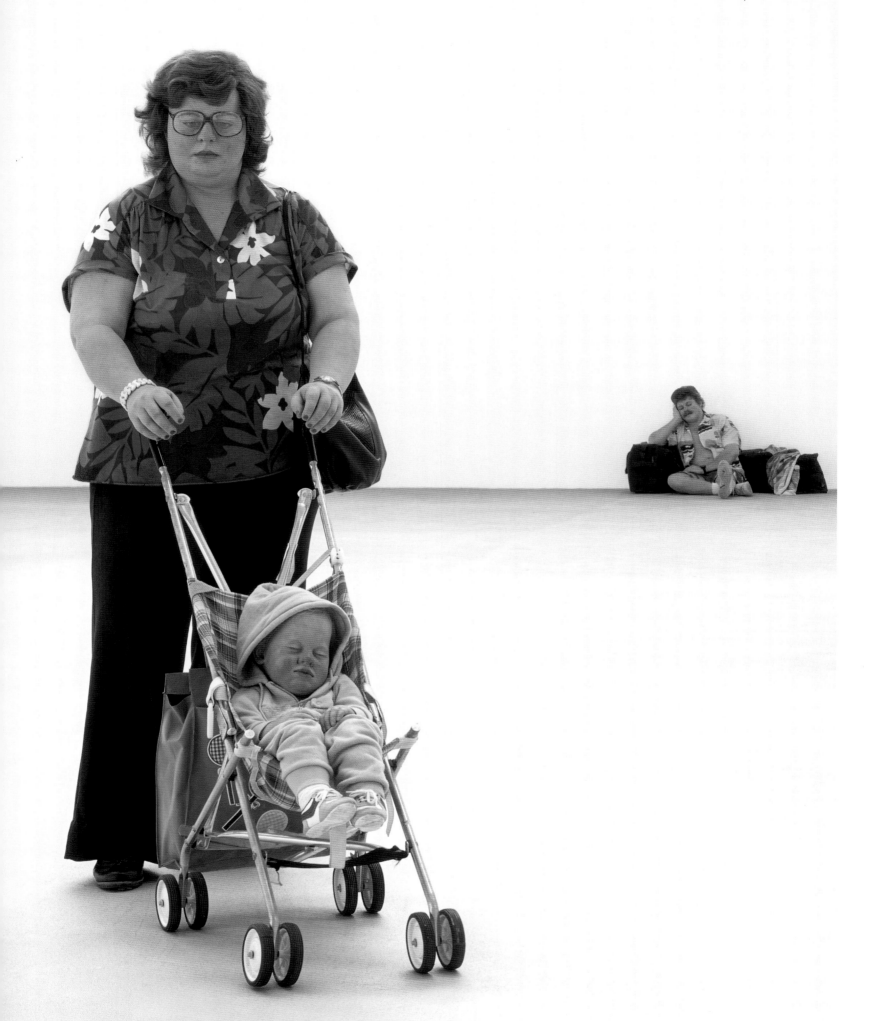

DUANE HANSON
LEFT TO RIGHT
Woman with Child in Stroller 1985 Autobody filler, polyvinyl and mixed media, with accessories Life-size
Traveller 1988 Autobody filler, fibreglass and mixed media, with accessories Life-size

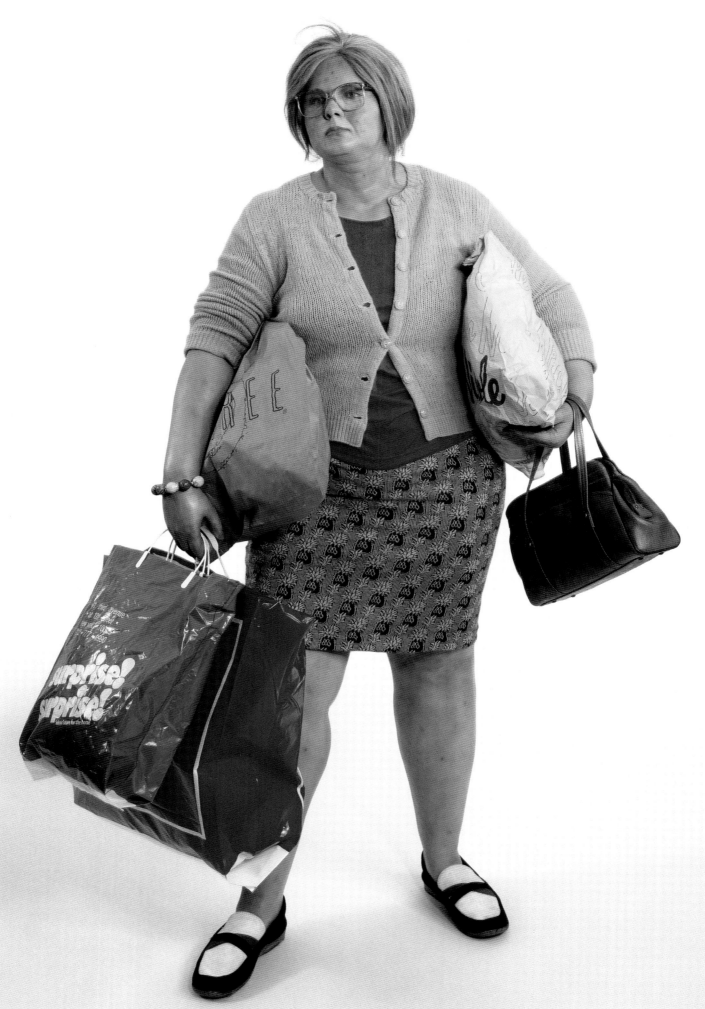

DUANE HANSON *Young Shopper* 1973 Polyester and fibreglass, polychromed in oil, with accessories Life-size

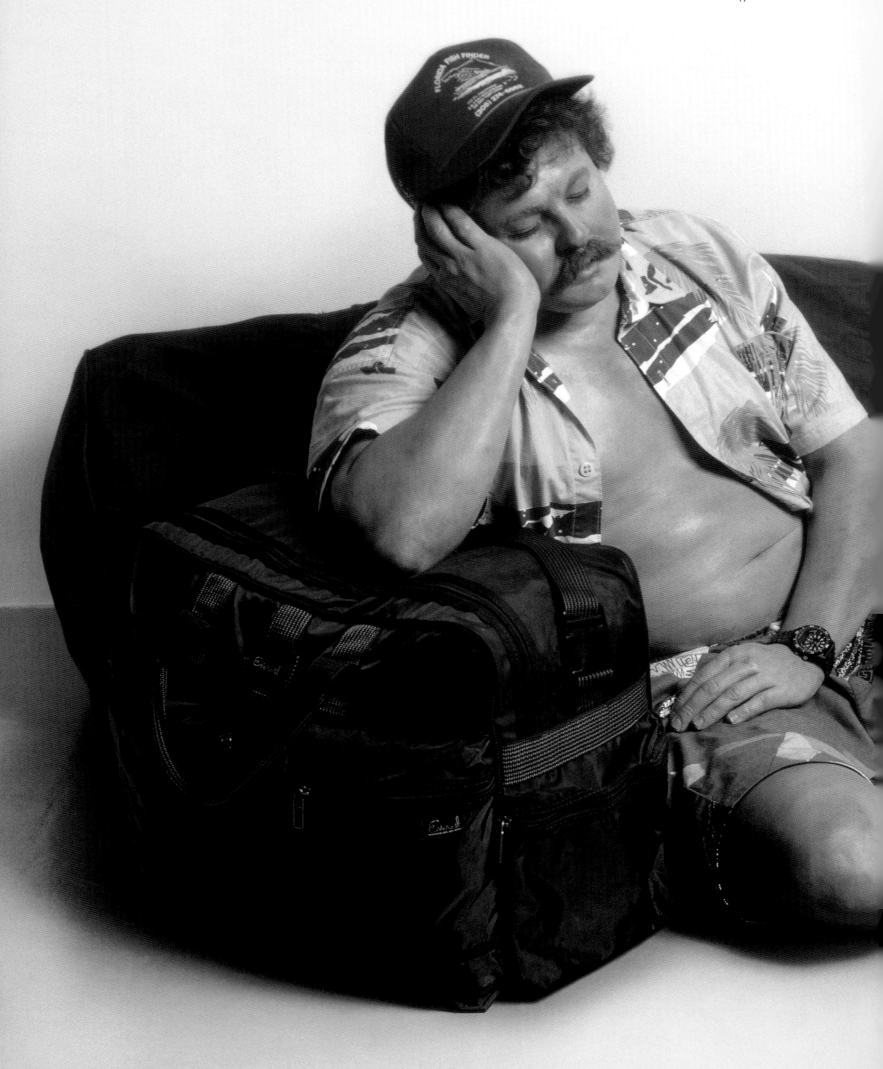

DUANE HANSON *Traveller* 1988 Autobody filler, fibreglass and mixed media, with accessories Life-size

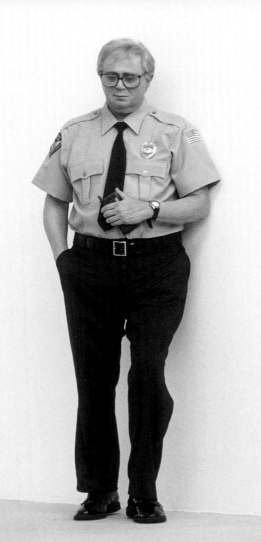

DUANE HANSON
LEFT TO RIGHT
Security Guard 1990 Polychromed bronze, with accessories Life-size
Flea Market Vendor 1990 Polychromed bronze, with accessories Life-size

DUANE HANSON *Tourists II* 1988 Autobody filler, fibreglass and mixed media, with accessories Life-size

DUANE HANSON *Queenie II* 1988 Polychromed bronze, with accessories Life-size

YOUNG GERMAN ARTISTS

BALKENHOL,
GURSKY,
HONERT, RUFF,
SCHÜTTE

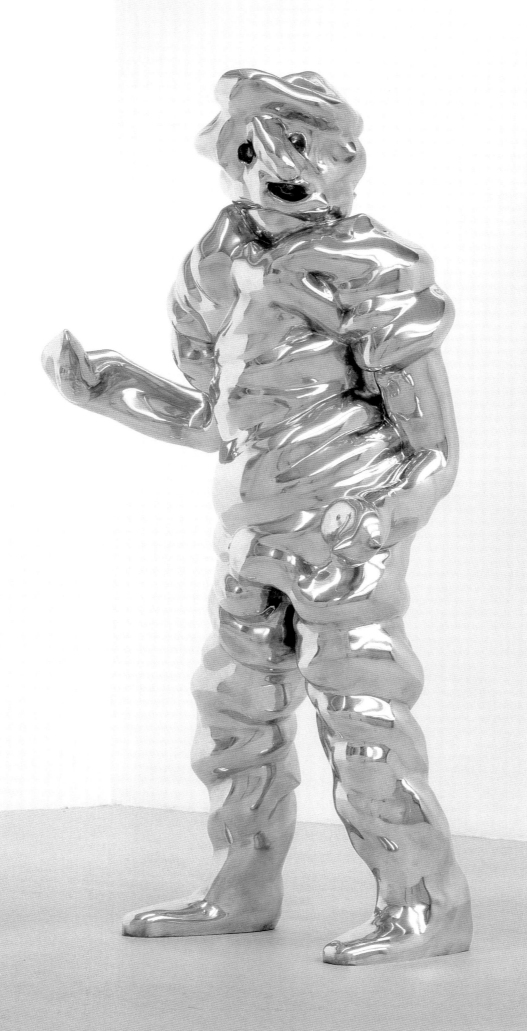

THOMAS SCHÜTTE *Grosse Geister* [Big Ghosts] 1996 Three cast aluminium figures Figure 1: 244 × 152 × 102 cm 96 × 59¾ × 40¼"
Figure 2: 241 × 117 × 112 cm 95 × 46 × 44" Figure 3: 241 × 117 × 91 cm 95 × 46 × 35¾" (detail)

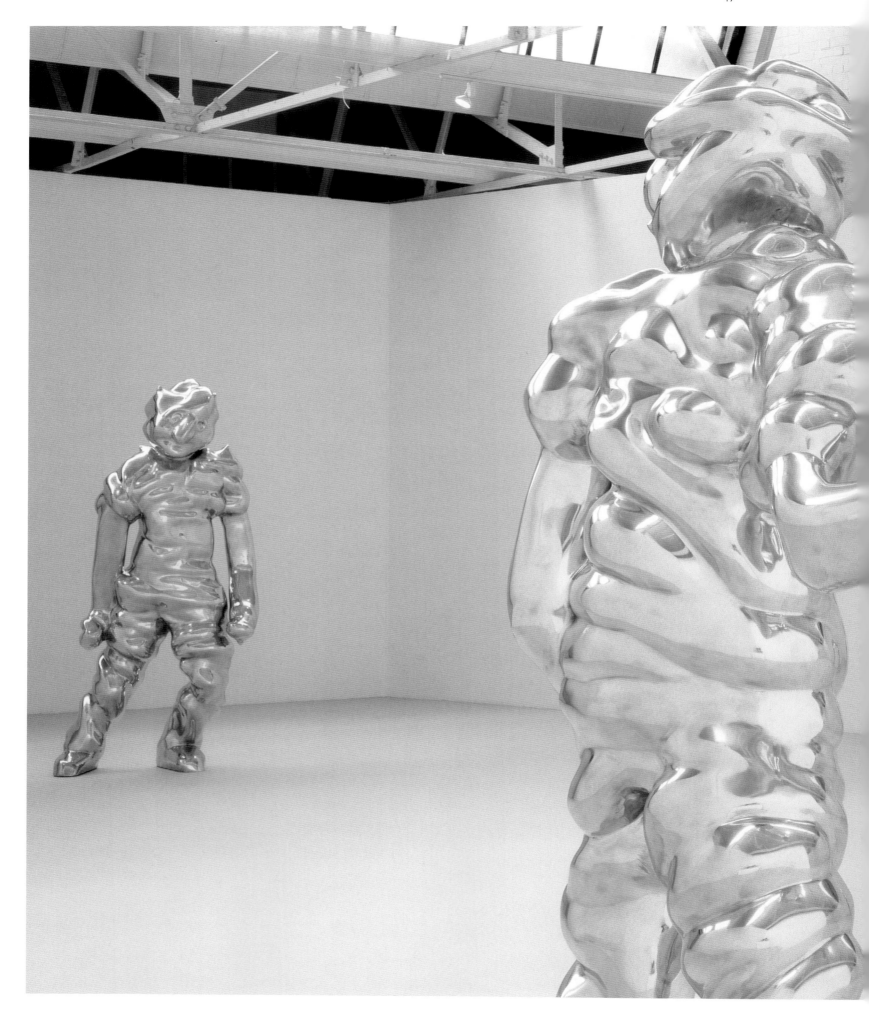

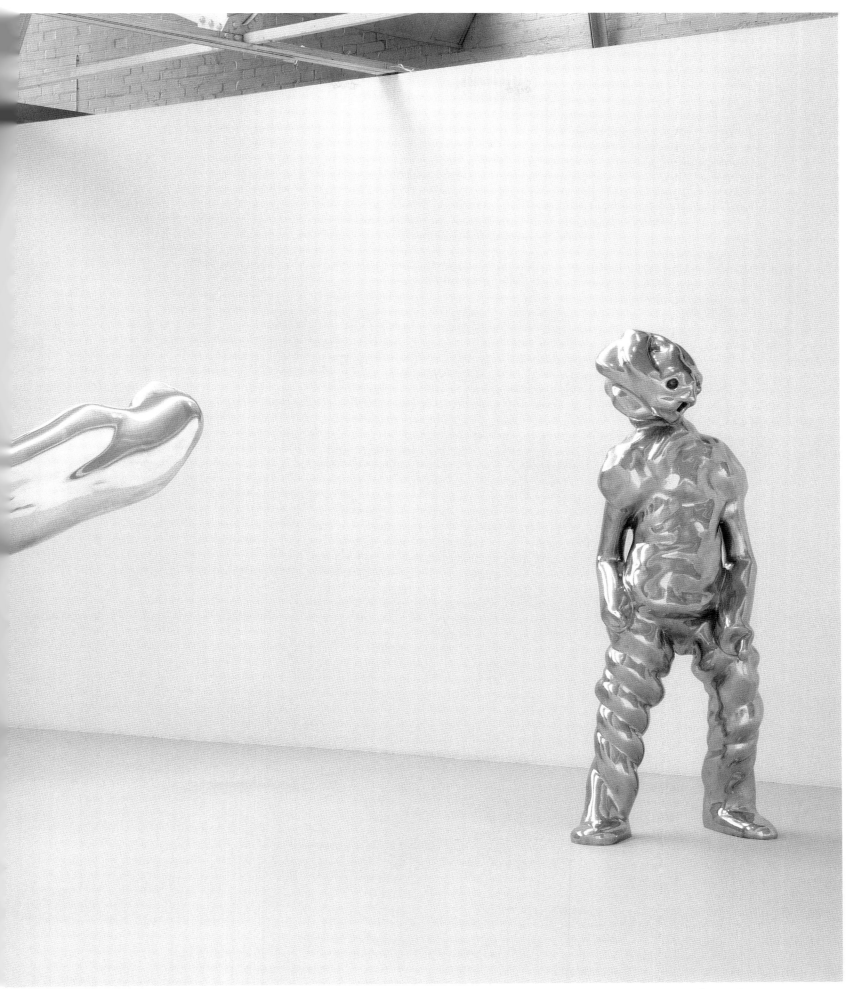

THOMAS SCHÜTTE *Grosse Geister* [*Big Ghosts*] 1996 Three cast aluminium figures Figure 1: 244 × 152 × 102 cm 96 × 59¾ × 40¼"
Figure 2: 241 × 117 × 112 cm 95 × 46 × 44" Figure 3: 241 × 117 × 91 cm 95 × 46 × 35¾"

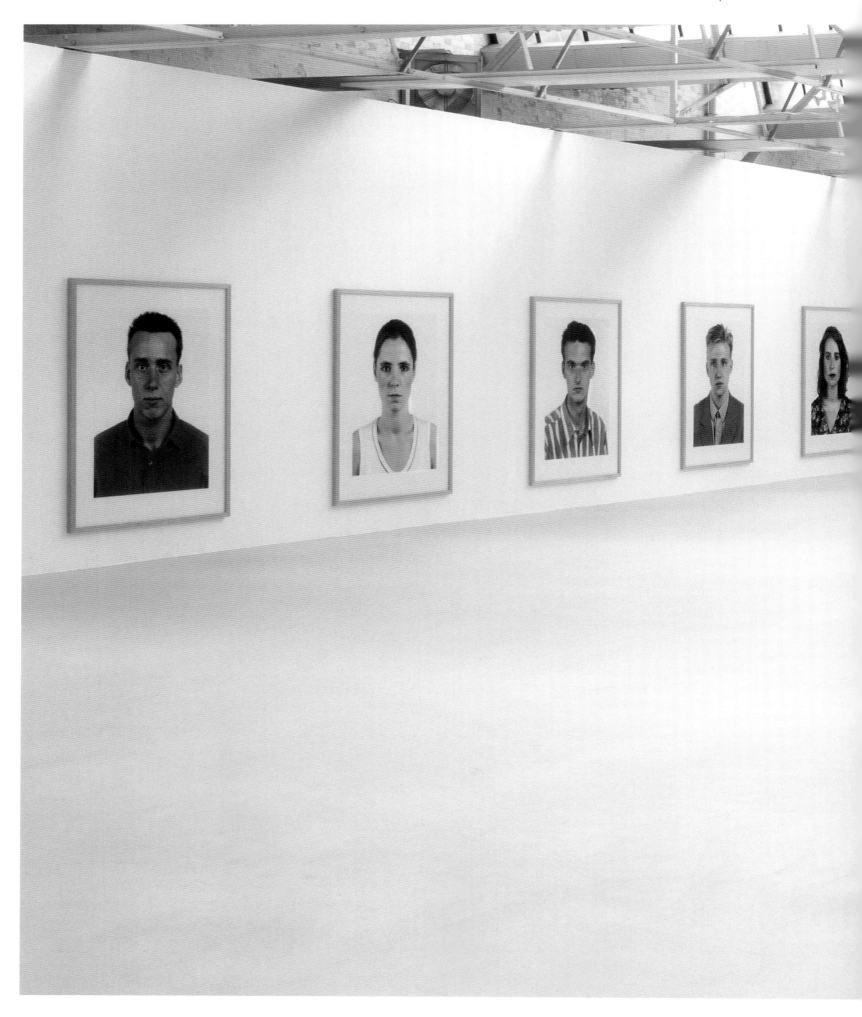

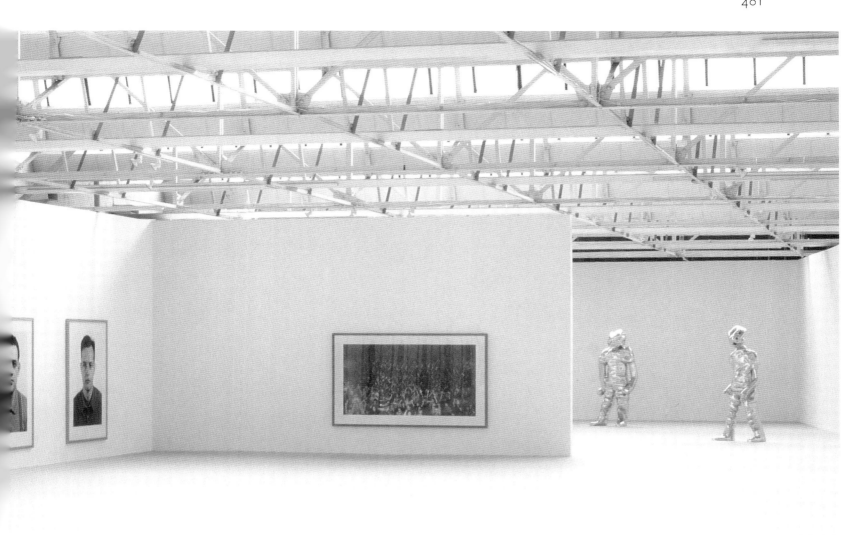

THOMAS RUFF (LEFT) *Porträts [Portraits]* (M. Turk, A. Geise, A. Siekeman, O. Cleslik, C. Pilar, Stoya, E. Zapp) 1986–90 C-prints, plexiglass and wood
Approximate dimensions of each portrait: 210 × 165 cm 82¾ × 65"
ANDREAS GURSKY (MIDDLE) *Union Rave* 1995 C-print 164 × 275 cm 64¼ × 108¼"
THOMAS RUFF (RIGHT) THOMAS SCHÜTTE *Grosse Geister [Big Ghosts]* 1996 Three cast aluminium figures Figure 1: 244 × 152 × 102 cm 96 × 59¾ × 40¼"
Figure 2: 241 × 117 × 112 cm 95 × 46 × 44" Figure 3: 241 × 117 × 91 cm 95 × 46 × 35¾" (detail)

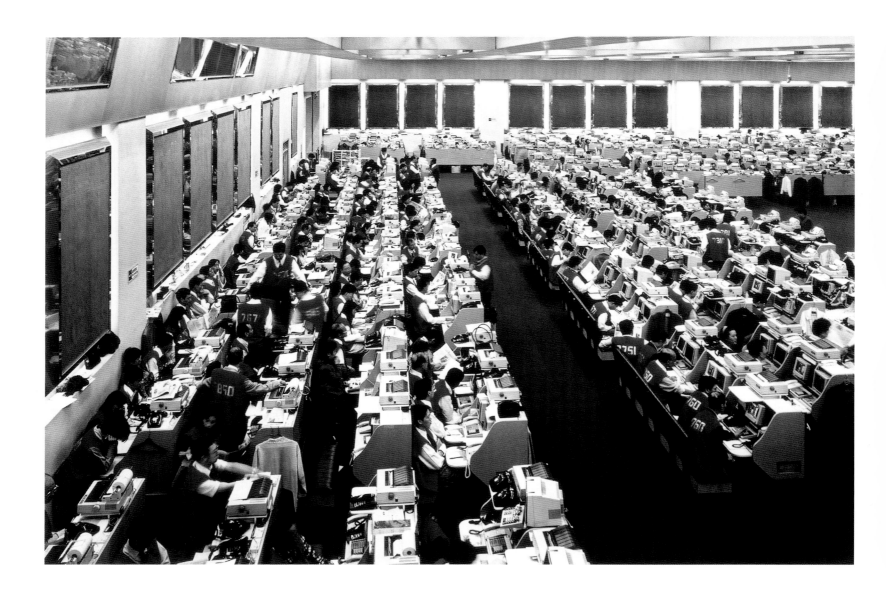

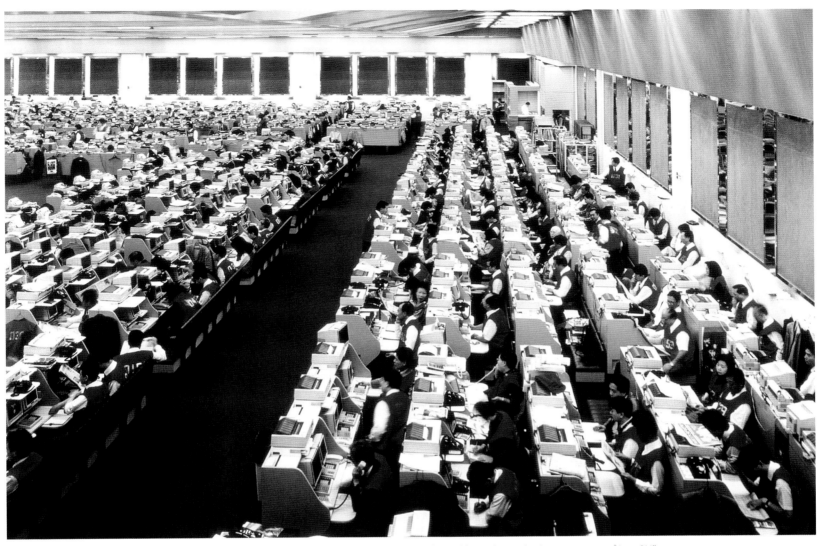

ANDREAS GURSKY *Hong Kong Stock Exchange* 1994 C-print (diptych) Each panel: 180 × 250 cm 70¾ × 98½"

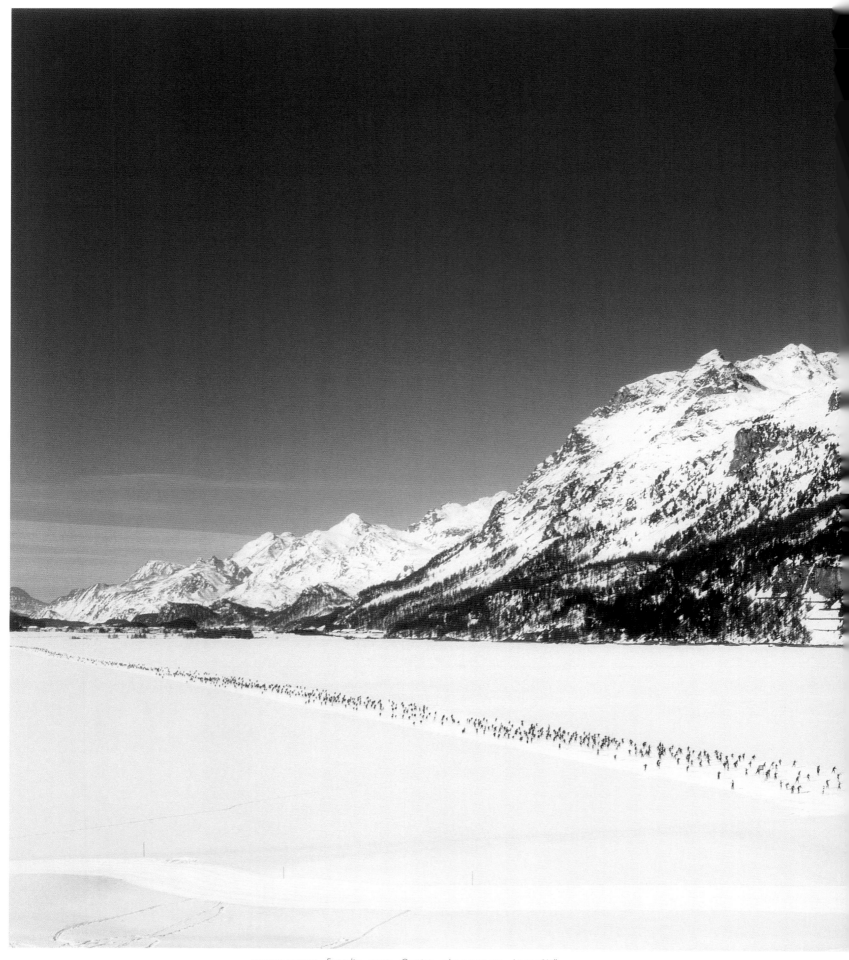

ANDREAS GURSKY *Engadin* 1995 C-print 160 × 250 cm 63 × 98⅛"

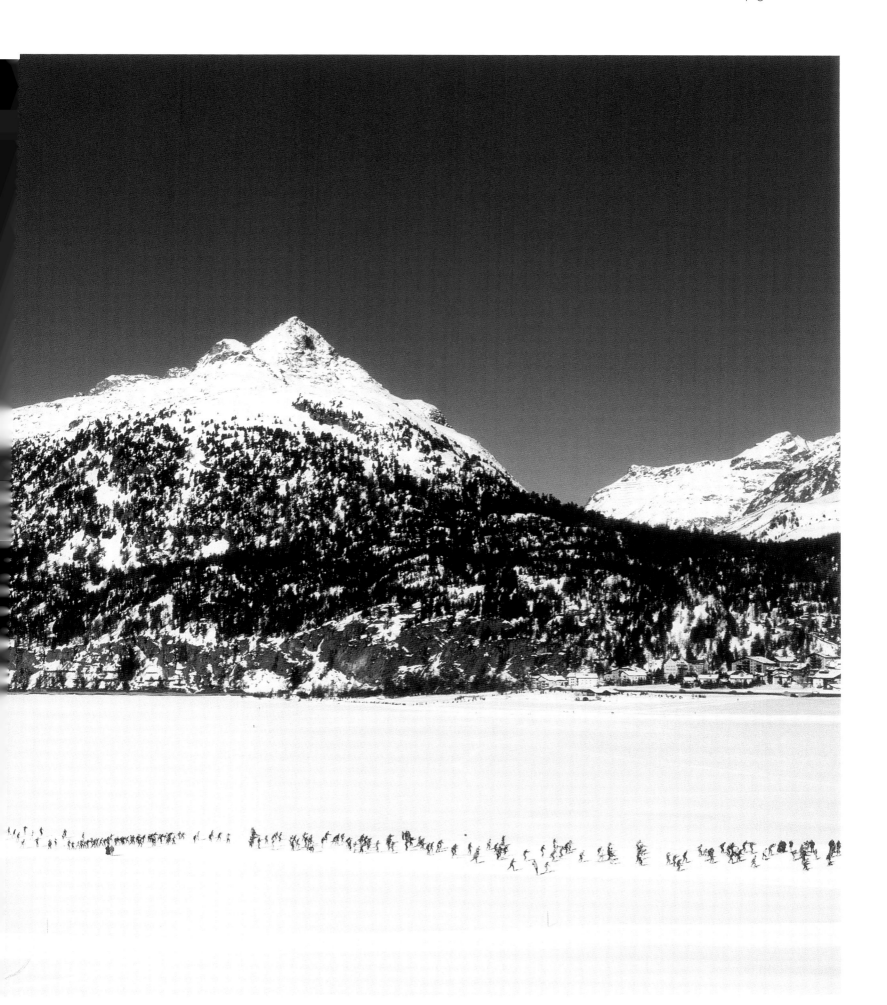

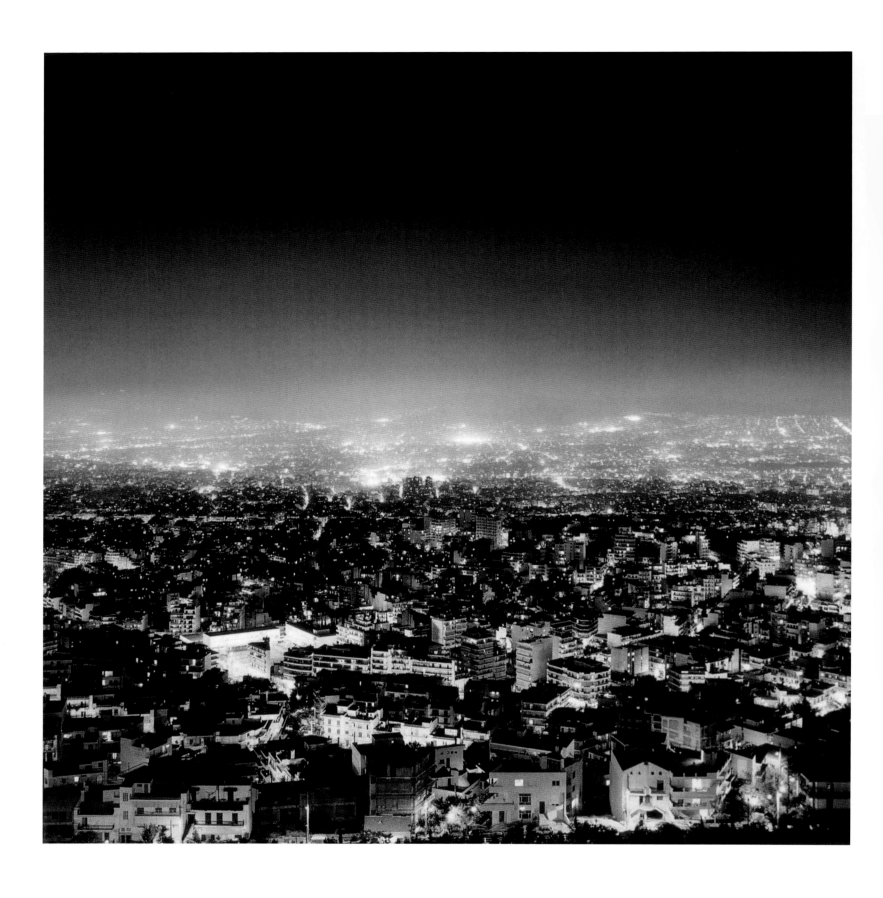

ANDREAS GURSKY *Athens* 1995 C-print (diptych) Each panel: 180 x 180 cm 70¾ x 70¾"

ANDREAS GURSKY *Atlanta* 1996 C-Print 180 × 253 cm 71 × 99¾"

ANDREAS GURSKY *Grundig, Nürnberg* 1993 C-print 169 × 204 cm 66½ × 80¼"

ANDREAS GURSKY *Hong Kong Shanghai Bank* 1994 C-print 220 × 170 cm 86⅔ × 67"

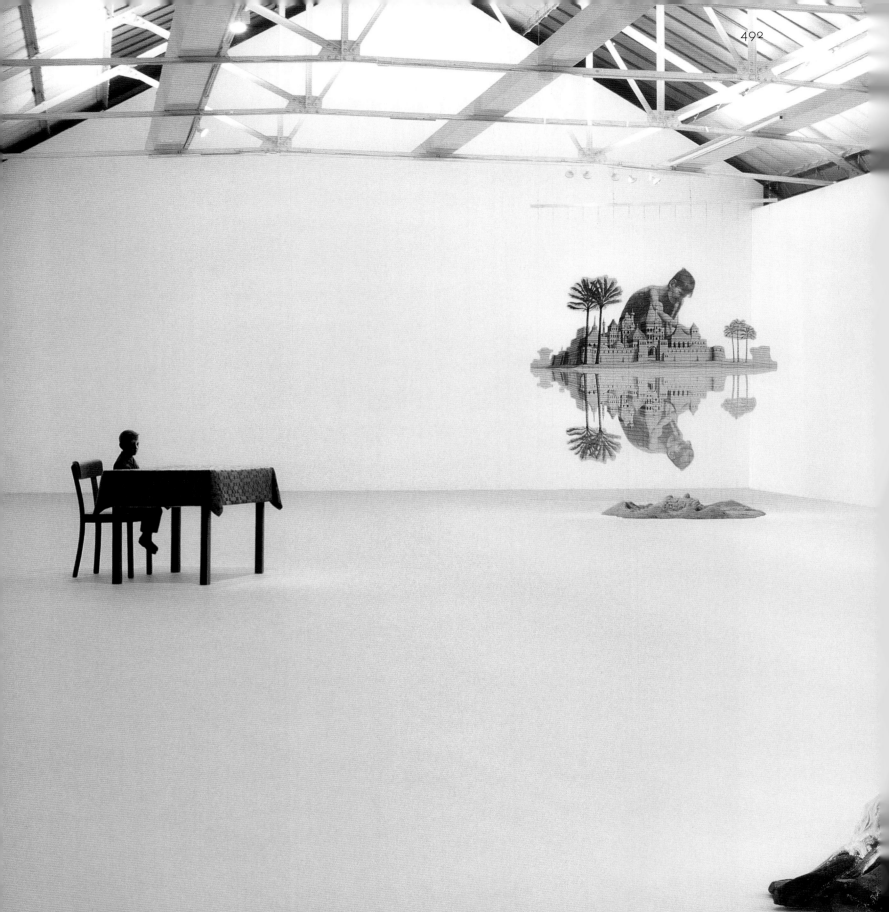

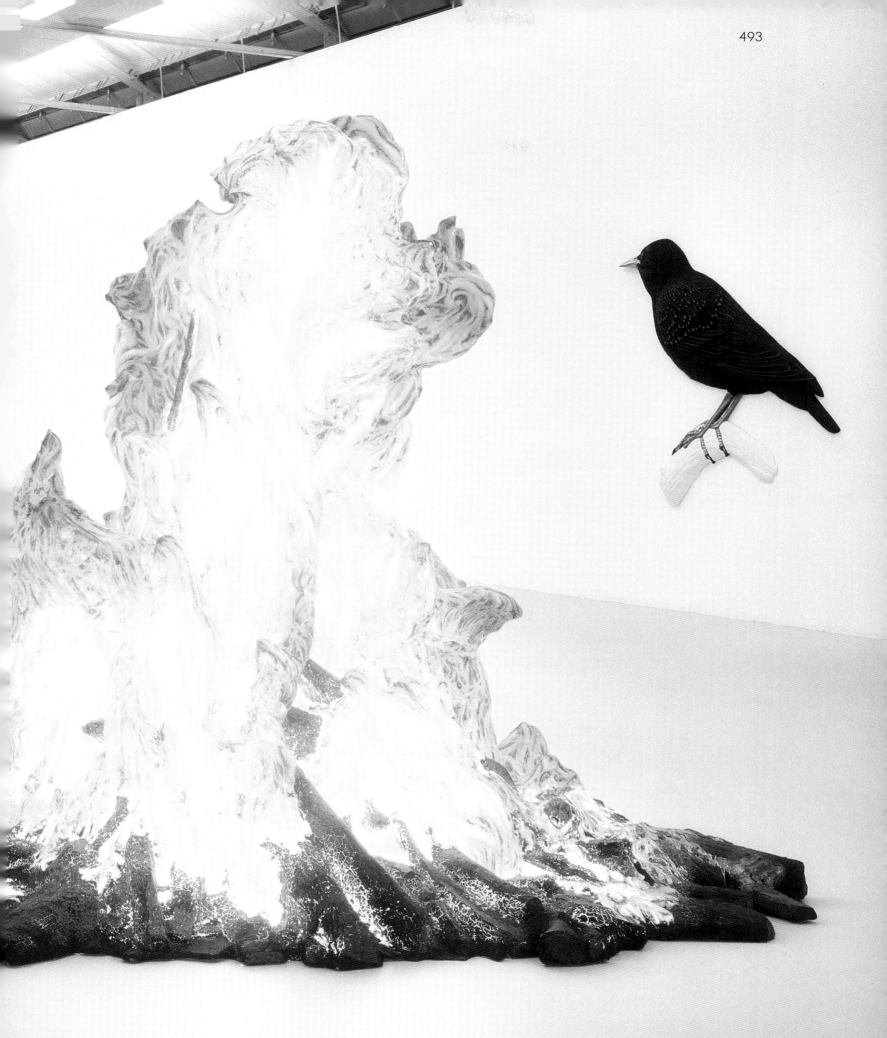

MARTIN HONERT

CLOCKWISE FROM FAR LEFT

Foto [Photo] 1993 Epoxy, wood and paint Height of figure: 100 cm 39¼" Table: 79 × 73 × 123 cm 31 × 28¾ × 48½"
Fata Morgana [Mirage] 1996 Epoxy, polyester and sand Image: 260 × 320 cm 102¼ × 126" Sand castle: 240 × 180 cm 94¼ × 70¾"
Vogel [Bird] 1992 Polyester and paint 195 × 171 × 16 cm 76¾ × 67¼ × 6¼"
Feuer [Fire] 1992 Polyester, paint and light 245 × 205 × 205 cm 96¼ × 80¾ × 80¾"

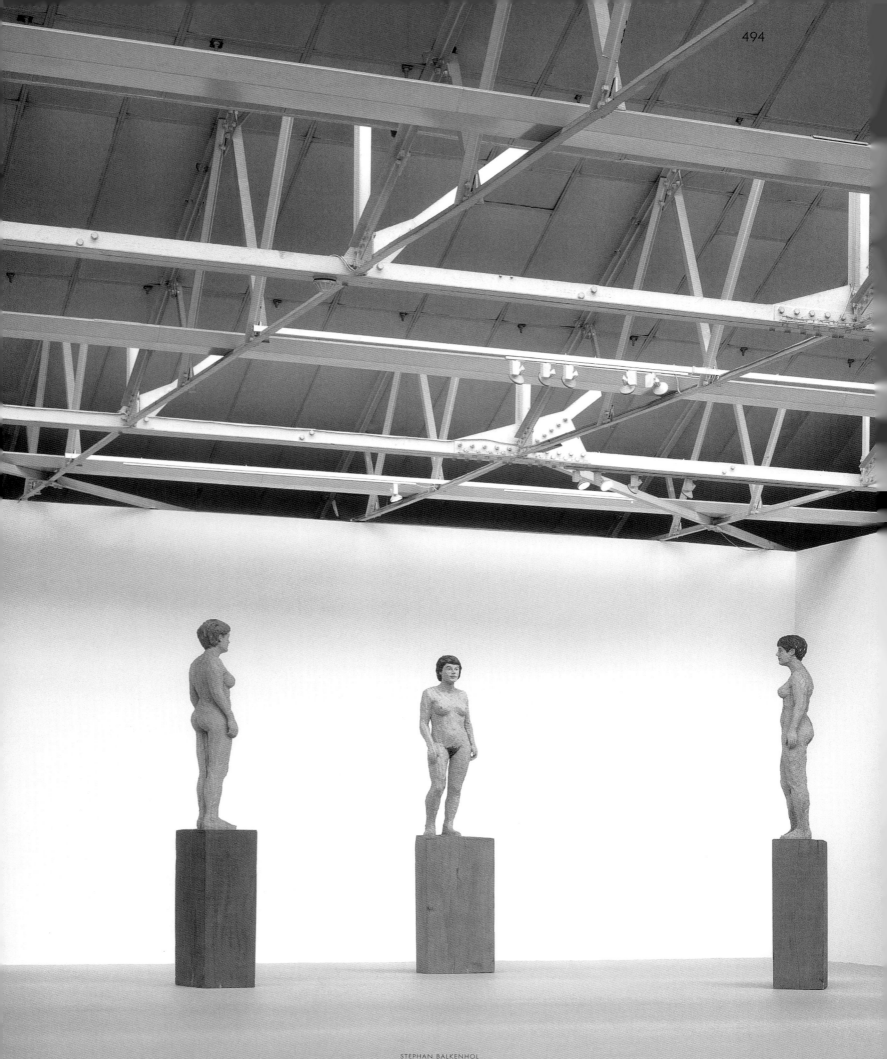

STEPHAN BALKENHOL
CLOCKWISE FROM LEFT
Three Large Female Nudes 1993 Wawa wood and paint Height: 300 cm 118"
Harlequin 1995 Limewood and paint 170 × 56 × 28 cm 67 × 22 × 11"
Head of a Man 1992 Wawa wood and paint Height: 380 cm 149½"

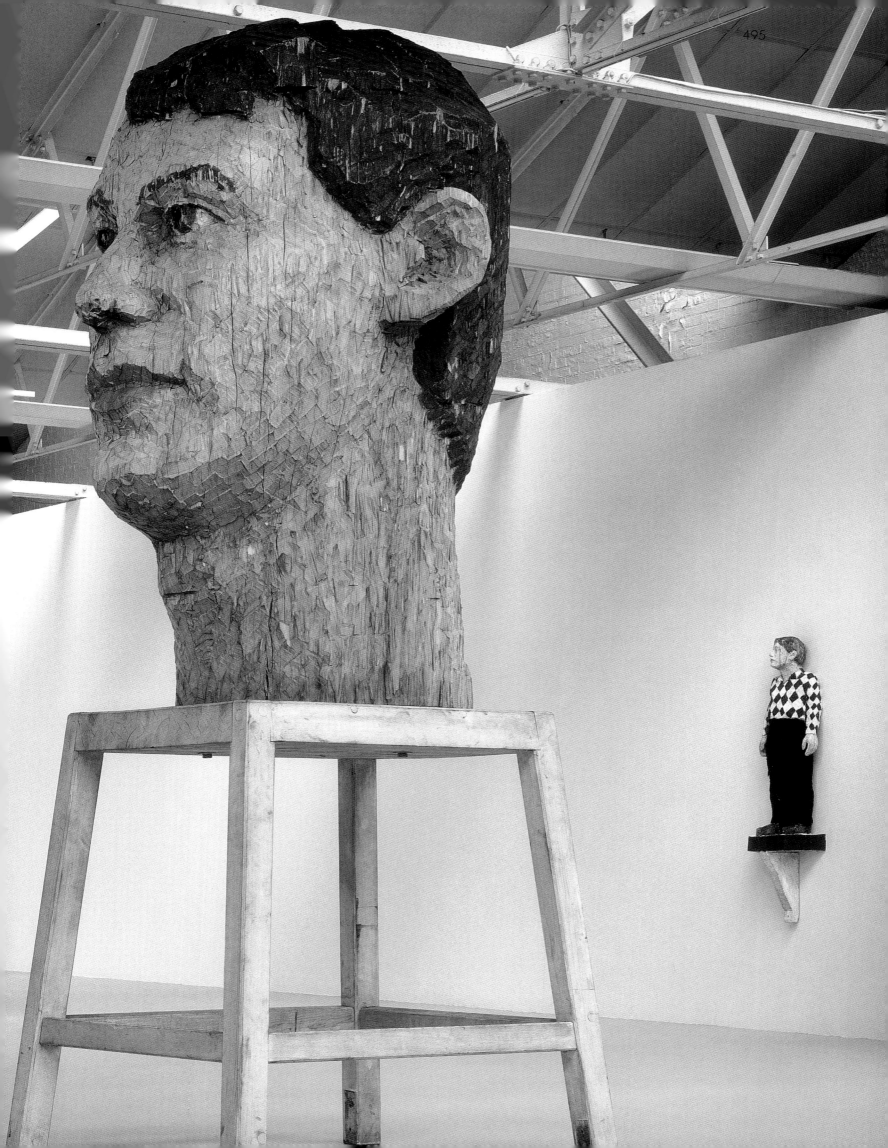

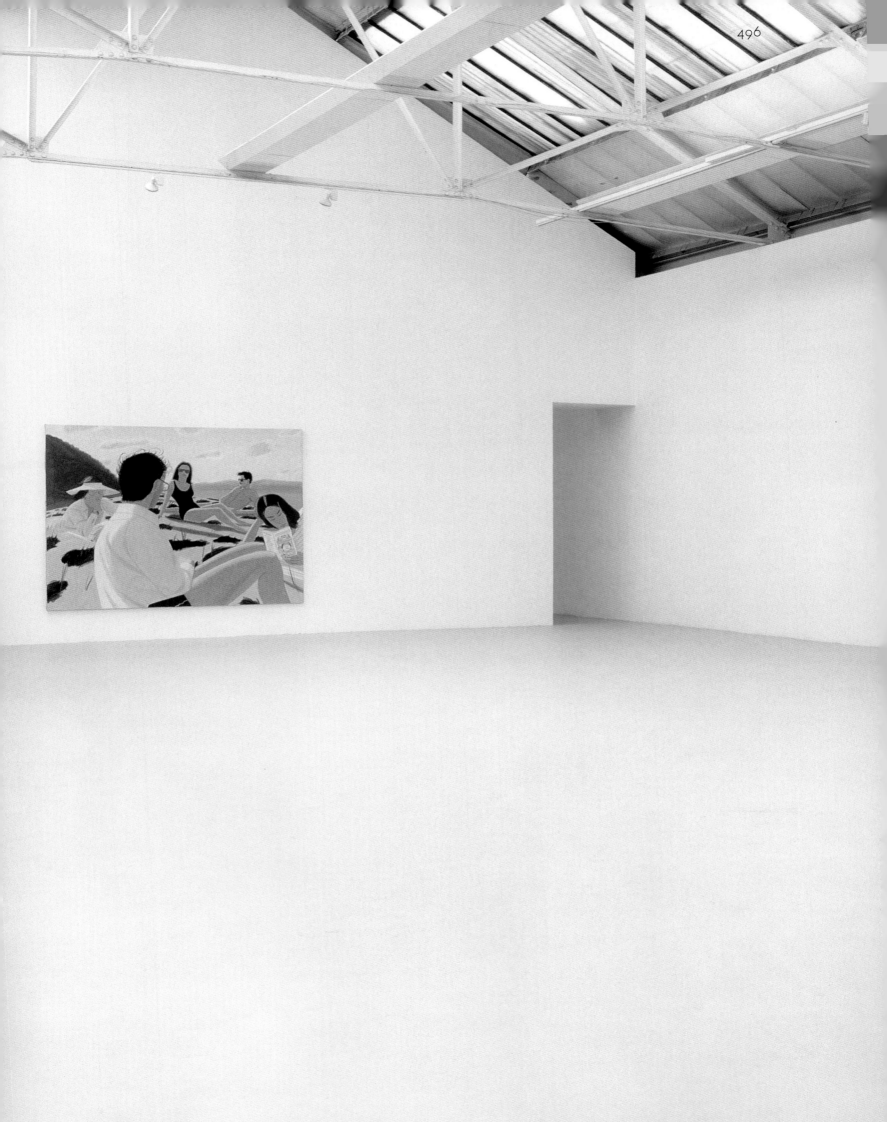

KATZ

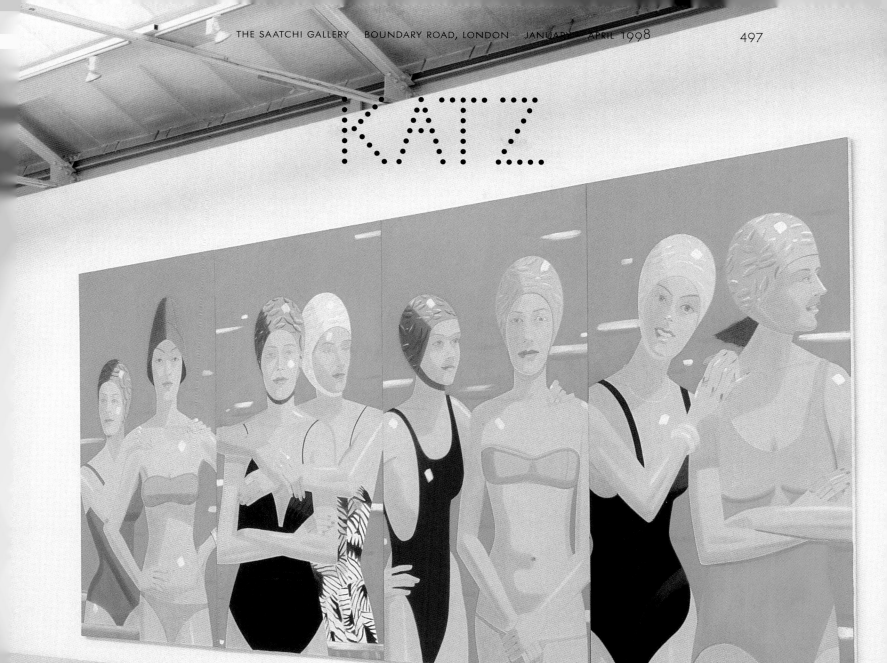

ALEX KATZ
LEFT TO RIGHT
Round Hill 1977 Oil on canvas 183 × 244 cm 72 × 96"
Eleuthera 1984 Oil on canvas 305 × 671 cm 120 × 264"

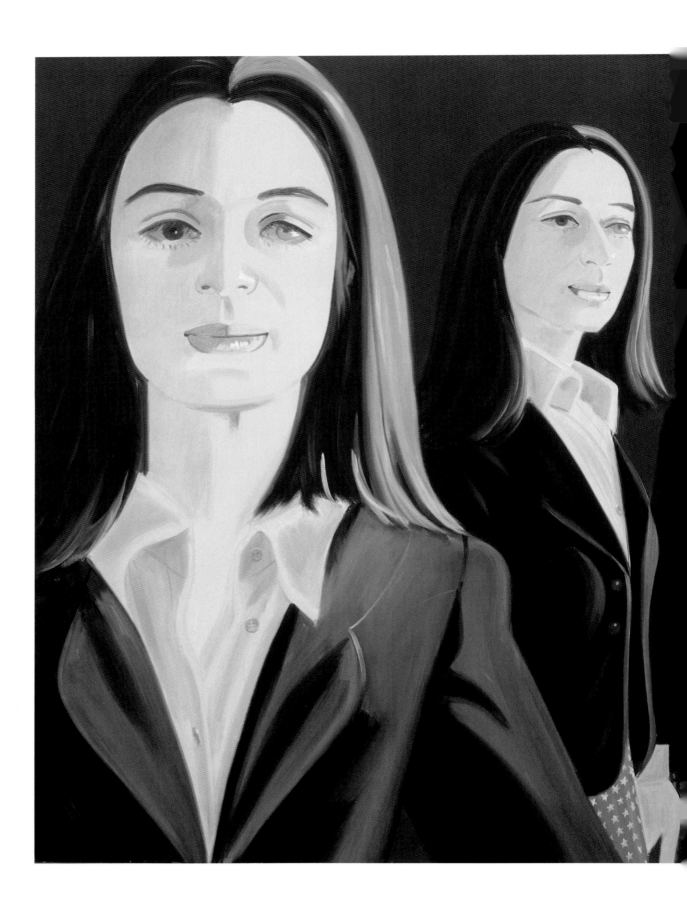

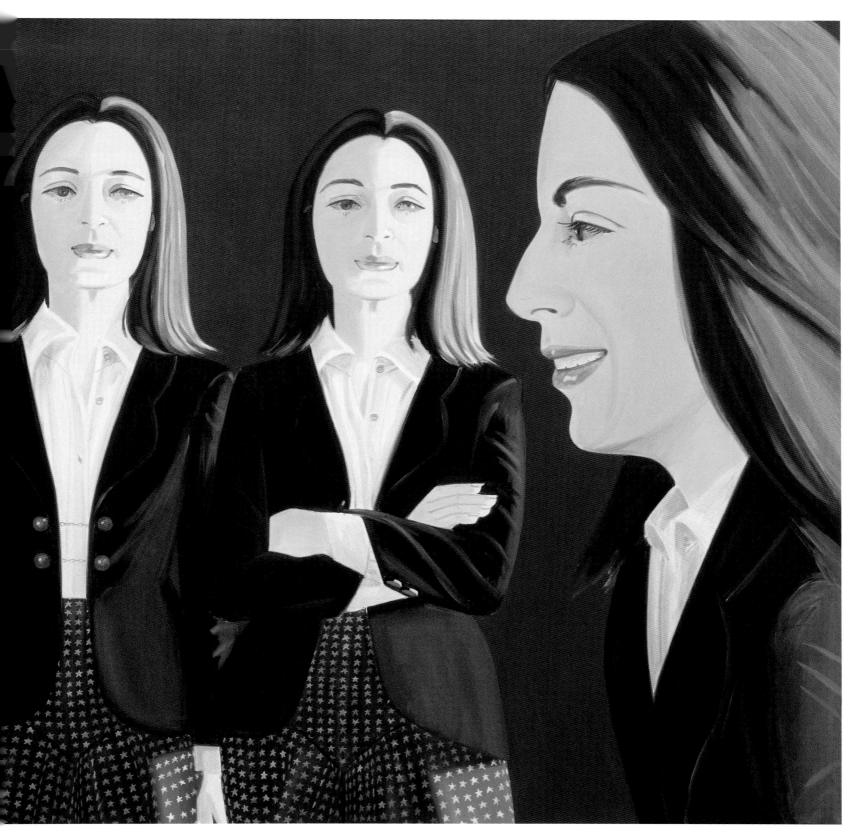

ALEX KATZ *The Black Jacket* 1972 Oil on canvas 198 × 366 cm 78 × 144"

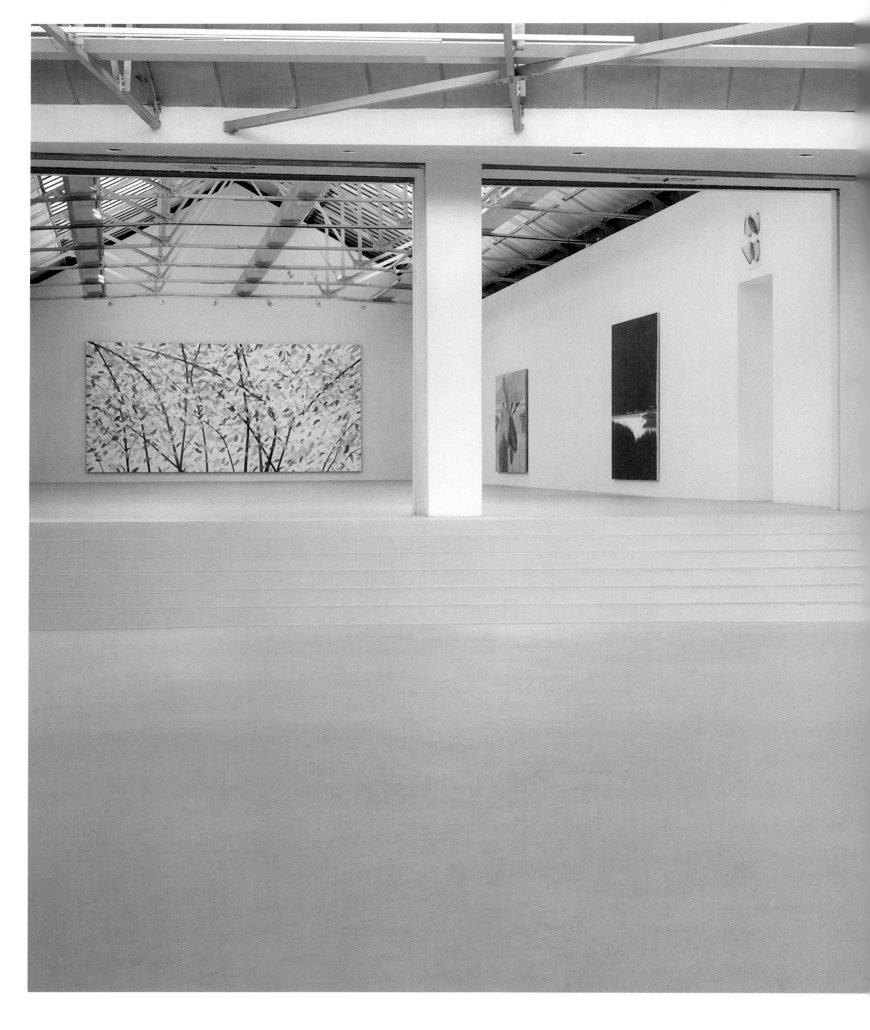

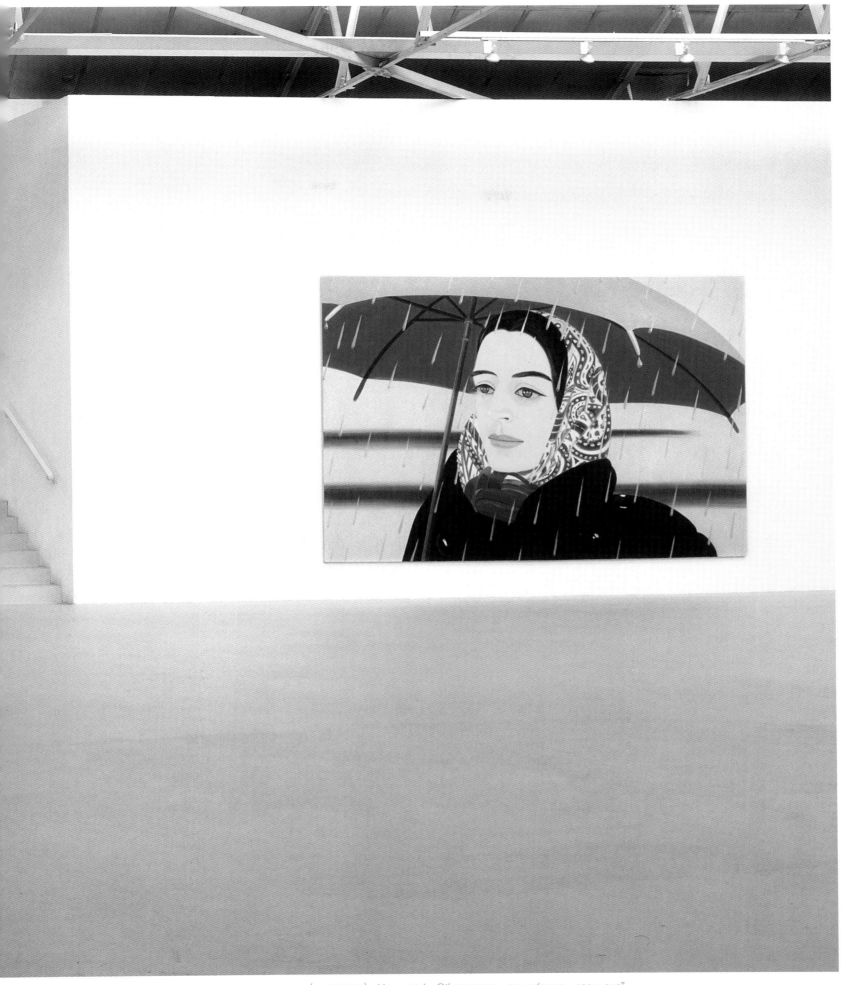

ALEX KATZ (BACKGROUND) May 1996 Oil on canvas 305 × 610 cm 120 × 240"
ALEX KATZ (FOREGROUND) *Blue Umbrella No.2* 1972 Oil on canvas 244 × 366 cm 96 × 144"

ALEX KATZ *Red Coat* 1982 Oil on canvas 244 × 122 cm 96 × 48"

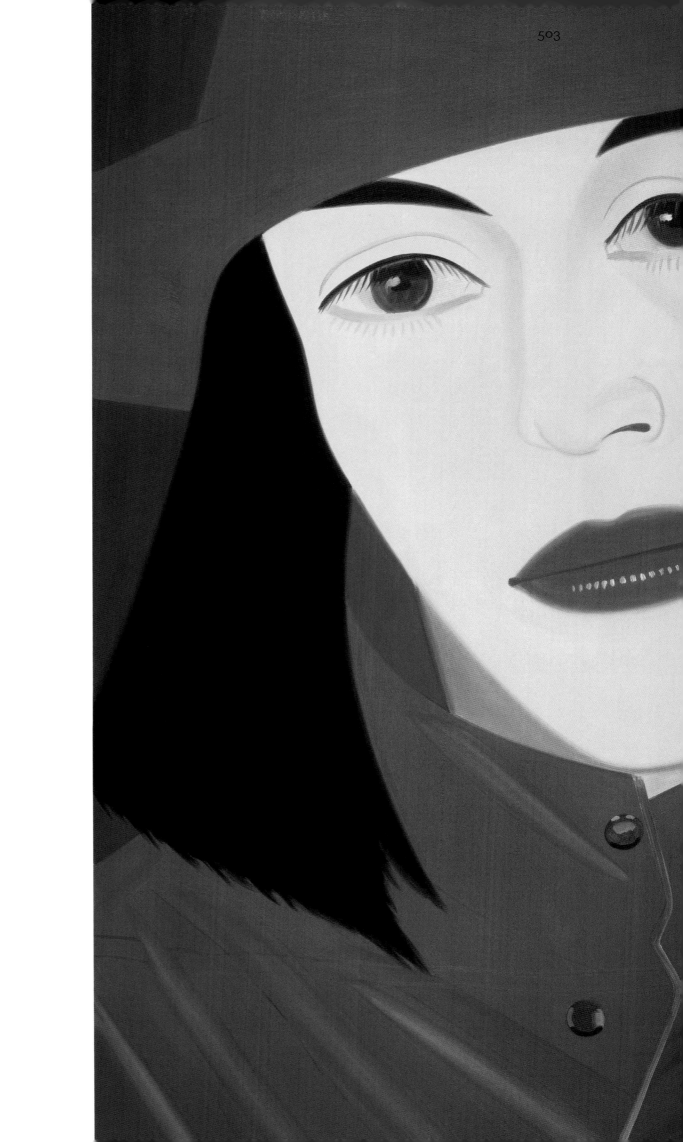

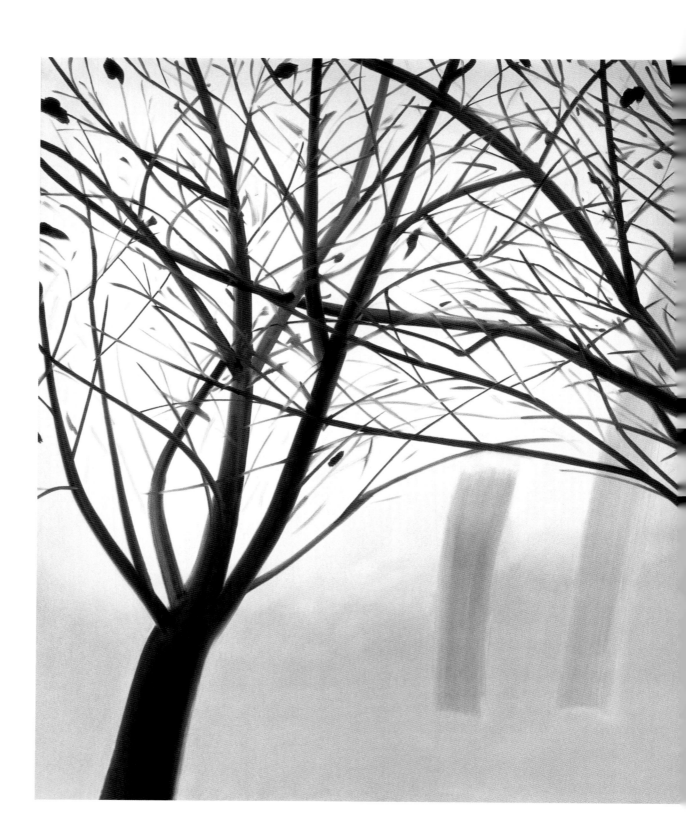

ALEX KATZ *Winter Landscape* 1993 Oil on canvas 305 × 610 cm 120 × 240"

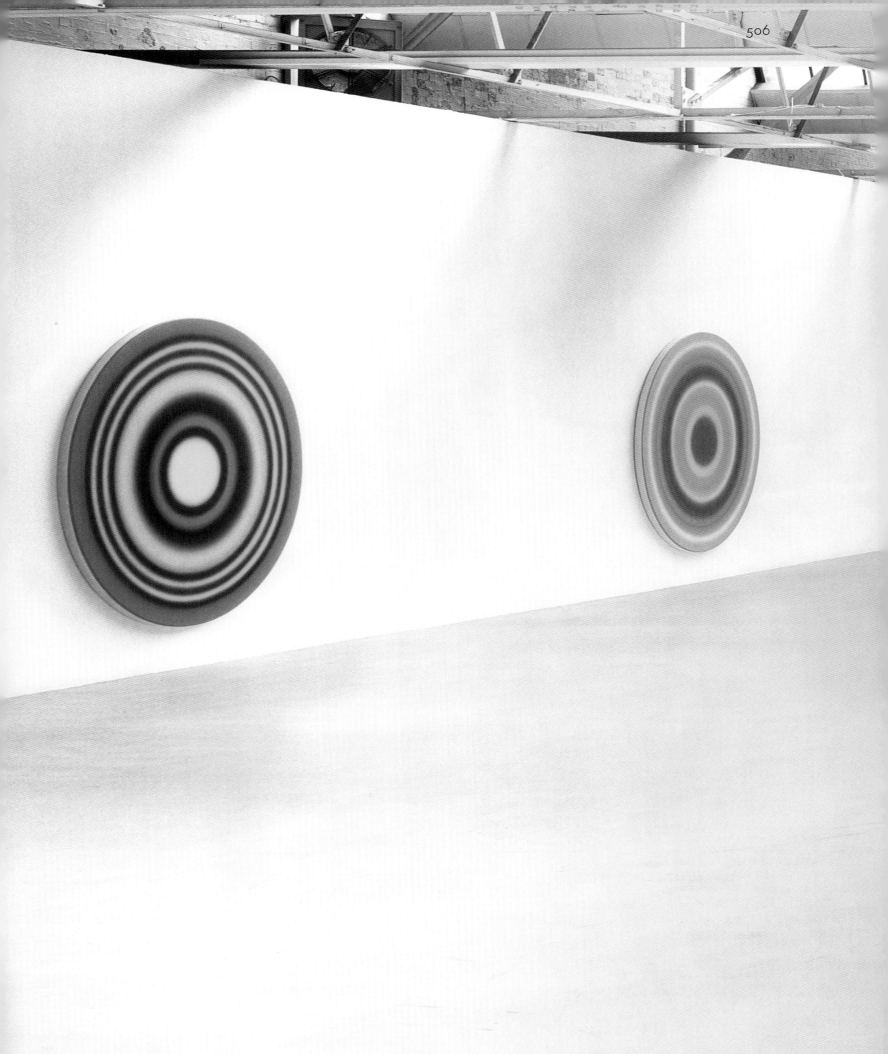

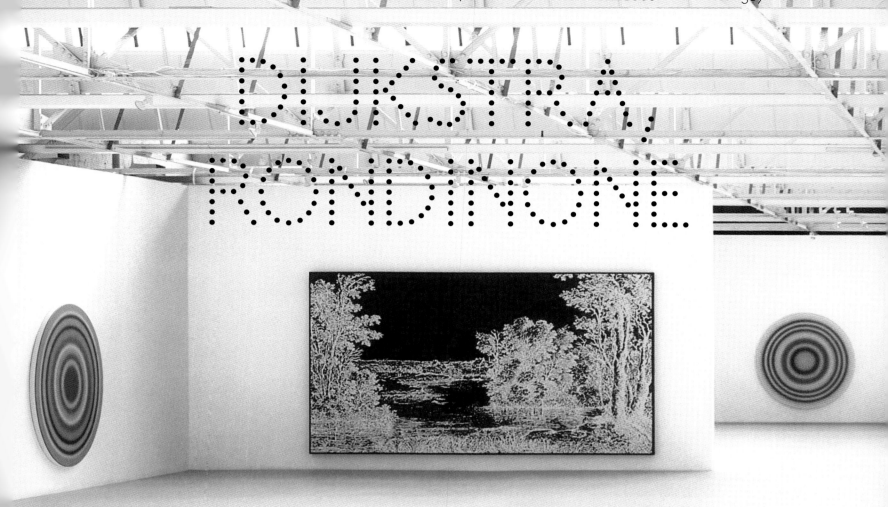

UGO RONDINONE
CLOCKWISE LEFT AND RIGHT
Target Paintings No.104 viertermaineunzehnhundertachtundneunzig/No.102 ersterfebruarneunzehnhundertachtundneunzig/
No.90 zehnteraprilneunzehnhundertsiebenundneunzig 1996–98 Acrylic on canvas Diameter of each painting: 220 cm 86½"
CENTRE
Landscape No.69 vierundzwanzigsternovemberneunzehnhundertfünfundneunzig 1996 Ink and paper on canvas 300 × 500 cm 118 × 196¾"

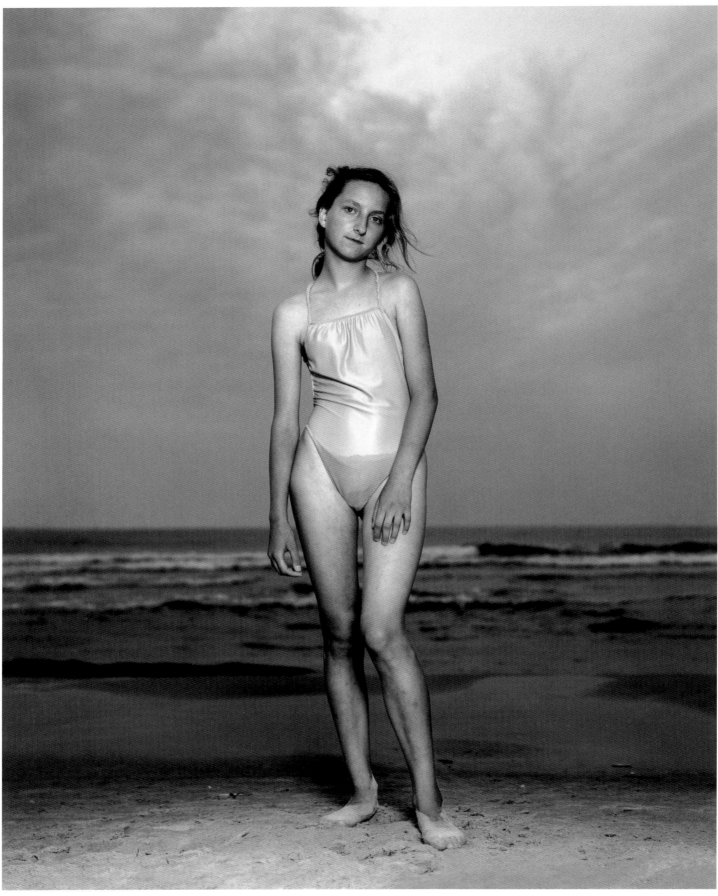

RINEKE DIJKSTRA *Kolobrzeg, Poland, July 26* 1992 Colour print 190 × 156 cm 74¾ × 61½"

RINEKE DIJKSTRA *Hilton Head Island, S. C., USA, June 24* 1992 Colour print 190 × 156 cm 74¾ × 61½"

RINEKE DIJKSTRA *Odessa, Ukraine, August 4* 1993 Colour print 190 × 156 cm 74¾ × 61½"

RINEKE DIJKSTRA *Dubrovnik, Croatia, July 13* 1996 Colour print 190 × 156 cm 74¾ × 61½"

RINEKE DIJKSTRA *Saskia Harderwijk, Netherlands, March 16* 1994 Colour print 154 × 130 cm 60⅛ × 51¼"

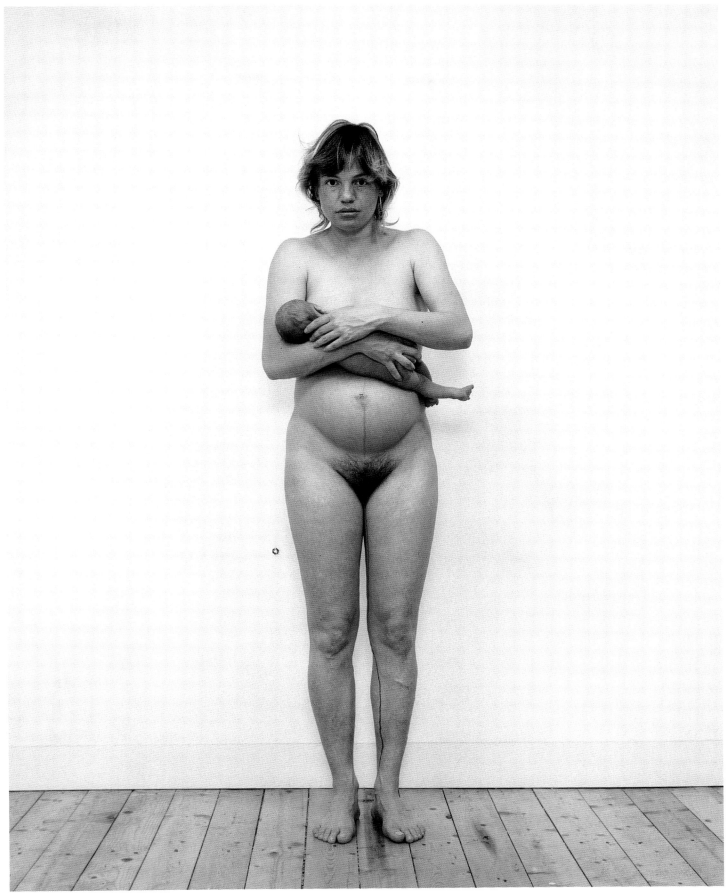

RINEKE DIJKSTRA *Tecla, Amsterdam, Netherlands, May 16* 1994 Colour print 154 × 130 cm 60½ × 51¼"

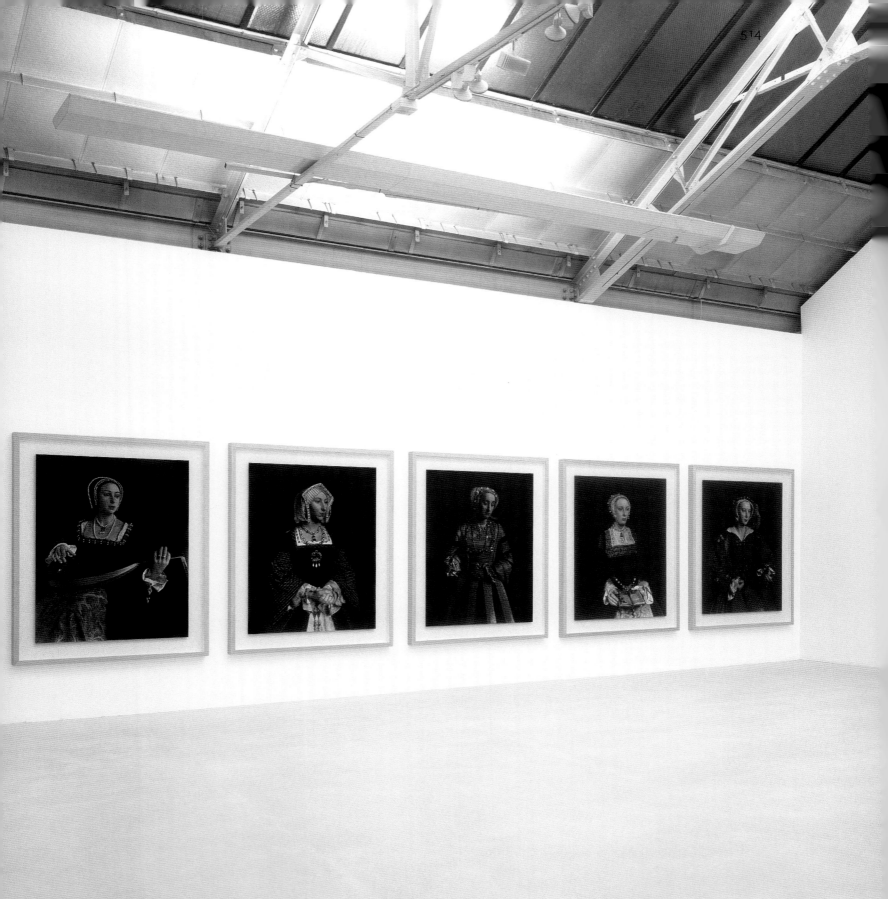

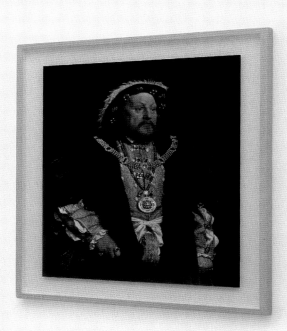

HIROSHI SUGIMOTO
LEFT TO RIGHT
Anne Boleyn/Jane Seymour/Anne of Cleves/Catherine Howard/Catherine Parr/Henry VIII 1999
Gelatin silver prints Each photograph: 182.2 × 152.4 cm 71¾ × 60"

HIROSHI SUGIMOTO *Catherine Parr* 1999 Gelatin silver print 182.2 × 152.4 cm 71¾ × 60"

HIROSHI SUGIMOTO *Anne of Cleves* 1999 Gelatin silver print 182.2 × 152.4 cm 71¾ × 60"

HIROSHI SUGIMOTO *Jane Seymour* 1999 Gelatin silver print 182.2 × 152.4 cm 71¾ × 60"

HIROSHI SUGIMOTO *Catherine Howard* 1999 Gelatin silver print 182.2 × 152.4 cm 71¾ × 60"

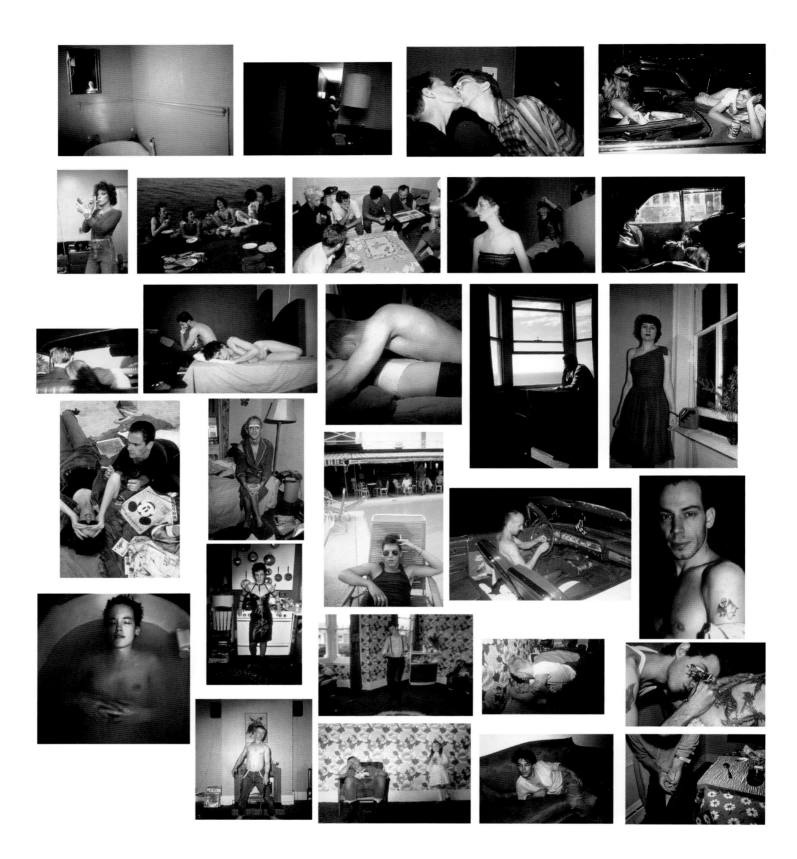

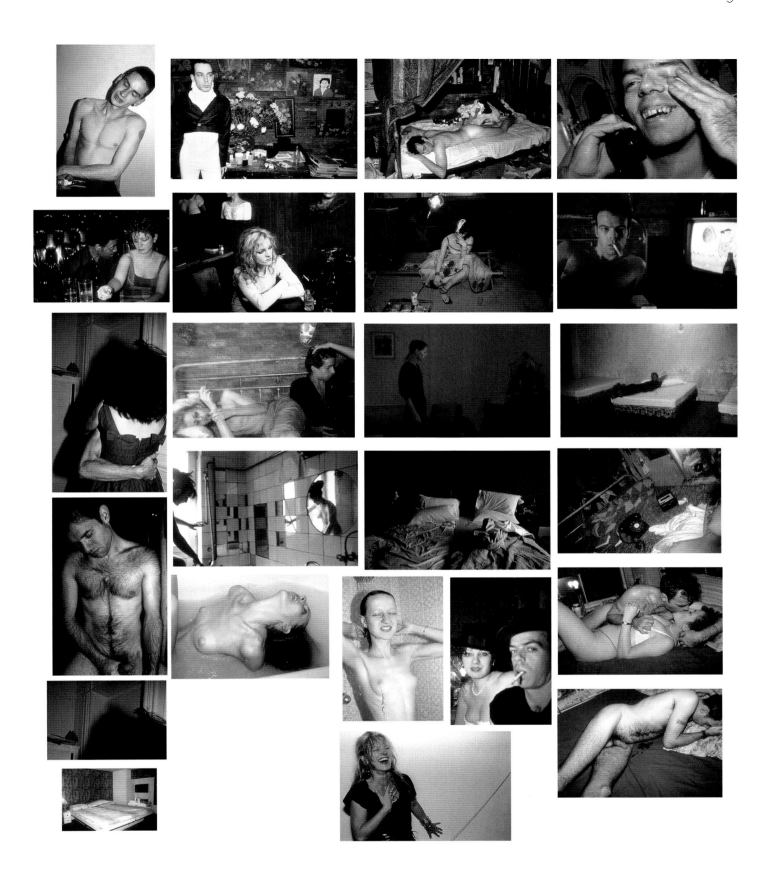

PAGES 520–523
NAN GOLDIN *Thanksgiving* 1999 Installation of 149 Cibachrome prints Dimensions variable (detail)

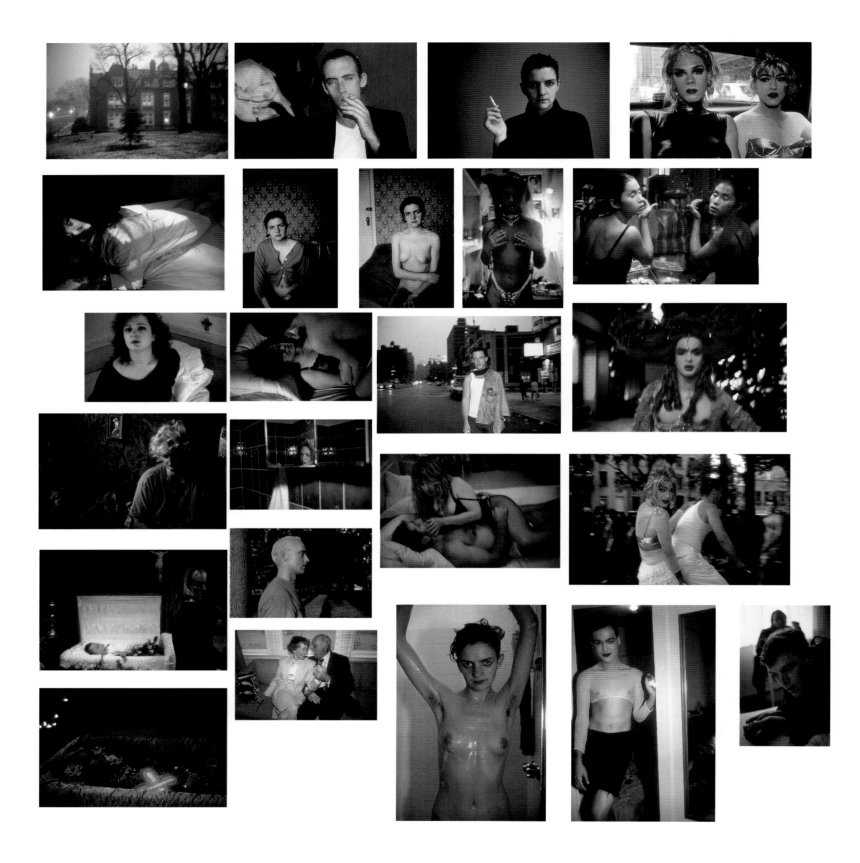

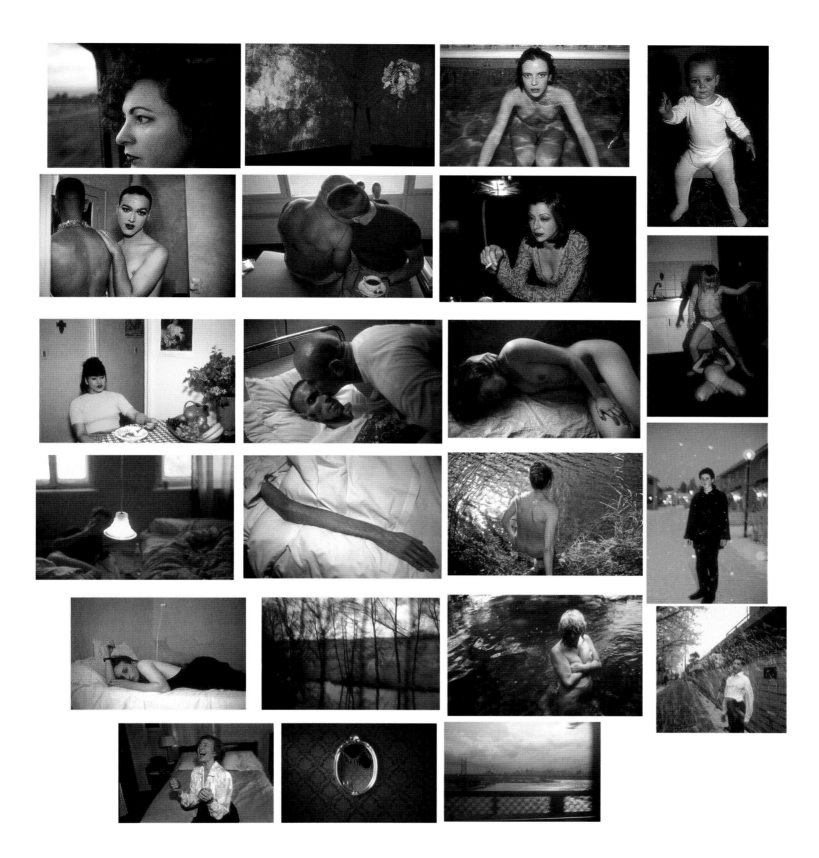

NAN GOLDIN *Nan One Month after Being Battered* 1984 Chibachrome print Dimensions variable

NAN GOLDIN *Philippe H and Suzanne Kissing at Euthanasia, NYC* 1980 Chibachrome print Dimensions variable

BORIS MIKHAILOV INSTALLATION VIEW

BORIS MIKHAILOV *Case History* 1999 Colour photograph (part of a set of 430) Dimensions variable

BORIS MIKHAILOV *Case History* 1999 Colour photograph (part of a set of 430) Dimensions variable

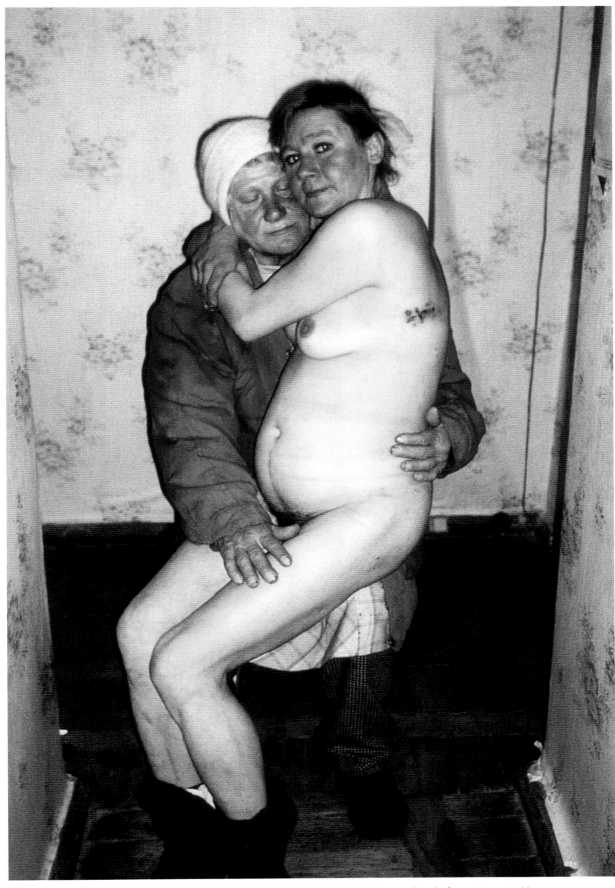

BORIS MIKHAILOV *Case History* 1999 Colour photograph (part of a set of 430) Dimensions variable

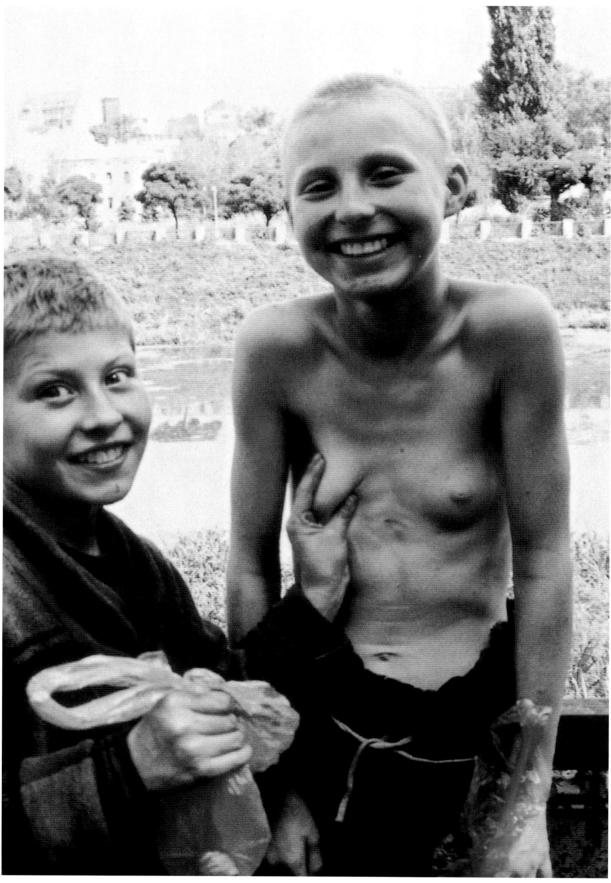

BORIS MIKHAILOV *Case History* 1999 Colour photograph (part of a set of 430) Dimensions variable

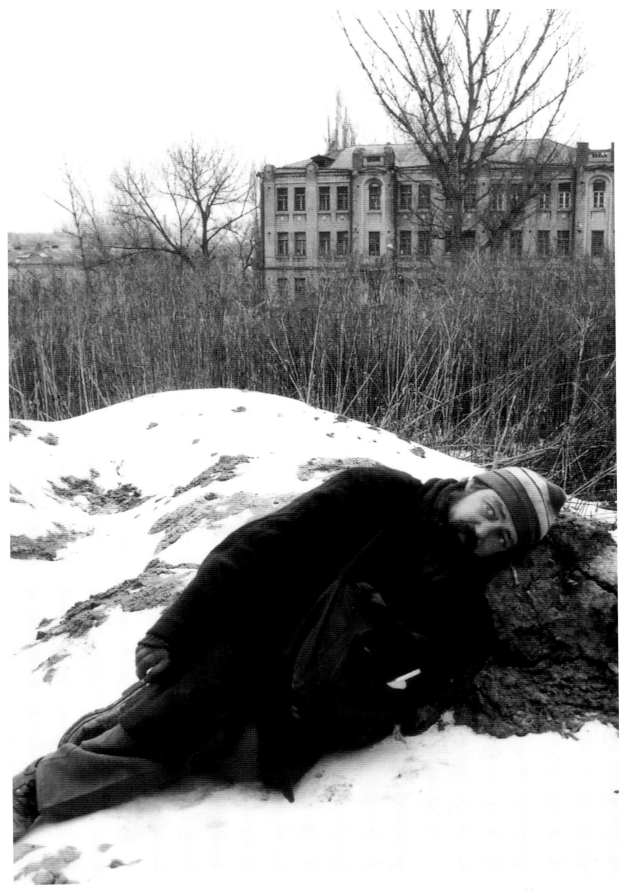

BORIS MIKHAILOV *Case History* 1999 Colour photograph (part of a set of 430) Dimensions variable

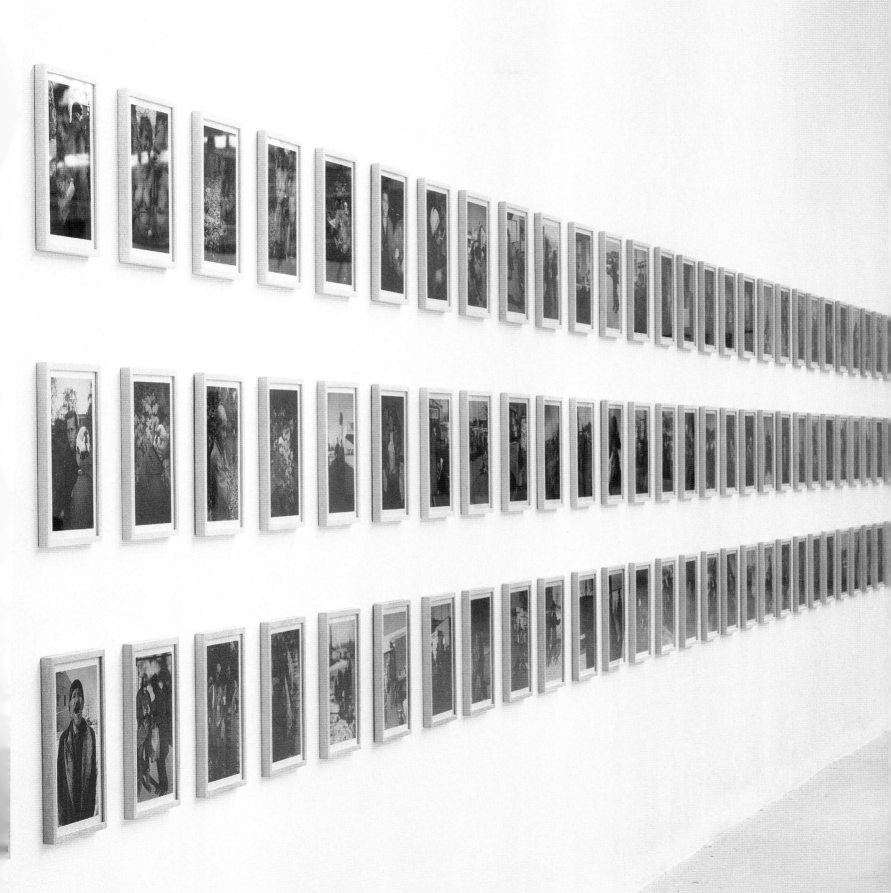

BORIS MIKHAILOV INSTALLATION VIEW

THE TRIUMPH OF PAINTING

ACKERMANN,
ALTHOFF, BROWN,
DOIG, DUMAS,
IMMENDORFF,
KIPPENBERGER
MEESE, NITSCH,
OEHLEN, RICHTER,
TALR, SASNAL,
SCHEIBITZ, SKREBER,
TUYMANS, WEISCHER

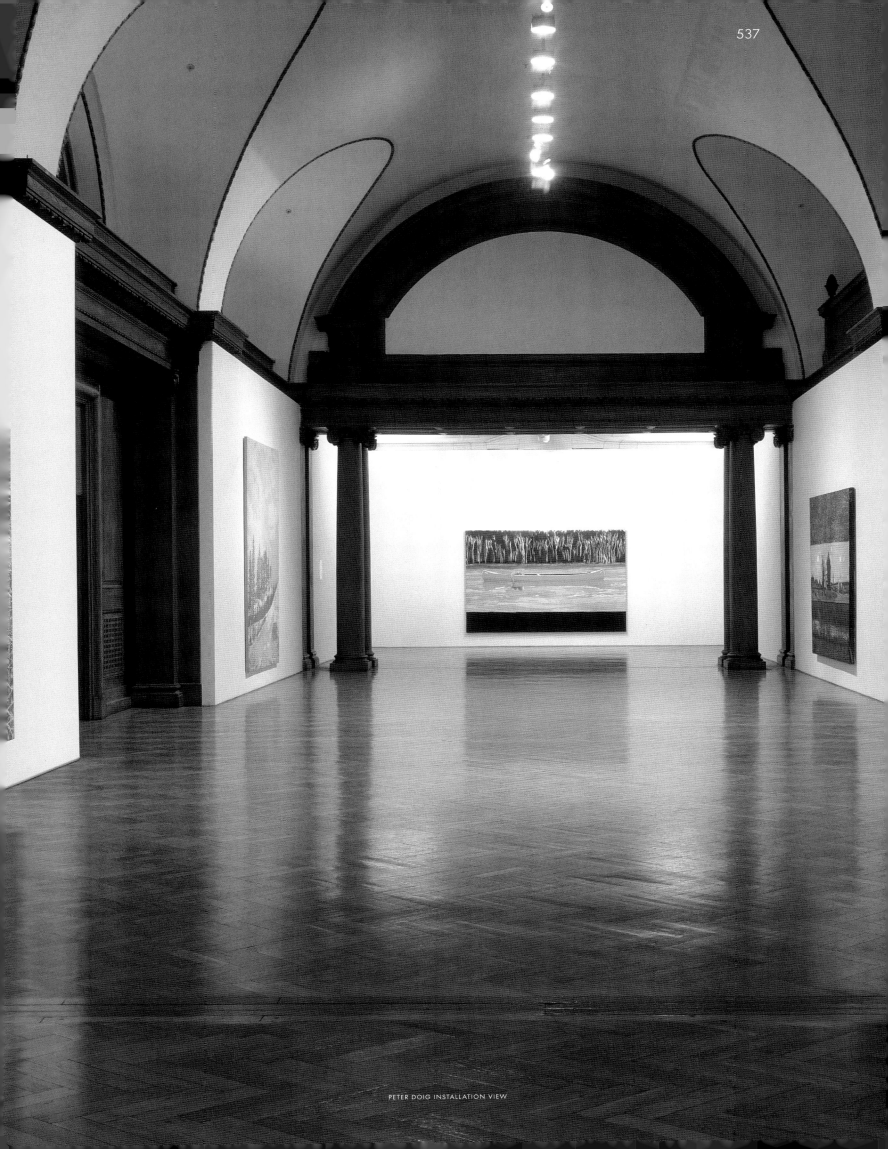

PETER DOIG INSTALLATION VIEW

MARTIN KIPPENBERGER *Self Portrait* 1988 Oil on canvas 200 × 240 cm 79 × 94"

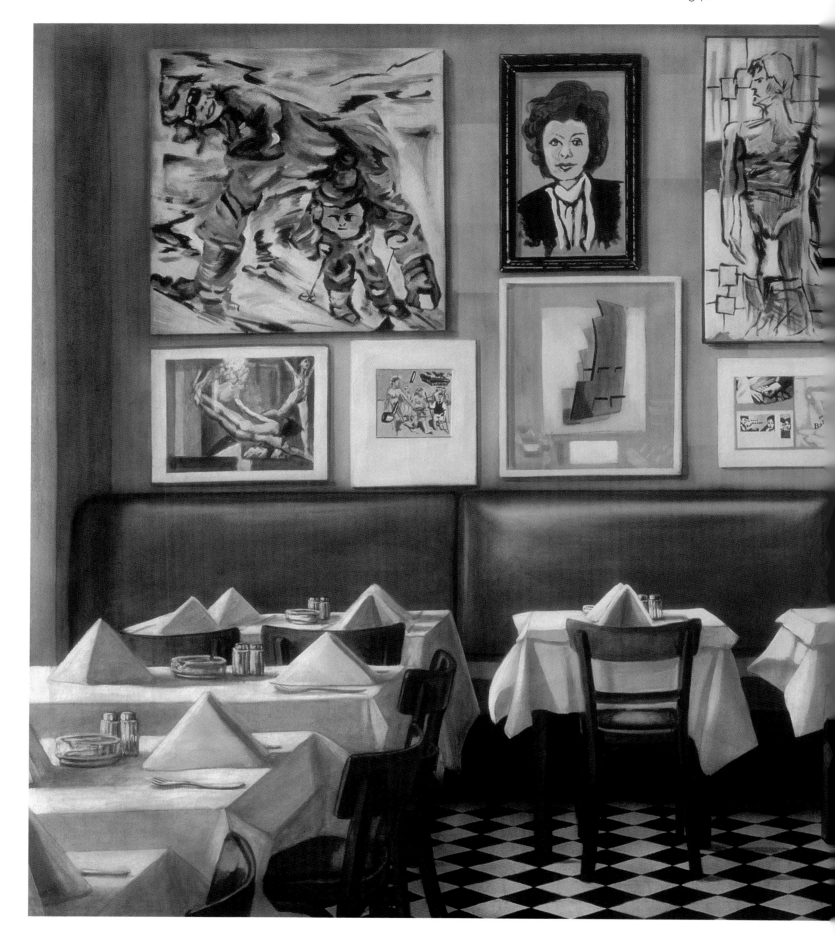

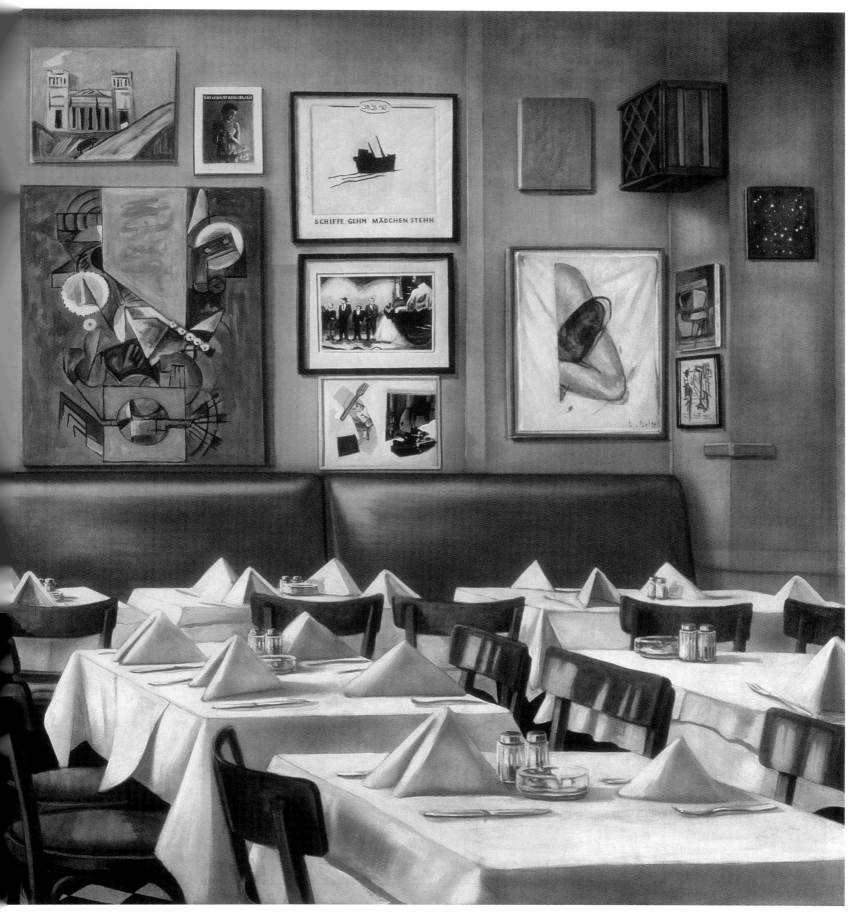

MARTIN KIPPENBERGER *Paris Bar Berlin* 1993 Oil on cotton 212 × 382 cm 83 × 150"

MARTIN KIPPENBERGER *Kellner Des... (Waiter Of...)* 1991 Oil on canvas 200 × 240 cm 79 × 94"

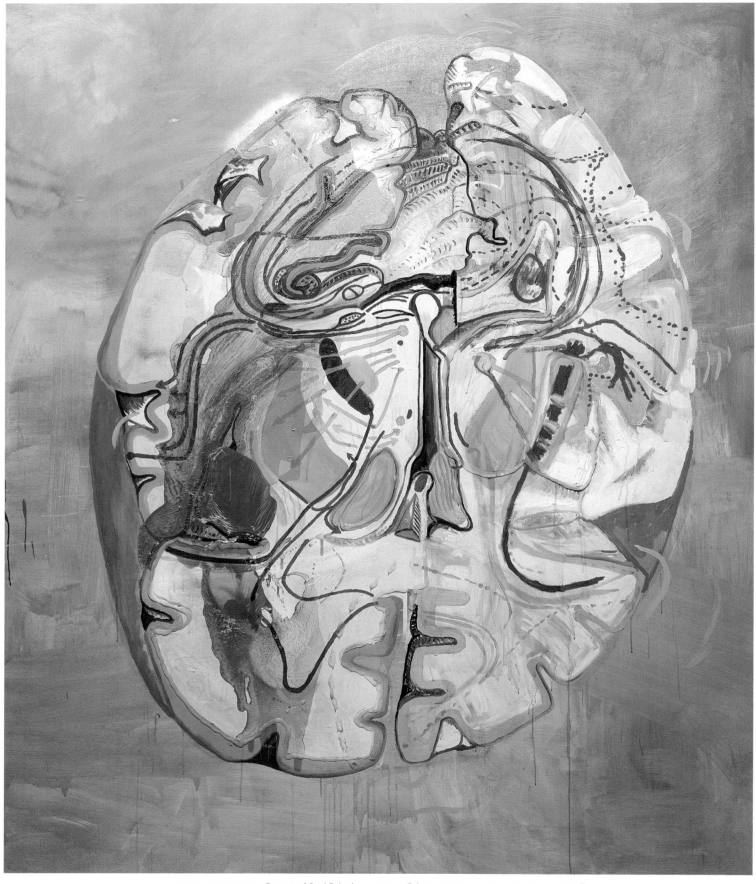

MARTIN KIPPENBERGER *Portrait of Paul Schreber* 1994 Oil on canvas 240 × 200 cm 94 × 79"

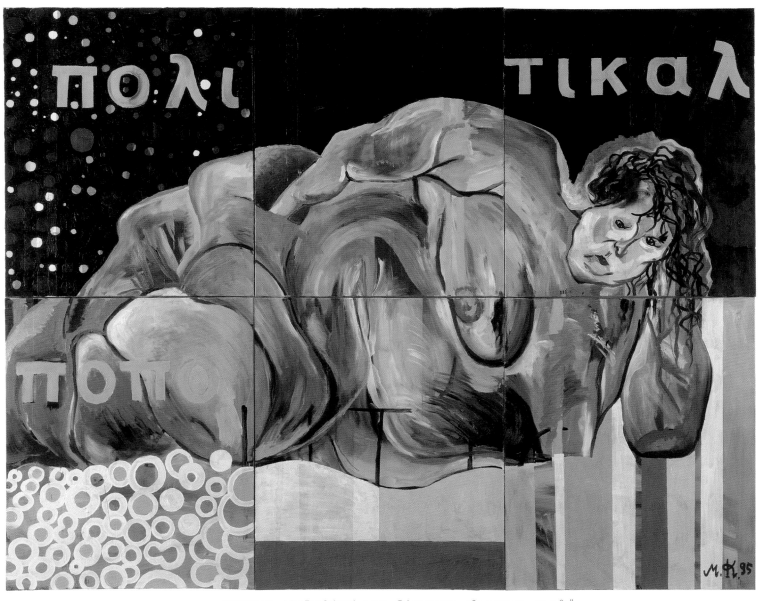

MARTIN KIPPENBERGER *I Am Too Political* 1995 Oil on canvas 180 × 225 cm 71 × 89"

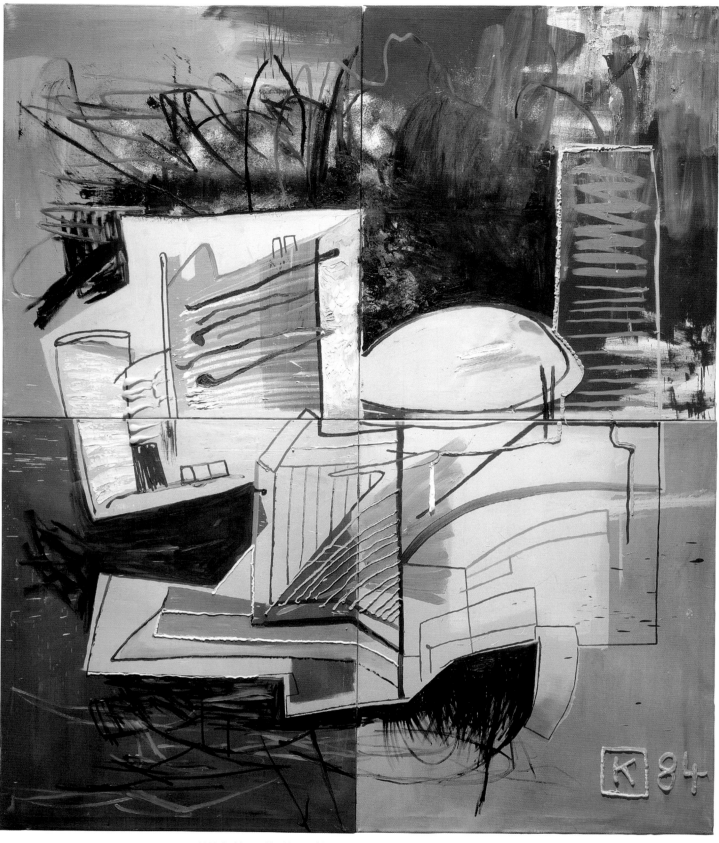

MARTIN KIPPENBERGER *U.N. Building – The Home of Peace* 1984 Oil and silicone on linen 240 × 200 cm 95 × 79"

MARTIN KIPPENBERGER *Untitled Lieber Maler, Male Mir... (Dear Painter, Paint For Me...)* 1983 Oil on Canvas 200 × 130 cm 78¾ × 51¼"

PETER DOIG *Canoe-lake* 1997–98 Oil on canvas 200 × 300 cm 78¾ × 118"

PETER DOIG *The Architect's Home in the Ravine* 1991 Oil on canvas 200 × 275 cm 78¾ × 108"

PETER DOIG *White Creep* 1995–96 Oil on canvas 290 × 199 cm 114¼ × 78¼"

PETER DOIG *White Canoe* 1990–91 Oil on canvas 200.5 × 243 cm 79 × 95¾"

PETER DOIG *Orange Sunshine* 1995–96 Oil on canvas 276 × 201 cm 108¾ × 79¼"

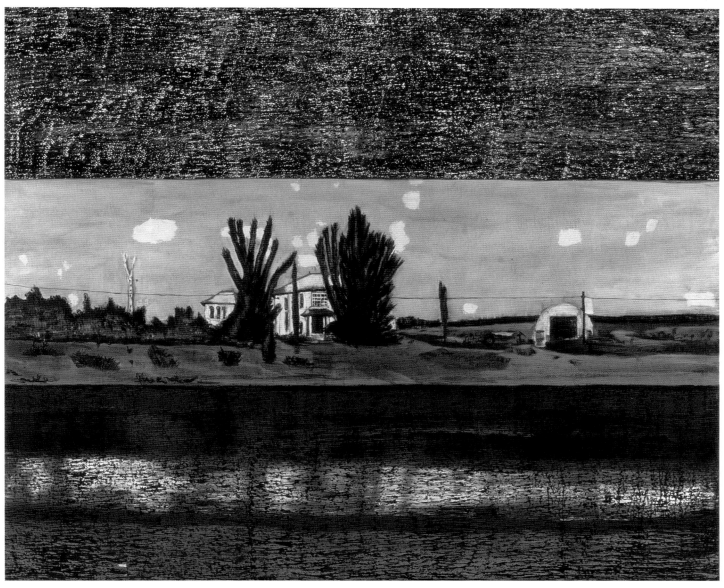

PETER DOIG *Grasshopper* 1990 Oil on canvas 200 × 250 cm 78¾ × 98⅜"

PETER DOIG *Concrete Cabin* 1994 Oil on canvas 198 × 275 cm 78 × 23½"

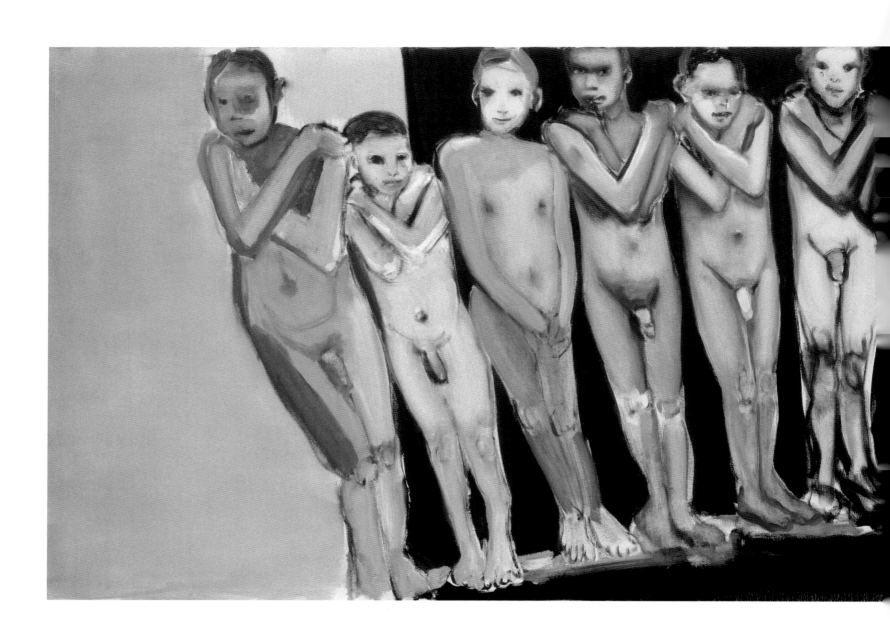

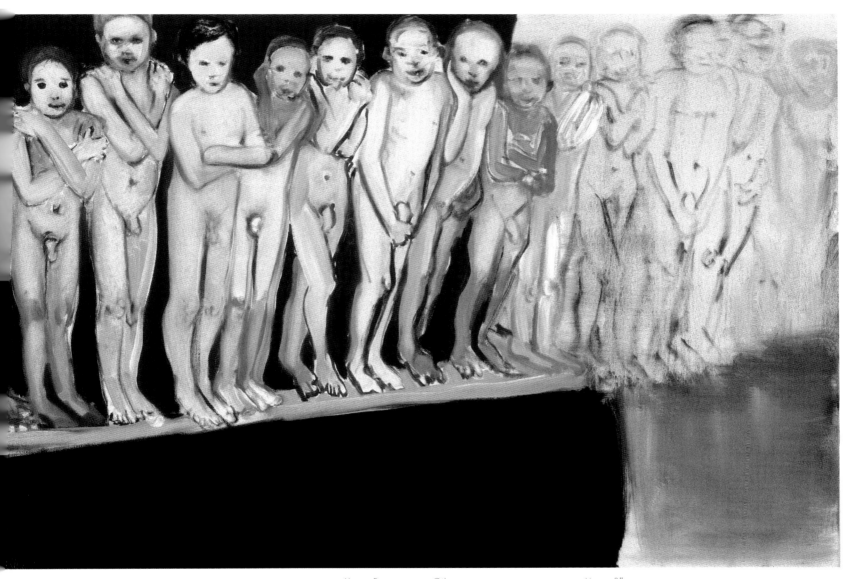

MARLENE DUMAS *Young Boys* 1993 Oil on canvas 100 x 300 cm 39¼ x 118"

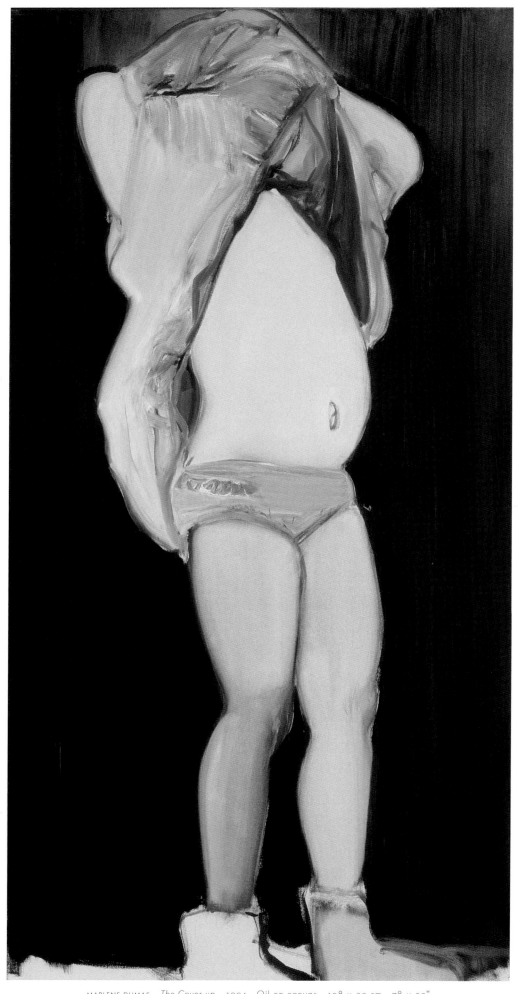

MARLENE DUMAS *The Cover-up* 1994 Oil on canvas 198 × 99 cm 78 × 39"

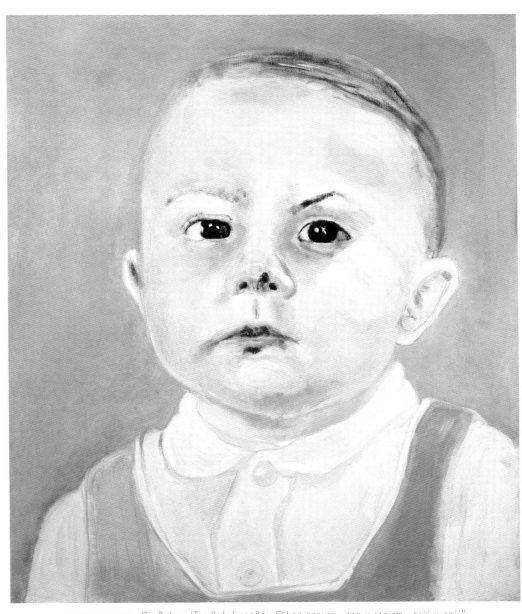

MARLENE DUMAS *Die Baba* *[The Baby]* 1985 Oil on canvas 130 × 110 cm 51¼ × 43¼"

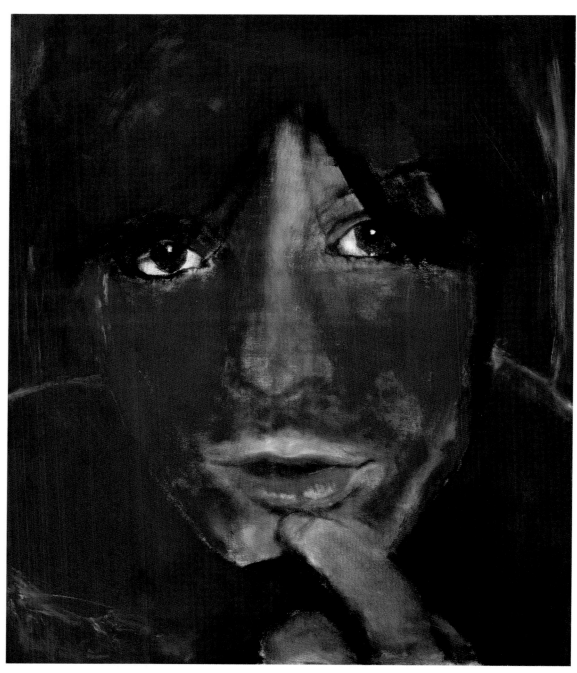

MARLENE DUMAS *Jule — die Vrou* *[Jule — the Woman]* 1985 Oil on canvas 125 × 105 cm 49¼ × 41¼"

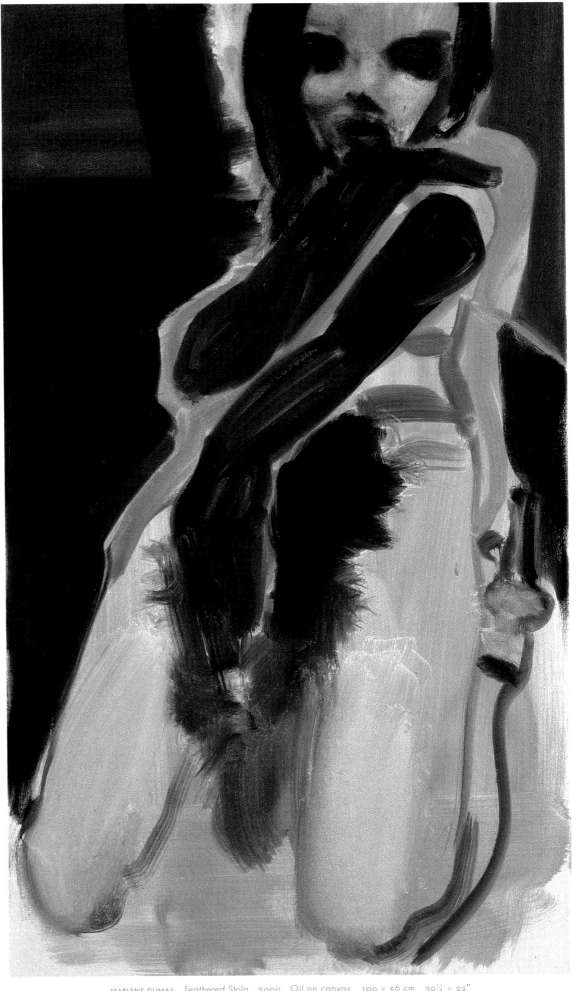

MARLENE DUMAS *Feathered Stola* 2000 Oil on canvas 100 × 56 cm 39¼ × 22"

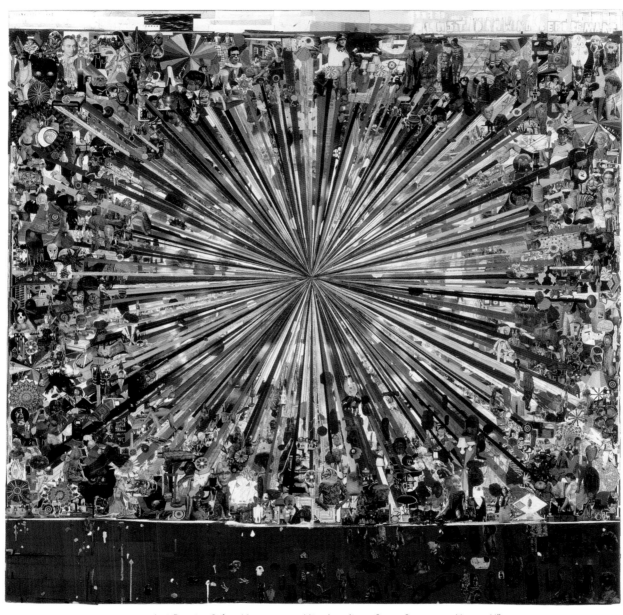

TAL R *Last Drawing Before Mars* 2004 Mixed media 280 × 280 cm 110¼ × 110¼"

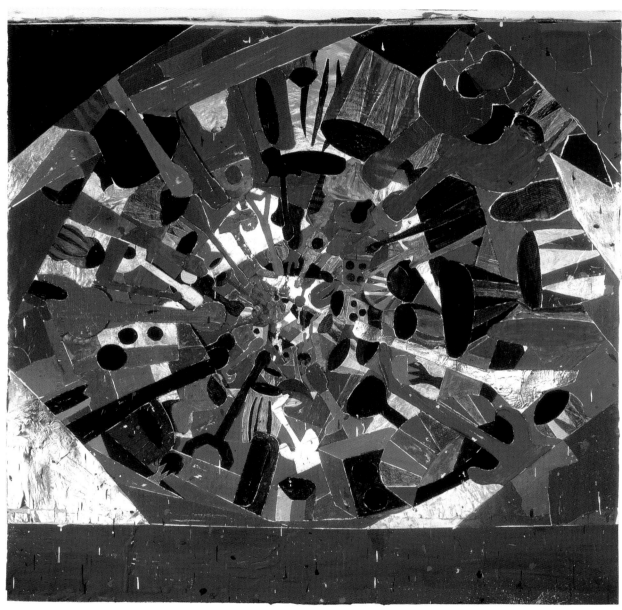

TAL R *Melody* 2003 Mixed media on canvas 280 × 280 cm 110¼ × 110¼"

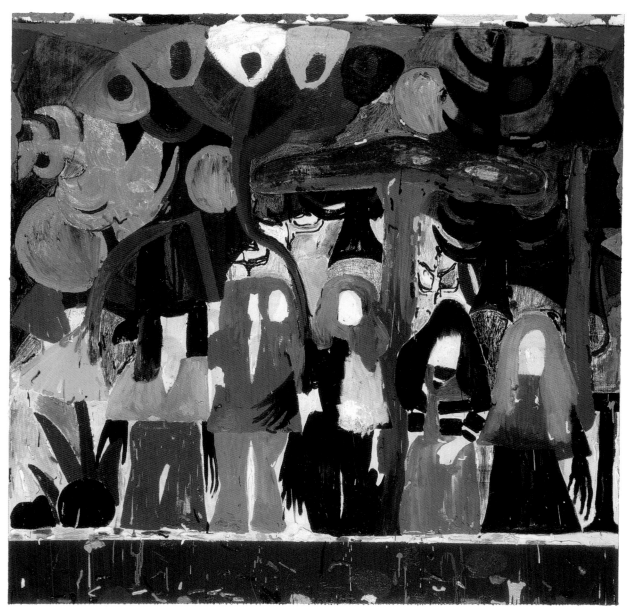

TAL R *Sisters of Kolbojnik* 2002 Oil on canvas 250 × 250 cm 98⅜ × 98⅜"

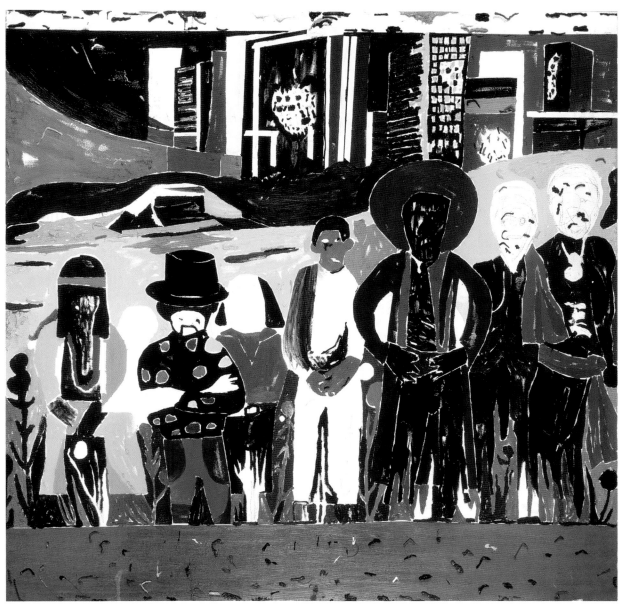

TAL R *New Quarter* 2003 Mixed media on canvas 250 × 250 cm 98⅓ × 98⅓"

DANIEL RICHTER *Trevelfest* 2004 Oil on canvas 283 × 232 cm 111⅛ × 91¼"

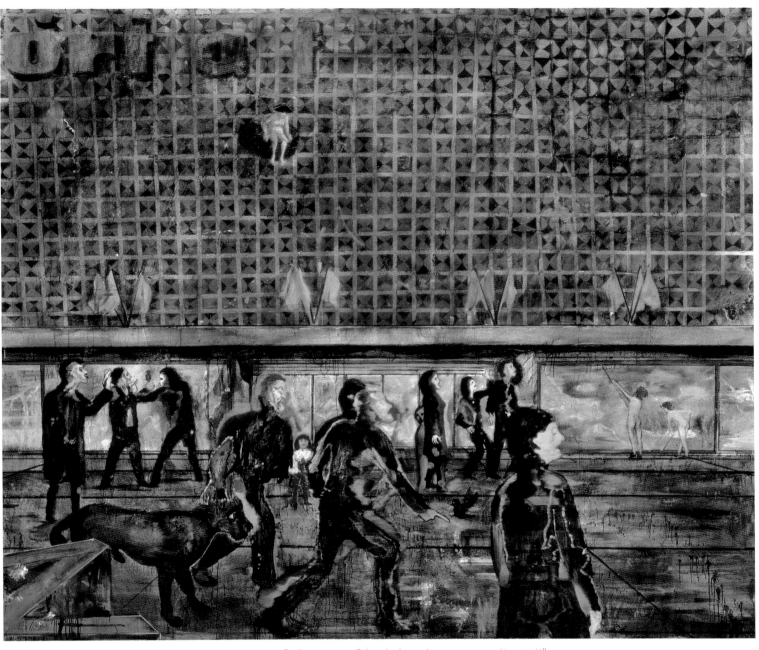

DANIEL RICHTER *Gedion* 2002 Oil and ink 306 × 339 cm 120½ × 133½"

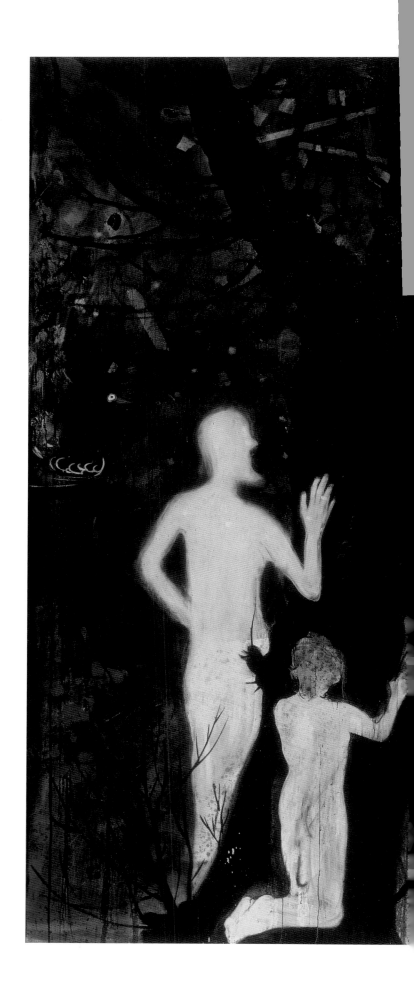

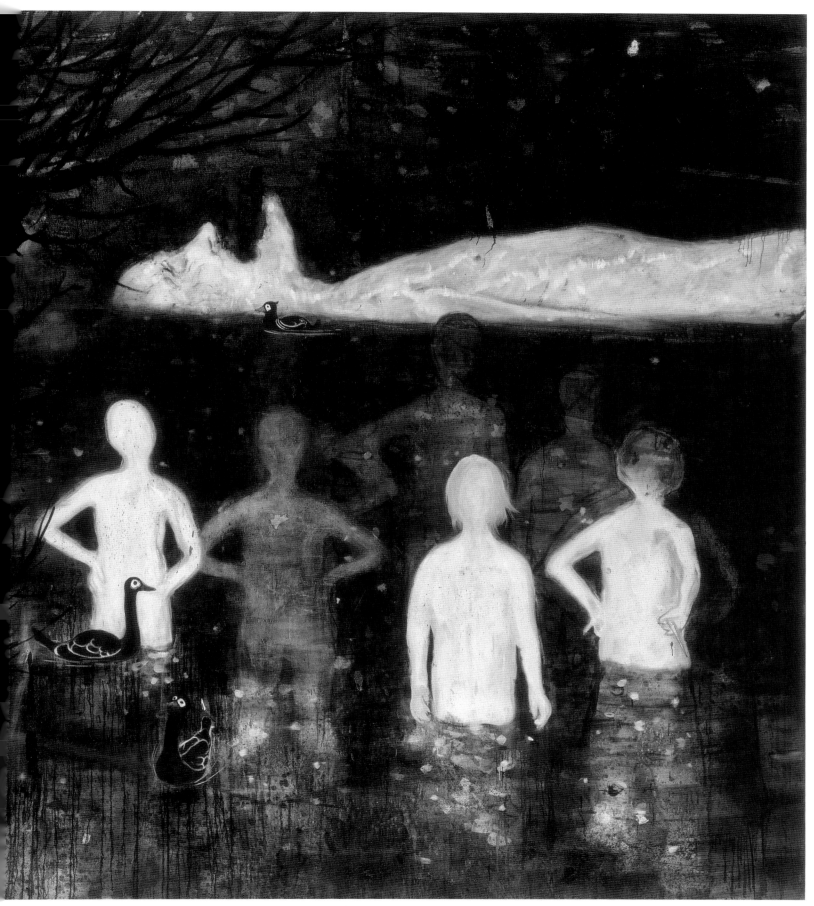

DANIEL RICHTER *Still* 2002 Oil on canvas 280 × 380 cm 110¼ × 149½"

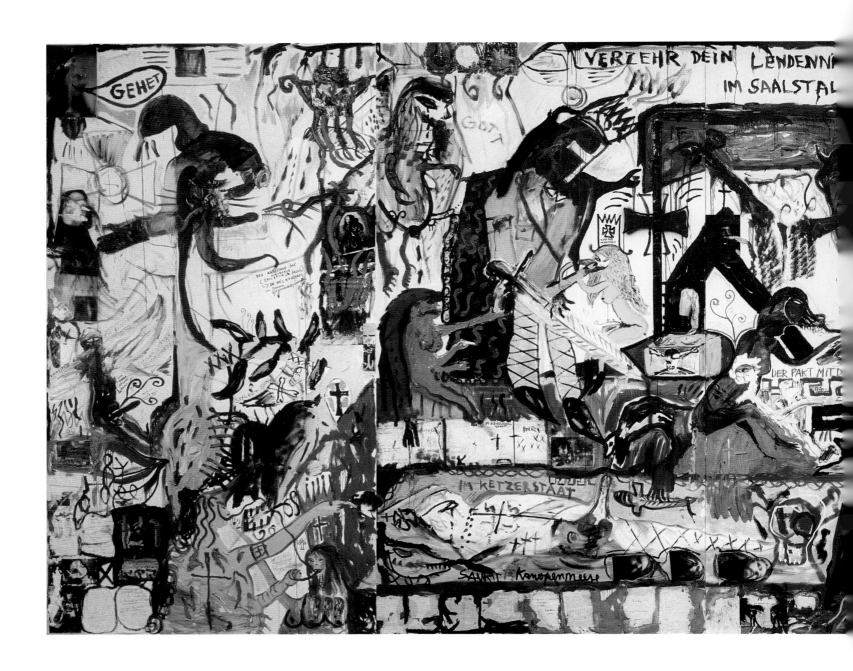

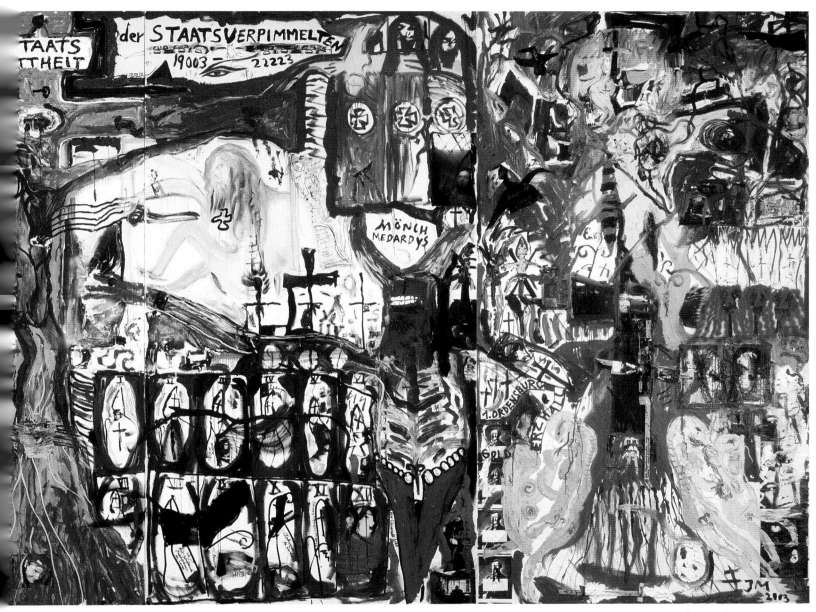

JONATHAN MEESE *The Temptation of the State of the Blessed Ones in 'Archland'* 2003 Oil paint on canvas 370 × 1000 cm 145¾ × 393¾"

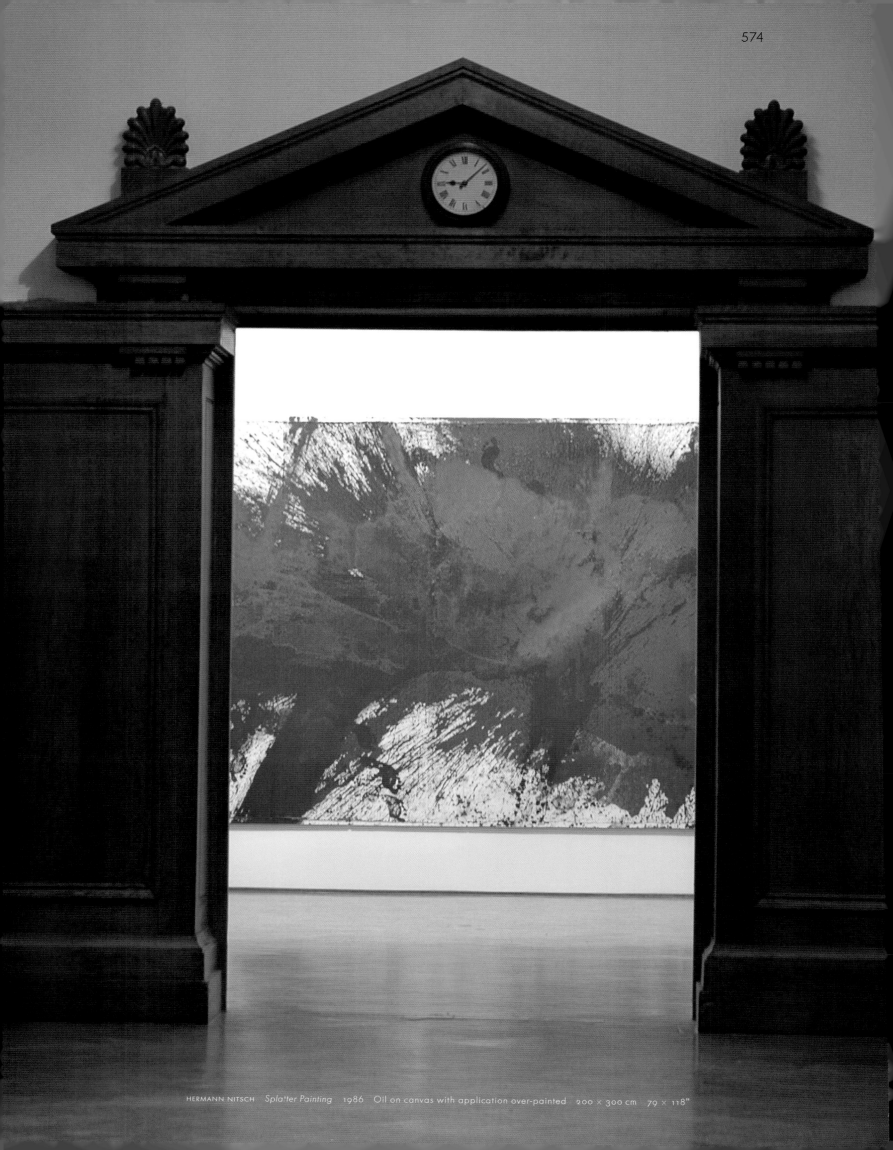

HERMANN NITSCH *Splatter Painting* 1986 Oil on canvas with application over-painted 200 × 300 cm 79 × 118"

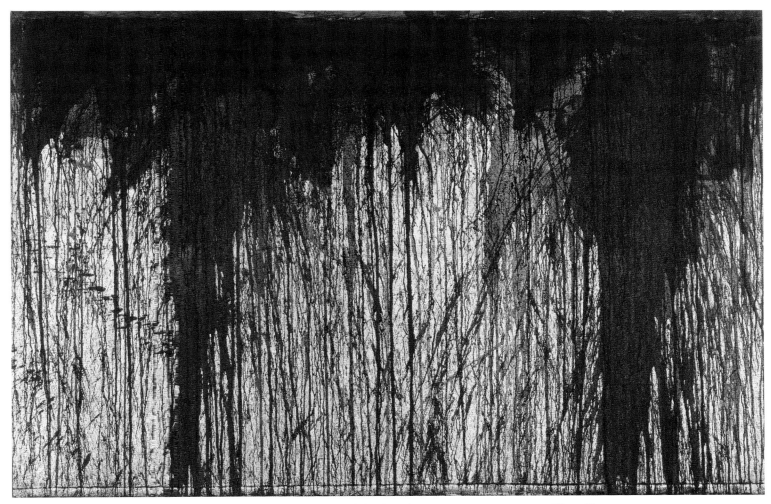

HERMANN NITSCH *Six Day Play* 1998 Oil and acrylic on canvas 200 × 300 cm 78¾ × 118"

LUC TUYMANS *Still Life* 2002 Oil on canvas 347 × 500 cm 136⅛ × 196¾"

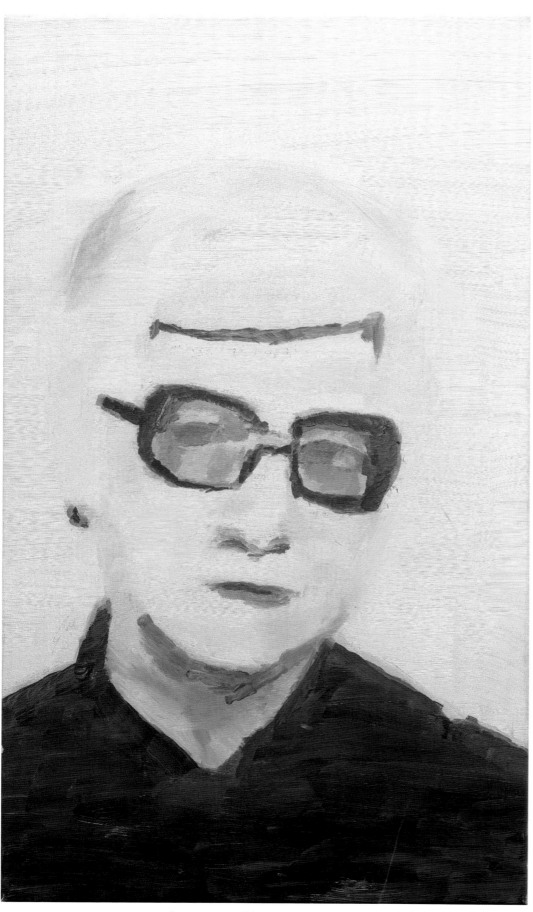

LUC TUYMANS *Portrait* 2000 Oil on canvas 57 × 30 cm 22½ × 11¾"

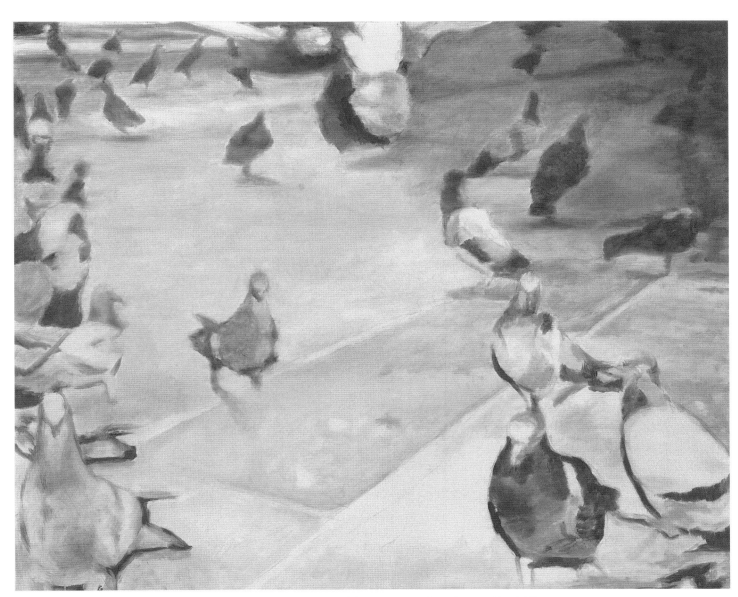

LUC TUYMANS *Pigeons* 2001 Oil on canvas 128 × 156 cm 50½ × 61½"

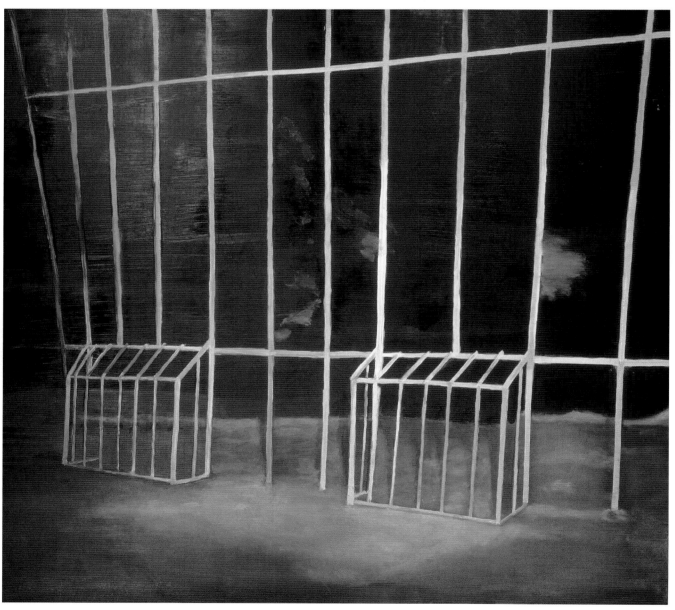

LUC TUYMANS *Within* 2001 Oil on canvas 223 × 243 cm 87¾ × 95¾"

LUC TUYMANS *Maypole* 2000 Oil on canvas 224 × 116 cm 88¼ × 45¾"

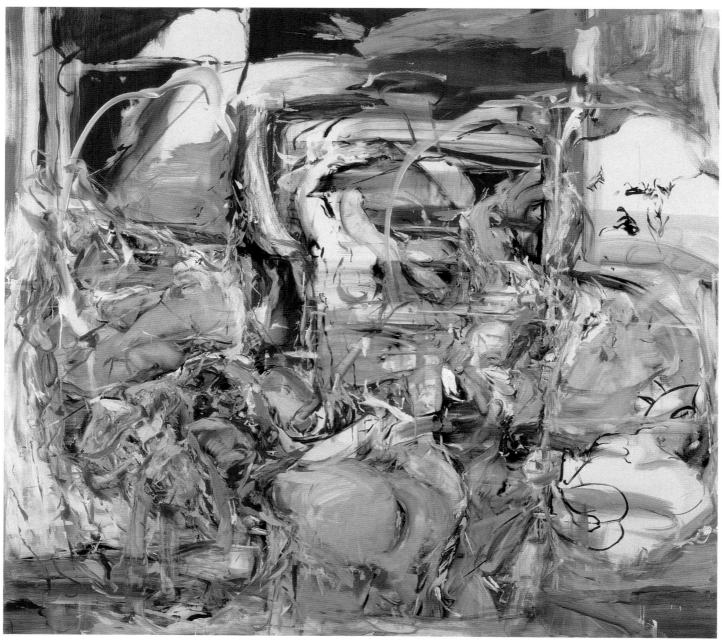

CECILY BROWN *The Girl Who Had Everything* 1998 Oil on linen 254 × 279 cm 100 × 109¾"

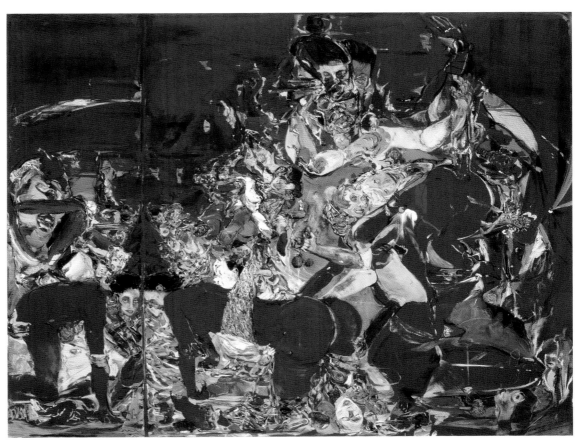

CECILY BROWN *Pyjama Game* 1998 Oil on linen 193 × 249 cm 76 × 93"

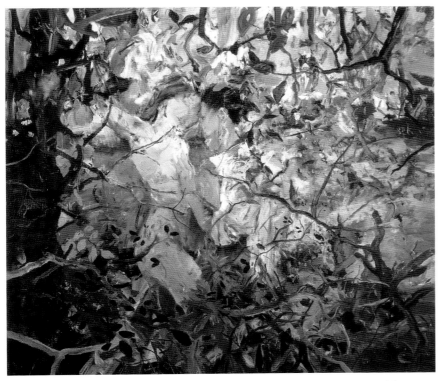

CECILY BROWN *Teenage Wildlife* 2003 Oil on linen 203 × 229 cm 80 × 90¼"

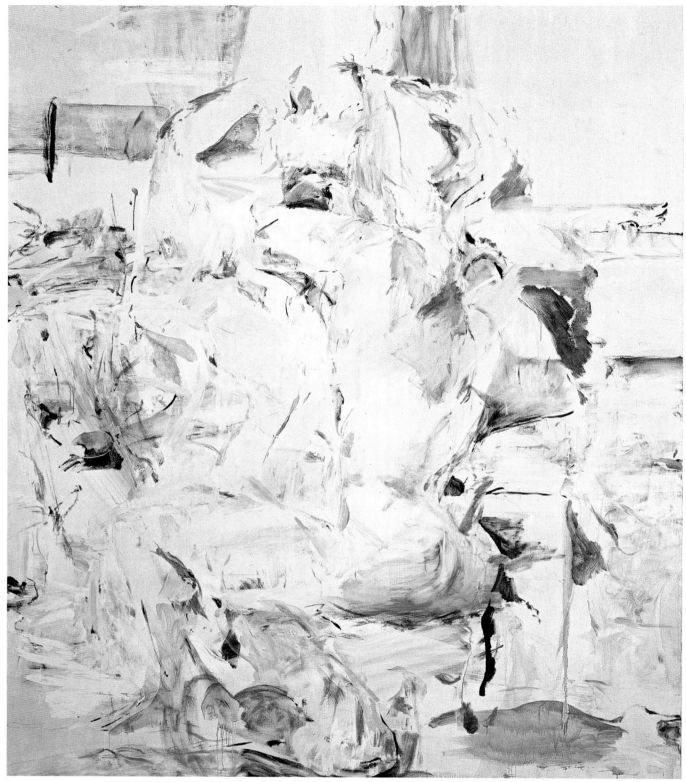

CECILY BROWN *The Fugitive Kind* 2000 Oil on linen 229 × 190.5 cm 90¼ × 75"

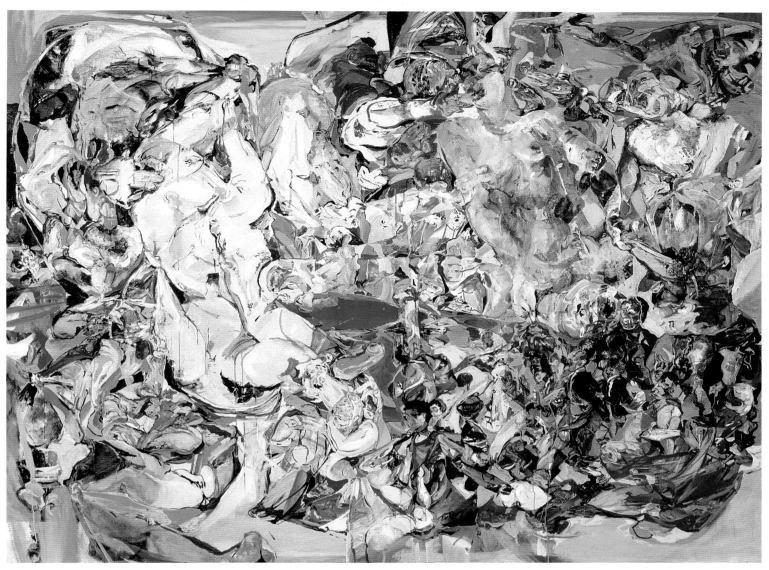

CECILY BROWN *High Society* 1998 Oil on linen 193 × 248.9 cm 76 × 98"

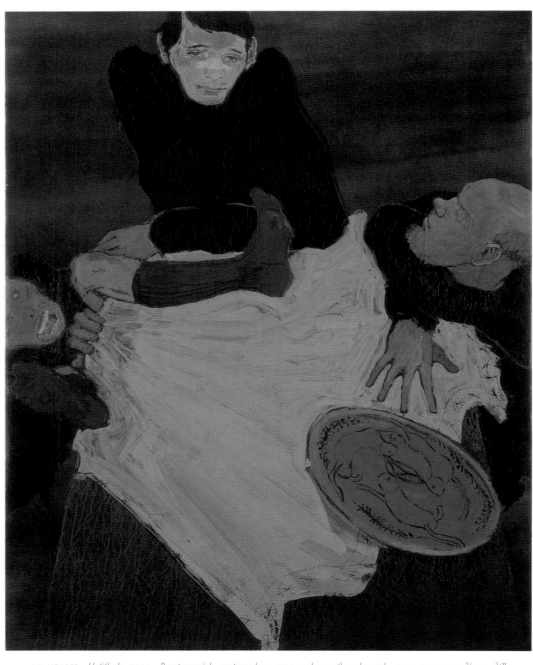

KAI ALTHOFF *Untitled* 2001 Boat varnish, watercolour, pen and pencil on board 50 × 40 cm 19¾ × 15¾"

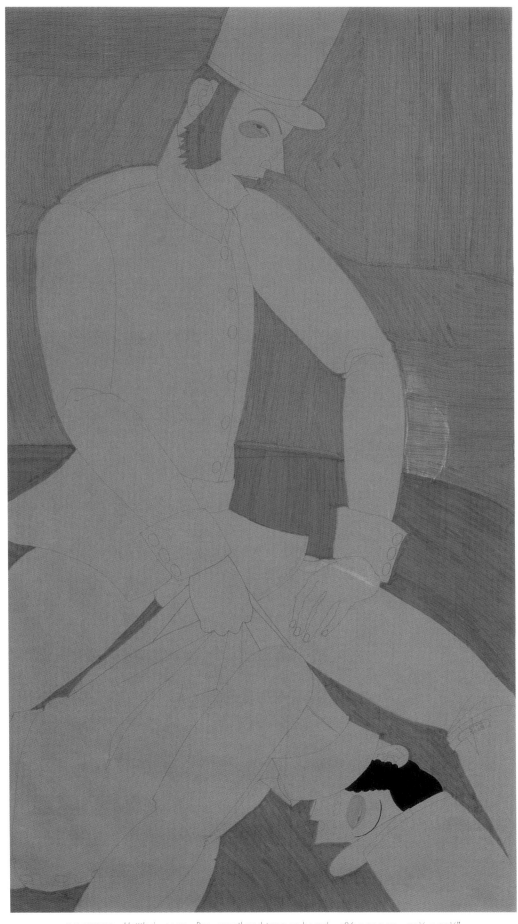

KAI ALTHOFF *Untitled* 1997 Pen, pencil and tape on board 186 × 100 cm 73¼ × 39¼"

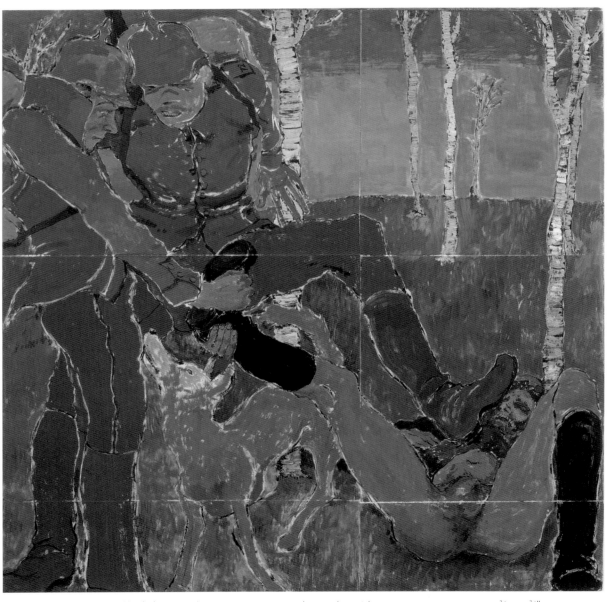

KAI ALTHOFF *Untitled* 2000 Lacquer, paper, watercolour and varnish on canvas 50 × 50 cm 19¾ × 19¾"

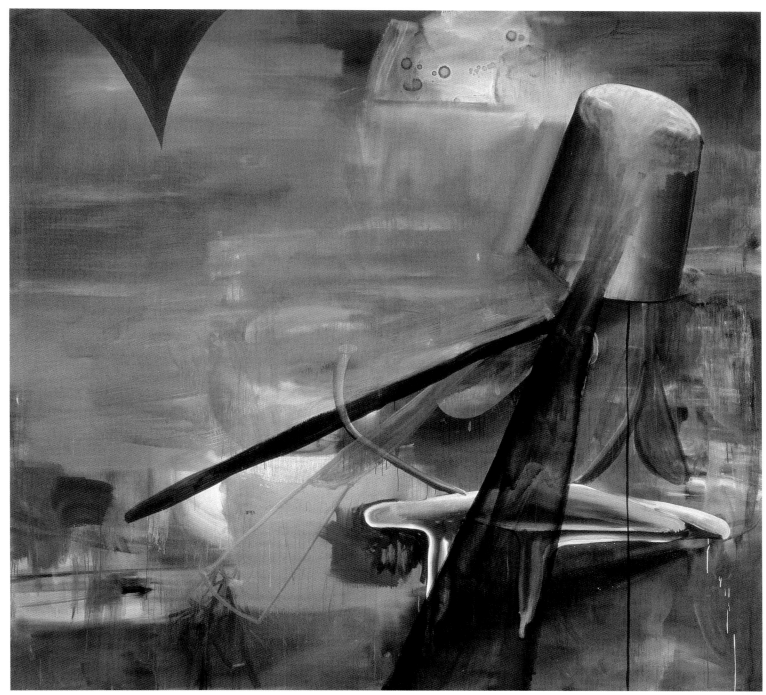

ALBERT OEHLEN *Descending Hot Rays* 2003 Oil on canvas 280 × 300 cm 110¼ × 118"

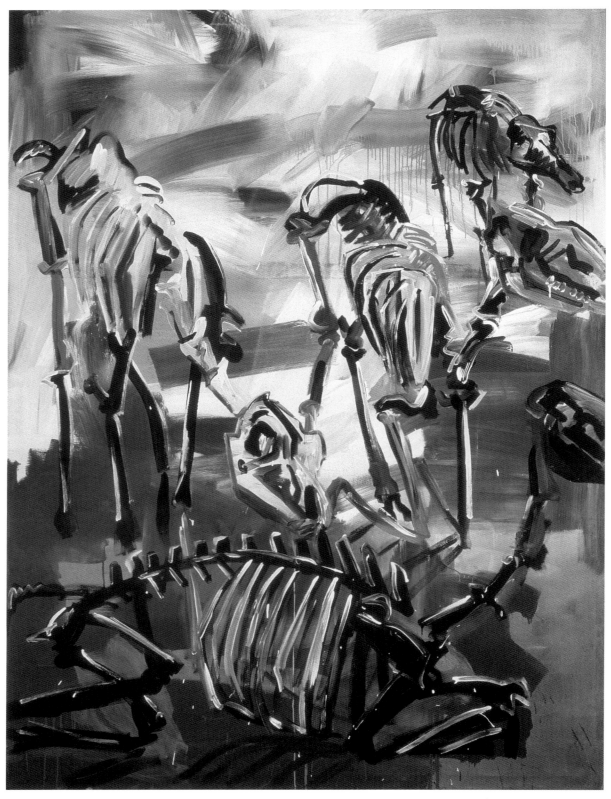

ALBERT OEHLEN *Black Rationality* 1982 Latex on canvas 260 × 190 cm 102¼ × 74¾"

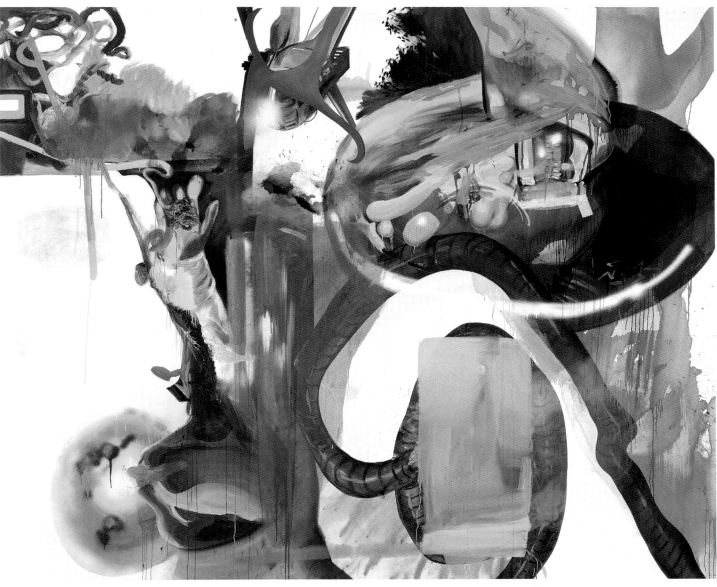

ALBERT OEHLEN *Piece* 2003 Oil on canvas 280 × 340 cm 110¼ × 133¾"

ALBERT OEHLEN
LEFT TO RIGHT
Untitled (Eyes) 1990 Oil on canvas 213.5 × 162.5 cm 84 × 64"
Descending Hot Rays 2003 Oil on canvas 280 × 300 cm 110 × 118"
Black Rationality 1982 Latex on canvas 260 × 190 cm 102 × 75"
Mirage of Steel 2003 Oil on canvas 280 × 340 cm 110 × 134"
Untitled 1989 Oil on canvas 200 × 200 cm 78¾ × 78¾"

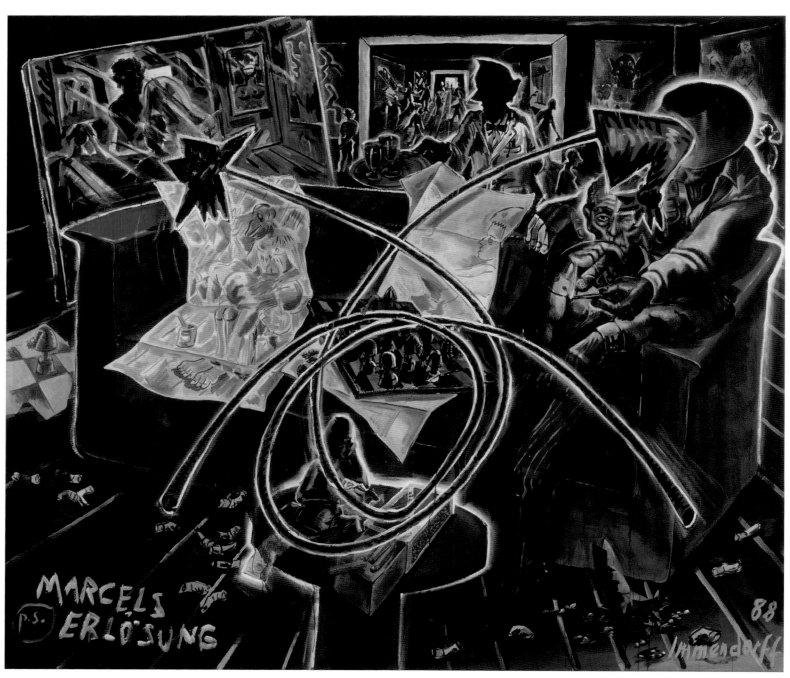

JÖRG IMMENDORFF *Marcels Erlösung* [Marcel's Salvation] 1988 Oil on canvas 260 × 300 cm 102¼ × 118"

JÖRG IMMENDORFF *Ende Gut, Alles Gut* *[All's Well That Ends Well]* 1983 Oil on Canvas 282 × 330 cm 111 × 130"

JÖRG IMMENDORFF *Gyntiana – Geburt Zwiebelmann* [*Gyntiana – The Birth of Onionman*] 1992 Oil on canvas 300 x 400 cm 118 x 157½"

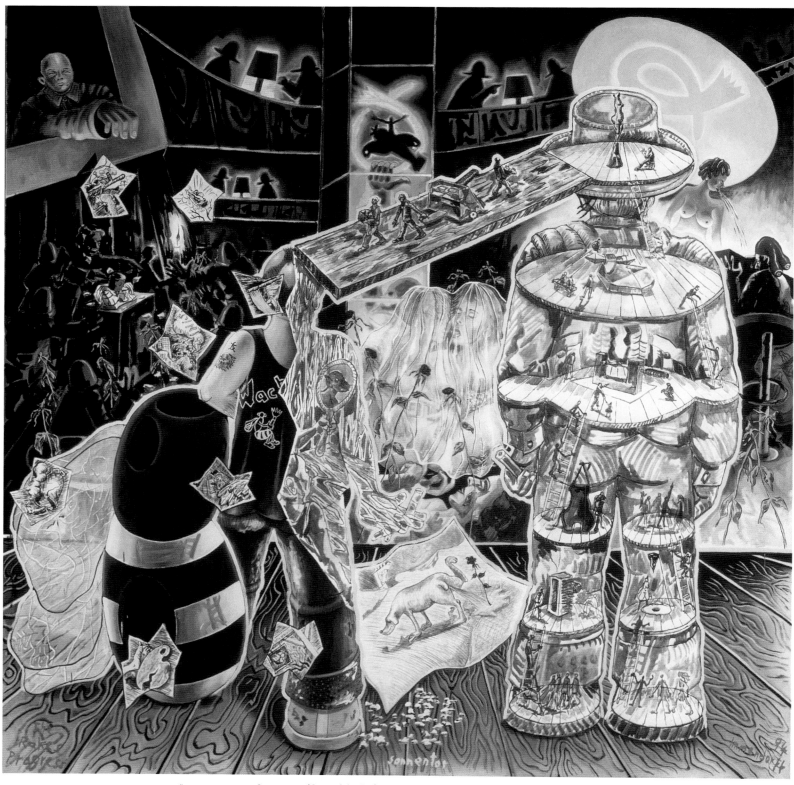

JÖRG IMMENDORFF *Sonnentor* [Gate of the Sun] 1994 Oil on canvas 280 × 280 cm 110¼ × 110¼"

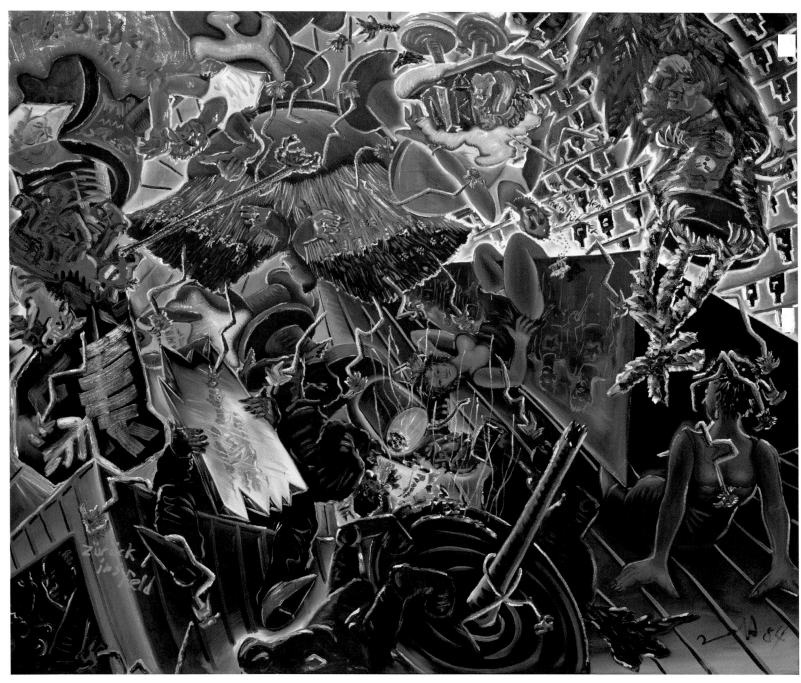

JÖRG IMMENDORFF *Café Deutschland (Lift/Tremble/Back)* 1984 Oil on canvas 285 × 330 cm 112 × 130"

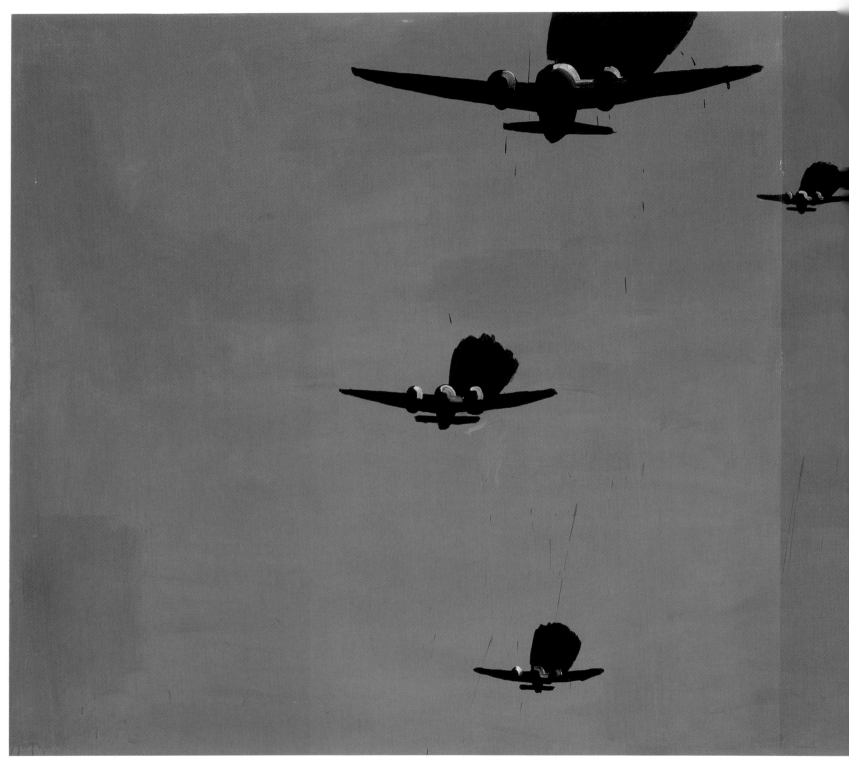

WILHELM SASNAL *Airplanes* 2001 Oil on canvas 150 × 300 cm 59 × 118"

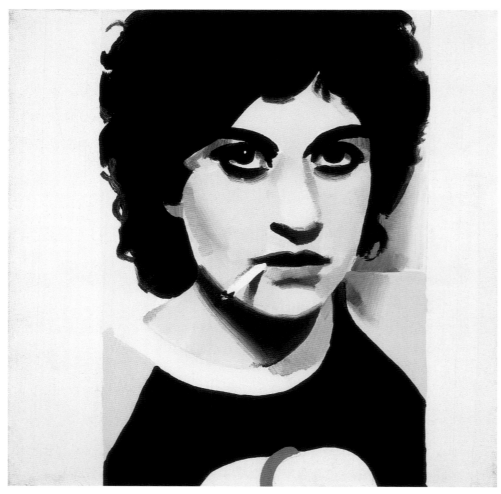

WILHELM SASNAL *Girl Smoking (Peaches)* 2001 Oil on canvas 33 × 33 cm 13 × 13"

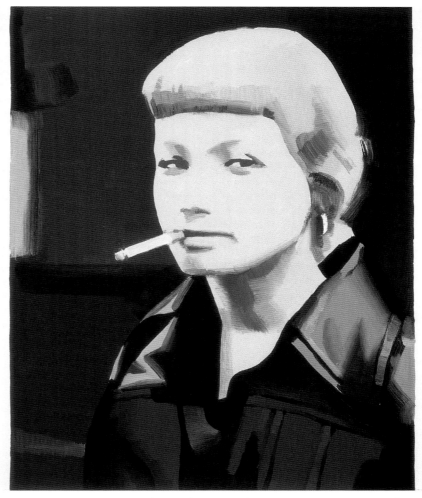

WILHELM SASNAL *Girl Smoking (Dominika)* 2001 Oil on canvas 33 × 33 cm 13 × 13"

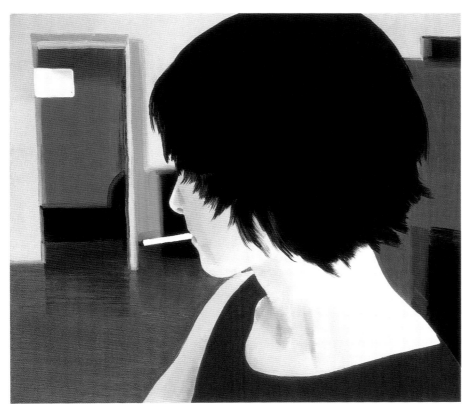

WILHELM SASNAL *Girl Smoking (Anka)* 2001 Oil on canvas 45 × 50 cm 17¾ × 19¾"

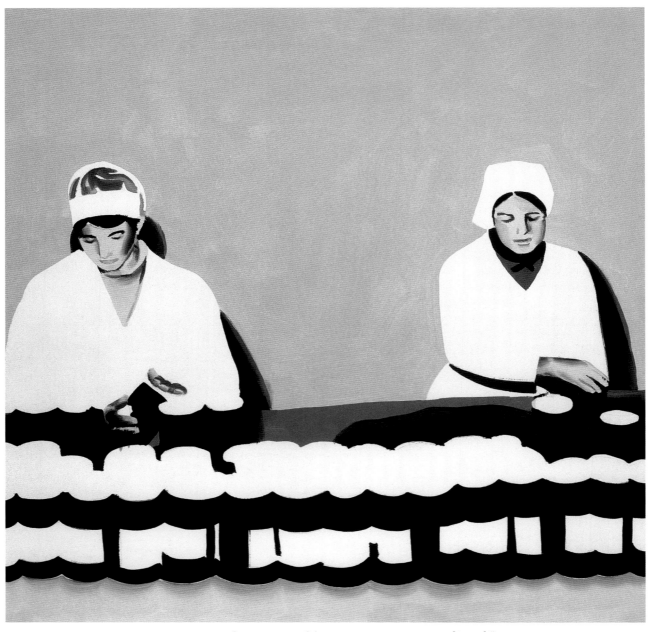

WILHELM SASNAL *Factory* 2000 Oil on canvas 101 × 101 cm 39¾ × 39¾"

WILHELM SASNAL *Man at the Control Panel* 2000 Oil on canvas 180 × 160 cm 70¾ × 63"

MATTHIAS WEISCHER *Egyptian Room* 2001 Oil on canvas 220 x 220 cm 86½ x 86½"

MATTHIAS WEISCHER *Living Room* 2003 Oil on canvas 170 × 190 cm 67 × 74¾"

DIRK SKREBER *It Rocks Us So Hard — Ho, Ho, Ho No.2* 2002 Oil on canvas 160 × 280 cm 63 × 110¼"

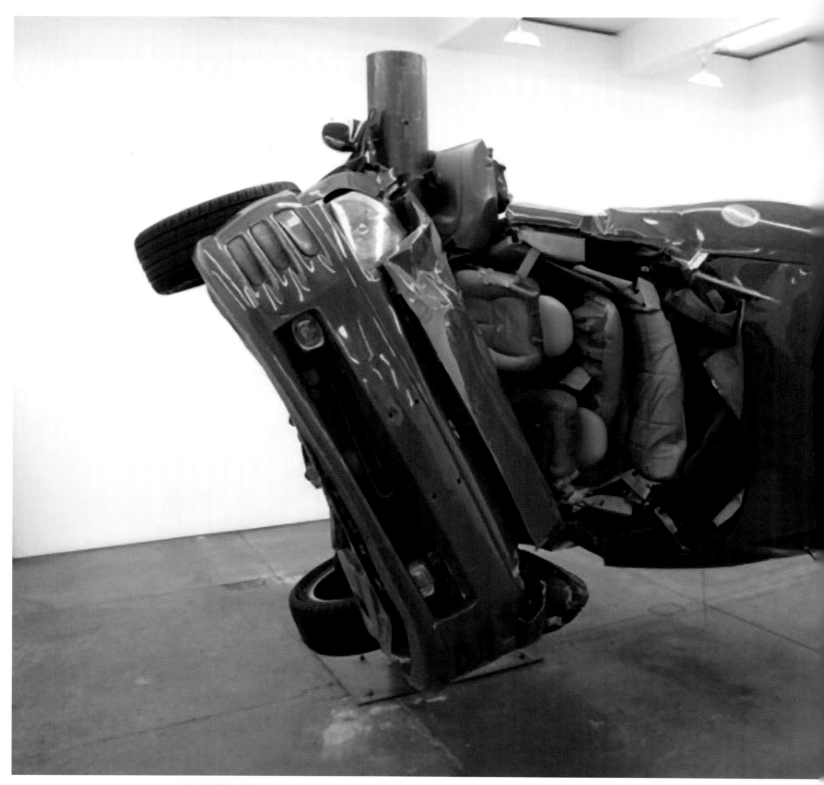

DIRK SKREBER *Untitled (Crash 1)* 2009 Red Mitsubishi Eclipse Spider 2001 292.1 × 322.6 × 236.2 cm 115 × 127 × 93"

FRANZ ACKERMANN
LEFT TO RIGHT
Mental Map: Evasion VI 1996 Acrylic on canvas 195 × 210 cm 77 × 83"
Helicopter XVI (On The Balcony) 2001 Oil on canvas 287 × 278 cm 113 × 109"
Mental Map: Evasion IV 1996 Acrylic on canvas 275 × 305 cm 108 × 120"

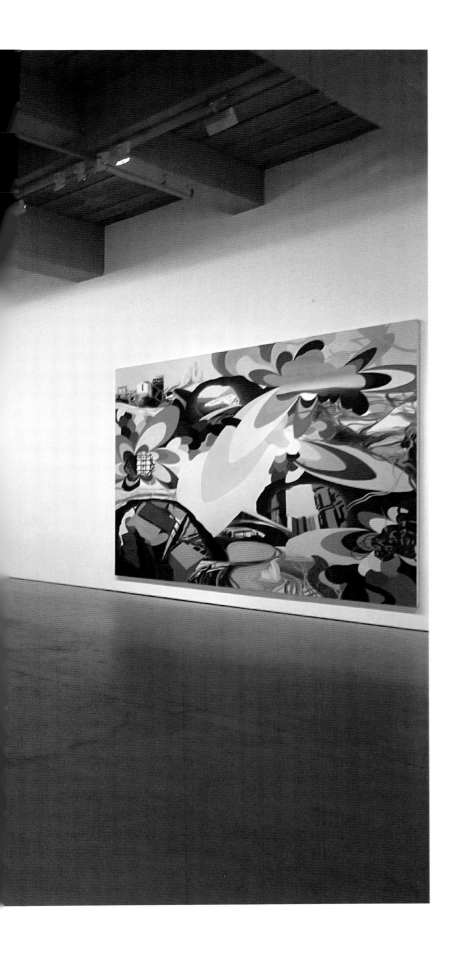

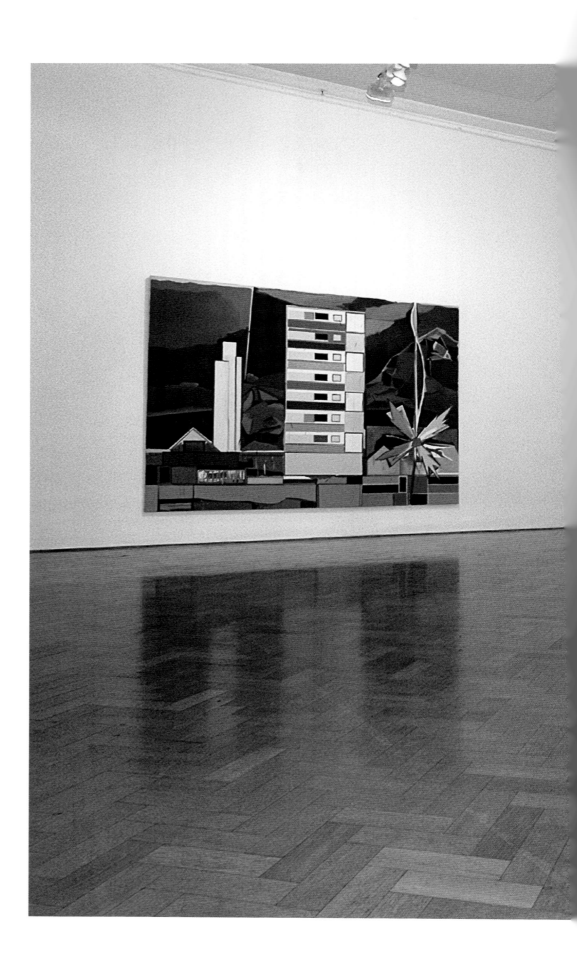

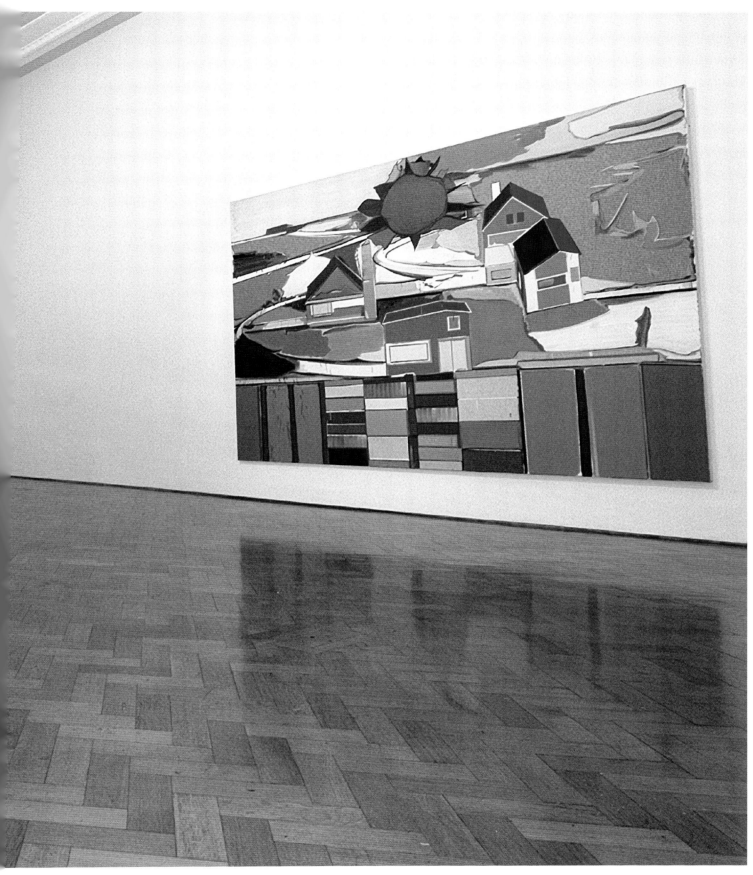

THOMAS SCHEIBITZ
LEFT TO RIGHT
Rosenweg 1999 Oil on canvas 200 × 270 cm 79 × 106"
Untitled 2002 Oil on canvas 205 × 281 cm 81 × 111"

USA TODAY:
NEW AMERICAN ART FROM THE SAATCHI GALLERY

BAKER,
DE BALINCOURT,
BHABHA,
BRADFORD, COLEN,
DAVIS, ESSENHIGH,
FURNAS,
GROTJAHN,
HINKLEY

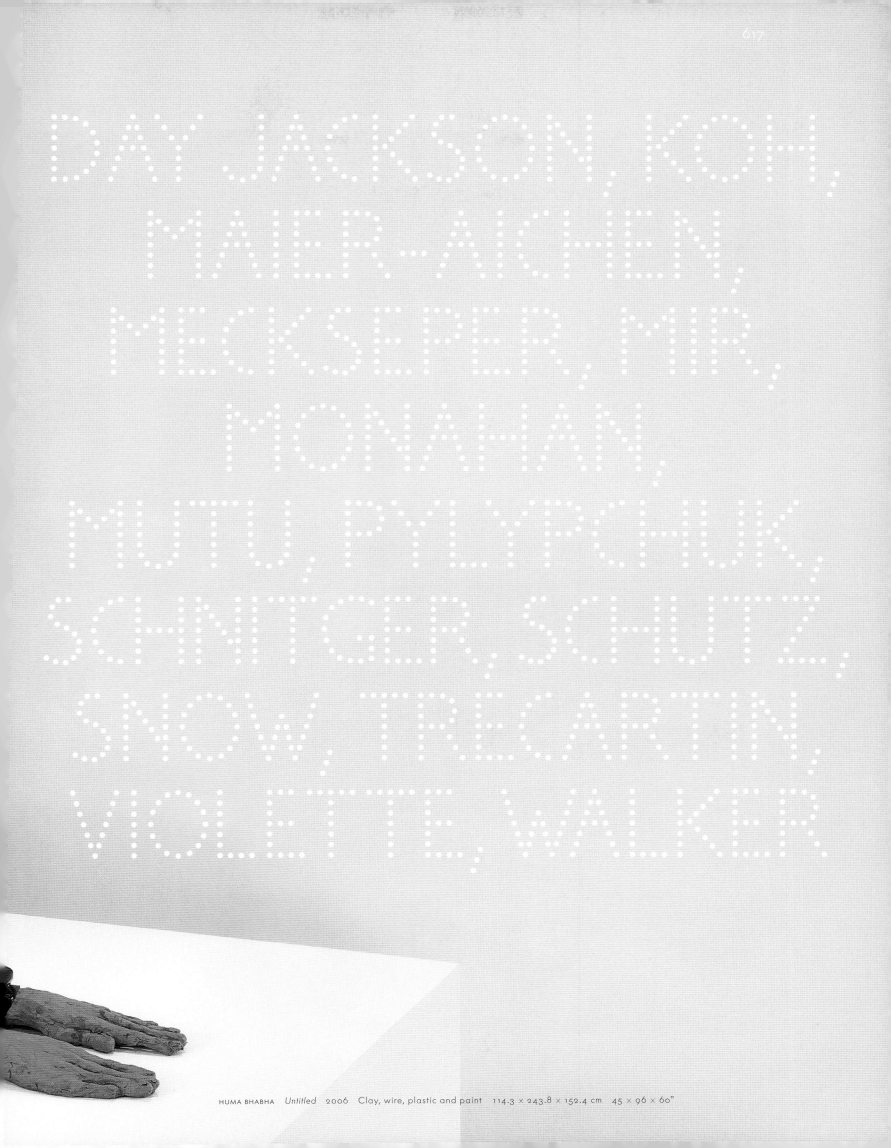

HUMA BHABHA *Untitled* 2006 Clay, wire, plastic and paint 114.3 × 243.8 × 152.4 cm 45 × 96 × 60"

ALEKSANDRA MIR *Cold War* 2005 Felt-tip pen on paper 305 × 483 cm 120 × 190¼"

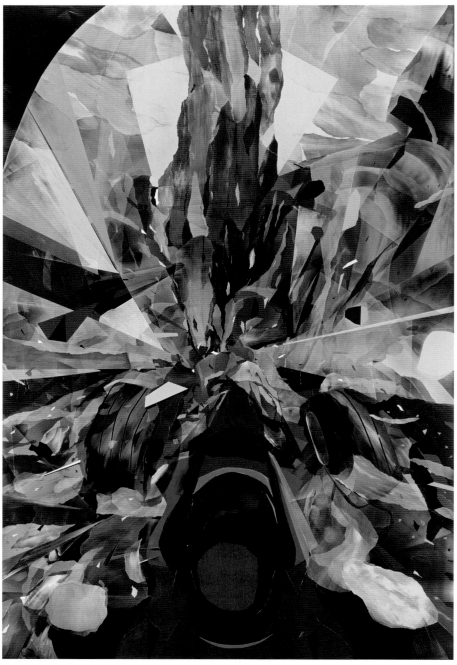

KRISTIN BAKER *Washzert Suisse* 2005 Acrylic on mylar 304.8 × 198.1 cm 120 × 78"

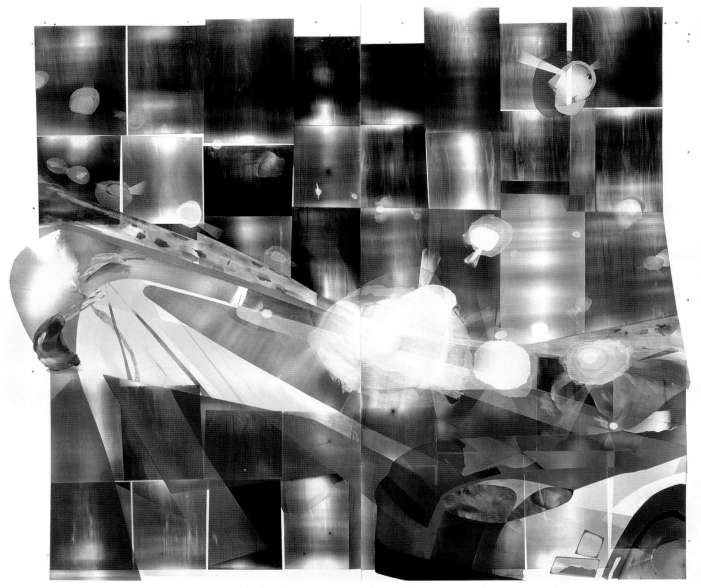

KRISTIN BAKER *Ride the Lightning* 2003 Acrylic on PVC 259.1 × 304.8 cm 102 × 120"

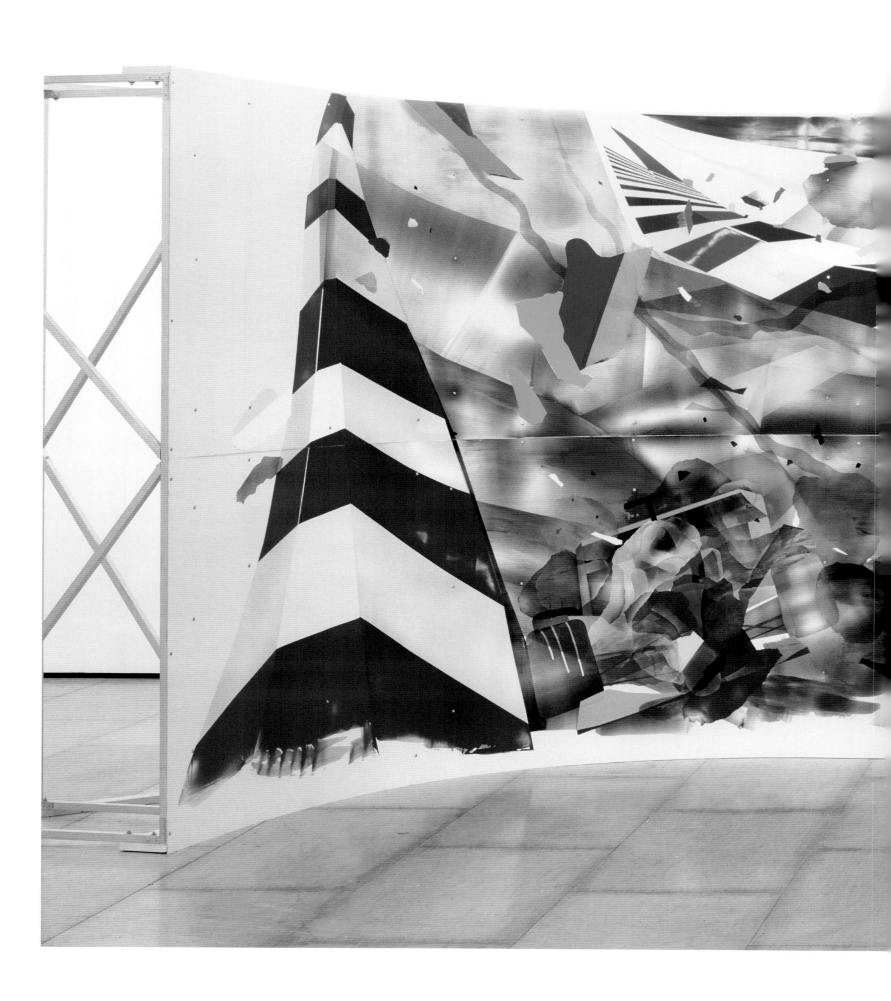

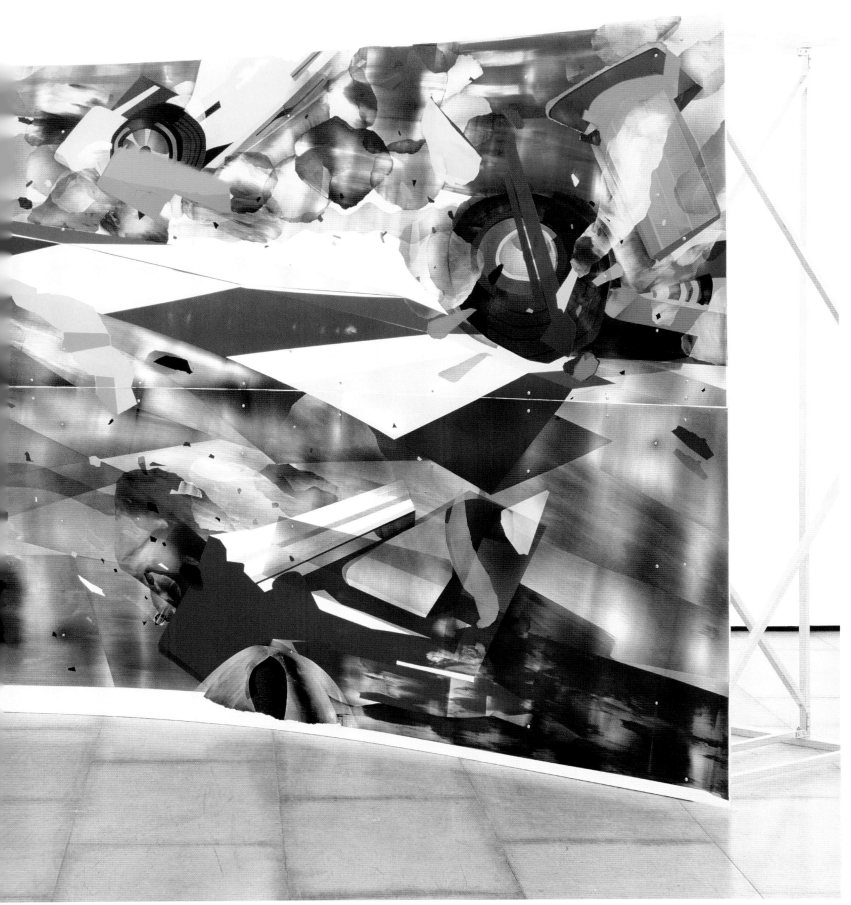

KRISTIN BAKER *Kurtoplac Kurve* 2004 Acrylic on PVC 304.8 × 609 cm 120 × 239¾"

KRISTIN BAKER *The Unfair Advantage* 2003 Acrylic on PVC 152.4 × 274.3 cm 60 × 108"

KRISTIN BAKER *Excide Batteries Beer-a-Sphere* 2003 Acrylic on PVC 244 × 304.8 cm 96 × 120"

KRISTIN BAKER *The Raft of Perseus* 2006 Acrylic on PVC 255.3 × 406.4 cm 100½ × 160"

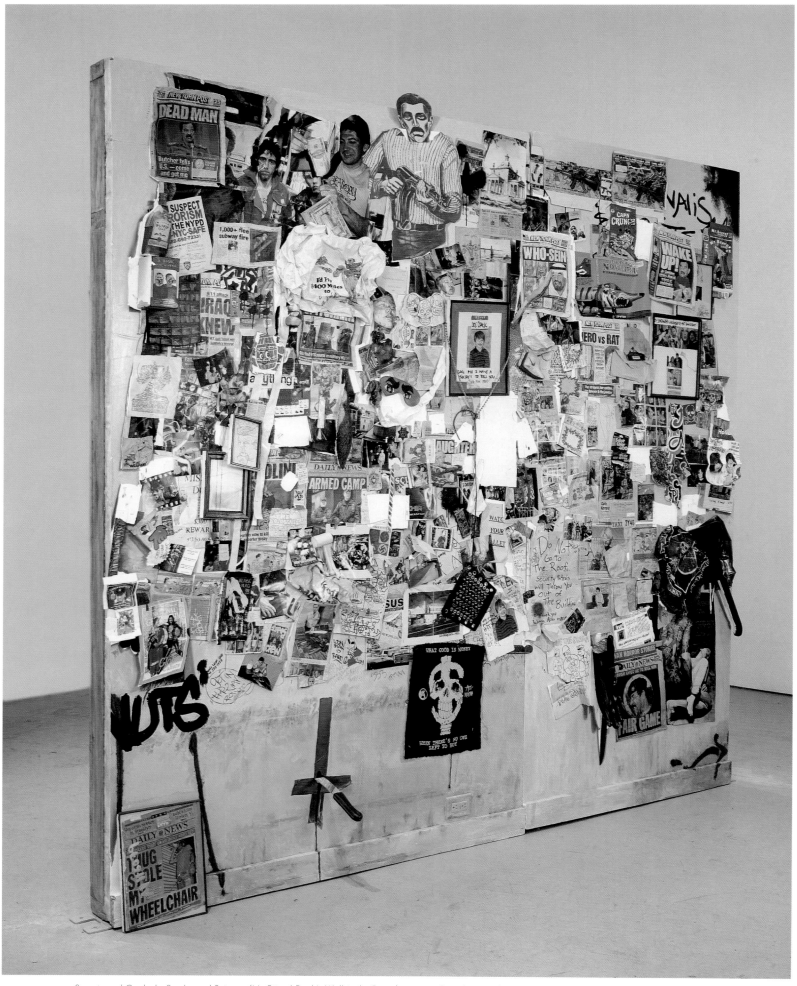

DAN COLEN *Secrets and Cymbals, Smoke and Scissors (My Friend Dash's Wall in the Future)* 2004 Styrofoam, oil paint, paper and metal 269 × 287 × 15 cm 106 × 113 × 6"
RIGHT DAN COLEN *Secrets and Cymbals, Smoke and Scissors (My Friend Dash's Wall in the Future)* 2004 (detail)

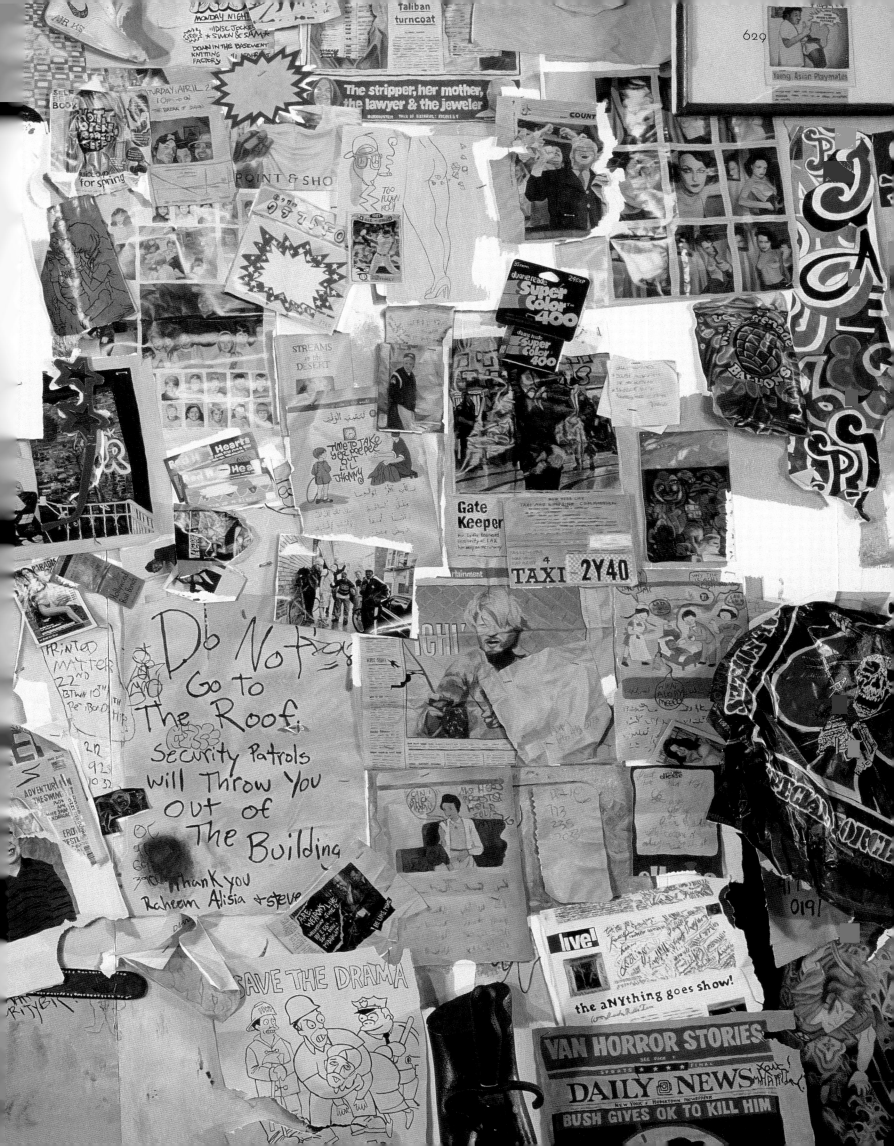

DAN COLEN *Rama Lama Ding Dong* 2006 Enamel and moulding paste on wood 134.6 × 101.6 cm 53 × 40"

DAN COLEN *Untitled (Vete al Diablo)* 2006 Wood, wire, polyurethane, papier-mâché, gesso and oil paint
Body: 182.9 × 121.9 cm 72 × 48" Height of base: 30.5 cm 12"

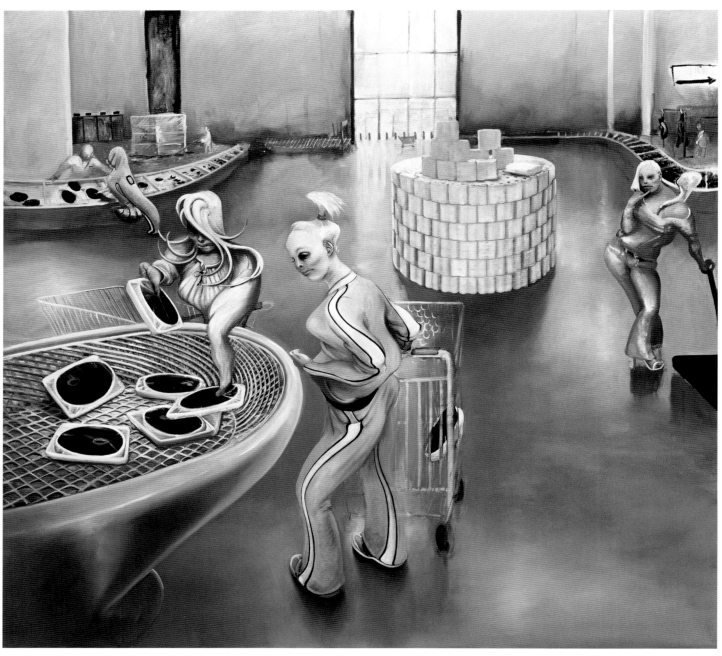

INKA ESSENHIGH *Shopping* 2005 Oil on linen 178 × 193 cm 70 × 76"

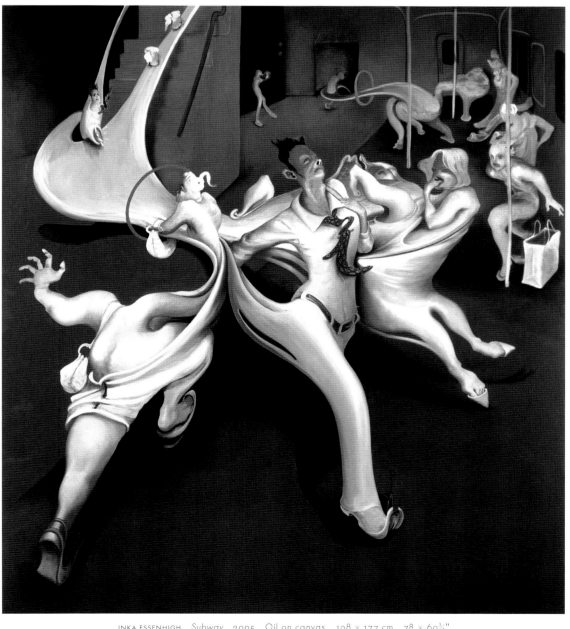

INKA ESSENHIGH *Subway* 2005 Oil on canvas 198 × 177 cm 78 × 69¾"

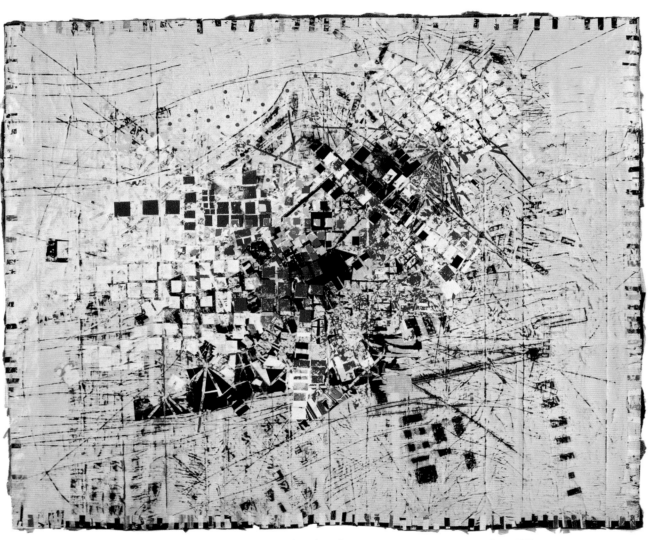

MARK BRADFORD *Kryptonite* 2006 Mixed media collage on paper 249 × 301 cm 98 × 118½"

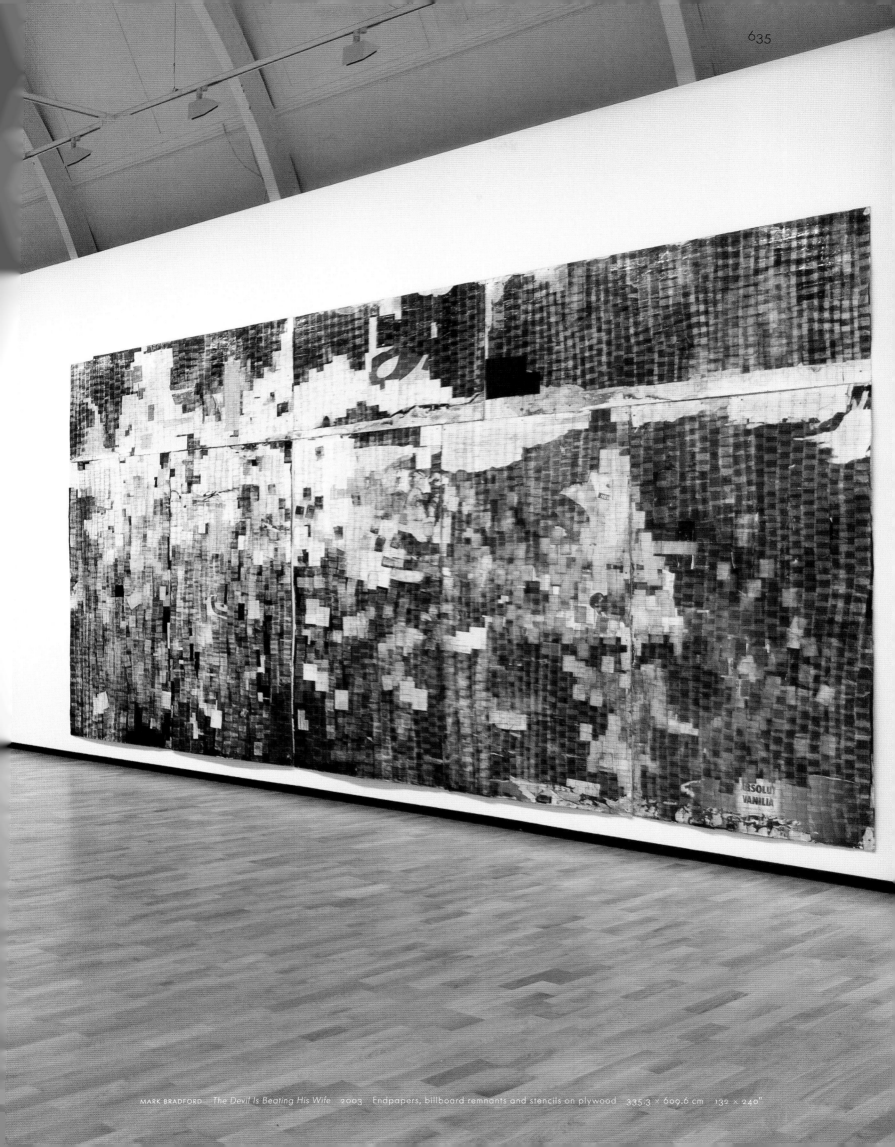

MARK BRADFORD *The Devil Is Beating His Wife* 2003 Endpapers, billboard remnants and stencils on plywood 335.3 × 609.6 cm 132 × 240"

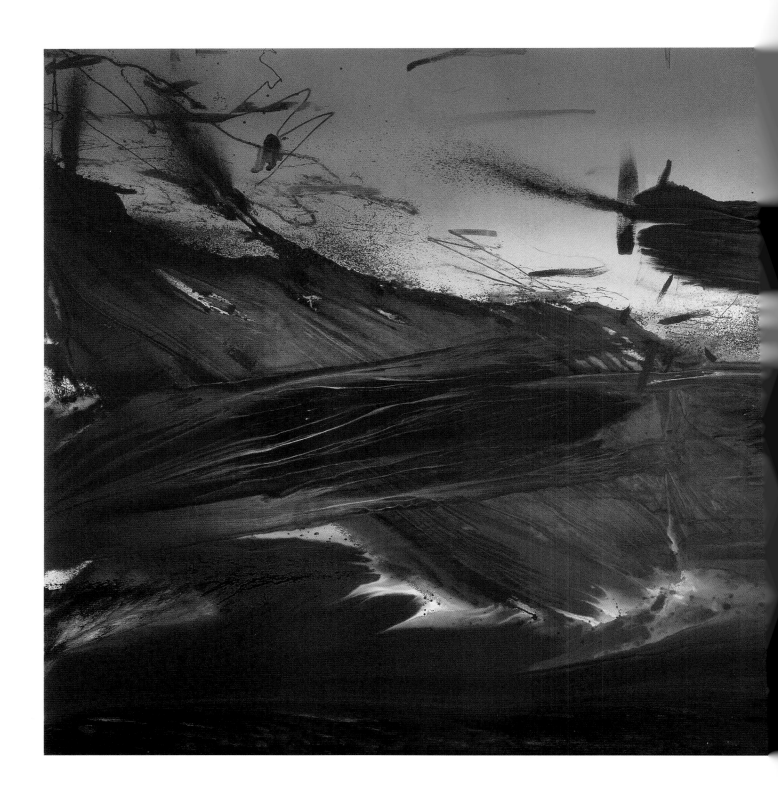

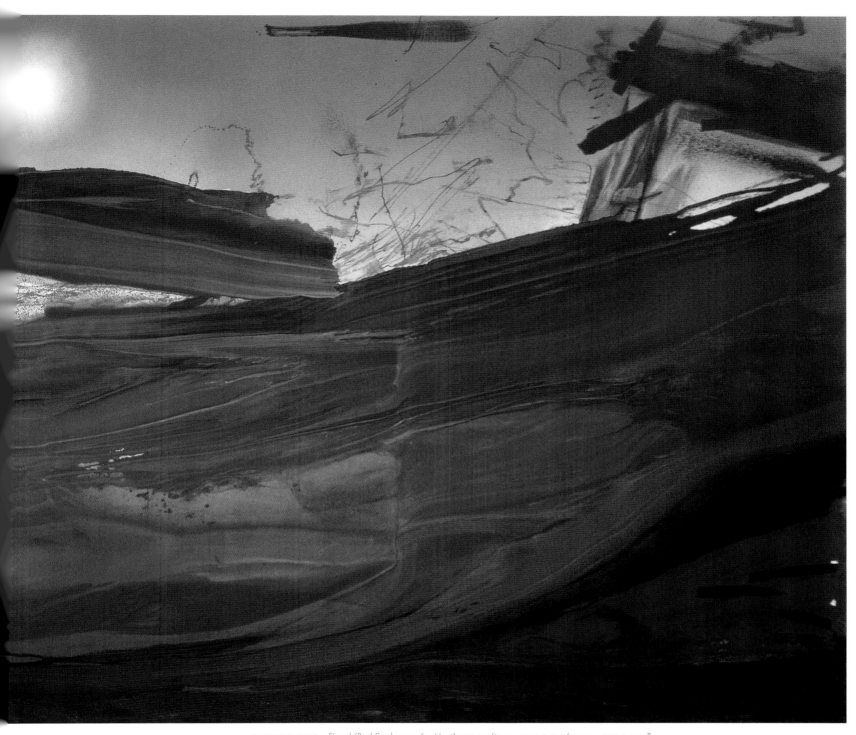

BARNABY FURNAS *Flood (Red Sea)* 2006 Urethane on linen 330.2 × 762 cm 130 × 300"

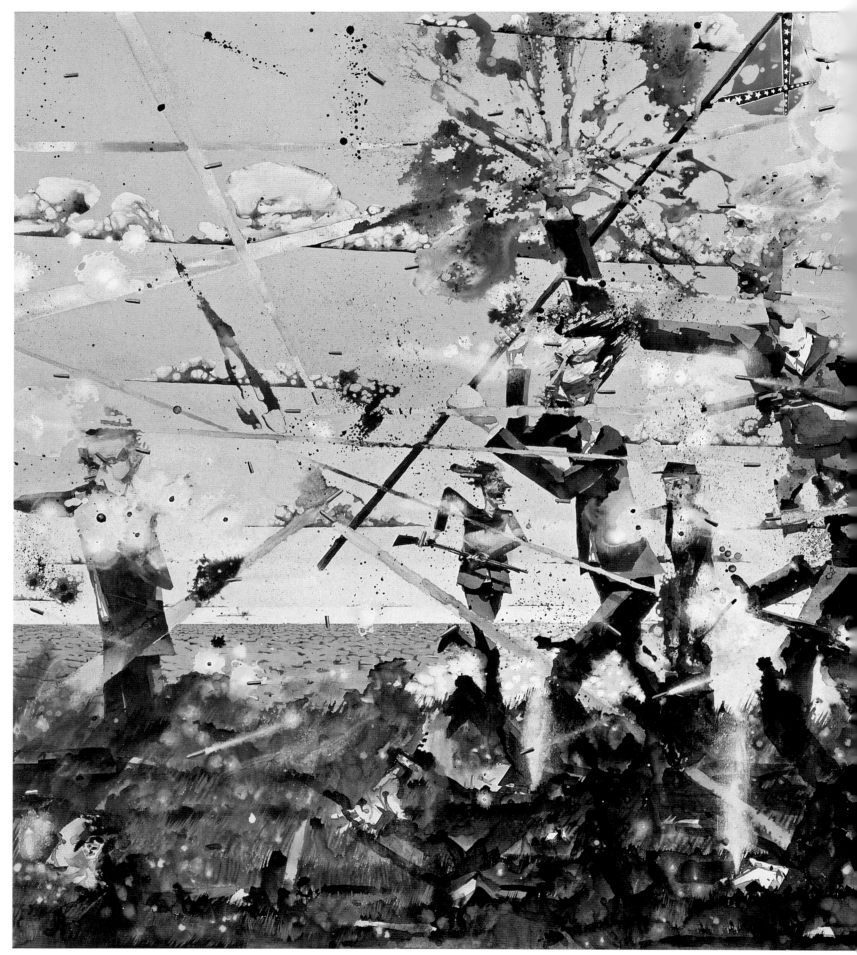

BARNABY FURNAS *Hamburger Hill* 2002 Urethane on linen 182.9 × 304.8 cm 72 × 120"

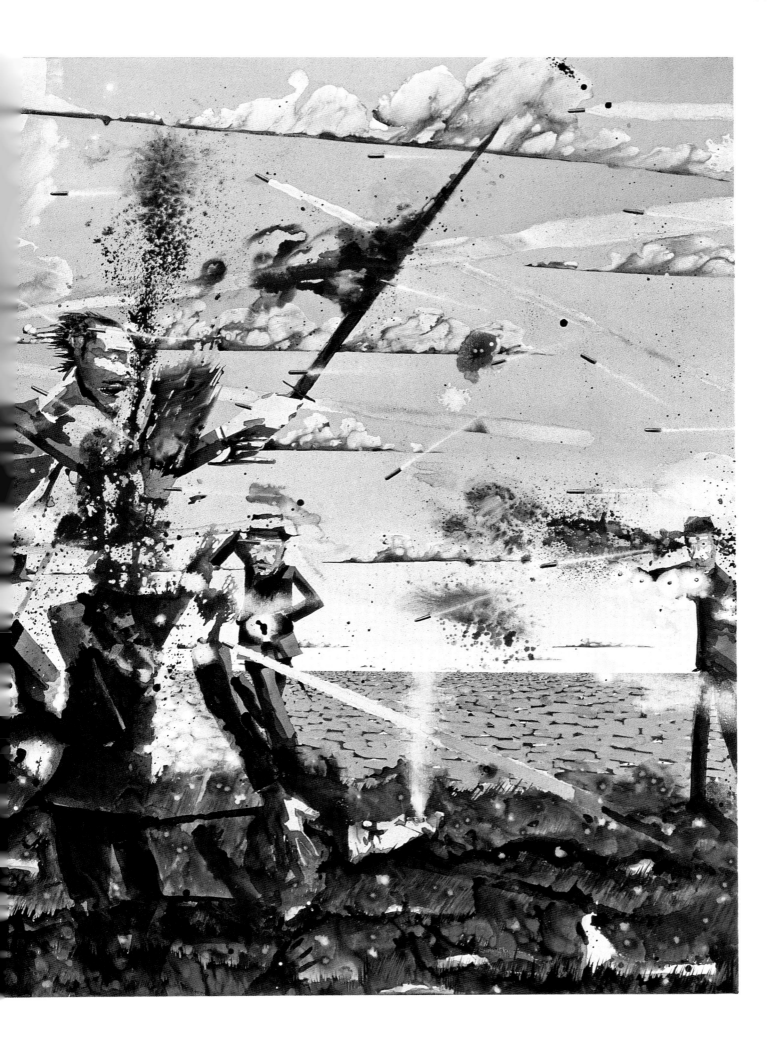

BARNABY FURNAS *Duel* 2004 Oil on canvas 325 × 193 cm 128 × 76"

ELLIOTT HUNDLEY *Hyacinth* 2006 Corkboard, paper, photographs, plastic, fabric, pins, wood, oil paint, acrylic, charcoal, pastel, string, ceramic and shells
244 × 216 × 38.1 cm 96 × 85 × 15"

ELLIOT HUNDLEY *Untitled* 2005 Mixed media on styrofoam core, pins, wax, paper, string and various found objects 5 panels: 244 × 61 cm 96 × 24"

ELLIOT HUNDLEY *The Hanging Garden, The Invention of Drawing* 2005 Collage, mixed media, pastel, graphite, collage, cut outs on paper 216 × 142 cm 85 × 56"

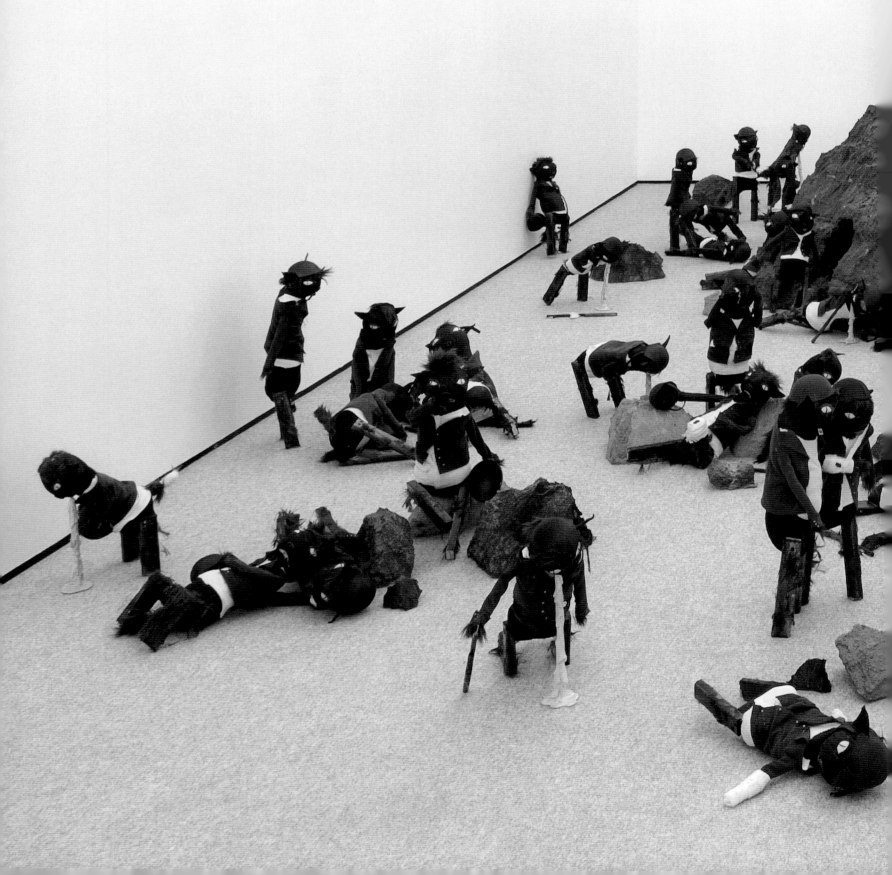

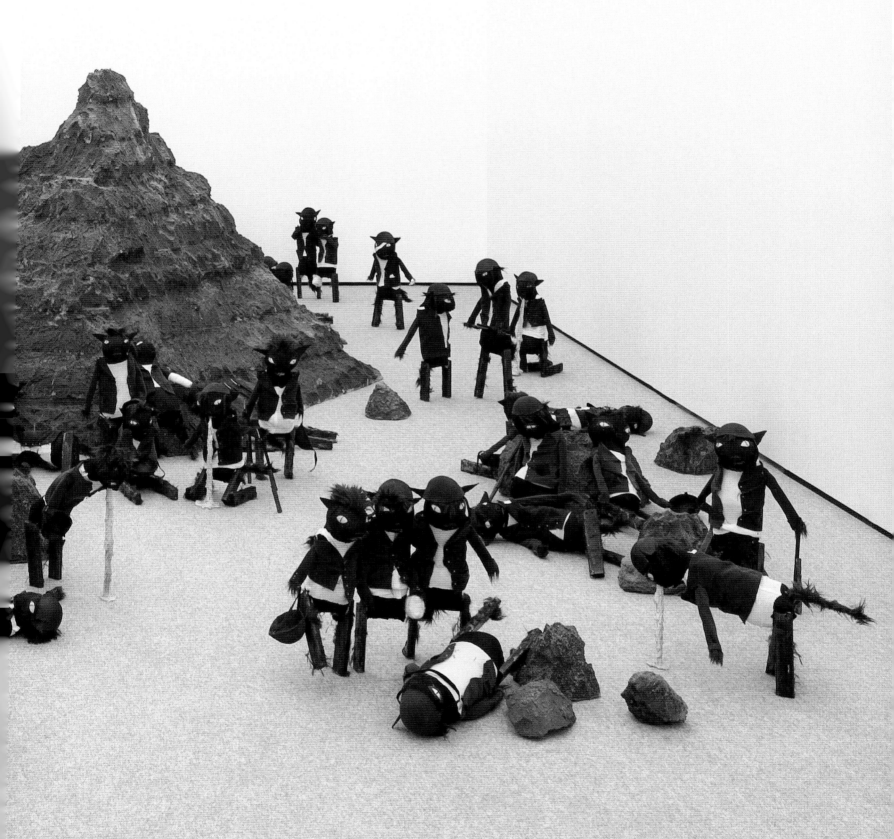

JON PYLYPCHUK *Hopefully, I Will Live Through This with a Little Bit of Dignity* 2005 Mixed media Dimensions variable

MATTHEW DAY JACKSON *Dance of Destruction (Featuring 'Lady Liberty' as Shiva, Wovako, Eleanor and Jim Jones)* 2005
Posters, stickers, photographs, acrylic, push pins and needlepoint Dimensions variable

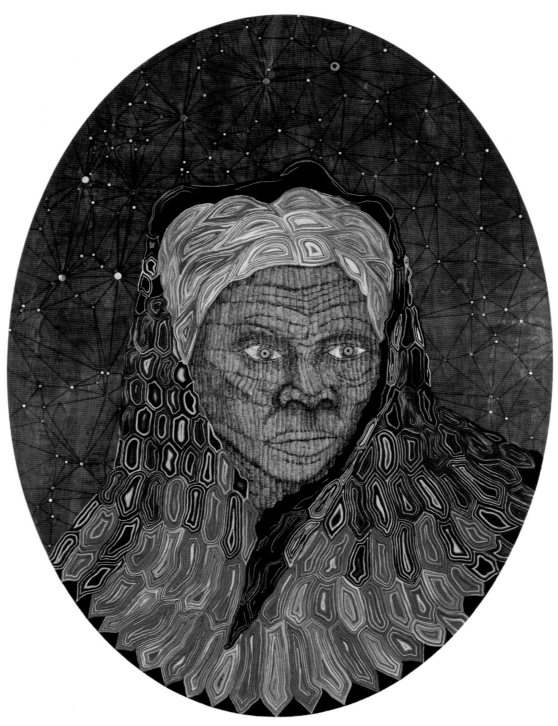

MATTHEW DAY JACKSON *Harriet (Last Portrait)* 2006
Wood-burned drawing, yarn, aniline dye, mother of pearl, abalone and black panther eyes on wood panel 243.8 × 182.9 cm 96 × 72"

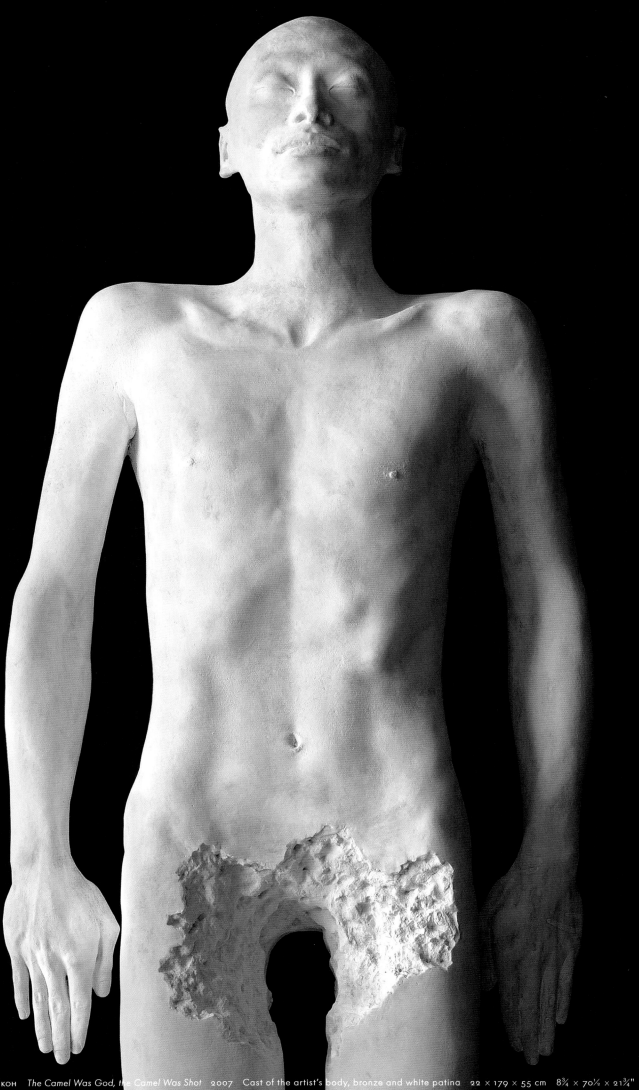

TERENCE KOH *The Camel Was God, the Camel Was Shot* 2007 Cast of the artist's body, bronze and white patina 22 × 179 × 55 cm 8¾ × 70½ × 21¾"

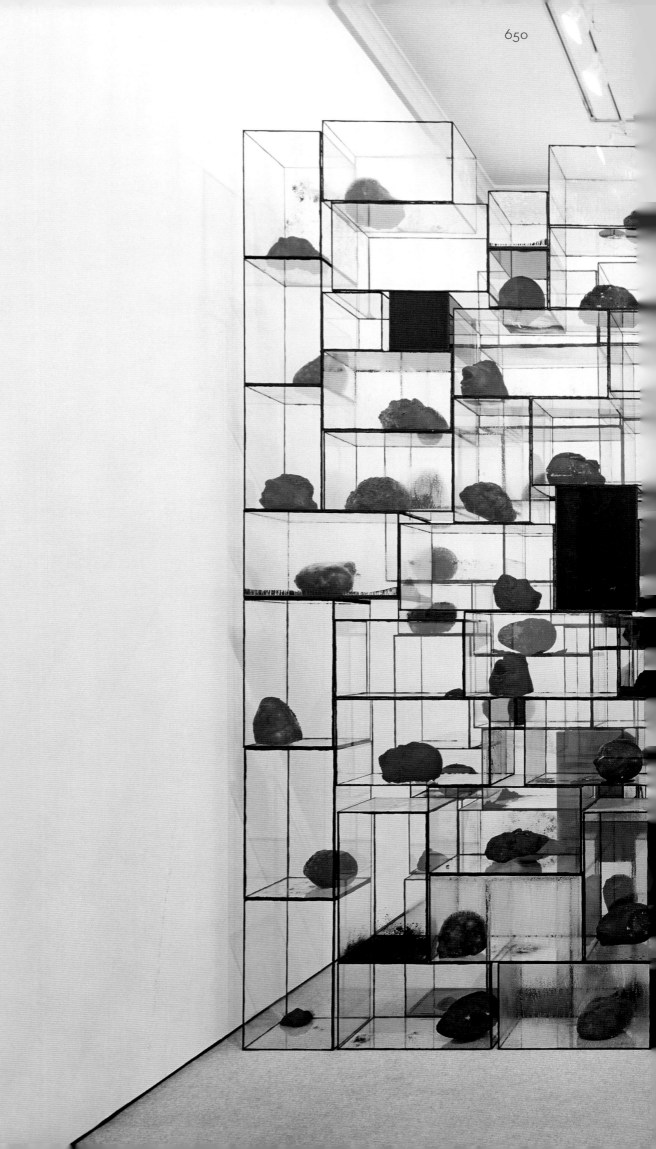

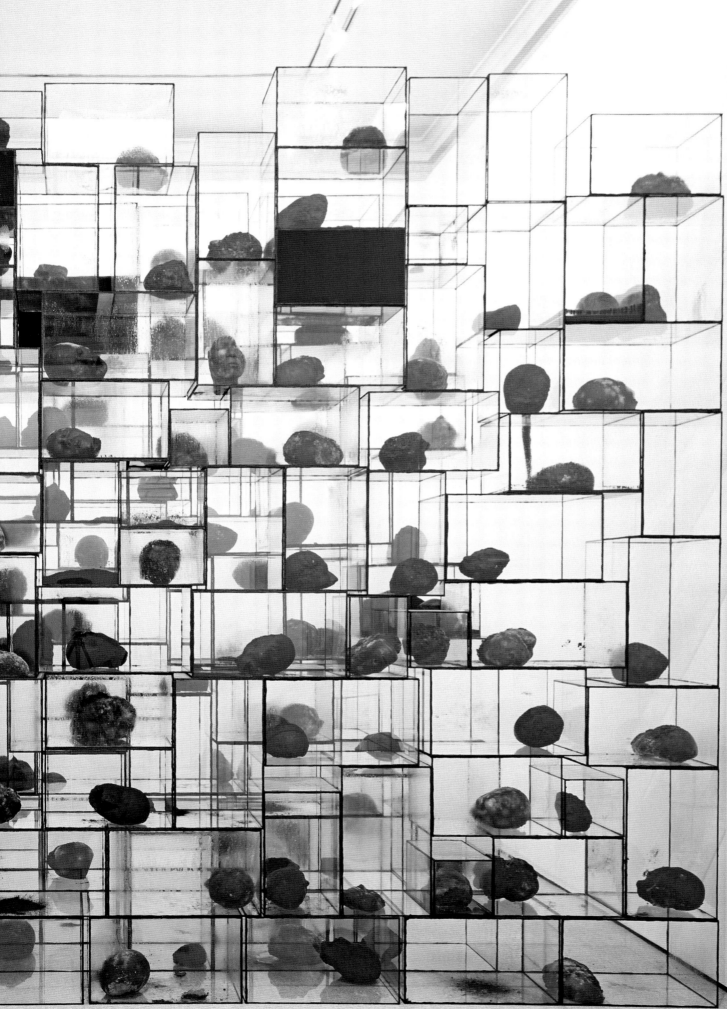

TERENCE KOH *Crackhead* 2006 222 plaster heads, 222 glass vitrines, paint, wax, fire, charcoal, UV glue, paint and fingerprints Dimensions variable

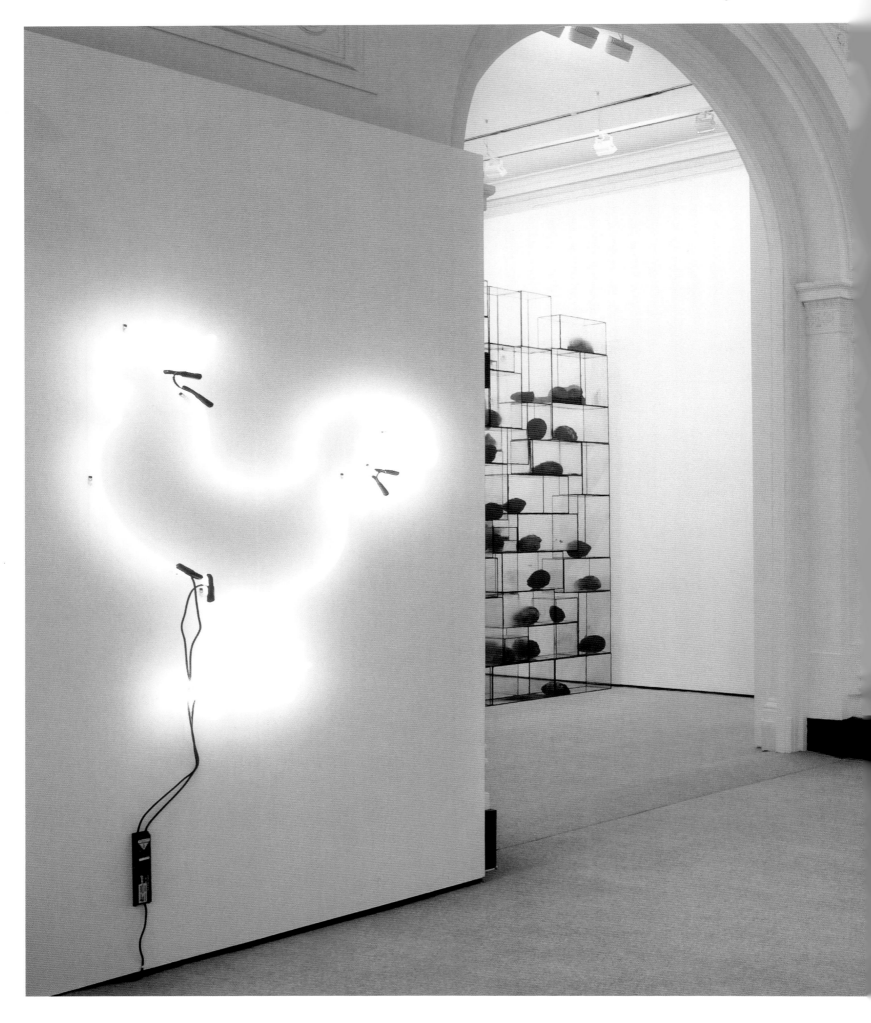

TERENCE KOH (LEFT) *Big White Cock* 2006 White neon 132.1 × 121.9 cm 52 × 48"
JULES DE BALINCOURT (RIGHT) *US World Studies III* 2005 Oil, acrylic and enamel on panel 150 × 183 cm 59 × 72"

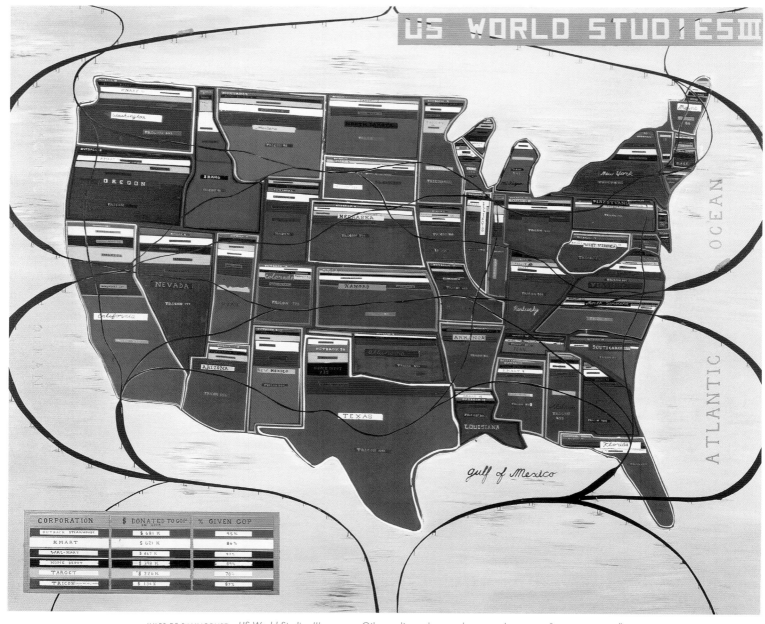

JULES DE BALINCOURT *US World Studies III* 2005 Oil, acrylic and enamel on panel 150 × 183 cm 59 × 72"

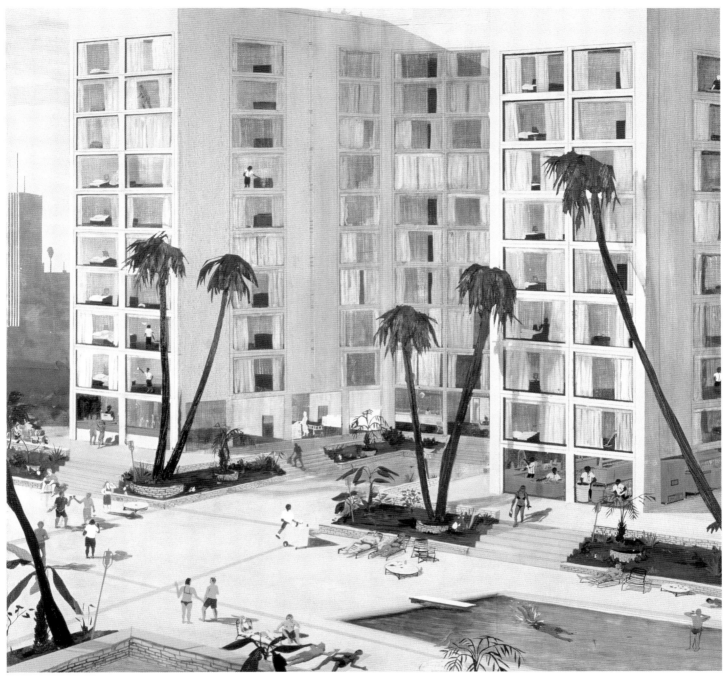

JULES DE BALINCOURT *The People Who Play and the People Who Pay* 2004 Oil and enamel on panel 127 × 122 cm 50 × 48"

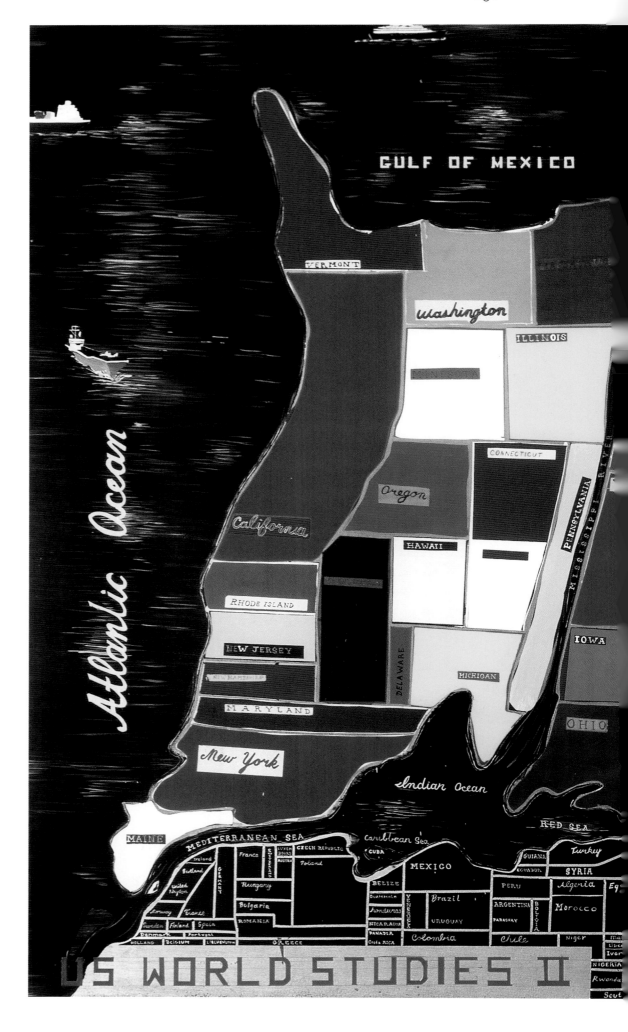

JULES DE BALINCOURT *US World Studies II* 2005 Oil, acrylic and enamel on panel 122 × 173 cm 48 × 68"

FLORIAN MAIER-AICHEN *Untitled* 2005 C-print 183 × 229.8 cm 72 × 90½"

FLORIAN MAIER-AICHEN *Untitled (Long Beach)* 2004 C-print 182 × 235 cm 71¾ × 92½"

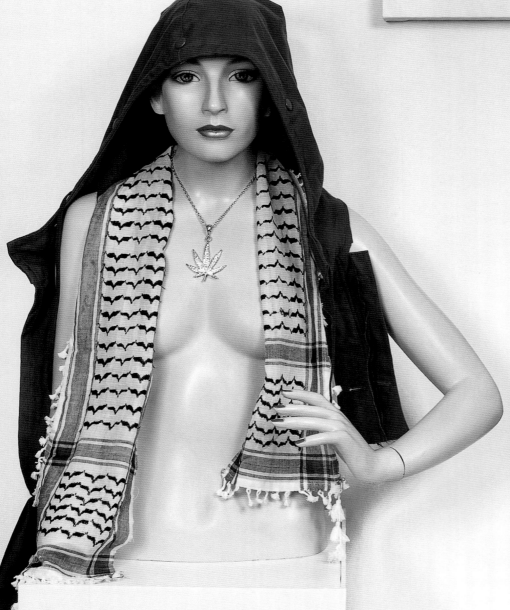

JOSEPHINE MECKSEPER *Untitled* 2005 Mannequin, fabric, found jewellery, inkjet print on fabric, acrylic and fabric on canvas
Mannequin: 144.8 × 66 × 43.8 cm 57 × 26 × 17¼" Painting: 61 × 61 cm 24 × 24" Collage: 41 × 41 cm 16¼ × 16¼"

JOSEPHINE MECKSEPER *Ubi Pedes, Ibi Patria (Where the Feet Are, There Is the Fatherland)* 2006
Shoes and display carousel 153 × 83 cm 60¼ × 32¾"

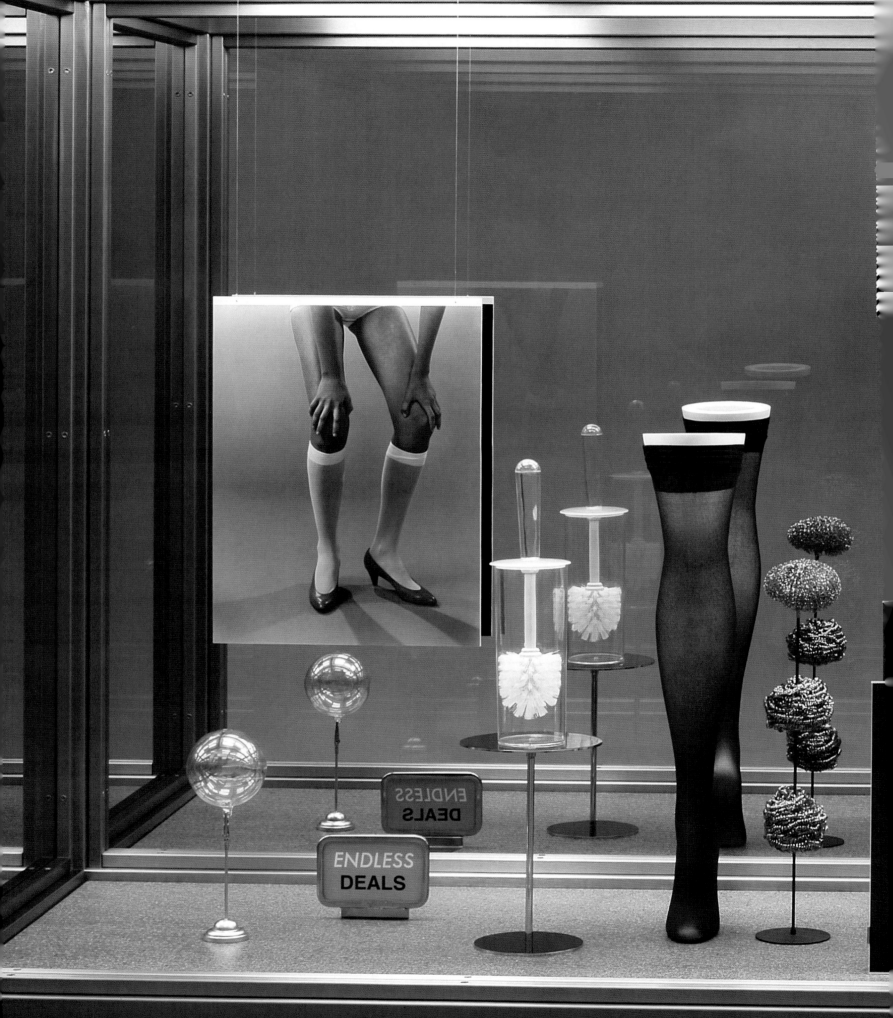

JOSEPHINE MECKSEPER *Blow Up (Michelli)* 2006 Mixed media in display vitrine 208.3 × 243.8 × 68.6 cm 82 × 96 × 27"

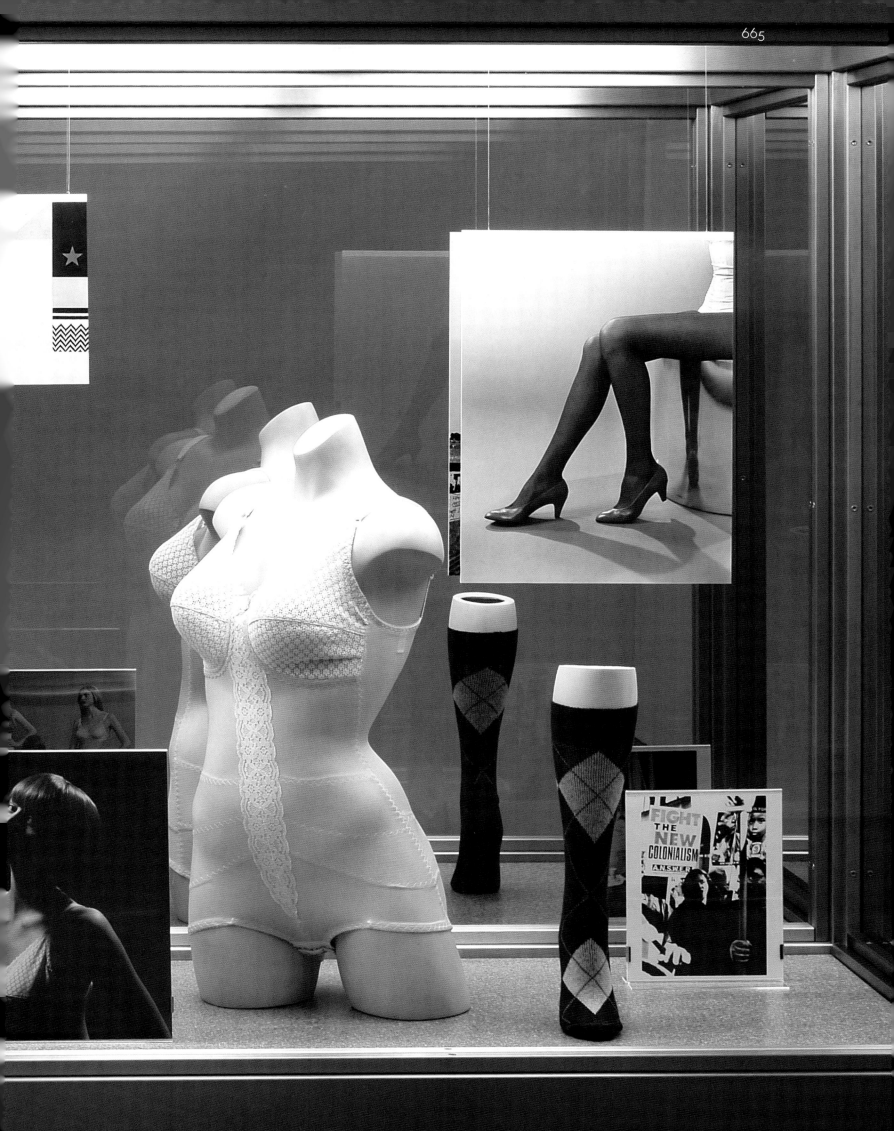

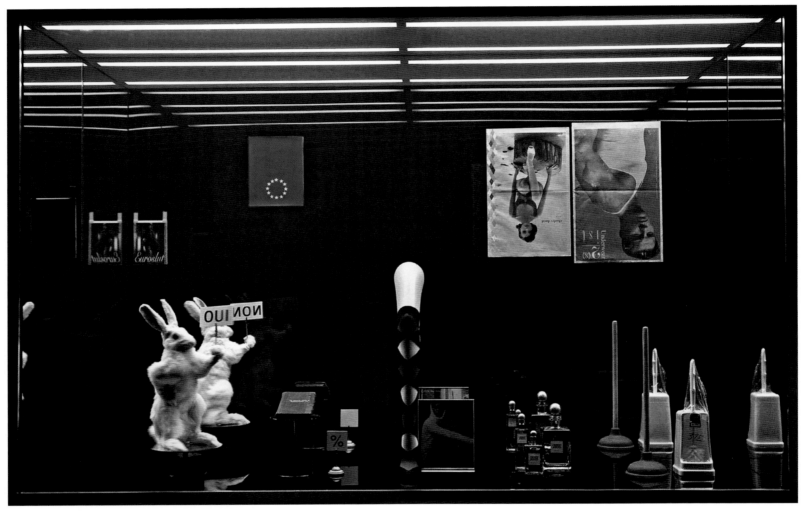

JOSEPHINE MECKSEPER *The Complete History of Postcontemporary Art* 2005 Mixed media in display window
160 × 250.2 × 60 cm 63 × 98½ × 23½"

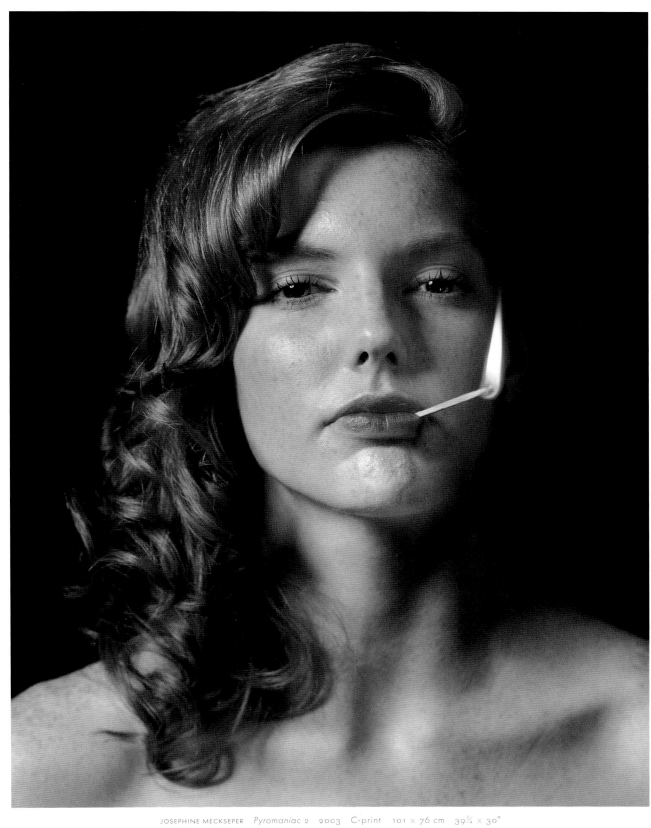

JOSEPHINE MECKSEPER *Pyromaniac 2* 2003 C-print 101 × 76 cm 39¾ × 30"

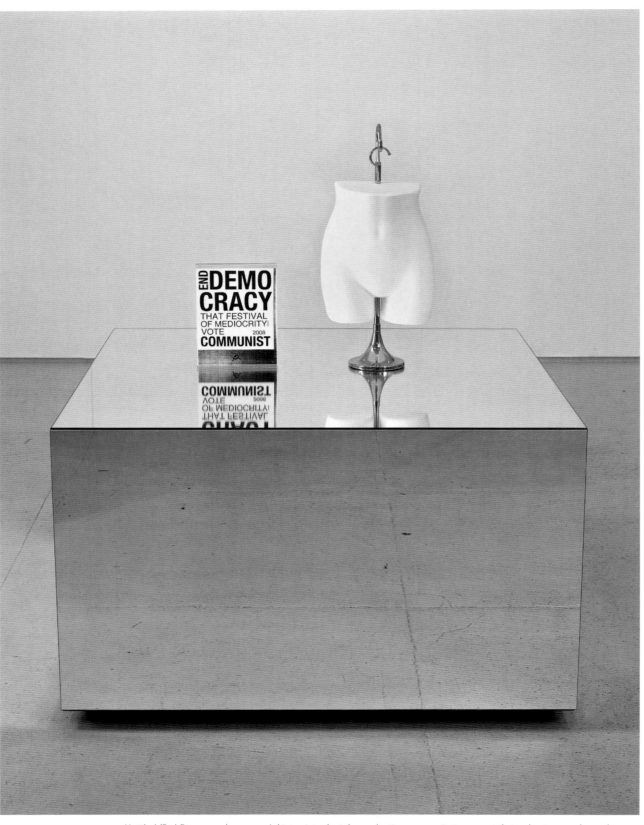

JOSEPHINE MECKSEPER *Untitled (End Democracy)* 2005 Inkjet print, plexiglass, plastic mannequin torso, metal stand, mirror and wood
144 × 122 × 122 cm 56¾ × 48 × 48"

JOSEPHINE MECKSEPER *Selling Out* 2004 Mixed media in window display 78 × 148 × 35 cm 30¾ × 58¼ × 13¾"

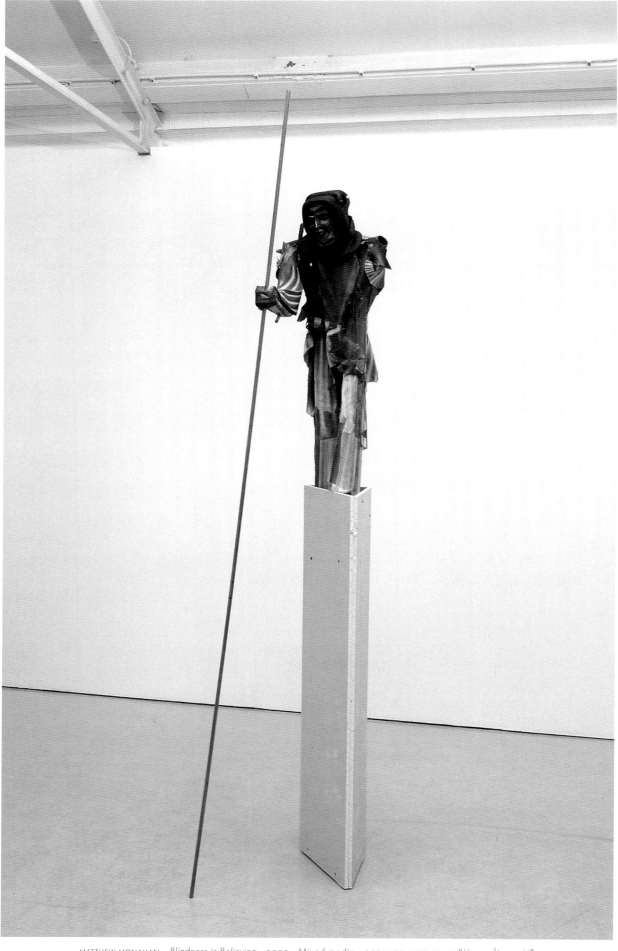

MATTHEW MONAHAN *Blindness is Believing* 2005 Mixed media 250 × 50 × 37 cm 98½ × 19¾ × 14½"

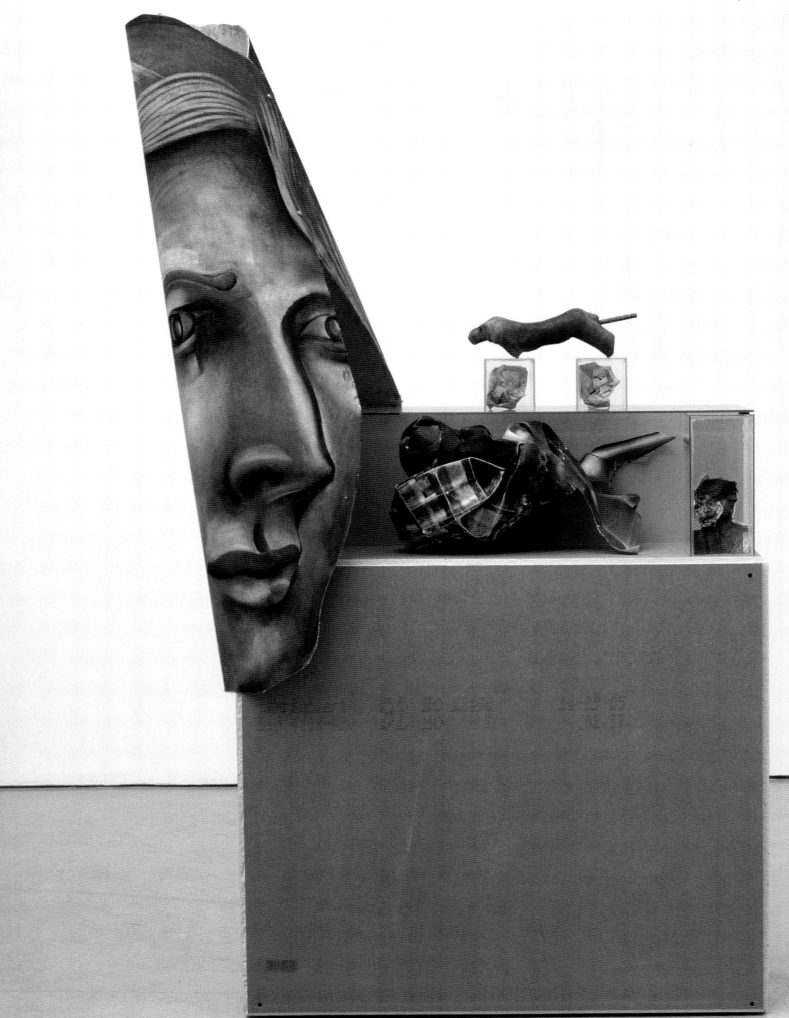

MATTHEW MONAHAN *Riker's Island* 2005 Mixed media 205 × 110 × 45 cm 80¾ × 43¼ × 17¾"

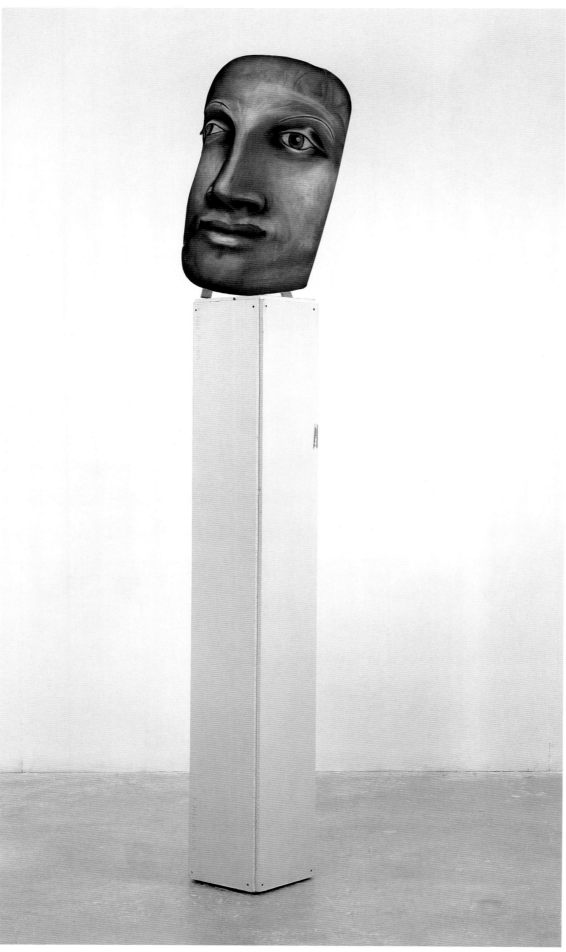

MATTHEW MONAHAN *Lesser Known Son* 1994–2005 Charcoal, paper, wood and dry wall
313 × 66 × 41 cm 123¼ × 26 × 16¼"

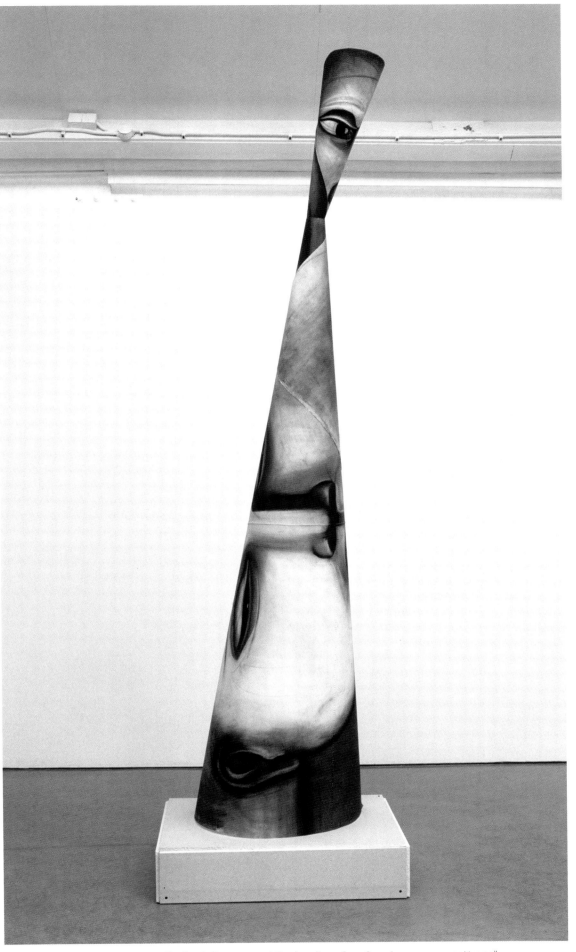

MATTHEW MONAHAN *The Family Tree* 2005 Mixed media 285 × 82 × 63 cm 112 × 32⅛ × 25"

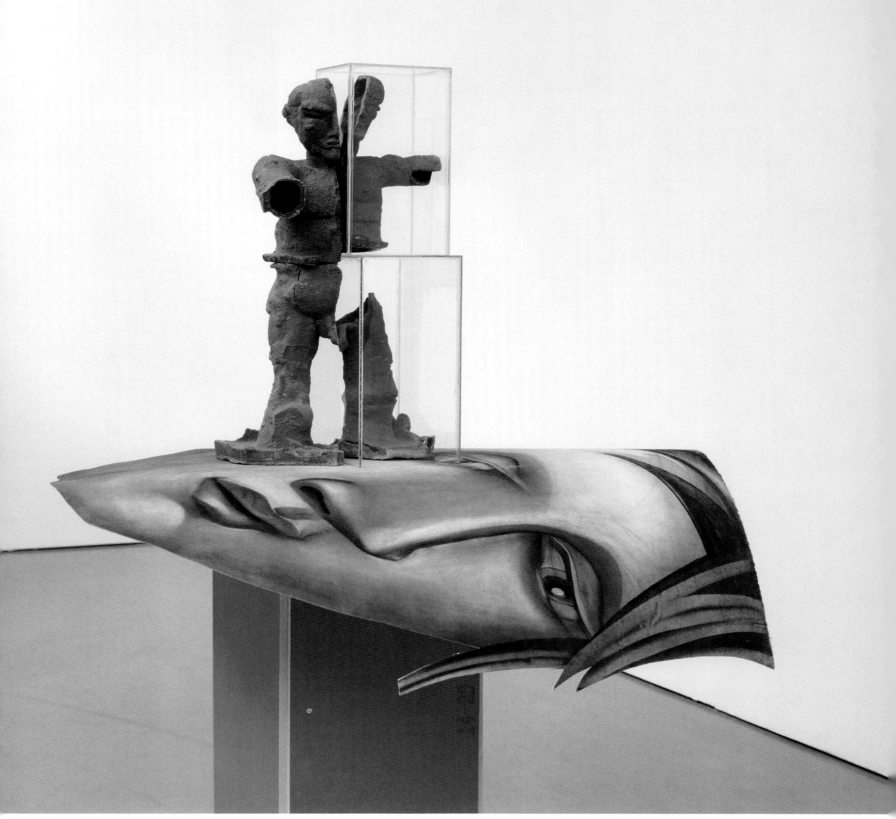

MATTHEW MONAHAN *Sweet Grunt* 2005 Mixed media 165 × 100 × 110 cm 65 × 39½ × 43¼"

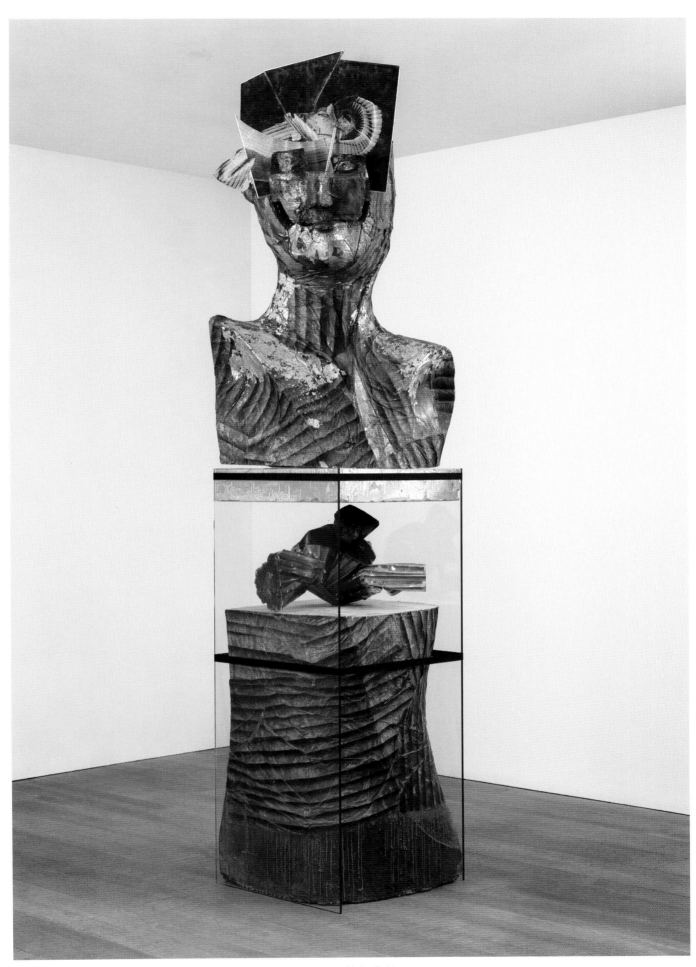

MATTHEW MONAHAN *Midnight Mission* 2009
Polyurethane foam, wax, epoxy resin, photocopy and charcoal on paper, paint, pigment, metal leaf, glitter, glass, ratchet straps
295 × 61 × 63.5 cm 116 × 24 × 25"

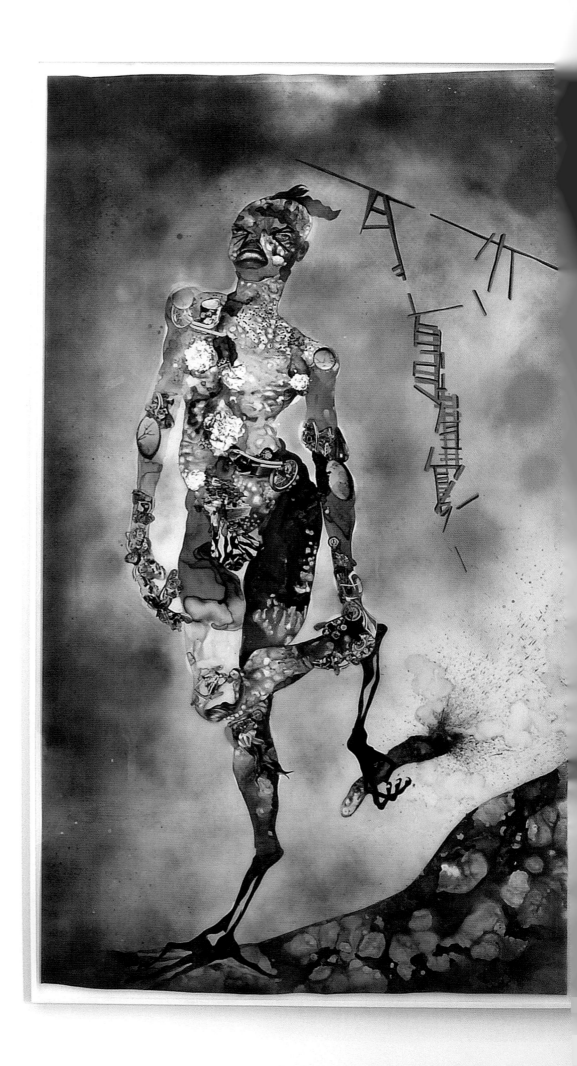

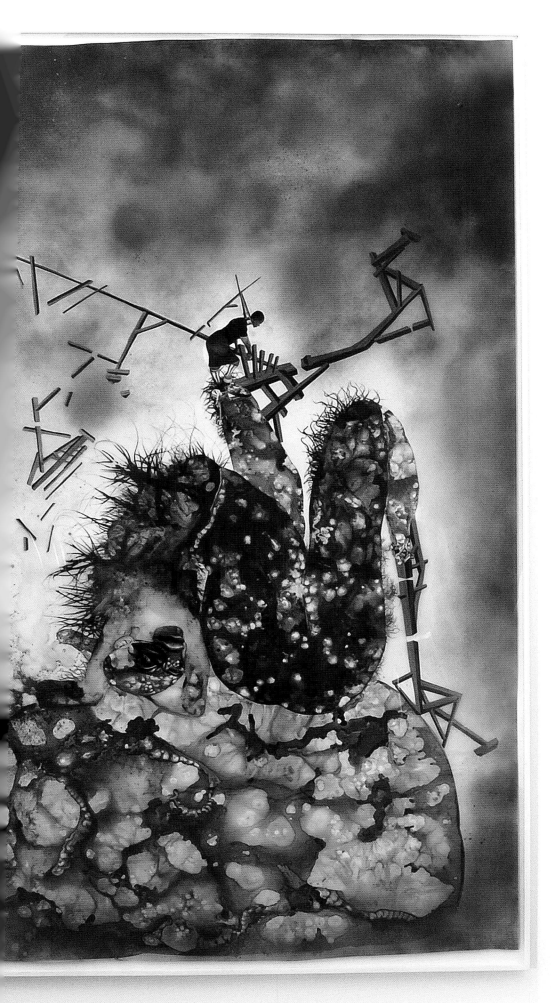

WANGECHI MUTU *My Strength Lies* 2006 Ink, acrylic, photo collage and contact paper on mylar (diptych)
228.6 × 137.2 cm 90 × 54"

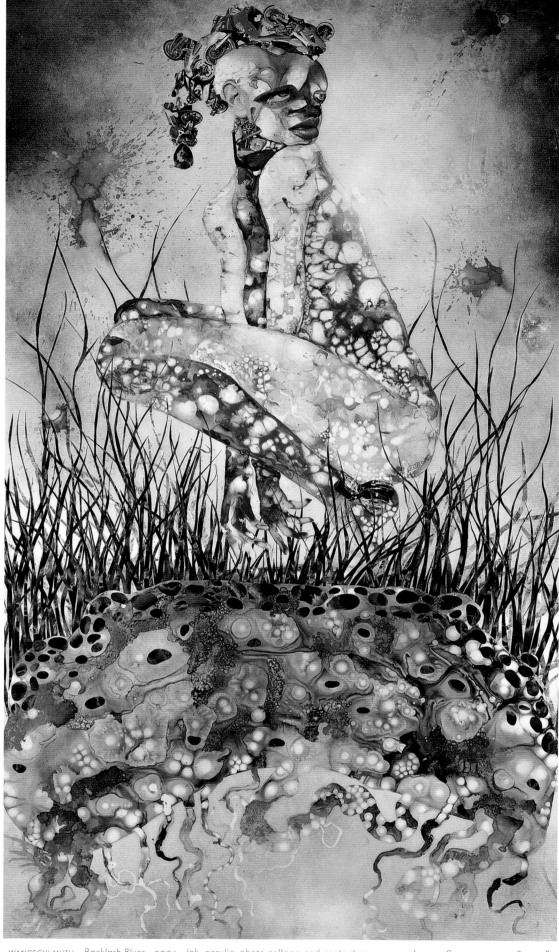

WANGECHI MUTU *Backlash Blues* 2004 Ink, acrylic, photo collage and contact paper on mylar 198 × 119.4 cm 78 × 47"

WANGECHI MUTU *Uterine Catarrh* 2004
Glitter, ink and collage on found medical illustration paper 46 × 31 cm 18 × 12¼"

WANGECHI MUTU *Indurated Ulcers of the Cervix* 2005
Collage on found medical illustration paper 45.7 × 32.4 cm 18 × 12¾"

WANGECHI MUTU *Cervical Hypertrophy* 2005
Collage on found medical illustration paper 45.7 × 32.4 cm 18 × 12¾"

WANGECHI MUTU *Ovarian Cysts* 2005
Collage on found medical illustration paper 45.7 × 32.4 cm 18 × 12¾"

WANGECHI MUTU *Complete Prolapsus of the Uterus* 2005
Glitter, ink and collage on found medical illustration paper 46 × 31 cm 18 × 12¼"

WANGECHI MUTU *Tumors of the Uterus* 2005
Collage on found medical illustration paper 45.7 × 32.4 cm 18 × 12¾"

WANGECHI MUTU *Ectopic Pregnancy* 2005
Glitter, ink and collage on found medical illustration paper 46 × 31 cm 18 × 12¼"

WANGECHI MUTU *Adult Female Sexual Organs* 2005
Packaging tape, fur and collage on found medical illustration paper 46 × 31 cm 18 × 12¼"

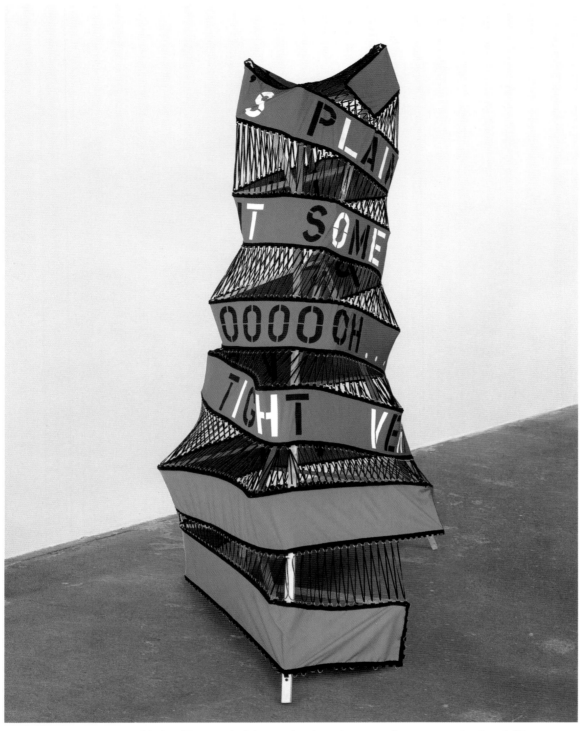

LARA SCHNITGER *126 Inches of Fun* 2006 Fabric, cord and wood 320 × 208 × 172 cm 126 × 82 × 67¾"

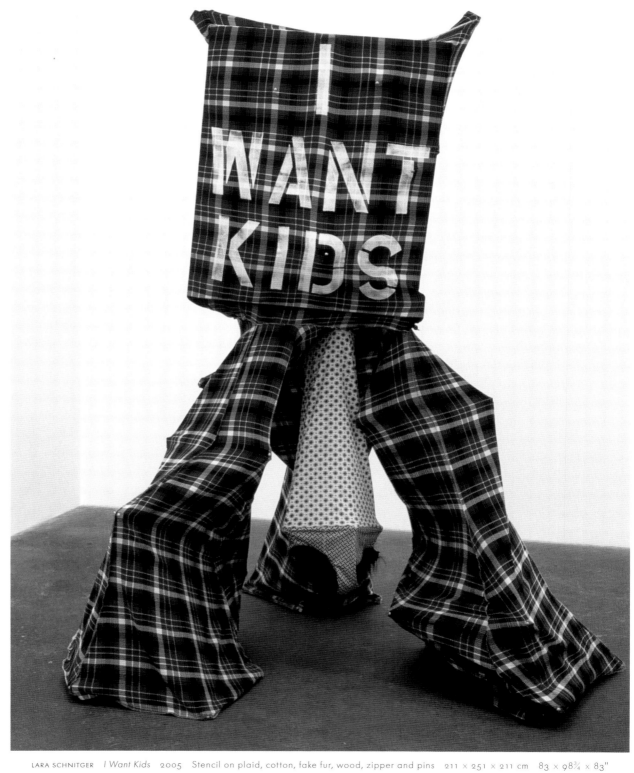

LARA SCHNITGER *I Want Kids* 2005 Stencil on plaid, cotton, fake fur, wood, zipper and pins 211 × 251 × 211 cm 83 × 98¾ × 83"

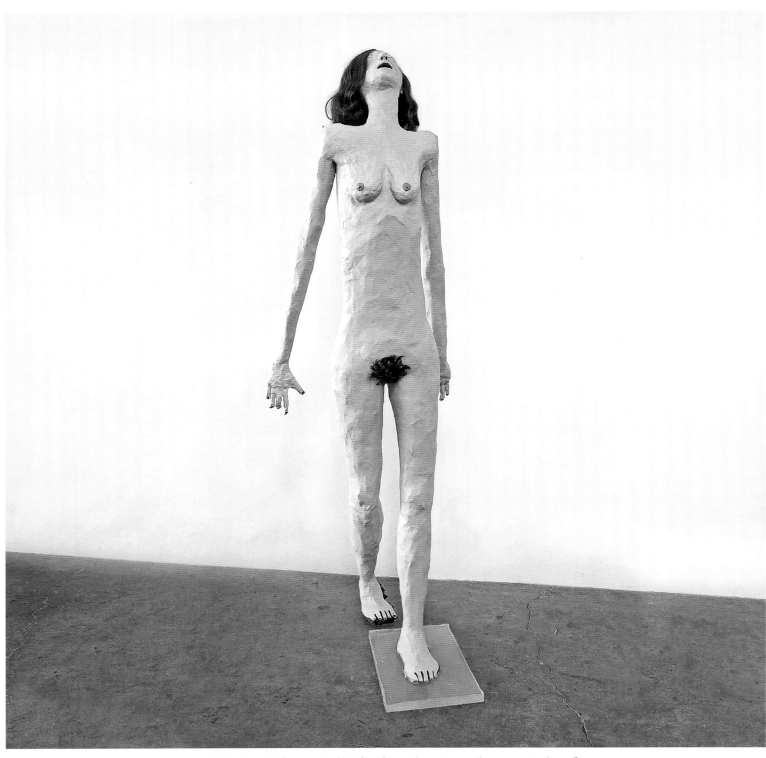

RYAN TRECARTIN *Mother* 2006 Mixed media 236.2 × 91.4 × 76.2 cm 93 × 36 × 30"

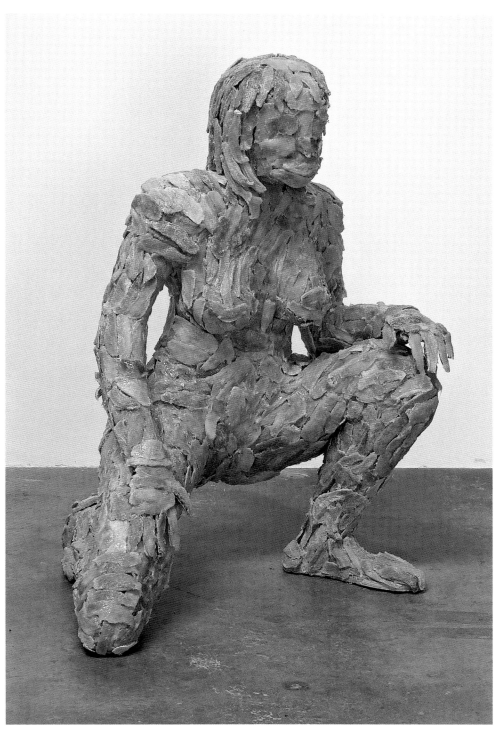

RYAN TRECARTIN *Mango Lady* 2006 Mixed media 99.1 × 68.6 × 58.4 cm 39 × 27 × 23"

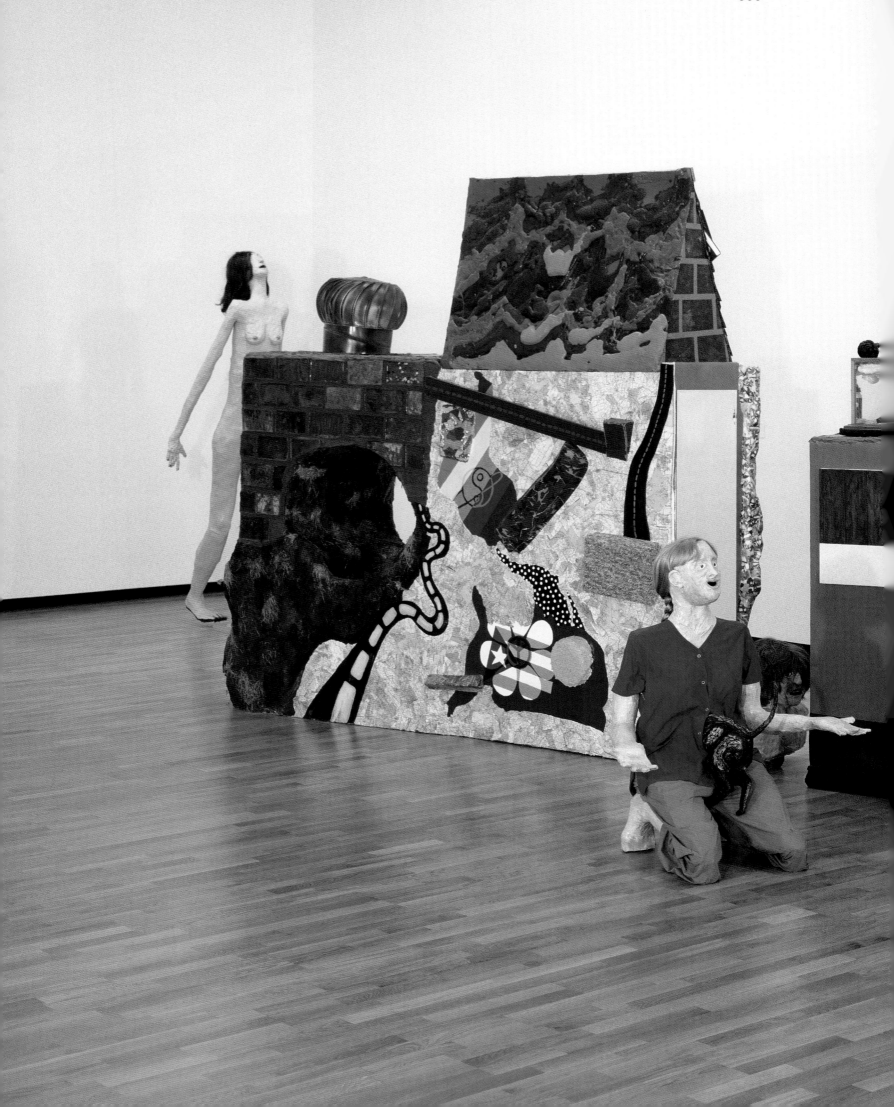

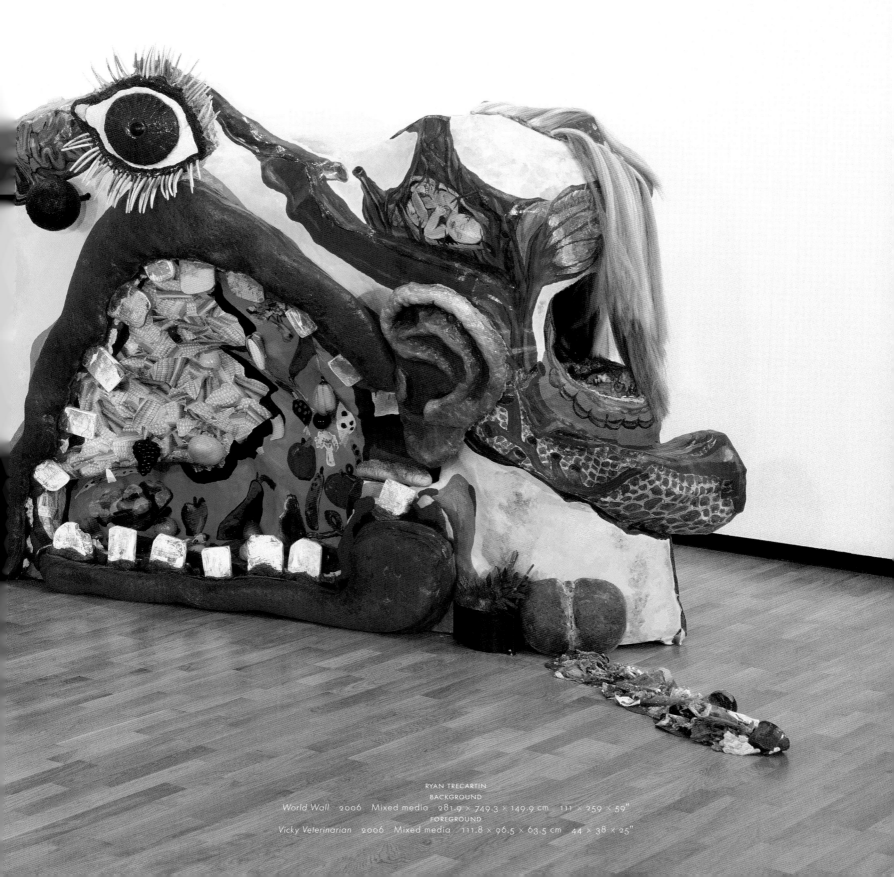

RYAN TRECARTIN
BACKGROUND
World Wall 2006 Mixed media 281.9 × 749.3 × 149.9 cm 111 × 259 × 59"
FOREGROUND
Vicky Veterinarian 2006 Mixed media 111.8 × 96.5 × 63.5 cm 44 × 38 × 25"

MARK GROTJAHN *Untitled (Green Butterfly)* 2002 Oil on canvas
122 × 86.3 cm 48 × 34"

MARK GROTJAHN *Untitled (Pink Butterfly)* 2002 Oil on canvas
122 × 73.6 cm 48 × 29"

MARK GROTJAHN *Untitled (Black Butterfly Dioxide Purple MPG 05)* 2005 Oil on linen
147 × 122 cm 57¾ × 48"

MARK GROTJAHN *Untitled (White Butterfly Blue MG)* 2001 Oil on linen
182.9 × 66 cm 72 × 26"

MARK GROTJAHN *Untitled (Lavender Butterfly Jacaranda over Green)* 2004 Oil on linen
178 × 89 cm 70 × 35"

MARK GROTJAHN *Untitled (Large Coloured Butterfly White Background 10 Wings)* 2004 Coloured pencil on paper
176.8 × 130 cm 69⅓ × 51¼"

MARK GROTJAHN *Untitled (Face)* 2007 Oil on cardboard on linen on canvas 152.4 × 129.5 cm 60 × 51"

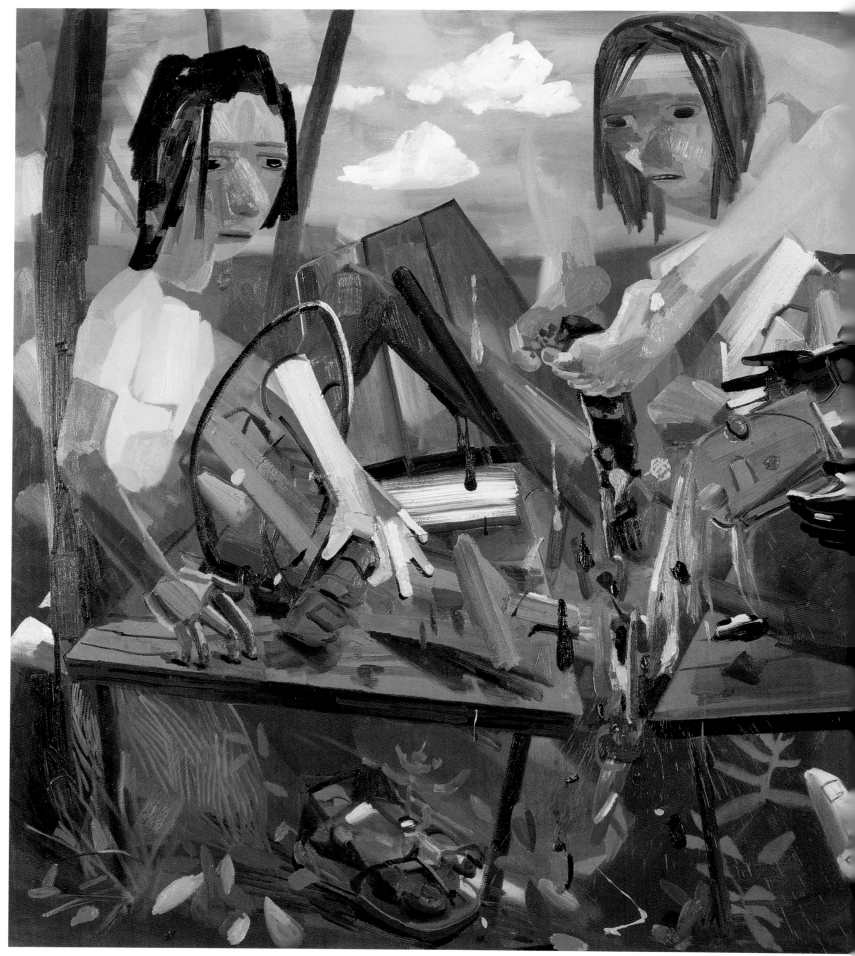

DANA SCHUTZ *Reformers* 2004 Oil on canvas 190.5 × 231 cm 75 × 91"

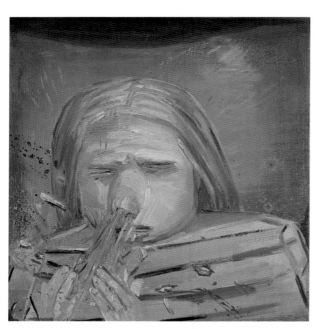

DANA SCHUTZ *Sneeze* 2002 Oil on canvas 48 × 48 cm 19 × 19"

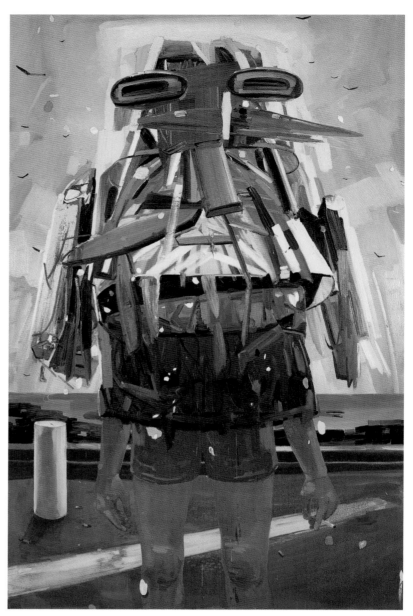

DANA SCHUTZ *Death Comes to Us All* 2003 Oil on canvas 305 × 198 cm 120 × 78"

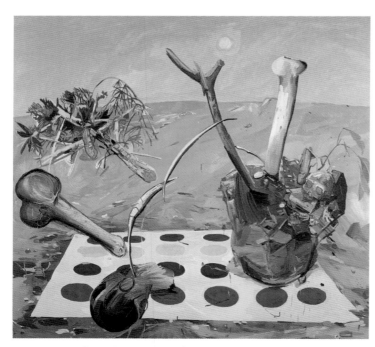

DANA SCHUTZ *Twister Mat* 2003 Oil on canvas 214 × 229 cm 84¼ × 90¼"

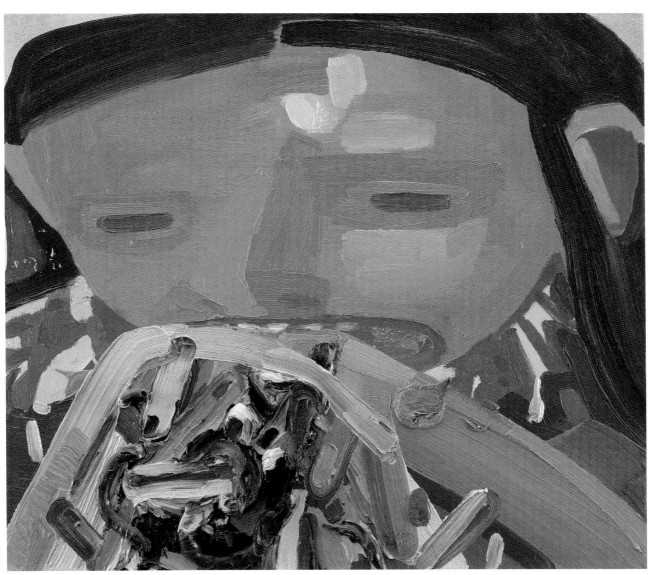

DANA SCHUTZ *Feelings* 2003 Oil on canvas 46 × 51 cm 18 × 20"

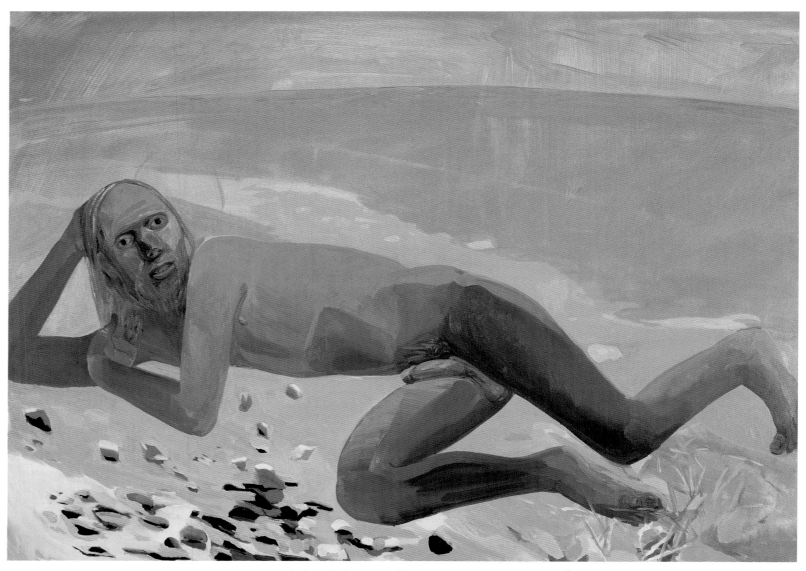

DANA SCHUTZ *Reclining Nude* 2002 Oil on canvas 122 × 152 cm 48 × 59¾"

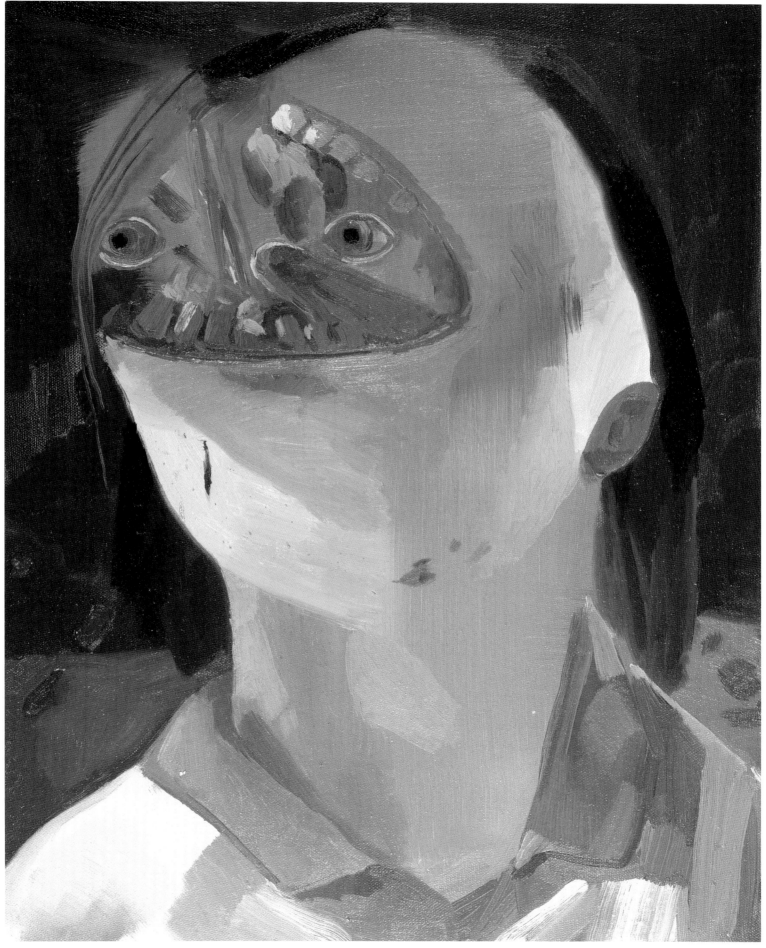

DANA SCHUTZ *Face Eater* 2004 Oil on canvas 58 × 46 cm 22¾ × 18"

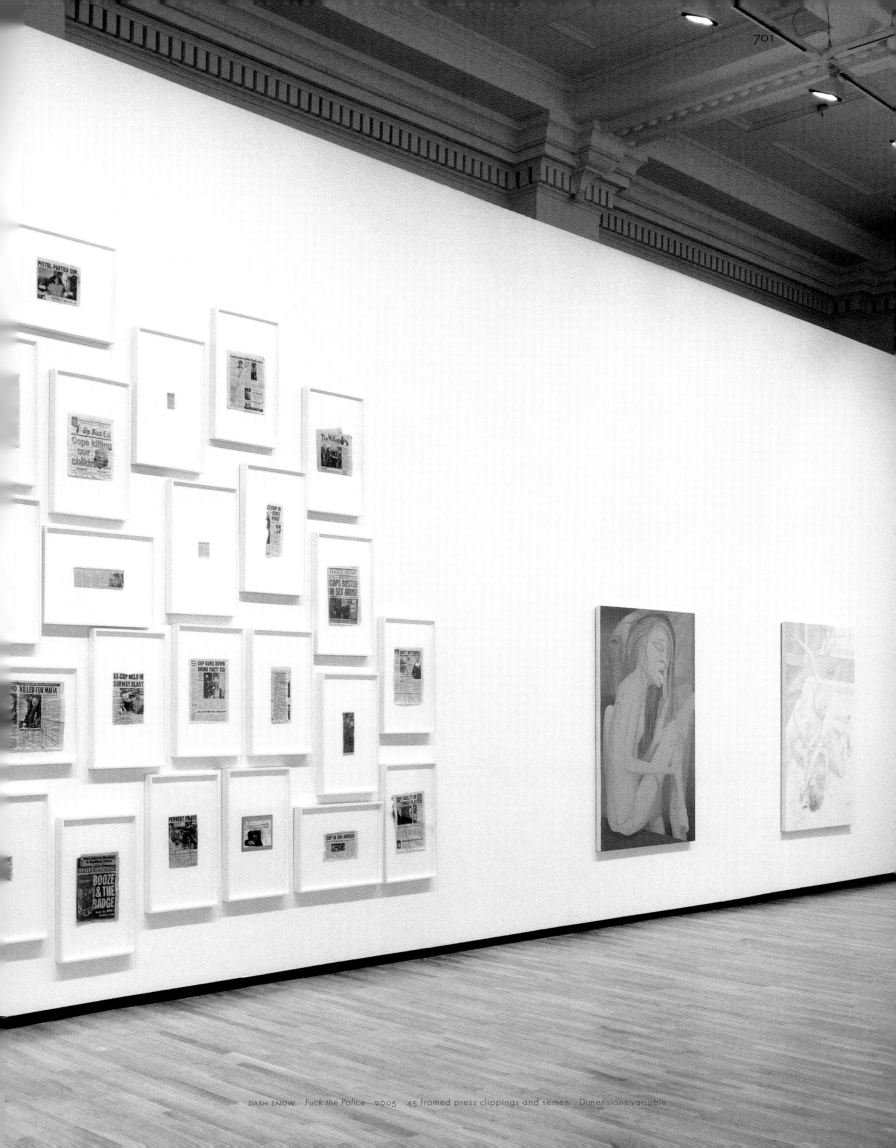

DASH SNOW Fuck the Police 2005 45 framed press clippings and semen Dimensions variable

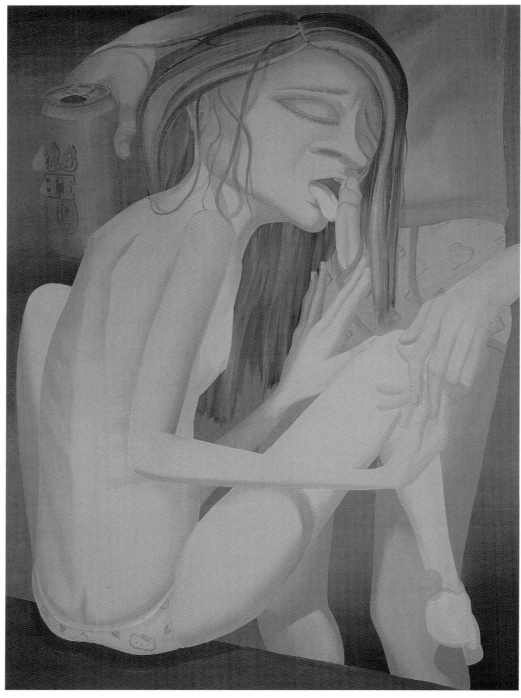

GERALD DAVIS *Monica* 2004 Oil on canvas 174 × 126 cm 68¼ × 49½"

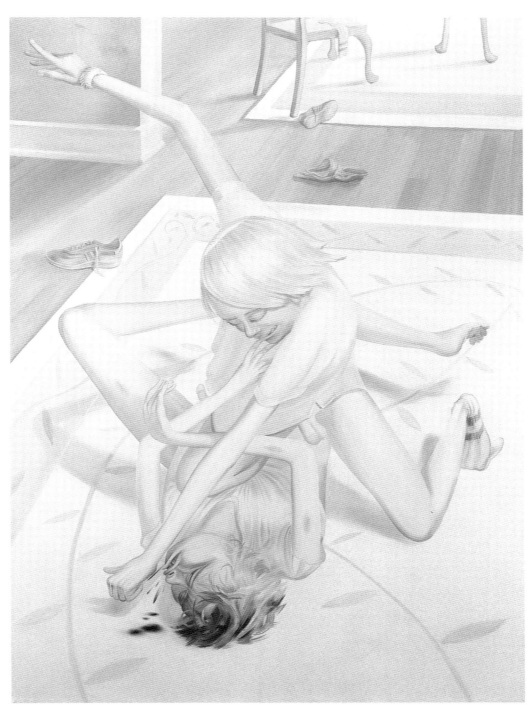

GERALD DAVIS *Boy-fight* 2004 Oil on canvas 174 × 126 cm 68½ × 49⅛"

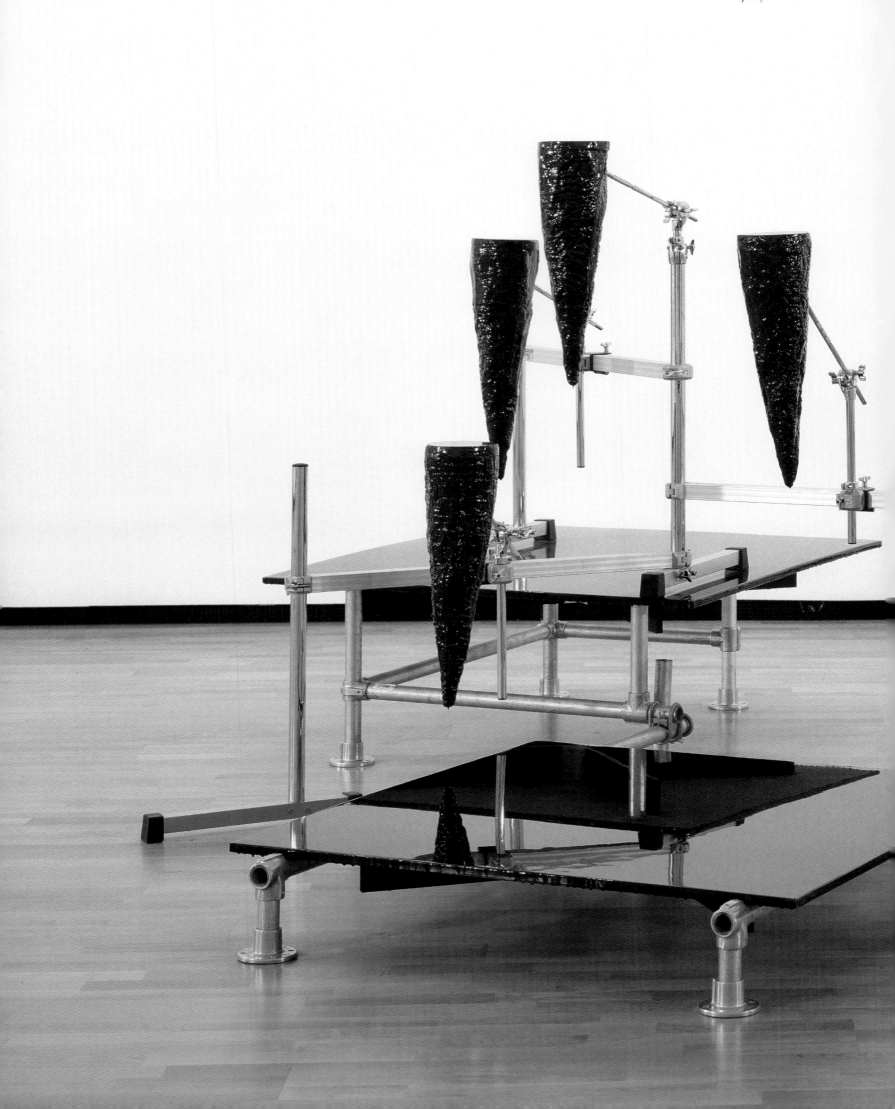

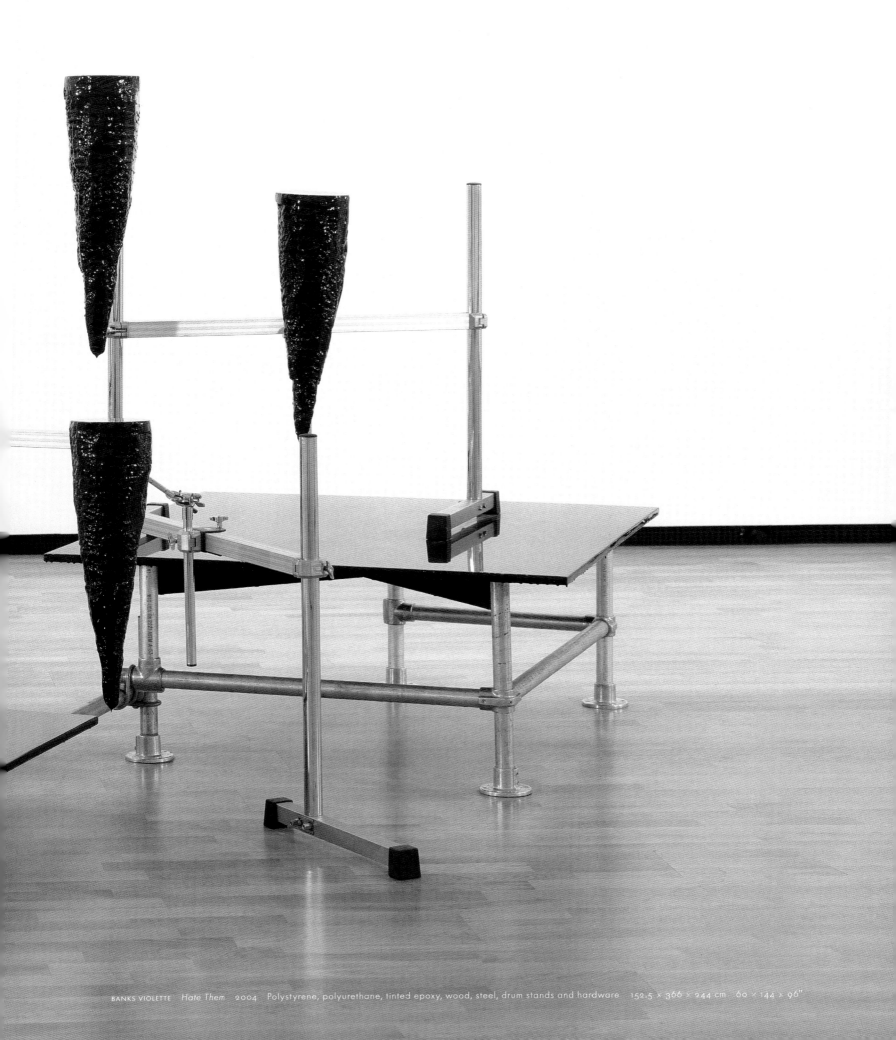

BANKS VIOLETTE *Hate Them* 2004 Polystyrene, polyurethane, tinted epoxy, wood, steel, drum stands and hardware 152.5 × 366 × 244 cm 60 × 144 × 96"

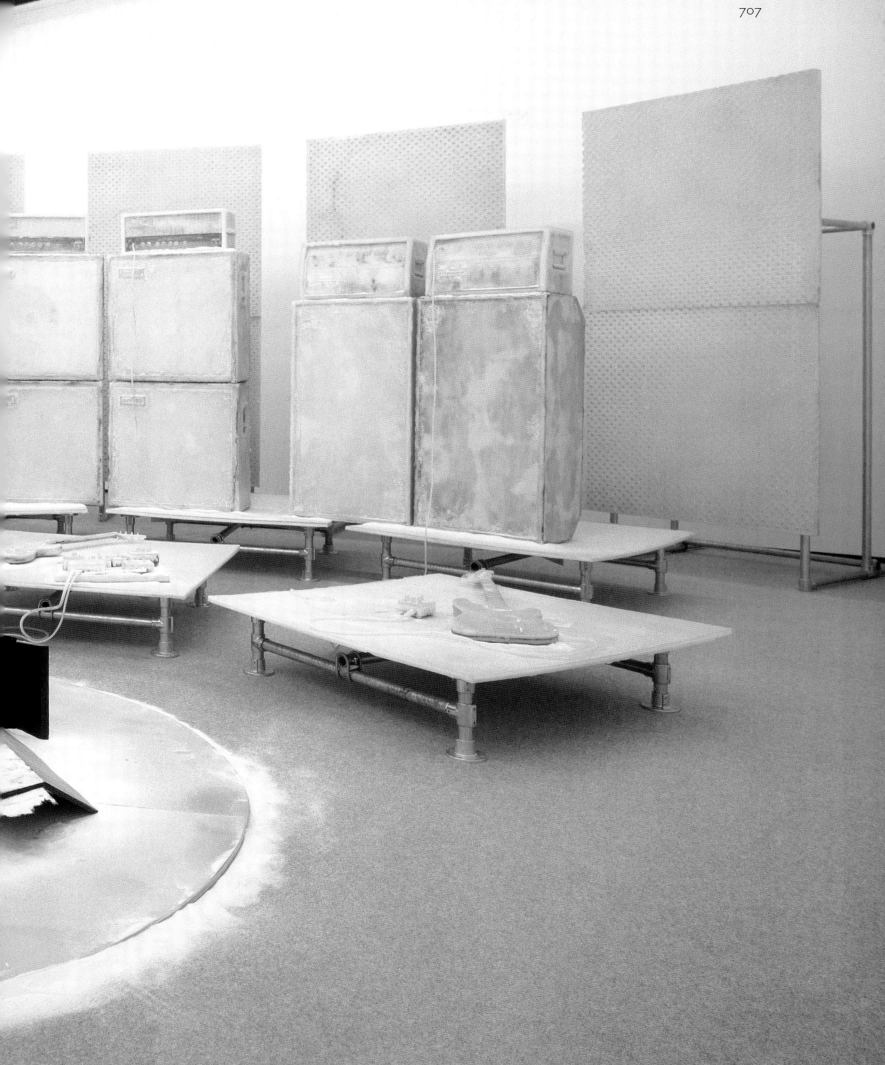

BANKS VIOLETTE *Untitled (White Cast Salt Space)* 2006 Steel, hardware, plywood, paint, fibreglass, tinted epoxy, salt and resin Dimensions variable

KELLEY WALKER *Black Star Press (rotated 90 degrees counterclockwise): Black Star, Black Press, Star Press* 2006
Silkscreened white and dark chocolate over digital print on canvas (triptych) 213.4 × 792.5 cm 84 × 312"

KELLEY WALKER *Schema; Aquafresh plus Crest with Whitening Expressions (Regina Hall)* 2006
Scanned image and toothpaste; CD-rom; digital poster on archival paper 304.8 × 243.8 cm 120 × 96"

KELLEY WALKER *Schema; Aquafresh plus Crest with Whitening Expressions (Trina)* 2006
Scanned image and toothpaste; CD-rom; digital poster on archival paper 304.8 × 243.8 cm 120 × 96"

THE REVOLUTION CONTINUES:
NEW ART FROM CHINA

LI, LIU, QIU, SHEN, SHI, SUN & PENG,

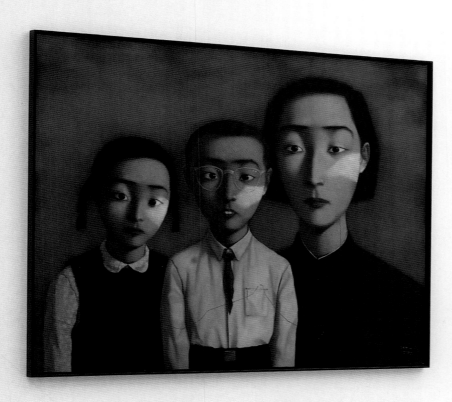

ZHAN;
ZHANG D,
ZHANG H,
ZHANG X

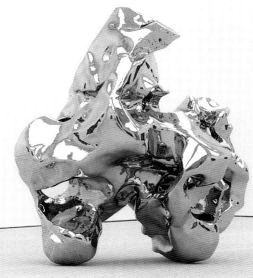

LEFT TO RIGHT

ZHANG XIAOGANG *A Big Family* 1995 Oil on canvas 179 × 229 cm 70½ × 90¼"
ZHAN WANG *Ornamental Rock No.71* 2006–08 Polished stainless steel 170.2 × 157.5 × 106.7 cm 67 × 62 × 42"

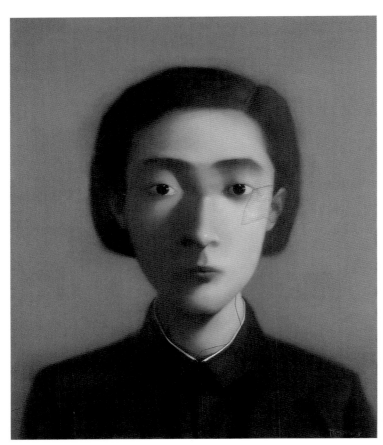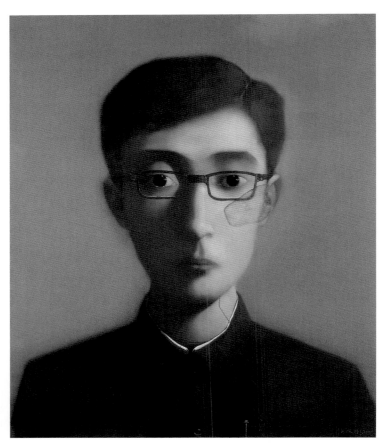

ZHANG XIAOGANG *Comrade* 2005 Oil on canvas (diptych) 130 × 220 cm 51¼ × 86⅓"

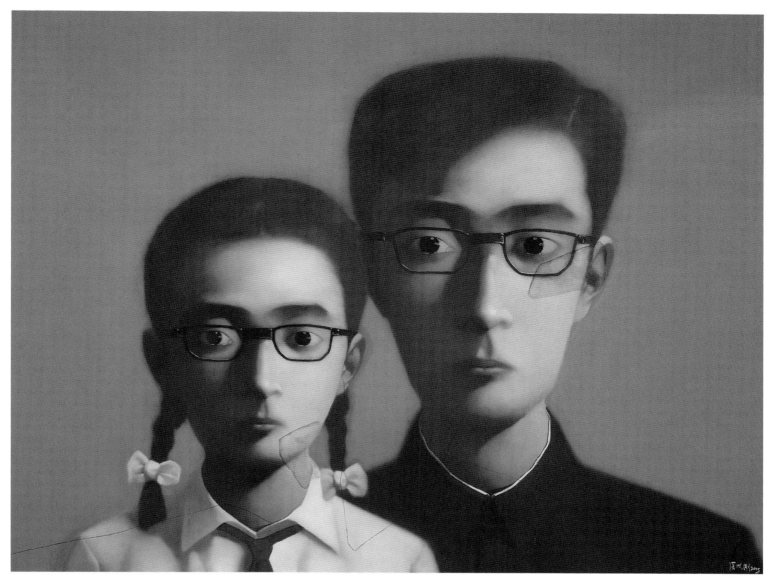

ZHANG XIAOGANG *Bloodline* 2005 Oil on canvas 200 × 260 cm 78¾ × 102⅓"

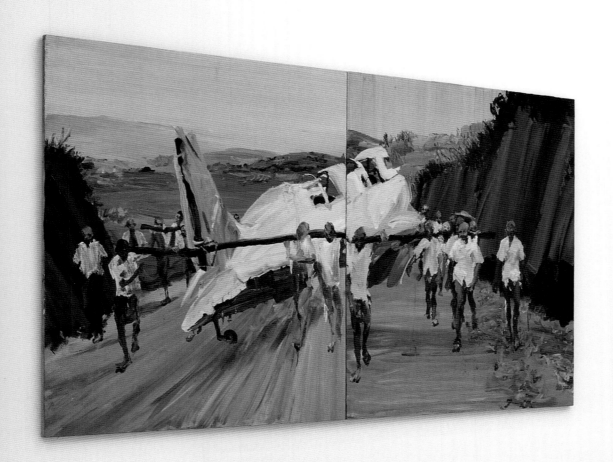

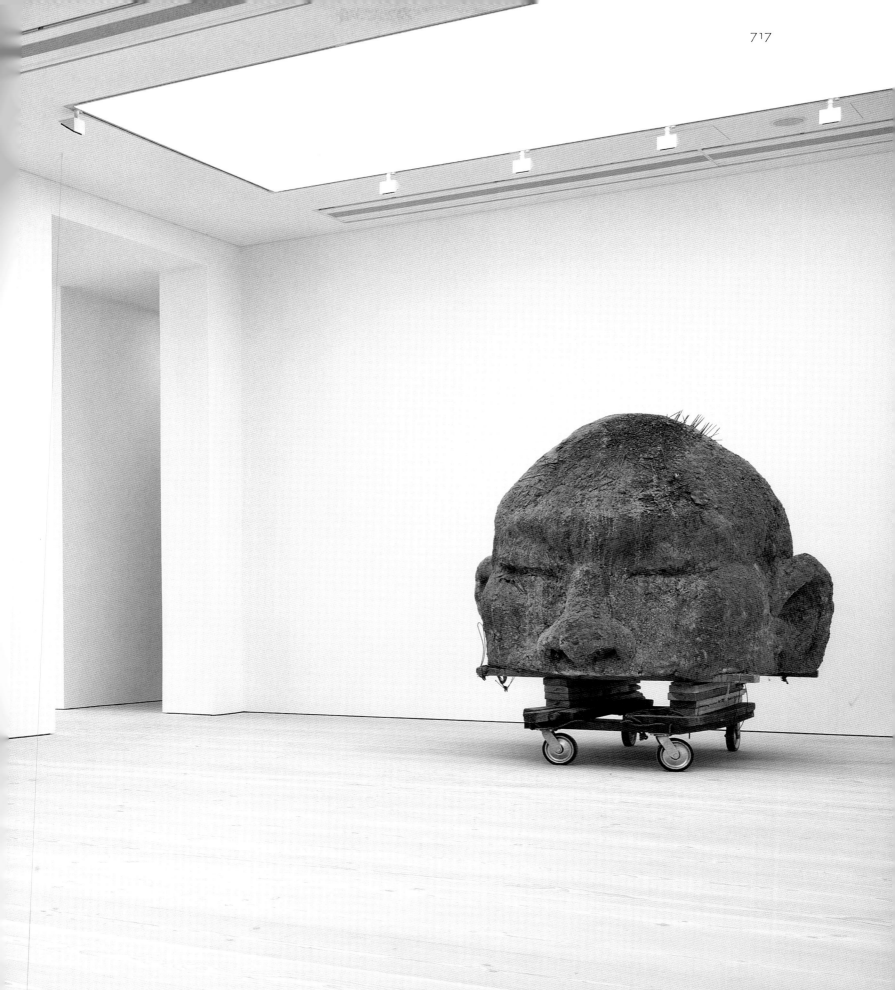

LEFT TO RIGHT
LI SONGSONG *Gift* 2003 Oil on canvas (diptych) 180 × 300 cm 70¾ × 118"
ZHANG HUAN *Ash Head No.1* 2007 Ash and mixed media 228 × 227 × 244 cm 89¾ × 89¼ × 96"

LI SONGSONG *Cuban Sugar* 2006 Oil on aluminium panels 280 × 400 cm 110¼ × 157½"

QIU JIE *Portrait of Mao* 2007 Lead on paper 250 × 168 cm 98½ × 66¼"

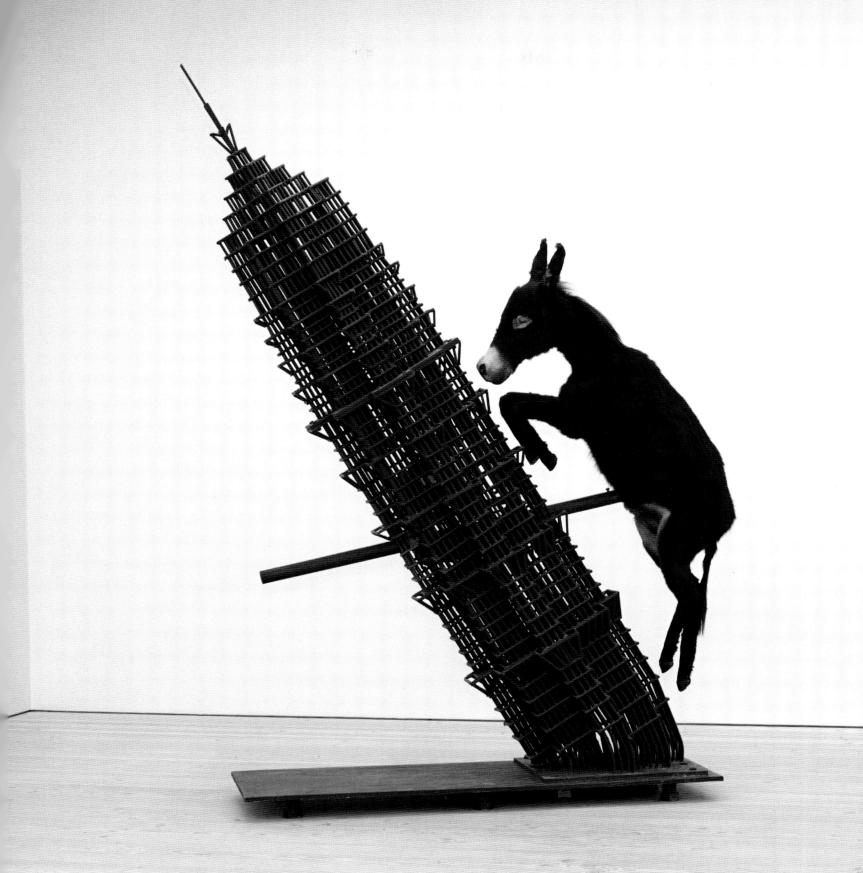

ZHANG HUAN *Donkey* 2005 Mixed media 320 × 220 × 80 cm 126 × 86½ × 31½"

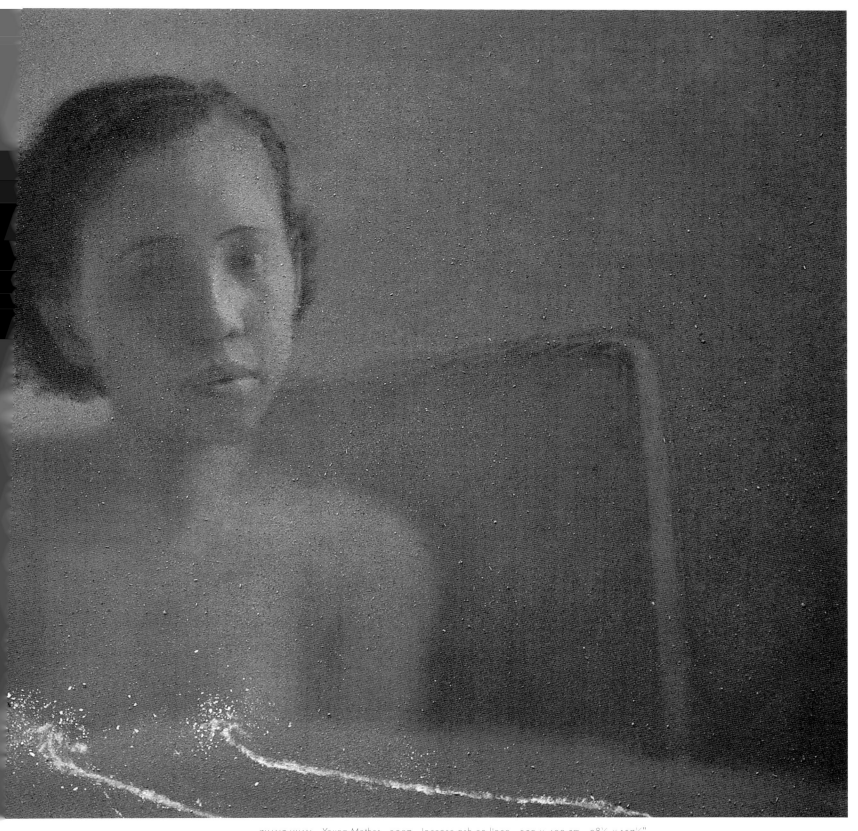

ZHANG HUAN *Young Mother* 2007 Incense ash on linen 250 × 400 cm 98½ × 157½"

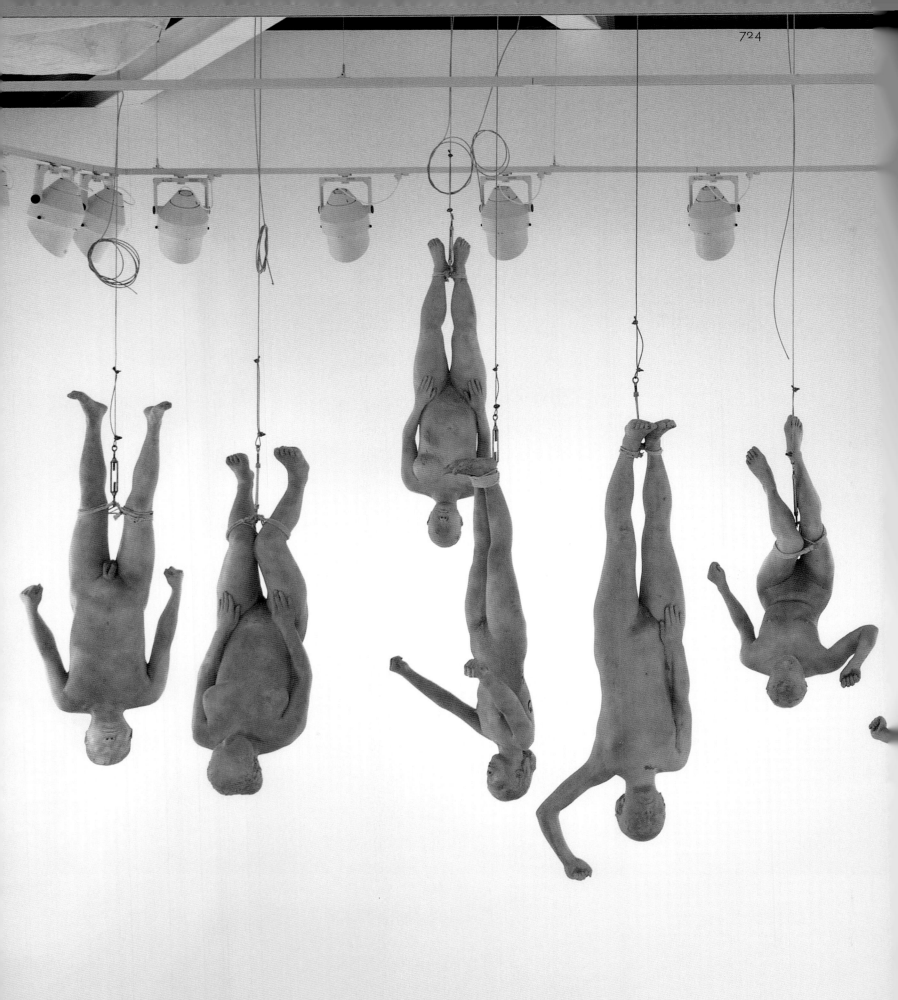

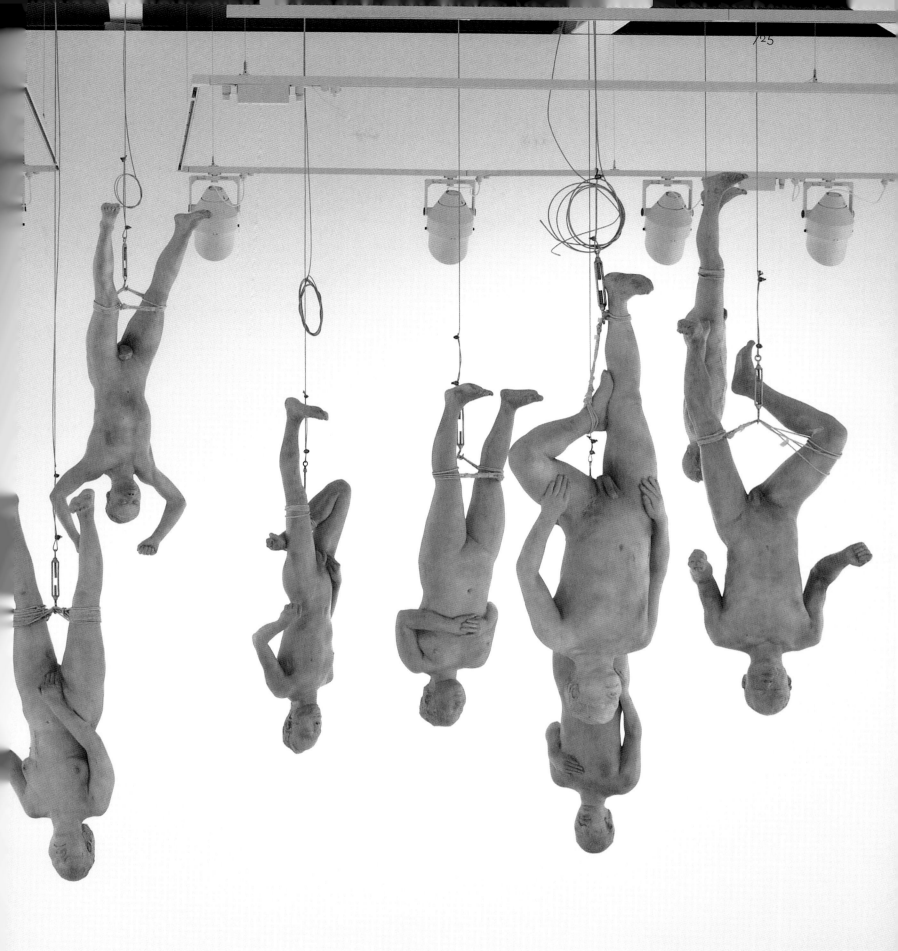

ZHANG DALI *Chinese Offspring* 2003–05 Mixed media (15 life-size cast figures) Average height of each figure: 170 cm 67"

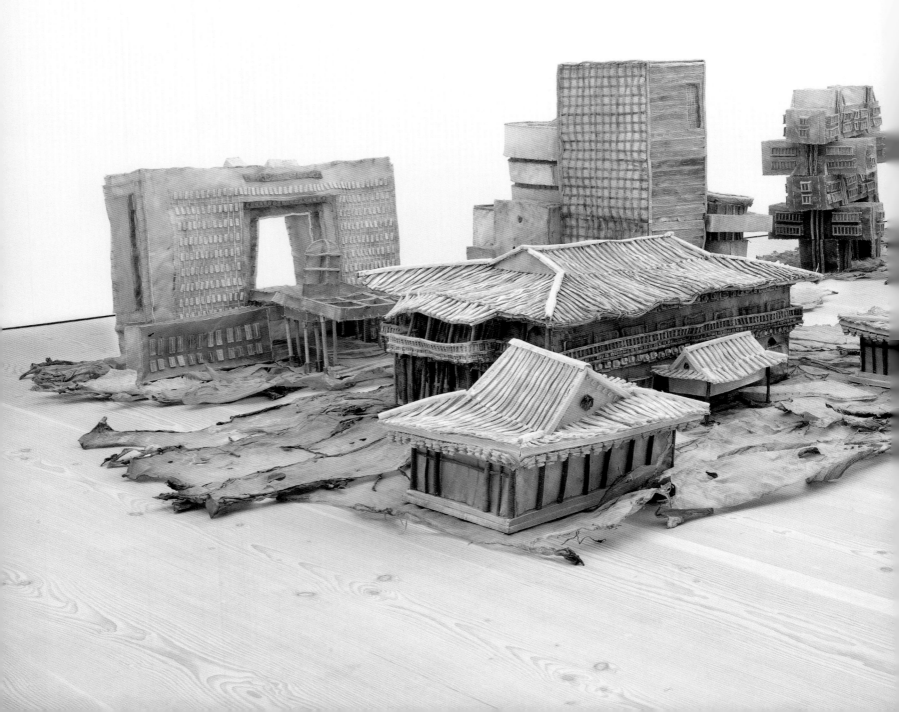

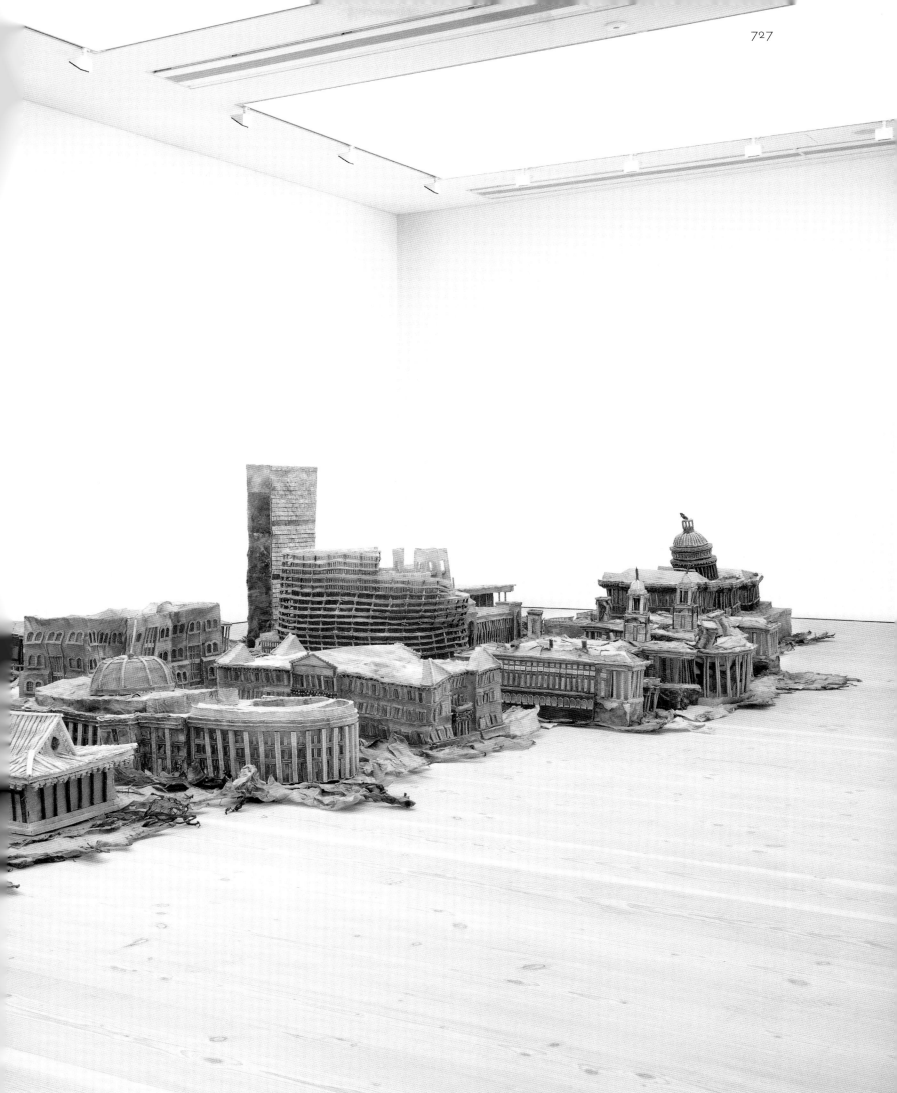

LIU WEI *Love It! Bite It!* 2005–07 Edible dog chews Dimensions variable

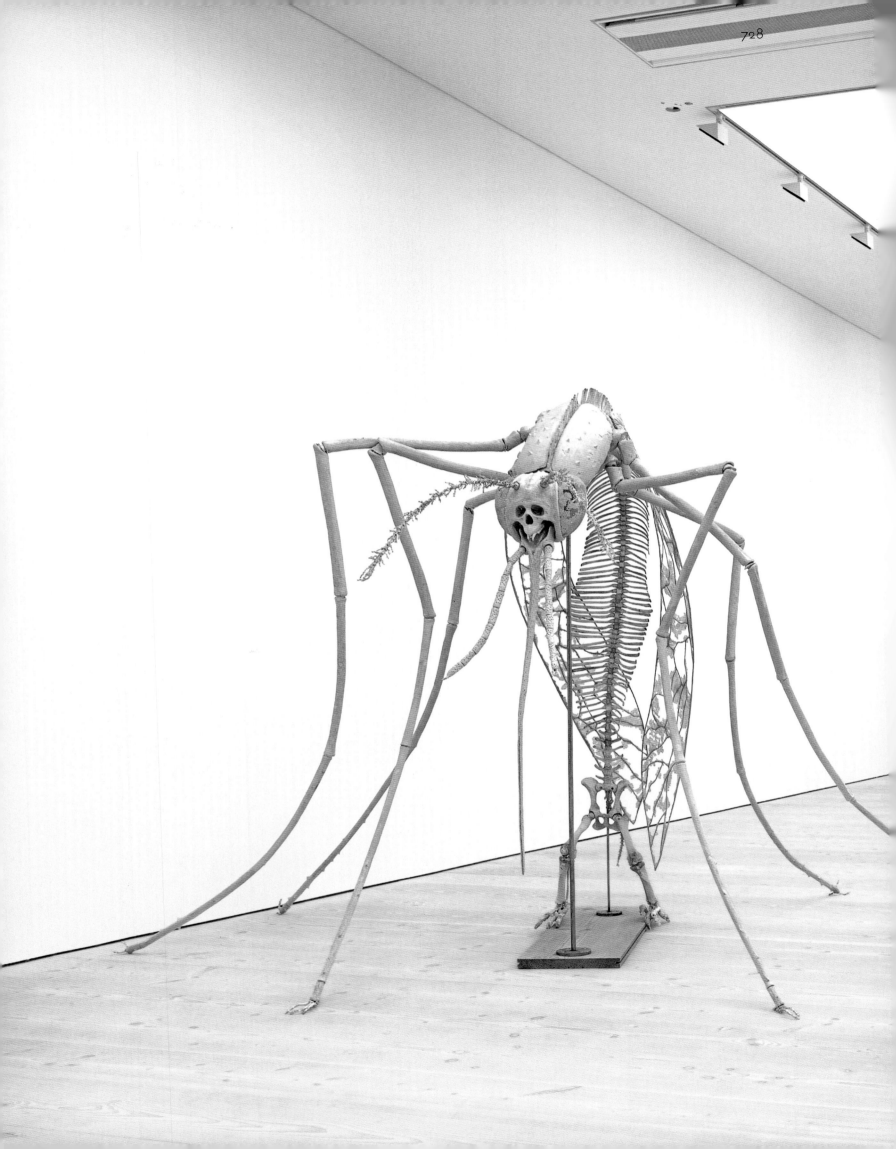

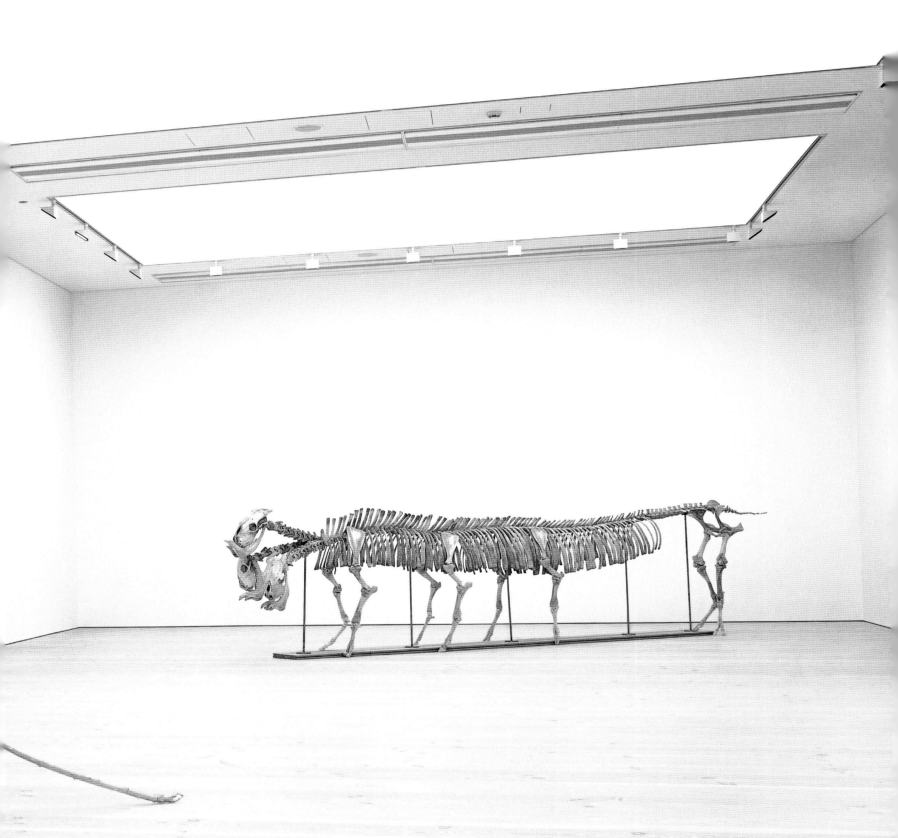

SHEN SHAOMIN
LEFT TO RIGHT
Unknown Creature — Mosquito 2002 Bone, meal and glue 240 × 240 × 230 cm 94½ × 94½ × 90½"
Unknown Creature — Three-headed Monster 2002 Bone, meal and glue 150 × 70 × 670 cm 59 × 27½ × 263¾"

SHI XINNING *Mao and McCarthy* 2005 Oil on canvas 192 × 313 cm 75½ × 123¼"

SHI XINNING *A Holiday in Venice — at the Balcony of Ms. Guggenheim* 2006 Oil on canvas 210 × 272 cm 82¾ × 107"

SHI XINNING *Yalta No.2* 2006 Oil on canvas 210 × 317 cm 82¾ × 124¾"

PAGES 732-735
SUN YUAN AND PENG YU *Old Persons Home* 2007 13 life-size sculptures and 13 dynamo-electric wheelchairs Dimensions variable (detail)

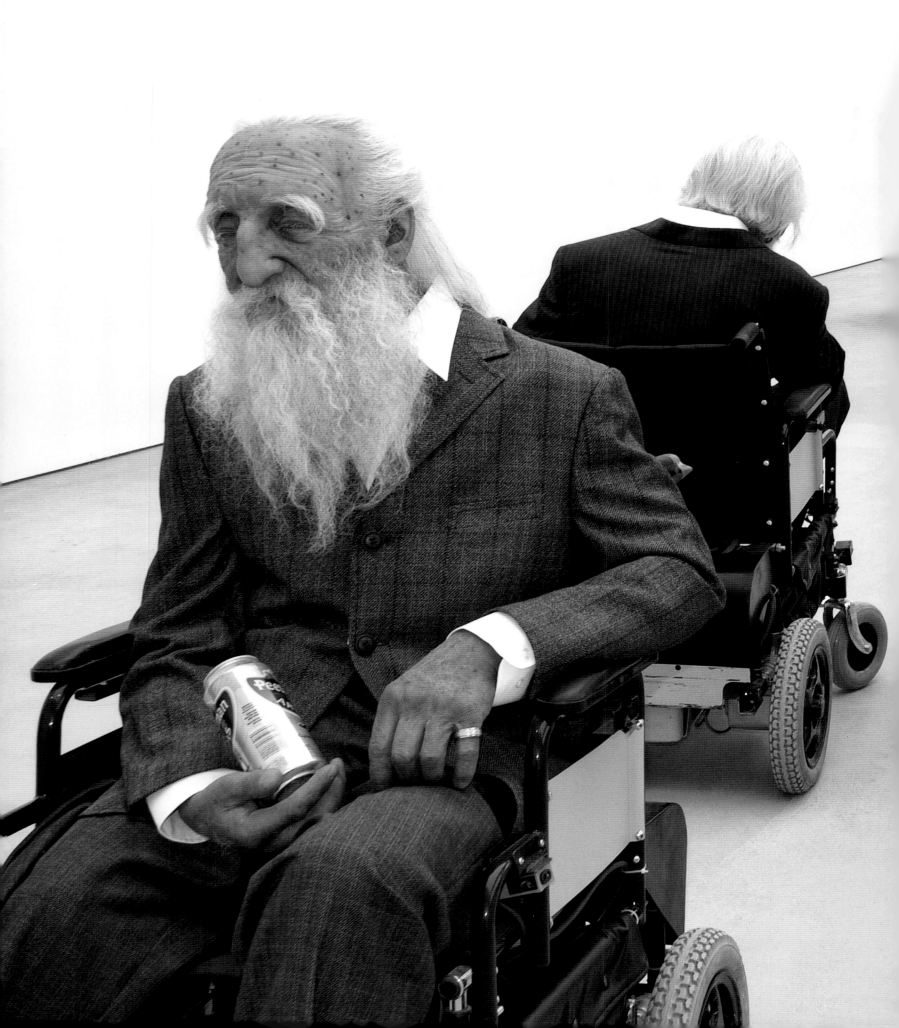

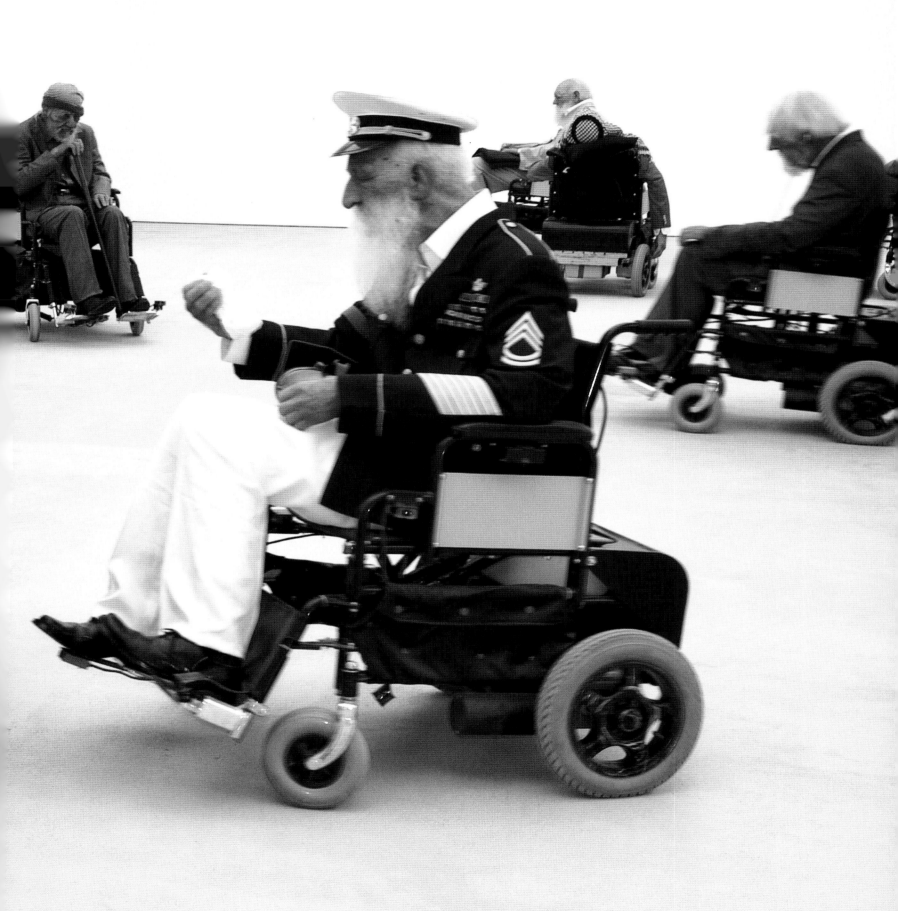

UNVEILED:
NEW ART FROM THE MIDDLE EAST

AL-HADID, AL-KARIM, ALSOUDANI, ATTIA, GHADIRIAN,

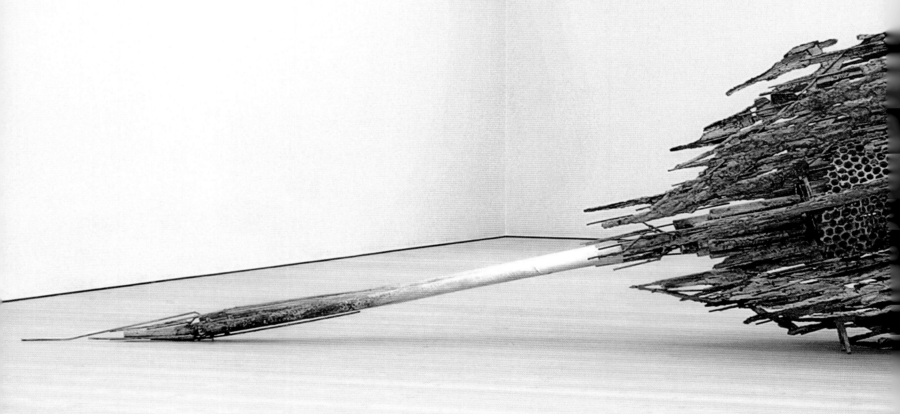

HAERIZADEH, MADANI, RECHMAOUI

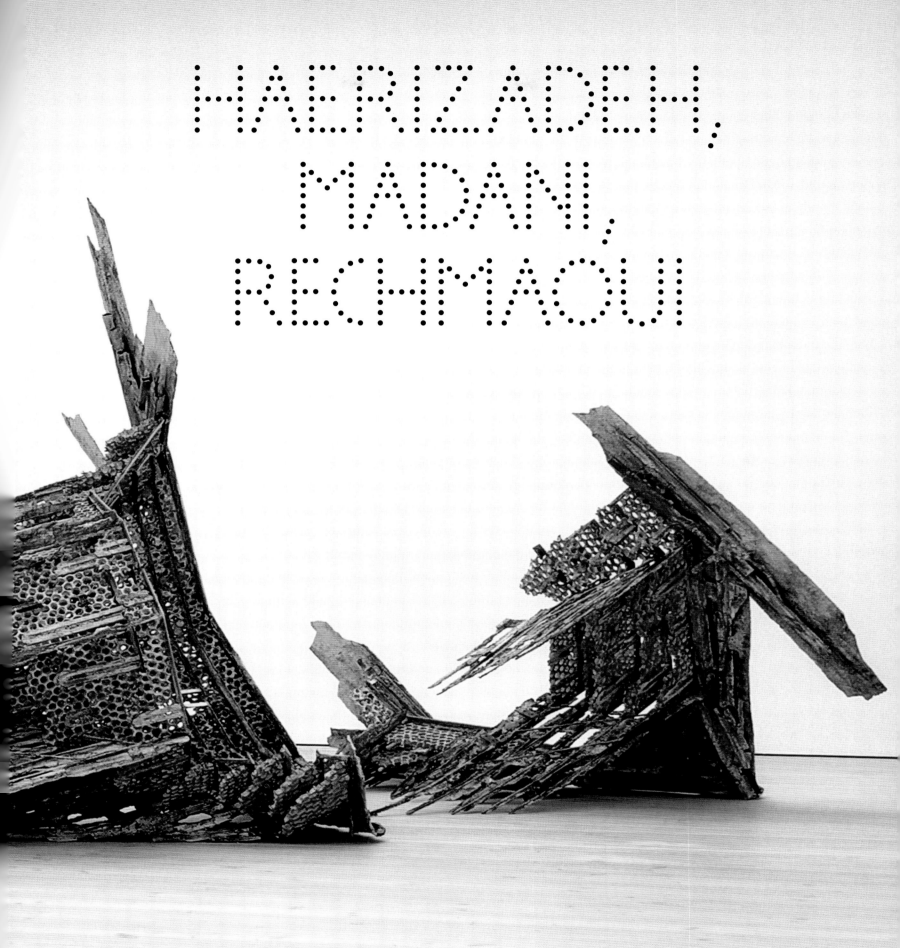

DIANA AL-HADID *The Tower of Infinite Problems* 2008 Polymer gypsum, steel, plaster, fibreglass, wood, polystyrene, cardboard, wax and paint (2 parts)
Part 1: 241.3 × 442 × 251.5 cm 95 × 174 × 99" Part 2: 160 × 210.8 × 266.7 cm 63 × 83 × 105"

HALIM AL-KARIM *Hidden Doll* 2008 Lambda print covered with white silk (triptych) 200 × 360 cm 78¾ × 141¾"

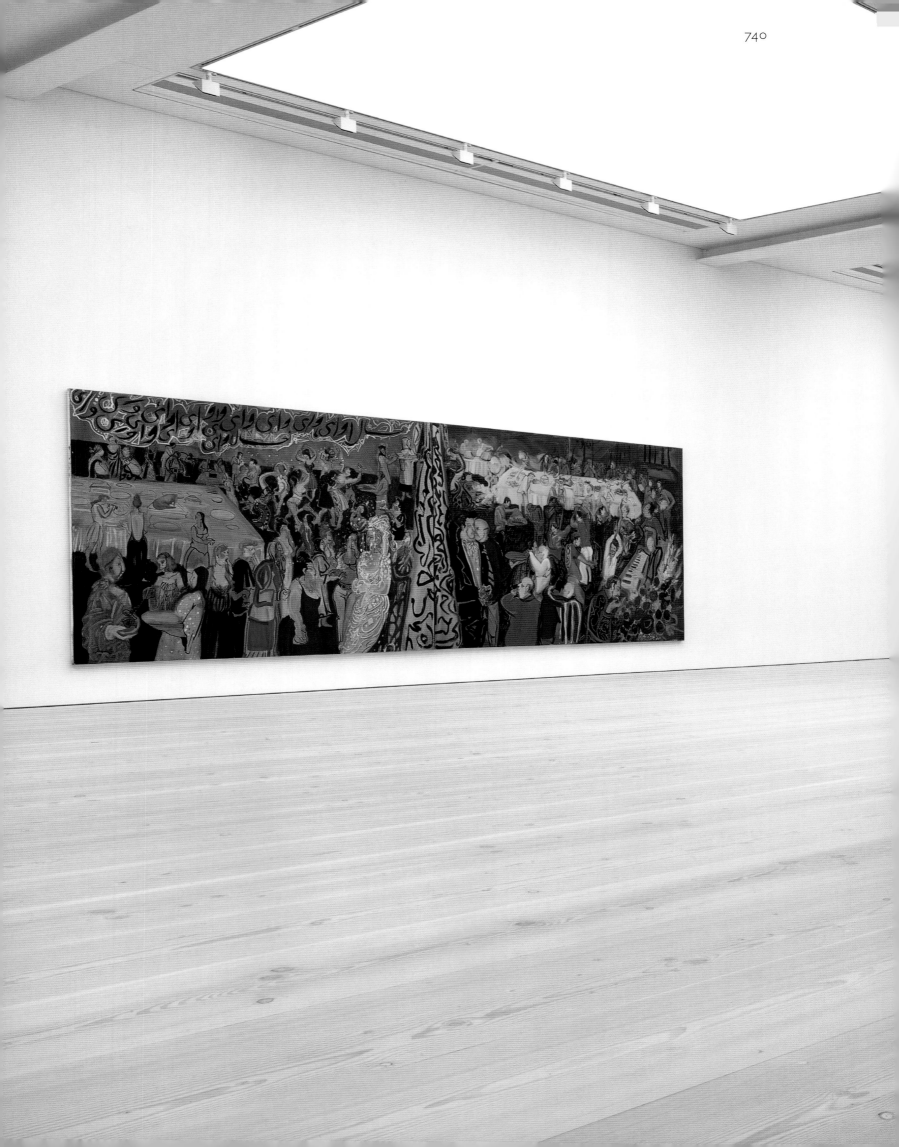

ROKNI HAERIZADEH
LEFT TO RIGHT
Typical Iranian Wedding 2008 Oil on canvas (diptych) 200 × 600 cm 78¾ × 236¼"
Shomal (Beach at the Caspian) 2008 Oil on canvas (diptych) 200 × 600 cm 78¾ × 236¼"

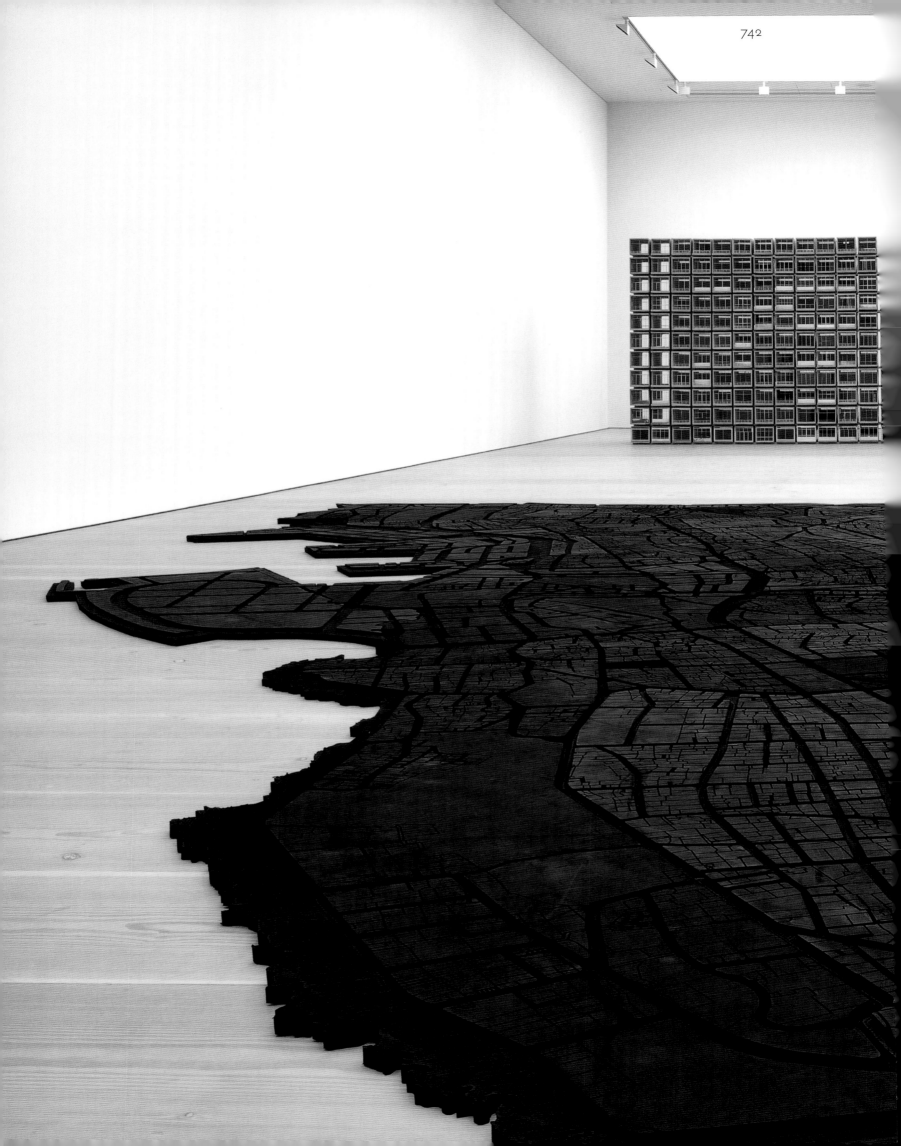

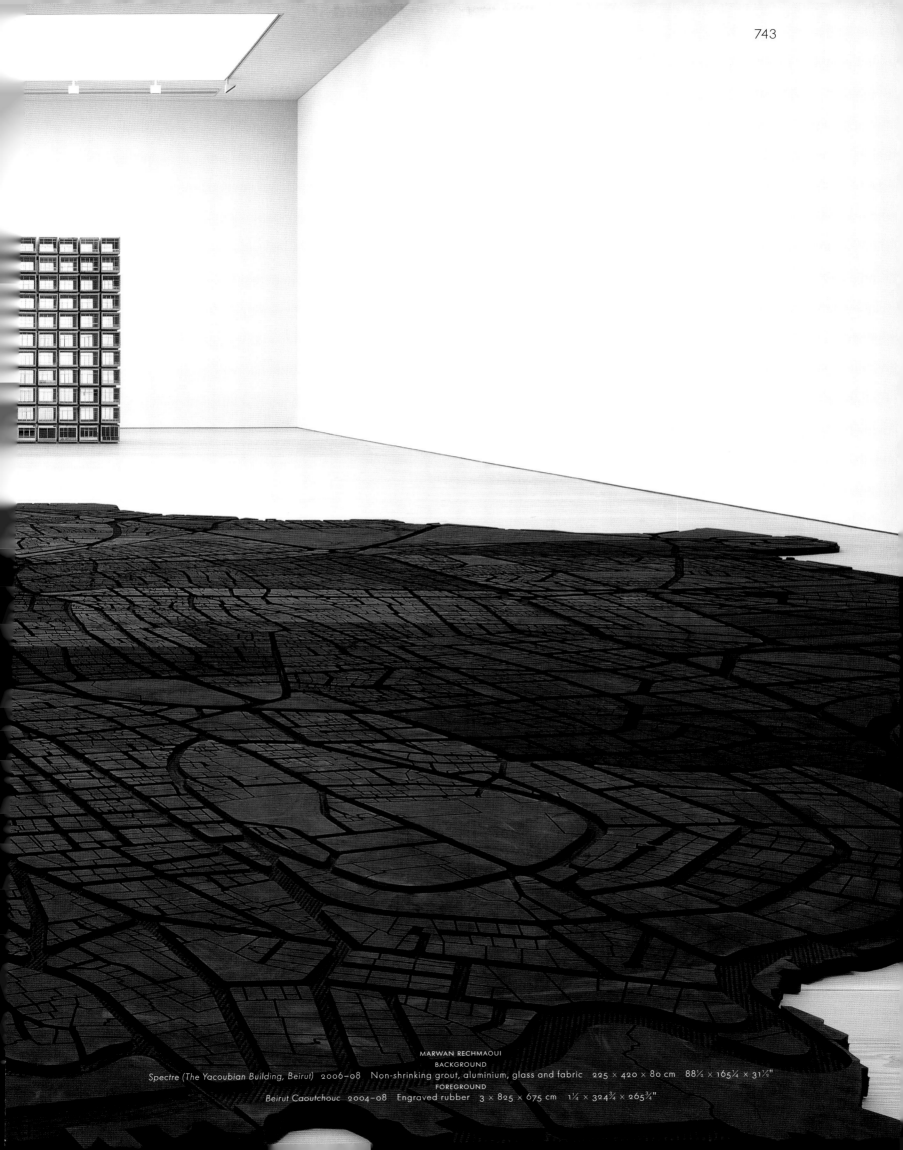

MARWAN RECHMAOUI
BACKGROUND
Spectre (The Yacoubian Building, Beirut) 2006–08 Non-shrinking grout, aluminium, glass and fabric 225 × 420 × 80 cm 88½ × 165¼ × 31½"
FOREGROUND
Beirut Caoutchouc 2004–08 Engraved rubber 3 × 825 × 675 cm 1¼ × 324¾ × 265¾"

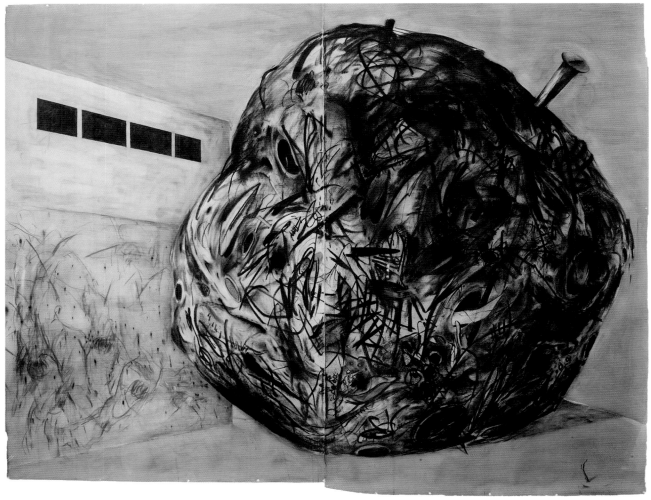

AHMED ALSOUDANI *You No Longer Have Hands* 2007 Charcoal on paper and acrylic on paper 213.4 × 274.3 cm 84 × 108"

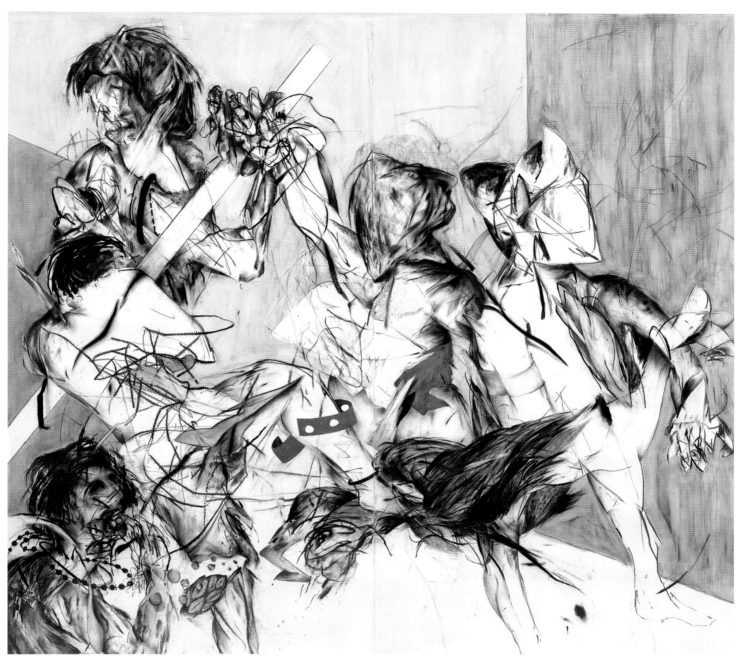

AHMED ALSOUDANI *We Die Out of Hand* 2007 Charcoal, pastel and acrylic on paper 243.8 × 274.3 cm 96 × 108"

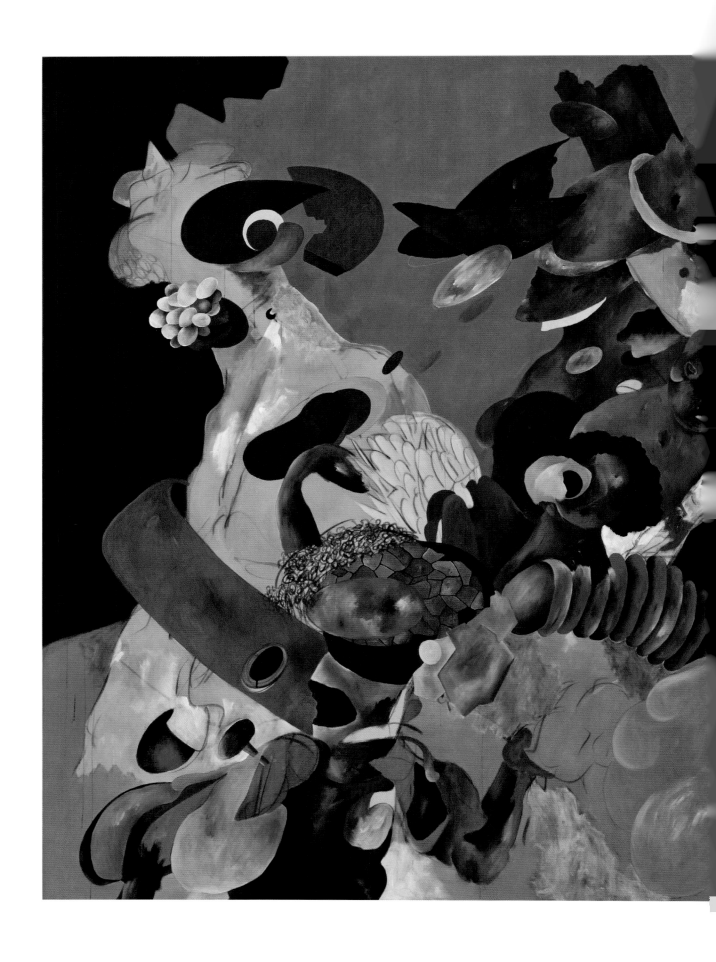

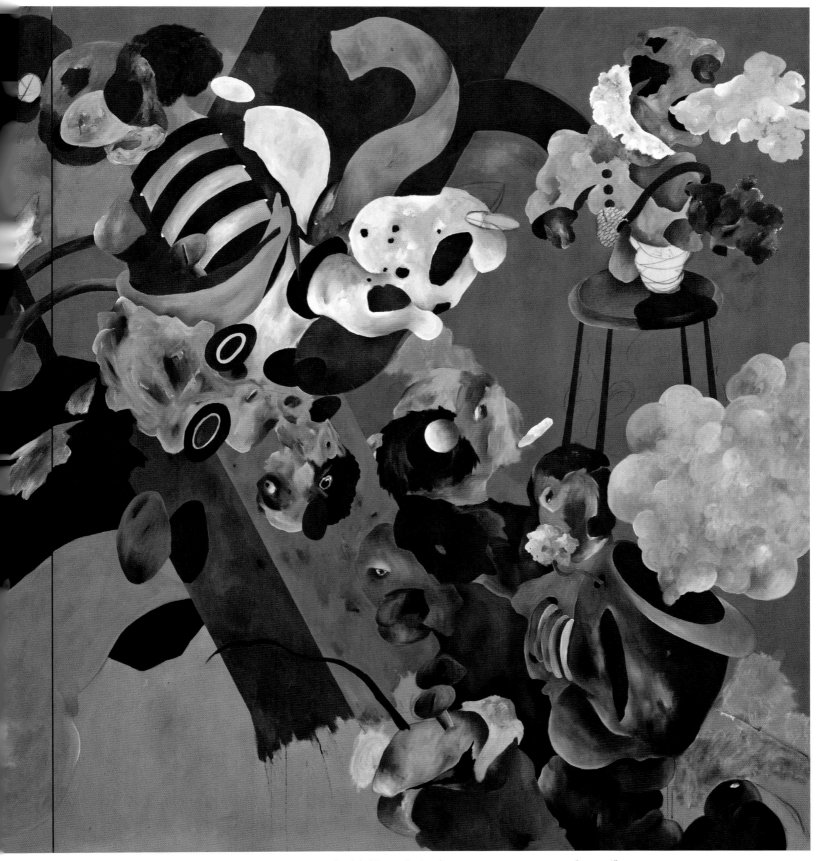

AHMED ALSOUDANI *Baghdad I* 2008 Acrylic on canvas 210 × 370 cm 83 × 146"

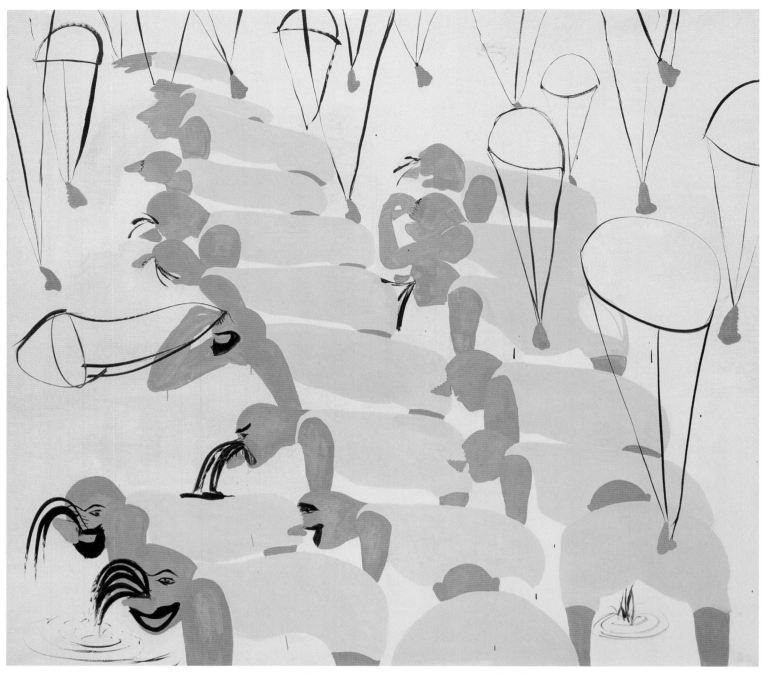

TALA MADANI *Nosefall* 2007 Oil on linen 190 × 210 cm 74¾ × 82¾"

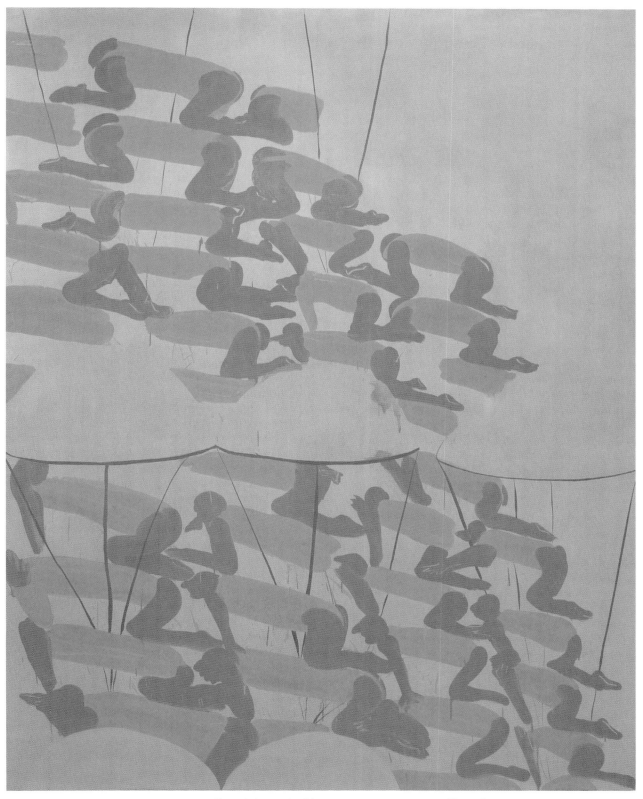

TALA MADANI *Elastic Pink* 2008 Oil on canvas 250 × 195 cm 98¼ × 77"

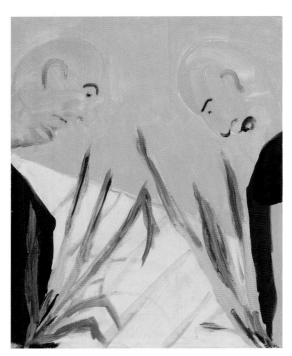

TALA MADANI *Withered* 2006 Oil on canvas
26 × 20 cm 10¼ × 8"

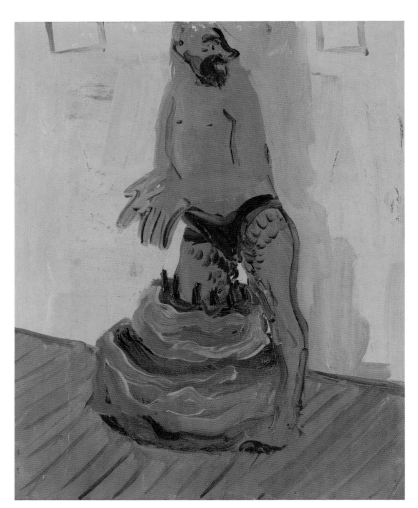

TALA MADANI *Diving in Cake* 2006 Oil on canvas
31 × 24 cm 12¼ × 9¼"

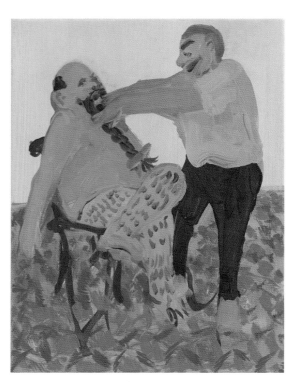

TALA MADANI *Braided Beard* 2007 Oil on canvas
36 × 28 cm 14¼ × 11"

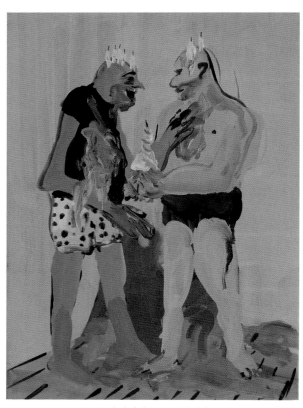

TALA MADANI *Pink Cake* 2008 Oil on canvas
40 × 30 cm 15¾ × 12"

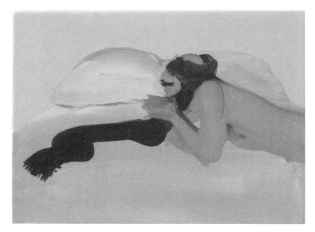

TALA MADANI *Two Pillows and a Bo'ster* 2007 Oil on linen
30 × 40 cm 12 × 15¾"

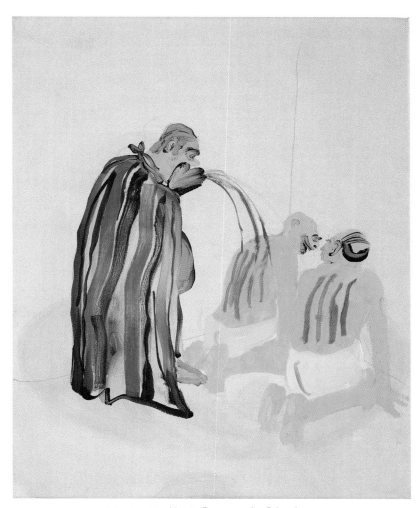

TALA MADANI *Man in Cape* 2008 Oil on linen
50 × 40 cm 19¾ × 15¾"

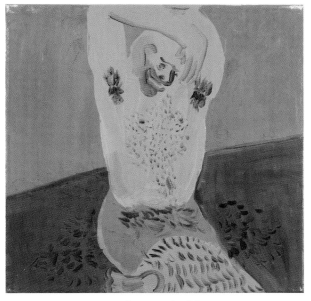

TALA MADANI *Pose* 2006 Oil on canvas
31 × 31 cm 12¼ × 12¼"

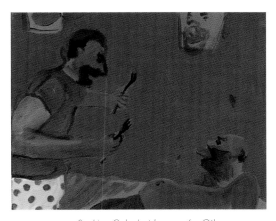

TALA MADANI *Seeking Cake Inside* 2006 Oil on canvas
24 × 31 cm 9¼ × 12¼"

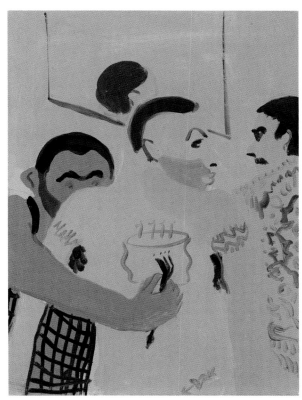

TALA MADANI *Fork in Tattoo* 2006 Oil on canvas
31 × 23 cm 12¼ × 9"

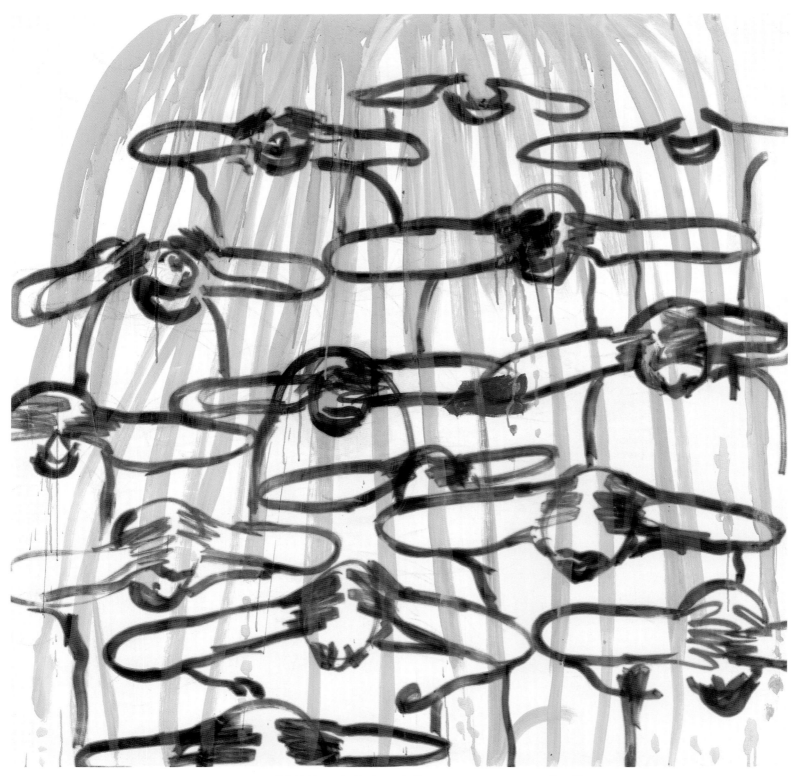

TALA MADANI *Holy Light* 2006 Marker and oil on canvas 122 × 122 cm 48 × 48"

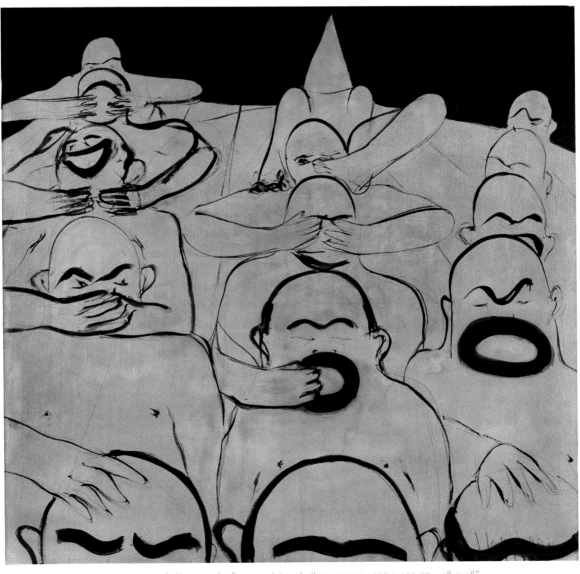

TALA MADANI *In Line* 2006 Spray paint and oil on canvas 122 × 122 cm 48 × 48"

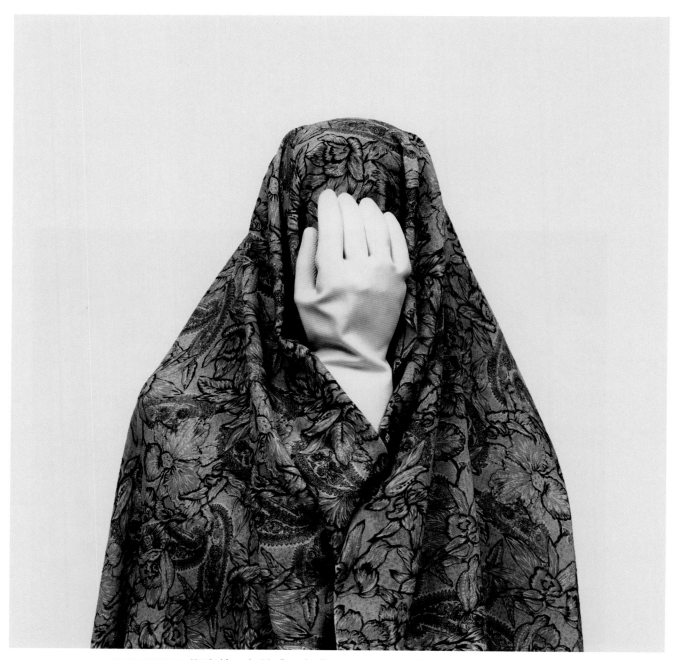

SHADI GHADIRIAN *Untitled from the Like Everyday Series* 2000–2001 C-print 183 × 183 cm 72 × 72"

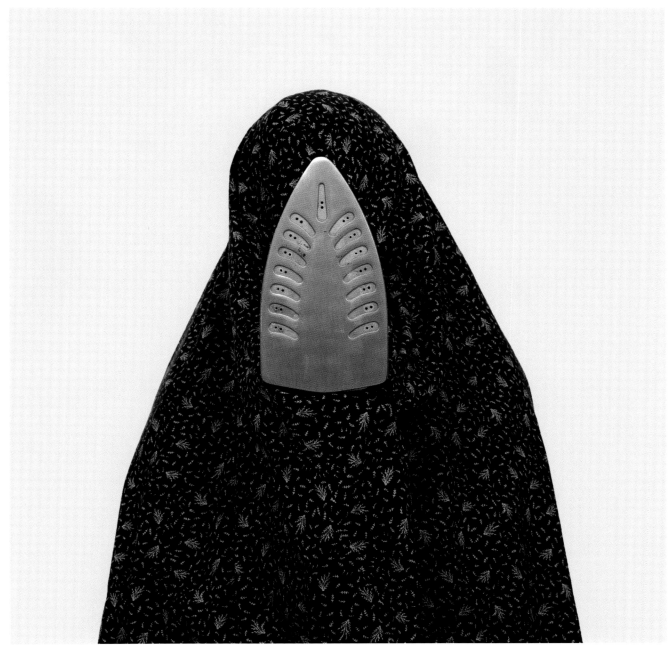

SHADI GHADIRIAN *Untitled from the Like Everyday Series* 2000–2001 C-print 183 × 183 cm 72 × 72"

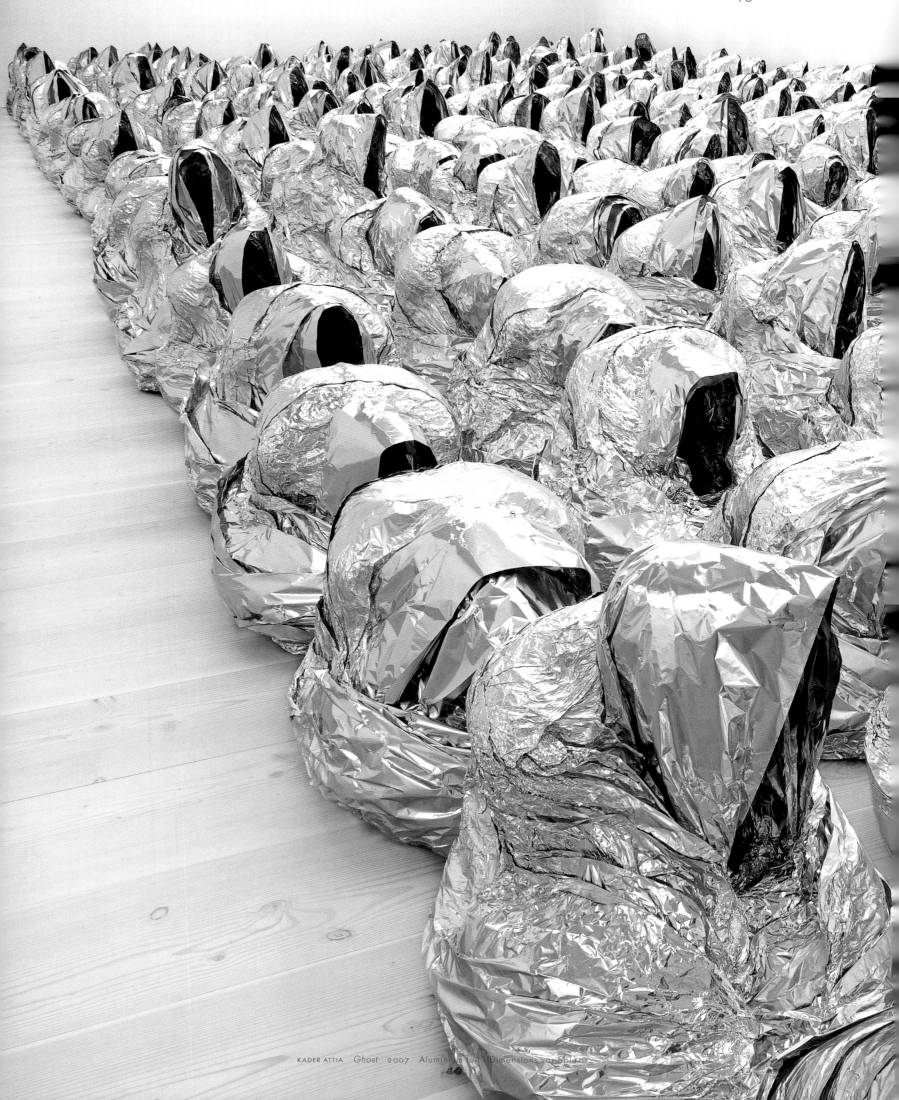

KADER ATTIA *Ghost* 2007 Aluminium foil Dimensions variable

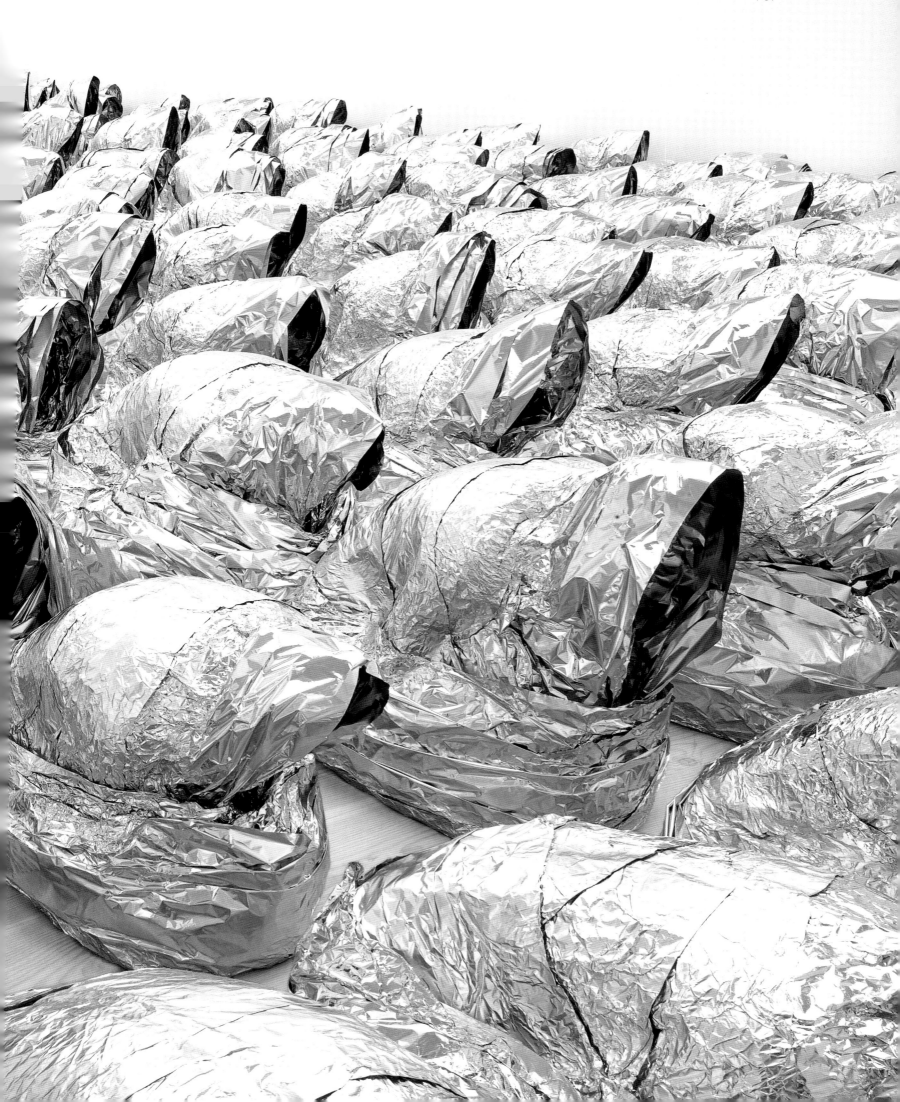

ABSTRACT AMERICA:
NEW PAINTING AND SCULPTURE

BRADFORD,
COFFIN, HARRISON,
HILL, JOHNSON,
NEEL, RHODES,
RUBY, SIBONY,
SILLMAN,
SNOW,
YOUNG, WOOD

LEFT TO RIGHT

AARON YOUNG Greeting Card 10a 2007 Stained plywood, acrylic, burnt rubber 6 panels (of ten): 1.2 × 2.4 m 4 × 8' each overall 4.8 × 6 m 16 × 20'
PATRICK HILL Forming 2007 Glass, steel granite, canvas, dye, paint, glue 274.3 × 304.8 × 213.4 cm 108 × 120 × 84"

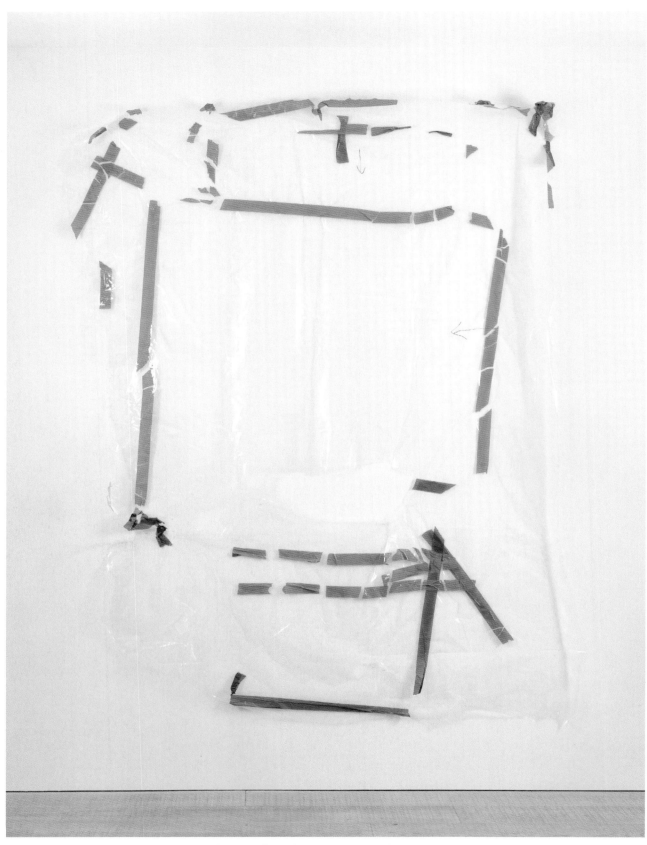

GEDI SIBONY *Untitled* 2009 Plastic sheet, packing tape, ink 290 × 183 cm 114¼ × 72"

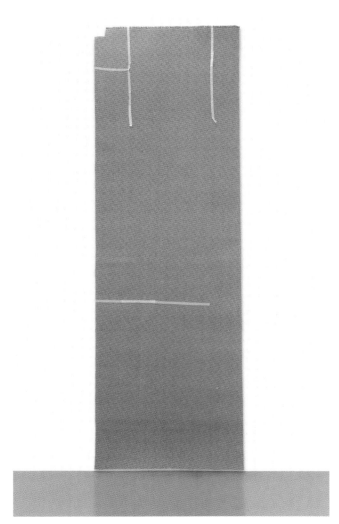

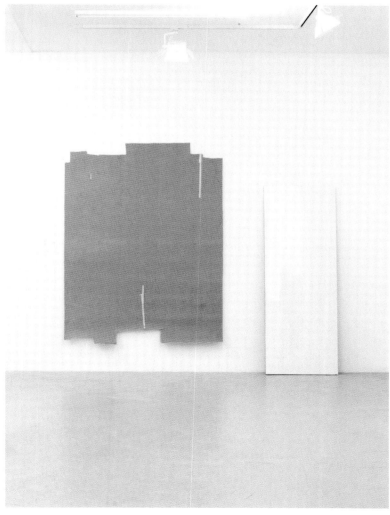

GEDI SIBONY *Untitled* 2008 Carpet, tape
305 × 107 cm 120 × 42"

GEDI SIBONY *Untitled* 2009 Diptych, carpet, wood door painted in white
Carpet: 220 × 170 cm 96¾ × 67" Door: 203 × 76 cm 80 × 30"
Overall dimensions: 220 × 270 cm 96¾ × 106½"

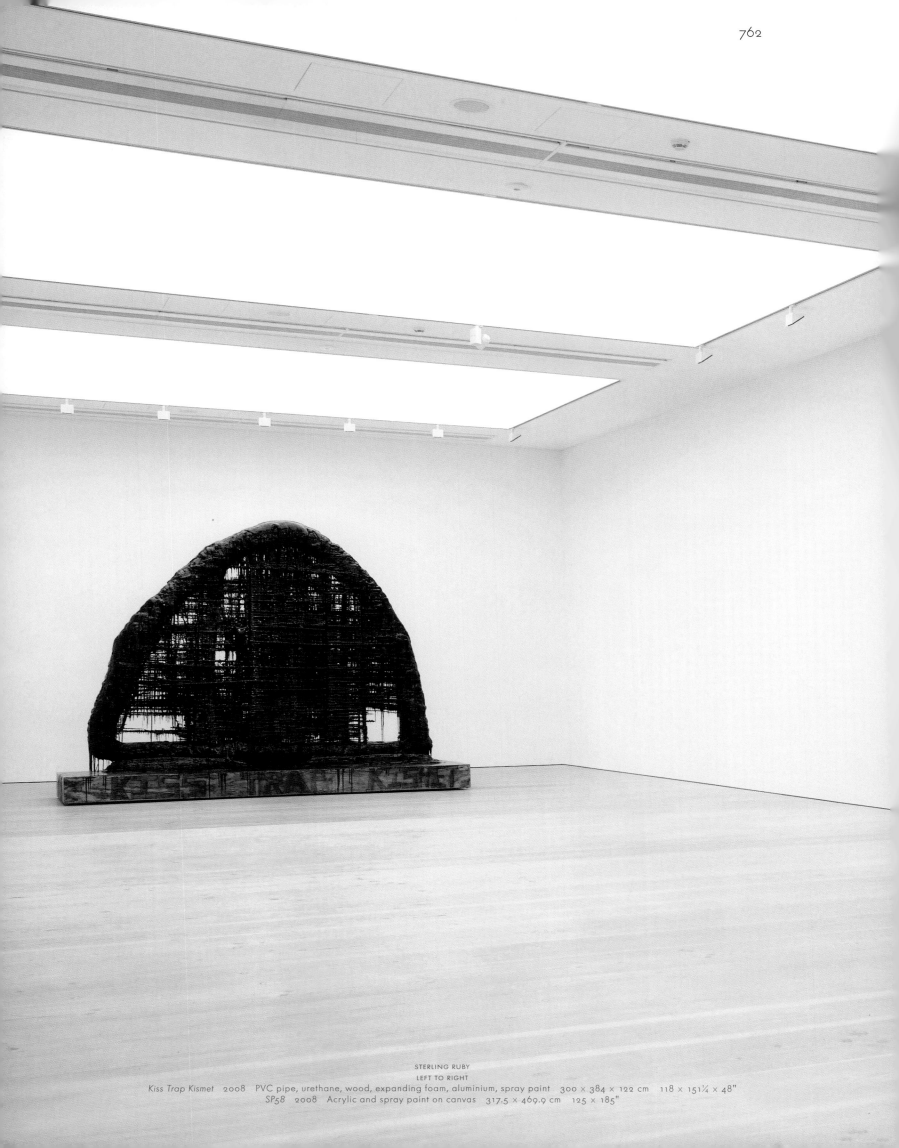

STERLING RUBY
LEFT TO RIGHT

Kiss Trap Kismet 2008 PVC pipe, urethane, wood, expanding foam, aluminium, spray paint 300 × 384 × 122 cm 118 × 151¼ × 48"
SP58 2008 Acrylic and spray paint on canvas 317.5 × 469.9 cm 125 × 185"

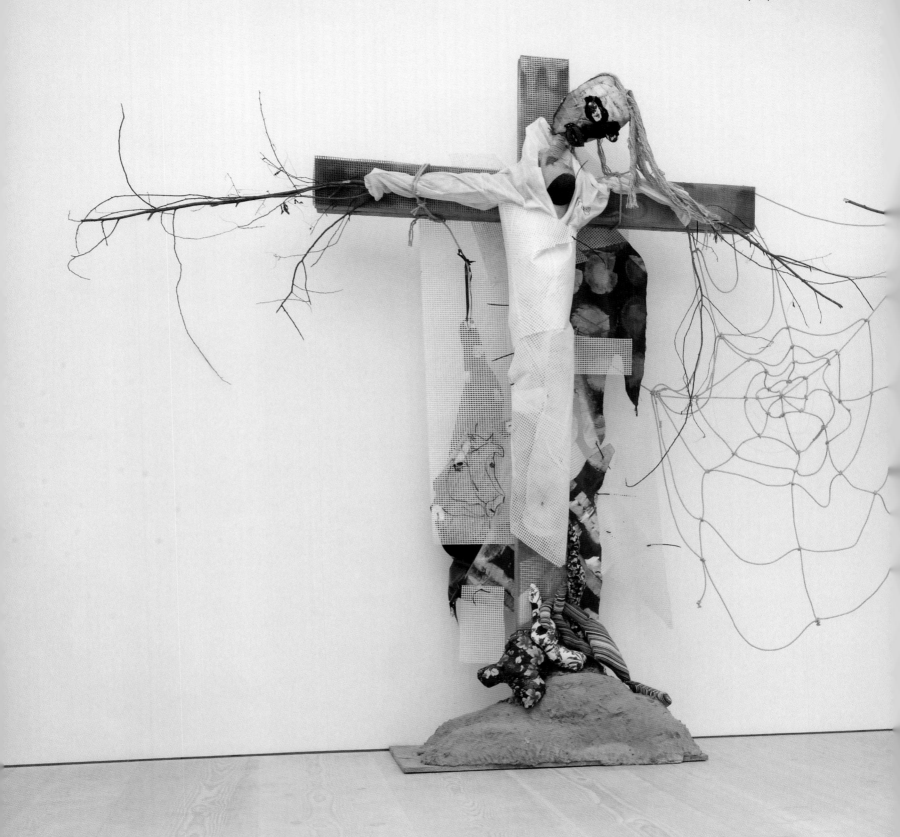

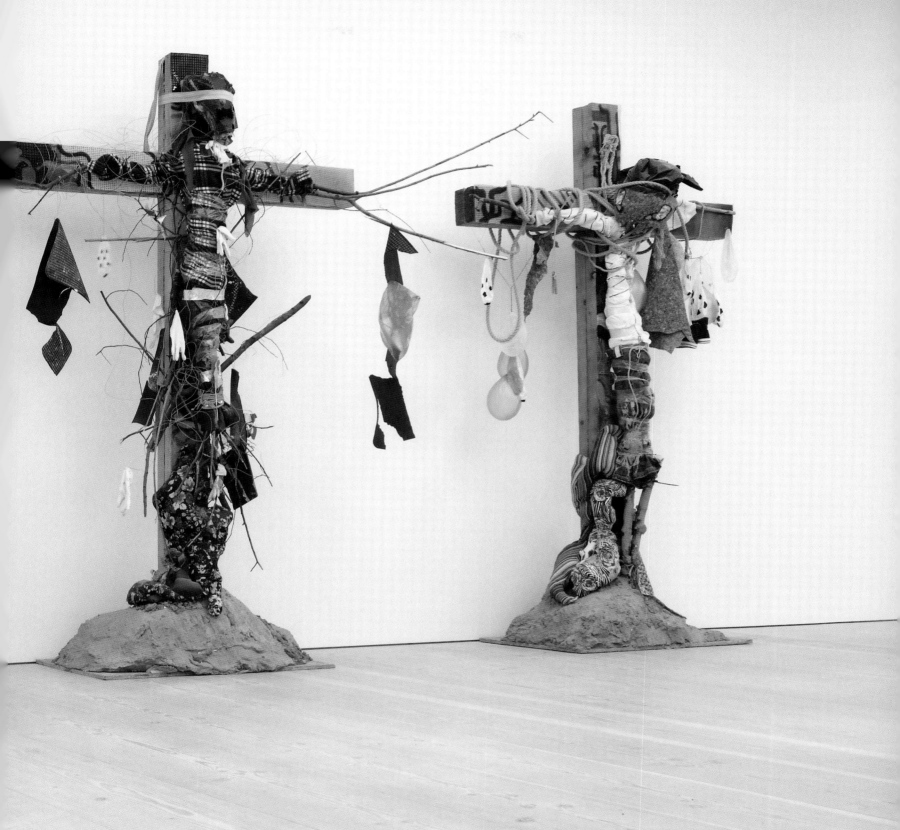

AGATHE SNOW
LEFT TO RIGHT
Five (Cross on the Left with Spider Web) 2007 Mixed-media sculpture — materials include balloons, found objects, cloth, rope, wood, concrete and wire mesh
Dimensions vary with installation 320 × 330 × 100 cm 126 × 130 × 39½"
Four (Center Cross) 2007 Mixed-media sculpture — materials include balloons, found objects, cloth, wood, concrete and wire mesh
Dimensions vary with installation 320 × 330 × 100 cm 126 × 130 × 39½"
Three (Cross With Balloons) 2007 Mixed-media sculpture — materials include balloons, found objects, cloth, wood, concrete and wire mesh 320 × 216 × 80 cm 126 × 85 × 31½"

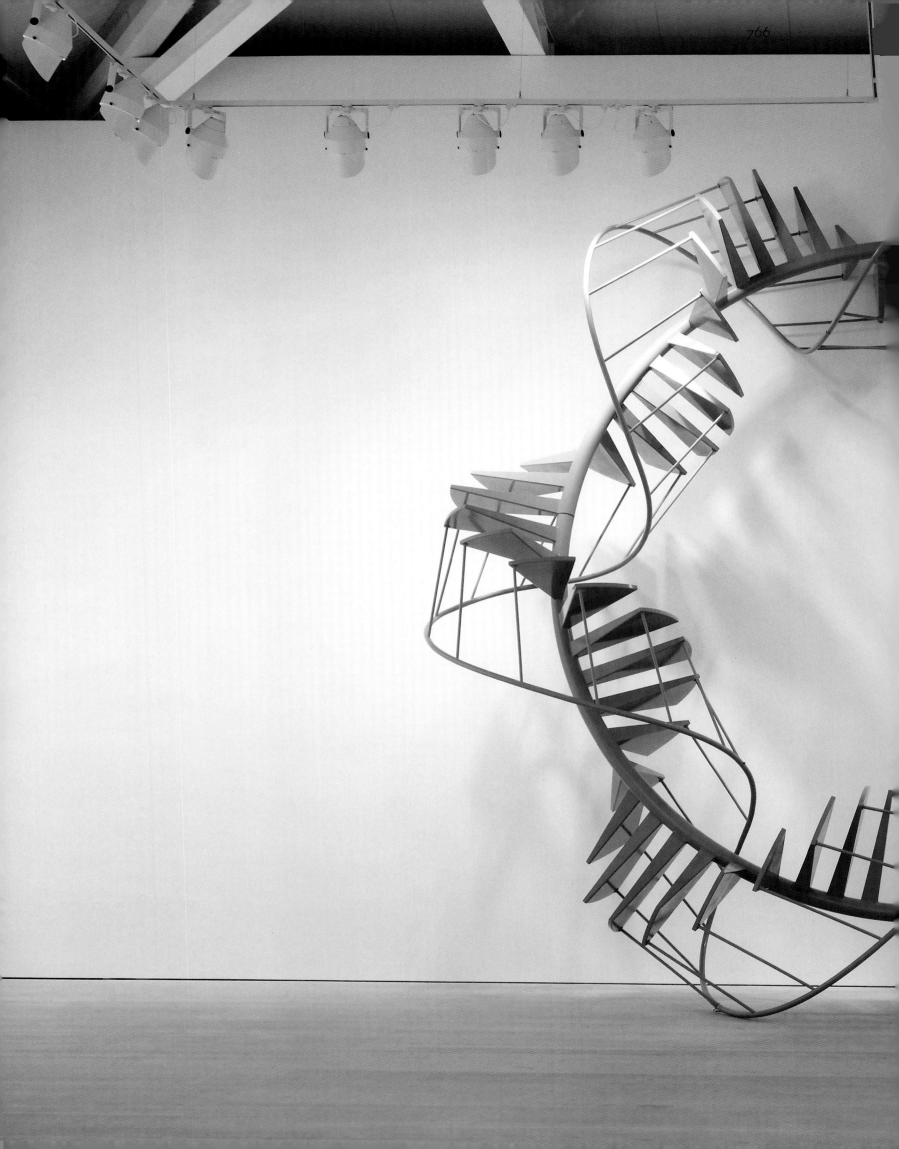

PETER COFFIN *Untitled (Spiral Staircase)* 2007 Aluminium and steel 670.6 × 670.6 × 213.4 cm 264 × 264 × 84"

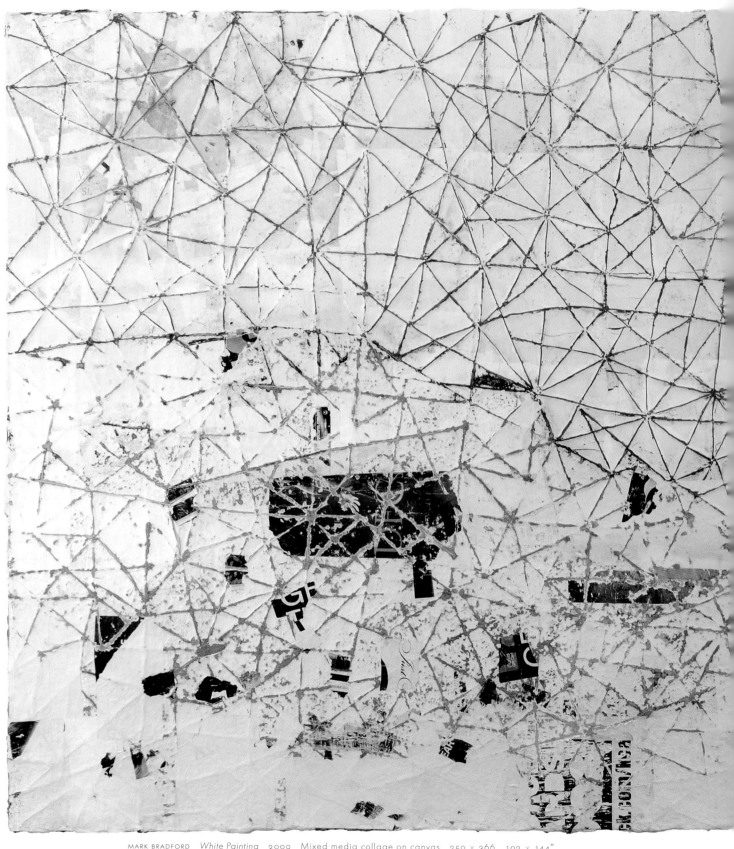

MARK BRADFORD *White Painting* 2009 Mixed media collage on canvas 259 × 366 102 × 144"

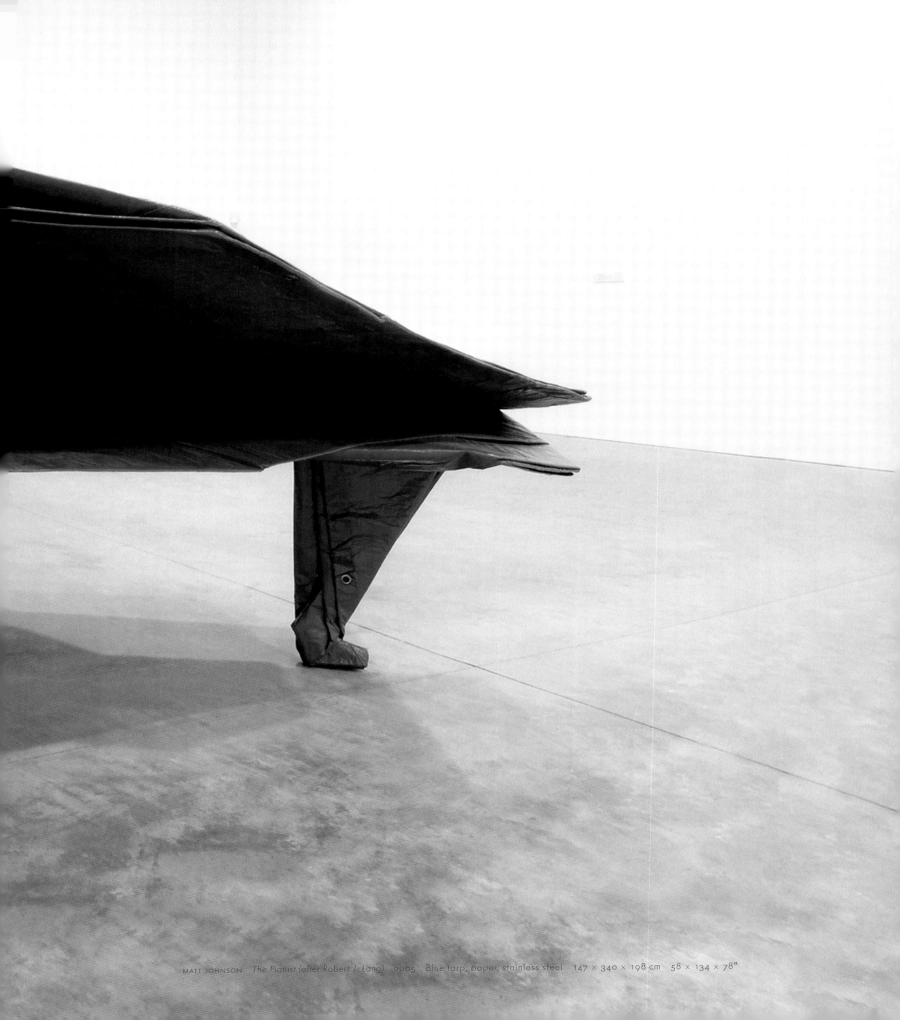

MATT JOHNSON *The Pianist (after Robert J. Lang)* 2005 Blue tarp, paper, stainless steel 147 × 340 × 198 cm 58 × 134 × 78"

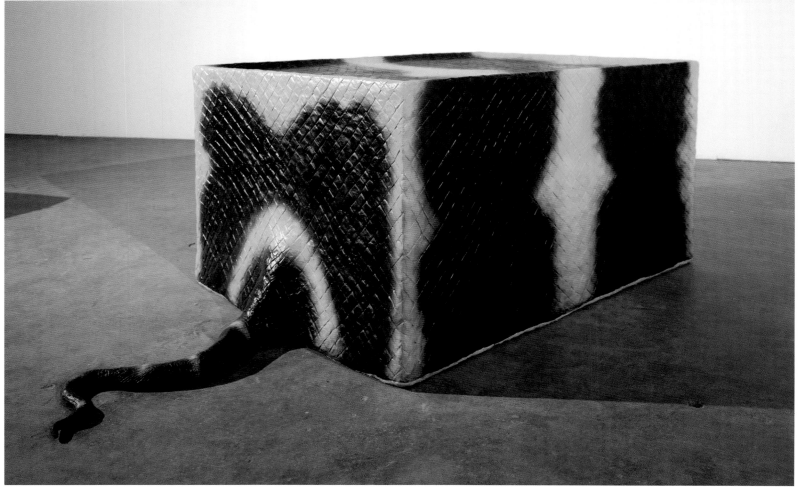

STEPHEN G. RHODES *Ssspecific Object* 2006 Rubber 122 × 84 × 122 cm 48 × 84 × 48"

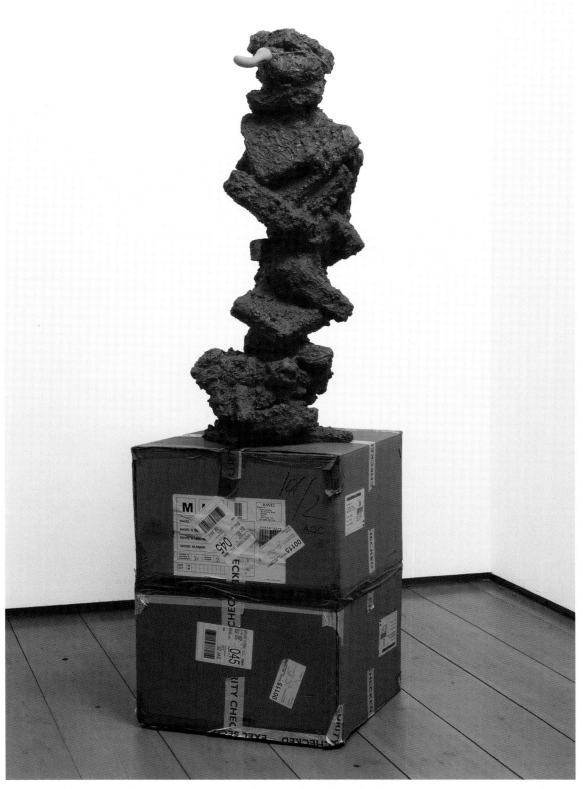

RACHEL HARRISON Nose 2005 Wood, polystyrene, cement, Parex, acrylic, cardboard, rubber nose 193 × 76.2 × 45.7 cm 76 × 30 × 18"

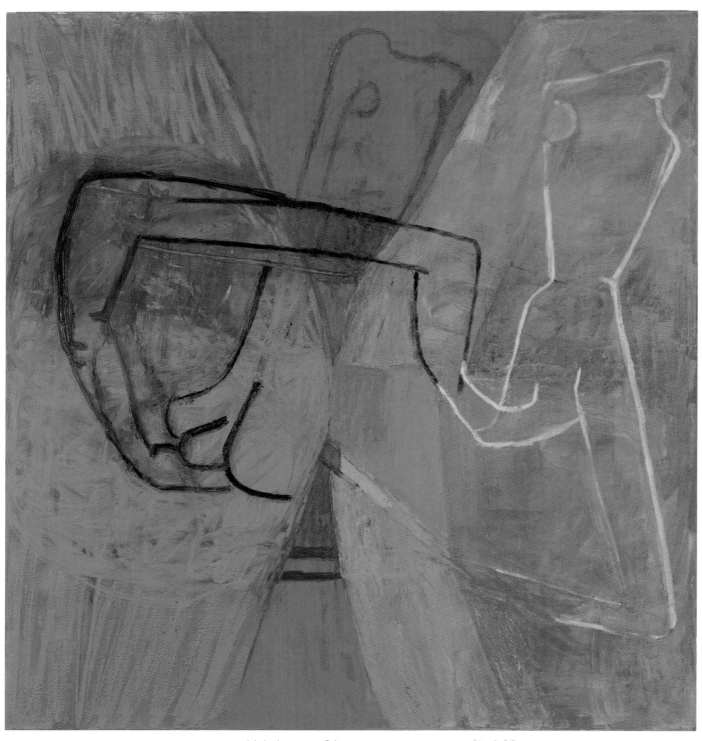

AMY SILLMAN *Ich Auch* 2009 Oil on canvas 230 × 215 cm 90¾ × 84¾"

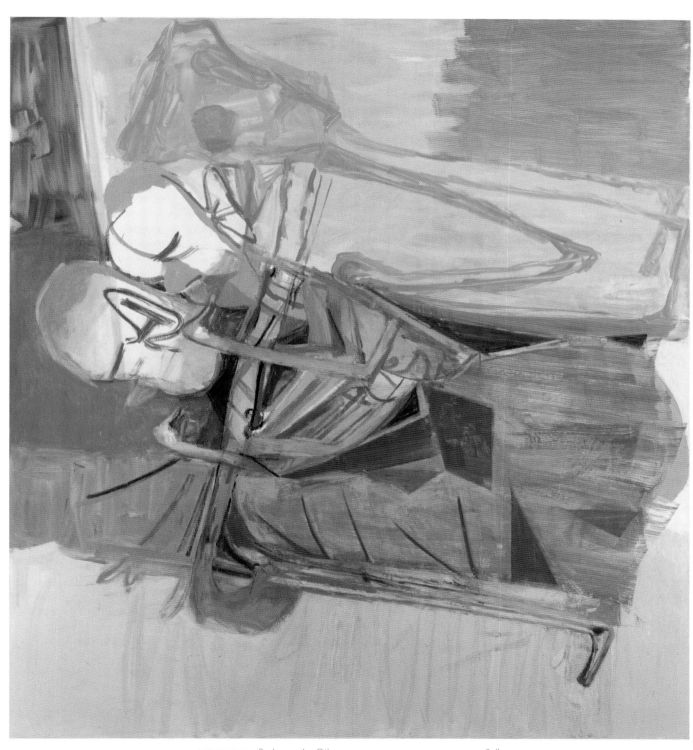

AMY SILLMAN *Bed* 2006 Oil on canvas 231 × 213.4 cm 91 × 84"

ELIZABETH NEEL *The Humpndump* 2008 Oil on canvas 216 × 193 cm 85 × 76"

ELIZABETH NEEL *Good vs Evil* 2009 Oil on canvas 201 × 168 cm 79 × 66"

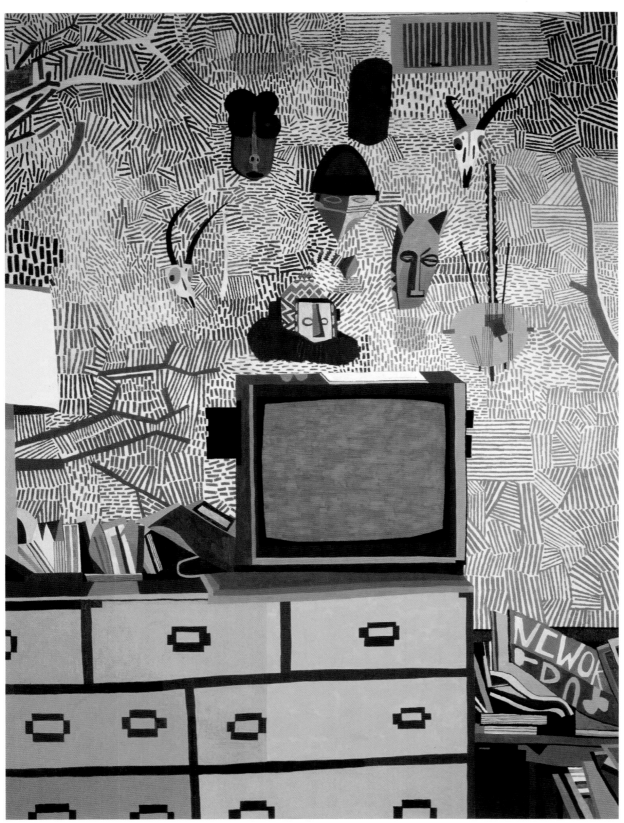

JONAS WOOD *Rosy's Masks* 2008 Oil on linen 259 × 191 cm 102 × 75¼"

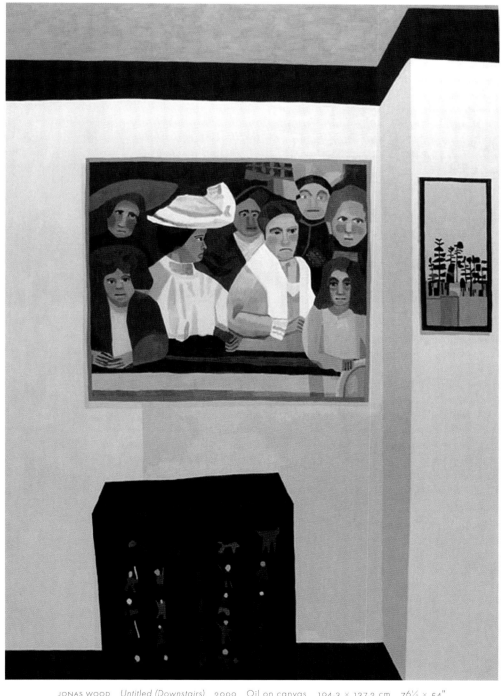

JONAS WOOD *Untitled (Downstairs)* 2009 Oil on canvas 194.3 × 137.2 cm 76½ × 54"

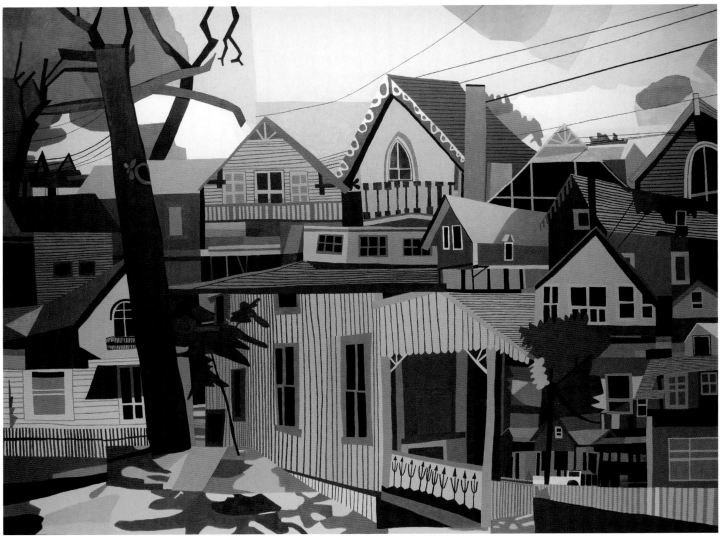

JONAS WOOD *Untitled (M.V. Landscape)* 2008 Oil on canvas 305 × 396 cm 120 × 156"

JONAS WOOD *Untitled (Big Yellow Dot)* 2009 Oil on linen
188 × 132 cm 74 × 52"

JONAS WOOD *Untitled (Red And Pink On Tan)* 2009 Oil on linen
190.5 × 122 cm 75 × 48"

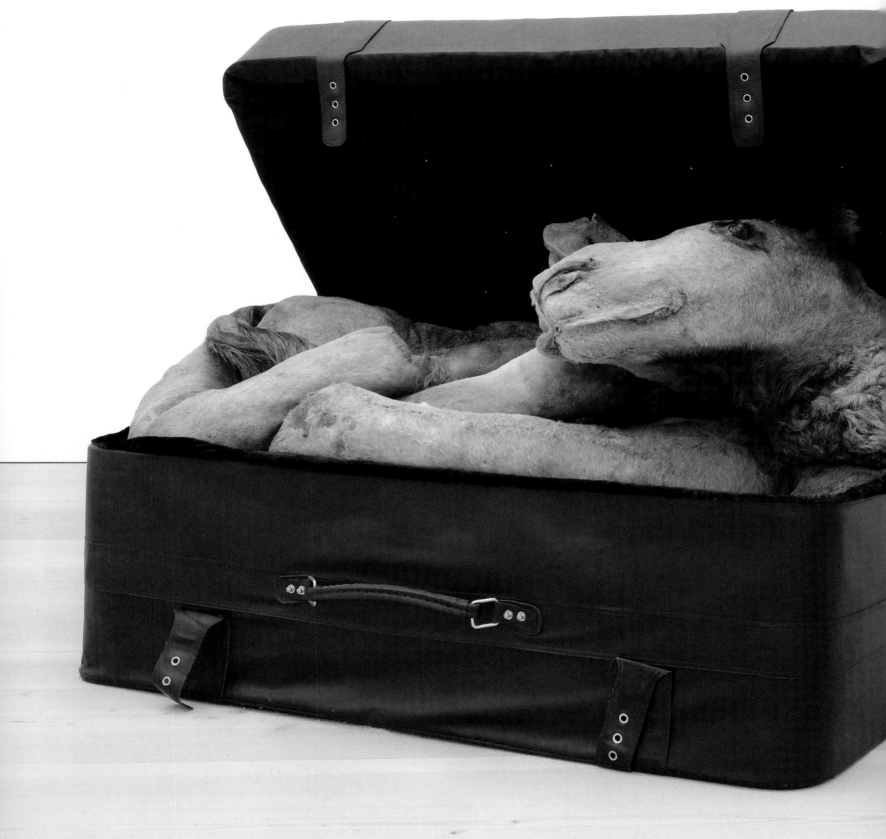

HUMA MULJI *Arabian Delight* 2008 Rexine suitcase, taxidermy camel, metal rods, wood, cotton wool, fabric
105 × 144 × 155 cm 41⅛ × 56¾ × 61" (Open with lid)

THE EMPIRE STRIKES BACK:
INDIAN ART TODAY

BHABHA,
DODIYA,
S GUPTA, JOAG,
KALLAT, KHER,
MULJI,
TALLUR L N

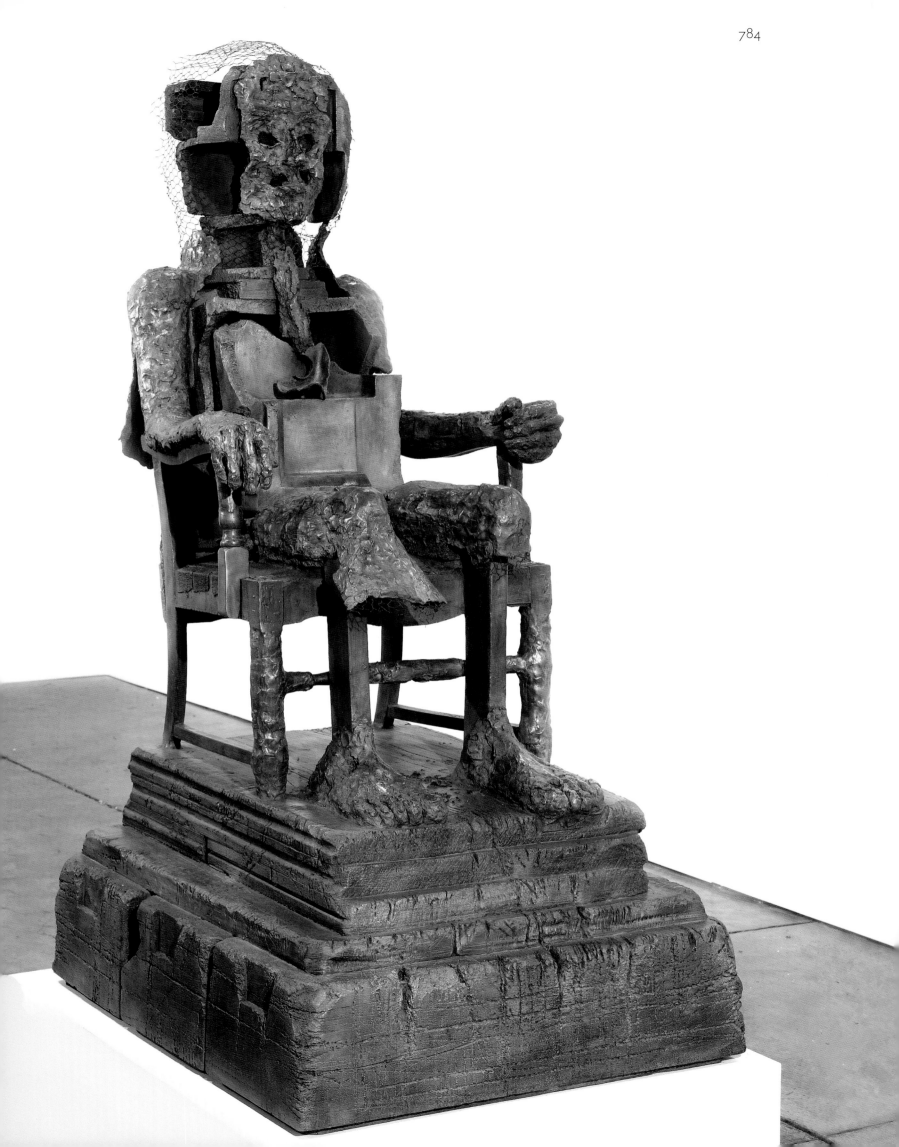

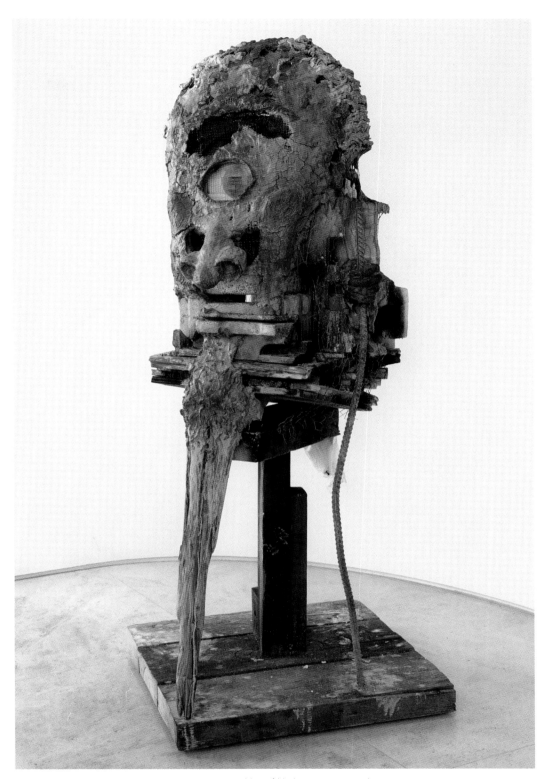

HUMA BHABHA *Man of No Importance* 2006
Clay, wire, wood, bones, iron, cotton, fabric, glass 165.1 × 104.1 × 76.2 cm 65 × 41 × 30"
LEFT HUMA BHABHA *The Orientalist* 2007 Bronze 177.8 × 83.8 × 104.1 cm 70 × 33 × 41"

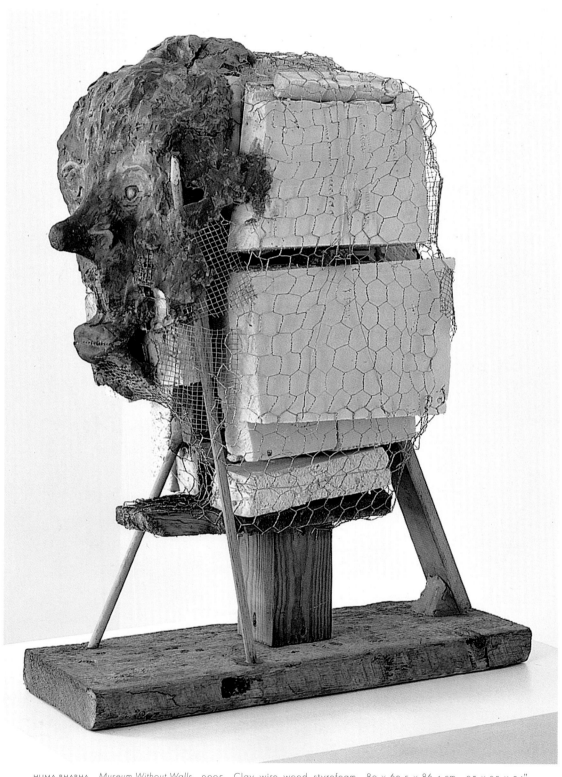

HUMA BHABHA *Museum Without Walls* 2005 Clay, wire, wood, styrofoam 89 × 63.5 × 86.4 cm 35 × 25 × 34"
RIGHT HUMA BHABHA *Sell the House* 2006 Mixed media 139.7 × 96.5 × 71.1 cm 55 × 38 × 28"

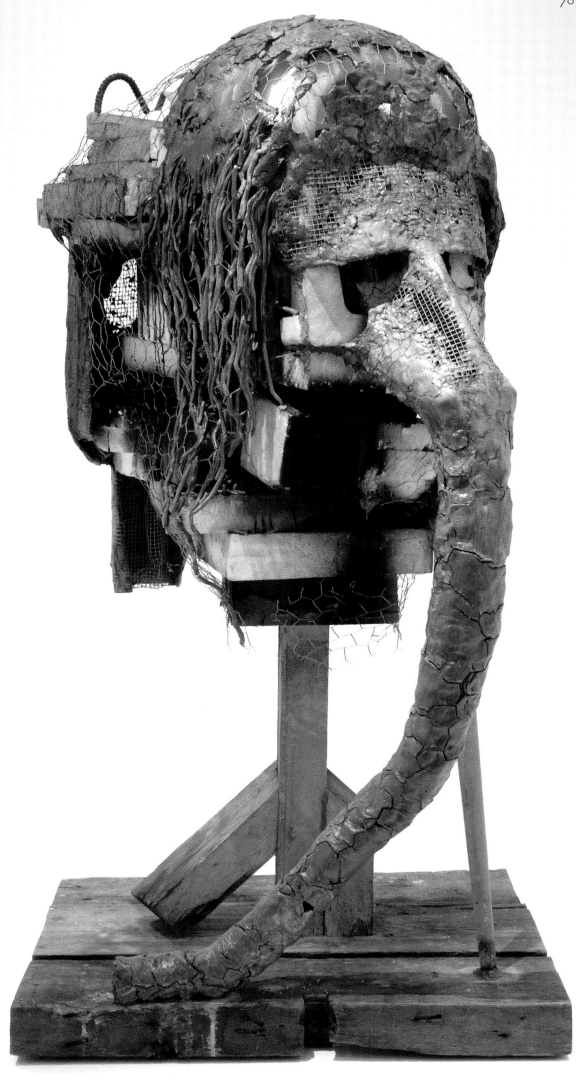

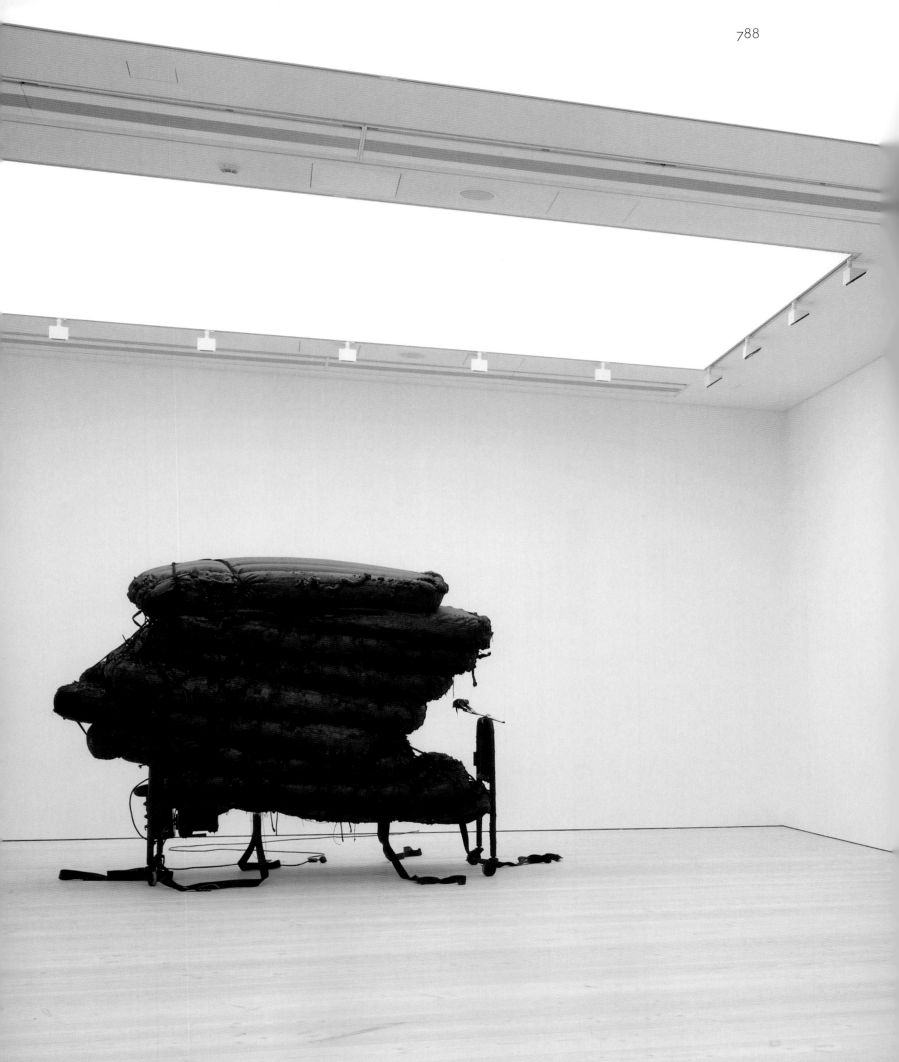

TALLUR L.N. (ABOVE) *Untitled* 2007 Inflatable bed, silicon, latex rubber, medical cot and forceps 275 × 280 × 160 cm 108 × 110 × 63"
JITISH KALLAT (RIGHT) *Rickshawpolis 4* 2006 Acrylic on canvas with bronze gargoyles 178 × 274 cm 70 × 108"

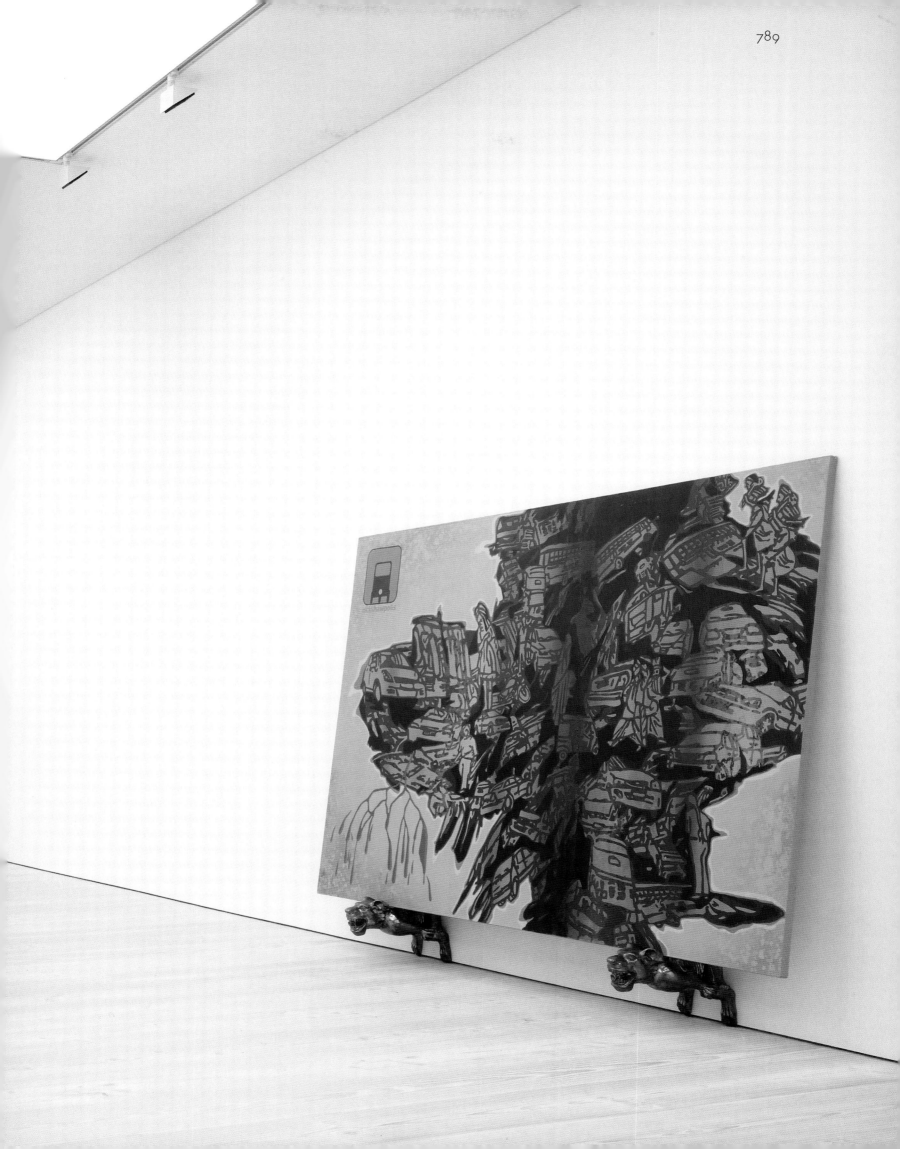

ATUL DODIYA *Woman from Kabul* 2001
Acrylic and marble dust on fabric 183 × 122 cm 72 × 48"

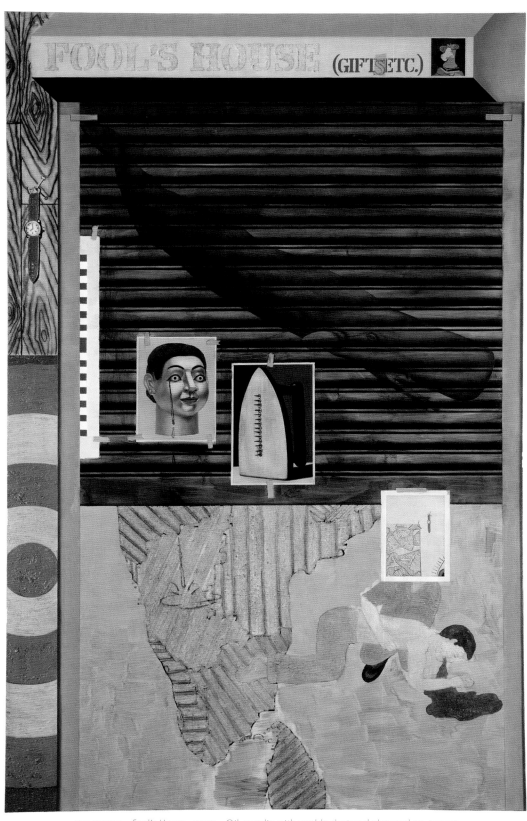

ATUL DODIYA *Fool's House* 2009 Oil, acrylic with marble dust and charcoal on canvas
243.8 × 152.4 cm 96 × 60"

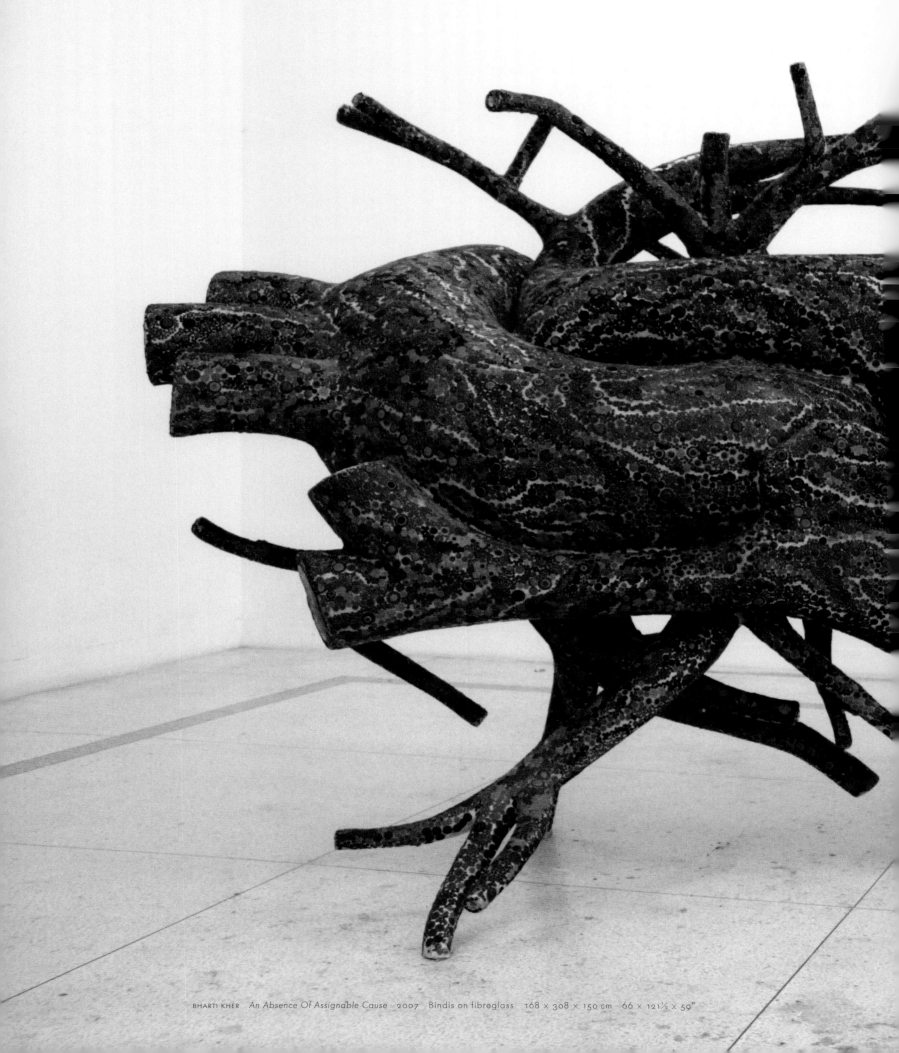

BHARTI KHER *An Absence Of Assignable Cause* 2007 Bindis on fibreglass 168 × 308 × 150 cm 66 × 121½ × 59"

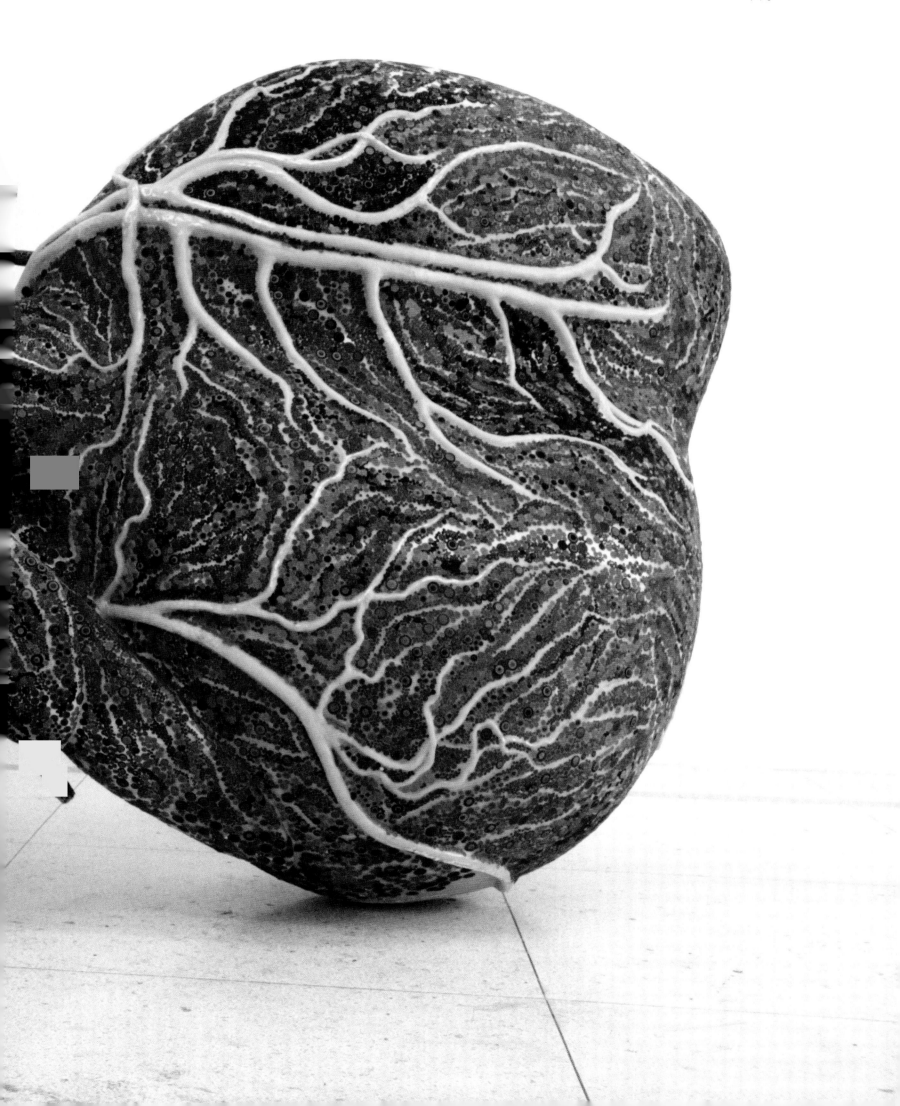

BHARTI KHER *Untitled* 2008 Bindis on painted board 173 × 311 cm 68 × 122⅓"

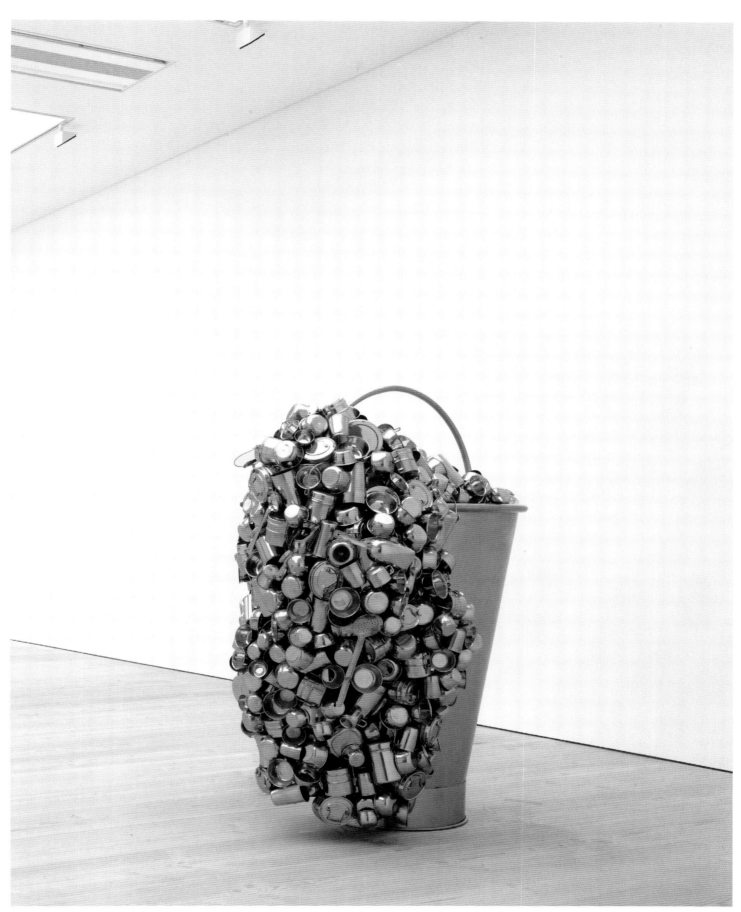

SUBODH GUPTA *Spill* 2007 Stainless steel and stainless steel utensils 170 × 145 × 95 cm 67 × 57 × 37⅜"

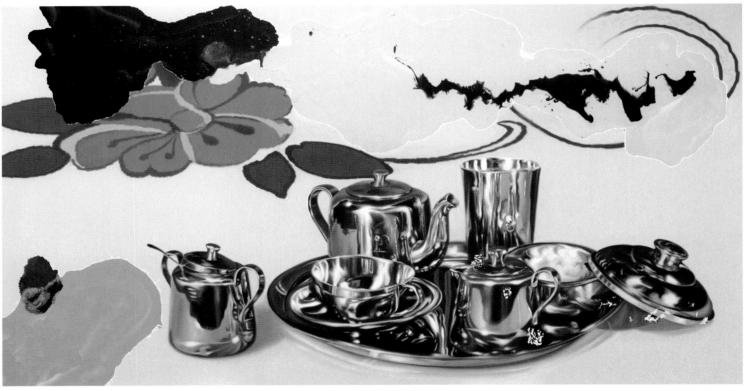

SUBODH GUPTA *Still Steal Steel #1* 2007 Oil and enamel on canvas 198 × 366 cm 78 × 144"

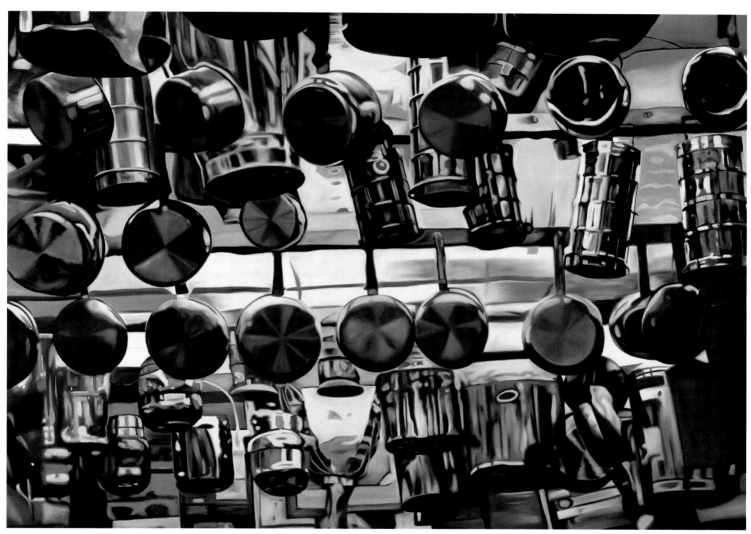

SUBODH GUPTA *Untitled (Pot)* 2004 Oil on canvas 168 × 229 cm 66 × 90¼"

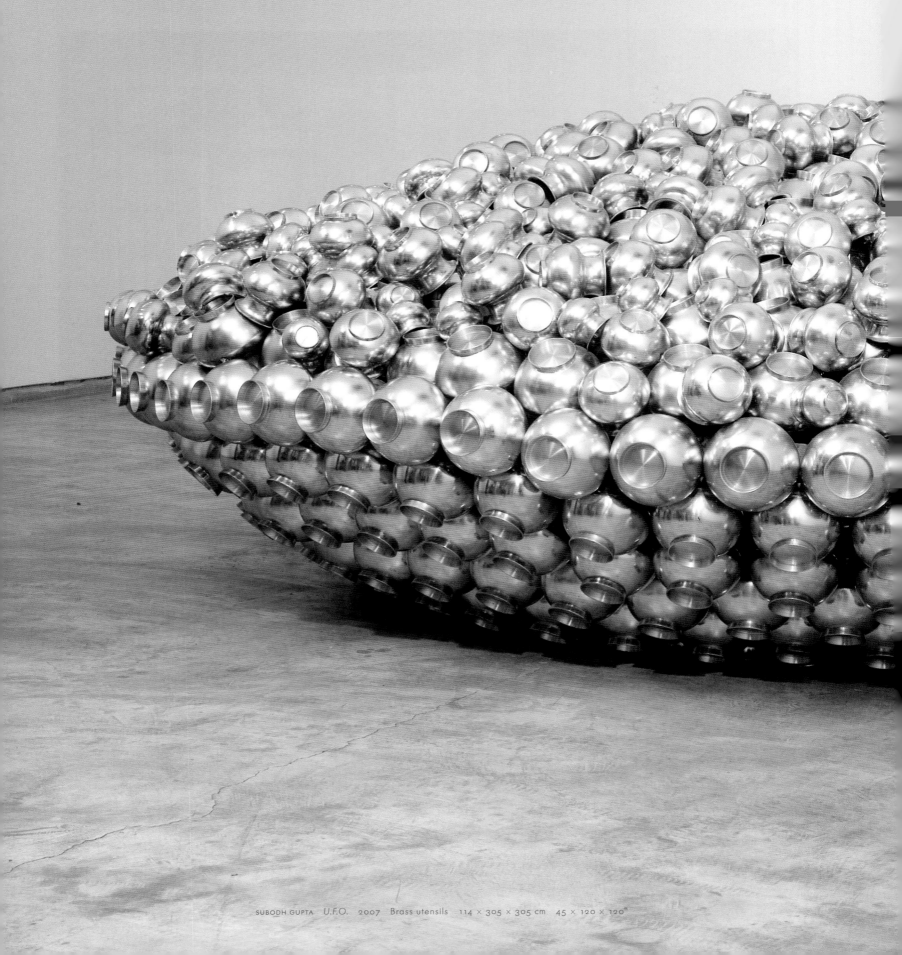

SUBODH GUPTA *U.F.O.* 2007 Brass utensils 114 × 305 × 305 cm 45 × 120 × 120"

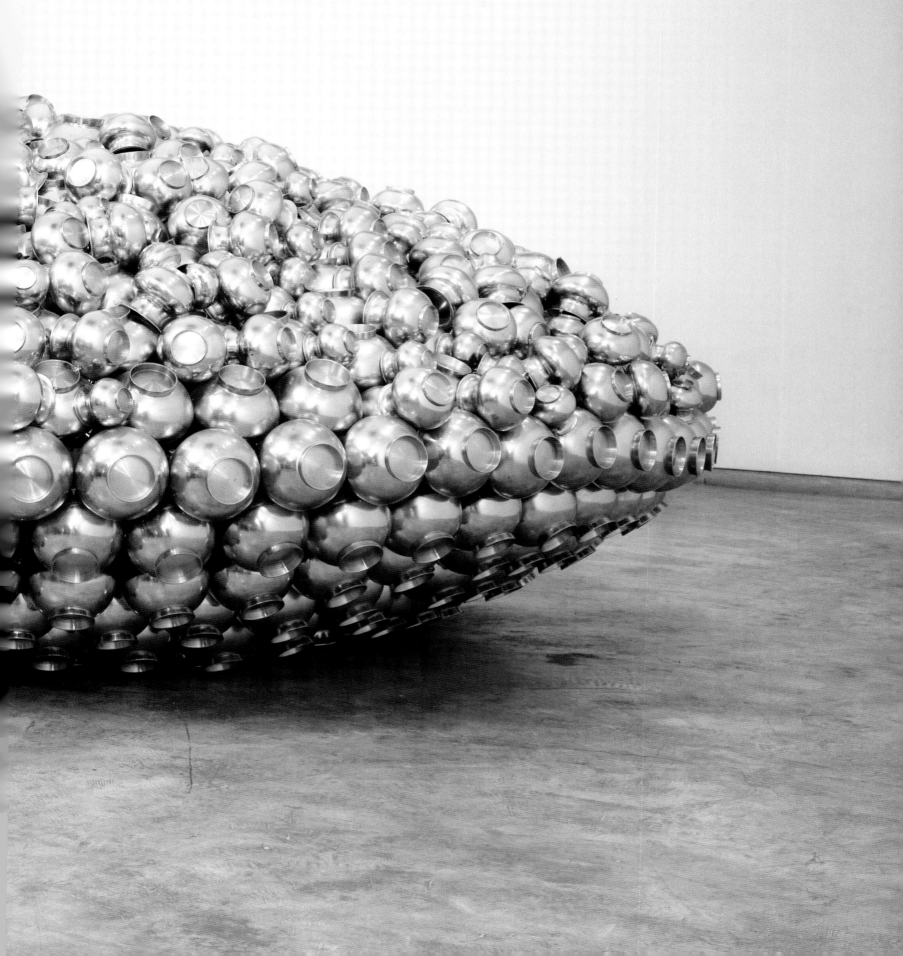

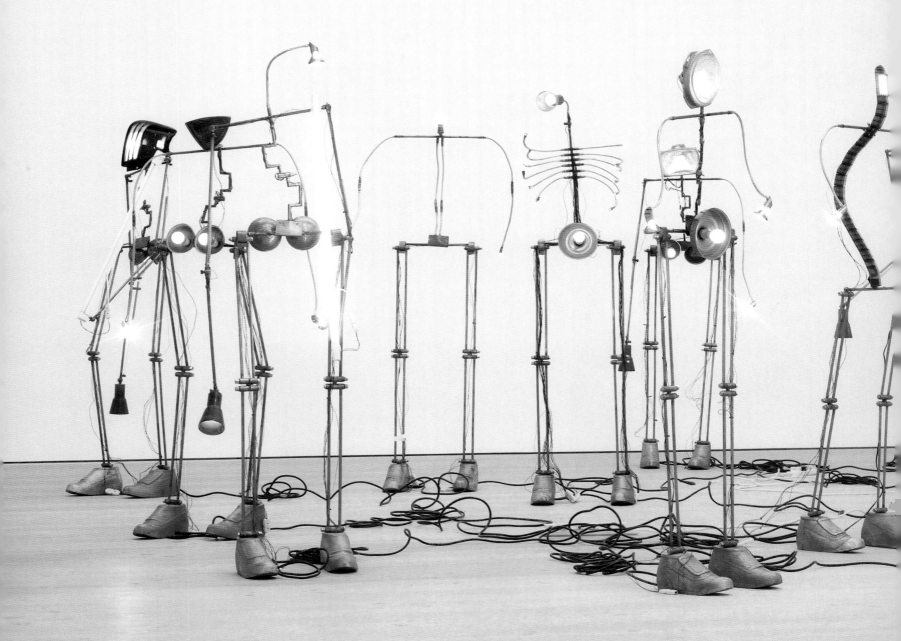

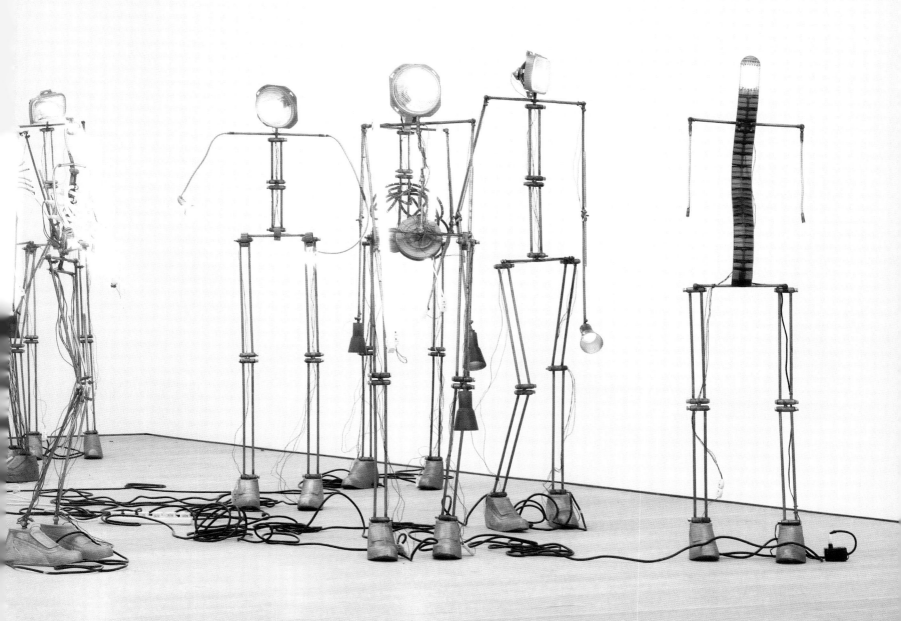

TUSHAR JOAG *The Enlightening Army Of The Empire* 2008 Installation comprising 16 figures, perspex, plastic, brass, mild steel, wood, electric bulbs, wire and mixed media
Figure size: approximately 183 × 49 × 61 cm 72 × 19¼ × 24"

9TH OCTOBER 2008–4TH JANUARY 2009
ALEKSANDRA MIR *Newsroom 1986–2000, Cops and Teens* 2007 21 drawings, marker on paper 188 × 147.3 74 × 58" each

PROJECT ROOM

MIR, PRINCE, RYMAN

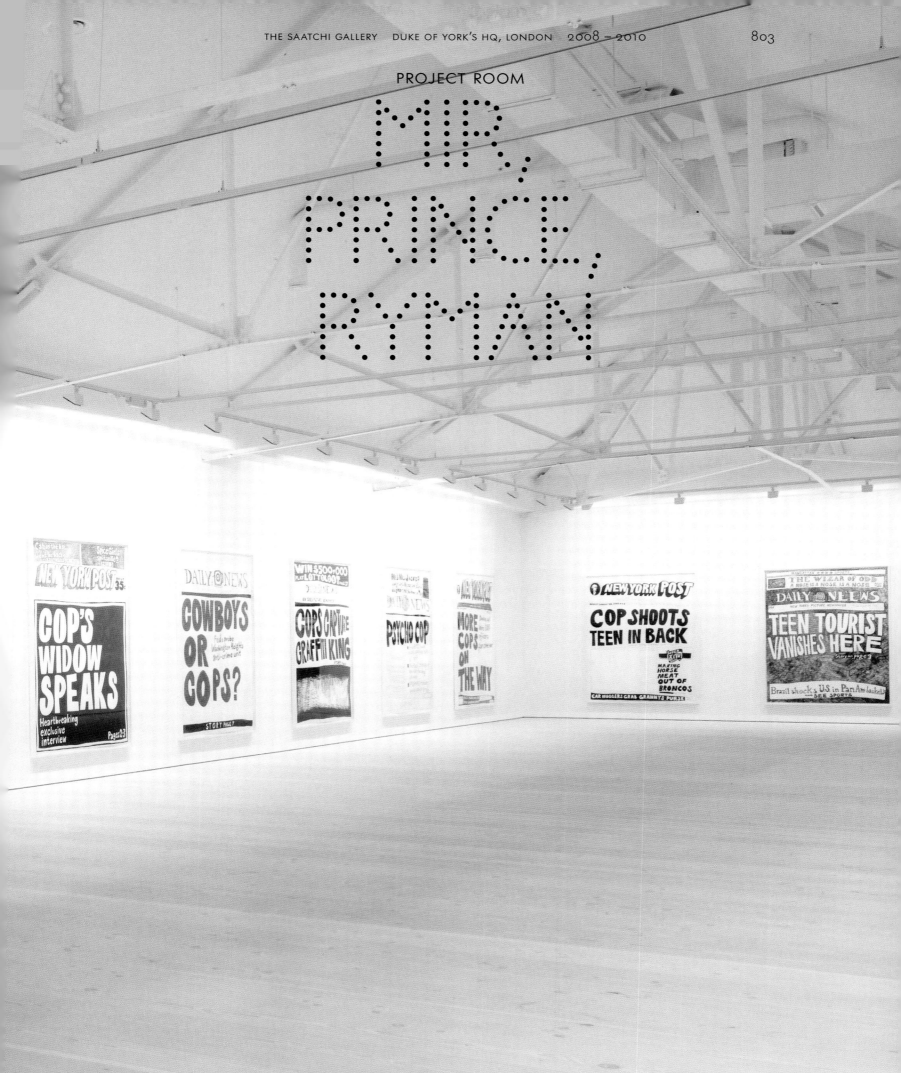

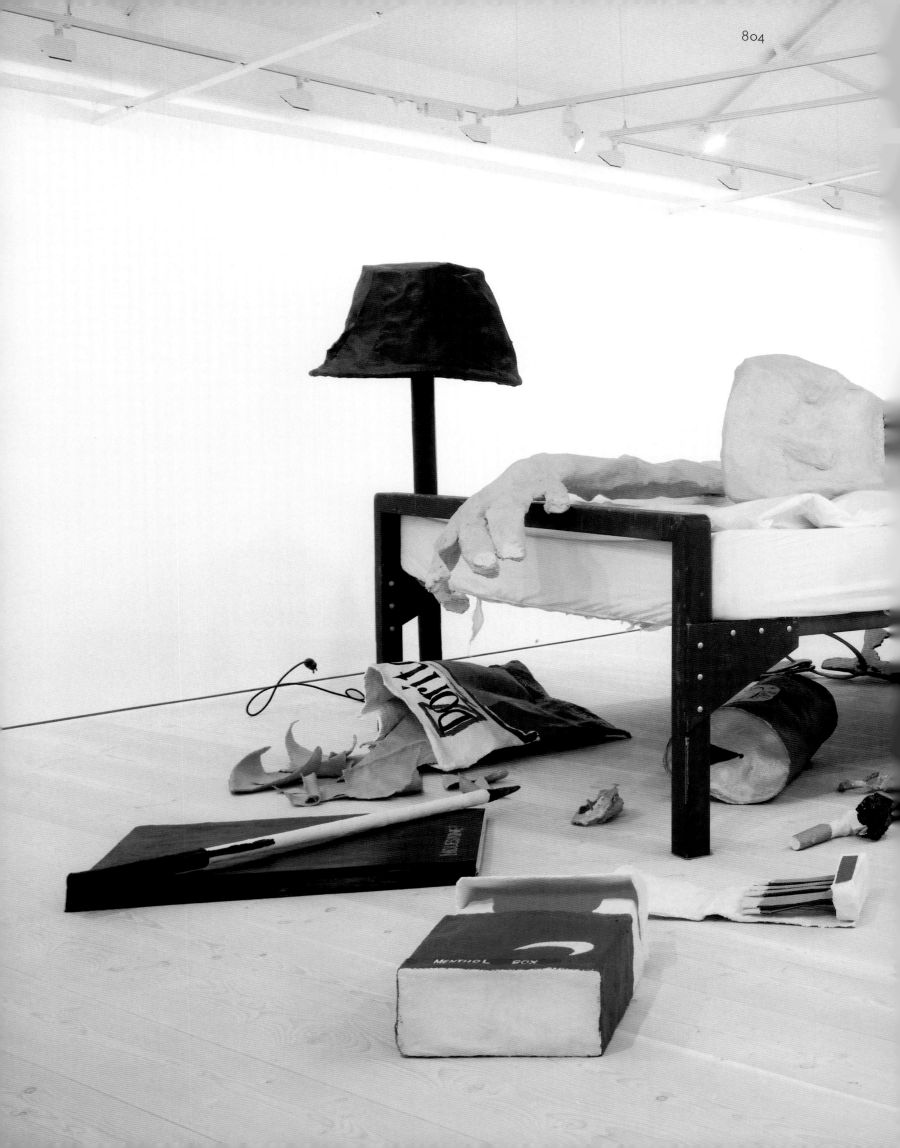

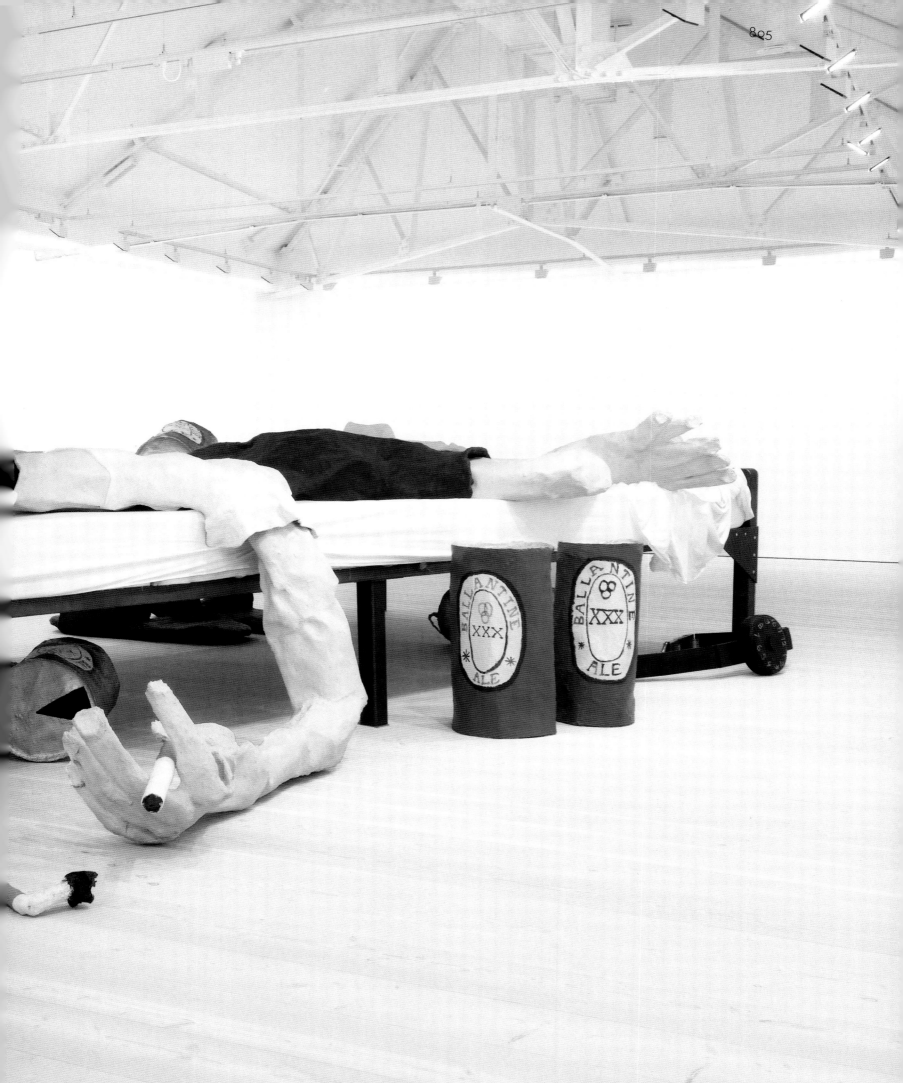

12TH JANUARY—9TH MAY 2009
WILL RYMAN *The Bed* 2007 Papier mâché, magic sculpt resin, acrylic, wire mesh, wood, cloth 243.8 × 457.2 × 838.2 cm 96 × 180 × 330"

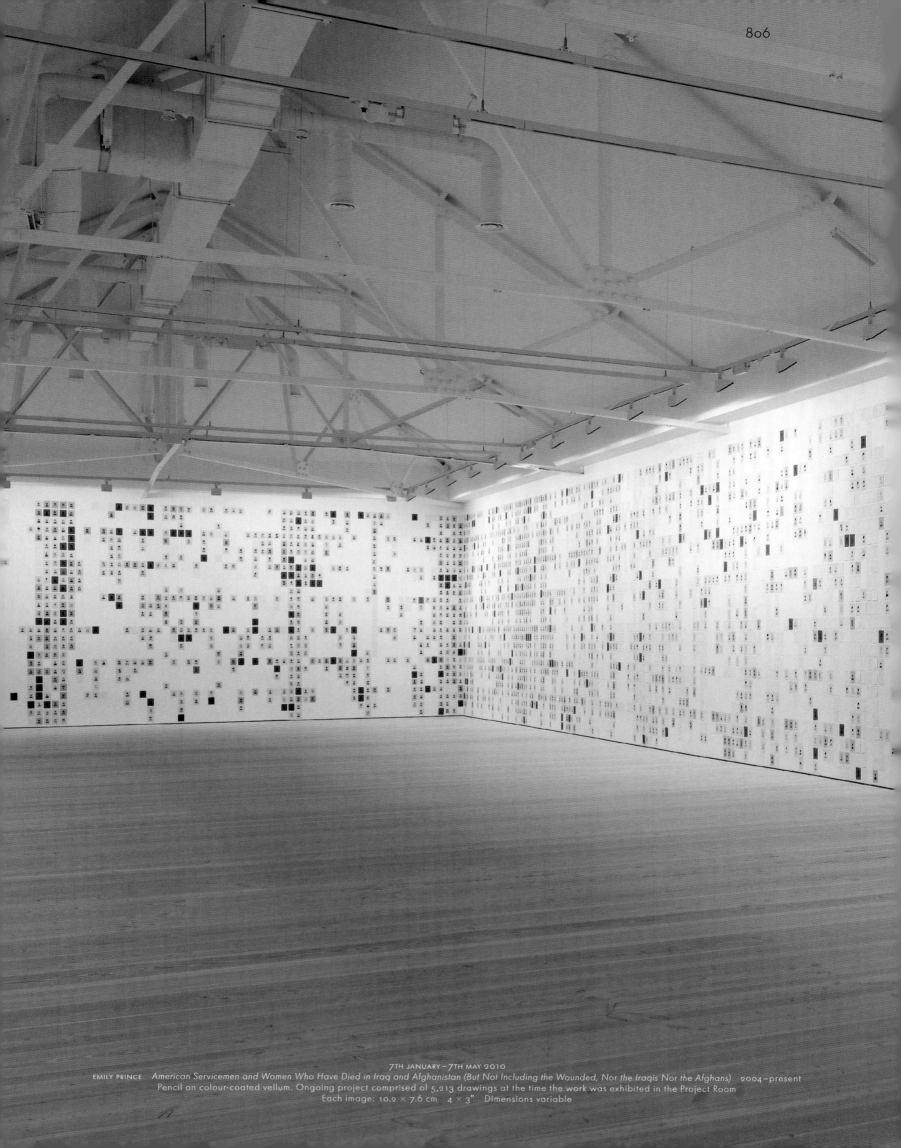

7TH JANUARY – 7TH MAY 2010
EMILY PRINCE *American Servicemen and Women Who Have Died in Iraq and Afghanistan (But Not Including the Wounded, Nor the Iraqis Nor the Afghans)* 2004–present
Pencil on colour-coated vellum. Ongoing project comprised of 5,213 drawings at the time the work was exhibited in the Project Room
Each image: 10.2 × 7.6 cm 4 × 3" Dimensions variable

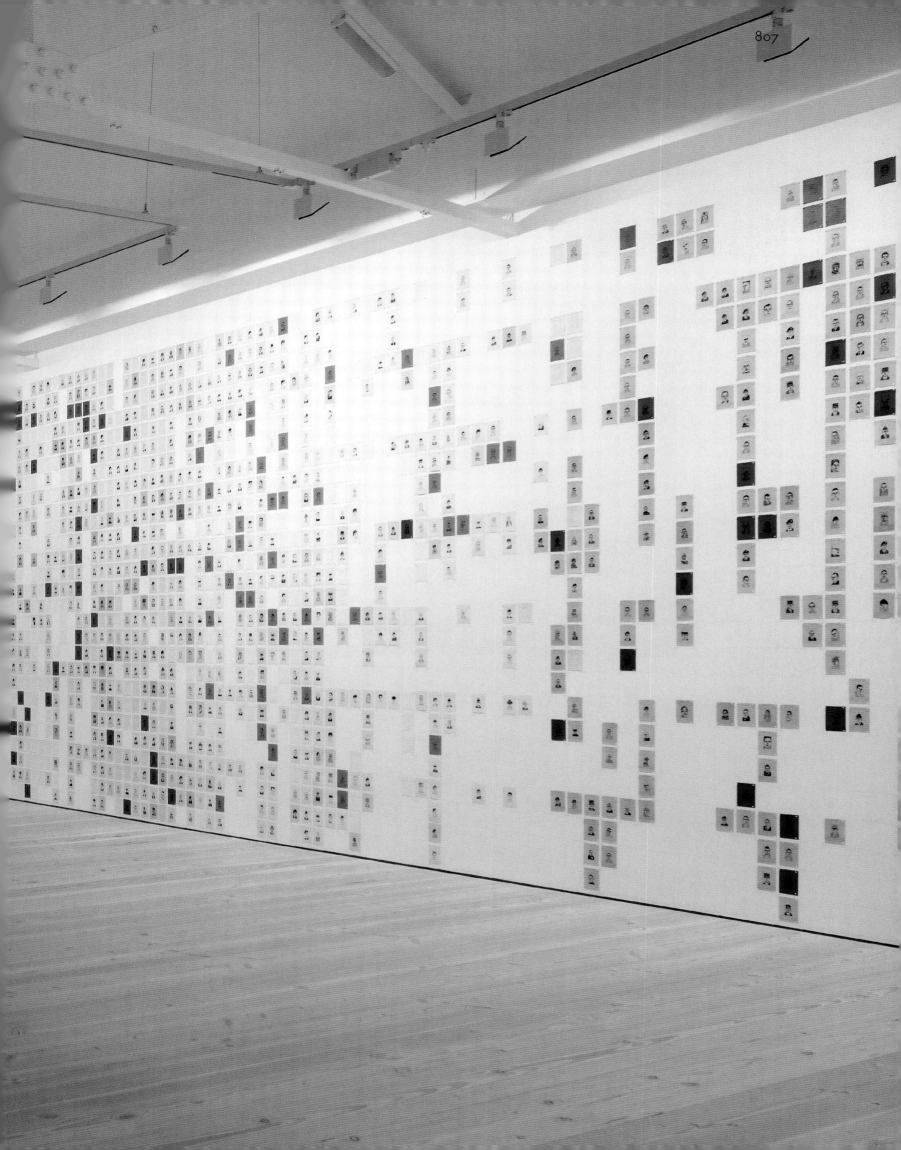

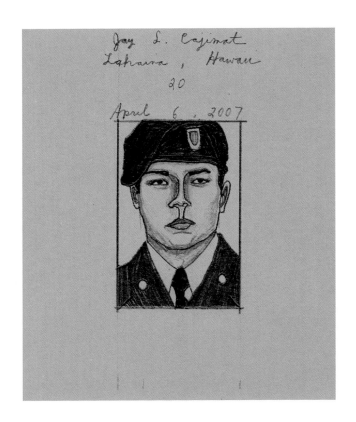

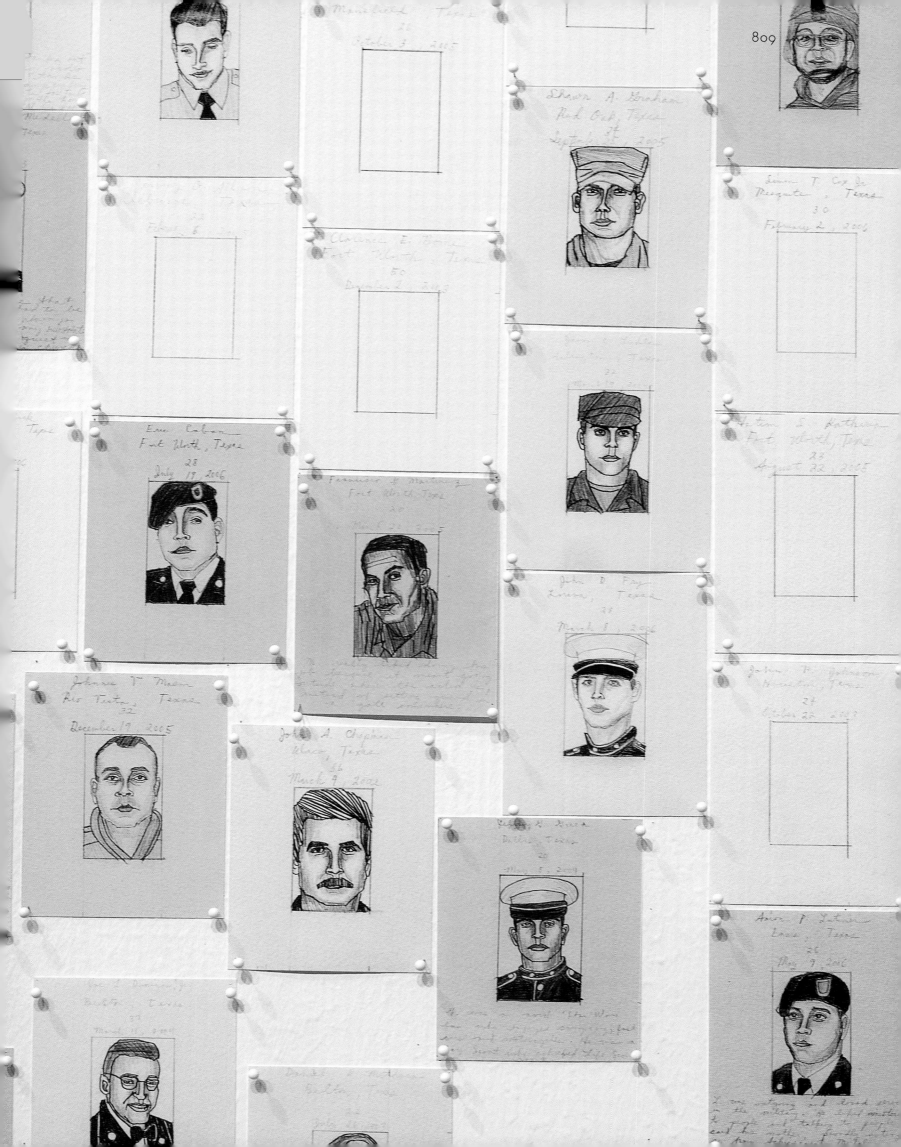

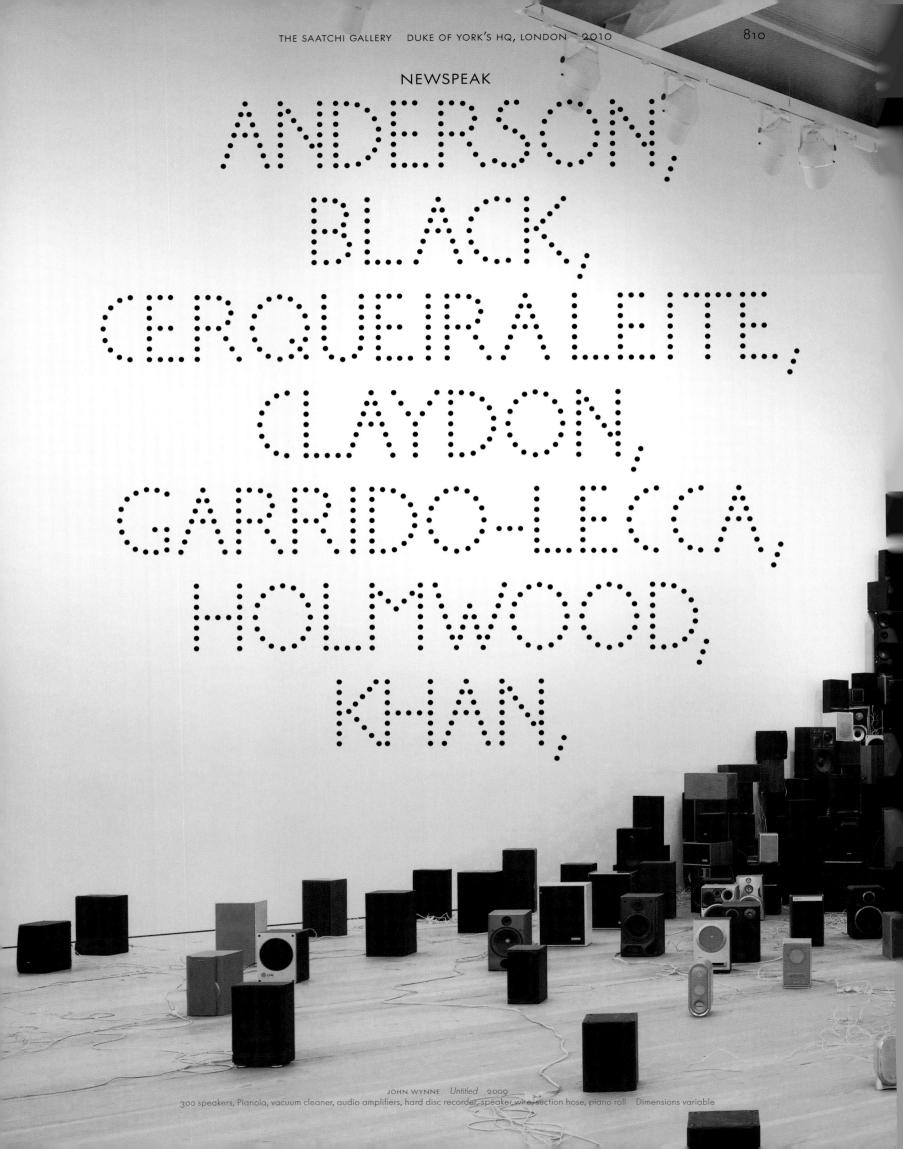

NEWSPEAK

ANDERSON,
BLACK,
CERQUEIRA LEITE,
CLAYDON,
GARRIDO-LECCA,
HOLMWOOD,
KHAN,

JOHN WYNNE *Untitled* 2009
300 speakers, Pianola, vacuum cleaner, audio amplifiers, hard disc recorder, speaker wire, suction hose, piano roll Dimensions variable

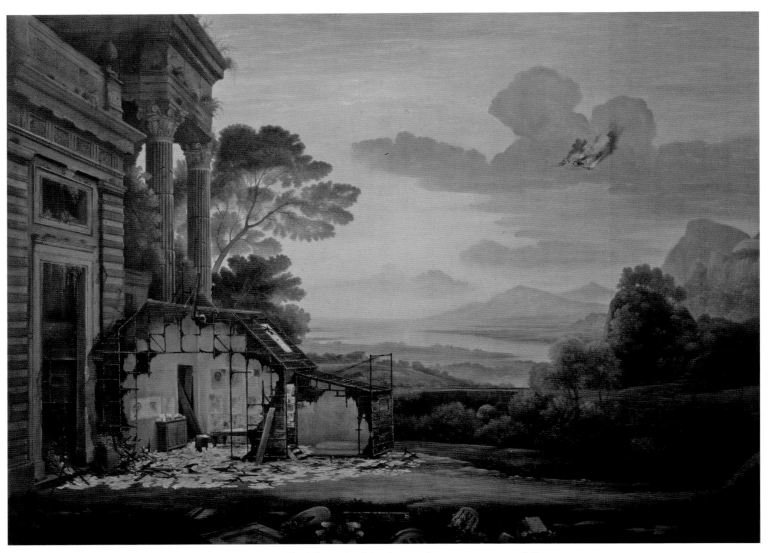

GED QUINN *The Fall* 2006 Oil on linen 183 × 250 cm 72 × 98½"

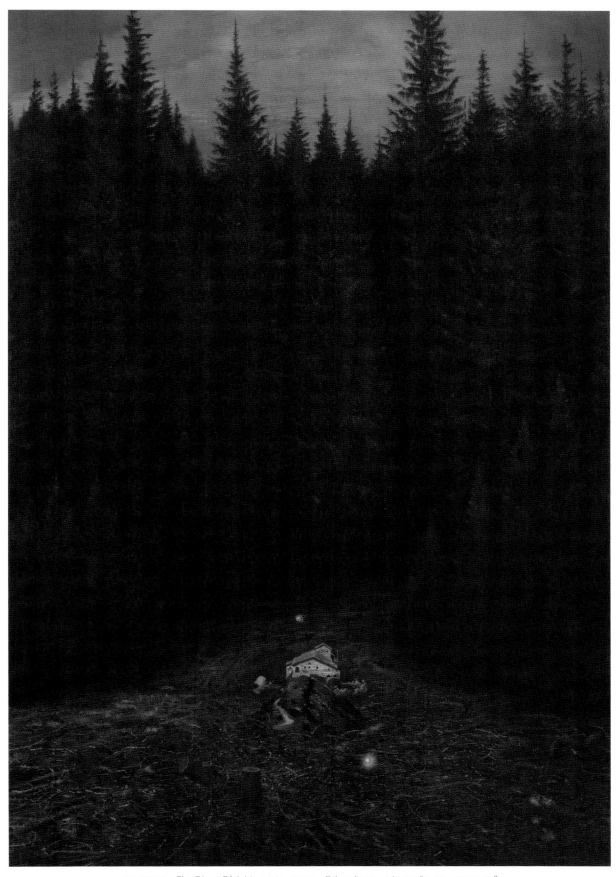

GED QUINN *The Ghost Of A Mountain* 2005 Oil on linen 267 × 183 cm 105 × 72"

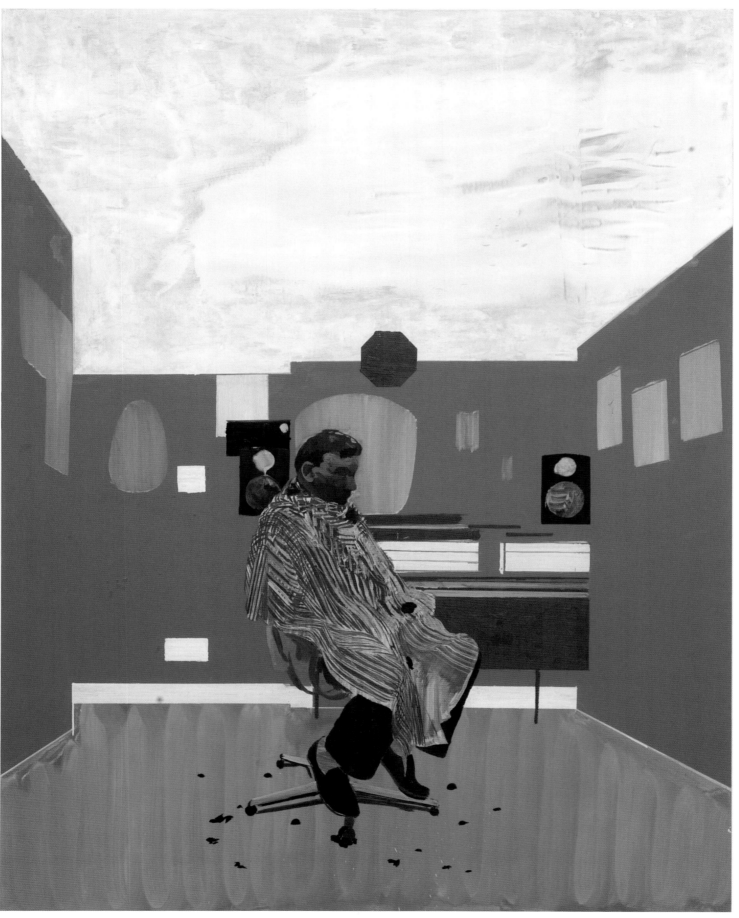

HURVIN ANDERSON *Peter's Sitters 3* 2009 Oil on canvas 187 × 147 cm 73¾ × 58"

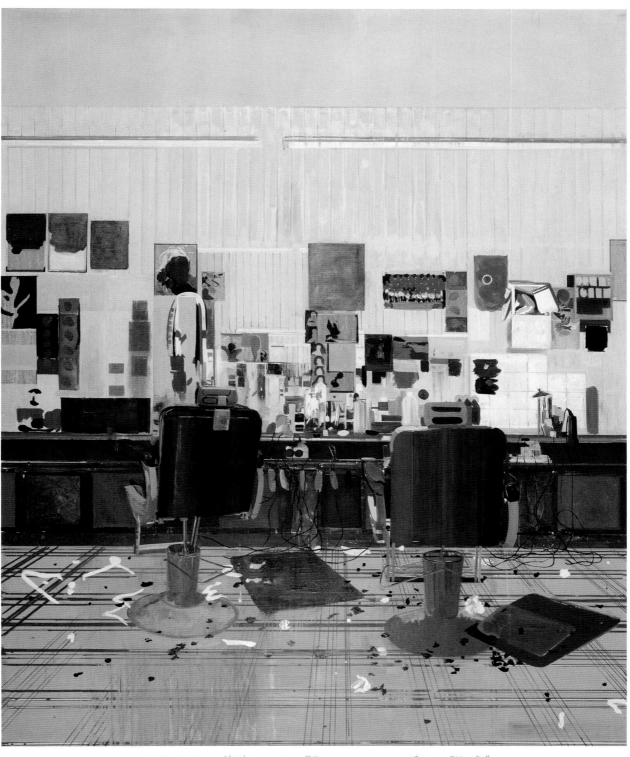

HURVIN ANDERSON *Afrosheen* 2009 Oil on canvas 250 × 208 cm 98⅓ × 82"

HURVIN ANDERSON *Untitled (Welcome Series)* 2004 Oil on canvas 165.1 × 256.5 cm 65 × 101"

SIGRID HOLMWOOD *Old Woman Hugging A Goat* 2008
Fluorescent lemon yellow, fluorescent flame red, lead white, cochineal, ultramarine, green earth,
Spanish red ochre in egg tempera and oils on board 122 × 153 cm 48 × 60¼"

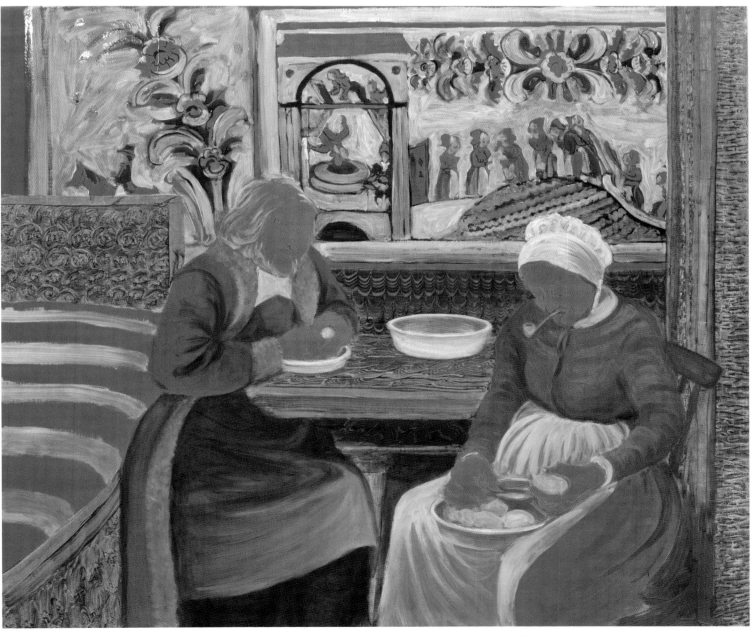

SIGRID HOLMWOOD *The Last Peasant-Painters Peeling Potatoes (Old Woman Mill)* 2007
Fluorescent orange egg tempera; lead white, Prussian blue, Chrome yellow light, lead antimonate, Bohemian green earth,
Spanish glazing ochre; iron oxide in soured milk; birch leaf lake in pine resin on board 122 × 142 cm 48 × 56"

SCOTT KING (LEFT) *Pink Cher* 2008 Screenprint and paint on canvas 300 × 200 cm 118 × 78¾"
STEVEN CLAYDON (ABOVE) *Omar (Emergent)* 2008 Ceramic, powder-coated steel, carpet, plywood, starched hessian, found objects, aluminium
189 × 125 × 125 cm 74½ × 49¼ × 49¼"

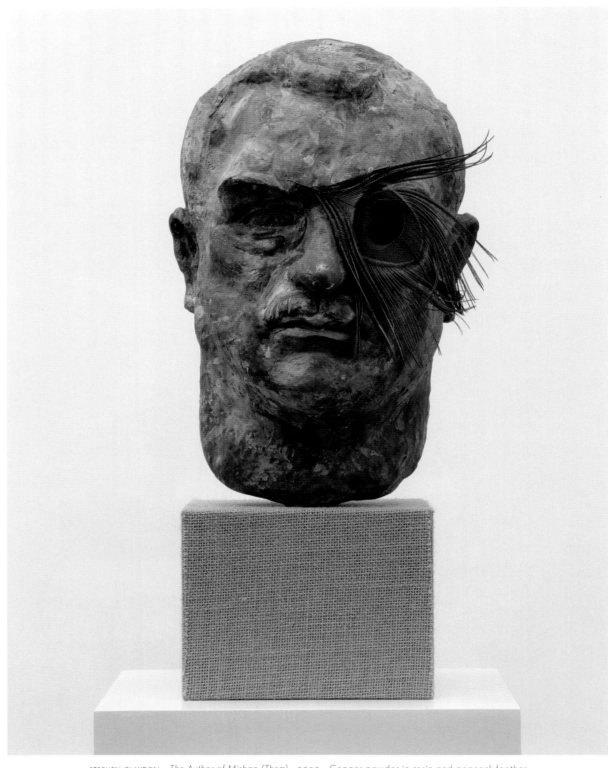

STEPHEN CLAYDON *The Author of Mishap (Them)* 2005 Copper powder in resin and peacock feather
Sculpture: 36 × 21.5 × 23.5 cm 14.2 × 8½ × 9½" Plinth: 125 × 30 × 30 cm 49¼ × 12 × 12"

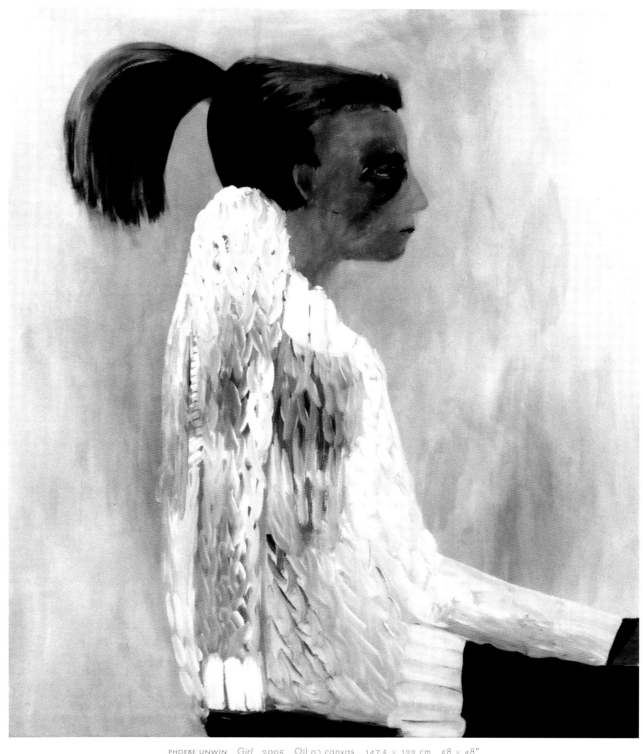

PHOEBE UNWIN *Girl* 2005 Oil on canvas 147.5 × 122 cm 58 × 48"

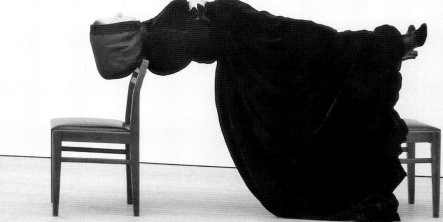

LEFT TO RIGHT
GOSHKA MACUGA *Library Table* 2005 oak table, leather bound books, customised lamps 140 × 206 cm 140 × 206 cm 55¼ × 81¼"
GOSHKA MACUGA *Madame Blavatsky* 2007 Carved wood, fibreglass, clothes, chairs 114.3 × 190.5 × 73.6 cm 114.3 × 190.5 × 73.6 cm 45 × 75 × 29"
PHOEBE UNWIN *Night Life* 2006 Oil on canvas 50 × 40 cm 50 × 40 cm 19¾ × 35½"

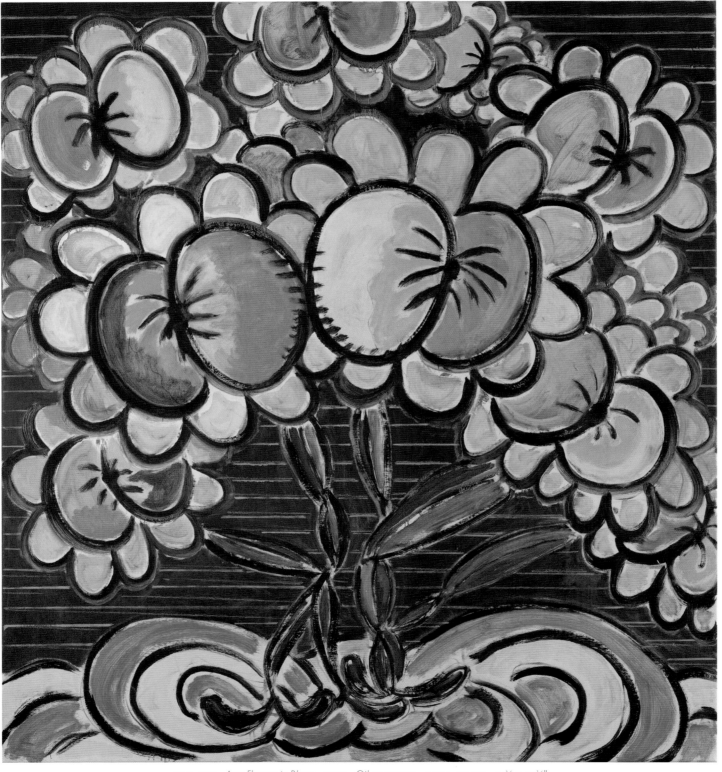

ANSEL KRUT *Arse Flowers in Bloom* 2010 Oil on canvas 120 × 110 cm 47¼ × 43½"

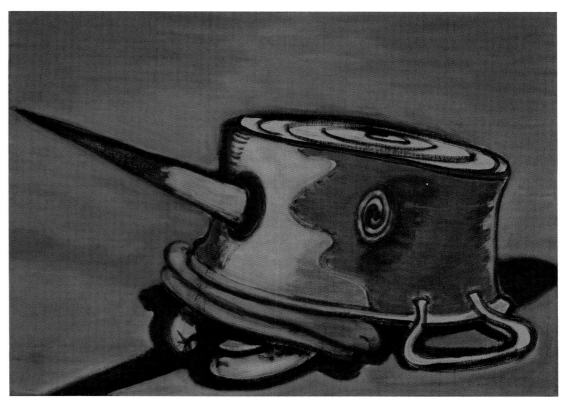

ANSEL KRUT *Saucepan With Spilled Sausages* 2007 Oil on canvas 80 × 110 cm 31⅓ × 43⅓"

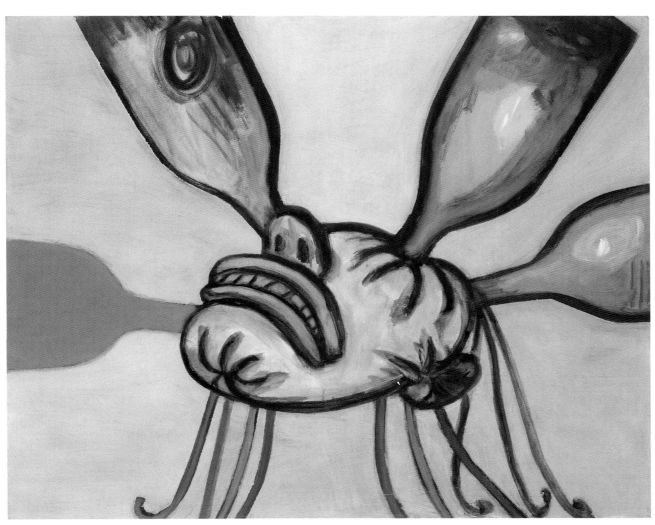

ANSEL KRUT *Head With Bottles* 2008 Oil on canvas 80 × 110 cm 31⅓ × 43⅓"

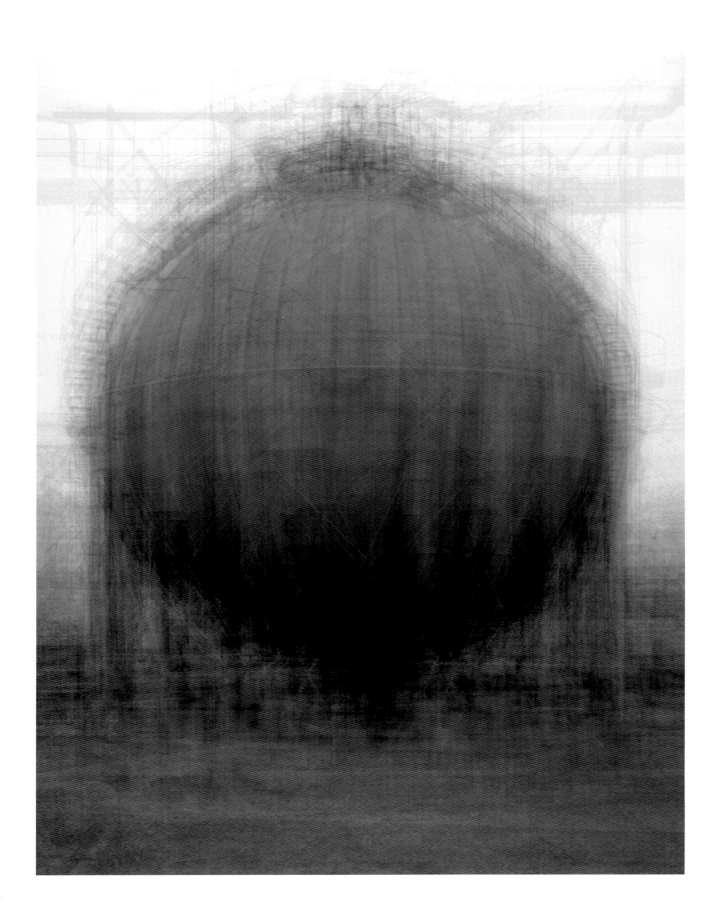

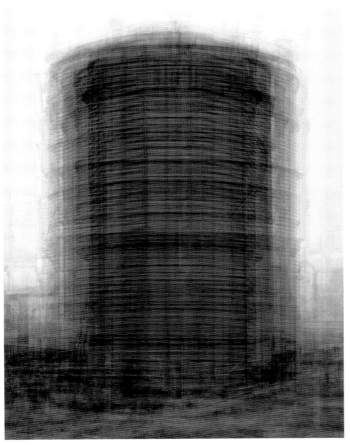
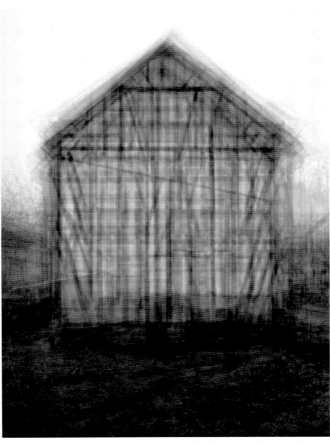

IDRIS KHAN every ... Bernd & Hilla Becher Spherical Type Gasholder, every ... Bernd & Hilla Becher Prison Type Gasholder, every ... Bernd & Hilla Becher Gable Sided House 2004
Lambda digital C print mounted on aluminium Triptych, each part 203.2 × 165.1 cm 80 × 65"

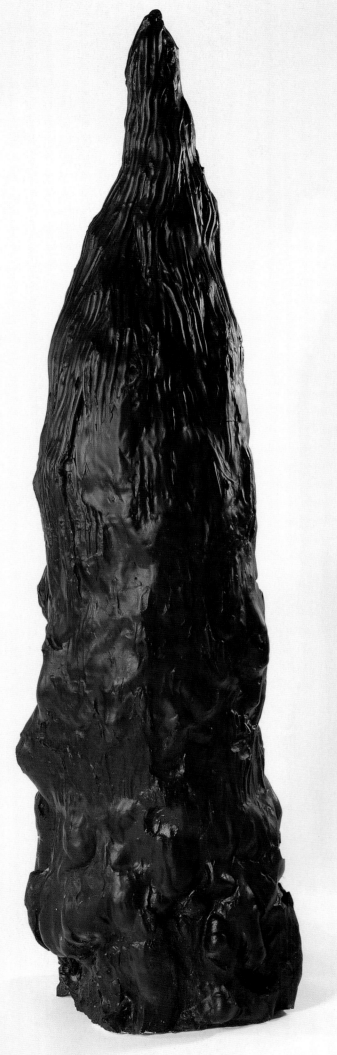

JULIANA CERQUEIRA LEITE *Up* 2008 Plaster and acrylic polymer, polyurethane rigid foam 210 × 47 × 45 cm 82¾ × 18½ × 17¾"

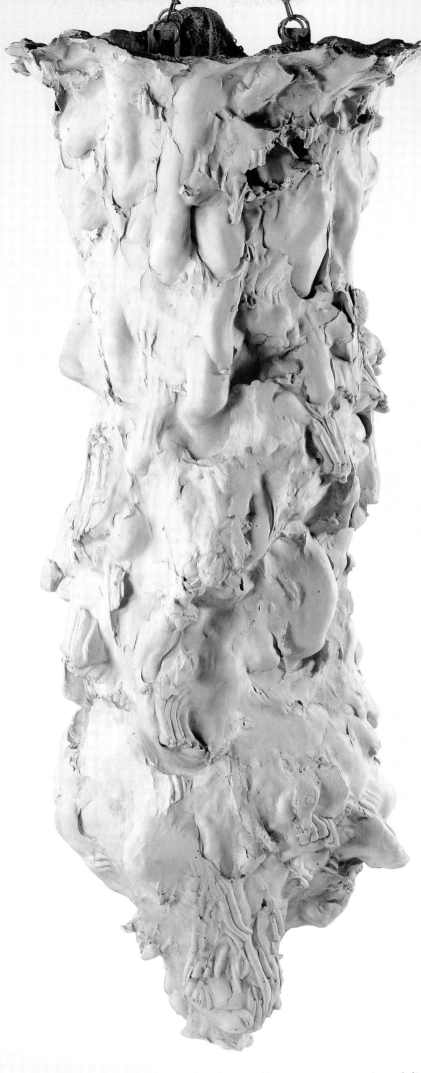

JULIANA CERQUEIRA LEITE *Down* 2008 Plaster and acrylic polymer, polyurethane rigid foam 210 × 27.2 × 25.6 cm 82¾ × 27¼ × 25¾"

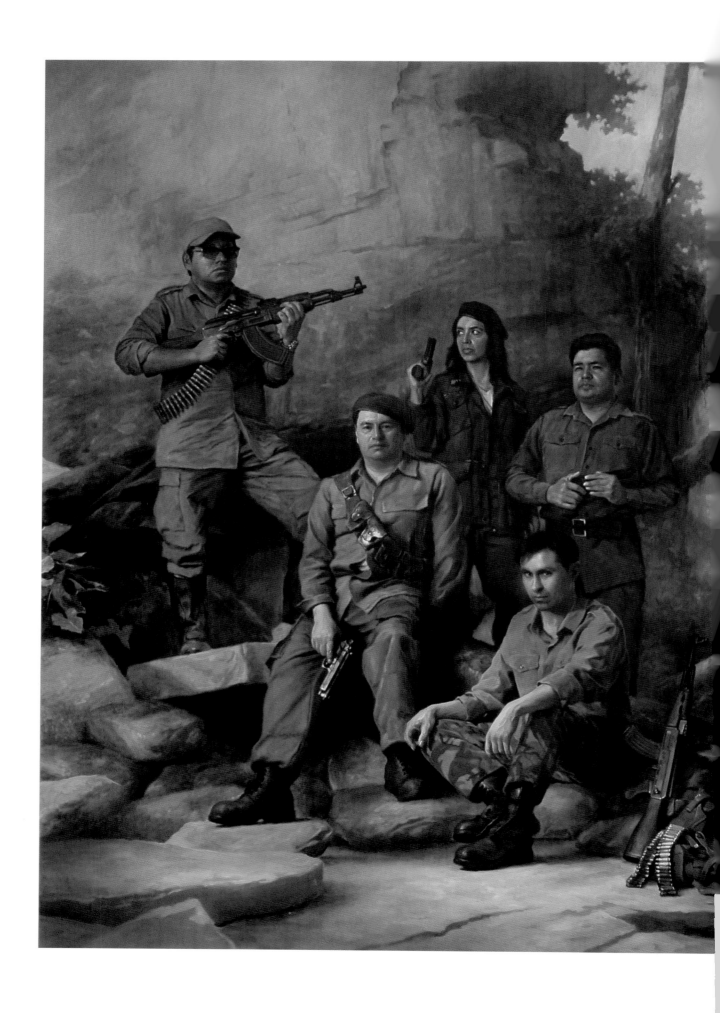

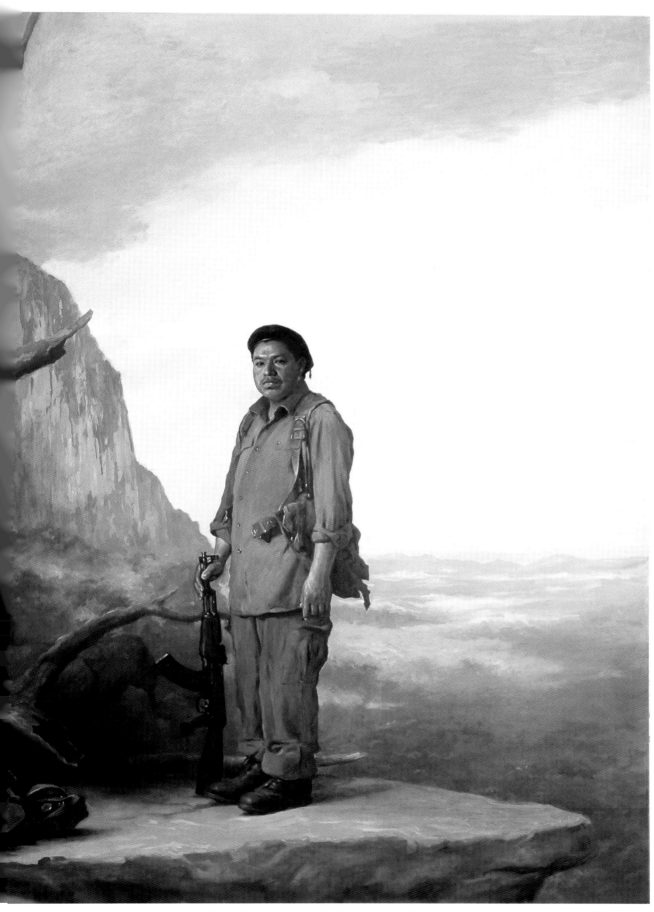

JONATHAN WATERIDGE *Group Series Number 1 – Sandinistas* 2007 Oil on canvas 272 × 400 cm 107 × 157½"

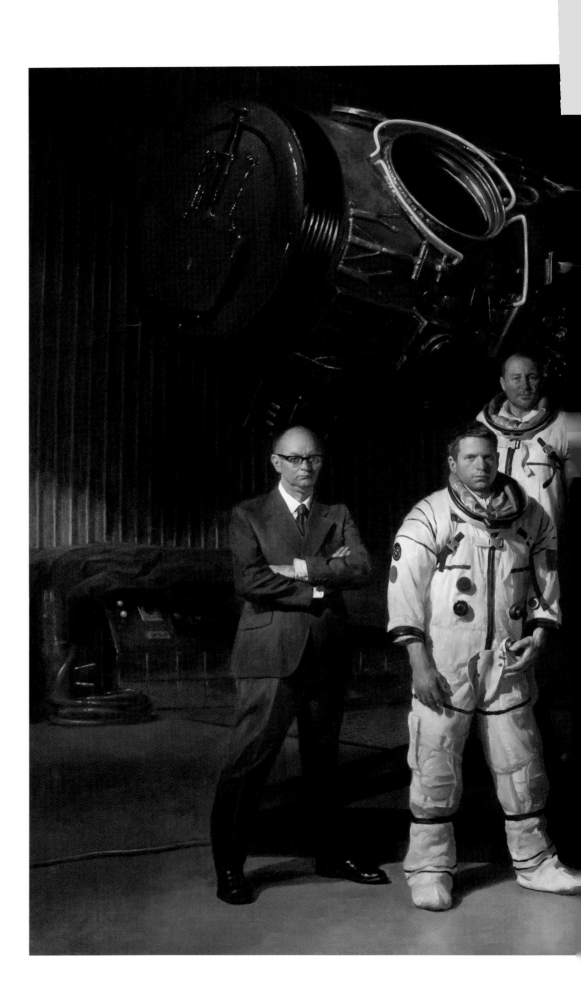

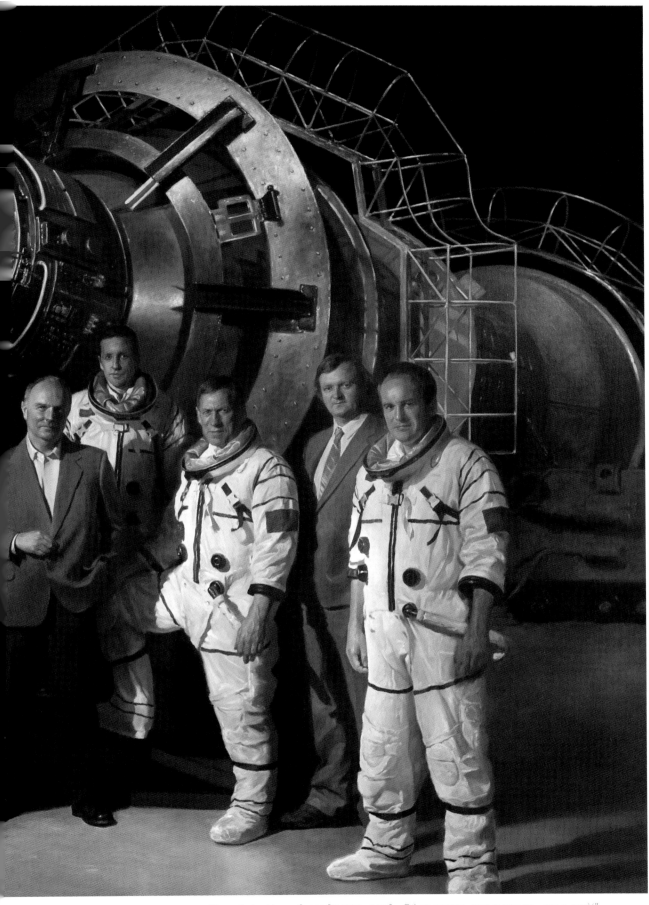

JONATHAN WATERIDGE *Group Series No.2 – Space Program* 2008 Oil on canvas 292 × 390 cm 115 × 153½"

DAN PERFECT *Antelope Canyon* 2005 Oil and acrylic on linen 183 × 257 cm 72 × 101¼"

DAN PERFECT *Aleph* 2007 Oil and acrylic on linen 183 × 257 cm 72 × 101¼"

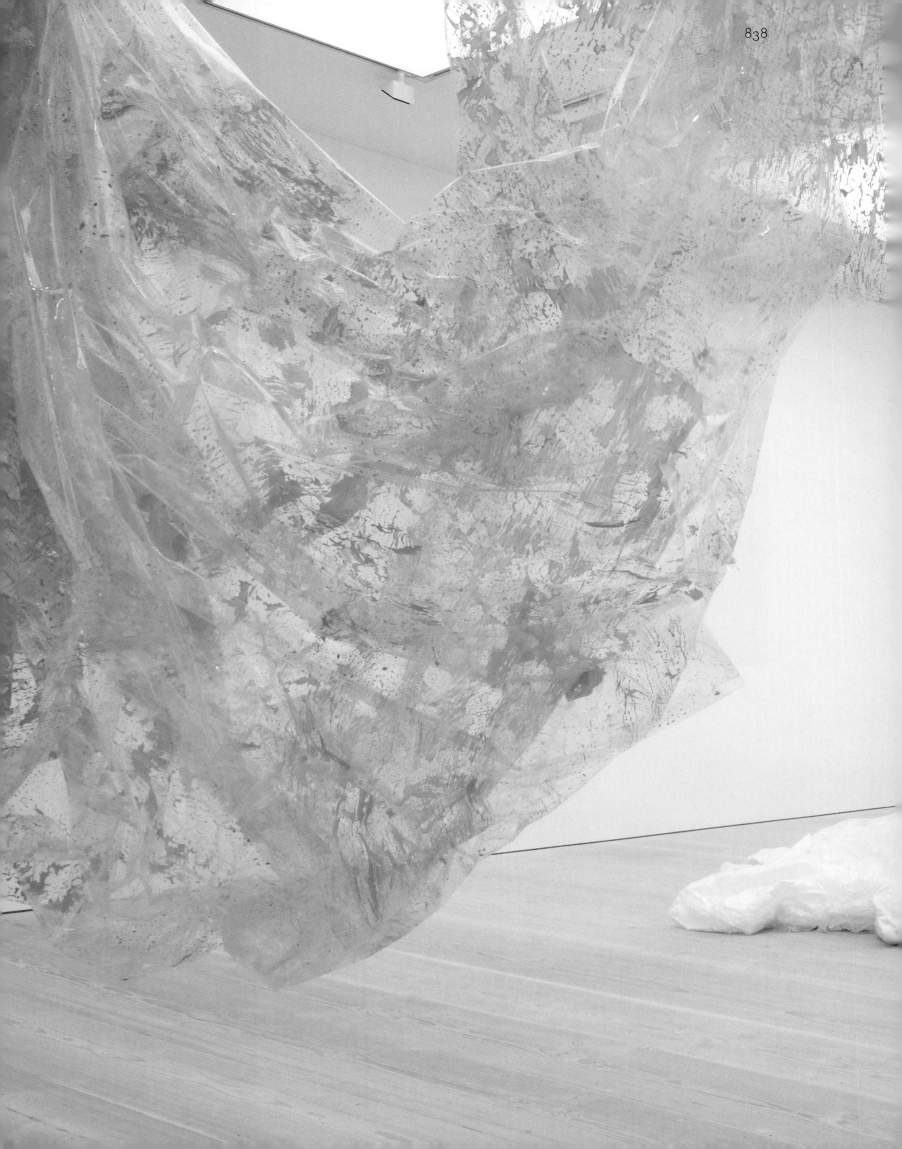

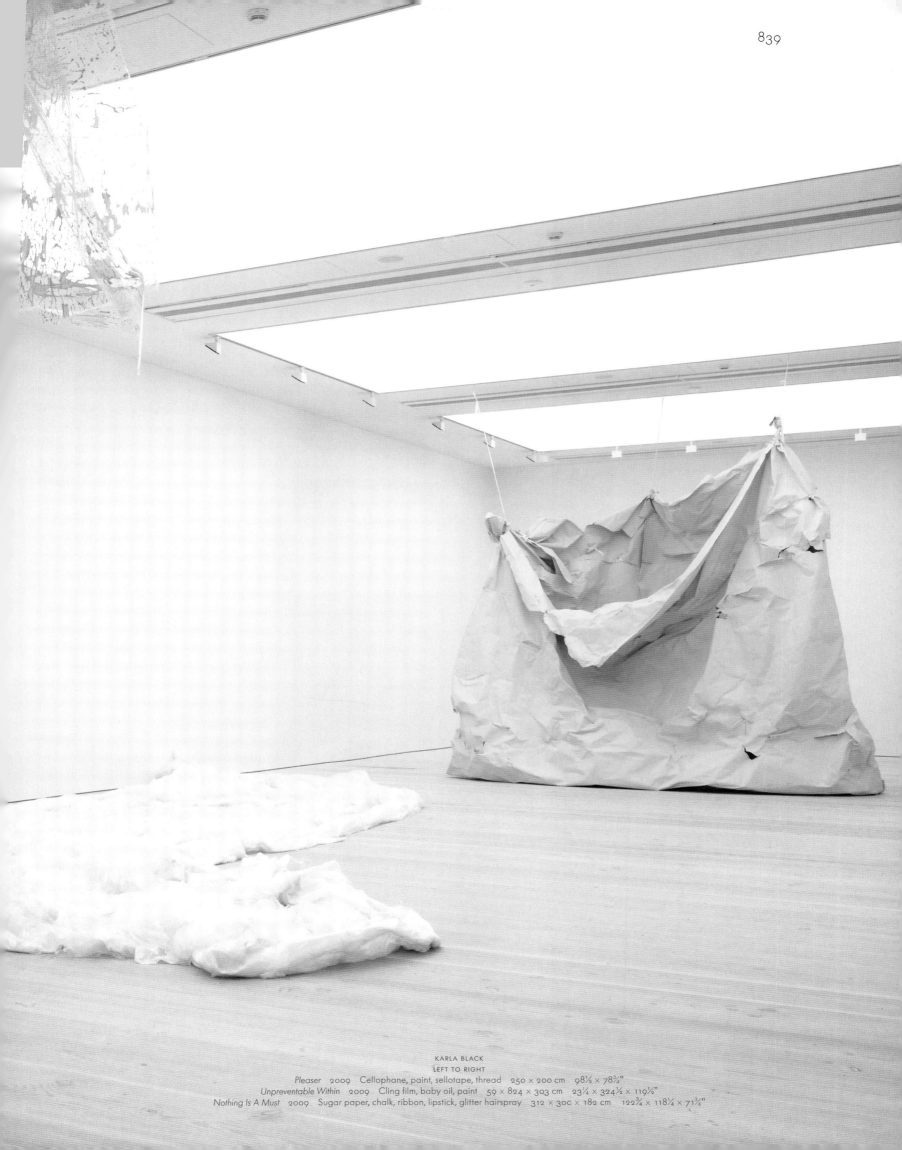

KARLA BLACK
LEFT TO RIGHT
Pleaser 2009 Cellophane, paint, sellotape, thread 250 × 200 cm 98⅜ × 78¾"
Unpreventable Within 2009 Cling film, baby oil, paint 59 × 824 × 303 cm 23¼ × 324½ × 119½"
Nothing Is A Must 2009 Sugar paper, chalk, ribbon, lipstick, glitter hairspray 312 × 300 × 182 cm 122¾ × 118¼ × 71¾"

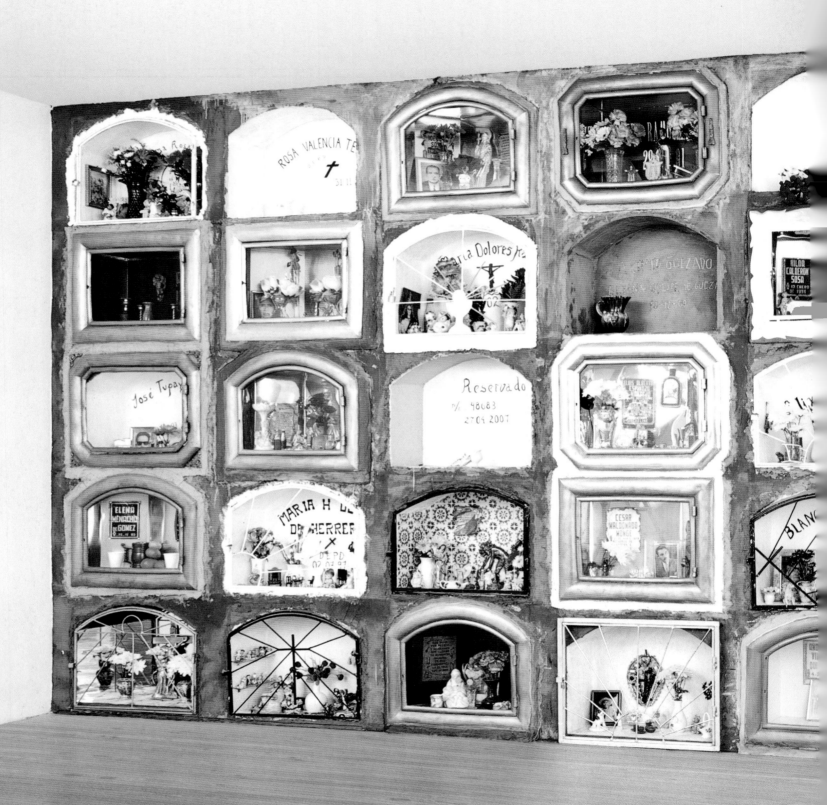

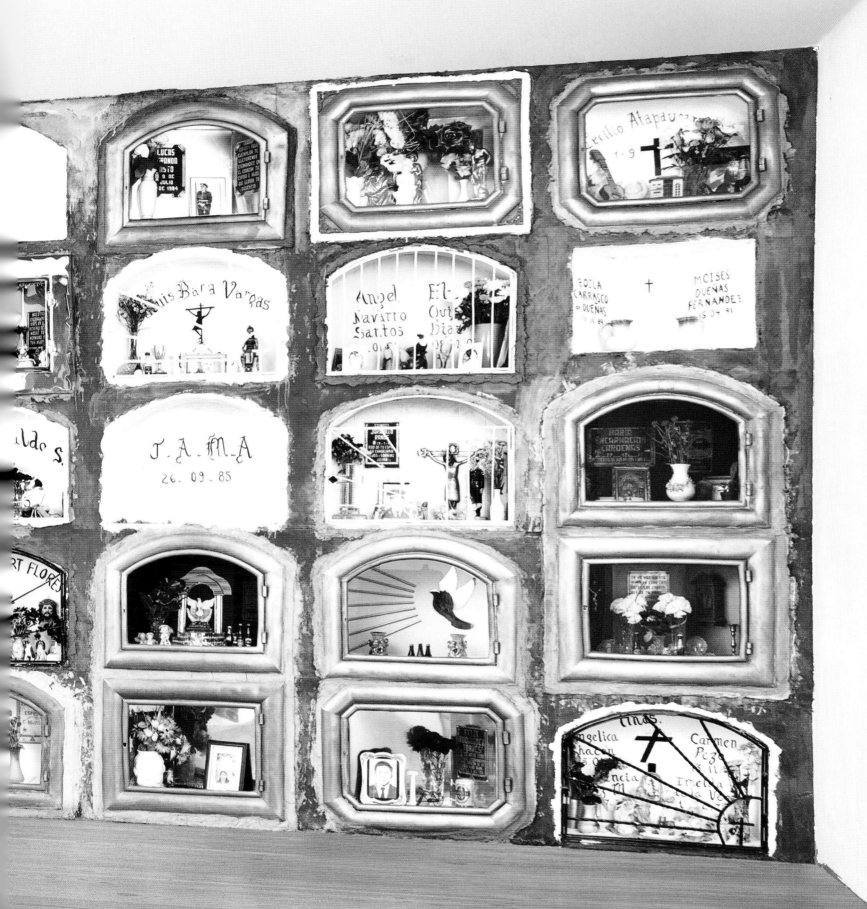

XIMENA GARRIDO-LECCA *The Followers* 2010 Mixed media installation 457 × 1,169 × 27.5 cm 180 × 460¼ × 11"

LITTLEWHITEHEAD *Sentient Orbs* 2009 Shoes, chinos, sweater, balloons, wire, stuffing Approx 250 × 200 × 200 cm 98⅜ × 78¾ × 78¾"

A

FRANZ ACKERMANN
Born 1963
Neumarkt-Sankt Veit, Germany
Lives and works in Berlin

DIANA AL-HADID
Born 1981
Aleppo, Syria
Lives and works in New York

HALIM AL-KARIM
Born 1963
Najaf, Iraq
Lives and works in Denver

AHMED ALSOUDANI
Born 1975
Baghdad, Iraq
Lives and works in Berlin

KAI ALTHOFF
Born 1966
Cologne, Germany
Lives and works in Cologne

HURVIN ANDERSON
Born 1965
Birmingham, UK
Lives and works in London

CARL ANDRE
Born 1935
Quincy, Massachusetts, USA
Lives and works in New York

JANINE ANTONI
Born 1964
Freeport, Bahamas
Lives and works in New York

RICHARD ARTSCHWAGER
Born 1923
Washington, D.C., USA
Lives and works in Hudson, New York

KADER ATTIA
Born 1970
Paris, France
Lives and works in Paris

FRANK AUERBACH
Born 1931
Berlin, Germany
Lives and works in London

B

KRISTIN BAKER
Born 1975
Stamford, Connecticut, USA
Lives and works in New York

JULES DE BALINCOURT
Born 1972
Paris, France
Lives and works in New York

STEPHAN BALKENHOL
Born 1957
Fritzlar, Germany
Lives and works in Karlsruhe

GEORG BASELITZ
Born 1938
Deutschbaselitz, Germany
Lives and works in Derneburg
and Imperia

HUMA BHABHA
Born 1962
Karachi, Pakistan
Lives and works in Poughkeepsie,
New York

KARLA BLACK
Born 1972
Alexandria, Scotland
Lives and works in Glasgow

MARK BRADFORD
Born 1961
Los Angeles, USA
Lives and works in Los Angeles

CECILY BROWN
Born 1969
London, UK
Lives and works in New York

GLENN BROWN
Born 1966
Hexham, Northumberland, UK
Lives and works in London

C

JULIANA CERQUEIRA LEITE
Born 1981
Chicago, USA
Lives and works in London

JOHN CHAMBERLAIN
Born 1927
Rochester, Indiana, USA
Lives and works in Florida

JAKE CHAPMAN
Born 1966
Cheltenham, UK
Lives and works in London

DINOS CHAPMAN
Born 1962
London, UK
Lives and works in London

STEVEN CLAYDON
Born 1969
London, UK
Lives and works in London

CHUCK CLOSE
Born 1940
Monroe, Washington, USA
Lives and works in New York

PETER COFFIN
Born 1972
Berkeley, California, USA
Lives and works in New York

DAN COLEN
Born 1979
New Jersey, USA
Lives and works in New York

JOHN CURRIN
Born 1962
Boulder, Colorado, USA
Lives and works in New York

D

DEXTER DALWOOD
Born 1960
Bristol, UK
Lives and works in London

D

GERALD DAVIS
Born 1974
Pittsburgh, Pennsylvania, USA
Lives and works in Los Angeles

PETER DAVIES
Born 1970
Edinburgh, Scotland
Lives and works in London

RICHARD DEACON
Born 1949
Bangor, Wales
Lives and works in London

RINEKE DIJKSTRA
Born 1959
Sittard, Netherlands
Lives and works in Amsterdam

ATUL DODIYA
Born 1959
Mumbai, India
Lives and works in Mumbai

PETER DOIG
Born 1959
Edinburgh, Scotland
Lives and works in Trinidad

MARLENE DUMAS
Born 1953
Cape Town, South Africa
Lives and works in Amsterdam

E

TRACEY EMIN
Born 1963
London, UK
Lives and works in London

INKA ESSENHIGH
Born 1969
Belfonte, Pennsylvania, USA
Lives and works in New York

F

ERIC FISCHL
Born 1948
New York, USA
Lives and works in New York

ERIC FISCDAN FLAVIN
Born 1933
New York, USA
Died 1966 Riverhead, New York

LUCIAN FREUD
Born 1922
Berlin, Germany
Lives and works in London

TOM FRIEDMAN
Born 1965
St. Louis, Missouri, USA
Lives and works in Leverett,
Massachusetts

BARNABY FURNAS
Born 1973
Philadelphia, Pennsylvania, USA
Lives and works in New York

G

XIMENA GARRIDO-LECCA
Born 1980
Lima, Peru
Lives and works in London

SHADI GHADIRIAN
Born 1974
Tehran, Iran
Lives and works in Tehran

ROBERT GOBER
Born 1954
Wallingford, Connecticut, USA
Lives and works in New York

NAN GOLDIN
Born 1953
Washington, D.C., USA
Lives and works in Paris

LEON GOLUB
Born 1922
Chicago, Illinois, USA
Died 2004 New York

MARK GROTJAHN
Born 1968
Pasadena, California, USA
Lives and works in Los Angeles

G

SUBODH GUPTA
Born 1964
Khagaul, Bihar, India
Lives and works in New Delhi

ANDREAS GURSKY
Born 1955
Leipzig, Germany
Lives and works in Düsseldorf

PHILIP GUSTON
Born 1913
Montreal, Canada
Died 1980 Woodstock, New York

H

ROKNI HAERIZADEH
Born 1978
Tehran, Iran
Lives and works in Tehran

DUANE HANSON
Born 1925
Alexandria, Minnesota, USA
Died 1996 Boca Raton, Florida

RACHEL HARRISON
Born 1966
New York, USA
Lives and works in New York

MARCUS HARVEY
Born 1963
Leeds, UK
Lives and works in London

EVA HESSE
Born 1936
Hamburg, Germany
Died 1970 New York

PATRICK HILL
Born 1972
Royal Oak, Michigan, USA
Lives and works in Los Angeles

DAMIEN HIRST
Born 1965
Bristol, UK
Lives and works in London and Devon

H

HOWARD HODGKIN
Born 1932
London, UK
Lives and works in London

SIGRID HOLMWOOD
Born 1978
Hobart, Australia
Lives and works in London

MARTIN HONERT
Born 1953
Bottrop, Germany
Lives and works in Düsseldorf
and Dresden

GARY HUME
Born 1962
Kent, UK
Lives and works in London

ELLIOTT HUNDLEY
Born 1975
USA
Lives and works in Los Angeles

I

JÖRG IMMENDORFF
Born 1945
Bleckede, Germany
Died 2007 Düsseldorf

J

MATTHEW DAY JACKSON
Born 1974
Panorama City, California, USA
Lives and works in New York

TUSHAR JOAG
Born 1966
Mumbai, India
Lives and works in Mumbai

MATT JOHNSON
Born 1978
New York, USA
Lives and works in Los Angeles

DONALD JUDD
Born 1928
Excelsior Springs, Missouri, USA
Died 1994 New York

K

JITISH KALLAT
Born 1974
Mumbai, India
Lives and works in Mumbai

ALEX KATZ
Born 1927
New York, USA
Lives and works in New York

IDRIS KHAN
Born 1978
Birmingham, UK
Lives and works in London

BHARTI KHER
Born 1969
London, UK
Lives and works in New Delhi

ANSELM KIEFER
Born 1945
Donaueschingen, Germany
Lives and works in Provence

SCOTT KING
Born 1969
Goole, UK
Lives and works in London

MARTIN KIPPENBERGER
Born 1953
Dortmund, Germany
Died 1997 Vienna, Austria

R.B. KITAJ
Born 1935
Cleveland, Ohio, USA
Died 2007 Los Angeles

TERENCE KOH
Born 1977
Beijing, China
Lives and works in New York

JEFF KOONS
Born 1955
York, Pennsylvania, USA
Lives and works in New York

LEON KOSSOFF
Born 1926
London, UK
Lives and works in London

K

ANSEL KRUT
Born 1959
Cape Town, South Africa
Lives and works in London

L

SOL LEWITT
Born 1928
Hartford, Connecticut, USA
Died 2007 New York

LITTLEWHITEHEAD
CRAIG LITTLE
Born 1980
Glasgow, Scotland
Lives and works in Glasgow
BLAKE WHITEHEAD
Born 1985
Lanark, Scotland
Lives and works in Glasgow

LI SONGSONG
Born 1973
Beijing, China
Lives and works in Beijing

LIU WEI
Born 1972
Beijing, China
Lives and works in Beijing

SARAH LUCAS
Born 1962
London, UK
Lives and works in London

M

GOSHKA MACUGA
Born 1967
Poland
Lives and works in London

TALA MADANI
Born 1981
Tehran, Iran
Lives and works in Amsterdam

FLORIAN MAIER-AICHEN
Born 1973
Stuttgart, Germany
Lives and works in Cologne and
Los Angeles

M

MARTIN MALONEY
Born 1961
London, UK
Lives and works in London

ROBERT MANGOLD
Born 1937
North Tonawanda, New York, USA
Lives and works in Washingtonville

BRICE MARDEN
Born 1938
Bronxville, New York, USA
Lives and works in New York

AGNES MARTIN
Born 1912
Macklin, Saskatchewan, Canada
Died 2004 Taos, New Mexico

JOHN MCCRACKEN
Born 1934
Berkeley, California, USA
Lives and works in New Mexico

JOSEPHINE MECKSEPER
Born 1964
Lilienthal, Germany
Lives and works in New York

JONATHAN MEESE
Born 1970
Tokyo, Japan
Lives and works in Berlin
and Hamburg

BORIS MIKHAILOV
Born 1938
Kharkov, Ukraine (former USSR)
Lives and works in Kharkov
and Berlin

ALEKSANDRA MIR
Born 1967
Lubin, Poland
Lives and works in Palermo

MATTHEW MONAHAN
Born 1972
Eureka, California, USA
Lives and works in Los Angeles

M

MALCOLM MORLEY
Born 1931
London, UK
Lives and works in Bellport

ROBERT MORRIS
Born 1931
Kansas City, Missouri, USA
Lives and works in New York

RON MUECK
Born 1958
Melbourne, Australia
Lives and works in London

HUMA MULJI
Born 1970
Karachi, Pakistan
Lives and works in Lahore

WANGECHI MUTU
Born 1972
Nairobi, Kenya, Africa
Lives and works in New York

N

BRUCE NAUMAN
Born 1941
Fort Wayne, Indiana, USA
Lives and works in New Mexico

ELIZABETH NEEL
Born 1975
Vermont, USA
Lives and works in New York

HERMANN NITSCH
Born 1938
Vienna, Austria
Lives and works in Prinzendorf

O

ALBERT OEHLEN
Born 1954
Krefeld, Germany
Lives and works in Spain
and Switzerland

CHRIS OFILI
Born 1968
Manchester, UK
Lives and works in London

P

PENG YU
Born 1974
Heilongjiang Province, China
Lives and works in Beijing

DAN PERFECT
Born 1965
London
Lives and works in London

GRAYSON PERRY
Born 1960
Chelmsford, UK
Lives and works in London

ELIZABETH PEYTON
Born 1965
Danbury, Connecticut, USA
Lives and works in New York

SIGMAR POLKE
Born 1941
Oels, Silesia
(now Ole´snica, Poland)
Lives and works in Cologne

EMILY PRINCE
Born 1981
Gold Run, California, USA
Lives and works in San Francisco

RICHARD PRINCE
Born 1949
Panama Canal Zone
Lives and works in New York

JON PYLYPCHUK
Born 1972
Winnipeg, Manitoba, Canada
Lives and works in Los Angeles

Q

QIU JIE
Born 1961
Shanghai, China
Lives and works in Geneva

GED QUINN
Born 1963
Liverpool, UK
Lives and works in Cornwall

Q

MARC QUINN
Born 1964
London, UK
Lives and works in London

R

CHARLES RAY
Born 1953
Chicago, USA
Lives and works in Los Angeles

MARWAN RECHMAOUI
Born 1964
Beirut, Lebanon
Lives and works in Beirut

PAULA REGO
Born 1935
Lisbon, Portugal
Lives and works in London

STEPHEN G. RHODES
Born 1977
Houston, Texas, USA
Lives and works in Los Angeles

DANIEL RICHTER
Born 1962
Eutin, Germany
Lives and works in Berlin
and Hamburg

UGO RONDINONE
Born 1963
Brunnen, Switzerland
Lives and works in New York

SUSAN ROTHENBERG
Born 1945
Buffalo, New York, USA
Lives and works in New Mexico

STERLING RUBY
Born 1972
Stuttgart, Germany
Lives and works in Los Angeles

THOMAS RUFF
Born 1958
Zell am Harmersbach, Germany
Lives and works in Düsseldorf

R

ROBERT RYMAN
Born 1930
Nashville, Tennessee, USA
Lives and works in New York
and Pennsylvania

WILL RYMAN
Born 1969
New York, USA
Lives and works in New York

S

DAVID SALLE
Born 1952
Norman, Oklahoma, USA
Lives and works in New York
and Sagaponack

WILHELM SASNAL
Born 1972
Tarnow, Poland
Lives and works in Tarnow

JENNY SAVILLE
Born 1970
Cambridge, UK
Lives and works in Sicily

THOMAS SCHEIBITZ
Born 1968
Radeberg, Germany
Lives and works in Berlin

JULIAN SCHNABEL
Born 1951
New York, USA
Lives and works in New York

LARA SCHNITGER
Born 1969
Haarlem, Netherlands
Lives and works in Los Angeles
and Amsterdam

THOMAS SCHÜTTE
Born 1954
Oldenburg, Germany
Lives and works in Düsseldorf

DANA SCHUTZ
Born 1976
Livonia, Michigan, USA
Lives and works in New York

S

RICHARD SERRA
Born 1939
San Francisco, USA
Lives and works in New York
and Nova Scotia

SHEN SHAOMIN
Born 1956
Heilongjiang Province, China
Lives and works in Sydney
and Beijing

CINDY SHERMAN
Born 1954
Glen Ridge, New Jersey, USA
Lives and works in New York

SHI XINNING
Born 1969
Liaoning Province, China
Lives and works in Beijing

GEDI SIBONY
Born 1973
New York, USA
Lives and works in New York

AMY SILLMAN
Born 1966
Detroit, Michigan, USA
Lives and works in New York

DIRK SKREBER
Born 1961
Lübeck, Germany
Lives and works in Düsseldorf
and New York

AGATHE SNOW
Born 1976
Corsica
Lives and works in New York

DASH SNOW
Born 1981
New York, USA
Died 2009 New York

FRANK STELLA
Born 1936
Malden, Massachusetts, USA
Lives and works in New York

S

HIROSHI SUGIMOTO
Born 1948
Tokyo, Japan
Lives and works in New York
and Tokyo

SUN YUAN
Born 1972
Beijing, China
Lives and works in Beijing

T

TOMOKO TAKAHASHI
Born 1966
Tokyo, Japan
Lives and works in London

TAL R
Born 1967
Tel Aviv, Israel
Lives and works in Copenhagen

TALLUR L.N.
Born 1971
India
Lives and works in India
and Korea

DAVID THORPE
Born 1972
London, UK
Lives and works in London

RYAN TRECARTIN
Born 1981
Webster, Texas, USA
Lives and works in Philadelphia

GAVIN TURK
Born 1967
Guildford, UK
Lives and works in London

LUC TUYMANS
Born 1958
Mortsel, Belgium
Lives and works in Antwerp

CY TWOMBLY
Born 1928
Lexington, Virginia, USA
Lives and works in Lexington
and Italy

U

PHOEBE UNWIN
Born 1979
Cambridge, England
Lives and works in London

V

BANKS VIOLETTE
Born 1973
Ithaca, New York, USA
Lives and works in New York

W

KELLEY WALKER
Born 1969
Columbus, Georgia, USA
Lives and works in New York

ANDY WARHOL
Born 1928
Pittsburgh, Pennsylvania, USA
Died 1987 New York

JONATHAN WATERIDGE
Born 1972
Zambia, Africa
Lives and works in London

MATTHIAS WEISCHER
Born 1973
Rheine, Germany
Lives and works in Leipzig

RACHEL WHITEREAD
Born 1963
London, UK
Lives and works in London

RICHARD WILSON
Born 1953
London, UK
Lives and works in London

JONAS WOOD
Born 1977
Boston, Massachusetts, USA
Lives and works in Los Angeles

JOHN WYNNE
Born 1972
Zweibrücken, Germany
Lives and works in London

Y

AARON YOUNG
Born 1972
San Francisco, USA
Lives and works in New York

LISA YUSKAVAGE
Born 1962
Philadelphia, Pennsylvania, USA
Lives and works in New York

Z

ZHANG DALI
Born 1963
Harbin, Heilongjiang Province, China
Lives and works in Beijing

ZHANG HUAN
Born 1965
An Yang City, He Nan Province, China
Lives and works in Shanghai and
New York

ZHANG WANG
Born 1962
Beijing, China
Lives and works in Beijing

ZHANG XIAOGANG
Born 1958
Kunming, Yunnan Province, China
Lives and works in Beijing

ARTISTS' CREDITS
Carl Andre courtesy DACS
Richard Artschwager courtesy DACS
Frank Auerbach courtesy
Marlborough Fine Art, London
Stephan Balkenhol courtesy DACS
John Chamberlain courtesy DACS
Peter Coffin courtesy the artist
and Galerie Perrotin, Paris
Rineke Dijkstra © Rineke Dijkstra
Tracey Emin courtesy DACS
Tracey Emin (I've Got It All) photograph
courtesy Jay Jopling/White Cube
Dan Flavin courtesy DACS
Robert Gober courtesy
Matthew Marks Gallery, New York
Nan Goldin © Nan Goldin
Leon Golub courtesy DACS
Andreas Gursky courtesy DACS
Duane Hanson courtesy DACS
Rachel Harrison courtesy the artist and
Greene Naftali Gallery, New York
Eva Hesse (Several)
© The Estate of Eva Hesse,
Hauser & Wirth Zürich/London
Damien Hirst courtesy DACS
Martin Honert courtesy DACS
Jörg Immendorff © The Estate of
Jörg Immendorff, courtesy Michael
Werner Gallery, New York/Berlin
Donald Judd courtesy DACS
Alex Katz courtesy DACS
Idris Khan © Idris Khan
courtesy Victoria Miro Gallery
R.B. Kitaj © The Estate of R.B. Kitaj
Sol LeWitt courtesy DACS
Sarah Lucas courtesy Sadie Coles
HQ, London

Robert Mangold courtesy DACS
Brice Marden courtesy DACS
Agnes Martin courtesy DACS
Josephine Meckseper courtesy DACS
Boris Mikhailov courtesy DACS
Malcolm Morley © Malcolm Morley
courtesy the artist and
Sperone Westwater, New York
Robert Morris courtesy DACS
Elizabeth Murray © Elizabeth Murray
courtesy Pace Wildenstein, New York
Bruce Nauman courtesy DACS
Hermann Nitsch courtesy DACS
Chris Ofili (Holy Virgin Mary)
photograph courtesy
Brooklyn Museum Archives
Paula Rego (Swallows the Poisoned
Apple) photograph courtesy
Marlborough Fine Art, London
Daniel Richter courtesy
Contemporary Fine Arts, Berlin
Sterling Ruby courtesy The Pace Gallery
Thomas Ruff courtesy DACS
Robert Ryman courtesy
Pace Wildenstein, New York
David Salle courtesy DACS
Thomas Schütte courtesy DACS
Thomas Scheibitz courtesy DACS
Richard Serra courtesy DACS
Dirk Skreber courtesy DACS
Frank Stella courtesy DACS
Hiroshi Sugimoto the artist's
former collection
David Thorpe courtesy
Maureen Paley, London
Banks Violette courtesy
Maureen Paley, London
Kelley Walker © Kelly Walker, courtesy
Paula Cooper Gallery, New York
Andy Warhol © The Andy Warhol
Foundation for the Visual Arts/
Artists Rights Society (ARS),
New York/DACS, London 2009
Matthias Weischer courtesy DACS

PHOTO CREDITS
Tom Baker
Adam Bartos
Gerd Geyer/Hattingen
Kavanagh/Rex Features
James King
Russell Lee
Jochen Littkemann
Antony Makinson at
Prudence Cuming Associates
Robert McKeever
Jenny Okun
Anthony Oliver
Hugh Palmer
Prudence Cuming Associates Limited
Abby Robinson
Sipa Press/Rex Features
Norbert Schoerner
Francis Ware
Stephen White
Zindman/Fremont

Sensation installation views
© Royal Academy of Arts

Commissioned photography by
Leon Chew, 'The Hysteric Cell',
from a series of photographs made
during the construction of the
Saatchi Gallery, Duke of York's
Headquarters, Summer 2008

EDITOR-IN-CHIEF
Edward Booth-Clibborn

ART DIRECTION AND DESIGN
Value and Service

Edward Booth-Clibborn © 2011
Norman Rosenthal © 2009
Richard Cork © 2009
Steve Martin © 2009
Brian Sewell © 2009

Copyright for all images are the
property of the artists © 2011

First published as an Opus in 2009
by Opus Media Group
Second Edition (Revised) published
by Booth-Clibborn Editions 2011

A Cataloguing-in-Publication
record for this book is available
from the Publisher.

ISBN 978-1-86154 315 8
Printed in China